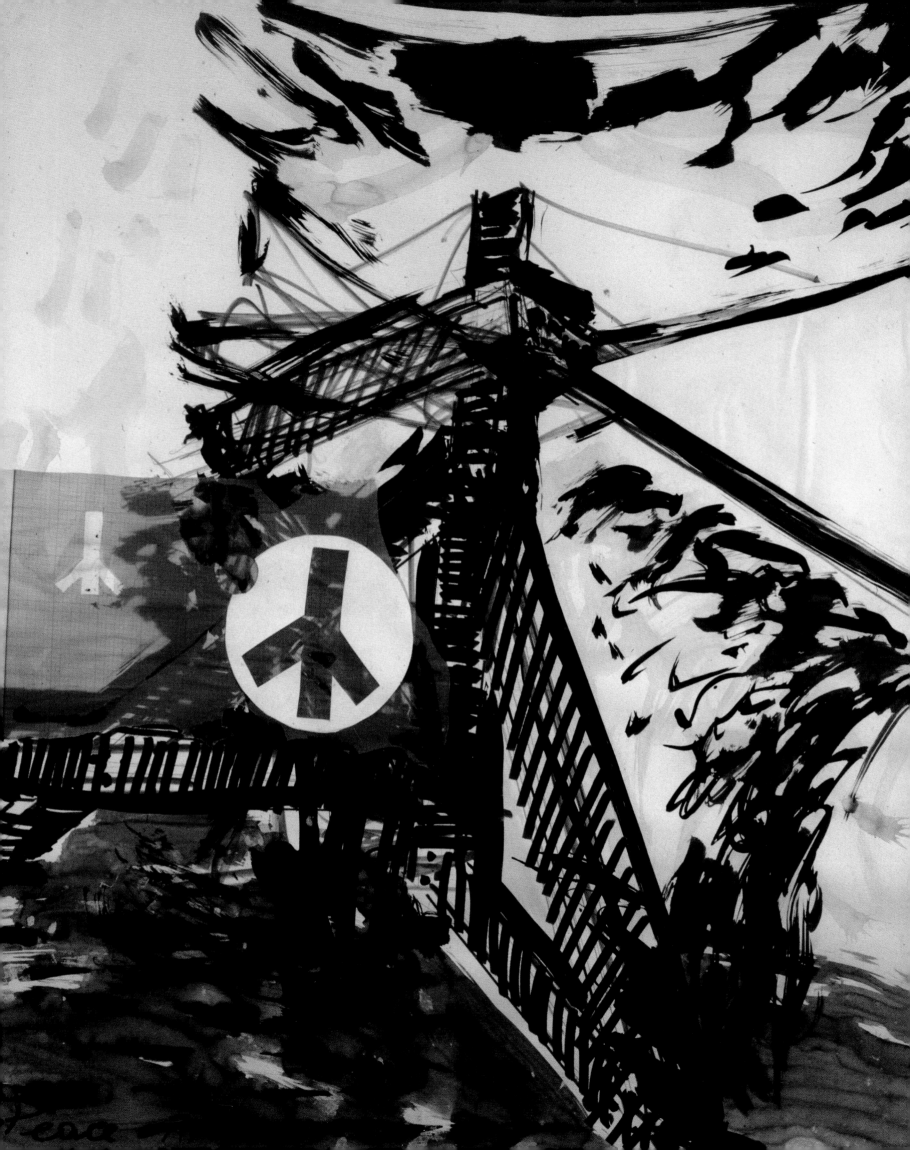

MELISSA HO

THOMAS CROW

ERICA LEVIN

KATHERINE MARKOSKI

MIGNON NIXON

MARTHA ROSLER

Edited by Melissa Ho

ARTISTS RESPOND

American Art
and the
Vietnam War,
1965–1975

Smithsonian American Art Museum,
Washington, D.C., in association with
Princeton University Press,
Princeton and Oxford

ARTISTS RESPOND
American Art and the Vietnam War, 1965–1975

Edited by Melissa Ho

Authored by Melissa Ho, Thomas Crow, Erica Levin, Katherine Markoski, Mignon Nixon, and Martha Rosler

with contributions by Robert Cozzolino, Joe Madura, Sarah Newman, and E. Carmen Ramos

Published in conjunction with the exhibition of the same name, on view at the Smithsonian American Art Museum, Washington, DC, March 15, 2019 to August 18, 2019.

The exhibition will tour to the Minneapolis Institute of Art from September 28, 2019 to January 5, 2020.

© 2019 Smithsonian American Art Museum

Produced by the Publications Office, Smithsonian American Art Museum, Washington, DC, americanart.si.edu

Theresa J. Slowik, Chief of Publications
Tiffany D. Farrell, Editor
Karen Siatras, Designer
Aubrey Vinson, Permissions Coordinator
Theresa Blackinton, Copyeditor
Julianna C. White and Magda Nakassis, Proofreaders
Laura Augustin, Curatorial Assistant
Helen McNiell of Studio A, Robert Killian, and Nathaniel Phillips, Production Designers

Typeset in Publico and Acumin and printed on GardaMatt Art by Verona Libri in Italy

The Smithsonian American Art Museum is home to one of the largest collections of American art in the world. Its holdings—more than 43,000 works—tell the story of America through the visual arts and represent the most inclusive collection of American art of any museum today. It is the nation's first federal art collection, predating the 1846 founding of the Smithsonian Institution. The Museum celebrates the exceptional creativity of the nation's artists, whose insights into history, society, and the individual reveal the essence of the American experience. For more information, write to:

Office of Publications
Smithsonian American Art Museum
MRC 970, PO Box 37012
Washington, DC 20013-7012

Published by the Smithsonian American Art Museum in association with Princeton University Press, Princeton and Oxford, press.princeton.edu

Smithsonian American Art Museum

Library of Congress Cataloging-in-Publication Data

Names:
Ho, Melissa. One thing. | Smithsonian American Art Museum, organizer, host institution. | Minneapolis Institute of Art, host institution.

Title:
Artists respond: American art and the Vietnam War, 1965–1975 / Melissa Ho, Thomas Crow, Erica Levin, Katherine Markoski, Mignon Nixon, and Martha Rosler; edited by Melissa Ho.

Other titles:
Artists respond (Smithsonian American Art Museum)

Description:
Washington, DC: Smithsonian American Art Museum; Princeton: in association with Princeton University Press, 2019. | "Published in conjunction with the exhibition of the same name, on view at the Smithsonian American Art Museum, Washington, DC, March 15, 2019 to August 18, 2019." | Includes bibliographical references and index.

Identifiers:
LCCN 2018054925 | ISBN 9780691191188 (hardback)

Subjects:
LCSH: Art—Political aspects United States—History—20th century—Exhibitions. | Art, American—20th century—Exhibitions. | Art and war—Exhibitions. | Art and society—United States—History—20th century—Exhibitions.

BISAC: ART / Art & Politics. | ART / American / General. | ART / History / Contemporary (1945-). | ART / Popular Culture. | HISTORY / Military / Vietnam War. | ART / Mixed Media.

Classification:
LCC N72.P6 A794 2019 | DDC 701/.03—dc23

LC record available at https://lccn.loc.gov/2018054925

Cover: Martha Rosler, *Red Stripe Kitchen* (detail), from the series *House Beautiful: Bringing the War Home*, ca. 1967-72, photomontage. See p. 94.

Back cover: William Copley, *Untitled*, from the portfolio *Artists and Writers Protest against the War in Viet Nam*, 1967, screenprint. See p. 80.

Frontispiece: Mark di Suvero, *For Peace* (detail), 1971-72, ink, watercolor, and collage. See p. 250.

pp. vi-vii: Edward Kienholz, *The Non-War Memorial Book* (detail), 1972. See p. 207.

p. viii: Claes Oldenburg, *Lipstick (Ascending) on Caterpillar Tracks* (detail), 1969, photo of installation by Shunk-Kender. See p. 142.

p. x: Carlos Irizarry, *Moratorium* (detail), 1969, screenprint. See pp. 152-53.

pp. xvii-xix: Wally Hedrick, *War Room* (detail and interior view), 1967-68/2002, oil on canvas. See p. 106.

Artists Respond: American Art and the Vietnam War, 1965–1975
is organized by the Smithsonian American Art Museum
with generous support from:

Anonymous

Diane and Norman Bernstein Foundation

Sheri and Joe Boulos

Gene Davis Memorial Fund

Glenstone Foundation

Norbert Hornstein and Amy Weinberg

Henry Luce Foundation

Nion McEvoy and Leslie Berriman

Cindy Miscikowski

Daniel C. and Teresa Moran Schwartz

Smithsonian Scholarly Studies Grant Program

Terra Foundation for American Art

HENRY LUCE
FOUNDATION

TERRA
FOUNDATION FOR AMERICAN ART

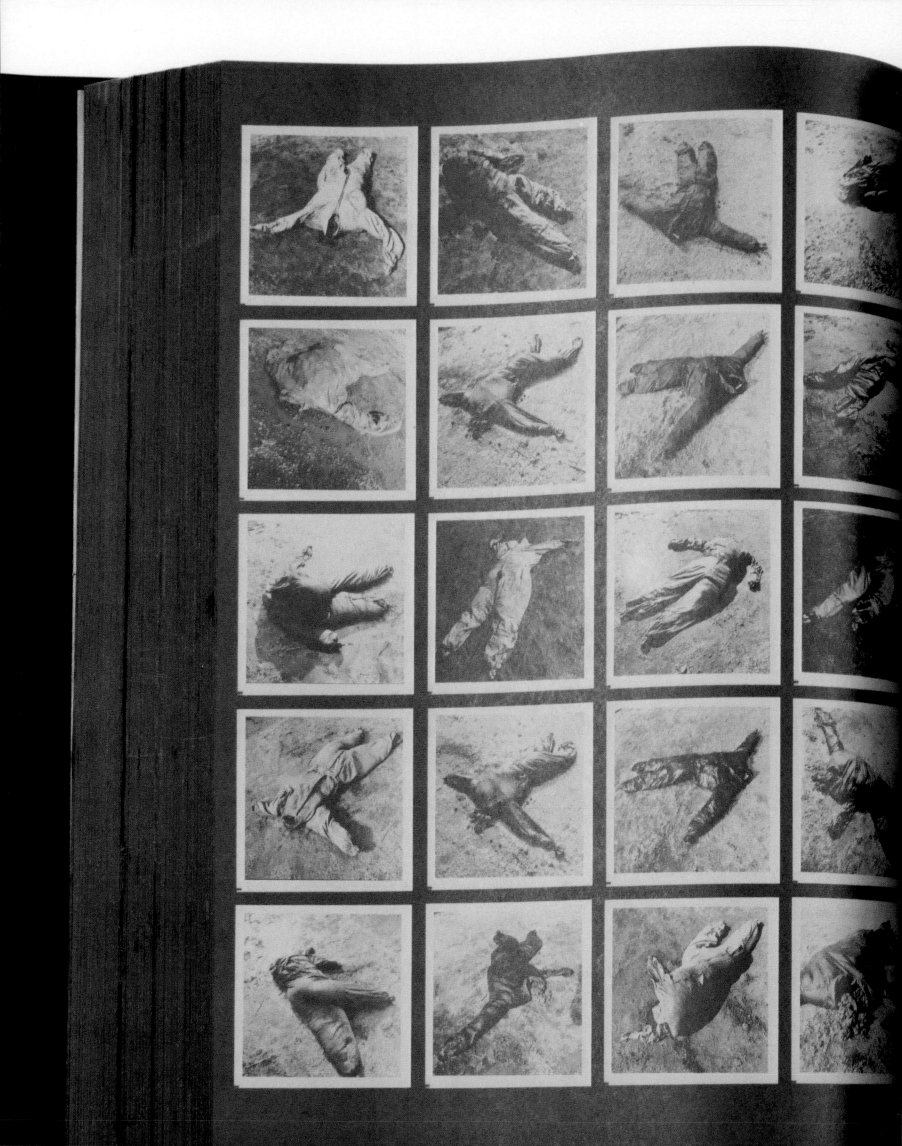

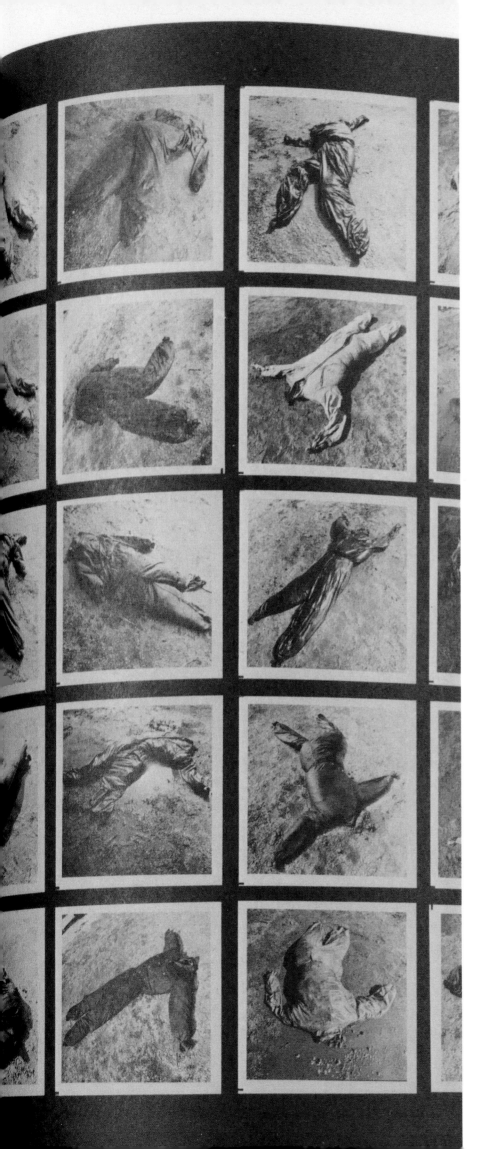

Contents

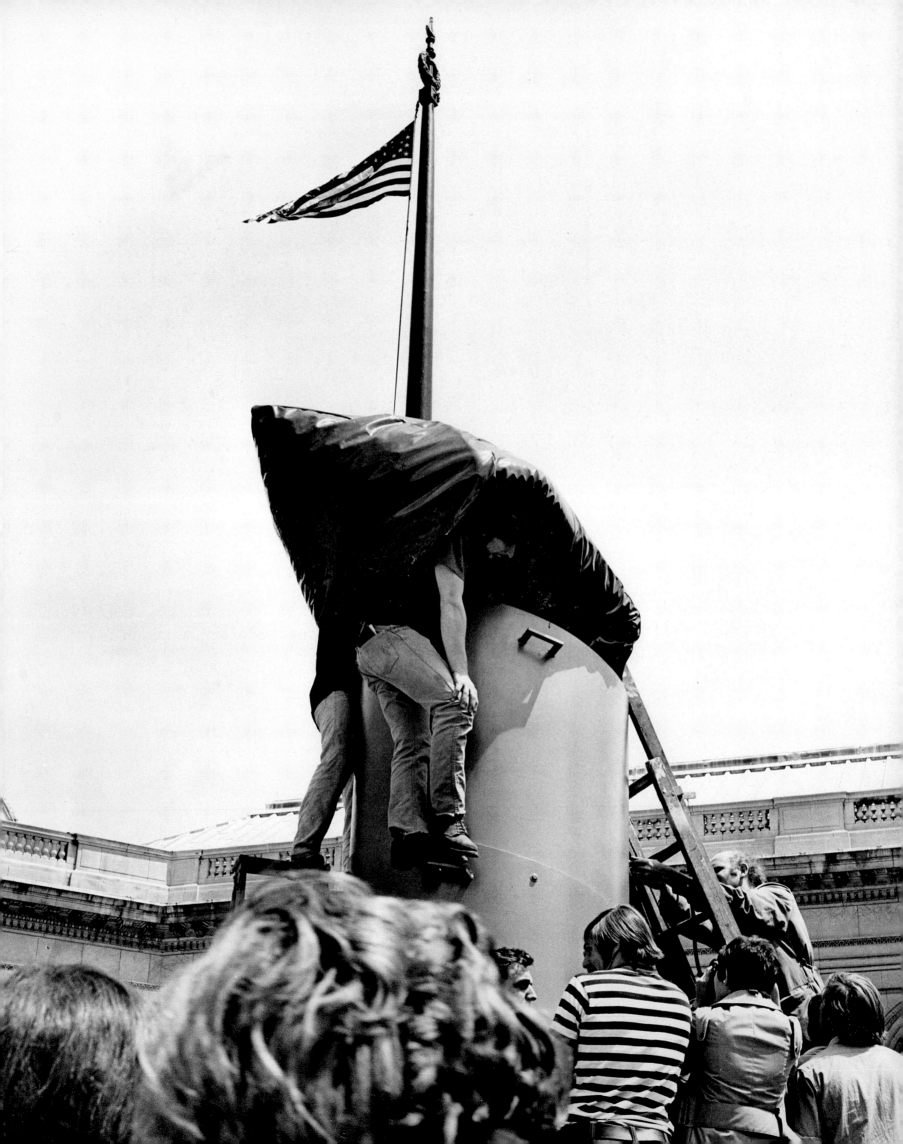

Lenders to the Exhibition

Jason Aberbach
The Art Institute of Chicago
Baltimore Museum of Art
The Box, LA
Brooklyn Museum
The Chris Burden Estate
Mel Casas Family Trust
The Estate of Rosemarie Castoro
Corbett vs. Dempsey
Corita Art Center
Electronic Arts Intermix
Fine Arts Museums of San Francisco
The Dan Flavin Estate
Inez Cindy Gabriel
The Getty Research Institute
Glenstone Museum
Hans Haacke
The Wally Hedrick Estate
Jon Hendricks
Hirshhorn Museum and Sculpture Garden
International Center of Photography
The J. Paul Getty Museum
Yoko Ono Lennon
The Paul and Karen McCarthy Collection
The Metropolitan Museum of Art
Linn Meyers

Mitchell-Innes & Nash
Museum of Contemporary Art, Chicago
National Gallery of Art
The New School Art Collection
Oakland Museum of California
Claes Oldenburg
Paula Cooper Gallery
Pennsylvania Academy of the Fine Arts
Philip Jones Griffiths Foundation
Danniel Rangel
Martha Rosler
San Francisco Museum of Modern Art
San Francisco State College Art Department Collection
Stephen Simoni + John Sacchi
Tate
University of California, Berkeley Art Museum
 and Pacific Film Archive
William Weege
Terri Weissman
Whitney Museum of American Art
Leah and Andrew Witkin
Yale University Art Gallery
Yayoi Kusama Inc.
Zeno X Gallery

several private collectors

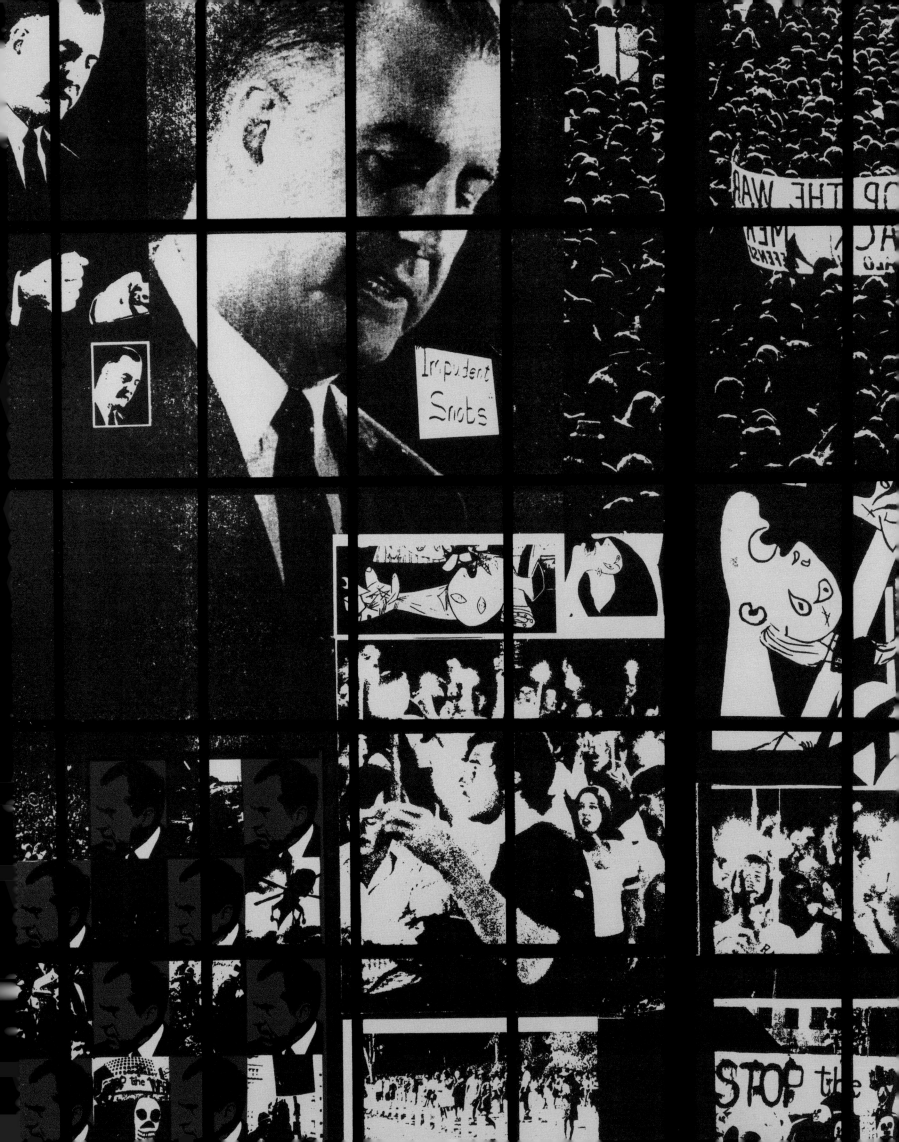

Director's Foreword

The late 1960s and early 1970s is one of the richest and most examined periods in all of American art. Yet this book and exhibition are the first to deeply explore how the turbulence of the Vietnam War era influenced the art of its time and forever changed it. While it might seem natural to consider the aesthetic innovations of this period in relation to their backdrop of broad social upheaval, initial surveys of sixties art mentioned the impact of the Vietnam War (and of the antiwar movement that it inspired) only obliquely, if at all. Contemporary commentators remarked that, despite the war's huge import, it seemed to have little effect on visual art—because it could not be seen clearly in the art then most well known and acclaimed. Critically and commercially prominent movements such as minimalism and pop were frequently interpreted as apolitical and aloof from current events. But as this project reveals, the passionate debates and powerful emotions elicited by the Vietnam War were inescapable. Artists of all backgrounds created work that testifies to how the war prompted widespread moral reckoning and civic engagement. At the time, much of this art was unseen or critically ignored, marginalized by art institutions and the market. In the decades since, generations of scholars and curators have worked to expand the canon of the 1960s and to render more visible art of legible emotional and political content as well as important work created by women and people of color. *Artists Respond: American Art and the Vietnam War, 1965-1975* confirms an important shift in our understanding of the intersection of American art and war, a needed reevaluation that has been achieved only with the passage of time.

The opening of this exhibition marks thirty years since the last curatorial project of comparable ambition, if not parallel scope—*A Different War: Vietnam in Art*, which Lucy R. Lippard organized in 1989 for the Whatcom Museum of History and Art in Bellingham, Washington. Lippard had herself been a key participant in artist activist groups against the war and began work on *A Different War* little more than a decade after the unification of Vietnam. Her exhibition included American art made both during the conflict and since 1975, but was weighted toward the latter, emphasizing themes of commemoration, aftermath, and trauma. This orientation reflected the circumstances of the 1980s, when the tumult of the Vietnam War period required no explanation and the psychic wounds of the conflict were still fresh. The current exhibition addresses a very different audience, one mostly born since the war's end or otherwise too young to know the period other than through its renderings in popular culture. Not an eyewitness to this history but benefiting from the historical, archival, and theoretical work that has come since, curator Melissa Ho has created a powerful exhibition both challenging and revelatory. *Artists Respond: American Art and the Vietnam War, 1965-1975* brings together nearly one hundred works, ranging across a stunning array of material and aesthetic approaches. More than forty years after the last American soldiers withdrew from Sài Gòn, this art affords a "real time" view of the Vietnam era as seen through the eyes of artists. Each work discussed in these pages was created as the conflict raged at home and abroad and is a record of how artists absorbed and contended with the dilemmas of the war as they unfolded.

The Vietnam War was a divisive and controversial event whose meanings and impacts are still debated. Insofar as the art in this exhibition necessarily highlights social and political ruptures still felt in American life, the project could not avoid touching on areas that are contentious or sensitive. Instead, *Artists Respond: American Art and the Vietnam War, 1965–1975* demonstrates how the breakdown in national consensus prompted by the war led to profound upheavals not just in society, but in art—and that this led to new ways of making and thinking about aesthetic meaning. SAAM is well situated to foster dialogue on this subject; as the nation's museum of American art, we commit to illuminating the American experience through the contributions and stories of artists. The outstanding financial help of an array of foundations and individuals allows us to undertake this important work. The museum is deeply grateful to the Henry Luce Foundation, the Terra Foundation for American Art, and the Smithsonian Scholarly Studies Grant Program for their generous and timely awards that enabled us to pursue this project. We owe warm thanks as well to the Diane and Norman Bernstein Foundation, Sheri and Joe Boulos, the Gene Davis Memorial Fund, the Glenstone Foundation, Norbert Hornstein and Amy Weinberg, Nion McEvoy

and Leslie Berriman, Cindy Miscikowski, and Daniel C. and Teresa Moran Schwartz, who made important financial contributions. We salute their commitment and leadership in encouraging adventurous exhibitions and new scholarship.

We also wish to warmly acknowledge and thank the many private individuals and museum colleagues who recognized the significance of this project and allowed precious works from their collections to be a part of it. With the generosity and support of our lenders—which include many artists and artists' estates—we were able to assemble an eloquent and stunning presentation.

Curator Melissa Ho has been unwavering in her focus and examination of this chapter in American art. In the pages of this catalogue, she weaves a complex story of how art, politics, and history are deeply interlinked, even when not obvious at first glance. Her sophisticated vision and research will shape future narratives of modern and contemporary art.

A project of this complexity and scale requires the dedication and talents of the entire museum staff and our commissioners. I offer them my sincere admiration and, on their behalf, proudly present to the public this groundbreaking exhibition and publication.

Stephanie Stebich
The Margaret and Terry Stent Director
Smithsonian American Art Museum

Acknowledgments

Artists Respond: American Art and the Vietnam War 1965-1975 came into being thanks to the remarkable commitment of the Smithsonian Institution. I feel fortunate to have had the opportunity to create such an unusual exhibition—one that is both thematic and historical in approach, and which encompasses a diverse array of artists. Such a curatorial project takes much time to develop and is intrinsically challenging to organize and fund. The art in this exhibition also reflects a painful period in the life of our nation, one more easily avoided than engaged. For the Smithsonian to endorse and encourage this presentation therefore required both imagination and courage, at levels for which I am grateful. I thank John Davis, provost of the Smithsonian Institution, and Stephanie Stebich, director of the Smithsonian American Art Museum (SAAM), for their unwavering advocacy, and their faith in my stewardship. Rachel Allen, deputy director (recently retired); Virginia Mecklenburg, chief curator; and E. Carmen Ramos, deputy chief curator, have been equally generous in their support. Elizabeth Broun, director emerita, recognized the exhibition's significance and played a key role in securing it a home at SAAM. My research for *Artists Respond* began while I was a curator at the Smithsonian's Hirshhorn Museum and Sculpture Garden, and I am indebted to Chief Curator Stéphane Aquin and Director Melissa Chiu for their crucial endorsement of the project at its earliest stages, and for their lasting support.

Numerous people helped me shape and conceptualize this exhibition. Their contributions strengthened the project immeasurably. I owe sincere thanks to Katherine Markoski, a trusted partner from the outset. She has been a source of precious advice and insights, and provided superb research and writing for the catalogue. Warm thanks go also to Thomas Crow, Erica Levin, Mignon Nixon, and Martha Rosler. Their acumen, creativity, and deep knowledge have been inspiring, and their beautiful essays elevate this volume. Robert Cozzolino, curator of paintings at the Minneapolis Institute of Art, has been an extraordinarily generous collaborator and contributed outstanding texts to the catalogue. I thank my Smithsonian colleagues Lawrence-Minh Bùi Davis, curator of the Asian Pacific American Center, and Frank Blazich, curator at the National Museum of American History, for offering me their expertise and sound counsel over the last two years. Elizabeth Broun, Emily Hage, Lynne Cooke, Lucy Lippard, and Matthew Israel read early versions of my manuscript and provided much valued feedback. My gratitude extends also to my fellow curators at SAAM, on whom I consistently rely for advice: Saisha Grayson, Eleanor Harvey, John Jacob, Karen Lemmey, Crawford Alexander Mann III, Virginia Mecklenburg, and Leslie Umberger. I am especially thankful to E. Carmen Ramos for contributing vital research and writing to the book, and to Sarah Newman, not only for her writing but for her brilliant organization of *Tiffany Chung: Vietnam, Past Is Prologue*, an important and poignant companion exhibition to *Artists Respond*, on view at SAAM. I wish to acknowledge as well my former colleagues at the Hirshhorn—Stéphane Aquin, Evelyn Hankins, Mika Yoshitake, Larry Hyman, Betsy Johnson, Gwynne Ryan, Rhys Conlon, and Stephanie Lussier—for their professional generosity and continued friendship.

The most essential support has come from my family, Alexander Williams and Marcel Ho. I owe them

thanks that cannot be expressed in words. I lost my dear father, Samuel Ho, while working on *Artists Respond*, a lack I feel keenly as the project comes to completion. I dedicate this book to the memories of him and my mother, Sharon Ho—the two people who would have been most proud and gratified by its realization.

A multitude of colleagues at the Smithsonian American Art Museum have played key roles throughout our many months of preparation. The exhibition has benefited vitally from Curatorial Researcher Joe Madura and Curatorial Assistant Laura Augustin. Joe provided crucial administrative support and carried out extensive research that laid much of the groundwork for the checklist. He also wrote perceptive entries for the catalogue. Joining the project after Joe, Laura has been instrumental in its realization, expertly handling an enormous array of art historical, logistical, and diplomatic tasks. Neither the installation nor the publication could have been completed without her intelligence and industry. For indispensable administrative support, I thank Elizabeth Anderson, Anne Hyland, Stacy Mince, and, in the director's office, Kate Fernstrom and Jean Lavery. Zoe Kwa, Margaret MacDonald, Katrina Lukes, Samuel Shapiro, and Emily Rohan all generously gave their time as interns at SAAM or the Hirshhorn to lend valuable research assistance. I am also indebted to Anna Brooke, Anne Evenhaugen, and Alexandra Reigle at Smithsonian Libraries and Marisa Bourgoin at the Archives of American Art for their help.

The catalogue for this exhibition depended on the commitment and expertise of the publications department. I am grateful to Theresa Slowik for her enthusiasm and leadership on the project, particularly in managing the collaboration with Princeton University Press. Tiffany Farrell brought wisdom, patience, and thoughtful insight to the editing of this volume. Every element of the catalogue is stronger thanks to her. Karen Siatras showed enormous grace under pressure in creating an elegant and navigable design for this complex book. Her talent and dedication were great gifts to the project. Helen McNiell of Studio A and Robert Killian made crucial design contributions, Theresa Blackinton and Julianna White provided editing, and Kelly Jerkins lent administrative support. Aubrey Vinson handled the immense task of securing image permissions with remarkable industriousness and good cheer.

I deeply appreciate the creativity and resourcefulness of the exhibitions office under the leadership of David Gleeson. The design of the installation took form over the course of more than two years in which I worked closely with Eunice Park Kim, who brought to bear tremendous skill, professionalism, and attention to detail. I thank as well Adam Rice, Grace Lopez, Erin Bryan, Harvey Sandler, Scott Rosenfeld, Martin Kotler, Tom Irion, and the rest of the exhibits team for their work on this project. In the education department, led by Carol Wilson, I owe special thanks to Joanna Marsh and Melissa Hendrickson, with whom I have shared many long conversations about the interpretative elements of the show. Their dedication and professionalism have been a great benefit. I thank Anne Showalter and Carlos Parada for creating the media components and Elizabeth Dale-Deines and Geoffrey Cohrs for their work with teachers and docents. Jennifer Lee has handled the enormous amount of registrarial work presented by an exhibition of this diversity and scale, and I am grateful for her commitment and steady hand. I thank Melissa Kroning, David DeAnna, Denise Wamaling, Lily Sehn, Riche Sorensen, Mildred Baldwin, and the rest of the registrars' department for their efforts on behalf of this project. The conservation team, led by Amber Kerr, has been instrumental to the show's success: I thank Daniel Finn, Gregory Bailey, Ariel O'Connor, Gwen Manthey, Catherine Maynor, and Casey Magrys. In development, I owe warm thanks to Donna Rim, Kate Earnest, and Elizabeth Daoust for graciously rising

to the challenge of raising funds for this exhibition. Thanks are also due to the department of external affairs and digital strategies, led by Sara Snyder. Laura Baptiste, Amy Hutchins, Kayleigh Bryant-Greenwell, Chavon Jones, Gloria Kenyon, Andrew Rondinone, Ryan Linthicum, Howard Kaplan, and Amy Fox, among many others, have made crucial contributions in the realms of communications, marketing, public programs, and special events. I am also very grateful to David Voyles, Doug Wilde, and Connie Badowski for their budgeting, administrative, and personnel expertise.

Countless individuals have been friends of this project, offering valuable information, advice, and assistance with research and loans. I have received crucial help from scholars and museum colleagues as well as numerous gallery directors and their staffs, collectors, artists, and artists' estates. Although it would be impossible to list all who deserve thanks, I wish to acknowledge: Susan Aberbach, Anthony Allen, Jennifer Alleyn, Anamarie Alongi, Carl Andre, Kathleen Ash-Milby, Jenny Baie, Anneliis Beadnell, Eve-Lyne Beaudry, Kristine Bell, Broc Bergen, Dorian Bergen, Christian Berger, Polina Berlin, Judith Bernstein, Susanneh Bieber, Jennifer Bindman, Courtney Willis Blair, Katherine Bourguignon, Hal Bromm, Josh Brown, Julia Bryan-Wilson, Timothy Anglin Burgard, Bianca Cabrera, Terry Carbone, Gary Carson, Mary Anne Carter, Bruce Casas, Grace Casas, Daisy Charles, Judy Chicago, Rebecca Cleman, Leontine Coelewij, Vivien Collens, Ina Conzen, Harry Cooper, Paula Cooper, John Corbett, Emily Cushman, Katherine Danalakis, Stephanie Daniel, Kimberly Davis, Jill Dawsey, Nancy de Antonio, René de Guzman, François de Menil, Mark di Suvero, Claudine Dixon, James Gong Fu Dong, Molly Donovan, Christine Downie, Caitlin Draayer, Stephanie Dudzinski, Fanella Ferrato, Rudolf Frieling, Anna Furney, Rupert García, Harry Gamboa Jr., Mark Godfrey, Jennie Goldstein,

Rita Gonzalez, Suzanne Greenawalt, Benedicte Goesaert, Danica Gomes, Hans Haacke, Martina Haidvogl, Samantha Halstead, Elizabeth Anne Hanson, Mazie Harris, Carrie Haslett, Jon Hendricks, Steve Henry, Jo Farb Hernández, Kristen Hileman, Meghan Hill, Alison Hoffman, Isabelle Hogenkamp, Heather Holden, Katherine Holden, Nancy Hom, Lisa Jann, Kim Jones, Leslie Jones, Frauke Josenhans, Yukie Kamiya, Anke Kempkes, Kathrin Kessler, Nancy Reddin Kienholz, James Kopp, Karen Kramer, Mark Lanctôt, Sarah Landry, Jeff Lee, Constance Lewallen, Fred Lonidier, Marita Loosen-Fox, Margo Machida, Julie Maguire, Keri Marken, Mara McCarthy, Karl McCool, Liza McLaughlin, Sean Meredith, Ivana Mestrovic, James Meyer, Lucy Mitchell, Gaby Mizes, Barbara Moore, Stacy Mueller, Yuta Nakajima, David Nash, Josephine Nash, Jennifer Noonan, David Novros, Steven O'Banion, Grady O'Connor, Claes Oldenburg, Amy Plumb Oppenheim, Lauren Palmor, Diana Pardue, Emily Park, Priya Parthasarathy, Jessica Pepe, David Platzker, Lois Plehn, Liliana Porter, Sukanya Rajaratnam, Emily Rales, Chris Rawson, Gale Rawson, Anne Reeve, Meredith Reiss, Nora Riccio, Silvia Rocciolo, Emily Rothrum, Paige Rozanski, Jack Rutberg, Mary Ryan, Mary Sabbatino, Peter Saul, Mary Savig, Carolee Schneemann, Jaime Schwartz, Rachel Selekman, Jonas Storsve, Megumi Takasugi, Jacqueline Tarquinio, Veerle Thielemans, Connie Tilton, Jesse Treviño, William Troughton, Eugenie Tsai, John Tyson, Claartje van Dijk, Christine Varney, Gabriel Velasquez, Lynn Warren, Jeffrey Weiss, Carol Wells, Cecilia Wichmann, Sarah Womble, Danielle Wu, Joyce Cannon Yi, and Karin Zonis-Sawrey.

I gratefully thank all of the individuals and institutional colleagues who granted loans to the exhibition. Their generosity has made this presentation possible. I also wish to express deep appreciation for the critical role played by the Terra Foundation for American Art and the Henry Luce Foundation.

Without their encouragement and exceptional support, the project could not have been realized. An award from the Smithsonian's Scholarly Studies Grant Program enabled my initial research, and I remain grateful for this early investment in the show. My warm thanks to all of our sponsors. These individuals and foundations deserve high praise for supporting this museum project.

My final thanks goes to the artists whose powerful works are presented here, especially those who shared with me their experiences of the Vietnam War era with moving generosity. These conversations have been an essential and rewarding part of my work over the last four years. I am supremely grateful to all who offered me their memories, insights, and reflections.

Melissa Ho
Curator of Twentieth-Century Art
Smithsonian American Art Museum

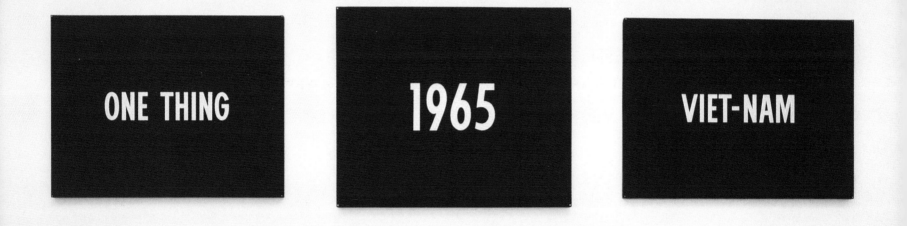

MELISSA HO

When I first encountered On Kawara's *Title* nearly ten years ago, I had never seen a photograph of the painting or heard of its existence. The work hung by itself, highlighted on an oversized wall at the entrance to the National Gallery of Art's display of modern and contemporary art [FIG. 1].[1] *Title* consists of three canvases, each a field of deep magenta punctuated by neatly lettered white text and—upon close inspection—tiny adhesive stars, one adorning each corner. Taken in at a glance, the words ONE THING / 1965 / VIET-NAM are immediately striking.

ONE THING: VIET-NAM
American Art and the Vietnam War

Created the year after Kawara settled in New York, *Title* was a breakthrough for the Japanese-born artist. It marked a turning point in his practice, initiating an engagement with time as subject matter that he pursued for the rest of his life. Following the trip-tych, Kawara embarked on his *Today* series of date paintings; he completed his last, of hundreds, in 2013. Each of these works records the date of its making on a monochromatic ground of gray, red, or blue and is free of overt emotional or topical content [FIG. 2]. The carefully rendered works refer again and again to "today," conveying the shape and experience of time, how it cycles and accumulates, more than imparting the particulars of any historical moment.

Title, however, is endowed with powerfully spe-cific connotations. Unique within Kawara's oeuvre, it names a place, "VIET-NAM," in combination with the year it was made, "1965." In 1965—and still for many Americans even today—the country of Vietnam was associated with one thing only: war. For the Vietnamese, the war being waged there was both a complex civil conflict and a chapter in a much longer history of armed struggle against foreign domination, fought previously against the Chinese, the Japanese, and the French. For Americans, 1965 ushered in a new phase in the fight against communist North Vietnam, which the United States had been involved in since the early 1950s. After years of providing massive economic and military support, first to France and subse-quently to the state of South Vietnam, the United States took the consequential step of committing ground troops to the south and beginning a bomb-ing campaign against the north.

FIG. 1
On Kawara, *Title*, 1965.
See p. 41

At the time he created *Title*, Kawara could not have guessed that the war in Vietnam would continue another ten years, claiming millions of lives and resulting in a mass migration of refugees from Southeast Asia. Yet he understood enough of the human and geopolitical stakes to employ the words "ONE THING,"[2] a phrase that seems to anticipate the overwhelming presence the Vietnam War would soon have in the public consciousness. As the war widened and casualties mounted, more observers in the United States would become alarmed by developments in Southeast Asia. That Kawara was already alert to the trauma unfolding there is perhaps unsurprising; he had direct experience of war—and of the force of U.S. military power—having been a twelve-year-old in Japan when atomic bombs were dropped on Hiroshima and Nagasaki.[3]

The brushwork in *Title* is uninflected and tidy.[4] Yet the painting, through its understatement, broadcasts a strong sense of moral urgency. Kawara is well-known for his reticence. For most of his career—in fact, since 1965—he refused to grant interviews or make public statements. That such a self-effacing, reserved artist created a painting that so pointedly references a current event seemed to me remarkable upon first sight. It was evidence of how intensely the war in Vietnam was experienced even from afar. And it made me wonder, were there other unexpected traces of the Vietnam War to be found in the art of its time?

The 1960s had begun dominated by American art movements considered cool and autonomous. It ended with a small but influential wave of artists choosing to *engage*—with their present moment, with politics, and with the public sphere. Though far from the only social factor, America's war in Vietnam profoundly influenced this shift from ideals of aesthetic purity toward a realm of shared conscience and civic action. Due to the military draft, unprecedented media coverage of combat, and mounting evidence of a "credibility gap" in the government's account of events, the Vietnam War had pervasive impact. Indeed, by the late 1960s, the war loomed, for many Americans, as *the* "one thing." Among visual artists, there was no consensus about how best to address the war through art, or even whether this was an appropriate goal. Some sought in their work to raise political consciousness about the Vietnam War and thus, it was hoped, to help end it. Many others, while not explicitly activist in their practice, produced work steeped in the iconography and emotions of the conflict. As we trace how the effects of the war interacted with broader developments in American art between 1965 and 1975, we see a revival of openly affective imagery, a widespread preoccupation with the body and its vulnerability, and an embrace of facts or information as material for art. New artistic genres, all oriented toward narrowing the gap between art and life, emerged—such as body art, institutional critique, documentary art. So too did an ever greater range of artistic voices, as people of color and women demanded to have their perspectives on the war heard. This catalogue brings together both well-known and rarely discussed works, presenting an era in which artists struggled to synthesize the turbulent times and participated in a process of free and open questioning inherent to American civic life.

Scope of the Exhibition

An exploration of the impact of the Vietnam War on American art is a weighty and sobering project. At its center is a traumatic event—the war itself—that, for many, makes this art history painful to contemplate. For those who lost family, comrades, culture, or homeland, the war is not over; their losses continue to be felt every day. Moreover, the Vietnam War is a subject that for years has caused either loud disagreement or terrible silence among Americans. It is a war of countless and often contradictory perspectives that, as a country, we have struggled

FIG. 2
On Kawara, *JAN. 4, 1966*,
1966, 8 × 10 in.; *11 ABR. 68*,
1968, 10 × 13 in.; *NOV.3, 1967*,
1967, 10 × 13 in.; *24 FEV. 1969*,
1969, 8 × 10 in.; *FEB. 5, 1970*,
1970, 10 × 13 in.; all acrylic on
canvas, all from *Today* series,
1966–2013. *FEB. 5, 1970* also
from *Everyday Meditation*
(97 paintings from *Today*
series). Courtesy One Million
Years Foundation and David
Zwirner

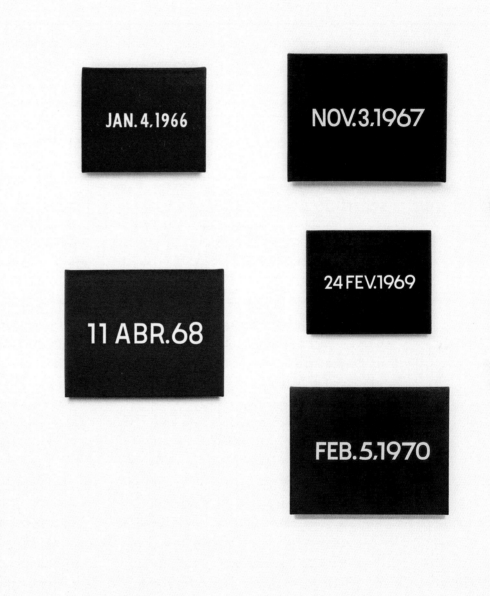

to recognize and discuss. Reflecting the split state of opinion over the lessons and meanings of the Vietnam War, its historical study in the United States has been divided since the 1960s between a dominant, so-called "orthodox school" of left-liberal scholars and a "revisionist school" of right-leaning ones. Their interpretations differ on the case for the U.S. intervention in Southeast Asia, the origins and autonomy of the insurgency in South Vietnam, and the motivations of Hồ Chí Minh, among other topics.[5] In recent decades, these clashing American narratives have been increasingly challenged by a new generation

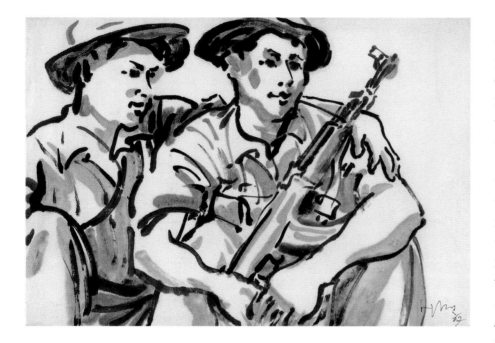

FIG. 3
Colonel Quang Tho, *Untitled*, 1967, black ink and wash painting on handmade paper, The British Museum, Purchase from Mrs. Thu Stern. Quang Tho was an artist who served in the People's Army of Vietnam during both the French and American wars.

of historians who engage a more diverse range of arguments and sources on the conflict. Benefiting from improved access to archives in Vietnam and the former communist world, study of the war today focuses less on American motives and consequences, and more on wartime Vietnamese agency, society, and politics. The emergent field of critical refugee studies has further expanded the story of the Vietnam War beyond 1975, demanding that the lives and experiences of Southeast Asian refugees, and the forces that displaced them, be strenuously reckoned with.[6]

Artists Respond: American Art and the Vietnam War, 1965–1975 is not a monumental narrative that attempts to tell the story of the war from all sides—military and civilian, communist and anti-communist, American and Southeast Asian, dove and hawk.[7] Rather, it aims to historicize a specific perspective on the war not widely discussed—that of America's fine artists. The shattering of national consensus in the United States over the Vietnam War prompted an intense questioning of authority, both political and aesthetic. The socially critical, formally innovative art that developed under these

conditions, and which is the focus of this book, contrasts sharply with that made during the same period in Vietnam, where nationalism and wartime service were overwhelming concerns. In the Democratic Republic of Vietnam (DRV) in the north, visual artists were required to join the artists' union and follow Communist Party dictates of subject matter and style. Largely taking the form of posters, documentary photography, and combat art, visual production under the DRV stressed values of solidarity and sacrifice rather than individuality or opposition [FIG. 3]. In the Republic of Vietnam in the south, artists were permitted to experiment with abstraction and sell their work independently but, as in the communist north, antiwar commentary was forbidden. As Southeast Asian art historian Nora Annesley Taylor has observed, painters working in the south generally pursued a "romanticized realism" that yielded works not dissimilar from the landscapes and portrayals of workers and soldiers produced in the north.[8]

The fifty-eight artists and artist groups represented in this exhibition worked free of the deprivations and demands of total war endured by their counterparts in North and South Vietnam. With important exceptions, they experienced the war—as did the vast majority of Americans—at a physical remove. They lived it around the dinner table, in front of the television, sometimes in the streets. Included in this study are artists who, regardless of their country of origin or nationality, worked in the United States at the time or otherwise can be understood as participating in America's cultural self-interrogation about the war, as well as in the formation of American art history. Many were deeply conflicted about the American-led war in Vietnam, if not openly critical of it. That no art in the exhibition expresses full-throated support for the U.S. war effort both reflects the widespread unpopularity of the conflict by the late 1960s[9] and confirms the inclination of modern artists to identify

with progressive or utopian projects.[10] These were independent artists, creating work unsanctioned by government or industry. They took full advantage of their right to personal expression and public dissent.

Highlighting the period between 1965, the year the United States sent its first combat troops to Vietnam, and 1975, when the last Americans evacuated Sài Gòn, this gathering of works shows artists contending with the dilemmas of the war as it unfolded. Rather than exploring issues of commemoration and aftermath in relation to the Vietnam War, I have chosen to emphasize a "present-tense" experience of the war period, which reveals artists striving to absorb and address momentous events in real time. The moral urgency of the war both galvanized individual creators and inflected the course of entire movements, changing how art was talked about, created, and understood in the United States. The pieces in the exhibition have been selected for their aesthetic impact and ambition, and for the power with which they convey the pressures and debates of the Vietnam War era. Collectively, they demonstrate how the war ran as an undercurrent through consequential developments in art practice throughout the decade. They show, too, how deeply some American artists reflected on the costs and consequences of war and how their thinking led to new ways of visualizing and critiquing a distant conflict.

Currents of international influence and exchange naturally run through this story. Among American artists who actively opposed the Vietnam War are several—including Leon Golub, Hans Haacke, Jon Hendricks, Peter Saul, Nancy Spero, and May Stevens— who lived in Paris earlier in their careers. There they developed artistically at a distance from the dominant modernist discourse of the New York school. Many were familiar with the consequences of French colonialism and well aware of the role French artists had played in opposing the First Indochina War (1946–1954). That the French past in

Vietnam was a direct antecedent to the American experience is referenced in an open letter published in the *New York Times* on June 27, 1965, one of the first public protests made by American artists against the Second Indochina War (that is, America's Vietnam War). Initiated by the group Artists and Writers Protest, it reads: "A decade ago, when the people of Vietnam were fighting French colonialism, the artists and intellectuals of France—from Sartre to Mauriac, from Picasso to Camus—called on the French people's conscience to protest their leaders' policy as immoral and to demand an end to that dirty war—'la sale guerre.' Today we in our own country can do no less."[11]

Also notable in this collection are the number of U.S.-based artists who had personal experience of war, having either served in wars abroad or come from countries occupied or devastated in prior conflicts. The latter include Kawara, Yayoi Kusama, and Yoko Ono from Japan, Haacke from Germany, Jean Toche (of Guerrilla Art Action Group, or GAAG) from Belgium, and Tomi Ungerer of Alsace. Mark di Suvero is another example; born in China to Italian parents, he lived as a child in Japanese-controlled Tianjin and cites his first-hand witnessing of colonial occupation as the root of his eventual staunch opposition to the American war in Vietnam.[12] These varied transnational perspectives and experiences prove significant in the context of a country whose population has largely been spared warfare within its borders since the nineteenth century. Fortunate to be so sheltered, the majority living in the continental United States has needed to be reminded that mass death and destruction are real phenomena—as Leon Golub insisted, not "make-believe" or "symbolism."[13] Significantly, it is often war veterans who strive to deliver this message. In *Artists Respond*, these include T. C. Cannon, Rupert García, Kim Jones, and Jesse Treviño, who fought in Southeast Asia; Mel (Melesio) Casas, Wally Hedrick,

and Robert Morris, who served in the Korean War; and Emile de Antonio, Douglas Huebler, and Leon Golub, all veterans of the Second World War. Other artists in the show, including Benny Andrews, Dan Flavin, Donald Judd, and Malaquias Montoya, also served in the armed forces, though either not abroad or during a period of active war.[14]

Missing here from the spectrum of global American voices are artists of Vietnamese descent.

In the 1960s, Asian Americans represented less than six-tenths of one percent of the U.S. population[15] and had yet to become welcome participants in the mainstream art world. Concentrated in urban ethnic ghettos and on the islands of Hawai'i, few traced their roots to Southeast Asia; one study estimates that only between 16,000 and 37,000 people originating from Vietnam lived in the United States before 1975.[16] Due to the influx of refugees from

Back then a lot of people went collecting scrap metal and other recycling stuff. You picked up some stuff in the water and some on dry land.

FIG. 4
Tiffany Chung, *reconstructing an exodus history: flight routes from camps and of ODP cases*, 2017, embroidery on fabric, Courtesy the artist and Tyler Rollins Fine Art, New York

FIG. 5
Tiffany Chung, *recipes of necessity* (still), 2014, single-channel HD video, color, sound, 33 min., Courtesy the artist and Tyler Rollins Fine Art, New York

Southeast Asia following the wars there, there are now more than 1.7 million Vietnamese Americans and over a million Americans who are of Lao, Hmong, Cambodian, or Thai descent.[17] The lack of Southeast Asian American artists in this exhibition thus reflects the limits of perspective inherent to the historical moment it examines, even as the project demonstrates that American art, like American society, was then expanding and becoming more pluralist. Only after 1965—when discriminatory national origin quotas were eliminated—were immigrants from Asia able to begin arriving in more significant numbers.[18] As the cultural contours of Asian America have stretched with each generation of newcomers from across the Pacific, and patterns of exclusion continue to be challenged, Asian American art unceasingly evolves.[19] The contributions of Southeast Asian diasporic artists to contemporary visual art have been remarkable over the last two decades, with the work of Tiffany Chung, Dinh Q. Lê, Tung Andrew Nguyen, and the Propeller Group, among many others, pushing American cultural memory of the Vietnam War to become more unbounded, inclusive, and just.[20] Chung's exhibition *Vietnam, Past Is Prologue*—organized and presented by the Smithsonian American Art Museum concurrently with *Artists Respond: American Art and the Vietnam War, 1965–1975*—traces patterns of conflict, migration, and resettlement, highlighting the stories of Vietnamese refugees now living in Texas, California, and Virginia. Her art [FIGS. 4, 5] illuminates neglected accounts of the war and reveals how the contemporary United States has been shaped by the history and people of Vietnam. Such narratives are poignantly absent from art of the Vietnam War era itself.

A combined chronology and plate section follow this introductory essay, with the works of art discussed roughly in the order they were created or appeared before the public. This structure aims to provide readers unfamiliar with the history of the Vietnam War with an outline of relevant developments in Southeast Asia and the United States. The context illuminates how current events influenced artists in both overt and indirect ways. Even a concise account of the Vietnam War era also conveys the turmoil of this period in American life and reminds us that many of the social and political ruptures we live with today have roots in that moment. The art speaks of the convulsions of the past, whose tremors still animate the present.

The Vietnam War in American Art

There is by now a recognized American art of the Vietnam War. Certain works created in resistance to the violence and militarism of that era have become iconic—Nancy Spero's searing wartime visions, for example, or Martha Rosler's incisive *House Beautiful: Bringing the War Home* photomontages. Yet it took years for this art to gain critical attention, and a richly textured history still demands to be told. The passage of decades has made possible a broader view of the art created in response to the Vietnam War. So much of it, I have learned, was unseen, unexhibited, not written about, perhaps not even considered art at the time it was made. There are multiple reasons for this lack of visibility. In the late sixties and early seventies, galleries and museums had barely begun to acknowledge issues of institutional sexism and racism, which meant that war-related art by women and people of color was little seen or considered. Performance art, newly vitalized in this period, was also experienced by very few people. It was ephemeral by nature, often took place unannounced in public spaces, and was not always well documented. Other works fell outside discussion because they were anomalous within an artist's career, perhaps created for a protest exhibition, and therefore deemed irrelevant. This was also true of work created explicitly as agitprop and distributed in unlimited numbers and without authorial attribution. In

these cases, the makers themselves often rejected the label of "art." Documentary photography and film likewise were not considered established categories within fine art as they are today and had not entered the conversation.

Most telling, a few artists intentionally held back their war-related works. Philip Guston preserved but never publicly displayed his painting of Richard Nixon, *San Clemente* [p. 269], so deep was his ambivalence about addressing such topical subject matter. Other artworks were exhibited but remained undiscussed in relation to the war, like Dan Flavin's *monument 4 for those who have been killed in ambush (to P. K. who reminded me about death)* [p. 58]. The sculpture was shown in the influential exhibition of minimal art *Primary Structures: Younger American and British Sculptors* at the Jewish Museum in 1966; but its war-inflected content, underscored by its title as well as Flavin's status as a military veteran, went largely unexplored in the art historical record until recently.[21] Another example is Kawara's *Title*, whose direct allusion to the Vietnam War received little attention in scholarship until 2010.[22] Although the painting was made in New York, it was not exhibited in the United States until three decades later, when it appeared in *1965–1975: Reconsidering the Object of Art* at the Museum of Contemporary Art, Los Angeles in 1995. That exhibition positioned *Title* as a work of art about art. Its catalogue states that the piece "proclaim[s] its own, physical presence as an abstract message concerning painting: an object ('one thing') whose creation is necessarily 'located' in time ('1965') and 'takes place' in history ('Vietnam')."[23] In this reading, Kawara's phrase "ONE THING" refers to the literal art object—not the consequences and effects of war.

These patterns of blindness and omission derive in part from the belief prevalent during the post–World War II era that art and politics should not mix. Today it is assumed that visual artists can and do engage with issues drawn from the broader world.

Indeed, recent years have seen a resurgence of activist currents in contemporary art. But at mid-twentieth century, leading American artists and critics rejected the model of populist, Depression-era social realism to privilege high culture as a sphere of elevated purpose and integrity, separate from everyday life.[24] The triumph of abstract expressionist painting gave rise to a critical orthodoxy that valued "advanced" art as abstract, timeless, and autonomous. Especially in New York, dominant art discourse assumed a division between aesthetic and political expression. The works assembled here, however, cast doubt about whether such a sharp distinction could really be made.

Watching the War

To consider the impact of the Vietnam War on the thinking and moral imagination of American artists, it is necessary to emphasize its scale and toll. The war known in this country as the "Vietnam War" and in Vietnam as the "American War" was an event that shaped the world. At war's end, Vietnam became a single, independent state under communist rule, culminating a transformational period of Third World national liberation movements. The result also refuted clearly and for the first time the U.S. foreign policy of communist containment.[25]

The human cost of the war was staggering. The number of Vietnamese who died during the conflict is difficult to confirm but has been estimated at more than three million, when north and south, fighter and civilian, communist and noncommunist, are combined.[26] There were vast casualties in Laos and Cambodia as well; while precise figures are elusive, close to a million likely died in those countries. The land itself was ravaged: between 1961 and 1975, an enormous volume of American bombs was dropped on Southeast Asia—approximately one million tons on North Vietnam, four million on South Vietnam, two million on Laos, and a quarter

ton on Cambodia.[27] Today leftover, unexploded ordnance, as well as the lingering effects of the use of tactical herbicides such as Agent Orange, continue to have dire health and ecological consequences.[28] The U.S. intervention transformed South Vietnam's economy wholesale, fraying familial and societal bonds. Millions of rural people were forcibly displaced from land they were attached to by livelihood, tradition, and culture. By 1968 almost a third of the population had become refugees in their own country.[29] Shantytowns outside of cities grew, swelling the urban population from 15 to 64 percent of the nation by 1974.[30] After the communist victory, the new regime executed thousands who had served the South Vietnamese government and sent some 200,000 more to reeducation camps.[31] By the late 1970s, roughly two million refugees had fled the conflict and wreckage of Southeast Asia to points around the world.[32] Their migration redefined the region and beyond.

Americans at home did not experience the Vietnam War as the people of Southeast Asia did. As author and scholar Viet Thanh Nguyen has reminded us, there were "no massacres committed on American soil, no bombs dropped on American cities, no Americans forced to become sex workers, no Americans turned into refugees."[33] Yet the impact of the war cut deep. The conflict in Vietnam was arguably America's most divisive military action outside the Civil War itself. Many who lived through the period remember it as an ordeal during which, as author and Vietnam War veteran Tim O'Brien has described, "The only certainty…was moral confusion."[34] More than two and a half million Americans served in Vietnam. Some 58,000 died there.[35] Many more came home bearing grave physical or psychological scars. In contrast to their parents, who returned from the Second World War victorious and celebrated for the role they had played in combating fascism, Vietnam veterans bore a far more uneasy

legacy. They were associated not only with a war that ended in failure; it was a war whose purpose, legitimacy, and conduct were loudly and often bitterly debated in every sector of society for years.[36]

As America's war in Vietnam progressed, more and more citizens came to question the rationales their leaders gave for intervening there, for pursuing indiscriminately lethal military tactics, and for refusing to withdraw when they could not find a way to achieve their stated goals. By 1971, public opinion polls showed that 58 percent of Americans believed the war in Vietnam was not only a mistake, but "morally wrong."[37] Never before had so many U.S. citizens disagreed with their government's exertion of military force. At the same time, equally significant numbers disapproved of antiwar protest and the counterculture associated with it—viewing such criticism as damaging not only to the country's military aims, but also to its national pride and very way of life.[38] By the late 1960s, the United States was in pitched conflict both in Vietnam, against a foreign enemy, and at home—between Americans for and against the war, for and against the status quo.

This catalogue presents art made amid this turmoil—during a long decade in which war began to feel like a never-ending condition, and no one understood how or when the conflict would finally come to a close. Considered chronologically, the works track an arc of artistic engagement that corresponds to the degree of Western media coverage and public awareness. Few Americans, artists or otherwise, closely followed events in Vietnam before the escalation of 1965[39]—even though the United States had been deeply involved there since at least the early fifties, when it bankrolled France's war against Hồ Chí Minh's recently declared Việt Minh government. (Still fewer were aware that the United States had previously supported Hồ Chí Minh and the Việt Minh in their resistance to Japanese

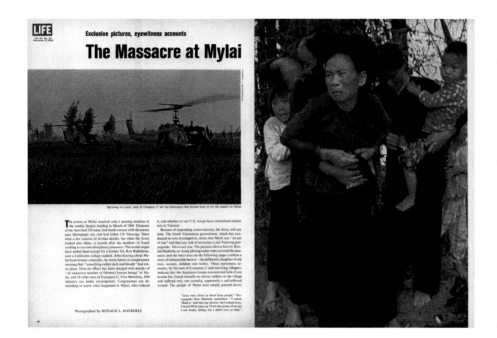

FIG. 6
"The Massacre at Mylai," *Life Magazine*, December 5, 1969, pp. 36–37, photo by Ronald S. Haeberle/the LIFE image collection/Getty Images

authority during the Second World War.) After the French attempt to regain colonial control over Vietnam failed in 1954, the Geneva Accords split the country at the 17th parallel and called for a nation-wide plebiscite to take place in 1956—elections that many expected Hồ Chí Minh to win. American leadership, however, sought to halt global communist expansion in its tracks by establishing a permanent, noncommunist state in Vietnam and thus backed the anticommunist nationalist Ngô Đình Diệm as prime minister in the south in 1954. A year later, after a referendum marred by fraud, Ngô Đình Diệm became president of the newly created Republic of Vietnam (i.e., South Vietnam). Such moves were at odds with the aspirations and desires of many Vietnamese, as reflected in the growing, violent insurgency against the South Vietnamese government.

By the time most Americans began following these events in the mid-1960s they found themselves enmeshed in a complex and confounding war already well underway in a country whose history, culture, and politics were deeply unfamiliar. The

military draft—which affected men aged eighteen to twenty-six and sent hundreds of thousands to war—ensured that younger Americans could not avoid thinking about the conflict in Vietnam, even if the more affluent and educated could often find ways to avoid combat if they desired. Further intensifying public discourse was the war's unparalleled visualization. This was the first U.S. military conflict to be televised; never before had Americans been able to absorb in moving pictures ongoing scenes of a faraway war from the comfort of their living rooms. It was also a war heavily documented by photojournalists, at a time when picture and news magazines, such as *Life* and *Time*, still enjoyed widespread circulation and influence.[40] Uniquely for a modern American war, Western photographers obtained credentials in South Vietnam with relative ease and operated free of military censorship.[41] Thus, as the country's leaders sought to reassure the American public that their goals in Vietnam could be honorably achieved, shock upon bloody shock unfolded, often underscored by unforgettable images: the self-immolation of Buddhist monk Thích Quảng Đức in protest of the South Vietnamese government in 1963, the stunning coordinated attacks of the Tết Offensive in 1968, the exposé of mass atrocities at Sơn Mỹ (My Lai) in 1969 [FIG. 6], the killing of student protesters on American campuses after the invasion of Cambodia in 1970. As citizens took in these developments in vivid pictures, the government's account of events fell increasingly into question.

Mainstream America objected to the war in Vietnam most of all because American soldiers were dying there. In an effort to appease public discontent, President Nixon began a process of gradual troop withdrawal in June of 1969. By the end of that year, the draft was made a lottery, with men turning nineteen years old now eligible for only one year. The drawdown of U.S. troops was linked to Nixon's policy of "Vietnamization," an effort to shift the

fighting from American to South Vietnamese forces. For most American observers, the war effectively ended in 1973, with the signing of the Paris Peace Accords. Although the agreement officially declared a ceasefire and initiated the end of the draft and the homecoming of U.S. ground troops, it did not bring peace to Vietnam. It did lead to a drastic reduction in the number of Western journalists covering the unresolved struggle there. Contemporary artistic engagement with the war dwindled in the United States in the remaining two years before the North Vietnamese army entered Sài Gòn and the last American helicopter receded from view.

Political Aesthetics

What is the relationship between politics and art?
A. Art is a political weapon
B. Art has nothing to do with politics
C. Art serves imperialism
D. Art serves revolution
E. The relationship between politics and art is none of these things, some of these things, all of these things. — Carl Andre, 1969[42]

With its intensely high costs and visibility, the Vietnam War prompted many artists—and Americans of all backgrounds—to become politically active for the first time. Modern visual artists, concentrated in urban centers, were in general left-leaning and took an antiwar stance. From their earliest collective actions organized in the spring of 1965, dozens of prominent artists in Los Angeles and New York signed letters of dissent, marched, staged demonstrations, and donated their work to benefit the cause of peace.[43] These experiences did not necessarily alter their artistic practice. Several of the most politically dedicated and well informed, such as Carl Andre and Donald Judd, were also the least inclined to include overt references to the war in their production. Many of them did view their

work as having the power to model new political and social ways of being; but, following the example of the "artist-citizen"[44] established by senior figures such as Ad Reinhardt and Barnett Newman, they kept their activism out of their art and avoided taking a legible stand on topical issues.

As the tragedies of the Vietnam War accumulated, more artists were troubled by the disconnect between their work and real-world events. To be an "artist-citizen" became an unpleasantly divided existence. Painter Philip Guston described his "schizophrenic" state of mind in the late 1960s: "The war, what was happening to America, the brutality of the world. What kind of man am I, sitting at home reading magazines, going into a frustrated fury about everything—and then going into my studio to adjust a red to a blue?"[45] With deep discord at home and horror abroad, the socially detached, "art-for-art's-sake" dictum of modernism seemed more and more inadequate. Art that remained aloof from life, some argued, constituted a corrosive, self-deceiving lie—at least if you were an American who disagreed with the foreign policy of the government representing you. In a text written in 1967 but not published until 1986, painter Leon Golub wrote:

> *What is the meaning of a symbolically perfect and physically faultless perfect art?...*
>
> *It is impossible to export fascism and destruction, to burn and drive peasants from their homes, and maintain the dream of the perfectibility of art.*
>
> *For if American aggression continues, the freedom we Americans have can only be a partial, privileged freedom, a privilege of affluence, and therefore a lie. And art and its dream of perfectibility and freedom is also a lie. Art is the record of a civilization and if America exports fascism, then its art—its art which claimed to speak of the possible—no matter its scale or intention, can only be an esoteric and frightened separation from what is the fearful truth.[46]*

An early activist against the war as well as an unapologetic figurative painter long critical of the cultural stranglehold of abstract expressionism, Golub forcefully voiced a motive shared by many of the artists collected in this volume. With U.S. justification for pursuing war in Vietnam under passionate debate, these artists oriented their work toward revealing and confronting what they considered the "fearful truth"—not deflecting from or offering relief from it. Americans were killing and being killed every day. Such circumstances demanded that the artist "shout fire when there is a fire; robbery when there is a robbery; murder when there is a murder; rape when there is a rape"[47]—to borrow language from a manifesto signed by the fervently activist artists Jon Hendricks and Jean Toche (of the Guerrilla Art Action Group) in 1967.

Some antiwar works did shout, and little more. The *Collage of Indignation*—a ten-foot-high and 120-foot-long multipart painting created for Angry Arts Week in early 1967[48]—was successful as a very visible political statement created by artists but fell short, many seemed to agree, as an aesthetic experience. The *Collage* consisted of a series of canvases that dozens of artists, working over the course of five days, filled with antiwar images and slogans; some simply signed their names to indicate their dissent [FIG. 7]. Critic Harold Rosenberg observed that the end result "expressed the hopelessness of artists in that almost all the works were dashed off without regard for style or standards, as if in a rush to return to the serious business of making paintings and sculpture."[49] Max Kozloff, with fellow critic Dore Ashton, had helped organize artist participation in the *Collage* and himself contributed to it a scene spattered in red paint. In the end, he saw the project as a "dismal" response to the urgency of the moment. Speaking years later, he recalled, "I didn't think [the artists] were very imaginative. They *weren't allowing* [his emphasis] the full scope and range and resources of their personalities to be affected and be sensitized by what was happening."[50] In a text written at the time of Angry Arts Week, Kozloff pointed out that the prevalent notion of autonomous art had creators in a bind; art was supposed to be "metaphorical and ritually self-contained," and political action "pragmatic and literal."[51] They were thus on opposite expressive poles. Facing this contradiction and suffering a failure of imagination, the artists had created no more than a scrawled petition. There must be more room to operate, Kozloff lamented: "In our situation, both metaphor and action are vital to existence."[52]

Could art resist war and violence *and* have aesthetic significance and power? Could it break its contained limits yet rise above the clichés of blood spattering and angry slogans? Could it be both

FIG. 7
Collage of Indignation exhibited at New York University, 1967. Photo by E. Tulchin

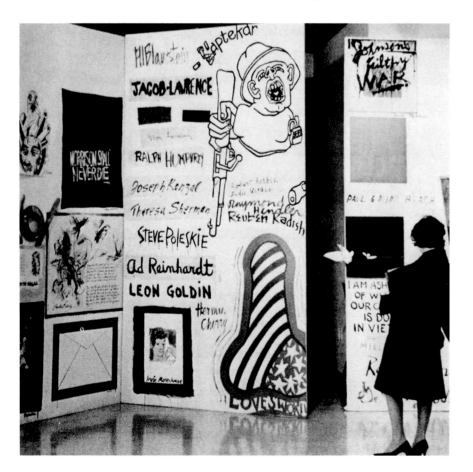

politically meaningful and culturally "advanced"? The works in this publication suggest "yes"—but only if tired dichotomies are overturned and fresh forms pursued. Even as Kozloff was airing his complaint, individual and collective artistic responses to contemporary politics were, in fact, undergoing a crucial shift. In January 1967, *Art in America* published responses to an artists' questionnaire devised by the critics Barbara Rose and Irving Sandler. The lead questions were: "Is there a 'sensibility' of the sixties?" and "Is there an avant-garde today?" As Rose summarized, it was widely agreed that the decade's sensibility was "slick, hard-edge, impersonal." Many of the respondents scoffed at the idea of an avant-garde. At a moment when the market was defining and sustaining artists as never before, they saw the notion as obsolete. Allan Kaprow, however, answered that there *was* an avant-garde. He saw it in the areas of "cross-overs, the areas of impurity, the blurs which remain after the usual boundaries have been erased." The most important kind of mixing, he stated, takes place where "the identity of 'art' becomes uncertain and the artist can no longer take refuge in its superiority to life.…This is where, suddenly, decisions regarding *human* values [his emphasis] become imperative."[53]

As he had in earlier writings, the innovator of Happenings and Environments was critiquing the strictures of formalist criticism. He was also making an implicit political case for the mingling of art with life.[54] When art becomes confused with everyday life, Kaprow said, "a new ethics and social commitment will emerge"—art moves into the realm of conscience. Kaprow questioned how art could be constrained to a separate sphere given the "rising temperature" of world affairs. He concluded, "Artists do not have to illustrate current events to respond to [the] pressures [of the time]. If the sensibility of the mid-sixties is warming I suspect it will get even warmer."[55]

Kaprow was correct. Between 1967 and 1971 especially—that is, at the height of U.S. military action in Vietnam and the corresponding peak of public outcry against it—American artists created not only notable works of explicit protest, but many more shot through with themes resonant with the war—themes of violence, power, the fragility of the human body, mourning, sacrifice, resistance. They brought their art into the realm of conscience and human values. As critic Pauline Kael commented in 1972, speaking of contemporary Hollywood film, "Everybody can feel what the war has done to us.… Vietnam we experience indirectly in just about every movie we go to."[56] In the art world, too, the impact of the war could be detected across virtually all movements and media. Close looking reveals works imbued with the psychological and emotional significance of the Vietnam War, if not always its literal depiction. This was accomplished, to use Kaprow's words, in "impure, cross-over" ways. By turning to the real world as the material and means of their work, artists dramatically expanded their creative territory. New art forms emphasizing critical intervention and disruptive perspectives—conceptualism, feminist art, body art—were born in this fertile moment. Artists increasingly did not choose between aesthetic innovation and social relevance—they pursued both.

Growing Pluralism

Examining the late 1960s and early 1970s now from a considerable historical distance, we see that the pluralism of what we think of today as "contemporary art" is rooted in this moment of heightened political consciousness and imagination. By 1967, a growing number of artists rejected the social and aesthetic status quo, many of whom had the least to lose under the prevailing system: women, people of color, those at a geographic remove from the art world power center of New York. For these artists, opposition to the war frequently coexisted with

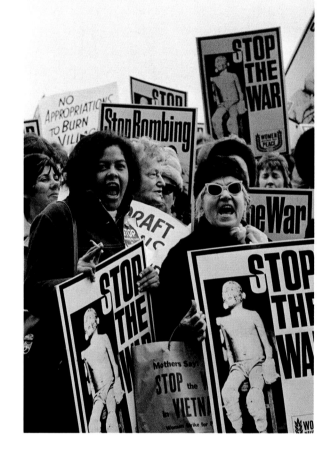

political engagement on other fronts, especially those of gender and race. Female artists have a significant presence here, reflecting the important role women took in organizing against the war (a subject Mignon Nixon addresses at length elsewhere in this volume) [FIG. 8].[57] Their voices illustrate how the antiwar movement overlapped with and fed into the feminist revolution that transformed the country in the 1970s. Even before it had a name, feminist art offered a forceful critique of militarism and the constructs of masculinity, often underscoring the correlation between sexual and military aggression. Perhaps because their work was so roundly ignored by the art establishment, women were especially daring and transgressive in expressing their dissent. As Nancy Spero [pp. 48–52] remembered of her work

during this time, "No one was looking; nobody cared."[58] Painters like herself and Judith Bernstein [pp. 53–56] consequently raged all the louder—even though it took years for their work to be acknowledged by art institutions or the market.

The Vietnam War also corresponded with growing racial and ethnic consciousness in American art. Both the Black Arts and Chicano art movements, ascendant at this time, insisted on art's political role, critiquing white establishment aesthetics and emphasizing cultural self-determination. Works in the exhibition by African American and Latino artists demonstrate how the Vietnam-era draft—a system of deferments and exemptions that channeled working-class men into military service and college-bound students into fields of the "national interest"[59]—became a galvanizing political issue in minority communities [FIG. 9]. Refusing to be inducted to the armed forces in 1967, boxer Muhammed Ali voiced an opinion then rising among young African Americans when he asked, "Why should they ask me to put on a uniform and go ten thousand miles from home and drop bombs and bullets on brown people in Vietnam while so-called Negro people in Louisville are treated like dogs and denied simple human rights?"[60] The trenchant commentary of Faith Ringgold's *Flag for the Moon: Die Nigger* [p. 146] and Asco's *Stations of the Cross* [p. 235] reflect the multiple challenges Americans of color faced, struggling for full civil rights at home even as they fought for their country abroad—often in disproportionately high numbers.[61] These included Native Americans, who served in combat in Vietnam at a higher rate than any other ethnic group.[62] Experiencing oppression in their own lives, many artists of color came to view the war through the lens of racism and imperialism and sought to express solidarity with their Vietnamese "brothers and sisters."

For artists of Asian descent, the sense of connection to this war was especially acute. At a time

narrow slice of documentary practice related to the war in Vietnam. Through mid-twentieth century, "photojournalism" and "art photography" remained largely distinct categories, with most documentary photography being created on assignment with a client or employer (usually the government or a commercial news organization) exercising ownership and editorial control. However, the cooperative structure of Magnum Photos, founded in 1947, allowed its photographer-members to pursue stories of their own choosing and to retain intellectual control over their work. By the 1960s, a few were developing new modes of long-form documentary representation that transcend the genre of on-the-spot reporting.[72] Welsh photographer Philip Jones Griffiths (who later served as president of Magnum New York) was one

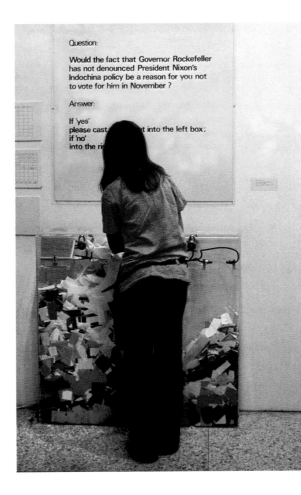

FIG. 12
Hans Haacke, *MoMA Poll*, 1970, on view in the exhibition *Information*, Museum of Modern Art, New York. See p. 189

such pioneer, whose creative independence and sustained engagement with the Vietnam War deserves inclusion in this discussion. Griffiths spent years in Vietnam pursuing a book-length examination of the conflict for which he produced both pictures and text. His *Vietnam Inc.*, unleashed on American readers in 1971, is a searing analysis of the war, unusual for its emphasis on sustained observation over incidents of sensational violence [pp. 211–19]. Emile de Antonio's *In the Year of the Pig* [p. 132] is an equivalently independent and deeply researched work, the first American film that sought to contextualize the war in Vietnam within a larger historical framework. Both artists sought to inform and influence the public through what de Antonio called "the mass of facts" and did so via media that could reach beyond the cloistered limits of the art world.

While most photojournalism of the Vietnam War was produced on assignment or distributed without the photographer's editorial control, thus falling outside the scope of this project, its influence can be readily seen and felt throughout. The Vietnam War is regarded as both the first television war and the last great photojournalist's war. War images sourced from news and picture magazines appear again and again in the art of this period, sometimes quoted directly, sometimes considerably transformed. The constant visual transmission from combat zones to home front rendered the conflict vivid and present for many Americans, yet could also have a numbing or trivializing effect. Edward Kienholz's living room tableau *The Eleventh Hour Final* [pp. 116–17], for instance, shows mass death reduced to the scale of a television screen—in the background and easily ignored. Artists debated both the ethics and efficacy of appropriating images of real suffering and death. Some worried that exposure to brutal photographs only cultivated indifference—Susan Sontag's 1973 essay "In Plato's Cave"[73] powerfully articulates this view—while others deployed upsetting images

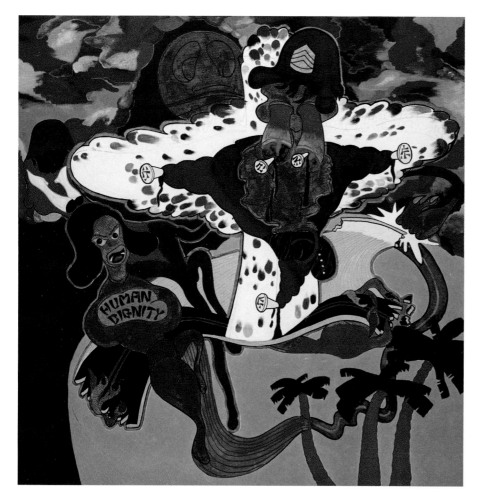

Peter Saul, *Human Dignity*,
1966, acrylic and pen on
canvas, Private Collection,
Courtesy Venus Over
Manhattan, New York

immersive *War Room*—demonstrate that powerful statements could be made through the denial of pictorial content.

A WAR OF INFORMATION The Vietnam War era witnessed the coalescence of conceptual art in the United States.[69] Circumventing traditional aesthetics, conceptualism privileges concept over object and thinking over form. The notion that a work of art could exist as an idea—and that art practice could consist of the gathering and distribution of facts—had special valence during a war in which the control of public information was so heavily contested. Knowing that government dissemblance and the general public's lack of historical awareness

about the conflict in Vietnam had made possible the U.S. escalation of the war, peace activists had since the earliest teach-ins sought to educate Americans about the country of Vietnam and U.S. policy there.[70] (A representative antiwar flyer circa 1970 reads, "We must fight a war of ideas, not bullets....Read! Think! Educate!"[71]) Revelatory eruptions of knowledge, such as with Seymour Hersh's exposé of atrocities at Sơn Mỹ or Daniel Ellsberg's leaking of the Pentagon Papers, challenged official accounts of the war and helped shift public opinion. Against this background, conceptual artists like Hans Haacke and Douglas Huebler [p. 149] embraced practices of research and reportage, restaging journalism as art. Their amplification of real-world information in the supposedly "neutral" context of the gallery or the museum—as Haacke did in his milestone work *News* [p. 156]—demanded that these settings shift from being places of passive contemplation to arenas of active questioning. Haacke's *MoMA Poll* [p. 189], shown in the 1970 exhibition *Information* at the Museum of Modern Art is another emblematic work. Designed specifically for this context, *MoMA Poll* asked viewers to register their opinion of Nelson Rockefeller, the New York State governor and a long-time trustee of the museum, given his failure to denounce President Nixon's conduct of the war, which then recently included the invasion of Cambodia. The piece invites viewers to participate in its realization by casting votes in transparent ballot boxes [FIG. 12]—making visible a process of participatory citizenship and highlighting the live connections between artist, audience, museum, and larger power structures.

Self-consciously engaged in interrogating the boundaries of art, conceptual artists relied on art world institutions and conventions as context to generate meaning. Participating more directly in the public flow of war-related information were documentary artists. This book includes only a very

this kaleidoscopic gathering of works. While formally diverse, the pieces in the exhibition have in common an engagement with matters of civic conscience and participation. Rather than focus on issues intrinsic to art, they emphasize the intersection between art and lived experience.

CRITICAL PICTURES In painting, we see artists depart from the dominant norms of modernist abstraction and the sunny, consumerist ethos of American pop to create pictorial work that is overtly topical and dissenting. Many turned to deliberately "low" sources of inspiration and rhetorical extremes in an effort to make painting sufficient to the emotional and ethical exigencies of the times. Peter Saul and Judith Bernstein knowingly channeled the dark humor and taboo imagery of cartoons, bathroom graffiti, and caricature to deliver a "cold shower" (as Saul put it)[66] of bad conscience to the viewer. Saul's wild, allegorical Vietnam scenes link war with racism and sexual aggression, combining the extreme language of underground comic books with fierce satire and a Day-Glo palette [FIG. 11]. In skewering what he saw as a racist war, Saul puts on display distinctly American stereotypes of Asians, from buck teeth and yellow skin to the "chop suey" typeface of American Chinese restaurant signs [p. 71]. Bernstein likewise employs provocative sexual imagery and transgressive language in *A Soldier's Christmas* [p. 55], further adding an over-the-top array of found materials, including Brillo pads and blinking lights, to underscore her outrage at what she considered an obscene war. Leon Golub turned to extravagant size to convey what he described as the "grotesqueness"[67] of U.S. military might [pp. 258–59]. The enormous, unstretched canvases of his *Vietnam* series immerse the viewer in harrowing scenes of heavily weaponed American soldiers confronting unarmed Vietnamese; Golub created these compositions based on photographs

he collected from newspapers and magazines. Nancy Spero also referenced U.S. technological dominance in her ferocious and disturbing *War* paintings, which portray bombers and helicopters as monstrously embodied machines of destruction. None of these works were merely "dashed off" so that the artist could quickly return to the "serious business" of making paintings and sculpture. Rather, each represents a sustained and considered body of work that purposely challenged the conventional criteria for aesthetic "quality," just as it challenged the excesses of state power.

ABSTRACTION As we have seen, most abstract artists resisted making the Vietnam War legible in their work—or at least, found it difficult to do so. In a few instances, however, the language of abstraction is powerfully employed to confront themes of mortality, mourning, and resistance. Dan Flavin's *monument 4 for those who have been killed in ambush (to P. K. who reminded me about death)* evokes the aggression and terror of combat through color and form—and by activating an expanded aesthetic field that includes the viewer's perceptual and kinesthetic experience of the object in real space. This minimal sculpture immerses the spectator in thick red light and menacingly trains one of its fluorescent tubes at roughly head level. For Wally Hedrick, a turn to abstraction was a political act of refusal, part of a wider "withdrawal of his services from mankind," akin to the walk-outs, boycotts, and moratoria that proliferated along with rising antiwar sentiment in the later 1960s.[68] Many of his *Vietnam* series of monochromes were made by literally obliterating his existing pictorial works in thick black paint. Having himself suffered the trauma of combat during the Korean War, Hedrick likened his negated paintings to "wounded veterans." Especially in the context of news media saturated with war images, Hedrick's black paintings—which culminated with the

when U.S. public discourse often reduced Southeast Asian lives to mere numbers or symbols, Asian Americans could hardly fail to register that the majority of those dying in the war looked like them and their family members. Racist and dehumanizing language directed at the Vietnamese during the war reminded Asian Americans of their perpetual "alien" status in this country, and that Asian lives were considered less precious than white ones [FIG. 10]. (Reflecting in 1974 on the conflict in Vietnam, General William Westmoreland, who served as commander of Allied forces from 1963 to 1968, notoriously observed, "The Oriental doesn't put the same high price on life as does a Westerner. Life is plentiful. Life is cheap in the Orient.")[63] The war in Vietnam was indeed an animating force in the formation of Asian American identity and politics beginning in the mid-1960s.[64] James Gong Fu Dong's *Vietnam Scoreboard* [p. 135] is a pioneering work that combines nascent Asian American consciousness with an antiwar message.[65] Born in San Francisco's Chinatown, Dong was part of a generation of Asian American artists who created art with the aim of social impact at a grassroots, activist level. Other artists of Asian descent in the exhibition

include several who are Japanese born, including Yoko Ono, who presented her *Cut Piece* in New York City less than two weeks after marines first landed at Đà Nẵng in 1965. In this work, audience members were invited to approach the artist as she sat onstage in her best outfit, and, one by one, cut away pieces of her clothing. The drama that unfolded placed spectators in a disconcerting position of complicity as the acts of aggression multiplied. Although problematic given Ono's Japanese heritage, the artist's racial "otherness" can't help but inform the reading of this rendition of *Cut Piece*, taking place against the backdrop of mounting American intervention in Vietnam. In film footage of the performance, we do not see the artist interrupt or halt the stream of participants. She simply presents herself as a live presence, her open humanity confronting audience members as they consider whether to stop, interfere with, or escalate the action.

Patterns of Response
The fifty-eight entries in the plate section describe distinct case studies of how America's artists responded to the Vietnam War between 1965 and 1975. Multiple themes and patterns emerge from

FIG. 9
Participants in the Harlem Peace March during the Spring Mobilization to End the War in Vietnam, March 1967. Photo by Builder Levy

FIG. 10
Flyer calling for Asian Americans to participate in the March on Washington on April 24, 1971. Text on verso reads, in part, "Asian Lives Are Not Cheap! And Asians Must Say So Now!" Made by the Asian Coalition, New York

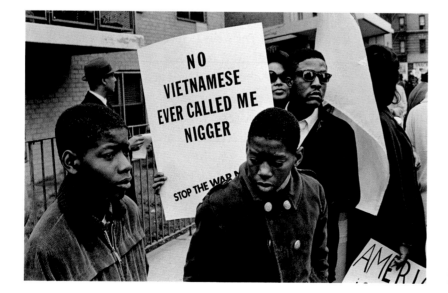

exactly to activate and mobilize the viewer. In her *House Beautiful: Bringing the War Home* series [pp. 94–98], Martha Rosler cut and collaged pictures from popular magazines, bringing scenes from the war into affluent American homes, thereby forcing "here" and "there" into one representational space. She distributed the images as black-and-white photocopies at protests and demonstrations and (as she describes in her contribution to this publication) refused to show them as art while the war continued.[74] In Carolee Schneemann's short film *Viet-Flakes* [p. 64], the camera stutters and jitters over scenes of war violence, abruptly pulling in and out of focus. The effect is disorienting and sickening, an acknowledgement of the mix of helplessness, outrage, and apathy with which Americans regarded images of faraway anguish and death.

The use of such documentary images by artists remains ethically fraught. Antiwar artists (and the antiwar movement in general) recognized the evidentiary power of photography to stir empathy and political action. It was, for example, seeing images of Vietnamese children burned by napalm that pushed Martin Luther King Jr. in early 1967 to loudly denounce his government's conduct of the war. Similarly, atrocities committed by U.S. soldiers at Sơn Mỹ became undeniable to the American public when photographs of the victims circulated in the media and protest art [p. 169]. But the camera also flattens and dehumanizes as it transforms human lives into political symbols—especially when wielded across vast power differentials of race, wealth, and nationality. We cannot today regard Vietnam War–era works that incorporate unidentified images of Vietnamese suffering without pausing to recognize the human agency and subjectivity lost behind these pictures. Liliana Porter's *Untitled* (The New York Times, *Sunday, September 13, 1970)* [p. 195] is a rare work contemporary to the war that quietly makes this point. Text added by the artist to a photograph

of a nameless, captive Vietnamese woman poetically leads the viewer from a position of representational privilege through acts of identification with the female, the colonized, the "other." Porter's verse begins, "This woman is northvietnamese" and ends with "my mother, my sister, you, I."

PRINTS FOR PEACE Affordable and easy to distribute, prints have long been a medium for social critique and raising awareness. The outpouring of graphic art during the Vietnam War ranged from conventional protest posters with clear texts and a strong message to more experimental pieces that reflected contemporary developments in pop, conceptualism, and even land art. During the war years, American art experienced a "Print Renaissance" that revived interest in printmaking as a creative medium and led to the establishment of new, ambitious workshops across the country.[75] Artists created fine-art prints to sell as limited editions to raise funds for the antiwar movement, and they also produced prints cheaply, anonymously, and in quantity to give away at demonstrations, sell at low cost, or post in the streets. This catalogue focuses on graphic art created for specific antiwar protest events, circumstances that gave artists like Donald Judd [p. 225] and Ad Reinhardt [p. 81], who normally eschewed activism in their work, a rare pretext to engage directly with political content. The project also highlights artists who, by contrast, had an ongoing commitment both to the medium of printmaking and to political discourse—such as Rupert García [FIG. 13 and p. 192], James Gong Fu Dong, and Corita Kent [pp. 88–92]. García and Dong were both young artists in the San Francisco Bay area, developing their work in the context of the burgeoning Chicano, Asian American, and Third World Solidarity movements. Kent was a Roman Catholic nun in Los Angeles, teaching and making art in the midst of the Second Vatican Council's call for a more open and modern Church. All embraced printmaking for its democratic

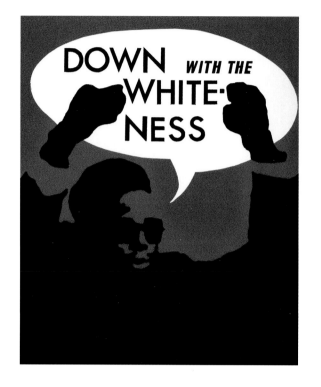

qualities and sought to apply the language of mass media (and pop art) to the work of promoting social justice—which for them included trying to end the war in Vietnam. As Kent said in 1965, "The idea is to beat the system of advertising at its own game....To oppose crass realism, crass materialism, with religious values, or at least with real values."[76] These artists embraced the visual impact and accessibility of pop aesthetics while eschewing the movement's association with consumerism and the impersonal, banal qualities of contemporary American life.

SHOOT, BURN, RESIST: THE BODY The later years of the Vietnam War also coincided with the flourishing of another, very different art form: performance. With bodily injury and death on routine media display, the vulnerability of the human form emerged as a key theme in the art of the period. Beyond performance art, it can be seen in the disembodied "warrior" limbs of Paul Thek [p. 69], the chafed and blistered surfaces of Leon Golub's *Napalm* canvases

[FIG. 14], and the tenderly indexical and politically charged body prints of David Hammons [p. 109]. However, it was most strikingly addressed in the incipient field of body art, which tapped into the immediacy and visceral power of live corporeal experience. Early body-based work by Chris Burden [pp. 230–31] and Yoko Ono [pp. 44–45] pushed artists to extremes while challenging viewers to consider their participation as potential perpetrators or witnesses of violence. Burden's landmark performance piece *Shoot*, in which the artist was shot through the arm with a rifle before a group of onlookers (the shooter was a friend who had trained as a marksman in the army[77]), enacted literal bloodshed and the constitution of a willing audience around it.[78] The work uncomfortably encapsulates the experience of the bulk of the American people as onlookers to the Vietnam War[79]—and is a reminder that, as Viet Thanh Nguyen wrote, "War is not just about the shooting, but about the people who make the bullets and deliver the bullets and, perhaps most importantly, pay for the bullets." Wars are fought by soldiers, but the "distracted mass of citizenry" at home helps pull the trigger.[80]

Human bodies not only fought the war, they became tools of protest as well. Inspired by the accomplishments of the black civil rights movement, antiwar activists adopted techniques of direct action and civil disobedience. By the later 1960s, "putting your body on the line" had become a common precept for demanding social change, and political action meant moving oneself physically in marches, rallies, and strikes that took place nationwide. Artists echoed these actions, unleashing antiwar Happenings in public spaces. Yayoi Kusama employed nudity to celebrate freedom and denounce militarism in her series of *Anatomic Explosions* staged at sites across New York City during the run-up to the 1968 presidential election [pp. 119–20]. Asco marched down Whittier

Boulevard in East Los Angeles, enacting a passion play that ended as they blocked the entrance to a U.S. Marine recruiting office with an oversized cardboard cross [p. 235]. The Guerrilla Art Action Group bloodily "died" in the lobby of the Museum of Modern Art, giving physical presence in a rarified art space to the damage behind euphemistic "body counts" [p. 159]. In its insistence on the continuity between life and art and in its aggressive foregrounding of the body as both subject matter and artistic means, performance art is deeply characteristic of art forged in the Vietnam War years.

SELECTIVE SERVICE Many works here share not only common artistic practice but also a concern with thorny issues of patriotism and sacrifice, issues that animate civil discourse in a democracy, especially during wartime. Pieces like Rosemarie Castoro's *A Day in the Life of a Conscientious Objector* and Timothy Washington's *1A* reflect how conflicting perspectives on military service divided the American body politic, families, and the consciences of individuals. Castoro's twenty-four-part work of visual poetry channels and contrasts the imagined perspectives of a draft evader, a soldier at war, and a political revolutionary

[pp. 138–39], while Washington depicts himself and his older brother as nearly identical figures in painful opposition over the draft [p. 239]. In airing these discordant views, artists were participating in an ongoing debate about democratic rights and responsibilities and the tension between the values of dissent and service.

Roughly one-third of the Americans who served in Vietnam were volunteers, another third "draft-motivated" volunteers (who, knowing of the likelihood of being drafted, signed up in order to retain greater control over their assignment within the armed forces), and the final third conscripts.[81] Hundreds of thousands of others resisted induction, pursuing conscientious objector status, leaving the country, going into hiding, or serving time in prison rather than participate in what they considered an unjustified war. On both sides, individuals were motivated by deeply felt conviction and love of the country's ideals. But it was those who accepted military duty and lost their lives that paid the harshest price. In the later years of the conflict especially, artists created works acknowledging the country's sacrifice of its young. In 1966 Edward Kienholz had declined to participate in group actions against the war.[82] But after 1968, he made multiple works calling out its terrible human cost (or, at least, U.S. losses) [pp. 116–17, 291]. His last, *The Non-War Memorial* [p. 205], proposes a visionary "living" memorial that would consist of surplus army uniforms—numbering the same as American soldiers killed so far in the war[83]—filled with clay and placed in a chemically destroyed meadow in Northern Idaho. After the "bodies" eventually decomposed, the area would be plowed over and reseeded with alfalfa and wildflowers.

By the early 1970s as well, more artists who had served in Vietnam had come home and were creating works informed by their wartime experiences. Jesse Treviño, who lost an arm due to injuries sustained in Vietnam, reinvented his painting practice as he

FIG. 14
Leon Golub, *Napalm Man*, 1972, oil on canvas, The Jewish Museum, Gift of Dr. and Mrs. Isidore Samuels

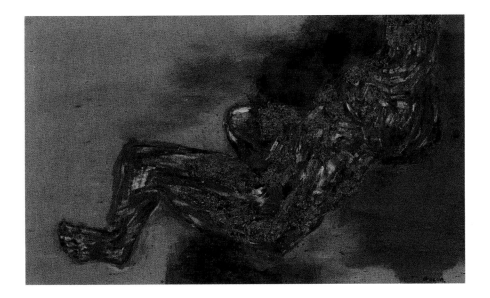

recovered, newly asserting his experiences and perspective as a military veteran and a Chicano [p. 263]. T. C. Cannon, a Kiowa who volunteered for service in Vietnam, took pride in his tribal warrior tradition but considered the U.S. mission in Southeast Asia a tragedy. His ambivalence informs the war-related drawings and poems he created years after departing the army [p. 271]. Kim Jones developed his Mudman performance persona following his time as a marine stationed in Đông Hà. In *Wilshire Boulevard Walk* [pp. 275–76], performed nine months after the war's end in 1975, he marched eighteen miles across Los Angeles, first from sunrise to sunset and then from sunset to sunrise. Wearing combat boots, his face covered by a stocking and his body slathered in mud,

Mudman traveled with an oversized, exoskeleton-like structure of bound sticks strapped to his back. Both imposing and vulnerable, Jones as "walking sculpture" embodies the outsider status assigned to many Vietnam veterans upon their return to what U.S. soldiers abroad call "the world." In the years since *Wilshire Boulevard Walk*, Jones has continued his public forays as Mudman in cities, including Washington, D.C., where in 1983 he ended his march at the then newly dedicated Vietnam Veterans Memorial [FIG. 15]. It is Jones, a single figure traveling on foot, who brings this gathering of works to its chronological conclusion. Negotiating the terrain between military and civilian worlds, Mudman bears, as if on behalf of the entire body politic, the cumulative baggage of war.

Cultural Impact

Paintings don't change wars. They show feelings about wars. —Leon Golub, 1967[84]

Two months before his death in 1970, Barnett Newman recalled that the mass devastation of the Second World War had compelled him and his New York school peers to "start from scratch."

> *The old stuff was out. It was no longer meaningful...the lazy nude, the flowers, the bric-a-brac that in the end had been reduced to a kind of folklore. We introduced a different subject matter that the painting itself entails.... People [had been] painting a beautiful world, and at that time we realized that the world wasn't beautiful....The only way to find a beginning was to give up the whole notion of an external world.*[85]

In 1970, the circumstances were again different, as was the response of a new generation of American artists. With the United States pursuing a war that fewer and fewer of its citizens supported and Americans debating uncomfortable but essential questions about their country and its role in the world, a radical reimagining of the relationship between the aesthetic and the social took place. As curator Kynaston McShine wrote that year in the exhibition catalogue for *Information*, his groundbreaking presentation of conceptual art at the Museum of Modern Art, "Art cannot afford to be provincial, or to exist only within its own history, or to continue to be perhaps only a commentary on art. An alternative [is] to extend the idea of art, to renew the definition, and to think beyond the traditional categories."[86]

Art in the late 1960s and early 1970s did expand, becoming more critically motivated and socially engaged. Rather than pursue a new beginning, it opened itself up to the external world in all its ugliness and tumult. Facing pervasive social and political crisis, artists pushed against established conventions of form and medium. A very young Martha Rosler had initially nurtured "utopian" aims in her practice as an abstract painter. By the early seventies, she abandoned these aspirations because, she said, "I had another agenda. I felt that I had an obligation to take part in political structures, not only deciding eventually to become involved in antiwar work and antimilitarism but to make work that expressed that."[87] She had come to believe that the "closure" of modernism was "a mistake": "I guess I was more comfortable with the idea of asking questions. And, of course, if a work is involved with asking questions, the first thing that has to go is the notion of closure."[88]

In the spring of 1969—roughly two and a half years after the "Sensibility of the Sixties" survey appeared in *Art in America*—Barbara Rose wrote in *Artforum* of the emergence of a "new art," describing it as "constantly reactive to political, social, and environmental as well as aesthetic factors, [and] defying absolutes and fixed definitions." Art and artists, she observed, were being "desanctified" and "brought down to earth." The new art "is not a mystery but a fact; it may have content, but that content is not absolute, not transcendent, above all, not *spiritual*."[89] What was lost in transcendence was gained in immediacy and social relevance. In giving up its aspiration to timelessness, art was free to become corporeal, personal, evidentiary, environmental, durational, participatory. It could call into question the gallery's status as a neutral arena; it could convey real-world stories and information; it could act to stir outrage, empathy, and opposition; it could (as voiced by William Copley's print [p. 80]) simply exhort audiences to "THINK." Vis-à-vis the war in Vietnam, art could register emotional and factual truths about events that continued to be repressed or misrepresented by official sources.

None of this meant that antiwar artists during the era were confident that their art—or even their activism outside of art—had particular political efficacy. To the contrary, they were well aware that their

work addressed a select, minority audience and that its power and reach paled in comparison to that of mass cultural forms such as television, popular music, and film. In the face of brute economic and political instruments—such as, in Allan Kaprow's listing, "guns, strikes, price wars, embargos, taxes, and the daily decisions of international diplomacy"[90]—art appeared even weaker. By the end of the 1960s, too, there was a common sense of alienation and helplessness as the war rolled on despite a broad social movement having risen up against it. Some American artists against the war (notably Mark di Suvero and Carolee Schneemann) physically removed themselves from the United States for a number of years, such was their personal anguish and exhaustion over the continuing social and military conflicts.[91]

But art's inability to mobilize immediate political change was not sufficient reason for artists to stop making it or to stop engaging with the wider world. Giving a public lecture in April 1968—and reeling from the assassination of Martin Luther King Jr. only days earlier—Hans Haacke admitted that artists were, as he put it, "unsuited" for "making society more humane." He continued, "This in fact is probably not their task. Their profession does not lend itself to a meaningful contribution." Despite this pained perspective, Haacke concluded, "Rather than staying aloof…artists should speak out against society's attempts to use their work as a means to cover up the failure of tackling urgent issues."[92] The comment anticipated a significant shift in the artist's own practice. Haacke thereafter reoriented his focus from biological and physical systems to social ones, leading to the creation of works like *News* and *MoMA Poll*, which underscore the continuity between artistic production and reception and the circulation of power beyond the studio and the gallery. Not incidentally, Haacke directed his critique at a system in which he was a player and had some hope of influence—the art world. The museum became for

many artists during the Vietnam War era what the university was for students: the institutional locus of authority at which they could direct their demands for change.

Haacke's work, like Rosler's, is committed to opening art up and asking questions. This critical, interrogative orientation, formed in the crucible of the Vietnam War era, is a prime reason this chapter of American art history is important to explore and remember. Art with a moral imperative—art that refuses to participate in the "covering up" of urgent issues—is invaluable to our civil society and the historical record. This is especially true in regards to the Vietnam War, an event that U.S. leaders kept out of sight for as long as possible and on which, once finally concluded, they urged the public not to dwell. After 1975, few Americans were eager to continue the agonizing debates of the prior decade. Weary from years of loss and division, the country was anxious to move on and to restore national power and pride. However, as the Vietnam War recedes further into history, we must continue to reckon with the facts of its events and its ethical complexity. "Present-tense" works of art from the Vietnam War era do not offer commemoration or closure. Nor, as mentioned at the outset of this essay, can they provide a fully inclusive memory of the war. But they make vivid the moral questioning and spiritual pain of that time—and demonstrate how, during a period of profound national crisis, there were American artists who challenged conventional thinking, imagined and made visible revelatory perspectives, and mobilized the practice of dissent central to ideals of democracy and citizenship. They approached artmaking as a principled civic obligation and right.

Art does not lead the larger culture—it reflects and influences. The responses of artists to the Vietnam War were in a real sense ordinary; that is, shared by millions of other Americans. What was exceptional was their ability to express their

feelings and opinions in meaningful artistic form, to make lasting and profound works of art. Artists' voices speak to the present and the future. Works of art move through time and across geographies, forming strands in our collective history and self-understanding. As those of us in middle age and beyond can attest, we live in a society transformed not only since the Vietnam War, but also since just ten or fifteen years ago. When cultural change occurs, it can seem to manifest suddenly, but such shifts take place over the course of years, through innumerable incremental steps. A work of art can be one of those steps that serves to unsettle established thought and thus move consciousness forward. "A picture never changed the price of eggs," Allan Kaprow observed, "But a picture can change our dreams; and pictures may in time clarify our values."[93] All of us are participants in this work. When the art in this exhibition was created, the outcome of the Vietnam War was unknowable—just as today our nation's future is still unfixed and open to change. We the people must decide what is acceptable, what is ethical, what is valued, what is just. Art is a part of that process and helps us imagine what is yet to come.

1 The National Gallery of Art in Washington, D.C., acquired On Kawara's *Title* in 2006.

2 The left-hand canvas of *Title* originally bore the words "RED CHINA," indicating the ongoing ideological conflict in Asia. Kawara replaced these words with "ONE THING" after a studio visit from Honma Masayoshi, then curator of the National Museum of Modern Art in Tokyo. Artist and curator shared concern that an overt reference to the Chinese regime would provoke a negative response among audiences in Japan, a country then in the grips of "anticommunist paranoia." See the account of Jung-Ah Woo, "On Kawara's Date Paintings: Series of Horror and Boredom," *Art Journal* 69, no. 3 (Fall 2010): 62.

3 Kawara may also have been aware that Japanese civilians were involved in the current U.S. war effort. The island of Okinawa, then under American governance, provided a crucial hub for the movement of American troops and materiel in and out of Vietnam, activity that came to employ some 50,000 Japanese. Over the course of the war, about 75 percent of U.S. supplies to Vietnam passed through the island's military ports. Jon Mitchell, "Vietnam: Okinawa's Forgotten War," *The Asia-Pacific Journal: Japan Focus* 13, no. 16 (April 20, 2015): 2.

4 Unlike the date paintings, which Kawara lettered by eye, the text in *Title* was executed using stencils. Artist questionnaire, August 30, 2006, National Gallery of Art curatorial records, Washington, D.C.

5 For more on these conflicting views, see Andrew Wiest and Michael Doidge, eds., *Triumph Revisited: Historians Battle for the Vietnam War* (New York: Routledge, 2010).

6 A helpful introduction to the field of refugee studies is provided by Critical Refugee Studies Collective of the University of California at http://criticalrefugeestudies.com/.

7 The "all voices" approach was pursued in epic projects like Christian Appy's oral history, *Patriots: The Vietnam War Remembered from All Sides* (New York: Penguin, 2003); and Ken Burns and Lynn Novick's public television documentary series *The Vietnam War* (PBS, 2017).

8 Nora Annesley Taylor, "Is Danh Vo a Vietnamese Artist?" Lecture given at the School of Art, Design, and Media, Singapore on September 17, 2014. See Taylor's article, page 26. Download essay at http://www.academia.edu/35844776/Is_Danh_Vo_a_Vietnamese_Artist_.pdf. For an extended and nuanced study of the history of painting in modern Vietnam, including the role of government in the arts, see Taylor, *Painters in Hanoi: An Ethnography of Vietnamese Art* (Honolulu: University of Hawai'i Press, 2009). For more on North Vietnamese photography during the war period, see Horst Faas and Tim Page, *Requiem: By the Photographers Who Died in Vietnam and Indochina* (New York: Random House, 1997); and *Another Vietnam: Pictures of the War from the Other Side* (Washington, DC: National Geographic Society, 2002).

9 Between 1965 and 1973, Gallup regularly polled Americans on the question of whether the United States had "made a mistake sending troops to fight in Vietnam." The year 1968 was the tipping point after which more than half of those polled responded that it had been a mistake. Lydia Saad, "Gallup Vault: Hawks vs. Doves on Vietnam," Gallup Vault, May 24, 2016, https://news.gallup.com/vault/191828/gallup-vault-hawks-doves-vietnam.aspx

10 There are a few examples of popular art made during the Vietnam War that sought to stir patriotic feeling and rally support for the war effort—for example, the John Wayne movie *The Green Berets* (1968) and the song "The Ballad of the Green Berets" (1966), written and performed by Sgt. Barry Sadler, both of which were commercial successes.

11 To read the advertisement in its entirety, see Matthew Israel, *Kill for Peace: American Artists against the Vietnam War* (Austin: University of Texas Press, 2013), 25, fig. 2.

12 Di Suvero was born in China in 1933 and lived there until the age of seven, when his family was able to emigrate to America. He recalled that during the Japanese occupation, his family lived in Tianjin near a prison "where women would come and wait outside, all night long, for bodies to be thrown out on the street after they were, quote, 'interrogated' [by the authorities]. So we really saw a vicious part of colonialism....That part was quite clear in our memory." Mark di Suvero, conversation with author, November 2, 2017. For more on di Suvero's early life in China and his opposition to the Vietnam War, see the film directed by François de Menil and Barbara Rose, *North Star: Mark di Suvero* (1977).

13 Leon Golub, quoted in Kate Horsfield, "Profile: Leon Golub" (interview), *Profile* 2, no. 2 (March 1982): 22.

14 Benny Andrews served during the Korean War as a military policeman posted in California and Alaska. J. Richard Gruber, *American Icons: From Madison to Manhattan, the Art of Benny Andrews, 1948-1997* (Augusta, GA: Morris Museum of Art, 1997), 63–65. Donald Judd served in the army in Korea in the late 1940s, before the outbreak of the Korean War. "Donald Judd in Conversation with Regina Wyrwoll," October 4–5,

1993, https://chinati.org/programs/donald-judd-in-conversation-with-regina-wyrwoll/. Dan Flavin was in Korea with the air force in the mid-1950s, after the end of the war. Dan Flavin, "'…in daylight or cool white.' an autobiographical sketch," *Artforum* 4, no. 4 (December 1965): 20–24. Malaquias Montoya served tours as a marine in Japan, the Philippines, and Taiwan between 1957 and 1960. Terezita Romo, *Malaquias Montoya* (Los Angeles: UCLA Chicano Research Center Press, 2011). Although it is known that Carlos Irizarry served in the army, we have not been able to confirm when or where.

15 The U.S. Census counted 877,934 Asian Americans in 1960; by 1970, this number had increased to 1.4 million, and by 1980, to 3.4 million. Helen Zia, "Asian American: An Evolving Consciousness," in *One Way or Another: Asian American Art Now*, ed. Melissa Chiu (New York: The Asia Society, 2006), 10–14. By contrast, as of the 2010 U.S. Census, Asian Americans accounted for 5.6 percent of the population. Elizabeth M. Hoeffel, Sonya Rastogi, Myoung Ouk Kim, and Hasan Shahid, *The Asian Population* (2010 Census Briefs), U.S. Census Bureau, March 2012, p. 3, https://www.census.gov/prod/cen2010/briefs/c2010br-11.pdf.

16 Most Vietnamese living in the United States at this time were students, children of the South Vietnamese elite sent abroad for their education. Tram Quang Nguyen, "Caring for the Soul of Our Community: Vietnamese Youth Activism in the 1960s and Today," in *Asian Americans: The Movement and the Moment*, ed. Steven G. Louie and Glenn K. Omatsu (Los Angeles: UCLA Asian American Studies Center Press, 2001), 286.

17 Specific statistics are not available for Americans of Southeast Asian descent from ethnic minority groups such as the Montagnard, Cham, Karen, and others. Linda B. Gordon, "Southeast Asian Refugee Migration to the United States," *Center for Migration Studies* 5, no. 3 (May 1987): 153–73, https://onlinelibrary.wiley.com/doi/abs/10.1111/j.2050-411X.1987.tb00959. See also population estimates compiled

by the Pew Research Center in 2015 in Gustavo López, Neil G. Ruiz, and Eileen Patten, "Key Facts about Asian Americans, a Diverse and Growing Population," *Fact Tank*, September 8, 2017, http://www.pewresearch.org/fact-tank/2017/09/08/key-facts-about-asian-americans/.

18 The number of Chinese allowed to come to the United States, for example, went from 250 to 20,000 per year. Before then most immigrants to the United States were of European descent. See Jie Zong and Jeanne Batalova, "Asian Immigrants in the United States," Migration Policy Institute, January 6, 2016, fig. 2, https://www.migrationpolicy.org/article/asian-immigrants-united-states.

19 The visibility of Asian American art reached an important watershed by the turn of the 1990s. See especially Margo Machida, Vishakha N. Desai, and John Kuo Wei Tchen, *Asia/America: Identities in Contemporary Asian American Art* (New York: Asia Society Galleries, 1994). For more on Asian American contemporary art, see Margo Machida, *Unsettled Visions: Contemporary Asian American Artists and the Social Imaginary* (Durham, NC: Duke University Press, 2008); and Melissa Chiu, Karin Higa, and Susette S. Min, eds., *One Way or Another: Asian American Art Now* (New York: Asia Society, 2008).

20 Author and scholar Viet Thanh Nguyen has been influential in arguing for a "just memory" of the wars in Southeast Asia, meaning one that is truly transnational and acknowledges the humanity and inhumanity of all participants. See his book *Nothing Ever Dies: Vietnam and the Memory of War* (Cambridge, MA: Harvard University Press, 2016). Nguyen has pointed out that the disproportionate cultural dominance of American memories of the war (in news media, film, literature, and art) have resulted in other remembrances of events in Vietnam, Cambodia, and Laos being ignored or repressed.

21 In the exhibition catalogue *Drawings and Diagrams 1963-1972 from Dan Flavin*, the entry for a drawing for *monument 4 for those who have been killed in ambush…* noted

that the work's title "refers to the then most typical way for being killed in South Vietnam." Emily S. Rauh and Dan Flavin, *Drawings and Diagrams 1963-1972 from Dan Flavin* (St. Louis, MO: Saint Louis Art Museum, 1973). The Swiss painter and writer Grégoire Müller was rare in discussing the title further, calling out "the deep emotional charge of the title, as opposed to the cold simplicity of the work" as well as citing Flavin's experience as a solider. Grégoire Müller, *The New Avant-Garde: Issues for the Art of the Seventies* (New York: Praeger Publishers, 1972), 9–10.

22 Jung-Ah Woo, "On Kawara's Date Paintings: Series of Horror and Boredom," 62.

23 The exhibition *1965-1975: Reconsidering the Object of Art* was on view at the Museum of Contemporary Art, Los Angeles from October 15, 1995 through February 4, 1996. Ann Goldstein and Anne Rorimer, eds., *Reconsidering the Object of Art: 1965-1975* (Cambridge, MA: MIT Press, 1995), 144.

24 Articulating this philosophy is Meyer Schapiro, "The Liberating Quality of Avant-Garde Art," *Art News* 56, no. 4 (Summer 1956): 36–42; and Clement Greenberg, "Modernist Painting," *The Voice of America Forum Lectures* (Washington: U.S. Information Agency, 1961), 1–7.

25 The literature on the history of the Vietnam War is immense. Some general one-volume accounts that I have drawn on are George C. Herring, *America's Longest War: The United States and Vietnam, 1950-1975* (New York: McGraw-Hill, 2002); Larry H. Addington, *America's War in Vietnam: A Short Narrative History* (Bloomington: Indiana University Press, 2000); Marilyn B. Young, *The Vietnam Wars, 1945-1990* (New York: Harper, 1991); and Charles E. Neu, *America's Lost War: Vietnam: 1945-1975* (Hoboken, NJ: Wiley-Blackwell, 2005).

26 This figure represents one-tenth of the total prewar population of Vietnam. Cited in Nguyen, *Nothing Ever Dies*, 7.

27 At times, some of these figures have been estimated as much higher. Technical analysis of the Department

of Defense's Southeast Asian bombing databases is known to be challenging, and as a result estimates of the volume of U.S. bombs dropped during the Vietnam War have fluctuated over the years. See Ben Kiernan and Taylor Owen, "Making More Enemies than We Kill? Calculating U.S. Bomb Tonnages Dropped on Laos And Cambodia, and Weighing Their Implications," *The Asia-Pacific Journal* 13, April 27, 2015, https://apjjf.org/Ben-Kiernan/4313.html.

28 At least 40,000 Vietnamese have been killed by unexploded munitions since 1975. George Black, "The Vietnam War Is Still Killing People," *The New Yorker*, May 20, 2016, www.newyorker.com/news/news-desk/the-vietnam-war-is-still-killing-people. Some 400,000 tons of napalm and 19 million gallons of herbicides—primarily the dioxin Agent Orange—were dropped on rural South Vietnam by the United States. Kiernan and Owen, "Making More Enemies than We Kill? Calculating U.S. Bomb Tonnages Dropped on Laos And Cambodia, and Weighing Their Implications." According to the World Health Organization, dioxins "cause reproductive and development problems, damage the immune system, interfere with hormones and also cause cancer." http://www.who.int/news-room/fact-sheets/detail/dioxins-and-their-effects-on-human-health.

29 Roughly 5 million out of a population of 17 million in South Vietnam were classed as refugees. Young, *The Vietnam Wars, 1945-1990*, 177.

30 Ibid.

31 Addington, *America's War in Vietnam*, 160–61.

32 Rubén G. Rumbaut, "A Legacy of War: Refugees from Vietnam, Laos, and Cambodia," in *Origins and Destinies: Immigration, Race, and Ethnicity in America*, ed. Silvia Pedraza and Rubén G. Rumbaut (Belmont, CA: Wadsworth, 1996), 318. Some 130,000 South Vietnamese escaped the country before Sài Gòn was captured by the North Vietnamese Army. Addington, *America's War in Vietnam*, 158.

33 Nguyen, *Nothing Ever Dies: Vietnam and the Memory of War*, 114.

34 This quote comes from Tim O'Brien's autobiographical short story "On the Rainy River," collected in *The Things They Carried* (Boston: Houghton Mifflin, 1990), 38.

35 The statistics on fatalities from the Defense Casualty Analysis System Extract Files are current as of April 29, 2008. See "Vietnam War, U.S. Military Fatal Casualty Statistics, Electronic Records Reference Report," National Archives, accessed October 4, 2018, https://www.archives.gov/research/military/vietnam-war/casualty-statistics. For total number of troops deployed during the Vietnam War, see Military Health History Pocket Card, Vietnam, U.S. Department of Veterans Affairs, accessed October 4, 2018, https://www.va.gov/oaa/pocket-card/m-vietnam.asp.

36 Even today, strong disagreement continues about the conclusions to be drawn from this war. Although the majority of historians consider the U.S. war in Vietnam a mistake, others have described it as justified or necessary. For instance, see Mark Moyar, *Triumph Forsaken: The Vietnam War 1954–1965* (New York: Cambridge University Press, 2006).

37 Louis Harris Poll, "Tide of Public Opinion Turns Decisively against the War," *Washington Post*, May 3, 1971, A14.

38 A Harris Poll conducted after the March on the Pentagon in 1967 showed growing disapproval of antiwar demonstrations, with 76 percent of respondents agreeing that such protests "encourage communists to fight all the harder," and 68 percent agreeing that they "are acts of disloyalty against the boys in Vietnam." Quoted in William Conrad Gibbons, *The U.S. Government and the Vietnam War: Executive and Legislative Roles and Relationships, Part IV, July 1965–January 1968* (Princeton, NJ: Princeton University Press, 2014), 868. While many Americans associated the antiwar movement with the youth counterculture, many different kinds of Americans were involved in protesting the war. For a survey of the antiwar movement, see Simon Hall, *Rethinking the American Anti-War Movement* (London: Routledge, 2011); and Rhodri Jeffrey-Jones, *Peace Now!: American Society and*

the Ending of the Vietnam War* (New Haven, CT: Yale University Press, 1999).

39 At the beginning of 1964 there were only about forty press correspondents in South Vietnam. Their number grew to almost three hundred by the end of 1965. William M. Hammond, *Reporting Vietnam: Media and Military at War* (Lawrence: University Press of Kansas, 1998), 63.

40 For more on the joint influence of television and photographic coverage of the Vietnam War, see Liam Kennedy, *Afterimages: Photography and U.S. Foreign Policy* (Chicago: University of Chicago Press, 2016).

41 For more on the conditions under which journalists covered the Vietnam War in South Vietnam, see Daniel C. Hallin, *The Uncensored War: The Media and Vietnam* (Berkeley: University of California Press, 1989); Clarence Wyatt, *Paper Soldiers: The American Press and the Vietnam War* (Chicago: University of Chicago Press, 1995); and William M. Hammond, *Reporting Vietnam: Media and Military at War* (Lawrence: University Press of Kansas, 1998).

42 Carl Andre, quoted in Lucy R. Lippard, "The Dilemma," first published in *Arts Magazine*, November 1970, reprinted in *Get The Message?: A Decade of Art for Social Change* (New York: E. P. Dutton, 1984), 5.

43 For more on these early antiwar actions, see Francis Frascina, *Art, Politics and Dissent: Aspects of the Art Left in Sixties America* (New York: Manchester University Press, 1999); and Therese Schwartz, "The Politicalization of the Avant-Garde," *Art in America* 59, no. 6 (November/December 1971): 97–105.

44 Barnett Newman favored this term to describe himself. For Newman, his uncompromisingly abstract paintings were radical assertions of personal and political freedom. See Richard Shiff, "Introduction," and "Frontiers of Space" Interview with Dorothy Gees Seckler (1962) in *Barnett Newman: Selected Writings and Interviews*, ed. John P. O'Neill (Berkeley: University of California Press, 1990), xiv–xxvi and 247–51.

45 Philip Guston, quoted in Robert Slifkin, *Out of Time: Philip Guston and the Reconfiguration of Postwar American Art* (Berkeley: University of California Press, 2013), 65.

46 Leon Golub, "What Is the Meaning of a Symbolically Perfect and a Physically Faultless Perfect Art?" in *Leon Golub: Do Paintings Bite? Selected Texts, 1948–1996*, ed. Hans-Ulrich Obrist (Ostfildern, Germany: Hatje Cantz, 1997), 162.

47 "Judson Publications Manifesto, 1967," also signed by Ralph Ortiz, Al Hansen, and Lil Picard. *GAAG: The Guerrilla Art Action Group, 1967–1976, A Selection* (New York: Printed Matter, Inc., 1978), n.p.

48 Cosponsored by Artists and Writers Protest, the Greenwich Village Peace Centre, and the New York University chapter of Students for a Democratic Society (SDS), Angry Arts Week took place January 29 to February 5, 1967. The *Collage of Indignation* was exhibited at NYU's Loeb Student Center. It was just one of many offerings; the week also included poetry readings, dance performances, film screenings, Broadway and off-Broadway peace activities, folk rock and classical music programs, writers' forums, an antiwar float, street theater, and public discussions. See Frascina, *Art, Politics and Dissent*, 115–19; Matthew Israel, *Kill for Peace: American Artists against the Vietnam War*, 70–77; and David McCarthy, *American Artists against War, 1935–2010* (Oakland: University of California Press, 2015), 78–80.

49 Harold Rosenberg, "Art of Bad Conscience," reprinted in *Artworks and Packages* (New York: Horizon Press, 1969), 164.

50 Max Kozloff, quoted in Amy Newman, *Challenging Art: Artforum, 1962–1974* (New York: Soho Press, 2000), 299.

51 Max Kozloff, "Collage of Indignation," in Kozloff, *Cultivated Impasses: Essays on the Waning of the Avant-Garde, 1964–1975* (Marsilio Publishers, 2000), 393.

52 Ibid.

53 Allan Kaprow, quoted in Barbara Rose and Irving Sandler, "Sensibility

of the Sixties," *Art in America* 55, no. 1 (January/February 1967): 45.

54 Kaprow had since the 1950s predicted an expanded field of art; see "The Legacy of Jackson Pollock," 1958, reprinted in *Essays on the Blurring of Art and Life* (Berkeley and Los Angeles: University of California Press), 1–9. However, Kaprow avoided overt political content in his work. Asked in 1967 if his art could be effective as a political tool, he responded, "I don't feel that my work lends itself to this kind of an end. When I've been asked to prepare Happenings for this or that political function, peace movement or protest, I have said no in all but one case (and that was a fiasco). I felt that to the extent that my work was politically useful as a tool, it would be bad as a Happening. The more the end was literally a kind of reward, that is, the achievement of a political goal, the less the work would have the broader philosophical implications that I'm interested in. So you might say that my work is not strictly topical, although its materials are topical." Allan Kaprow, "Interview," in *Allan Kaprow* (Pasadena, CA: Pasadena Art Museum, 1967), 9.

55 Allan Kaprow, quoted in Rose and Sandler, "Sensibility of the Sixties," 45.

56 Pauline Kael, quoted in Will Brantley, ed., *Conversations with Pauline Kael* (Jackson: University Press of Mississippi, 1979), 36.

57 Women Strike for Peace and the Women's International League for Peace and Freedom led early protests against the war. The sexism many women encountered within the larger antiwar and New Left movements contributed to the creation of female-led peace groups. Later groups include Another Mother for Peace and the Jeannette Rankin Brigade. For further discussion of the role of women in the antiwar movement, see Amy Swerdlow, *Women Strike for Peace: Traditional Motherhood and Radical Politics in the 1960s* (Chicago: University of Chicago Press, 1992); and Rhodri Jeffrey-Jones, *Peace Now!: American Society and the Ending of the Vietnam War* (New Haven, CT: Yale University Press, 1999).

58 Examples of Nancy Spero's *War Drawings* were included in the *Collage of Indignation* during Angry Arts Week in 1967 and in a group exhibition at Colgate University in 1969 but otherwise were unseen publicly for many years thereafter. McCarthy, *American Artists against War*, 87. Similarly, Judith Bernstein reports that she had little opportunity to present her considerable body of Vietnam War–related paintings and drawings before 2009. Two works were included in *The People's Flag Show* at Judson Gallery in 1970 and a few drawings in a solo exhibition at the University of Colorado Art Museum in 1976. Bernstein, email with the author, June 29, 2018. Another feminist pioneer, Judy Chicago, noted that, until recently, no critical writing appeared about her pyrotechnic works, the *Atmospheres*, several of which reflect the imagery of the Vietnam War, attributing this to the general silence around art by women in the 1960s and 1970s. Chicago, phone conversation with the author, September 27, 2017.

59 For further discussion of Vietnam War-era draft resistance, see Michael Stewart Foley, *Confronting the War Machine: Draft Resistance during the Vietnam War* (Chapel Hill: University of North Carolina Press, 2003).

60 Muhammad Ali made this statement to reporters in Louisville in 1967. Mike Marqusee, *Redemption Song: Muhammad Ali and the Spirit of the Sixties*, 3rd ed. (London: Verso, 2017), 214.

61 African Americans made up about 13 percent of the U.S. population between 1961 and 1966, yet they accounted for almost 20 percent of U.S. combat deaths in Vietnam during the same period. After 1966, under heavy public criticism, army and marine leadership worked to reduce black casualties, bringing their combat deaths down to about 12 percent. See Spencer C. Tucker, ed., *Encyclopedia of the Vietnam War: A Political, Social, and Military History* (New York: Oxford University Press, 1998). The Department of Defense did not track information on Hispanic Americans during the Vietnam War. Census estimates indicate that Hispanic Americans

made up approximately 4.5 percent of the U.S. population in 1970, and one analysis, based on the surnames of service members, estimates that Hispanic Americans made up 5.5 percent of the casualties that year. Most of these casualties came from California and Texas, with smaller numbers from Colorado, New Mexico, Arizona, Florida, New York, and other states. "Vietnam War Casualties by Race, Ethnicity and National Origin," accessed July 17, 2018, www.americanwarlibrary.com/vietnam/vwc10. htm. Another study estimates that 20 percent of American casualties in Vietnam between 1961 and 1969 were Chicanos or other Latinos. Philip Brookman, "Looking for Alternatives: Notes on Chicano Art," in *Cara: Chicano Art, Resistance and Affirmation*, ed. Richard Griswold Del Castillo, Teresa McKenna, Yvonne Yarbro-Bejarano (Tucson: University of Arizona Press, 1991), 186.

62 More than 42,000 Native Americans served in Southeast Asia as military advisers or combat troops between 1960 and 1973. Representing less than 1 percent of the overall population, they made up 2 percent of soldiers. For more on the experiences of Native Americans in the Vietnam War, see Tom Holm's thorough and groundbreaking book, *Strong Hearts, Wounded Souls: Native American Veterans of the Vietnam War* (Austin: University of Texas, 1996).

63 Peter Davis, director of the documentary film *Hearts and Minds* (1974), interviewed General William Westmoreland. This quotation and interview are in the finished film by BBS Productions.

64 For additional discussion of the influence of the Vietnam War on Asian American consciousness, see Steven G. Louie and Glenn K. Omatsu, eds., *Asian Americas: The Movement and the Moment* (Los Angeles: UCLA Asian American Studies Center Press, 2001). For more on Asian American history and demographics, see William Wei, *The Asian American Movement* (Philadelphia: Temple University Press, 1993), 3–10, 64–71; Ronald Takaki, *Strangers for a Different Shore: A History of Asian Americans* (New York: Penguin, 1989); and Helen Zia, *Asian American Dreams: The Emergence of an*

American People (New York: Farrar, Straus, and Giroux, 2000).

65 I am grateful to art historian Margo Machida and artist and activist Nancy Hom for their advice as I sought out Asian American art made in response to the Vietnam War before 1975. Some helpful sources on Asian American art history in general include Irene Poon Anderson, Mark Johnson, Dawn Nakanishi and Diane Tani, eds., *With New Eyes: Towards an Asian American Art History in the West* (San Francisco: San Francisco State University, 1995); and Gordon H. Chang and Mark Dean Johnson, eds., *Asian American Art: A History, 1850–1970* (Stanford, CA: Stanford University Press, 2008).

66 Peter Saul to Allan Frumkin, November 1966, reprinted in *Peter Saul from Pop to Punk: Paintings from the '60s and '70s* (New York: Venus, 2015), 36.

67 Leon Golub, quoted in Irving Sandler, "Rhetoric and Violence: Interview with Leon Golub," *Arts Magazine* 44, no. 4 (February 1970): 23.

68 The most notable such action in the art world was the New York Art Strike on May 22, 1970, which saw galleries and museums shut down and artists withhold their work in a one-day act of "symbolic denial" in opposition to the war. See Julia Bryan-Wilson, *Art Workers: Radical Practice in the Vietnam War Era*, (Berkeley: University of California Press, 2009), 119n122.

69 Conceptual artist Joseph Kosuth, for one, connected the rise of conceptual art with the social ruptures of the Vietnam War era as well as his generation's break with "the myth of modernism." See his essay "1975," reprinted in Kosuth, *Art after Philosophy and After, Collected Writings, 1966–1990* (Cambridge, MA: MIT Press, 1991), 129–43.

70 The first teach-in was organized by faculty and members of SDS (Students for a Democratic Society) at the University of Michigan, Ann Arbor, and was held on March 24–25, 1965. It took the form of an all-night program of events that included lectures, debates, films, musical performances, and workshops, addressing topics such as

the military-industrial complex and the role of the university, U.S. intervention in the Third World, Cold War rhetoric, and mechanisms for changing U.S. foreign policy. See Jeremy Allen, "U-M Professors' First Teach-in 50 Years Ago Launched a National Movement," *Michigan Live*, March 23, 2015, https://www.mlive.com/news/ann-arbor/index.ssf/2015/03/u-m_plans_50th_anniversary_cel.html.

71 The text is printed in an unattributed photostat flyer found in the Lucy R. Lippard papers, 1930s–2010, bulk 1960s–1990, Archives of American Art, Smithsonian Institution.

72 Brett Abbott, *Engaged Observers: Documentary Photography since the Sixties* (Los Angeles: J. Paul Getty Museum, 2010).

73 "In Plato's Cave" was first published in the *New York Review of Books* (October 18, 1973), reprinted in Susan Sontag, *On Photography* (New York: Anchor Books, 1979), 3–24.

74 "It would be obscene to show. These are pictures of real people. We are in a war." Martha Rosler, in conversation with the author, February 26, 2016.

75 New print workshops included Universal Limited Art Editions (founded in West Islip, NY, 1957), Tamarind Lithography Workshop (founded in Los Angeles, 1960), Crown Point Press (founded in Berkeley, 1962), and Gemini G.E.L. (founded in Los Angeles, 1966).

76 Corita Kent, quoted in Rev. Don Ranly, "Sister Corita: Tomatoes and Happy Beatitudes," *National Catholic Reporter*, December 22, 1965, 2.

77 The shooter was Bruce Dunlap, who was drafted and served in the army but never went to Vietnam. "I became a marksman, we all became marksmen, but…I didn't relate to guns and I didn't relate to shooting. It was something I had to do, going through that process." Eric Kutner, "Shot in the Name of Art," *New York Times*, May 20, 2015, www.nytimes.com/2015/05/20/opinion/shot-in-the-name-of-art.html.

78 See Frazer Ward, "Gray Zone: Watching 'Shoot,'" *October* 95 (Winter 2001): 114–30.

79 Of *Shoot*, artist Chris Burden said, "I'm not exactly sure when I first came up with the idea. I mean...first of all, you saw a lot of people being shot on TV every night, in Vietnam. Guys my age." Kutner, "Shot in the Name of Art."

80 Nguyen, *Nothing Ever Dies*, 2–3.

81 Christian G. Appy, *Working-class War: American Combat Soldiers and Vietnam* (Chapel Hill: University of North Carolina Press, 1993), 28. For more on draft-motivated volunteers, see Lawrence M. Baskir and William A. Strauss, *Chance and Circumstance: The Draft, the War, and the Vietnam Generation* (New York: Alfred A. Knopf, 1978), 54–55. I am grateful to Lily Wong of the New-York Historical Society for these sources.

82 In 1965, Irving Petlin telephoned Kienholz seeking his participation in a meeting of artists against the war, but the sculptor refused, apparently out of solidarity with American soldiers fighting overseas. Frascina, *Art, Politics and Dissent*, 28.

83 Kienholz's notes included in *The Non-War Memorial Book* indicate that the figure "45,647" corresponds to Americans "K.I.A....through Feb. 24-72."

84 Golub, quoted in "How Effective Is Social Protest Art? (Vietnam)" (transcript of a panel discussion with Golub, Allan D'Arcangelo, Ad Reinhardt, and Marc Morrel, moderated by Jeanne Siegel and broadcast on WBAI, August 10, 1967), printed in Siegel, *Artwords, Discourse on the 60s and 70s* (Ann Arbor, MI: UMI Research Press, 1985), 106.

85 Barnett Newman, "Interview with Emile de Antonio," in *Barnett Newman: Selected Writings and Interviews*, ed. John P. O'Neill (Berkeley: University of California Press, 1990), 303–304.

86 Kynaston McShine, *Information* (New York: The Museum of Modern Art, 1970), 138–39.

87 Martha Rosler, quoted in Craig Owens, "On Art and Artists: Martha Rosler" (interview), *Profile* 5, no. 2 (spring 1986): 8.

88 Ibid., 21.

89 Barbara Rose, "Problems of Criticism VI: The Politics of Art, Part III," *Artforum*, May 1969, 50–51. Emphasis original.

90 Allan Kaprow, quoted in *Metro: An International Review of Art*, no. 14 (June 1968): 39.

91 Carolee Schneemann left the United States for London in 1968 and stayed abroad for four years. Mark di Suvero removed himself from the country twice—first in the late 1960s, when he went to live for a short time on Vancouver Island, Canada; and between 1971 and 1975, when he went into self-described exile in Europe.

92 Hans Haacke, "Untitled Talk at Annual Meeting of Intersocietal Color Council, New York, April 1968," in *Working Conditions: The Writings of Hans Haacke,* ed. Alexander Alberro (Cambridge, MA: MIT Press, 2016), 14.

93 Allan Kaprow, "The Artist as a Man in the World," in *Essays on the Blurring of Art and Life* (Berkeley: University of California Press, 1993), 53.

Chronology and Plates

NOTES TO THE READER This section offers short essays on the works in the exhibition, integrated with a historical chronology of the Vietnam War. The artworks appear roughly by the year they were created or presented to the public. To find information on a specific artist, consult the index beginning on page 383.

The chronology provides readers unfamiliar with the Vietnam War a narrative sketch of its origins and progression. It also highlights events related to media coverage of the war; shifts in U.S. public opinion; and the overlapping antiwar, civil rights, and feminist movements that influenced the artworks under discussion.

TERMS AND EVENTS **Indochina:** the continental portion of Southeast Asia. The term was used to refer to the colony of French Indochina (what is today Vietnam, Cambodia and Laos).

Indochina War (also called the First Indochina War and known in Vietnam as the French War): the war fought between the Democratic Republic of Vietnam and France between 1946 and 1954.

Vietnam War (also called the Second Indochina War and known in Vietnam as the American War): the war fought between the Democratic Republic of Vietnam, backed by the People's Republic of China and the Soviet Union, and the Republic of Vietnam and its allies, predominantly the United States, between 1955 and 1975.

———————

Việt Minh, or League for the Independence of Vietnam: the national independence coalition formed by Hồ Chí Minh in May 1941.

DRV, Democratic Republic of Vietnam (colloquially known as North Vietnam): the government established by Hồ Chí Minh and the Việt Minh in September 1945; renamed the Socialist Republic of Vietnam in July 1976.

PAVN, People's Army of Vietnam: the regular army of the Democratic Republic of Vietnam.

NLF, National Liberation Front: an alliance of resistance groups founded under DRV tutelage in South Vietnam in 1960.

VC, Viet Cong (short for Vietnamese Communist): a colloquial American term used to refer to NLF fighters.

Preceding pages:

American helicopters fly over South Vietnam, ca. 1961. Photo by Dickey Chappelle

———————

RVN, Republic of Vietnam (colloquially known as South Vietnam): the state below the seventeenth parallel established in 1955. The RVN ceased to exist in 1975 and was assimilated into the Socialist Republic of Vietnam in July 1976.

ARVN, Army of the RVN: the army of the Republic of Vietnam.

MACV, Military Assistance Command, Vietnam: the American joint-service command responsible for all U.S. military forces, operations, and assistance in South Vietnam.

———————

SRV, Socialist Republic of Vietnam: the current Vietnamese state established in 1976, after the end of the Vietnam War.

SOURCES Statistics regarding U.S. troop levels come from U.S. Department of Defense, OASD (Comptroller), Directorate for Information Operations, March 19, 1974; cited in George C. Herring, *America's Longest War: The United States and Vietnam, 1950–1975*, 5th ed. (New York: McGraw-Hill Education, 2013), 188.

Numbers of U.S. casualties come from the Defense Casualty Analysis System, Vietnam Conflict Extract Data File; made available through the National Archives, Vietnam War U.S. Military Fatal Casualty Statistics, https://www.archives.gov/research/military/vietnam-war/casualty-statistics.

AUTHORS Plate entries are written by Melissa Ho (MH), Katherine Markoski (KM), Robert Cozzolino (RC), Joe Madura (JM), Sarah Newman (SN), and E. Carmen Ramos (ECR).

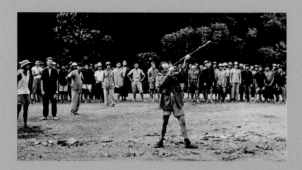

FIG. c1 An American
instructor from the Office
of Strategic Services trains
Việt Minh guerrilla fighters,
ca. 1945.

FIG. c2 French soldiers
during the Battle of Điện
Biên Phủ, 1954. Photo by
Jean Peraud

1940–1945

France's colonization of Vietnam begins in the seventeenth century with the arrival
of Catholic missionaries. By the late nineteenth century, France has taken control of
what is today Vietnam, Laos, and Cambodia, then known as French Indochina.

After the Fall of France (**1940**) during the Second World War, Japan occupies
Vietnam, though largely allowing Vichy-French colonial administration to continue.
In **1941**, communist revolutionary Hồ Chí Minh founds a nationalist resistance
group called the Việt Minh, to whom the United States supplies arms and training
for their fight against Japanese authority [FIG. c1].

On **SEPTEMBER 2, 1945**, Japan surrenders to the Allies, and Hồ Chí Minh declares
independence for the Democratic Republic of Vietnam (DRV).

1945–1956

Despite Hồ Chí Minh's proclamation of an independent Vietnam, France seeks to
reestablish colonial rule. A brutal struggle between France and the DRV ensues,
then known in the West as the Indochina War (**1946–54**). As the conditions of the
Cold War emerge — especially after the Chinese Revolution in **1949** and the out-
break of the Korean War in **1950** — U.S. policymakers regard Southeast Asia as an
important front in the fight against global communist expansion. Under President
Harry Truman (in office 1945–53), the United States begins sending military aid to
France in **1950** and is soon funding nearly 80 percent of the French war effort.

On **NOVEMBER 4, 1952**, Dwight Eisenhower defeats Adlai Stevenson to become
president of the United States (in office 1953–61).

In an **APRIL 1954** press conference, President Eisenhower warns that if Vietnam
falls under communist control, the rest of Southeast Asia will follow. This "falling
domino" theory heightens the geopolitical stakes in Vietnam and comes to domi-
nate U.S. foreign policy.

Facing defeat in the long-running Battle of Điện Biên Phủ in the **SPRING OF 1954**
[FIG. c2], France requests direct U.S. military intervention. However, Eisenhower
determines there is not sufficient congressional, public, and international support
for it. The subsequent French surrender leads to protracted peace negotiations in
Geneva among nine nations.

With the Geneva Accords of **JULY 1954**, Vietnam is temporarily divided at the sev-
enteenth parallel: the communist Democratic Republic of Vietnam (DRV), led by
Hồ Chí Minh, governs in the north, and the noncommunist State of Vietnam (SOV),

with former emperor Bảo Đại as head of state, in the south. The accords call for a nationwide plebiscite, to be held in **JULY 1956**, for unification under a single government chosen by the people.

Hoping to establish a permanent noncommunist nation in the south, the United States backs Ngô Đình Diệm, a Roman Catholic and anticommunist nationalist who is prime minister in the south. In **OCTOBER 1955**, a referendum marred by fraud takes place, ousting Bảo Đại and making Ngô Đình Diệm the head of state. Soon thereafter he names himself president of the newly declared Republic of Vietnam (RVN, or South Vietnam). With U.S. support, he declines to hold the 1956 plebiscite outlined in the Geneva Accords.

1956-1962

American support for Ngô Đình Diệm continues under the Eisenhower administration as well as that of his successor, John F. Kennedy (in office 1961–63).

South Vietnam is politically fractured, and Ngô Đình Diệm's autocratic, Catholic-dominated government alienates the large Buddhist population. As the state suppresses dissidents and political opponents, an insurgency forms in South Vietnam.

Lê Duẩn becomes First Party Secretary in the Democratic Republic of Vietnam (DRV, or North Vietnam) in **1960**, with Hồ Chí Minh remaining an important voice in the collective leadership. As Hồ Chí Minh's health declines in the mid-sixties, Lê Duẩn will become the leading political figure in the north.

In **1960**, the DRV establishes the National Liberation Front (NLF) — a political insurgency with its own military arm — to organize resistance to the South Vietnamese government.

A growing number of violent guerrilla attacks take place against the South Vietnamese state. American advisers begin referring to revolutionary fighters in the south as VC or Viet Cong, short for Vietnamese Communists.

In **1962**, President Kennedy increases U.S. military assistance to RVN and establishes a full field command, the Military Assistance Command, Vietnam (MACV). By the end of the year, 11,300 American military advisers are involved in the ground and air war against the insurgency in South Vietnam.

South Vietnam implements the Strategic Hamlet program in **1962**, forcibly moving peasants from their ancestral villages into hamlets newly created by the state. Aiming to deny VC fighters community support, the program fosters resentment of Ngô Đình Diệm's government among the rural South Vietnamese [FIG. c3].

FIG. c3 South Vietnamese villagers look out from behind barbed wire, ca. 1961–65. Photo by Dickey Chappelle

In **1962**, the U.S. Air Force begins Operation Ranch Hand, spraying herbicides over forested areas of South Vietnam and parts of Laos and Cambodia to deny Viet Cong cover and food supplies. Over nine years, about 19 million gallons of herbicides (mostly Agent Orange) will have been dropped.

1963

On **JANUARY 2**, an outnumbered NLF force stands and fights at Ấp Bắc, successfully holding back Army of the Republic of Vietnam (ARVN) forces and their American advisers before withdrawing under cover of darkness. This victory for the NLF raises doubts among U.S. leaders about the effectiveness of the South Vietnamese government and armed forces.

FIG. c4 Buddhists protest against the Ngô Đình Diệm government in streets of Sài Gòn, July 17, 1963. Photo by Horst Faas

NLF ranks grow, largely drawing recruits from the South Vietnamese population. Confronting growing evidence that the ARVN will be unable to defeat the insurgency, the Kennedy administration increases the number of U.S. military advisers. By the end of 1963, 16,300 Americans are serving in the country.

Buddhists in South Vietnam take to the streets to protest the government's repressive anti-Buddhist policies [FIG. c4]. From **JUNE** to **AUGUST**, six monks commit suicide by self-immolation as part of this campaign. Photographs of the first monk, Thích Quảng Đức, taking his life bring international attention to the unpopularity of Ngô Đình Diệm's regime [p. 241].

On **AUGUST 28**, more than 250,000 civil rights supporters attend the March on Washington for Jobs and Freedom. There Martin Luther King Jr. delivers his "I Have a Dream" speech in which he envisions the end of racism and calls for equality for all Americans.

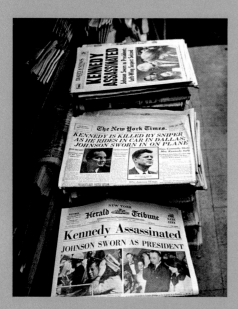

FIG. c5 Newspaper headlines announce the assassination of President John F. Kennedy, 1963.

With the tacit approval of the Kennedy administration, a military coup overthrows the South Vietnamese government on **NOVEMBER 1 AND 2**. The top leadership, Ngô Đình Diệm and his brother Ngô Đình Nhu, are killed. The United States continues military and economic aid to the new South Vietnamese government, initially led by General Dương Văn Minh.

On **NOVEMBER 22**, President Kennedy is assassinated in Dallas, Texas. Vice President Lyndon B. Johnson assumes the presidency (in office 1963–69) [FIG. c5]. He retains Secretary of Defense Robert McNamara, who has been one of the main architects of U.S. policy in Vietnam.

On the same day in Hà Nội, General Secretary Lê Duẩn introduces plans for a "General Offensive, General Uprising" strategy of coordinated attacks on South Vietnam, aimed at sparking popular revolution.

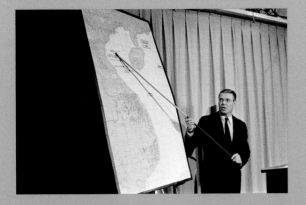

FIG. c6 Secretary of Defense
Robert McNamara addresses
incidents in the Gulf of Tonkin,
August 5, 1964.

FIG. c7 Bicycles carrying
supplies are unloaded in Thanh
Hóa, North Vietnam. Supplies
move with similar transport
along the Hồ Chí Minh Trail.

1964

A series of leadership changes in South Vietnam continue throughout the year. By mid-1965, Nguyễn Văn Thiệu will emerge as the head of state, with Nguyễn Cao Kỳ as prime minister. Both come to government through the military.

In a public event organized by the War Resisters League, about twelve men burn their draft cards in New York City in **MAY**. Such acts of protest multiply over the coming year.

Against a backdrop of Freedom Rides, lunch counter sit-ins, and other protests, President Johnson signs the Civil Rights Act of 1964 into law on **JULY 2**. This landmark legislation outlaws discrimination based on race, color, religion, or national origin, and prohibits unequal application of voter registration requirements and racial segregation in schools, employment, and public accommodations.

On **AUGUST 4**, President Johnson announces that U.S. warships patrolling international waters in the Gulf of Tonkin have twice been fired upon, unprovoked, by North Vietnamese torpedo ships [FIG. c6]. A series of retaliatory air strikes are launched against the DRV, resulting in the death of one American pilot and the capture of another.

Based on the White House's narrative of events, on **AUGUST 7**, Congress passes the Gulf of Tonkin Resolution authorizing the president to "take all necessary measures" to prevent further aggression from North Vietnam. The law enables the president to continue military action in Vietnam without an official declaration of war from Congress.

As the American public will later learn, the Johnson administration misled Congress: the first U.S. ship had been conducting a surveillance mission within DRV-claimed territorial waters, not neutral territory, at the time it was fired upon. The second incident, though reported, could not be confirmed and is now known not to have occurred.

On **NOVEMBER 3**, President Johnson defeats Republican Senator Barry Goldwater.

On **DECEMBER 1**, Johnson approves a secret bombing campaign in Laos intended to disable what Americans call the Hồ Chí Minh Trail, a series of trails and roads that run through Cambodia and Laos, used to supply manpower and materiel from North Vietnam to the insurgency in the south [FIG. c7].

1965

President Johnson orders U.S. ground combat troops to South Vietnam and begins air attacks on North Vietnam (Operation Rolling Thunder). The first two battalions of marines arrive in Đà Nẵng on **MARCH 8** [FIG. c8].

On what becomes known as "Bloody Sunday," **MARCH 7**, police brutally beat demonstrators protesting racial discrimination in voting registration as they set out to walk from Selma to Montgomery in Alabama. Led by members of the Student Nonviolent Coordinating Committee (SNCC) and the Southern Christian Leadership Conference, the activists reattempt and finally complete their march on **MARCH 25**.

Spearheaded by a group of professors and Students for a Democratic Society (SDS) at the University of Michigan, the first "teach-in" against the war takes place on **MARCH 24 AND 25** in Ann Arbor. This overnight gathering involves lectures, debates and group discussions about the history of Vietnam, U.S. policy in Southeast Asia, and the military draft. Dozens of such teaching events soon follow on college campuses across the country.

On **APRIL 17,** an estimated 20,000 people, many of them college students, participate in the March on Washington to End the War in Vietnam. Spearheaded by SDS, the march is also supported by Women Strike for Peace (WSP) and SNCC.

American artists organize their first group peace actions this spring. On **APRIL 18**, Artists and Writers Protest against the War in Vietnam (AWP) places a full-page ad in the *New York Times* headed "End Your Silence" and followed by nearly 600 signatures. In **MAY**, a similar open letter authored by the Artists' Protest Committee (APC) in Los Angeles appears in the *Los Angeles Free Press* [FIG. c9].

In **JUNE**, the APC organizes a demonstration at the RAND Corporation, a foreign-policy think tank involved in strategic planning for the Department of Defense. The protest leads to a public debate about U.S. policy in Southeast Asia between experts from RAND and APC representatives, including art critic Max Kozloff and painters Leon Golub and Irving Petlin.

In a television address on **JULY 28**, President Johnson announces, "We will stand in Vietnam." Without officially declaring America at war or seeking further authority from Congress, he orders an increase in the number of U.S. troops in South Vietnam to 125,000 and doubles the rate of the draft from 17,000 to 35,000 men per month.

Public opinion polls in **AUGUST** indicate that 60 percent of Americans approve of sending troops to Vietnam; only 24 percent consider it "a mistake."

On **AUGUST 5,** CBS airs a film report by correspondent Morley Safer showing U.S. Marines setting fire to the hamlet of Cam Ne during a search-and-destroy mission. "The day's operation burned down 150 houses, wounded three women, killed one

FIG. c8 United States
Marines land at Đà Nẵng,
1965.

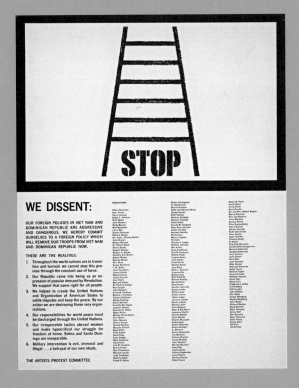

FIG. c9 Artists' Protest
Committee public statement,
1965.

baby, wounded one marine, and netted these four prisoners—four old men who could not answer questions put to them in English," Safer tells the evening news audience. Many viewers are outraged at the network for running a report that presents the U.S. military in a negative light.

In **AUGUST**, the Watts Rebellion breaks out in the predominantly African American neighborhood in Los Angeles, sparked by what is seen as racially motivated abuse by the police. Five days of looting, arson, and protest leave thirty-four dead, thousands arrested, and large areas of South Central Los Angeles destroyed.

American military engagement in Vietnam deepens, with the first major offensive battle conducted by a purely U.S. unit taking place in **AUGUST** at Văn Tường (Operation Starlite).

To limit the burning of draft cards as protest against the war, President Johnson signs a law on **AUGUST 31** making the deliberate destruction of one's draft card a federal offense.

On **OCTOBER 30**, more than 20,000 people parade down Fifth Avenue in support of the war, an event organized by the New York City Council, the American Legion, and Veterans of Foreign Wars.

In separate incidents this year, three Americans commit suicide by self-immolation to protest U.S. military action in Vietnam.

In **MID-NOVEMBER**, a major engagement between U.S. and PAVN forces occurs with the Battle of Ia Drang. North Vietnamese losses outnumber American ones by an order of ten. The differential in casualties reinforces the belief of General William Westmoreland (MACV commander, 1964–68) that, given America's superior air support and firepower, the war can be won by attrition. The PAVN takes a different strategic lesson from Ia Drang; they learn to quickly engage American forces by surprise and at close range. This tactic, to "grab them by the belt," offsets the U.S. advantage in air power and artillery.

In **DECEMBER**, President Johnson temporarily suspends bombing of the north in the hope of negotiating with the DRV. North Vietnam demands the complete withdrawal of foreign troops, the inclusion of the National Liberation Front in a neutralist government in Sài Gòn, and elections to determine South Vietnam's future. Rejecting these terms, the United States recommences bombing in January 1966.

By the end of December, there are 184,300 U.S. troops in Vietnam, up from 59,900 in June. Year-end American casualties for 1965 number 1,928, an increase from a total of 216 in 1964.

On Kawara | b. Kariya, Japan | d. New York City; 29,771 days

THE YEAR 1965 MARKED A CRUCIAL TURNING point in the Americanization of the war in Vietnam. On March 8, the first influx of what would eventually swell to more than half a million U.S. combat troops arrived in South Vietnam.[1] Around the same time, American bombs began hitting targets in the North, inaugurating an air war that continued with little pause for the next ten years. With these steps, President Lyndon Johnson set a new course of open war for the United States in Southeast Asia.

On Kawara's *Title* alludes to this consequential escalation in three succinct phrases: ONE THING / 1965 / VIET-NAM. Its restrained reference to a time and place beset with war lends the work its unexpected emotive power. *Title* was a watershed accomplishment in Kawara's development. With its creation (and that of another language-based painting called *Location*), he completed a transition from a late surrealist style of painting, the source of an early and successful career in Japan, to a radically austere, conceptual mode of art-making that occupied him for the rest of his life.

Kawara had left Japan in 1959 to travel extensively in Mexico, Central America, and Europe, remaining for significant periods in Mexico City and Paris. But it was in New York, where he landed in late 1964, that Kawara chose to establish a studio and embark on his *Today* series, a long-term project focusing on the representation and embodiment of time. *Today* encompasses a broad practice of systematic record keeping and documentation activities that includes the creation of Kawara's well-known date paintings (1966–2013) [p. 3]. *Title* both stands apart from and is rightly considered to have anticipated these signature works — each of which, like

Title's central canvas, depicts the date of its creation on a monochromatic background.

Conceptual art is often framed as a self-referential practice concerned solely with its own limits and definitions. *Title* has thus at times been presented as an apolitical work pointing to its own making. In such a reading, the words "ONE THING" refer to the material object of the painted canvas itself, and "VIET-NAM" merely serves to locate the piece in its historical moment. But as art historian Jung-Ah Woo has shown, Kawara consistently embedded references to trauma, war, and death in his art. Audiences outside of Japan are not always aware that Kawara first garnered attention making pictorial work that confronted the aftermath of Japan's defeat and devastation in the Second World War. His series of drawings titled *Bathroom* (1953–54),[2] for example, present horrific but emotionally blank scenes of murder and dismemberment — an apparent reference to the physical wounds and psychological numbness wrought by the atomic destruction of Hiroshima and Nagasaki.[3]

The artist's attentiveness to real-world events and his concern with the effects of war in particular continue in the date paintings. Kawara assigned each painting a subtitle, which he carefully logged in an accompanying journal. After 1972, these subtitles were determined by the day of the week that a painting was made. But prior to then, they consisted of either a personal remark (such as "Janine came to my studio") or, more often, a phrase taken from the day's news ("U.S. Marines estimated today they have killed 1,110 North Vietnamese in the last 4 days."). As Woo has reported, a preponderance of Kawara's selections concern incidents of violence and disaster.[4] Not surprisingly, given the escalation of U.S. military action at the time, multiple subtitles from 1966 relate to the war in Vietnam.[5] References to the war can also be found in the newspaper clippings that the artist, beginning in 1967, selected to preserve inside the cardboard boxes constructed to store his date paintings [FIG. 1].[6]

On Kawara

Title

1965
acrylic and collage
on canvas

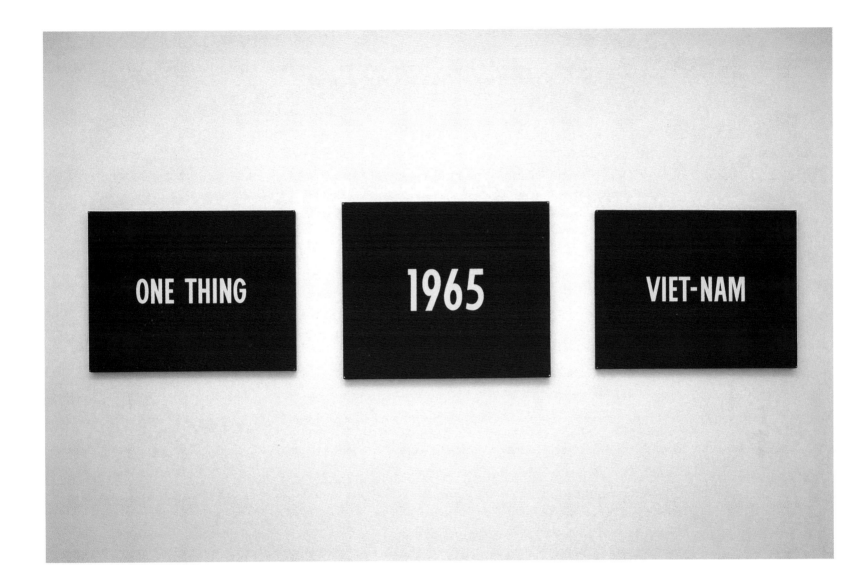

FIG. 1
On Kawara, *Everyday Meditation* (detail), 97 paintings from *Today* series, 1966–2013; *Feb. 5, 1970, Feb. 6, 1970,* and *Feb. 7, 1970*, 1970, acrylic on canvas, 10 × 13 in. each, accompanied by artist-made box and corresponding newspaper clipping, Courtesy One Million Years Foundation and David Zwirner

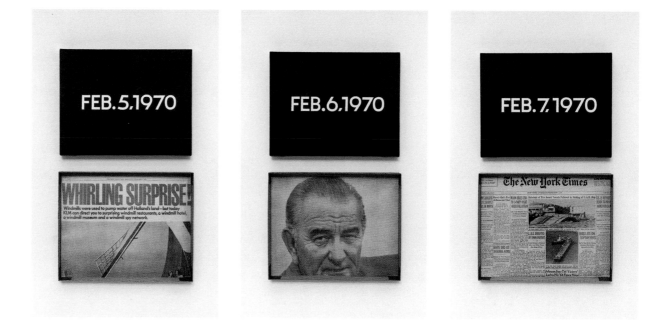

Kawara's subtitles and news cuttings are an important, though not always visible aspect of his practice.[7] They confirm that *Title* is not anomalous in the attention it pays to current events — rather, that a concern with politics and conflict is latent beneath the placid surface of Kawara's orderly, everyday work life.[8] Scanning his subtitles, we see abrupt shifts, day to day, from reports that "the New York Mets . . . won" and "Ay-O brought his cat to my apartment" to "President Johnson signed a bill authorizing 4.8 billion dollars more to support the war in Viet Nam." Such sequences speak to Kawara's — and most of the country's — anxious but highly mediated and distant observation of a devastating conflict. America's war in Vietnam was ongoing, but only erupted as the "ONE THING" on occasion. **MH**

1 At the end of 1964, there were roughly 23,000 American military advisers in South Vietnam. The number of U.S. troops in Vietnam would peak in April 1969, at more than 543,000.

2 Kawara's *Bathroom* drawings are held in the collection of the Tokyo National Museum of Modern Art. Reproductions of the series can be seen in On Kawara, *On Kawara 1952–1956 Tokyo* (Tokyo: Parco Col, 1991).

3 See Jung-Ah Woo, "Terror of the Bathroom: On Kawara's Early Figurative Drawings and Postwar Japan," *Oxford Art Journal* 33, no. 3 (2010): 262–76.

4 See Jung-Ah Woo, "On Kawara's 'Date Paintings': Series of Horror and Boredom," *Art Journal* 69, no. 3 (Fall 2010): 62–72.

5 Kawara's subtitles for 1966 to 1979 can be seen in *On Kawara, continuity/discontinuity, 1963–1979*

(Stockholm: Moderna Museet, 1980). In March 1966, for instance, four out of Kawara's twenty-three subtitles relate to the war in Vietnam; in April 1966, four out of twenty.

6 An array of Kawara's clippings could be clearly seen in the exhibition *On Kawara: Silence*, which offered a rare opportunity to view a large number of both paintings and boxes from an extended period of production in early 1970. Jeffrey Weiss et al., *On Kawara: Silence* (New York: Guggenheim Museum, 2015).

7 Although Kawara stipulated that his date paintings can be shown without or with their boxes (thus revealing the newspaper clippings), they have usually been shown alone.

8 Kawara's consumption of and attention to the news is given further weight in his series *I Read* that he began in 1966 and pursued until 1995. See Weiss et al., *On Kawara: Silence*, 109.

Yoko Ono | b. 1933, Tokyo, Japan

ON MARCH 21, 1965, YOKO ONO PERFORMED her *Cut Piece* at Carnegie Hall in New York, one of the five times she would stage the work between 1964 and 1966. Beginning with the initial performance in Kyoto, Japan, each iteration saw the artist sitting on the floor with a pair of scissors before her. After inviting audience members to come forward singly and cut off a piece of her clothing, taking the piece of fabric with them when done, she remained silent as the work unfolded. As numerous scholars have noted, the context of this multivalent work's performance — be it Kyoto or Tokyo, London or New York — could significantly inflect the meaning of *Cut Piece*, especially given the extent to which its realization was bound up with the specificity of its audience.[1] So, while *Cut Piece* was perhaps not conceived as an explicit work of protest against the war in Vietnam, Albert and David Maysles's film of its 1965 performance in New York, nonetheless, conjures something of the increasing American intervention abroad and the heightening cognizance of that escalation at home.

Ono came to global prominence as an avant-garde figure during the 1960s and, like many of the Fluxus artists with whom she was associated, worked comfortably in the visual, conceptual, and performing arts throughout the decade.[2] In interpretations of *Cut Piece*, the role played by her body and, as crucially, the audience's relationship to her body have quite rightly received the most attention from critics and scholars alike. Feminist readings have variously stressed the way Ono's piece foregrounds the vulnerability of an increasingly stripped female body and positioned the audience as exerting a nearly brutish aggression on her passive figure.[3] Related emphases

on violation and violence appear in scholarship that flags the work's connection to the war in Vietnam. Ono's body has been viewed as standing for that country while the audience becomes an army needlessly doing it harm — a problematic interpretation, given her Japanese identity.[4] There is, however, another and perhaps more productive way to understand the work's entanglement with the conflict abroad, especially with an eye to the Maysles's film: Ono's performance raises timely questions about how to respond to an evolving, uncertain situation, particularly one that potentially places others under duress.

The behavior of Ono's audience at Carnegie Hall varies. Some participants straightforwardly perform their given task, cutting a small piece of fabric from the artist's sleeve or skirt. Others take a seemingly more combative tack, including one male audience member who sets out to remove what remains of Ono's camisole with a somewhat menacing flourish. Ono later remarked that in *Cut Piece*, "Instead of giving the audience what the artist chooses to give, the artist gives what the audience chooses to take."[5] The audience, in other words, is placed in the driver's seat; they are left to decide how best to engage with the events confronting them. This is true not only for the audience member on stage but also for those watching at a remove. As Ono's camisole is clipped off over the course of more than a minute, for instance, other performance-goers register her apparent unease: they remark, "Look at the expression on her face," and note that the man doing the cutting is "getting carried away." No one intervenes, however; the laughter audible in the film, though perhaps uncomfortable, might even be taken as sanctioning the happenings on stage.

The entire performance becomes loaded when set against certain aspects of the year 1965. It was one that saw a war thus far waged in the shadows become increasing visible, with Operation Rolling Thunder unleashed and troop levels swelling from

Yoko Ono

Cut Piece

1964
performance at
Carnegie Hall,
New York,
March 21, 1965

twenty-three thousand at the end of 1964 to 184,300 by year's end. Opposition to this escalation was also beginning to emerge across the nation. For example, soon after Ono's performance, faculty at the University of Michigan's Ann Arbor campus organized the country's first teach-in on the conflict in Vietnam (March 24 to 25), and, in protest of the war, Students for a Democratic Society held its first major march on Washington (April 17). Within this context, *Cut Piece* seems to stage questions just beginning to take form for many: What would be the nature of their actions and their responses to those of others? Would they condone military aggression (even tacitly) or resist it?[6] That the Maysles's film cuts off mid-performance, leaving the viewer without a sense of how the work will conclude, is suggestive, too, in light of the war in Vietnam. In 1965, that conflict's American audience had just started watching in earnest and had no sense of how it might end. **KM**

1 See, for example, Julia Bryan-Wilson, "Remembering Yoko Ono's *Cut Piece*," *Oxford Art Journal* 26, no. 1 (2003): 101–23; Kevin Concannon, "Yoko Ono's *Cut Piece*: From Text to Performance and Back Again," *PAJ* 30, no. 3 (September 2008): 81–93; and Jieun Rhee, "Performing the Other: Yoko Ono's *Cut Piece*," *Art History* 28, no. 1 (February 2005): 96–118.

2 Fluxus was a global network of experimental artists working across a range of media in the 1960s. There was no single style, but these artists held in common a dedication to expanding understandings of what art could be.

3 Concannon's "Yoko Ono's *Cut Piece*" carefully traces the feminist reception of the work.

4 For this reading, see Barbara Tischler, "Counterculture and Over-the-Counter Culture," in *The Legacy: The Vietnam War in the American Imagination*, ed. D. Michael Shafer (Boston: Beacon Press, 1990), 286. Also see Robyn Brentano, *Outside the Frame: Performance and the Object* (Cleveland, OH: Cleveland Center for Contemporary Art, 1994), 42, 162. Bryan-Wilson usefully critiques such interpretations in "Remembering Yoko Ono's *Cut Piece*," 115–16.

5 Yoko Ono, quoted in Concannon's "Yoko Ono's *Cut Piece*," 89. Ono's statement is drawn from "If I Don't Give Birth Now, I Will Never Be Able To" (1974), in *Just Me! The Very First Autobiographical Essay by the World's Most Famous Japanese Woman* (Tokyo: Kodansha International, 1986), 34. Concannon commissioned the translation cited above.

6 The public's role in ending escalation would be addressed explicitly in Ono and John Lennon's 1969 *WAR IS OVER! IF YOU WANT IT* (p. 161).

1966

The United States expands the bombing of North Vietnam. With assistance from China and the Soviet Union, the DRV develops its air defense system, shooting down hundreds of U.S. planes over the course of the war.

In **FEBRUARY**, Senator William Fulbright holds public hearings questioning the war's justification and conduct. Although public opinion remains in favor of American involvement, approval of President Johnson's handling of the conflict erodes during the four weeks of televised hearings.

In Los Angeles, the Artists' Protest Committee (APC) constructs the *Artists' Tower of Protest*, otherwise known as the *Peace Tower* [**FIG. c10**]. The almost sixty-foot-high steel-pole structure (designed by Mark di Suvero) is accompanied by a wall of panel artworks submitted by hundreds of artists. Inaugurated on **FEBRUARY 26**, the *Peace Tower* remains on view for three months, attracting media attention and demonstrations of both opposition and support.

In late **MARCH**, massive Buddhist protests erupt against the military government in South Vietnam after a political struggle between Prime Minister Nguyễn Cao Kỳ and a Buddhist general Nguyễn Chánh Thi. After some two months of unrest, Nguyễn Cao Kỳ's forces succeed in quelling the opposition.

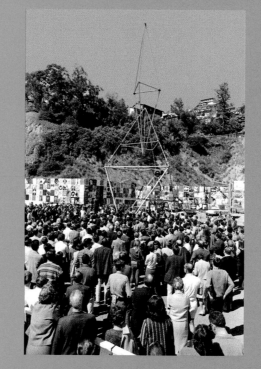

FIG. c10 Crowd at the inauguration of the *Artists' Tower of Protest*, Los Angeles, 1966.

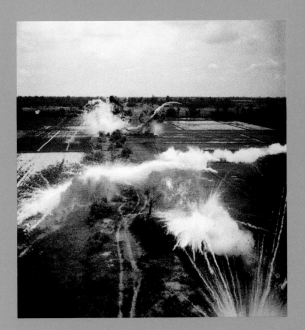

FIG. c11 American napalm
bombs are dropped in
South Vietnam, 1965.

FIG. c12 Recruits are
sworn in at the U.S. Army
induction center in Fort
Hamilton, New York, 1966.
Photo by Dick Durrance

Frustrated by the failure of the Equal Employment Opportunity Commission to ban discrimination in the workplace, feminists found the National Organization for Women (NOW) in **JUNE**. Betty Friedan, author of *The Feminine Mystique*, is chosen as the group's first president.

In **JULY**, the Congress of Racial Equality (CORE) passes a resolution that the U.S. Selective Service System places "a heavy discriminatory burden on minority groups and the poor" and calls for a withdrawal of U.S. troops from Vietnam.

Public outcry against the use of napalm in Vietnam leads to a nationwide campaign against its primary manufacturer, Dow Chemical Company, by the summer. The U.S. military has employed the gel as an incendiary weapon in Vietnam since 1962 [FIG. c11].

In **DECEMBER**, New York gallerist Stephen Radich is charged with flag desecration for presenting the work of Marc Morrel, an artist and former marine whose anti-war sculptures incorporate the American flag. Radich is later convicted in a ruling upheld by the Supreme Court in 1970.

At year's end, approximately 184,000 U.S. troops are in Vietnam [FIG. c12]. "Third-country" Allied troops, primarily from South Korea, Thailand, Australia, and New Zealand, are also in Vietnam fighting the communist forces.

Nancy Spero | b. 1926, Cleveland, OH | d. 2009, New York City

AFTER FIVE YEARS SPENT LIVING IN PARIS, Nancy Spero returned to the United States in 1964 with her husband, the artist Leon Golub [p. 257]. They had moved to France to escape the dominance of American abstract expressionism and to seek an environment more accepting of the allusive, figurative work they each pursued. Spero's somber *Black Paintings*, a series of canvases begun in Chicago in 1959 but executed mainly in Paris, depict figures, often in pairs, hovering within a dark, indeterminate space [FIG. 1]. A mood of existential isolation and submerged pain prevails in these delicate, enigmatic works, which present scenes of erotic coupling, childbirth, and motherhood.

America's war in Vietnam, however, reoriented Spero's practice. When she and Golub moved to New York, the war struck her as a personal and political crisis. "I had seen it in France with the Algerian War, but somehow I didn't take that personally. I am an American and an expatriate. And when one is an expatriate you are far removed from responsibility."[1] Spero's awakening sense of social accountability led to a radicalization in her work. With war as her subject, she no longer felt bound to an establishment

form of art. Abandoning oil paint and canvas for gouache and ink, she rendered fiercely expressionistic combat scenes on delicate sheets of paper. The artist made these works rapidly, sometimes mixing her own spit into the medium and tearing the support with the force of her applications and erasures. The choice to work on paper and at a small scale, she says, was "intentionally subversive, a personal rebellion"[2] against the preferences of collectors and gallerists who already overlooked her work, at least in part due to her gender.

Emotions that were obscured and muted in the *Black Paintings* became overt in the works comprising the *War* series. As the artist noted, "The Vietnam paintings are fragile in aspect, but very angry."[3] Spero's rage came from "not being heard, my being silenced"[4]—as a woman, an artist, and a citizen. The mother of three then-small boys, she was incensed by "all these young men [sent] to the carnage" of war.[5] "My anger really flowed...thinking as a mother, not tenderness, but rage."[6] The iconography in the *War* series includes images of the atomic bomb, that continual threat of total destruction. Spero's anthropomorphic mushroom clouds are often gendered—either phallic, violently asserting male power in an outburst of sex and warfare [p. 334], or female, with multiple breasts and heads that vomit or stick out their tongues. "I wanted to be as shocking as possible, and the way I could be most shocking, because it so upset people, was through sexuality."[7]

Spero also depicted military technology specific to the present conflict in Southeast Asia. She regarded the helicopter as exemplary of the domineering presence of the United States in South Vietnam. As with many Americans, her visualization of the war was influenced by television coverage. She recounted years later her horror and disbelief at encountering on TV a scene of an old Vietnamese woman fleeing her burning home; the footage had been shot from above, presumably from a U.S.

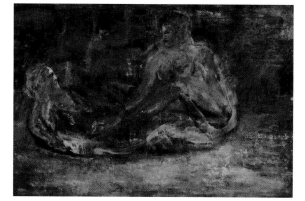

FIG. 1
Nancy Spero, *Le Couple (Lovers XIII)*, 1962, oil on canvas, Courtesy Galerie Lelong & Co., New York

Nancy Spero

Female Bomb

1966
gouache and ink on paper

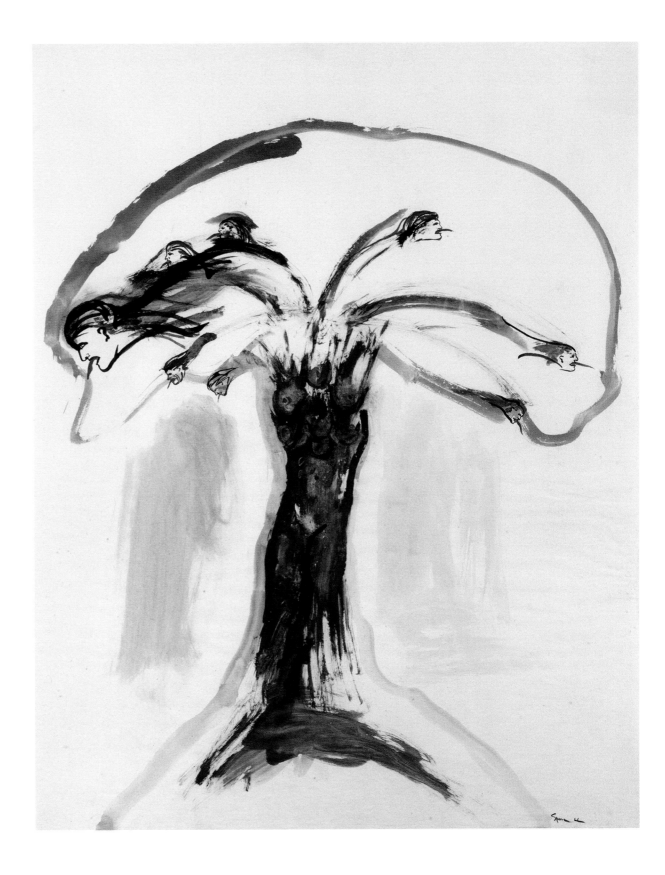

Nancy Spero

The Bug, Helicopter,
Victim

1966
gouache and ink
on paper

Nancy Spero

Victims on Helicopter
Blades

1968
gouache and ink
on paper

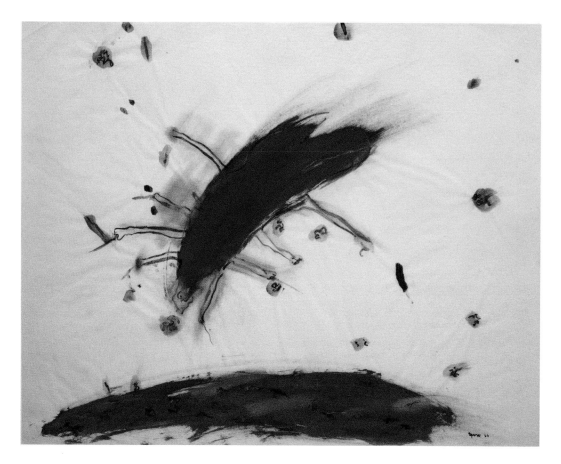

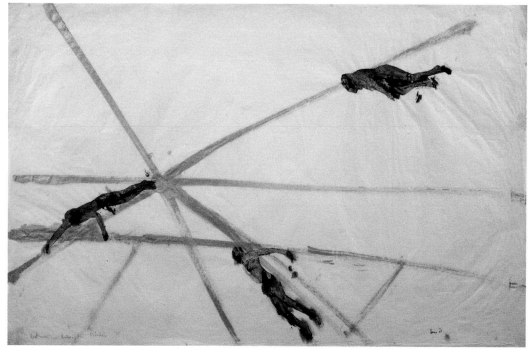

Nancy Spero

Gunship

1966
gouache on paper

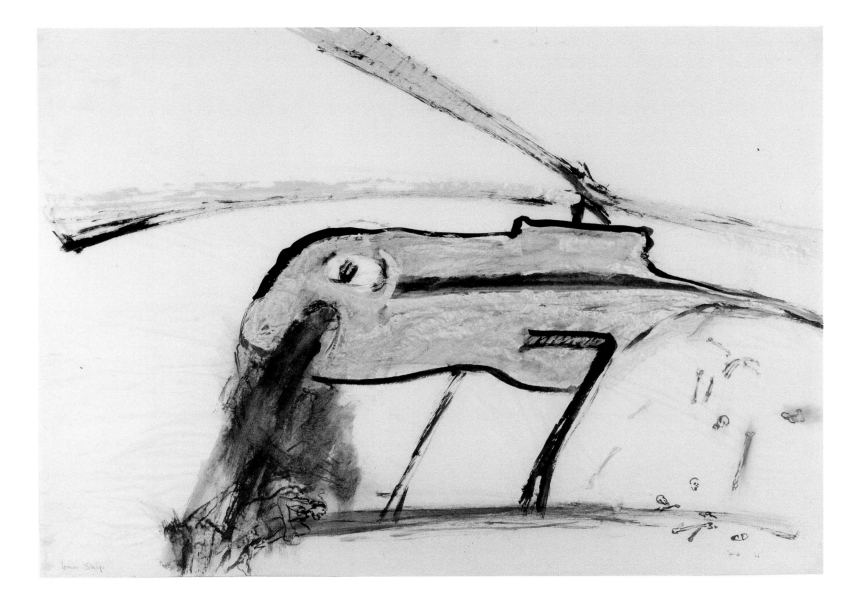

helicopter.[8] Spero's *War* paintings, however, present not the god-like perspective of airborne pilots and gunners, but her imagination of the experience below. "I visualized what the Vietnamese people might have thought of the helicopters, of these technological monsters wreaking destruction on them. I turned them into prehistoric, carnivorous dinosaur-like or insect-like creatures."[9] In *The Bug, Helicopter, Victim*, the helicopter appears as an enormous locust descending on a landscape littered with carnage, and in *Gunship*, it seems to devour its human victims, defecating their skeletal remains from its rear.

Spero made dozens of *War* paintings from 1966 to 1970. A few were exhibited in antiwar exhibitions (including during Angry Arts Week in 1967), but as works of art they remained underground. Even with the rising temperature of American public discourse about the war during the later sixties, Spero's ferocious, polemical art was profoundly out of sync with the "cool" preoccupations of the New York art world. Their uninhibited emotion and material fragility, as well as their maker's identity as a female artist, made the *War* series vulnerable to dismissal as unserious or childlike. During this period, Spero reports, Golub's monumental figurative paintings were "excluded from the mainstream" yet known; by contrast, her work was "unknown, ignored, and on occasion the *War* series was ridiculed."[10] But Spero

did not reverse course. Her art remained political, she continued to create works on paper, and she increasingly took on the experiences of women as her main subject matter. She remained political in her life as well, moving from peripheral involvement in the Art Workers' Coalition (AWC) to becoming a leading figure in Women Artists in Revolution and the Ad Hoc Women Artists' Committee, both groups that splintered from the male-dominated AWC in order to fight for women's rights and visibility in the art world. She described her involvement in these ventures at the turn of the 1970s as "the first time I had real colleagues…colleagues in a way of life, people I could really communicate with."[11] Though rooted in the Vietnam War, Spero's personal politicization, and the exquisitely tough and demanding art that grew from it, far outlasted the conflict itself. **MH/JM**

1 Spero, quoted in Kate Horsfield, "On Art and Artists: Nancy Spero," *Profile* 3, no. 1 (January 1983): 9.

2 Spero, quoted in Katy Kline and Helaine Posner, "A Conversation with Leon Golub and Nancy Spero," in *Leon Golub and Nancy Spero: War and Memory* (Cambridge, MA: MIT List Visual Arts Center, 1994): 28.

3 Spero, "On the Other Side of the Mirror, A Conversation with Robert Enright" (2000), in *Codex Spero, Nancy Spero — Selected Writings and Interviews, 1950–2008*, ed. Roel Arkesteijn (Amsterdam: Roma, 2008), 31.

4 Spero, "Defying the Death Machine, An Interview with Nicole Jolicoeur and Nell Tenhaaf," in *Codex Spero*, 9.

5 Ibid.

6 Spero, quoted in Mignon Nixon, "Spero's Curses," *October*, issue 122 (Fall 2007): 13.

7 Spero, "Defying the Death Machine," 9.

8 Spero, "Picturing the Autobiographical War, An Interview with Robert Enright" (2003), in *Codex Spero*, 35–37.

9 Spero, quoted in Kline and Posner, "A Conversation with Leon Golub and Nancy Spero," 45.

10 Ibid., 22.

11 Spero, interview with Corinne Robins, "Artists in Residence, The First Five Years," in *Codex Spero*, 43.

Judith Bernstein | b. 1942, Newark, NJ

WHEN JUDITH BERNSTEIN ENTERED THE YALE University School of Art as a graduate student in 1964, the head of the painting department immediately told her, "We cannot place you."[1] He meant that Bernstein, as a woman, should not expect to compete with her male peers for a teaching position upon graduation—nor, presumably, for exhibition opportunities. That an ostensible mentor would so openly undermine a student's hope for success before her career had even begun is galling. Yet his candor may have helped unleash Bernstein's voice as an artist. Taking for granted that she had no professional prospects, Bernstein "never thought there was a connection between being an artist, having a career, and showing work."[2] She applied herself to the first challenge—being an artist—and did not attempt to conform to the preferences of the establishment: "I always did what I wanted. I didn't always get what I wanted as a result, but I was independent."[3]

Bernstein had arrived at Yale making paintings that incorporated religious symbols and words in Hebrew, a reflection of her Jewish upbringing.[4] But as the Vietnam War escalated and public sentiment against the U.S. intervention intensified, her engagement with language veered from the sacred to the vulgar. Inspired by *Who's Afraid of Virginia Woolf?*, the acclaimed play by Edward Albee whose title was lifted from a barroom graffito,[5] Bernstein began reading the mood of the country on bathroom walls and adapting it in her work. She reveled in the raw, uncensored language she found on incursions into the men's room while her male friends stood guard—comments written anonymously in a presumed all-male space and at a moment of physical release. "While you're defecating," Bernstein noted,

"you're also going into your subconscious. I thought it was an interesting connection—to defecate and then to just write something that comes to your head."[6]

The bathroom scribbling Bernstein encountered included expressions of fear and anger about the war, some of which she repeated in her drawings: "I'd rather save my ass than Johnson's face"; "Going to Vietnam...hope I come back."[7] With American deployments on the rise during the years Bernstein was in graduate school, men of her generation had little choice but to consider their lives in relation to the military draft and potential service in Vietnam. The draw-by-number imagery in *Fucked by Number* puts the metaphor of screwing and getting screwed, ubiquitous in bathroom graffiti, in relation to a war so often described in statistical terms. (The drawing prominently states that 20,000 Americans had been killed in Vietnam by the time the work was made.) Bernstein here suggests that we connect the dots between the escalation of the war and the apparent need of the country's leaders to project toughness and masculinity. That she considered the intertwining of masculinity and national power dangerous, even fatal, is again suggested in *Vietnam Garden*, which depicts flag-adorned, erect phalluses as military tombstones.

Bernstein further channeled the darkly mocking and lewd tone of bathroom graffiti in works such as *A Soldier's Christmas*. This painting suggests a debased holiday abroad, its scrawled inscription accompanied by a crude image of a woman's spread legs adorned with Brillo pads, a tiny American flag, and blinking Christmas lights. Like Nancy Spero [p. 48], Bernstein used taboo sexual imagery to register her fury at what she considered an obscene war. Her marshaling of profanity and humor also challenged conventional assumptions about feminine aesthetics. Hers was a conscious effort to "make the ugliest paintings I could. I wanted them to be as ugly and horrifying as the war was."[8] She recalled the late sixties as a time

Judith Bernstein

Fucked by Number

1966
charcoal and mixed media
on paper

Judith Bernstein

Vietnam Garden

1967
charcoal, oil stick,
and steel wool on paper

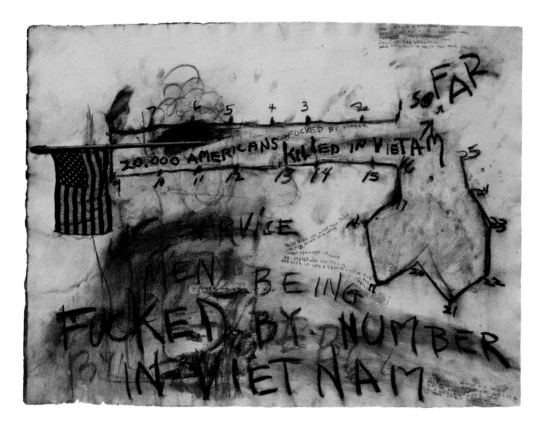

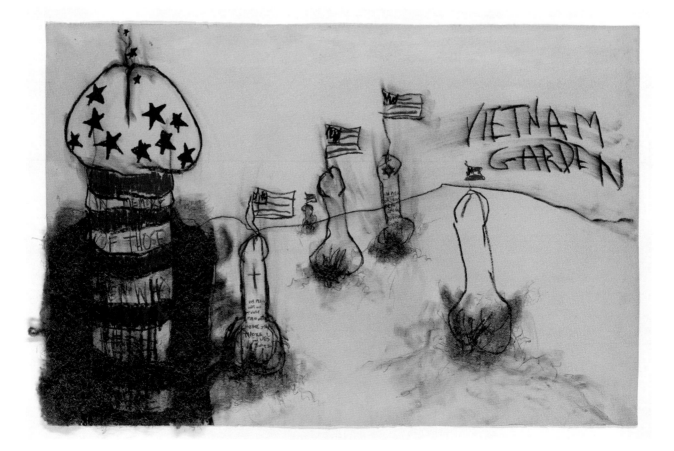

Judith Bernstein

A Soldier's Christmas

1967
oil, fabric, steel wool,
electric lights, and mixed
media on canvas

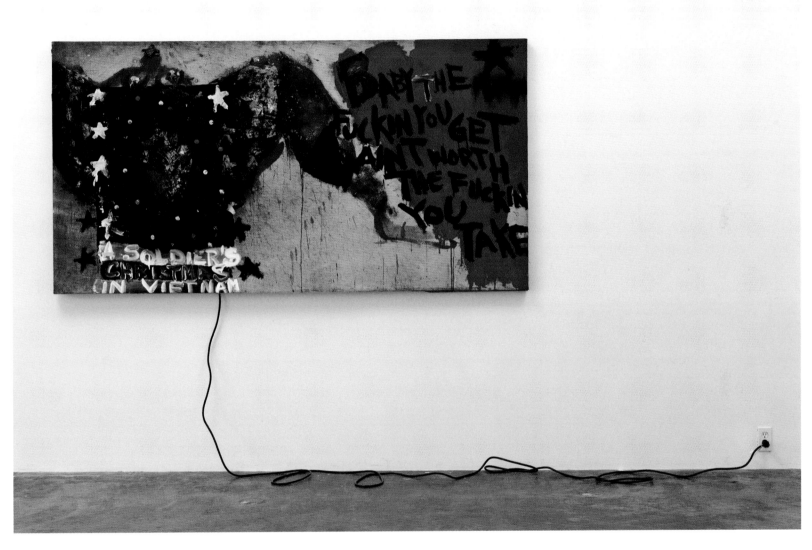

of extreme slogans and rhetoric: "You had to scream it for people to hear it."[9] But Bernstein's sense of rage was matched by her sense of humor. The excesses of her work—the blinking lights, the proliferating phalluses—were fueled by anger, yet often elicit laughter. Bernstein observed that "[you laugh] like an ejaculation...you get a release by laughing at it," even when the subject matter is "deadly serious."[10]

After Bernstein graduated in 1967 and moved to New York City, the forewarning given by her

professor three years earlier turned out to be accurate. Despite having earned a degree from the most prestigious art department in the country, Bernstein could not find a full-time teaching job, opportunities to exhibit, or gallery representation. In 1972, she became a founding member of A.I.R., the country's first all-woman gallery. There she showed work that continued to address militarism and masculinity, with the image of a helmet-headed screw emerging as her definitive symbol of overwhelming phallic power [FIG. 1]. These enormous bravura charcoal drawings hum with the artist's energy and rage—against war and against patriarchy. MH

FIG. 1
Judith Bernstein, solo exhibition, A.I.R. Gallery, New York, 1973

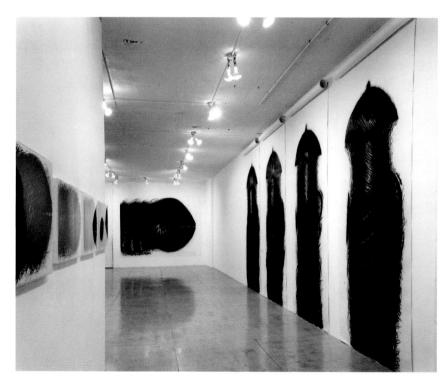

1 Bernstein, quoted in interview with M. H. Miller, "How to Screw Your Way to the Top: Judith Bernstein Brings Her Signature Style to the New Museum," *Observer*, October 9, 2012, http://observer.com/2012/10/how-to-screw-your-way-to-the-top-judith-bernstein-brings-her-signature-style-to-the-new-museum/.

2 Judith Bernstein, interview with Melissa Ho, January 26, 2016.

3 Bernstein, quoted in Julie L. Belcove, "Judith Bernstein, an Art Star at Last at 72, Has Never Been Afraid of Dirty Words," *Vulture*, May 5, 2015, http://www.vulture.com/2015/05/judith-bernstein-isnt-afraid-of-dirty-words.html.

4 Bernstein, interview with Melissa Ho.

5 Tim Adler, "Eight Things You Never Knew about *Who's Afraid of Virginia Woolf?*," *Telegraph*, May 12, 2017. http://www.telegraph.co.uk/theatre/national-theatre-live/whos-afraid-of-virginia-woolf-facts/. The film adaptation of *Who's Afraid of Virginia Woolf?* starring Richard Burton and Elizabeth Taylor and directed by Mike Nichols was released in June 1966, while Bernstein was a student at Yale.

6 Belcove, "Judith Bernstein, an Art Star at Last at 72."

7 These inscriptions appear in Bernstein's drawing *LBJ* (1967), collection of the Whitney Museum of American Art.

8 Bernstein, speaking at a panel discussion at The Box, Los Angeles (2011), quoted in Kate Wolf, "Sitings 5: War's a Dick," *Artslant*, May 16, 2011, https://www.artslant.com/la/articles/show/23438-sitings-5-wars-a-dick.

9 Whitney Museum of American Art, "Sinister Pop: Judith Bernstein," video, accessed October 17, 2018, https://vimeo.com/64179432.

10 Ibid.

Dan Flavin | b. 1933, New York City | d. 1996, Riverhead, NY

DAN FLAVIN PREMIERED *MONUMENT 4 FOR those who have been killed in ambush (to P. K. who reminded me about death)* in *Primary Structures: Younger American and British Sculptors* at the Jewish Museum in New York City in April 1966. This landmark exhibition brought to public attention a new type of three-dimensional art based in uncomplicated geometric forms.[1] It included works by several artists— among them Carl Andre, Donald Judd, and Robert Morris—who would soon form the canon of American minimalism. Their simple, nonobjective structures activated the architectural space of the gallery, making no apparent references beyond their own materiality. This reductive formal vocabulary became the visible link connecting the minimalists; despite differences of individual approach, they consciously separated their practices from overt political representation.

Dan Flavin's contribution to *Primary Structures* upended minimalist tenets with its allusive title: *monument 4 for those who have been killed in ambush (to P. K. who reminded me about death)*. Like many of the artist's light constructions, the title includes a personal dedication—in this case to Flavin's friend, artist Paul Katz. According to Katz, the dedication stemmed from a conversation between the two friends about U.S. involvement in Vietnam in which Katz emphasized the number of lives the war was likely to cost.[2] For this evocative sculpture, Flavin maintained the literal, mass-produced medium— fluorescent bulbs—that defined his artistic practice.[3] *Monument 4* is composed of four eight-foot-long tubes, all deep red—an unusual color that was nonetheless standard issue and could have been purchased off the hardware store shelf.[4] Two tubes are mounted horizontally on the wall at roughly eye level, their ends meeting at a corner. A third tube is positioned across those units to form a triangular armature on which the fourth tube rests, projecting directly out from the corner and into the center of the room.

Flavin's iconic works are typically self-referential— yet here a material description cannot suffice. The full title of *monument 4* announces the inherent aggression of its form. Intriguingly, Flavin submitted a quotation by the Nazi minister Hermann Göring for publication in the *Primary Structures* exhibition catalogue: "I am in the habit of shooting from time to time, and if I sometimes make mistakes, at least I have shot." The artist intended the quote to appear alongside the work's photographic reproduction, though ultimately it was left out.[5] Intimating a fascist, genocidal sentiment, Göring's words would seem to link the physical composition of *monument 4* to the horrors of World War II. Certainly, there is an integral connection between Flavin's textual support and the sculpture's spatial arrangement and immersive, bold coloration. Several commentators have described its form as a crossbow.[6] Yet given Göring's statement, the tube projecting outward from the corner more aptly evokes the muzzle of a gun.[7] If we choose to enter its firing line, we become targets. Red light claims the surrounding space, and wherever we walk, bloodlike fluorescence envelops us, indiscriminately, in a seething memorial.

Flavin's work speaks to realities of deadly military tactics in Vietnam. For American audiences in 1966, the title would have signaled conditions U.S. soldiers faced in combat, fighting in an unfamiliar landscape against an often unseen enemy. (This connection to the war was made clear in a 1973 exhibition catalogue that noted its reference to "the then most typical way for being killed in South Vietnam.")[8] Some Americans had assumed that superior U.S. military technology would lead to a clear victory in Vietnam. But North Vietnamese and insurgent fighters learned to engage American troops by surprise and at close range, an

58

Dan Flavin

*monument 4 for those
who have been killed
in ambush (to P. K.
who reminded me
about death)*

1966
red fluorescent light

intimate style of hit-and-run combat that offset U.S. advantages in airpower and artillery. That this was a guerrilla war, fought against hard-to-identify adversaries, added to the difficulties experienced by ordinary GIs on the ground. Remarkably, the simple structure of *monument 4* actualizes its allusion to guerrilla combat and an attendant sense of foreboding within the space of the art gallery. Its initial presentation, as the United States committed itself ever more in Vietnam, speaks to the inevitability of the conflict to reveal itself—even in the most restrained and reductive forms of American high culture.[9] **JM**

1 *Primary Structures* was curated by Kynaston McShine. The year before *Primary Structures* opened, a conversation between the curator and Lucy Lippard sparked ideas leading to the exhibition's premise. See James Meyer, *Minimalism: Art and Polemics in the Sixties* (New Haven, CT: Yale University Press, 2001), 22.

2 Flavin later told Katz he had dedicated a work to him, and Katz first saw the piece in the *Primary Structures* exhibition at the Jewish Museum. Paul Katz, phone conversation with Melissa Ho, September 7, 2018.

3 Flavin turned to factory-made fluorescent lights as his main sculptural components in 1963. Writing in 1972, Grégoire Müller discussed the artist's material sameness: "Essentially, all of his pieces are the same, dealing with the same basic problem. Flavin has, however, replaced the old idea of artistic evolution with another, more open, concept of free experimentation and inventory." Müller, "Dan Flavin," in *The New Avant-Garde: Issues for the Art of the Seventies* (New York: Praeger, 1972), 10.

4 On Dan Flavin's *Proposal,* artist Dan Graham wrote, "The use of fluorescent light available in any hardware store disenburdens [*sic*] the work of the weight of personal or historically generated (evolutionary) determination." Graham, "Flavin's *Proposal,*" *Arts* 44, no.4 (February 1970): 44.

5 Though Göring's quotation was omitted from the 1966 publication, Flavin cited Göring and others in relation to *monument 4* in *Dan Flavin, Fluorescent Light* (Ottawa: National Gallery of Canada, 1969), figure 103.

6 Such iconographic descriptions have circulated only in recent years, when critics have begun to connect Flavin's structural choices in *monument 4* directly to the context of America's war in Vietnam. A notable early instance of this criticism is Müller's *The New Avant-Garde,* 10.

7 For instance, the M60, a machine gun introduced in the final years of World War II, became an iconic symbol of rapid-firing weapons and ambush tactics common during the Vietnam War.

8 Emily S. Rauh, *Drawings and Diagrams 1963–1972 from Dan Flavin* (St. Louis: St. Louis Art Museum, 1973), 50.

9 Outside the boundaries of an art gallery, *monument 4* took on a radically different tone in the early 1970s, when famed New York art world hangout Max's Kansas City installed the sculpture in the club's back room above eye level. See Steven Kasher, *Max's Kansas City: Art, Glamour, Rock and Roll* (New York: Abrams, 2010) for documentation of poet Rene Ricard, musicians Eric Emerson and Alice Cooper, and queer icon Jason Holliday performing and partying under the glow of *monument 4.*

1967

United States and ARVN troops execute a massive search-and-destroy mission in **JANUARY** to eradicate enemy operations in the region outside Sài Gòn known as the "Iron Triangle" (Operation Cedar Falls). A huge system of VC hiding places and tunnels is discovered, and the entire civilian population of the area is moved into relocation camps. After U.S. and ARVN forces depart, communist fighters move back into the area with relative ease.

In **JANUARY**, three different magazines, representing both the mainstream and alternative press — *Ramparts*, *Ladies' Home Journal*, and *Redbook* — publish articles describing the impact of napalm on South Vietnamese civilians. The coverage includes photographs of badly burned children, images that fuel the protest campaign against the primary manufacturer of napalm, the Dow Chemical Company.

Initiated by Artists and Writers Protest against the War in Vietnam (AWP), Angry Arts Week takes place in New York from **JANUARY 29** to **FEBRUARY 5**. Hundreds of artists are involved in a slate of exhibitions, poetry readings, performances, and other artistic actions against the war, notably the *Collage of Indignation* [FIG. c13]. Later in the year, AWP creates a print portfolio to raise money for the antiwar movement [p. 78].

On **APRIL 4**, Martin Luther King Jr. gives a speech at Riverside Church in New York sharply denouncing the American war in Vietnam. King warns that if the United States does not "speak for peace in Vietnam, and justice through the developing world . . . we shall surely be dragged down the long, dark, and shameful corridors of time reserved for those who possess power without compassion, might without morality, and strength without sight."

FIG. c13　The *Collage of Indignation* exhibition at New York University, 1967. Photo by Karl Bissinger

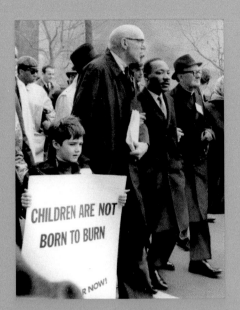

FIG. c14 Benjamin Spock
and Martin Luther King Jr.
attend the Spring
Mobilization March in
New York, 1967.

Organized by the Mobe, a coalition of peace groups, the Spring Mobilization to End the War in Vietnam takes place in New York on **APRIL 15**, drawing hundreds of thousands of protesters. Among the prominent citizens participating are Martin Luther King Jr. and Benjamin Spock [FIG. c14].

Vietnam Veterans against the War (VVAW) forms in New York with an initial membership of around one hundred.

President Johnson brings General Westmoreland back from the front to address U.S. legislators and the press in person. Speaking to the Associated Press on **APRIL 24**, the general cautions the public, "The end is not in sight."

On **APRIL 28**, world heavyweight champion Muhammad Ali refuses to be inducted into the U.S. Army and is arrested for draft evasion. He is convicted, fined, and sentenced to five years in prison. While appealing his case, he remains out of jail but is stripped of his boxing title and is unable to obtain a boxing license for three years.

Driven by black anger over racial injustice and oppression, a series of riots breaks out in American cities over the summer, the most devastating in Detroit and Newark. By **SEPTEMBER**, eighty-three people are dead, and entire neighborhoods have been burned to the ground.

The slow pace of progress in the war leads President Johnson's military advisers to propose an escalation of force against North Vietnam. Johnson ignores the most extreme of these proposals but increases the list of bombing targets in the north and requests an additional 55,000 troops. In **AUGUST**, he calls for a tax increase to fund the war effort.

In North Vietnam, General Secretary Lê Duẩn continues to pursue his goal of launching a coordinated attack on urban targets in South Vietnam, with the intent of breaking U.S. resolve and sparking a general uprising. The final plan for what will become known as the Tết Offensive is approved after months of political infighting among the communist leadership.

Already the figurehead chief of state, Nguyễn Văn Thiệu is elected president of the Republic of Vietnam (South Vietnam) on **SEPTEMBER 3**.

During Stop the Draft Week in **OCTOBER**, hundreds of young men turn in or burn their draft cards in protests held across the country. Culminating the week, a coalition of activists meet in Washington, D.C., and turn over more than 940 draft cards to the Department of Justice.

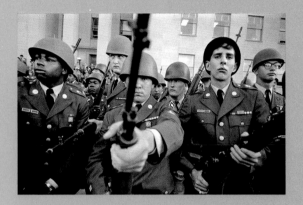

FIG. c15 Soldiers face
off with demonstrators
during the March on the
Pentagon, 1967. Photo by
Leonard Freed

The Mobe organizes a demonstration on **OCTOBER 21** that draws as many as 100,000 marchers to Washington. Following a rally at the Lincoln Memorial, a large subgroup of protesters marches to the Pentagon, where they are met by military police and federal marshals [FIG. c15]. Some protesters, led by the Yippies (Youth International Party), try to "exorcise and levitate" the Department of Defense headquarters; others cross the police line to court peaceful arrest or attempt to breach the building.

Public opinion polls show that the United States is sharply divided over its involvement in Vietnam, with a narrow majority of Americans believing that the country made a mistake intervening there. At the same time, an equal proportion of Americans disapprove of antiwar demonstrations as "acts of disloyalty against the boys in Vietnam."

Throughout the month of **NOVEMBER**, heavy fighting occurs in the Central Highlands in a series of engagements known as the Battle of Đắk Tô. Although considered a U.S. victory with the PAVN sustaining heavy losses, the sustained, violent fighting and the loss of 285 Americans dead and 985 wounded results in some American military leaders questioning the tactics employed.

Deciding that the U.S. air war against North Vietnam is ineffective, in **NOVEMBER** Secretary of Defense McNamara recommends a plan to end the bombing and cap troop levels, which President Johnson rejects. McNamara resigns on **NOVEMBER 29** and is replaced by Clark Clifford (Secretary of Defense 1968–69).

A blue-ribbon commission appointed by President Johnson to study the Selective Service recommends making the draft more equitable by eliminating educational and occupational deferments, adopting a lottery system, and consolidating local draft boards. Unable to reach consensus on these reforms, Congress passes the Military Selective Service Act of 1967, which made modest changes, such as the elimination of graduate school deferments.

President Johnson again brings General Westmoreland home from Vietnam in **NOVEMBER** to reassure the public about his war strategy. "With 1968," the general says, "a new phase is now starting. We have reached an important point where the end begins to come into view."

By year's end, there are 485,000 American troops in Vietnam. A total of 20,057 U.S. personnel have died in the conflict thus far, with 11,363 in 1967 alone.

Carolee Schneemann | b. 1939, Fox Chase, PA

IN JANUARY AND FEBRUARY 1967, CAROLEE Schneemann presented the kinetic theater piece *Snows* as part of Angry Arts Week, an artist-organized festival protesting the U.S. war in Vietnam.[1] *Snows* was a complex multimedia work integrating live performance with light, sound, film, and sculptural elements. Five separate films were projected in sequence as *Snows* progressed, filling and animating the surfaces of the set and of the performers' skin and clothing. Last to appear was *Viet-Flakes*, a film incorporating war photography Schneemann had collected since the early 1960s. Described by the artist as the "heart and core" of *Snows*,[2] *Viet-Flakes* provided the work's only explicit visual reference to the catastrophe in Vietnam. In the end, Schneemann recalled, viewers were stunned: "Those audiences in New York were very disturbed by the information centered in *Snows*, as they were meant to be!"[3]

The artist herself had been disturbed by events in Vietnam for some years. In the early 1960s, while a graduate student at the University of Illinois, Schneemann met a young poet who came from an unfamiliar part of the world—Vietnam. "[She] told us that we had troops in her country, destroying villages, arresting people. We had never heard of this."[4] The encounter prompted Schneemann to seek out information, primarily from international and alternative press sources, about the United States' involvement in what was formerly known as French Indochina. The photographs she found—of people dying, fleeing, being forcibly held—came to haunt her. By 1966, with the United States now openly at war in Vietnam, she reported suffering hallucinations of "bodies hanging in the trees; the kitchen stove became a miniature village, smouldering [*sic*]...and

I was afraid to bake in it." *Viet-Flakes* deals with images of faraway suffering, as well as Schneemann's feelings of responsibility and helplessness viewing them. Filming her collection of photographs arrayed on the floor, and often shooting through a distorting lens, Schneemann moved her camera across the pictures, at times seeming to animate still figures back to life. The film's sudden cuts and pulsing shifts in focus leave the viewer sickened and confused. The accompanying sound collage, created by James Tenney, is composed of snippets of Bach and Mozart, American pop songs, and Southeast Asian folk music. We also hear the noise of passing trains mixed with that of lovemaking—the latter sounds of sexual pleasure disconcertingly juxtaposed with visual images of physical torment. There are stuttering glimpses of a woman's anguished face, a pair of scrawny legs splayed on the ground, a man hung upside down.[5] In her notes about the film, Schneemann wrote, "purge at a distance/fury without effect/care without content/disembodiment."[6]

With *Snows*, Schneemann sought to advance an embodied response to brutal war imagery—to push the subject matter of *Viet-Flakes* into a "sensory arena" of heightened physical presence and live action. Writing about her approach to performance, Schneemann stated: "I want to make [imagery] palpable...[m]etaphors, which are carried out in the active body, in a[n] environment."[7] The performers in *Snows* play a series of changing and contradictory roles, which, over time, reveal themselves as related to the images in *Viet-Flakes*. The three men and three women, of varying racial identities, move between roles of "aggressor and victim, torturer and tortured, loved and beloved, as well as simply ourselves."[8] Seamless, almost invisible power shifts occur among the players, as controlling movements flow into supportive ones and back again. The performers' interactions were rehearsed but not predetermined. The length of a given action and the roles assigned

Carolee Schneemann

Viet-Flakes

1962–67
16 mm film, re-edited (2015)
on digital video, toned black
and white, sound

Carolee Schneemann

Snows

1967
kinetic theater performance

to the players, for instance, evolved during each performance. Members of the audience were also unwittingly involved. Seats in the theater were wired with contact mics that fed into an electronic system, producing the lighting and sound cues that the performers followed.[9] Thus, the movement of spectators in their seats set the rhythm of the action onstage, directly implicating the audience in the performance, as well as making the progression of events tension-filled and unpredictable.[10] Into this "vortex of increasingly disturbing energy" spilled, at last, the devastating imagery of *Viet-Flakes*.

Schneemann titled *Snows* in reference to her own name (*schnee* meaning "snow" in German), but, more importantly, as a metaphor for the vastness of destruction occurring in Southeast Asia. "The Vietnam War was a force of nature that never ceased…," she reflected, "enveloping every intentionality… a fierce inescapable weather… *Snows*."[11] Wintery imagery permeates the performance: the set was hung with icicle-like branches and sheets of white paper, lit in tones of green and blue, and filled with film projections of skiers, skaters, and snowy

New York. The distance between the audience and tropical Vietnam could not, on the surface, appear greater. Americans, Schneemann suggests, were "snowbound": taking in the evidence of their war from "a great remove, through reproduced photographs."[12] In *Snows*, through the remedy of physical contact and shared creation, performers and audience alike confronted and momentarily transcended that distance. **MH**

1 Eight performances of *Snows* took place from January 21 to February 5, 1967. Described in its program as "one of the events of Angry Arts Week," the piece debuted before that festival's official run of January 29 to February 5, 1967.

2 Carolee Schneemann, "Snows," in *More than Meat Joy: Complete Performance Works & Selected Writings*, ed. Bruce McPherson (New Paltz, NY: Documentext, 1979), 129.

3 Carolee Schneemann, interview with Melissa Ho, January 29, 2016.

4 Kenneth White, "Carolee Schneemann, Interviewed by Kenneth White," *Third Rail Quarterly*, no. 4 (Spring 2015): 16. http://thirdrailquarterly.org/wp-content/uploads/thirdrail_spring2015_final_kwhite.pdf. Schneemann received her Master of Fine Arts from the University of Illinois in 1961. Although the United States was not at this time openly at war in Vietnam, its military presence in the country was growing. By the end of 1962, there were approximately 11,000 American military advisers in South Vietnam, and the Kennedy administration had established a full field command in the country.

5 Among the images in *Viet-Flakes* is the same 1965 photo by Kyōichi Sawada of a Vietnamese woman caught in deep water described by Martha Rosler as having prompted her creation of her war-related photo collages [see p. 351]. The image of the hanging man was taken by Sean Flynn in 1966 [see p. 313]. For more on Schneemann's

source photography, see Erica Levin, "Dissent and the Aesthetics of Control: On Carolee Schneemann's *Snows*," in *Carolee Schneemann: Unforgivable*, ed. Kenneth White (London: Black Dog Publishing, 2015), 226–53.

6 Carolee Schneemann, *Snows* notes on film, Carolee Schneemann papers, Getty Research Institute, undated.

7 Carolee Schneemann, handwritten notes, "My idea of a sensory arena," Carolee Schneemann papers, Getty Research Institute, undated.

8 Schneemann, "Snows," in *More than Meat Joy*, 131.

9 The equipment and engineering expertise needed to realize the electronic elements of *Viet-Flakes* came courtesy of Experiments in Art and Technology (E.A.T.). Schneemann, "On the Making of *Snows*," in *More than Meat Joy*, 148.

10 The real-time feedback loop used in *Snows* is curiously analogous to the high-tech style of warfare the United States began pursuing in Southeast Asia with Operation Igloo White the following year, dropping thousands of electronic sensors along the Hồ Chí Minh Trail in order to determine the targets for air strikes. See Levin, "Dissent and the Aesthetics of Control."

11 Schneemann, interview with Melissa Ho.

12 Schneemann, "Snows," in *More than Meat Joy*, 129–30.

Paul Thek | b. 1933, Brooklyn, NY | d. 1988, New York City

IN 1964, AS MINIMALISM AND POP ART SOARED in critical reputation and visibility, Paul Thek first exhibited his sculptures known as the *Technological Reliquaries* or, more informally, his "meat pieces."[1] His most famous series, the works consist of hyper-realistic slabs of flesh meticulously rendered in wax and paint and sealed within pristine cases of plastic or glass. The play of raw against finished, dirty against clean, theatrical and uncanny against ordered and rational was a clear tweak on then-dominant art world trends. "[T]he name of the game seemed to be 'how cool can you be' and 'how refined,'" Thek said of New York in the mid-1960s. "Nobody ever mentioned anything that seemed real. The world was falling apart, anyone could see it. I was a wreck, the block was a wreck, the city was a wreck, and I'd go to a gallery and there would be a lot of fancy people looking at a lot of stuff that didn't say anything about anything to anyone."[2] Though the *Technological Reliquaries* do not overtly address

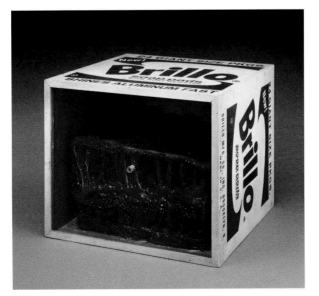

FIG. 1
Paul Thek, *Meat Piece with Brillo Box*, 1965, beeswax, painted wood and plexiglass, Philadelphia Museum of Art, Purchased with funds contributed by the Daniel W. Dietrich Foundation, 1990, 1990-111-1

the political or social upheavals of the Vietnam War period, they are far from emotionally or spiritually mute—indeed, they powerfully express the trauma and unease of their time.

Thek's meat pieces seem at once alive and putrid, advancing a visceral, embodied reality decidedly out of sync with the emotional detachment and quasi–mass production of pop and minimalism. His challenge to the coolness of that art is made literal in *Meat Piece with Warhol Brillo Box*, in which Thek upended a Andy Warhol multiple and used it as a vitrine for an especially bloody block of flesh [FIG. 1].[3] In the words of his friend and sometime collaborator Ann Wilson, Warhol's box was "a symbol of an abrasive, clean American standard"[4]—within it, Thek laid a booby trap for the viewer, suggesting violence, death, and rot lurking beneath the appealing facade of American commercial culture. The artist once commented of the *Technological Reliquaries*: "For me, it was absolutely obvious. Inside the glittery, swanky cases…was something very unpleasant, very frightening, and looking absolutely real.…I was working with the hottest subject known to man—the human body—and doing it in a totally controlled way."[5]

Thek's approach to his subject matter shifted in 1966 and 1967. With the Vietnam War steadily escalating, he turned from sculpting unidentifiable, often alien-seeming cuts of flesh to representing distinct pieces of anatomy cast from his own body. *Warrior's Leg* offers what appears to be an amputated foot and leg clad in archaic armor and held in a sleek plexiglass box. Combining associations of the sacred with the industrial vocabulary of minimalism, this work—and the related *Warrior's Arm*[6]—makes clear Thek's deep engagement with Catholicism and classical culture. The *Technological Reliquaries* were first inspired by Thek's 1963 visit to Sicily, where he had been enthralled by the hundreds of human corpses and mummies on display in the Capuchin catacombs of Palermo, as well as by the masses of ex-votos

depicting body parts left by worshippers in churches, a practice with roots that predate Christianity. The leather straps in *Warrior's Leg* additionally suggest sadomasochism, while other body part sculptures from this time, adorned with piercings, metallic paint, and butterfly wings, openly express Thek's queer sexuality. With all of its layers of associations, *Warrior's Leg* still unmistakably alludes to the rise and fall of empire and to the cycle of death and martial sacrifice, themes deeply resonant with the United States' then-ongoing war in Southeast Asia. **MH**

1 This was Thek's first New York show, a solo exhibition at Stable Gallery.

2 Thek, quoted in Richard Flood, "Paul Thek: Real Misunderstanding," *Artforum* 20, no. 2 (October 1981): 49.

3 Thek and Warhol were acquainted; Thek was the subject of a Warhol "screen test" and is included in Warhol's film *The Thirteen Most Beautiful Boys* (1964). Thek is said to have told Warhol, "All that your Brillo Boxes need is a piece of meat inside," and was subsequently given the box he used to create *Meat Piece with Warhol Brillo Box*. Philipp Wittmann, "Paul Thek: Vom Frühwerk zu den Technologischen Reliquiaren; mit einem Verzeichnis der Werke 1947–1967" (PhD diss., Friedland Bielefel,

2004), cited in George Baker, "Paul Thek: Notes from the Underground," in *Paul Thek: Diver, A Retrospective,* ed. Lynn Zelevansky and Elizabeth Sussman (New York: Whitney Museum, 2010), 193.

4 Ann Wilson, "Mare Tenebraryn: Sea of Darkness," in *Paul Thek: Artist's Artist,* ed. Harald Falckenberg and Peter Weibel (Cambridge, MA: MIT Press, 2008), 232.

5 Thek, quoted in Richard Flood, "Paul Thek: Real Misunderstanding," 49.

6 *Warrior's Arm* (1967) is in the collection of the Carnegie Museum of Art, Pittsburgh.

Peter Saul

Target Practice

1968
acrylic on canvas

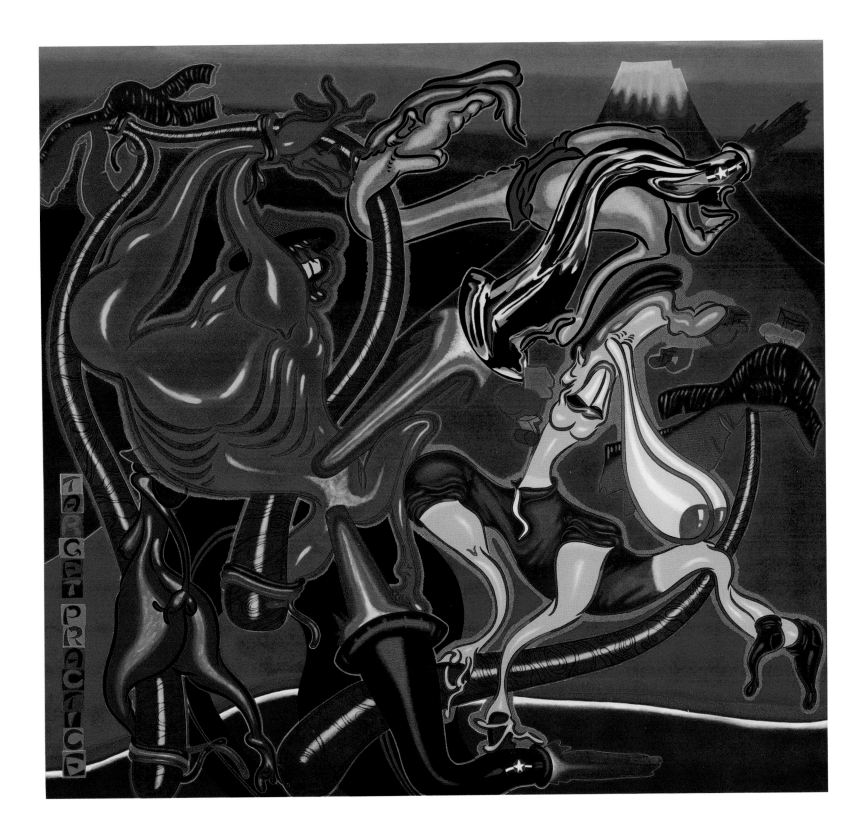

Peter Saul

Saigon

1967
acrylic, oil, enamel, and fiber-
tipped pen on canvas

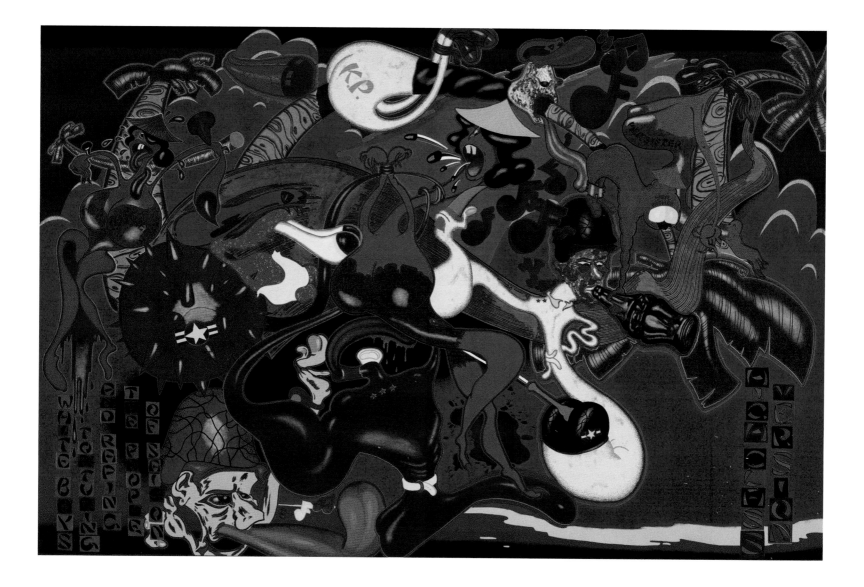

Peter Saul | b. 1934, San Francisco, CA

IN EARLY 1967, AN INTERVIEWER ASKED PETER Saul, "Ideally, what would you like your [Vietnam] pictures to do politically?" He responded:

> *To try to make good overcome bad. But it just hasn't happened that way. For example, by the time the painting is half finished, the Viet Cong are just as bad as the Yanks.... But I always start out to make it very anti-American and anti-the-war. I want it to be treasonable if possible. I hope the United States loses the war.... I think we're going to lose and that I'm going to have made a record of it. I feel so strongly about it. I feel justice demands that the [United] States lose it.*[1]

Two years into the United States' active combat in the war, Saul looked as radicalized and antiwar as the most extreme of his politically active peers.[2] He had come to his point of view by imaginatively channeling a lurid landscape of sexual violence as a ferocious allegory of the war. Each work delivers a potent shock in large part because of Saul's unrepentant deployment of stereotypes to represent both perpetrators and their victims. For many viewers, ranging from Joan Baez to Hilton Kramer, these paintings were obscene, their tone too extreme for the promotion of peace.[3] Saul's contemporary comments about these paintings revealed a political position every bit as unrestrained as the imagery with which they assaulted viewers. From his vantage point in California, the war was a filthy, nasty, sordid affair that required extreme imagery to match its living obscenity.

In several interviews since, Saul has disingenuously portrayed himself as an opportunistic, attention-seeking naïf, stumbling onto the subject of war because it broke all of the rules of a formalist art world he loved to hate.[4] Yet Saul's stated desire that the artworks go far enough to court treason and his taunting assertion that the United States should lose the war were astonishing statements for their time and still stand out for their boldness. Even a committed artist-activist like Leon Golub admitted the jarring power of Saul's 1966 to 1970 *Vietnam* paintings. Pablo Picasso's *Guernica* "was one thing" according to Golub, but Saul's "hysterical comic strip America, with...Day-Glo colors" was "something else." Despite the series's appearance, Golub said, "It really worked."[5]

It is easy to see why Saul's monumental war hallucinations appealed to a furious activist like Golub and so mortified pacifist Baez. Even today they continue to elicit strong feelings because they depict the most horrific war atrocities—the rape, torture, and mutilation of civilians—in a visual language that is more outrageous and convoluted than the cartoons and comics to which they are indebted.[6] Saul deployed the most vicious racist caricatures of the Vietnamese in his series matched by stereotyped American GIs and set their bloodlust against riffs on cheap generic landscape details that signified "the Far East." Saul's Vietnam is nonspecific, trading on the cultural assumptions that drove anger and rage about the war from both the political left and right.

Saigon, for instance, the most visible of Saul's *Vietnam* series during the late 1960s,[7] feels like an assault on the viewer: the scale monumental, the imagery fast-moving and kinetic, the colors a clash of high-keyed hues. In case the observer has difficulty puzzling out the bodies and action, Saul has cynically spelled it out on the left side of the picture in stylized letters that mimic restaurant signs in San Francisco's Chinatown: WHITE BOYS TORTURING AND RAPING THE PEOPLE OF SAIGON. On the right side he has added, "HIGH CLASS VERSION," as though the real events would make his painting look sanitized.[8] That clarifies the brute content but does little to untangle the elongated and disfigured web of bloody bodies that writhe around the central figure of an "innocent

Paul Thek

Warrior's Leg, from
the series *Technological
Reliquaries*

1966–67
plexiglass, wax, leather,
metal, and paint

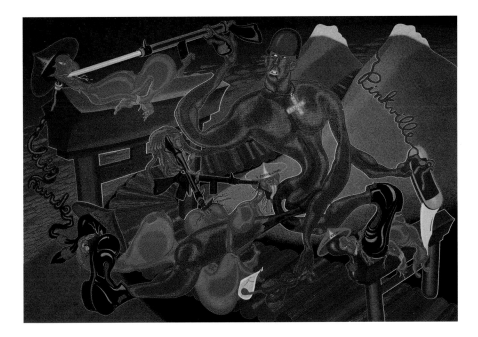

FIG. 1
Peter Saul, *Pinkville*, 1970,
acrylic on canvas, Private
Collection, Courtesy Venus
Over Manhattan, New York

virgin." She wears a skin-tight red dress, spouts bul-
lets from her mouth, and is licked by an enormous
tongue that sprouts from the metallic blue body of an
American three-star general devoid of a head. He is
all muscle and salivating lasciviousness.

Saul's concern about the indiscriminate mayhem
perpetrated by GIs in his allegories came to life in
1969 with Seymour Hersh's report about the mas-
sacre at Sơn Mỹ. Saul made one final monumental
Vietnam painting referring to the incident in 1970,
titled *Pinkville* [FIG. 1].[9] Sơn Mỹ forced Saul to consider
the distance between his painted war and the real
thing. The painting is among the most straightfor-
ward and blunt of Saul's *Vietnam* series, at a scale
that reveals his intention to make a bold statement as

his last major painting on the war. A young American
soldier assaults four bound female villagers. With
three rifles he blasts them in the back of the head,
through the mouth, and into an upturned bottom.
His foot brutally crushes one woman's face and
splits open another between her legs. No details are
obscured in the way previous paintings relied on out-
rageous body transformations. The setting is a catch-
all Mount Fuji backdrop and lava colored sky. Where
and why these atrocities are happening seems to be
forgotten. "Big murder" is the message spelled out by
the women's hair on the left side of the painting.

Saul came to believe that his art-world audience
considered the war distant and sanitized. He said,
they "never saw it in terms of hamburger—in terms
of getting in there with a jackknife and chopping
people up and things like that.... They felt that that
didn't happen anymore. And then this Pinkville
thing came out, the very week that that broke I
sold that large painting [*Saigon*] to the Whitney Art
Museum.... I lost all interest in the picture at that
instant, and also began to realize that... the idea of
painting pictures of Vietnam was dead and I should
look for my next theme."[10]

Saul had designed these ambitious pictures to
horrify and shake viewers out of complacency: "My
pictures always give me a hard time psychologically,
[they] are meant as a kind of 'cold shower' for other
people, to make them aware of their own feelings, or
'social skin.'"[11] After the world witnessed the massacre
at Sơn Mỹ, Saul moved on, too aware of the horror of
the real thing. **RC**

1 "Los Angeles: Subversive Art, Peter Saul & Joe Raffaele," *Arts Magazine*, May 1967, 51.

2 When Saul had his first Vietnam-themed show in 1966 at Allan Frumkin Gallery, Dore Ashton considered the "unequivocal" work as part of a strengthening antiwar movement. See her articles, "The Artist as Dissenter," *Studio International* 171, no. 876 (April 1966): 164; and "Art," *Arts and Architecture* 83, no. 3 (April 1966): 6–7, in which she suggests that the artists responsible for the L.A. *Peace Tower* could learn from Saul's directness. Saul had been addressing Vietnam in his work since 1965 and World War II since at least 1961.

3 Saul showed images of the paintings to Joan Baez and other peace activists at the Institute for the Study of Nonviolence in Carmel Valley, California, in 1967, and they were appalled, finding the subject matter counterproductive. Kramer considered them the epitome of bad taste. "Saul on Saul," in *Peter Saul* (De Kalb: Northern Illinois University, Swen Parson Gallery, 1980), 17; Hilton Kramer, "Peter Saul," *New York Times,* March 5, 1966, 45; and Hilton Kramer, "Peter Saul: Paintings on Vietnam," *New York Times,* December 16, 1967, 47.

4 For instance, Barry Schwartz, Oral History Interview with Peter Saul, 1972, Archives of American Art, Smithsonian Institution, transcript pp. 3–4; "Saul on Saul," 17; and Judith Olch Richards, Oral History Interview with Peter Saul, November 3–4, 2009, Archives of American Art, Smithsonian Institution, https://www.aaa.si.edu/collections/interviews/oral-history-interview-peter-saul-15737#transcript.

5 Irving Sandler, Oral History Interview with Leon Golub, October 28–November 18, 1968, Archives of American Art, Smithsonian Institution. Some reviewers felt the Day-Glo paint meaningfully added to the horror and anger conveyed. Alfred V. Frankenstein described it "as uncomfortable in its contrast as the point of a bayonet." Frankenstein, "Saul's Caricature of Agony," *San Francisco Chronicle,* August 11, 1968, 37.

6 Saul referred to the atrocities depicted as "'home' thrills" in a letter about the imagery to his dealer Allan Frumkin, explaining that he imagined soldiers on a ruthless crime spree rather than the specifics of modern combat. "Peter Saul: Letters to His Dealer," in *Peter Saul: New Paintings and Works on Paper* (New York: Allan Frumkin Gallery, 1987), n.p. For one take on sexuality and American GIs during wartime, see Mary Louise Roberts, *What Soldiers Do: Sex and the American GI in World War II France* (Chicago: University of Chicago Press, 2013).

7 *Saigon* was included in two major thematic exhibitions with multiple venues: *Violence in Recent American Art* (Museum of Contemporary Art in Chicago) and *Human Concern/Personal Torment: The Grotesque in American Art* (Whitney Museum of American Art, New York, and the University Art Museum, University of California, Berkeley).

8 David McCarthy notes this in "Dirty Freaks and High School Punks: Peter Saul's Critique of the Vietnam War," *American Art* 23, no. 1 (Spring 2009): 94.

9 American soldiers nicknamed the hamlet of Sơn Mỹ and surrounding area "Pinkville" because the region was rose colored on their maps and in reference to the Viet Cong domination of the area.

10 Schwartz, Oral History Interview with Saul, 4.

11 "Peter Saul: Letters to His Dealer," n.p.

Tomi Ungerer | b. 1931, Strasbourg, France

IN THE POSTER *EAT*, TOMI UNGERER EMPLOYS print advertising's direct legibility, using strong color cues to draw the eye across his simple, linear arrangement. "EAT" appears in bold red type on the blank sleeve of an arm that reaches into the composition, tightly grasping a model-sized Statue of Liberty and ramming it into the open mouth of a figure below. Here the friendly imperative "EAT," reminiscent of restaurant and diner signage, takes a deeply sinister tone. To shove a supposed symbol of freedom down the throat of a racially stereotyped Vietnamese replaces the statue's idealism with aggression, the sculpture's French heritage in this context harkening back to France's own colonial enterprise in Southeast Asia.

FIG. 1
Tomi Ungerer, *Deutschland!*, 1943, pencil, ink, and watercolor on paper, Musée Tomi Ungerer—Centre international de l'illustration, Strasbourg

There the French had pursued the model of most colonizers: oppressing local populations and plundering resources. However, the justification for U.S. action in Vietnam was based on notions of freeing its people and giving them the tools of democracy. Ungerer perverts this ideological nourishment—a particular brand of American generosity and plenty—into a force-feeding. Even though many on the antiwar left identified U.S. hypocrisy, they, too, wore cultural blinders. Rather than depicting a person of independent thought and agency, Ungerer here portrays the Vietnamese as a helpless victim of American aggression—a mere bystander of the war rather than an actor in it.

As a child born in Alsace just before the outset of World War II, Ungerer deeply understood acts of gross manipulation by political and military powers. In *Eat*, Ungerer returned to a motif he had used in a 1943 drawing that depicts the German army slaughtering the inhabitants of an Alsatian village [FIG. 1]. The prostrate man at left clutches a small statue with its right arm raised, the word "LIBERTY" partially written around its base. For Ungerer, the figure could be an anachronistic proxy for his Alsatian compatriot Frédéric Auguste Bartholdi, who designed the Statue of Liberty during the 1870s directly after his military service in the Franco-Prussian War.[1] Ungerer would have understood Bartholdi as a local hero; numerous preparatory models of the statue adorned a museum dedicated to the artist in Colmar.[2] If the figure bleeding out in the young artist's drawing is not Bartholdi himself, he is likely a contemporary Alsatian trying to preserve one of those models in vain.[3] In retrospect, Ungerer acerbically remarked, "[World War II] left a strong imprint on me and gave me my first lesson in relativity and cynicism—the prison camps, the propaganda, the bombings, the Russian front, the lack of everything."[4]

After moving to New York City in the mid-1950s, Ungerer achieved considerable success publishing

Tomi Ungerer

Eat

1967
offset lithograph

award-winning children's books and illustrating international ad campaigns, magazine articles, and books.[5] Sophisticated and punchy, his graphics were memorable in part due to their often overtly political themes: an undercutting of American-style big business, high society, militarization, religiosity, and the mechanization of human relations. His work caught the attention of a group of students and faculty, mostly from Columbia University, who commissioned a series of antiwar posters in 1967.[6] The escalation of the Vietnam War coincided with a growing market for mass-produced posters expressing countercultural views. Ungerer leveraged his exceptional skill in the vanguard of this new poster movement, though in this case his patrons ultimately rejected the commissioned drawings as too virulent and provocative. The artist quickly self-published the series.[7]

Ultimately, *Eat*'s enduring import stems from the self-critique its apparently straightforward message generates.[8] For the Alsatian artist, the Statue of Liberty had lost its associations with liberalism, democratic principles, human integrity, and self-governance—the ideals he sought to capture and preserve in youthful drawings. The statue seems to embody its ethical promise in the 1943 drawing, though within an irredeemably barbaric scene of domination and bloodlust. Ungerer's iconographic repetition throughout his wartime graphics, from World War II to America's War in Vietnam, reveals the sentiments he cultivated during his childhood and shared with many in the U.S. counterculture movement.[9] Producing images rooted in irony and hatred for the abuse of state power, he reinscribed over time a venerated American monument to condemn both ideological bullying and undue suffering in war. **JM**

1 Bartholdi's native Colmar fell when the Prussians annexed the city in 1871. Ungerer's native Strasbourg met a similar fate after the Nazi invasion of 1940.

2 The Musée Bartholdi has been situated in Colmar's historic center since 1922. A U.S. government publication on the Statue of Liberty illustrates an 1875 study model, 1.25 meters in height, and several other undated models of various sizes on display at the Musée Bartholdi, Colmar, Alsace. Benjamin Levine and Isabelle F. Story, *Statue of Liberty: National Monument, Liberty Island, New York*, historical handbook series no. 11 (Washington, DC: National Park Service, 1952, reprinted 1961), 12.

3 The German Reich took control of Alsace on June 17, 1940, and the Nazi Party administered the area, historically an idyllic and proud yet politically volatile borderland. Ungerer's 1943 drawing looks back on the conquest he witnessed, which was in fact less gory than he pictures it. The iconography and style exemplified by opposing French and German propaganda campaigns during the Second World War, along with a predilection for the bitingly satirical cartoons of Alsatian author and illustrator Hansi (Jean-Jacques Waltz), influenced Ungerer while he fashioned his own caricatures of life and death under German occupation. See Tomi Ungerer, *Tomi: A Childhood under the Nazis* (Boulder, CO: Roberts Rinehart, 1998), 28–30.

4 Tomi Ungerer, letter to Jack Rennert, published in Rennert, ed., *The Poster Art of Tomi Ungerer* (New York: Dover, 1973), 8.

5 In addition to regular appearances in *Esquire*, *Harper's Bazaar*, and other major magazines, Ungerer displayed his commercial work through other well-established American venues, such as a 1965 poster campaign for the *New York Times* installed throughout the metropolitan subway system.

6 Art historian David Kunzle identified 1968 as the height in production of the American commercial protest poster. Two years later, the rise of utilitarian action posters ("strike posters, legal-defense posters, basic information and propaganda posters, printed not on art-stock paper"), which were pasted publicly around campuses and urban centers, coincided with the summer 1970 invasion of Cambodia. See Kunzle, "Posters of Protest," *ARTnews* 70, no. 10 (February 1972): 53.

7 Ungerer stated that he published his antiwar posters with Richard Kasak, a friend "who had one of the biggest poster shops in New York." See Anna von Planta, *Tomi Ungerer: Poster* (Zurich: Diogenes, 1994), 32, translated by author.

8 For a compelling rereading of *Eat* based on Kunzle's changing perceptions of the poster throughout the 1970s and 1980s, see his "Killingly Funny: U.S. Posters of the Vietnam Era," in *Vietnam Images: War and Representation*, ed. Jeffrey Walsh and James Aulich (London: Palgrave MacMillan, 1989), 115–21.

9 Ungerer's insistent reworking of Statue of Liberty iconography during the Vietnam War, including a study for *Eat*, can be found in Tomi Ungerer, *Politrics: Posters, Cartoons 1960–1979* (Zurich: Diogenes, 1979), 10, 13, 18, 19. Though the publication does not date these drawings, the artist likely created them around the time he received the Columbia University commission.

William Copley | b. 1919, New York City | d. 1996 Sugar Loaf Key, FL

Ad Reinhardt | b. 1913, Buffalo, NY | d. 1967, New York City

Carol Summers | b. 1925, Kingston, NY | d. 2016, Santa Cruz, CA

THE *ARTISTS AND WRITERS PROTEST AGAINST the War in Viet Nam* portfolio was created to raise funds to support the work for peace undertaken by Artists and Writers Protest (AWP). Started in 1965, this antiwar group's first actions were to publish two full-page statements in the *New York Times* under the title "END YOUR SILENCE," each articulating opposition to the war and signed by a long list of artists and writers. In the years that followed, AWP participated in and facilitated a range of additional protest activities, playing a key role, for example, in Angry Arts Week and the *Collage of Indignation* in 1967.

That same year, Jack Sonenberg compiled contributions from sixteen artists and eighteen poets, along with an introduction by critic Max Kozloff, into the portfolio *Artists and Writers Protest against the War in Viet Nam*.[1] Issued in an edition of one hundred, the portfolio was sold first at the Associated American Artists gallery in New York in April 1967, then again at the Philip Freed Gallery of Fine Art in Chicago following the shocking violence of the 1968 Democratic National Convention. The artists who participated represented a wide range of contemporary perspectives, and the fine art prints they donated varied tremendously. Whereas some artists departed their practice to make explicit antiwar statements (Mark di Suvero), others registered their dissent through participation in the portfolio project alone, submitting works in their established idioms (George Sugarman).[2] Taken as a whole, the portfolio is at once a testament to the reach of the antiwar cause among artists and evidence of the absence of any common approach to articulating that opposition visually—or of agreement as to whether that opposition even *should* be registered visually. Yet as Kozloff put it in his introduction, "No matter how varied their theme or form, these visual and verbal images are meant to testify to their authors' deep alarm over a violence which, as they have shown here, has been impossible for them to ignore."[3]

Contributing to such a benefit work was among the more conventional ways that artists could take up the antiwar cause, and some prints engaged equally familiar, if still potent, tropes of protest art. Carol Summers's work, for instance, employed photography, the medium that did perhaps the most to stoke antiwar sentiment. His print of a Vietnamese woman and two children with a red X running across it invites empathy for their plight: the quick gestural quality of those red strokes suggests the speed and ease with which Vietnamese families were being eliminated, while the woman's steady, almost condemning gaze seems a refusal of the explanation offered by the work's title, *Kill for Peace*. For his part, William Copley turned to the American flag, a symbol regularly upended by dissenting artists of the period. Emptied of its standard red, white, and blue, Copley's flag placed the word "THINK" where the stars usually reside in a call for reflection on the nature of American patriotism. Ad Reinhardt's contribution presents a perhaps more complicated case, wading into ongoing debates on the very relationship between art and war. In his print, Reinhardt used language to express his opposition, penning a series of "nos" on both sides of a standard airmail postcard addressed to "War Chief, Washington, D.C., USA." The list on its back side begins with "no war" and goes on to include objections to other aspects of conflict: "no draft"; "no fear"; "no injustice." The flip side of the postcard then reveals the artist's sense of the distance that must be maintained between art and war: "no art of war"; "no art on war"; "no art about war."

Carol Summers

Kill for Peace, from the portfolio *Artists and Writers Protest against the War in Viet Nam*

1967
screenprint with punched holes

William Copley

Untitled, from the
portfolio *Artists and
Writers Protest against
the War in Viet Nam*

1967
screenprint

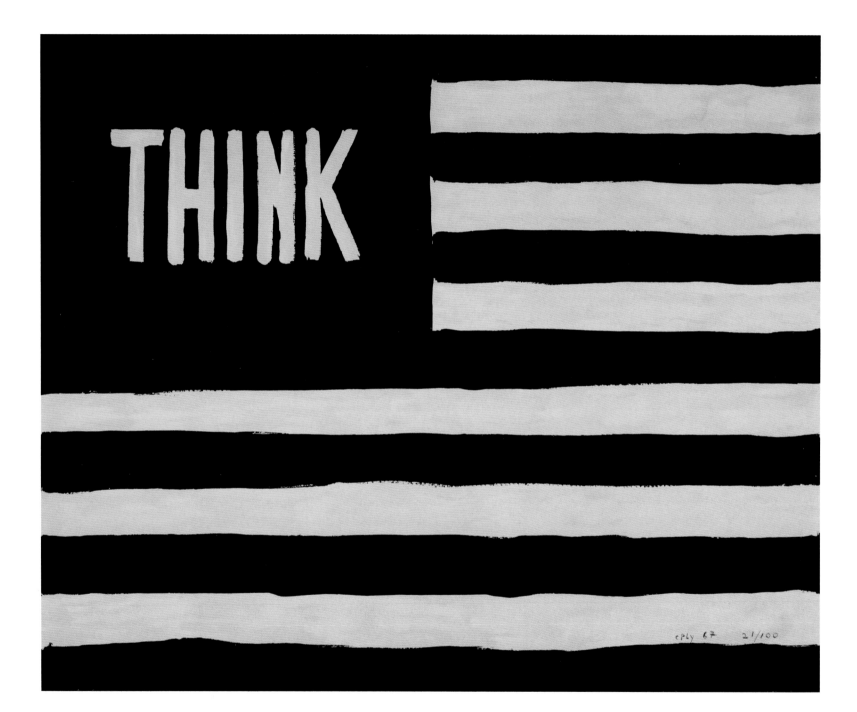

Corita Kent

yellow submarine

1967
screenprint

Corita Kent

handle with care

1967
screenprint

change in Kent's practice was at least partly due to her changed situation: not only was she newly free of pressures from the church hierarchy, but she also began working with a professional printer who made possible the use of previously unavailable photographic techniques. The nation, too, was altered that year: Martin Luther King Jr. and Robert F. Kennedy were assassinated, race riots broke out across the country, and, beginning with the Tết Offensive, more trenchant opposition to the war within both the media and peace movement took hold. On the one hand, it is as if Kent felt her earlier topsy-turvy linguistic compositions lacked the urgency demanded in the face of such tumult, so she instead turned to more direct, image-driven works. Yet, on the other, it is as though Kent is stressing that images, too, are hard to read, and that their meaning can change dramatically based on context — important points to make as the country was increasingly saturated with them.

A *Newsweek* cover printed in red and featuring the Viet Cong comprises the top three-quarters of *news of the week*; it sits atop an excerpt from Walt Whitman's "Song of Myself," a diagram of a slave ship, and a *Life* cover depicting American soldiers, all printed in green. Showing Viet Cong and American soldiers in complementary colors, Kent seems to insist on their inextricability. More than that, the visual weight of the Viet Cong, and their struggle, appears underpinned by what can seem an American penchant for suffering — Whitman's reflections on pain, the history of slavery, the injured soldier on the cover of *Life*. Indeed, the slave ship's adjacency to the American soldiers appears to link the American repression of Vietnamese liberation to that of blacks domestically, the latter also an issue important to Kent. Another image sourced from mass media dominates *phil and dan*: an Associated Press shot of Philip and Daniel Berrigan, well-known Catholic activists, taken on May 17, 1968.[8] On

Corita Kent | b. 1918, Fort Dodge, IA | d. 1986, Boston, MA

"I'M NOT GOOD AT MARCHING AND SPEAKING politically," Corita Kent remarked in 1971;[1] instead, during the 1960s, Kent used her artistic practice as the arena for her social interventions. Kent was a member of the progressive Roman Catholic order of nuns of the Immaculate Heart of Mary in Hollywood from 1936 until she left the order in 1968, and she was a teacher at Immaculate Heart College for much of that time. Following the Vatican II deliberations that began in 1962 and aspired to make the faith more proximate and accessible, the artist grappled with the modern world in her teaching and her artistic work alike.[2] Though higher forces in the Church voiced displeasure with her artistic activities and discomfort with the reform they exemplified, Kent nevertheless tackled a range of contemporary issues in her screenprints while a member of the order, and she continued to do so after her departure.[3] Among those issues was the conflict in Vietnam. In a number of deliberately hard-to-parse prints, Kent variously registers the difficulty of making sense of the war.

Kent's earliest Vietnam-related prints have much in common with her others from the mid-1960s. Drawn to the print medium in part for its accessibility, while at Immaculate Heart College Kent created her objects in the highly productive collaborative context of the school's screenprint workshop.[4] Her works from mid-decade typically consist of two levels of text: the structuring armature for the composition is generally a phrase that appears in larger lettering — "stop the bombing" or "wrong way" — and then meaningfully juxtaposed are smaller-scaled, often handwritten excerpts from poetry, philosophy, theology, and more.[5] In pop art, which had an early presence in Los Angeles through shows like Andy Warhol's

1962 exhibition of *Campbell's Soup Cans* at the Ferus Gallery, Kent found a formal language adequate to her ecumenical aims: pop demystified the realm of art in a manner consonant with Vatican II's urgings to demystify the faith.[6] For much of the decade, the artist drew her organizing phrases from commercial packaging (Del Monte tomato sauce, Wonder Bread), borrowing not just the language but the look of a logo or slogan. As evidenced by *right*'s truncated declaration "wrong way," by 1967 Kent was increasingly turning to traffic signage for source material. Teamed with the phrase "prophets of boom" and a passage from poet Rainer Maria Rilke that joins a thought of the difficult with one of the hopeful, this work indicates Kent's growing awareness of how important it was to take the right actions in the streets as the number of troops in Vietnam rose. The conflicting arrows then suggest an uncertain path forward, for country and antiwar movement alike.

In *yellow submarine*, Kent considers the impact of the war anew, querying: "Vietnam: What has it done to the home of the brave?" The question's answer is implicit in its form: the conflict has turned the world upside down. With this print, as with *stop the bombing*, the popular culture Kent borrows is now overtly protest culture, evidence perhaps of the growing ubiquity of antiwar sentiment. "Stop the bombing" and "make love, not war" were popular antiwar refrains, while the Beatles's *Yellow Submarine* was a regular soundtrack for protests and Kent's submarine design came from a peace movement button. Kent also gestures toward the pervasiveness of antiwar sentiment with the handwritten text in *stop the bombing*. The selected poem insists on the war's proximity, even for those at home (a home signaled by the print's palette), citing the conflict's presence in, for instance, "the headlines lurking on the street."[7]

In 1968, the year Kent left the Immaculate Heart of Mary, the organizing texts in her work were replaced by images taken from mass media. This

1 Weege met Edelson in Madison around the time of the Dow Chemical Company protests in 1967. He invited Weege to contribute a poster to counter the university's military ball. Eventually posters of *Napalm* and *Fuck the C.I.A.* became mass-produced, some published by the Happening Press, San Francisco, and distributed by Print Mint, Berkeley, California. John Corbett, "Peace Was Patriotic: William Weege in Conversation with John Corbett," in *William Weege: Peace Is Patriotic, Printworks, Collage, and Social Commentary 1966–1976* (Chicago: Corbett vs. Dempsey, 2017), 5. For a succinct overview of Weege's circuitous route to "fine art," see pp. 2–4.

2 Weege, quoted in Barbara E. Jones, "William F. Weege: An American Artist." (Masters thesis, University of Wisconsin, Madison, 1970), 46. I am grateful to Jennifer Noonan for sharing this source with me.

3 Carol Summers also titled a 1967 serigraph *Kill for Peace* [p. 79]. It depicts a Vietnamese mother and child crossed out with a bloody red "X." "Kill for Peace" was also the title of a 1966 single by the New York City–based rock band the Fugs, best known for their satirical and lewd protest songs and counter-culture shenanigans. See the funny but startling film for the song on YouTube, accessed November 11, 2018, https://www.youtube.com/watch?v=JvA1bKLQtbM.

4 Hamady was important to Weege's development in several ways, and he thanked Hamady in the presentation page of the portfolio. For more on that relationship, see Jones, "William F. Weege," 27.

5 Ibid., 46.

6 There had been peaceful demonstrations and protests against Dow recruiters before the incident described here, and University of Wisconsin students registered their outrage afterward on the steps of the capitol. Dow had come to Madison to recruit as early as February 1967. For more on the Madison incident and background, see David Maraniss, *They Marched into Sunlight: War and Peace, Vietnam and America, October 1967* (New York: Simon and Schuster, 2004). Other campuses across the nation witnessed student-led demonstrations over napalm and its manufacture by Dow in the period leading up to the Madison incident.

7 Corbett , "Peace Was Patriotic," 5.

8 Jones, "William F. Weege," 12. Weege took photographs during the incident and recalled, "That was my introduction to violence.…My wife at the time worked in the emergency room, and they would bring these kids in with broken scalps, bleeding, and the doctors wouldn't give them anesthetic, just sew them up. The whole thing was terrible, everything about it." Corbett, "Peace Was Patriotic," 5.

title appears in bold black letters, in reverse but clear and clean. A colon leads to a collage of imagery as if summarizing the results of using the horrific chemical weapon on human beings. A voluptuous pinup smiles and raises her arms above her head to reveal her bare breasts, though partially concealed behind the large print of a lipstick kiss. The nude woman seems to be suckled by the cross section of a human head, dissected to reveal its muscle system. A line of cavalry, lifted from the film *Lawrence of Arabia,* disappears between the disembodied lips. The entire arrangement floats before the image of a person horrifically disfigured by napalm wounds.

Here, as elsewhere in the series, Weege contrasts nudes sourced from pornography with diagrams of the body excised from a copy of *Gray's Anatomy* given to him by the artist Walter Hamady.[4] Weege included "porno-violent kitsch" in order to identify "pop violence with pop sex of the most blatant, narcissistic

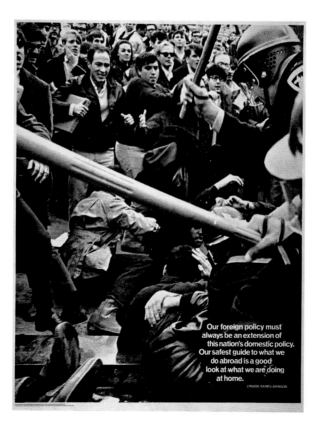

FIG. 2
Poster printed by the Madison, Wisconsin, underground newspaper *Connections,* featuring a photograph of riot police beating protesters on campus during the Dow Demonstration, October 18, 1967

kind."[5] Desirable bodies, the figures of film stars, and assertive battle-ready soldiers mingle with parts and portions, skin peeled away to reveal the insides. They provide backdrops, constant reminders of the costs of war, bodily vulnerability exposed by acts of honor, aggression, courage, and seduction.

As evidenced by *Napalm*, Weege was already compelled to make powerful statements about the war and its leadership in July 1967. His resolve to make searing political work was reinforced later in the year, when on October 18, Weege witnessed what became the first antiwar protest on a university campus to turn violent. Dow Chemical Company, the infamous manufacturer of napalm, arrived on the Madison campus to recruit potential employees from among the student body. Students commenced a peaceful civil disobedience sit-in to block the hallway in the Commerce Building (now Ingraham Hall) where job interviews were taking place. By noon that day, police arrived prepared to remove protesters through force [FIG. 2].[6] Weege and visiting artist and friend Jack Beal joined the protesters and hung banners they had made on campus bridges.[7] Weege was already prone to an antiestablishment worldview, but the brutality of the police toward protesters, mostly young students, turned him into a "benign radical," convinced that peaceful dissent was ineffectual because it would inevitably be met with force from the state.[8]

During the 1968 convention in Chicago, Weege stayed home, convinced that violence worse than what he experienced in Madison would erupt. In the fall, he exhibited *Peace is Patriotic* and other prints in his solo exhibition at Richard Gray Gallery in Chicago, where it was among several protest exhibitions directed at Mayor Daley and the ongoing war in Vietnam. **RC**

William Weege

Napalm, from the
portfolio *Peace is
Patriotic*

1967
offset lithograph

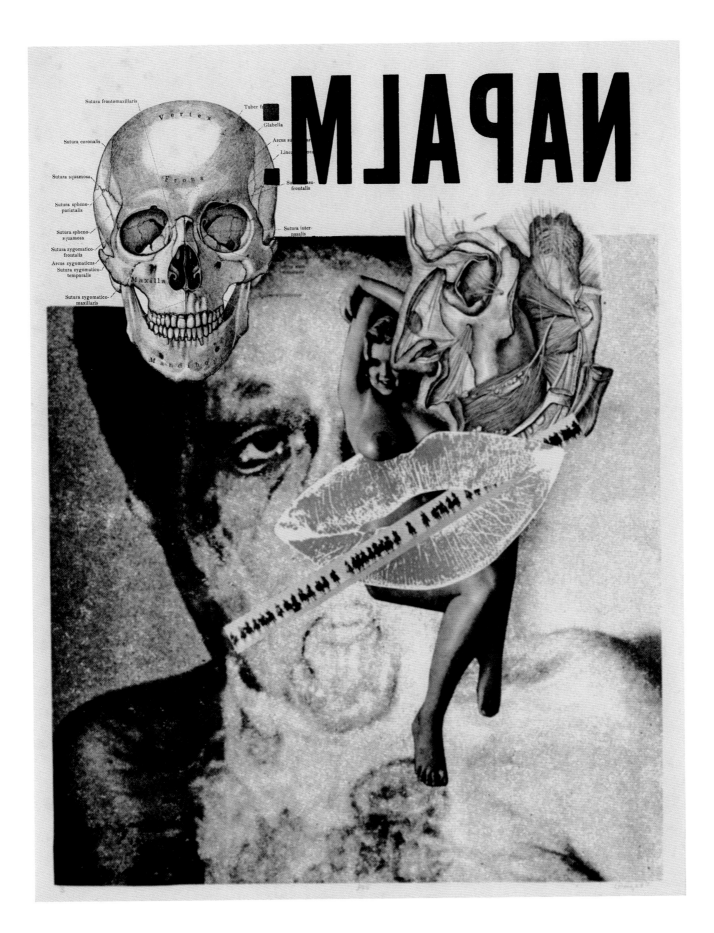

William Weege | b. 1935, Milwaukee, WI

WILLIAM WEEGE MADE HIS BOLD AND COMPLEX portfolio of twenty-five prints, *Peace is Patriotic*, as a master's thesis project at the University of Wisconsin, Madison. Pointedly published on July 4, 1967, the prints jarringly juxtapose sexualized bodies and medical illustrations, throbbing militarism and families, patriotic slogans and anachronistic celebrities. Weege exhibited the suite in Chicago in the wake of the 1968 Democratic National Convention, and individual plates such as *Napalm* became popular mass-produced posters. Fellow Madison graduate student Morris Edelson, founder of the journal *Quixote* and a prominent member of several counterculture communities, helped circulate posters based on the

FIG. 1
William Weege, *Thomas Jefferson*, 1967, from the portfolio *Peace is Patriotic*, serigraph-lithograph, Courtesy of Corbett vs. Dempsey, and the artist

portfolio. *Peace is Patriotic* was an ambitious project that combined Weege's accumulated skills in graphic design, cartography, and typography as well as his experience with photomechanical processes.[1] Together these tools allowed him to "dissect the psychology of the war" and "expose the vile underside of the American mentality."[2]

In a form of controlled chaos, Weege's image sources and compositional strategies shift constantly throughout the portfolio, yet the plates hold together. Humor punctuates the images, despite the horror underlying the message. Often Weege's wit foregrounds the absurdity of U.S. foreign policy, anticommunist paranoia, and militarism, as in the ironic declaration "Kill a Commie for Christ." In another print from the series, *Thomas Jefferson* [FIG. 1], a button exhorts viewers to "Kill for peace / Kill for freedom / Kill Vietnamese / Kill, Kill!"[3] The same print overlays bacchanalian imagery with a quote by the third president that warns, "In every government on earth there is some trace of human weakness, some germ of corruption and degeneracy." Weege in other plates caricatures President Lyndon Johnson, who pops in and out as an amused tyrant emceeing the war as though it were a game show, a film he is directing, or a manly sport. Weege astutely nods toward earlier government-sponsored military recruitment posters, playing on the relationship between male anxiety, sexuality selling adventure, and taunts about being worthy for war.

The body is a recurring motif throughout *Peace is Patriotic* and the inevitable focus of a print entitled *Napalm*. Manufactured for the U.S. military by the Dow Chemical Company, napalm B had by 1967 come to symbolize for the peace movement all that was repugnant about the war. A long-burning and tenaciously sticky gel used by the United States in flamethrowers and bombs in Vietnam, napalm was notorious for inflicting agonizing disfigurement and death on its often indiscriminate victims. Weege's

Though Reinhardt had a long history of political engagement, it was generally not overtly manifest within his creative output. Indeed, just after the completion of the portfolio, Reinhardt stated, "I think an artist should participate in any protests against war—as a human being." He then added, "There are no effective paintings or objects that one can make against the war."[4] Rather than understand his print as belonging to the orbit of the monochromes he was contemporaneously painting, it is perhaps better viewed as a political statement of protest—made by a human being, Reinhardt might say, instead of an artist. Yet even as his print exists at a decisive remove from his paintings, it nevertheless pointedly shares in the acts of refusal that had informed both his pictures and his writings about them. Already in his 1952 text "Abstract Art Refuses," Reinhardt had stressed

the importance of what painters "refuse to do" and offered a list of his own refusals: "no illusions, no representations, no associations, no distortions."[5] With his print, those refusals are now marshaled to antiwar ends, his art writing—if not his art—effectively turned political. **KM**

1 The contributing artists were Rudolf Baranik, Paul Burlin, Charles Cajori, William Copley, Allan d'Arcangelo, Mark di Suvero, Leon Golub, Charles Hinman, Louise Nevelson, Irving Petlin, Ad Reinhardt, Jack Sonenberg, George Sugarman, Carol Summers, David Weinrib, and Adja Yunkers. The poets submitting work were David Antin, Paul Blackburn, Robert Bly, Robert Creeley, Robert Duncan, Clayton Eshleman, Anthony Hecht, Stanley Kunitz, Denise Levertov, Walter Lowenfels, Joel Oppenheimer, Allen Planz, Jerome Rothenberg, Frank Samperi, Gilbert Sorrentino, Charles Stein, Tony Towle, and James Wright.

2 The entire portfolio is held in the collections of the Museum of Modern Art and the Whitney Museum of American Art, both in New York.

3 Max Kozloff, introduction to the *Portfolio.*

4 Ad Reinhardt, "Ad Reinhardt: Art as Art" (1967) in *Artwords: Discourse on the 60s and 70s*, ed. Jeanne Sigel (New York: Da Capo Press, 1992), 28.

5 Ad Reinhardt, "Abstract Art Refuses" (1952) in *Art as Art: The Selected Writings of Ad Reinhardt*, ed. Barbara Rose (Berkeley: University of California Press, 1991), 50.

Ad Reinhardt

Untitled, from the
portfolio *Artists and
Writers Protest against
the War in Viet Nam*

1967
screenprint and collage
on paper

Corita Kent

stop the bombing

1967
screenprint

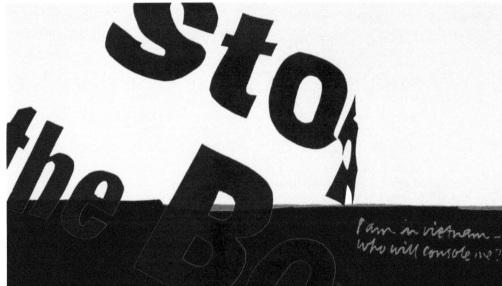

that day, the two brothers, along with seven others, stole draft records from a Selective Service office in Catonsville, Maryland, and set them ablaze in the parking lot.[9] The combination of burning orange and black that Kent deploys calls to mind the so-called Catonsville Nine's ignition fluid of choice: homemade napalm. Yet just as much as the print evokes the act of destruction, its central image also presents as a scene of becalmed ritual, like familiar rites within the Church. The work's ambiguity is further highlighted by the excerpts of testimony from the trial of the Catonsville Nine, including a quote from Henry David Thoreau cited by Thomas Lewis at the trial: "[U]nder a government which imprisons unjustly, the true place for a just man is also in prison."[10] In this world, the just are imprisoned, acts of destruction are ritual, and the enemy is our complement—or so read Corita Kent's images. **KM**

Corita Kent

phil and dan

1969
screenprint

1 Corita Kent, quoted in Mert Guswiler, "Corita Kent's 'Time of Conversation,'" *Los Angeles Herald-Examiner,* March 14, 1971.

2 For an overview of Vatican II, see John W. O'Malley, *What Happened at Vatican II* (Cambridge, MA: Belknap Press of Harvard University Press, 2008).

3 See Kristen Gaylord, "Catholic Art and Activism in Postwar Los Angeles," in *Conflict, Identity, and Protest in American Art,* ed. Miguel de Baca and Makeda Best (Newcastle upon Tyne: Cambridge Scholars Publishing, 2015), 102–3. Kent was at times a special target for Cardinal James Francis McIntyre, who opposed the reforms. By decade's end, many of the sisters in Kent's order were granted dispensation from their vows owing to conflict with the Church. For a history of the order, see Mark Stephen Massa, *The American Catholic Revolution: How the '60s Changed the Church Forever* (New York: Oxford University Press, 2010), 75–102.

4 Kent's printmaking was from the start a sort of political proposition, allowing as it did a wider dissemination of her message. See Cynthia Burlingham, "A Very Democratic Form: Corita Kent as Printmaker," in *Someday Is Now: The Art of Corita Kent,* ed. Ian Berry and Michael Duncan (Munich: DelMonico Books/Prestel, 2014), 24–30. For a penetrating account of the relation between Kent's medium and her politics, see Jennifer Roberts, "Backwords: Screenprinting and the Politics of Reversal," in *Corita Kent and the Language of Pop,* ed. Susan Dackerman (New Haven, CT: Yale University Press, 2015), 61–73. On the importance of the college context, see Julie Ault, *Come Alive! The Spirited Art of Sister Corita* (London: Four Corners Books, 2007), 27–30. The backdrop of the college was important not only to her artistic experimentations but also to her activism: she sought to cultivate political awareness in her students. See Gaylord, "Catholic Art and Activism in Postwar Los Angeles," 105.

5 The former were produced by way of paper stencil attached to the silkscreen, whereas the latter were usually applied to the screen in glue so that this wording appeared as negative space. For an overview of Kent's work with prints, see Ault, *Come Alive! The Spirited Art of Sister Corita.*

6 On Kent and pop art, see Susan Dackerman, "Corita Kent and the Language of Pop," in *Corita Kent and the Language of Pop* (New Haven, CT: Yale University Press, 2015), 14–32.

7 On these prints, also see the entry by Jordan Troeller in *Corita Kent and the Language of Pop,* 254. The poem was "I am in Vietnam…" by Gerald Huckaby, an English professor at Immaculate Heart College. In 1969 he published "I am in Vietnam…" in a book featuring his poems as well as contributions from Kent. See Huckaby, *City, Uncity* (Garden City, NY: Doubleday, 1969).

8 Kent credited Daniel Berrigan with turning her on to the antiwar movement. See Corita Kent, interview by Bernard Galm, "Los Angeles Art Community: Group Portrait, Corita Kent," transcript, Oral History Program, University of California, Los Angeles, 1977, 133. Berrigan had played a role textually in earlier works like *(give the gang) the clue is in the signs* and *(our best) reality proves very little* from 1966. On *news of the week* and *phil and dan,* also see the entry by Taylor Walsh in *Corita Kent and the Language of Pop,* 260–64.

9 For more on this event, see Shawn Francis Peters, *The Catonsville Nine: A Story of Faith and Resistance in the Vietnam Era* (New York: Oxford University Press, 2012).

10 The line is taken from Henry David Thoreau's "Civil Disobedience" (1849).

Martha Rosler | b. 1943, Brooklyn, NY

IN THE MID-1960S, MARTHA ROSLER HAD NOT yet begun openly opposing the war in her art, although her creative work was already progressing on two divergent tracks — one aspiring toward "a utopian space within high culture,"[1] the other aimed squarely at political critique. As she had done since her teenage years, Rosler was painting dark canvases informed by the work of the abstract expressionists. She was also beginning to make collages using pictures cut from mass-circulation magazines like the *New York Times Magazine, Ladies' Home Journal*, and *Playboy*. These works (now known as the *Body Beautiful, or Beauty Knows No Pain* series) deftly interrogate normative images of femininity, focusing on commercial representations of women and women's roles [pp. 332, 350].

But war photography from Vietnam caught Rosler's attention and demanded a response: "I had the realization that I could — and should — adapt my *détournements* of advertising to make antiwar agitation."[2] In the series of twenty photomontages now known as *House Beautiful: Bringing the War Home*, Rosler addresses both gender and militarism, juxtaposing the feminine realm of American domestic life with the manly business of waging war. She had noticed that media coverage of Vietnam reinforced the sense that the war was taking place "very far away, in a place we couldn't imagine."[3] In her own photomontages, Rosler was careful to craft pictorial spaces that collapse the distance between "those in the safety of the home country and those exposed to war."[4] Injured women and children wander through affluent suburban homes; a smiling housewife vacuums the drapes, beyond which GIs warily keep watch. These images assert the social and

economic connections that exist between worlds normally considered distinct. As Rosler put it, "We are not 'here' and 'there' — we are all one, and that is crucial."[5]

From the beginning, Rosler considered her antiwar images mobile and adaptable in format. She published a few in the underground press and showed others in slide lectures she gave as a visiting artist and at conferences. But, mostly, she handed them out in the form of black-and-white photocopies as agitprop at antiwar marches and demonstrations. She delighted in creating flyers that use no words at all, only pictures — a stark contrast with typical protest leaflets that are "text-heavy...covered with slogans and paragraphs and arguments."[6] America's war in Vietnam was, after all, unusually and powerfully visual; it was both the last photojournalists' war and the first television war.[7] Evidentiary images of the conflict regularly confronted Americans in the comfort of their own living rooms and kitchens. Such encounters could become numbing, but occasionally produced (as it had for Rosler) a moment of shock followed by questioning and action — a sequence of responses the artist sought to provoke in her own work.

Rosler kept her *House Beautiful: Bringing the War Home* photomontages out of any art context while American military action in Vietnam was ongoing. She considered it unacceptable to present images of war suffering for aesthetic assessment or enjoyment. Her aspiration for these works was to "get people to *move* and to do something,"[8] and she considered their proper place to be "on the street" or in the underground press.[9] It was only in the 1990s, as the Vietnam War era was solidifying as history (and art history), that Rosler allowed photographs of her antiwar collages to circulate in the art world and to become formally titled.[10]

Rosler made her final *House Beautiful: Bringing the War Home* collages around 1972 as U.S. troop levels in Vietnam were drawing down. Around the

Martha Rosler

Red Stripe Kitchen

ca. 1967–72
photomontage

Martha Rosler

Booby Trap

ca. 1967–72
photomontage

Martha Rosler

Makeup/Hands Up

ca. 1967–72
photomontage

Martha Rosler

First Lady (Pat Nixon)

ca. 1967–72
photomontage

Martha Rosler

Cleaning the Drapes

ca. 1967–72
photomontage

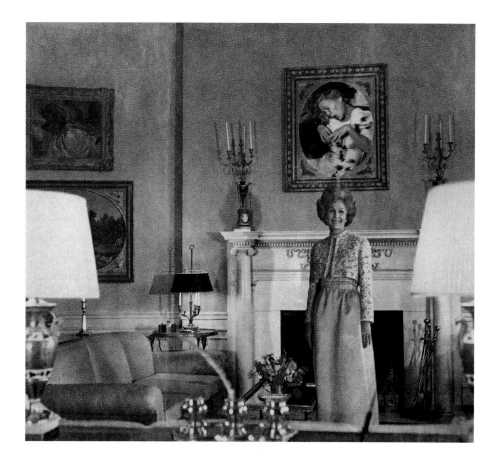

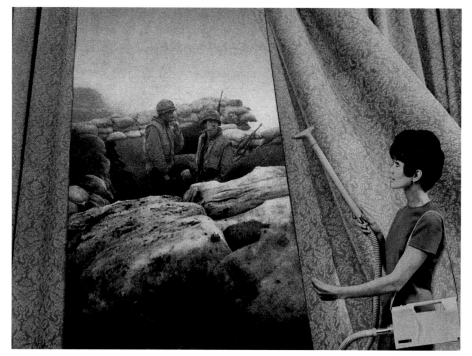

Martha Rosler

Beauty Rest

ca. 1967–72
photomontage

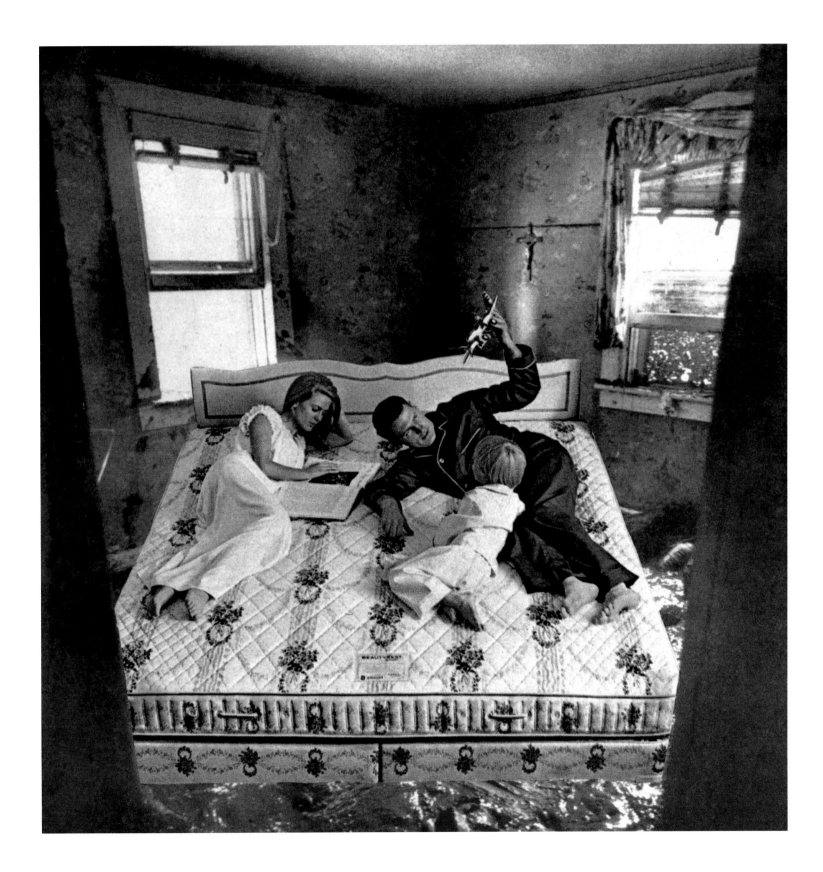

Martha Rosler

Balloons

ca. 1967–72
photomontage

same time, she also ceased making abstract paintings. She was by now a seasoned feminist and anti-war activist, part of a community of left-leaning students and intellectuals centered at the University of California, San Diego.[11] Her direction as an artist had been set. She was no longer interested in working in a particular medium or in separating her art production from the rest of life. "I saw, with my pals, modernism as having betrayed the possibilities of art as part of daily experience and as part of a collective endeavor . . . the work of art is really to move consciousness forward."[12] **MH**

1 Rosler, quoted in Craig Owens, "On Art and Artists: Martha Rosler," *Profile* 5, no. 2 (Spring 1986): 8.

2 Rosler, quoted in Walead Beshty, ed., *Picture Industry: A Provisional History of the Technical Image, 1844–2017* (Zurich: JRP Ringier Kunstverlag, 2018), 812–13.

3 Rosler, quoted in Laura Cottingham, "The War Is Always Home: Martha Rosler," a photo-copied brochure distributed with the exhibition *Bringing the War Home: Photomontages from the Vietnam Era* (New York: Simon Watson, 1991).

4 Rosler, "War in My Work," *Camera Austria International*, no. 47/48 (1994): 47–48.

5 Rosler, quoted in Laura Hubber, "The Living Room War: A Conversation with Artist Martha Rosler," *The Iris* (blog), February 16, 2017, http://blogs.getty.edu/iris/the-living-room-war-a-conversation-with-artist-martha-rosler/.

6 Martha Rosler, interview with Melissa Ho, February 25, 2016.

7 The Vietnam War was considered such because it took place at a time when picture magazines like *Life* were still influential and widely subscribed, and photojournalists were able to receive accreditation and military transport in Vietnam without submitting to military censorship. It was also the first U.S. war that received television coverage. For more on the news media and the Vietnam War, see William M. Hammond, *Reporting War: Media and Military at War* (Lawrence: University Press of Kansas, 1998); Daniel C. Hallin, *The Uncensored War: The Media and Vietnam* (Berkeley: University of California Press, 1989); and Clarence R. Wyatt, *Paper Soldiers: The American Press and the Vietnam War* (Chicago: University of Chicago Press, 1993).

8 Rosler, interview with Melissa Ho. Rosler's emphasis.

9 Rosler, "Place, Position, Power, Politics," in *Decoys and Disruptions: Selected Writings, 1975–2001* (Cambridge, MA: MIT Press, 2004), 355.

10 Frances Jacobus-Parker, "Shock-Photo: The War Images of Rosler, Spero, and Celmins," in *Conflict, Identity, and Protest in American Art*, ed. Miguel de Baca and Makeda Best (Newcastle upon Tyne: Cambridge Scholars Publishing, 2015), 63.

11 In San Diego, Rosler was involved in the Women's Liberation Front and other feminist groups and was a core member of an informal working group that included fellow photographers Fred Lonidier (pp. 246–47), Phil (later Phel) Steinmetz, Brian Connell, and Allan Sekula, which met regularly for years to discuss art, activism, politics, and art and film criticism. Beyond the art department, her intellectual circle included faculty member Herbert Marcuse and his students, including Angela Davis. For more on this milieu, see Karen Moss, "Martha Rosler's Photomontages and Garage Sales: Private and Public, Discursive and Dialogical," *Feminist Studies* 39, no. 3 (2013): 686–721; Jill Dawsey, ed., *The Uses of Photography: Art, Politics, and the Re-invention of a Medium* (Oakland: Museum of Contemporary Art San Diego and University of California Press, 2016); and Paul Alexander Juutilainen, *Herbert's Hippopotamus: A Story about Revolution in Paradise* (1996), film.

12 Rosler, quoted in Owens, "On Art and Artists: Martha Rosler," 22.

1968

On **JANUARY 21**, the Battle of Khe Sanh begins with some 20,000 NLF troops attacking a U.S. combat base manned by roughly 5,500 marines. Determined that Khe Sanh not become an "American Điện Biên Phủ," President Johnson and General Westmoreland order that the base, near the Laotian border, be held. After nearly three months of intense enemy bombardment, overland relief finally reaches the marines with the aid of massive U.S. airpower. After enemy forces withdraw, U.S. commanders order the evacuation and destruction of the base [FIG. c16].

During the Vietnamese Lunar New Year celebration of Tết on **JANUARY 30 AND 31**, North Vietnam launches a coordinated offensive with troops striking cities, towns, and airfields in South Vietnam previously considered safe. Though the attacks are repelled and there is no mass uprising in support of the communists, the American public is stunned by the resolve of PAVN and NLF fighters.

The Tết Offensive claims the lives of more than 3,400 U.S. and South Vietnamese soldiers and about 58,000 PAVN and NLF combatants. Thousands of South Vietnamese civilians are killed—many executed by communist fighters during the monthlong battle in the provincial capital of Huế [FIG. c17]—and hundreds of thousands are displaced. The losses damage confidence in President Nguyễn Văn Thiệu's government and confirm to the South Vietnamese people that the massive escalation of U.S. troops in their country has not brought them security.

In **MID-FEBRUARY**, CBS News anchor Walker Cronkite travels to Vietnam to report on conditions in Sài Gòn and Huế. Grueling block-to-block fighting is ongoing in the

FIG. c16 Marines
dismantle a bunker after
the Battle of Khe Sanh,
1968. Photo by Tim Page

FIG. c17 A U.S. Marine throws a grenade during the Tết Offensive, Huế, 1968. Photo by Don McCullen

FIG. c18 National Guardsmen patrol Washington, D.C., after riots following the assassination of Martin Luther King Jr., 1968. Photo by Burt Glinn

latter. In a special report that airs on **FEBRUARY 27**, the newsman ventures a rare "personal, subjective" opinion, calling the war a "stalemate."

On **MARCH 9**, the *New York Times* reports that General Westmoreland is requesting an additional 206,000 troops in Vietnam—a 40 percent increase over current levels.

Amid sharp criticism of the Johnson administration in the wake of the Tết Offensive, peace candidate Eugene McCarthy comes within a few hundred votes of defeating President Johnson in the New Hampshire Democratic primary for renomination on **MARCH 12**.

On **MARCH 16**, Robert Kennedy, John F. Kennedy's brother and former attorney general, announces his candidacy for the Democratic nomination for president.

Though not reported in the United States until the following year, **MARCH 16** is also the day that American soldiers enter two hamlets in the village Sơn Mỹ in South Vietnam and kill hundreds of unarmed Vietnamese civilians, mostly women, children, and old men. Some of the women are raped before they are murdered and bodies of victims are mutilated. The incident will become known in the West as the My Lai Massacre.

In a televised address on **MARCH 31**, Johnson declares that the United States will stop bombing above the twentieth parallel and seek peace negotiations with North Vietnam. The president also shocks the country by announcing he will not run for reelection. Vice President Hubert Humphrey announces his candidacy for the Democratic nomination on **APRIL 27**.

On **APRIL 4**, Martin Luther King Jr. is assassinated in Memphis, Tennessee. Violent disturbances break out across the country in response, especially in Washington, D.C., Baltimore, Chicago, and Louisville, leaving dozens dead and millions of dollars in property damage [FIG. c18].

On **APRIL 23**, students at Columbia University in New York take over five classroom buildings and force the university to shut down, protesting what they regard as the school's racism and role in the war effort. After a week, the police forcibly remove the remaining students.

In **MAY**, U.S. and DRV delegations arrive in Paris for peace talks. It takes weeks for them to meet, as the Americans refuse to accept a delegation from the NLF, and the North Vietnamese reject sharing a table with any representative of Nguyễn Văn Thiệu's government.

FIG. c19 Chicago police charge demonstrators during the Democratic National Convention, 1968. Photo by Paul Sequeira

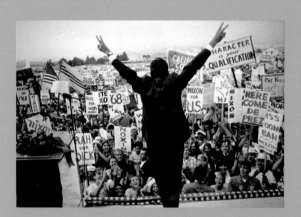

FIG. c20 Richard Nixon appears at a rally in California shortly before winning the presidency, 1968.

On **JUNE 5**, Robert Kennedy is assassinated in Los Angeles. Running on an antiwar platform, Kennedy had been the leading candidate in the Democratic presidential primaries at the time of his death.

In June, the South Vietnamese National Assembly approves President Nguyễn Văn Thiệu's request for general mobilization and the induction of 200,000 additional conscripts into the ARVN.

Taking over for General Westmoreland, on **JUNE 10** General Creighton Abrams becomes MACV commander (MACV commander 1968–72). Military priorities begin to shift from attrition warfare to the expansion of the ARVN and defense of the RVN's most populated areas.

In **JULY**, Richard Nixon is nominated by his party at the Republication convention in Miami. Nixon presents himself as a moderate with a plan to bring "peace with honor" in Vietnam, promising to end the draft and scale back U.S. troop levels in Southeast Asia.

The Central Intelligence Agency's Phoenix Program is established in **JULY**. This counterinsurgency operation seeks to "neutralize" undercover VC and dismantle the NLF political infrastructure in South Vietnam. Its tactics of capture, interrogation, and assassination would become controversial.

In **AUGUST**, Vice President Humphrey secures the nomination of the Democratic Party at the National Convention in Chicago. Outside the convention hall, a violent melee breaks out, later described by an official commission as a "police riot," with city police, National Guardsmen, and federal troops beating and tear gassing antiwar demonstrators [FIG. c19].

Leading up to the election, President Johnson announces that the bombing of North Vietnam will cease and that South Vietnam will participate in peace talks with the north. Secretly encouraged by candidate Nixon to expect better terms under a new American administration, however, President Nguyễn Văn Thiệu declines to negotiate with the communists.

On **NOVEMBER 5**, Richard Nixon defeats Humphrey by a small margin in the presidential election [FIG. c20].

There are 536,100 U.S. troops in Vietnam at the **END OF THE YEAR**. American fatalities for 1968 number 16,899.

Wally Hedrick | b. 1928, Pasadena, CA | d. 2003, Bodega Bay, CA

IN THE LATE 1940S, A YOUNG WALLY HEDRICK joined the National Guard. A bohemian who split his time between playing banjo in San Francisco and painting in Pasadena, Hedrick was not an obvious candidate for the military. But lacking the funds to enroll in art school, he turned to the Guard as a way to avoid the draft. His hopes of eluding full-time service, however, evaporated in 1950 when the Korean War broke out. Hedrick's reserve unit was called to active duty, and the artist spent two years abroad, first in Japan and then as an infantryman in Korea.[1] His experience of combat—which in later years he refused to describe—attuned him to recurring U.S. military operations in Asia and motivated his long-term opposition to the Vietnam War.

Upon his return from active service in 1952, Hedrick settled in San Francisco and quickly became part of the vibrant Bay Area community of Beat artists, musicians, and poets. His iconoclastic and wide-ranging practice, which encompassed junk assemblage, painting, and jazz, defies a coherent narrative.[2] Yet an antiwar stance, which he first made explicit in his *Vietnam* series, begun in 1957, pervades Hedrick's art. At this time, he was rare among American artists in paying attention to the U.S. involvement in Southeast Asia, much less protesting it. Only five years removed from his wartime duty, Hedrick felt there was no difference between Korea and Vietnam: "To me it was all the same. All I knew was we were there and we were going to get screwed again."[3]

The *Vietnam* paintings are all black monochromes, although the artist's approach to making them evolved over the sixteen years of the series. Hedrick described the very earliest as "a kind of spirit painting"[4]—works intended to "mirror the American soul."[5] He painted them while looking at his own dark reflection standing in an unlit room. After these initial experiments, Hedrick changed tack and, by 1958, was canceling out existing paintings in layers of black pigment, as with *Black and Blue Ideas*, a 1958 canvas he painted over in black in 1967. He was, he said, protesting the war in Vietnam by "destroying my 'contribution' 2 'western culture'."[6] For Hedrick, the black used to redact his prior work symbolized the absence of light and enlightened thought. As the war continued and he ran out of paintings to negate, Hedrick began to stretch and paint virgin black canvases. These paintings vary in size, shape, sheen, and hue, though as he progressed, Hedrick's brushwork became more slapdash and the texture of the surfaces less diverse. So irrelevant had conventional painting aesthetics become to his antiwar project, he even allowed one of his *Vietnam* paintings to be reproduced in a catalogue as only a black blot of printer's ink. Hedrick explained that the meaning of the work "has not so much to do with the surface of the paintings or the paints, the pigments, the canvas, but the blackness. And that reproduction is just as efficient as a painting."[7]

Between 1960 and 1970, Hedrick made almost nothing other than black paintings. The only exceptions were a handful of pictorial works created around 1963 that are clear-cut statements of dissent. *Anger* [p. 286], for example, is a stark indictment of the U.S.–supported South Vietnamese government, invoking Trần Lệ Xuân (known as Madame Nhu), the notorious sister-in-law of President Ngô Đình Diệm and de facto first lady of South Vietnam. The canvas features a vulgar phrase defaming Madame Nhu alongside the image of a large phallus, which doubles as a mushroom cloud. The crude sexual language and imagery were, no doubt, meant to match the shocking statements of Madame Nhu herself. *Madame Nhu's Bar-B-Qs*, another painting from 1963, refers to the self-immolation of the Buddhist

Wally Hedrick

Madame Nhu's Bar-B-Qs

1963
oil on canvas

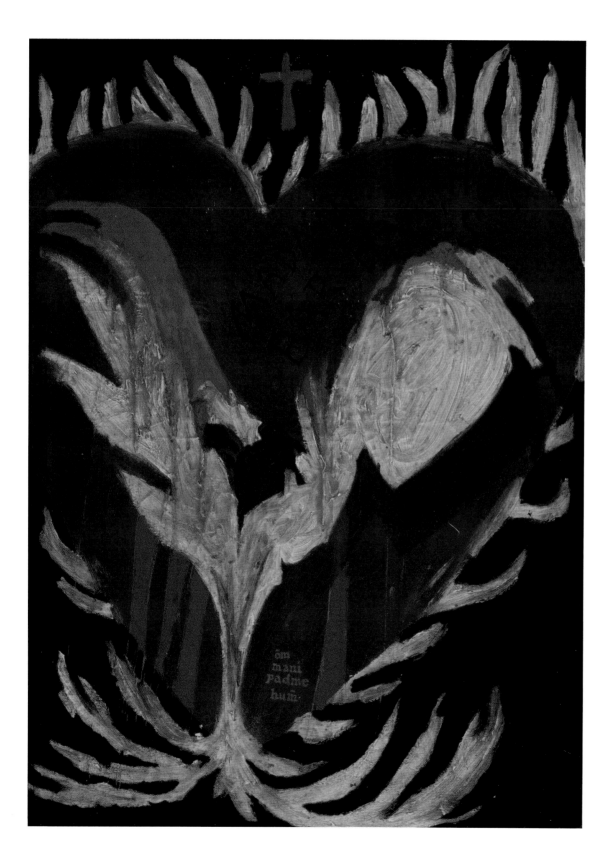

Wally Hedrick

Black and Blue Ideas

1958/1967
oil on canvas

monk Thích Quảng Đức, whose public suicide was part of a larger protest movement against the repressive policies of Ngô Đình Diệm's Catholic-dominated government. His death was broadcast to the world via indelible photographs showing the monk seated in the middle of a busy Sài Gòn street engulfed in flames [p. 242].[8] Madame Nhu's response to the suicide was to say she was "willing to provide the gasoline for the next barbeque."[9] In Hedrick's painting, the motif of the Catholic symbol, the Sacred Heart, is made to visually rhyme in our mind's eye with the iconic image of Thích Quảng Đức submitting to the fire. At its center is an ambiguous black form, surrounded by yellow and white, perhaps suggesting the monk's mortal remains.[10] The Buddhist mantra *Oṃ maṇi padme hūṃ* is lettered near the bottom of the heart, appearing in the same golden color as a cross that hovers above. Hedrick thus invokes both the sacred humanity of Christ and the compassion and enlightenment of Buddha in contrast to Madame Nhu's caustic remark.

The same year he completed these protest paintings, Hedrick decided to take a further step in "withdraw[ing] [his] services from almost everything."[11] His entry page for the Oakland Art Museum's exhibition catalogue *Pop Art USA* was not even a black blot but was simply left blank.[12] Following a presentation of his work at San Francisco's New Mission Gallery in 1963, Hedrick ceased exhibiting for several years. "I was going to stop the war by not letting anybody see my work," he explained decades later. "That sounds a little optimistic, I admit, but I did all kinds of things." The war continued to escalate and, Hedrick reported, "so did I. [The paintings] became larger and more useless. When 1970 rolled around, I made 'rondos.'... [W]hen we 'boxed ourselves in,' I constructed a[n] 11-foot square stretcher bar and proceded [*sic*] to paint it black on the inside."[13] This is a reference to *War Room*, Hedrick's largest *Vietnam* work, which was first completed in 1968, a time when many Americans

Wally Hedrick

War Room

1967–68/2002
oil on canvas

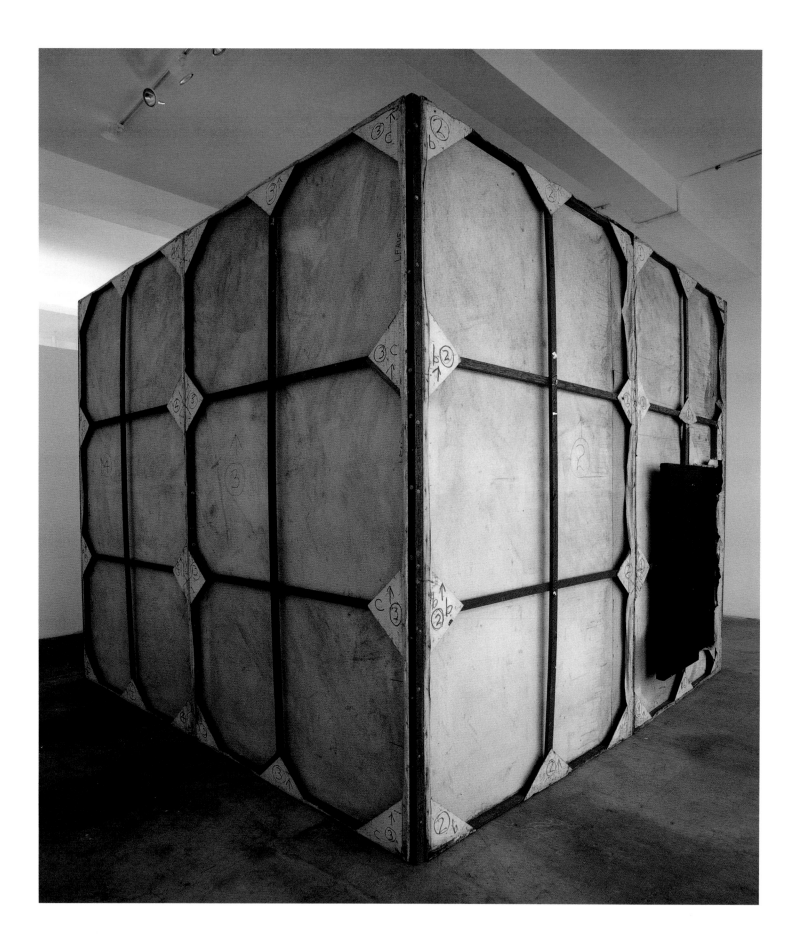

were losing faith in a positive outcome in Vietnam.[14] The construction, made from a series of inward-facing black canvases, functions like a trap. Once inside, the viewer is confronted by an overwhelming blackness that could be relieved only by looking up to the opening above. When the *War Room* was finally exhibited in 1975, one critic reported that it had made her nauseous: "physical discomfort, rather than visual boredom, forced me to leave."[15]

Hedrick's black paintings are not timeless abstractions but statements of protest created under wartime conditions and meant to be interpreted as such. Over

subsequent decades, Hedrick found opportunities to revive the series. During the First Gulf War, he pulled out what he called "the old veterans" and hung them on the side of his barn. ("5 people saw them," he reported.)[16] The run-up to the U.S. invasion of Iraq in 2003 was another opportunity, he felt, for the paintings to fulfill their proper role. He spent months restretching, relining, and repainting the works, and then wrote a plea asking for them to be shown: "THEY R READY 2 DO THEIR DUDY [*sic*]!...25+ SURVIVING VETS—RESTORED 2 HELP PEOPLE FROM KILLING THEMSELVES. ALL THEY NEED IS A VENUE!"[17] **MH**

1 Paul Karlstrom, Oral History Interview with Wally Hedrick, June 10–24, 1974, Archives of American Art, Smithsonian Institution, https://www.aaa.si.edu/collections/interviews/oral-history-interview-wally-hedrick-12869#transcript.

2 In an *Artforum* profile, John Coplans wrote, "Again, at a time when it is virtually a basic requirement for acceptance at a serious level, let alone the common practice, to create an identity by an easily identifiable and personal image, [Hedrick] resolutely refuses to nurture a style." Coplans, "Wally Hedrick: Offense Intended," *Artforum* 1, no. 11 (May 1963): 28.

3 Karlstrom, Oral History Interview.

4 Ibid.

5 Handwritten essay by Jeri MacDonald based on interview with Wally Hedrick (fall 1976). Research on Wally Hedrick, Box 42, Folder 25, "A Different War: Vietnam in Art" (1989–1991), Series 5: Exhibitions 1960s–1990s, Lucy R. Lippard papers, Archives of American Art, Smithsonian Institution.

6 Letter from Wally Hedrick to Ron Casentini, January 8, 2003. Research on Wally Hedrick, Box 42, Folder 25, "A Different War: Vietnam in Art" (1989–1991), Series 5: Exhibitions 1960s–1990s, Lucy R. Lippard papers, Archives of American Art, Smithsonian Institution.

7 Karlstrom, Oral History Interview.

8 American photojournalist Malcolm Browne won a Pulitzer Prize for his photograph of Thích Quảng Đức's self-immolation.

9 Quoted in Peter Selz, *Art of Engagement: Visual Politics in California and Beyond* (Oakland: University of California Press and San José Museum of Art, 2006), 40.

10 Thích Quảng Đức's heart miraculously survived both his self-immolation and subsequent funeral cremation. It was kept as a holy relic until confiscated by South Vietnamese authorities. Seth Jacobs, *Cold War Mandarin: Ngo Dinh Diem and the Origins of America's War in Vietnam, 1950–1963* (Lanham, MD: Rowman and Littlefield, 2006).

11 Karlstrom, Oral History Interview.

12 John Coplans, *Pop Art USA* (Oakland, CA: Oakland Art Museum, 1963), 34.

13 Letter from Wally Hedrick to Ron Casentini, Lippard papers.

14 Hedrick returned to the *War Room* in 2002, explaining its second completion date.

15 Judith L. Dunham, "Wally Hedrick Vietnam Series," *Artweek*, June 28, 1975, 20.

16 Letter from Wally Hedrick to Ron Casentini, Lippard papers. Casentini is a collector and arts patron.

17 Ibid. Hedrick succeeded in presenting his antiwar works during the run-up to the Iraq War. His exhibition *Preemptive Peace* was presented at the University Art Gallery, Sonoma State University, February 20–March 16, 2003. On March 20, 2003, U.S. forces invaded Iraq.

David Hammons | b. 1943, Springfield, IL

WHEN DAVID HAMMONS MADE HIS *AMERICA the Beautiful*, the nation's moral beauty was, for many, very much in doubt. In 1968, the country was beset by turmoil on a host of fronts, from race riots and the assassinations of Martin Luther King Jr. and Robert F. Kennedy at home to the Tết Offensive and escalating troop numbers abroad. That such conditions mattered to Hammons's work was suggested by the artist himself when he claimed, "I feel that my art relates to my total environment—my being a black, political, and social human being."[1] Something of this can be discerned in his print: it is a work about not just his body and its actions but also their relationship to the nation.

America the Beautiful belongs to a series of body prints that Hammons made during the late 1960s and into the 1970s in Los Angeles. Typically, the artist's process for these works involved him covering his body with grease, pressing it against a sheet of paper, then sprinkling the imprint with pigment [FIG. 1]. In this instance, a flag was also printed onto the picture's surface. Hammons, who studied with painter and printmaker Charles White at the Otis Art Institute after moving to Los Angeles in 1963, was affected by

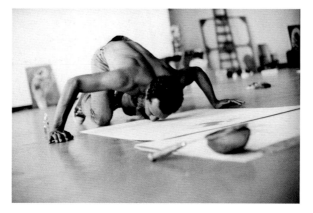

FIG. 1
David Hammons making a body print, Slauson Avenue studio, Los Angeles, 1974. Photo by Bruce W. Talamon

the way White's socially committed work attended to African Americans and their histories. This experience stood behind Hammons's belief that he had a "moral obligation as a black artist, to try to graphically document what I feel socially."[2]

The processes by which Hammons's body prints were made, as well as the forms that resulted, are bound up with questions around race and racism.[3] At a moment when the exclusionary practices of mainstream art institutions were under fire, a print like *America the Beautiful* at once made the black body (*his* black body) intimately present—emerging with great detail and specificity against a field of white—and marked it as hauntingly, pointedly absent.[4] Moreover, in this work, as in others from the same year, Hammons takes a very particular stance in relation to the flag, an emblem of American ideals, with all their possibilities and pitfalls.[5] With his torso and head draped beneath the flag and his left arm reaching out over it toward his face, the Stars and Stripes appears at once a comfort and a weight. Hammons's arm similarly can seem poised to both pull the flag closer and strip it from his body. A related dynamic informs his contemporaneous *Boy with Flag*, where the flag seems to reveal and conceal, to present the black body and to render it less than whole [FIG. 2]. Such dueling possibilities concurrently conjure the hopes or promises offered by the United States and their systematic denial for people of color. They also allude to a choice about how to identify—first as an American or first as an African American—with a decision seemingly reached by the time of Hammons's 1970 *Black First, American Second*. The way the artist printed his face in *America the Beautiful*, almost joining two profile views, underscores these poles while signaling the fundamentally distorting effect of disenfranchisement.

The war magnified the stakes of all of this for many black communities. While African Americans had long served in the military, in Vietnam they

David Hammons

America the Beautiful

1968
lithograph and body print

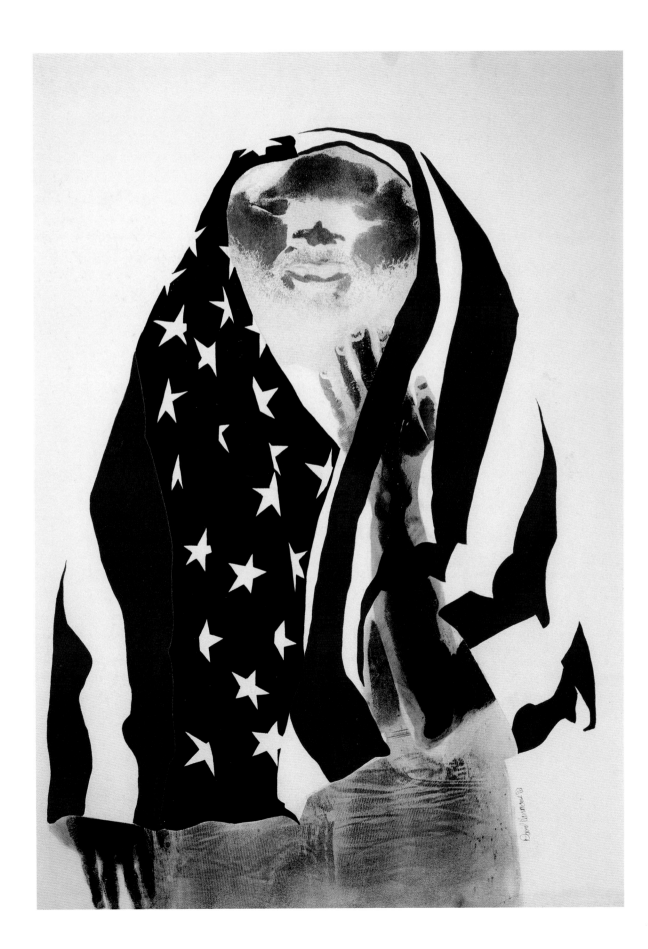

helped form the most integrated units to date. In ways, this was a tremendous achievement for a country where the battle over civil rights still ran red-hot. Yet the early years of the war also saw a disproportionate number of African Americans die, with blacks far more likely to be given combat assignments.[6] Though the percentage of African Americans killed overseas declined as the war went on, around the time that Hammons made his print, previously muted racial tensions among troops regularly began to boil over into violence—a situation set in motion by institutional discrimination within the military and further spurred by King's assassination and

the race riots that followed—with a steeper price frequently paid by black servicemen.[7] Against these backdrops that saw corporeal presence open onto corporeal threat for African American men, the simultaneous surfacing and ghost-like withdrawal of Hammons's body in *America the Beautiful*, as in *Boy with Flag*, take on still another, bleaker cast. If imagined horizontally, *Boy with Flag* seems to allude to a body in a casket draped with a flag as in a military funeral, and in *America the Beautiful* the flag can be read as a shroud. The flag, symbol for the nation, does more than obscure the black bodies; it forecasts their burial. KM

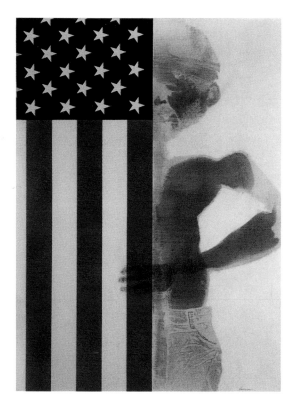

FIG. 2
David Hammons, *Boy with Flag*, 1968, body print and silkscreen, Private Collection

1 David Hammons, quoted in Joseph E. Young, *Three Graphic Artists: Charles White, David Hammons, Timothy Washington* (Los Angeles: Los Angeles County Museum of Art, 1971), 7.

2 David Hammons, quoted in Samella Lewis and Ruth Waddy, *Black Artists on Art*, vol. 1 (Los Angeles: Contemporary Crafts, 1969), 21. For more on the importance of White, see, for instance, Hammons's comments in *Three Graphic Artists*, 7.

3 On the ways Hammons's prints take up race, see Kellie Jones, *South of Pico: African American Artists in Los Angeles in the 1960s and 1970s* (Durham, NC: Duke University Press, 2017), 226–29; Mark Godfrey and Zoé Whitley, "Three Graphic Artists," in *Soul of a Nation: Art in the Age of Black Power* (New York: D.A.P., 2017), 98.

4 On this point, see Tobias Wofford, "Can You Dig It? Signifying Race in David Hammons' Spade Series," in *Now Dig This! Art and Black Los Angeles, 1960–1980*, ed. Kellie Jones (Los Angeles: UCLA Hammer Museum of Art, 2011), 101.

5 In so doing, Hammons joined a range of other artists, including many African Americans, making use of the flag at this moment. See Mary Schmidt Campbell, *Tradition and Conflict: Images of a Turbulent Decade, 1963–73* (New York: Studio Museum in Harlem, 1985), 60–61.

6 In 1968, for example, African Americans made up 9.8 percent of U.S. forces but close to 20 percent of combat troops and 14.1 percent of those killed that year. See Diane Canwell and Jon Sutherland, *African Americans in the Vietnam War* (Milwaukee, WI: World Almanac Library, 2005), 14. For a nuanced discussion of African American participation in the war, see Christian G. Appy, *American Reckoning: The Vietnam War and Our National Identity* (New York: Penguin Books, 2015), 137–40; Kimberly L. Phillips, *War! What Is It Good For? Black Freedom Struggles and the U.S. Military from World War II to Iraq* (Chapel Hill: University of North Carolina Press, 2012), 188–227.

7 Appy notes that the decrease in black deaths may have been due in part to the fact that more pilots died and there were relatively few African American pilots. He also observes that the military may have consciously responded to criticism of the percentage of blacks killed from 1965 to 1967 (Appy, *American Reckoning*, 140). On this racial violence abroad, see James E. Westhelder, *The African American Experience in Vietnam: Brothers in Arms* (Lanham, MD: Rowman and Littlefield, 2008), 81–104. The discrimination experienced by African Americans within the military was, of course, a fact of life for many at home. It is worth noting that when Martin Luther

King Jr. publicly denounced the war in his 1967 speech at Riverside Church, he noted, "[W]e have been repeatedly faced with the cruel irony of watching Negro and white boys on TV screens as they kill and die together for a nation that has been unable to seat them together in the same schools." Martin Luther King Jr., "Beyond Vietnam" (April 1, 1967), in *Voices of a People's History of the United States*, ed. Howard Zinn and Anthony Arnove (New York: Seven Stories Press, 2004), 424. This sense of African Americans sacrificing for a country that continued to fail them offers another lens through which to view Hammons's seemingly ambivalent relation to the Vietnam War–era nation conjured by his flag.

Mel (Melesio) Casas | b. 1929, El Paso, TX | d. 2014, San Antonio, TX

MEL CASAS BEGAN WORK ON WHAT WOULD come to be known as his *Humanscape* series in 1965 after a fateful trip down the highway in his home of San Antonio, Texas. Glimpsing from the road part of a drive-in movie theater screen, he was struck by the surreal juxtaposition of the actress it featured and the actual trees surrounding it, particularly the way the speaking character appeared to be "munching" on the leaves.[1] Over the course of the next twenty-four years, Casas went on to create 153 paintings that similarly yoked everyday life with popular or mass media imagery, making productive use of their incongruities. While these *Humanscapes* tackled a range of topics, from pop-like explorations of the female body to Chicano culture to the art world itself, after 1967 they hewed to roughly the same compositional format. Painted on six-by-eight-foot canvases, the upper section of each work includes a large, often slightly bowed, rectangular image that conjures the movie screen that gave rise to the series; the surface's lower register is then often populated with what might be taken as an audience for that screen [FIG. 1]. The series was consistent in another way as well. "The *Humanscapes* are deliberately ambiguous," Casas claimed in 2008. "If I spell everything out, I'm making an illustration, and I didn't want to make illustrations. That wasn't the point. The point was to make art."[2] As *Humanscape 43* makes clear, that ambiguity became especially potent when, in 1968, Casas turned his attention to explicitly political themes, including the war in Vietnam—themes he pursued until 1975, the year the conflict abroad ended.

This shift within Casas's practice—like those in many of his contemporaries' trajectories—occurred at a moment of great social and political unrest across the United States, with civil rights struggles and antiwar efforts in full swing. The artist was attentive to both. On behalf of the San Antonio–based Con Safo, one of the earliest Chicano art groups, Casas authored his "Brown Paper Report" in 1971. Promoting equality for Chicanos and Chicano culture in a context that saw basic power structures starkly skewed against them, Casas claimed in his text, "If Americana was 'sensed' through blue eyes, now brown vision is demanding equal views—polychroma instead of monochroma. Brown eyes have visions too."[3] Such brown eyes also had a very particular perspective on the ongoing war: Latinos represented a disproportionate number of those fighting and dying during the 1960s.[4] Casas was deeply opposed to the Vietnam conflict, having been drafted, served, and injured during the Korean War—a conflict that similarly pitted communism against democracy. The artist's record of service and activism resonates with his understanding of Chicano identity as hybrid: "George Washington and Che Guevara homogenized into one."[5] From this complex position, he articulates his protest in *Humanscape 43*.

The majority of that canvas is given over to the "screen," which reads "$KILL$," a multivalent play on the slippage between the letter *S* and the dollar sign. How we choose to read that phrase, in turn, shifts our understandings of the bottom register of the painting, executed in the straightforward language of pop. Set against a bright blue ground are a hand raised upright, two soldiers' helmets, four guns pointed upward or nearly so, and a soldier aiming a weapon, with the stenciled word "obscenity" jutting up near the middle of all of this like a subtitle for the scene. One way to take $KILL$ is as highlighting the obscenity of the fact that, in the artist's words, "the skills of war are killing"—a reality variously but regularly projected before the nation.[6] (That the screen's curved edges also call to mind a period television set is suggestive in this context: televisions were what

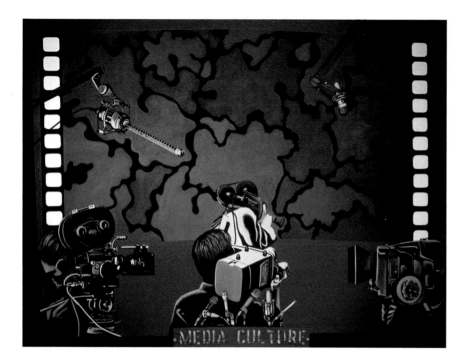

FIG. 1
Mel Casas, *Humanscape 81*,
1969, acrylic on canvas,
Mel Casas Family Trust

familiarized many with Vietnam.) The painting's figurative section could then seem to underscore this interpretation. Moving from left to right, we might see a soldier moving from induction, to being equipped, to prepared to fire. Alternatively, 1968 being a presidential election year, the suit sleeve of the arm stretched upward might position that figure as a president being sworn in; his action finding echoes in the weapons then serves to align his position with the skills of war.[7]

At the same time, $KILL$ stresses the financial motivations that drive wars in America: "dollars kill," as Casas later put it.[8] Viewed from this perspective,

the suit sleeve of the left most figure can be read as an emblem of the corporations fueling and profiting from the war, pledging their allegiance to the country at a marked remove. It seems no accident that, while the race of the soldier on the right is uncertain, this businessman is decidedly white. It is also striking that he is the figure on whom the gun is trained—his vanquishing perhaps foreshadowed by the owners of the now-bodiless helmets to his right. Whether their former occupants are dead or living, those helmets are further reminders of the goods war demands; the sexual quality of the two helmets with the upright bayonet between them hints at the libidinal force of this capitalist aspect of fighting.[9] Those helmets also speak to the way soldiers are dehumanized by the war machine, which is to say, the way their embodied presence is reduced to merely one more piece of equipment. The overarching presence of that machine is underscored by the uninflected, pristine surface of Casas's painting.

The multiple readings invited by *Humanscape 43* are set into new light by a remark Casas made after the series was completed. In America, he claimed, "to be bilingual is to be suspect."[10] As if in opposition to this perception, Casas's painting capitalizes on the possibilities that emerge from being able to speak or read in two different ways. These productive ambiguities move his work beyond not only mere illustration but also the passive consumption of the movies. Instead, the work's large-scale address fosters active reflection on the issues at hand.[11] KM

Mel Casas

Humanscape 43

1968
acrylic on canvas

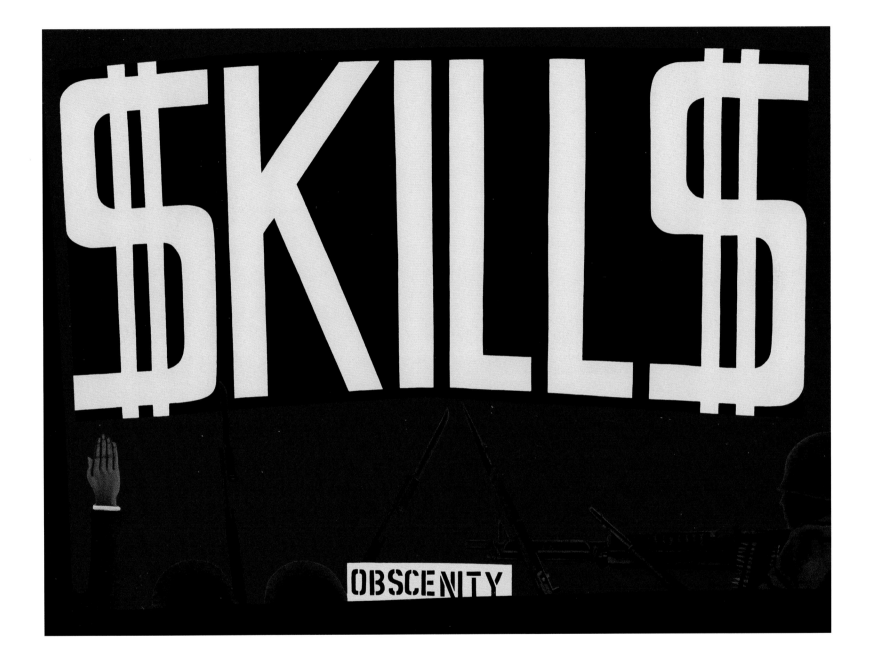

1 For Casas's description of this event, see "A Conversation with Mel Casas and Rubén C. Cordova," in *Born of Resistance:* Cara a Cara *Encounters with Chicana/o Visual Culture*, ed. Scott L. Baugh and Victor A. Sorell (Tucson: University of Arizona Press, 2015), 158–59.

2 Ibid., 166. For more wide-ranging accounts of the *Humanscapes*, see Rubén C. Cordova, "The Cinematic Genesis of the Mel Casas *Humanscape*, 1965–67," *Aztlán: A Journal of Chicano Studies* 36, no. 2 (Fall 2011): 51–87; Rubén C. Cordova, "Getting the Big Picture: Political Themes in the *Humanscapes* of Mel Casas," in *Born of Resistance,* 172–89; Dave Hickey, "Mel Casas: Border Lord," *Artspace: Southwestern Contemporary Arts Quarterly* 12, no. 4 (1988): 28–31; Nancy L. Kelker, *Mel Casas: Artist as Cultural Adjuster* (Lascassas, TN: Highship Press, 2014), 67–79.

3 Mel Casas, "Brown Paper Report" (1971), in *Con Safo: The Chicano Art Group and the Politics of South Texas*, ed. Rubén C. Cordova (Los Angeles: Chicano Studies Research Center, University of California, Los Angeles, 2011), 63. See this same volume for an important discussion of Con Safo. The position Casas takes in this text was foreshadowed in late 1967 when, after being named San Antonio's artist of the year, he used his acceptance speech to highlight the privilege bestowed upon the ideal of beauty represented by Barbie dolls. See Cordova, "The Cinematic Genesis of the Mel Casas *Humanscape*, 1965–67," 58.

4 For relevant statistics, see Melissa Ho, "ONE THING: VIET-NAM, American Art and the Vietnam War," in this volume, 28n61.

5 Casas, "Brown Paper Report," in *Con Safo*, 63.

6 Casas, quoted in Cordova, "Getting the Big Picture: Political Themes in the *Humanscapes* of Mel Casas," in *Born of Resistance*, 174.

7 Thanks to E. Carmen Ramos for this point.

8 Casas, quoted in Cordova, "Getting the Big Picture: Political Themes in the *Humanscapes* of Mel Casas," in *Born of Resistance*, 174.

9 A sexual charge is not unique to *Humanscape 43*. Figures elsewhere in the series take on the role of lovers, a play on the romantic possibilities of the drive-in.

10 Paul Karlstrom, Oral History Interview with Mel Casas, August 14 and 16, 1996, Archives of American Art, Smithsonian Institution, https://www.aaa.si.edu/collections/interviews/oral-history-interview-mel-casas-5449#transcript.

11 Ibid. Though the scale of Casas's series suggests public address, it is important to note that he did not frequently exhibit his works.

Edward Kienholz | b. 1927, Fairfield, WA | d. 1994, Sandpoint, ID

ON APRIL 23, 1968, EDWARD KIENHOLZ'S *THE Eleventh Hour Final* debuted at Gallery 669 in Los Angeles.[1] The artist had become well-known, even somewhat notorious, in the previous years for his large sculptural tableaux. Two years earlier, his *Back Seat Dodge '38* (1964) caused an art world scandal at the Los Angeles County Museum of Art, when its frank depiction of furtive teenage sex was swiftly denounced by the museum's Board of Supervisors. Calling it "revolting, pornographic, and blasphemous," the board threatened to withhold funding for the museum unless the sculpture was removed.[2] In comparison, Kienholz's *The Eleventh Hour Final* was remarkable for what appeared to be its tranquil domesticity.

The Eleventh Hour Final presents a middle-class American living room. One enters the dark paneled environment through a doorway, as if it were actually part of a house. While there are signs of recent human life—indentations on the cushion of the worn green sofa, and a lit lamp next to it—the scene is empty apart from the presence of the viewer. Above the sofa is a cheap-looking painting of an urban skyline and, just in front, a coffee table holding an ashtray, plastic flowers, and *TV Guide*. On the opposite wall, to which the furniture in the room is oriented, is an object that punctures the placid scene's illusion of normalcy: a concrete television in the form of a tombstone.

Kienholz here gives physical form to the idea of the "living-room war," the popular term coined by the essayist Michael J. Arlen to describe the first televised war.[3] The conflict in Vietnam was distinguished in part by the sheer amount of information about it and the novel way in which people consumed it; by 1967,

the three major networks had increased their evening news broadcast from fifteen minutes to thirty, and reporting about the ravages of battle became intimately entwined with domestic scenes like this one.[4] Indeed, only two months before Kienholz first presented *The Eleventh Hour Final*, the American public had been stunned to watch the protracted fighting of the Tết Offensive unfold on their television screens. The work's title makes the connection explicit, conflating the name for the last broadcast of the nightly news, "the eleven o'clock final," with a portentous sense of the hour before doom.

And yet, such televised doom was easily consumed and just as easily ignored, sandwiched cozily between commercials for laundry detergent and instant coffee. In the catalogue entry for an exhibition of *The Eleventh Hour Final* two years later, Kienholz posed the question, "What can one man's death, so remote and far away, mean to most people in the familiar safety of their middle-class homes?"[5] On first glance, the answer he seems to suggest on the tombstone television is: not a lot. Engraved on the screen is a set of figures, chilling in their implication yet numbing in their presentation:

This Week's Toll

American Dead	*217*
American Wounded	*536*
Enemy Dead	*435*
Enemy Wounded	*1291*

The facts contained in this statistical rundown might have earlier been cause for cheer in the mind of the famously technocratic Secretary of Defense Robert S. McNamara, who could see in them a victory augured by the differential in body counts.[6] On further observation, however, the television's cool abstraction is ruptured by the presence of a figure—a wax head lying within the television just behind the screen. The wax visage was heated and shrunk by the artist to evoke the ravages of napalm,

Edward Kienholz

The Eleventh Hour Final

1968
tableau: wood paneling, concrete
TV set with engraved screen and
remote control, furniture, lamp, ash
trays, artificial flowers, *TV Guide,*
pillows, painting, wall clock, window,
and curtain

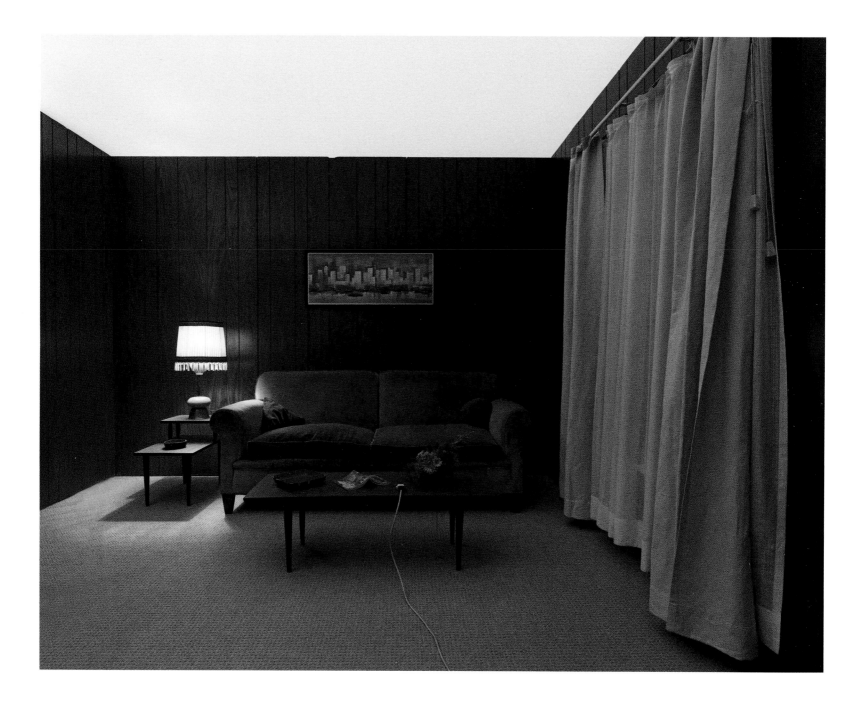

Edward Kienholz

The Eleventh Hour Final

(alternate view and detail)
1968

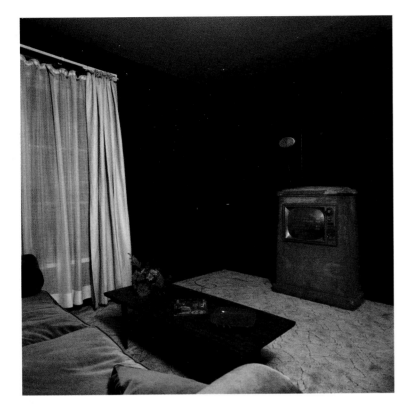

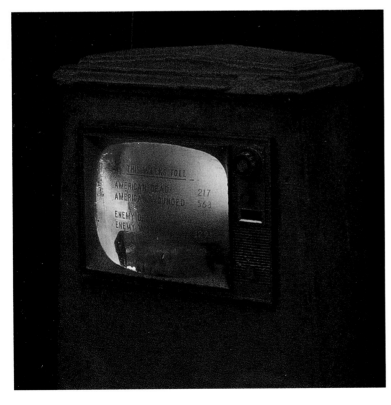

and its dark eyes stare into the room, establishing a visceral connection with the viewer.[7]

Once the head is visible, the scene loses its illusion of banality and becomes suffused with a surreal horror. The room's emptiness becomes charged, and the implicit invitation to the viewer to settle into the familiar-seeming space curdles, with Kienholz's tableau now signaling that complicity accompanies the comfort. Other physical details further implicate the viewer; a cord snakes from the body of the tombstone television to its remote control, umbilically extending outward. The *TV Guide* on the coffee table is the current issue, placing the scene always in the here and now and awakening us to the continuing effects of the living-room war's legacy of prepackaged, domesticated trauma. "Obviously television has a tremendous potential," Kienhnolz said when asked about the work and his attention to the medium. "But there is no communication in the world. Dead, dead, dead."[8] **SN/JM**

1 It is notable that Kienholz's exhibition was presented by a gallerist who was a military veteran; Eugenia Butler (who, with Riko Mizuno, ran Gallery 669) had been a nurse and master sergeant with the U.S. Marines during the Second World War. Eugenia Butler obituary, *Los Angeles Times*, January 19, 2001, http://articles.latimes.com/2001/jan/19/local/me-14272.

2 Edward Wyatt, "In Sunny Southern California, a Sculpture Finds Its Place in the Shadows," *New York Times*, October 2, 2007, https://www.nytimes.com/2007/10/02/arts/design/02dodg.html.

3 Arlen first coined the term in an essay in the *New Yorker* in 1966; it later became the title of a book of his essays in 1982. Michael J. Arlen, "Living-Room War," *New Yorker*, October 15, 1966, 200–202.

4 Michael Mandelbaum, "Vietnam: The Television War," *Daedalus* 111, no. 4 (Fall 1982): 157–69.

5 Edward Kienholz, *11 + 11 Tableaux*, ed. K. G. P. Hultén and Katja Waldén (Stockholm: Moderna Museet, 1970), 11.

6 By 1967, however, McNamara had lost faith in the U.S. war strategy in Vietnam. He resigned as secretary of defense on November 29, 1967, and departed office on February 29, 1968.

7 Hector Arce, "Eleventh Hour," *Home Furnishings Daily*, May 9, 1968, n.p.

8 Ibid.

Yayoi Kusama | b. 1929, Matsumoto, Japan

ACCORDING TO YAYOI KUSAMA, 1968 WAS "a year of upheaval, in which a presidential election was held even as the war in Vietnam escalated and the antiwar movement exploded."[1] So, too, did her art. In July of that year, Kusama staged the first of two *Anatomic Explosions on Wall Street*. On this occasion, she traveled to Wall Street with four dancers, two men and two women, who stripped on site. With a fairly sizable audience before them and a conga drummer playing, they danced in front of the New York Stock Exchange and the statue of George Washington across the street at Federal Hall while Kusama painted their bodies with her signature polka dots. It was no accident that when Kusama and company returned in October for the second *Anatomic Explosion on Wall Street,* the crowd did as well: Kusama had issued press releases in advance of each event. While both statements aligned themselves with antiwar sentiment and both took on the capitalist system symbolized by Wall Street, the second did so more pointedly: "The money made with this stock is enabling the war to continue. We protest this cruel, greedy instrument of the war establishment."[2]

Having recently turned away from her critically applauded paintings to embrace Happenings, the artist's July 1968 venture to Wall Street marked the first in a series of works deemed *Anatomic Explosions*.[3] These politically loaded events unfolded in the run up to and immediate aftermath of the November presidential election—one haunted by the assassinations of Robert F. Kennedy and Martin Luther King Jr. So strong was public desire to end the war that Richard Nixon presented himself as a moderate with a plan for peace. As that particularly freighted occasion

approached, Kusama and her changing but always nude groups of dancers enacted their opposition—to the war, to the government, to the status quo—in charged spaces across the city: in front of the Statue of Liberty, in Central Park, near the United Nations building, before the New York Board of Elections.[4] In both performances of *Anatomic Explosion on Wall Street*, Kusama focused on the potential connectedness of nudity, capitalism, and the conflict abroad.

More than mere backdrop to Kusama's antiwar stand, the chosen Wall Street sites gave shape to the works. If Norman Mailer's 1967 book asked, "Why Are We in Vietnam?" Kusama posed a similar question to her spectators: Why here?[5] As Mignon Nixon has incisively observed, positioning dancers in front of the statue of Washington outside of Federal Hall, where he took the oath of office, conjured thoughts of both revolution and colonial power—terms entirely relevant to the conflict in Vietnam, itself a nation fighting for liberation. The choice of the New York Stock Exchange as stage then suggests that behind the United States' switch from revolutionary state to colonialist power are economic motives.[6] Kusama flags the mutual imbrication of corporate capitalism and conflict, which is to say the quite literal payoff associated with all the bombs, chemical agents, and hardware that war required.[7]

In this context, the dancers' unabashed nudity appears to be offered as an alternative to the forces of a war-mongering capitalism, a means of replacing aggression with desire. Kusama reportedly stated, "People who wear clothes are frustrated. That is why there is so much war and killing."[8] On her account, liberated (nude) bodies might then be further freed from conflict by being covered with—or obliterated by, as the artist would say—polka dots. The press release for the first *Anatomic Explosion* at the Stock Exchange claims such "[s]elf-obliteration is the only way out," for it allows one to "become part of the unity of the universe"—rather, it is implied, than

Yayoi Kusama

*Anatomic Explosion on
Wall Street*

1968
Happening

Yayoi Kusama

Anatomic Explosion on
Wall Street

1968
Happening

a victim of war.[9] ("Our earth is only one polka dot among a million stars in the cosmos," Kusama explained elsewhere; "Polka dots are a way to infinity. When we obliterate nature and our bodies with polka dots, we become part of the unity of our environment.")[10] On the one hand, the notion that nudity, or polka dots, could counter the complexities and horrors of war strains credulity, particularly given that the media was offering up images of both soldiers and civilians suffering despite various degrees of undress. The artist was not, however, unfamiliar with the realities of armed conflict. Born in Japan in 1929, Kusama had lived through war as a child and was sixteen when atomic bombs were dropped on Hiroshima and Nagasaki. Her sense that "anatomic explosions are better than atomic explosions" was, quite literally, earned.[11]

Photographs of Kusama's *Anatomic Explosions* abound. In those from Wall Street, dancers spin and glide, manipulate flags, and welcome obliteration. Conspicuous in these images are the photographers documenting the scene, cuing us to the event's afterlife. More than documentation, however, these photographs are part of the event's point. As Nixon has noted, Kusama courted press attention for her antiwar Happenings—even deeming them "press happenings"—and her advances were reciprocated by coverage in everything from mainstream papers to pornographic publications. Though the performances' reception, by both the media and bystanders, tended to center around the dancers' nudity and attending thoughts of sexual liberation instead of Kusama's opposition to the war—her message perhaps missing the mark in real time—the artist's ambition vis-à-vis the press is nevertheless telling.[12] Just months before the October *Anatomic Explosion on Wall Street,* protesters had chanted, "The whole world is watching!" in front of a sea of cameras as violent clashes with the police unfolded around the Democratic National Convention in Chicago. That

the artist seemed to aspire to such coverage testifies to the press's importance to debates about the war, especially during a year in which media opinion increasingly turned against the conflict. Through this sort of attention, Kusama imagined she might most widely share the imperative to "OBLITERATE YOURSELF WITH POLKA DOTS!"[13] **KM**

1 Yayoi Kusama, *Infinity Net: The Autobiography of Yayoi Kusama,* trans. Ralph McCarthy (London: Tate Publishing, 2011), 121.

2 Yayoi Kusama, press release, "Naked Demonstration at Wall Street at 10:30 a.m. on Sunday October 13, 1968: *The Anatomic Explosion,*" reproduced in *Yayoi Kusama,* ed. Laura Hoptman, Akira Tatehata, and Udo Kultermann (London: Phaidon, 2000), 107.

3 First used by the artist Allan Kaprow in 1959, the term Happenings generally refers to multimedia theater pieces that were largely devoid of narrative and often invited spectator participation. Kusama has described her *Anatomic Explosions* as broadening this category of art by incorporating into it reflections on the tumult of the day; see Kusama, *Infinity Net,* 121.

4 On the *Anatomic Explosions,* see Kusama, *Infinity Net,* 121–26; Alexandra Munroe, "Obsession, Fantasy and Outrage: The Art of Yayoi Kusama," in *Yayoi Kusama: A Retrospective,* ed. Bhupendra Karia (New York: Center for International Contemporary Arts, 1989), 29–30; Mignon Nixon, "Anatomic Explosion on Wall Street," *October,* issue 142 (Fall 2012): 3–25; Rachel Taylor, "Kusama's Self-Obliteration and the Rise of Happenings 1967–73," in *Yayoi Kusama,* ed. Frances Morris (London: Tate Publishing, 2011), 116–17.

5 See Norman Mailer, *Why Are We in Vietnam?* (New York: Picador, [1967] 1977).

6 On both these points, see Nixon, "Anatomic Explosion on Wall Street," esp. 19–24.

7 She was not alone among artists in making this point. The Guerrilla Art

Action Group went on to do something similar in *Blood Bath* [p. 158].

8 Kusama, quoted in Al Van Starrex, "Naked Happenings," *Man* (October 1968): 46. In keeping with such a position, around this time Kusama also staged in her studio a series of orgies, some farcically taking as their targets the excesses of war. On these, see Munroe, "Obsession, Fantasy and Outrage," 28; Nixon, "Anatomic Explosions," 18.

9 Kusama, press release, "Naked Event Outside the Stock Exchange at 11 A.M. on Sunday, July 14, 1968."

10 Kusama, quoted in John Gruen, "Vogue's Spotlight: The Underground, *Anatomic Explosions,* Polka Dots for Love," *Vogue* 152 (October 1968): 17.

11 Kusama, quoted in "4 in Nude Protest the War in Vietnam," *New York Times,* November 12, 1968, 35. Nixon elegantly tracks the ways these protest works have faced critical and scholarly dismissal in the past and makes a compelling argument in favor of their seriousness (Nixon, "Anatomic Explosion on Wall Street," 3–25). Performing in this way was not without at least some risk: Kusama, appearing nude, was arrested at the second Wall Street Happening. See Kusama, *Infinity Net,* 116.

12 See Nixon, "Anatomic Explosion," esp. 6–12.

13 Kusama, press release, "Naked Event Outside the Stock Exchange at 11 A.M. on Sunday, July 14, 1968." Kusama once remarked, "Publicity is critical to my work because it offers the best way of communicating with large numbers of people" (Kusama, quoted in Munroe, "Obsession, Fantasy and Outrage," 30).

Claes Oldenburg | b. 1929, Stockholm, Sweden

"IN CHICAGO, I, LIKE SO MANY OTHERS, RAN head-on into the model American police state," wrote Claes Oldenburg to gallerist Richard Feigen in September 1968 of his experience at the August Democratic National Convention. "I was tossed to the ground by six swearing troopers who kicked me and choked me and called me a communist."[1] The artist was not alone in receiving such treatment. Over the course of the convention, a range of antiwar protesters came into intensifying conflict with law enforcement officers deployed by Chicago Mayor Richard J. Daley, who seemed intent on maintaining order at all costs. Protesters, as well as bystanders, were variously subjected to tear gas, clubs, and other abuse with a particularly violent clash taking place outside of the Democratic Party's headquarters, the Conrad Hilton Hotel. As some protesters launched various objects, police brutally attacked demonstrators and media alike; the cameras of the latter beamed this rioting into homes across the country, further galvanizing the antiwar movement. Following these jarring events, Oldenburg went on to cancel a one-person show he was meant to open at Feigen's Chicago gallery in late October — one designed to cast that city, the artist's hometown, in a positive light — stating, "[A] gentle one-man show about pleasure seems a bit obscene in the present context."[2] Many other artists shared Oldenburg's outrage at the savage police actions undertaken with Daley's blessing. On the same day that Oldenburg wrote his letter, more than fifty artists voiced their support of a boycott of Chicago, proposing to show no work there until the mayor's term ended two years later. As an alternative to this boycott, Feigen suggested replacing Oldenburg's exhibition with one in which artists could voice their opposition to Daley and the events that had transpired in Chicago, either directly in their work or through their participation alone.[3] Not only was Oldenburg among those who took part in the resulting *Richard J. Daley* protest show, his letter to Feigen was used as promotional material for it.

In addition to two drawings for a Chicago monument that showed Daley's head on a platter, Oldenburg contributed to the exhibition fifty small fireplugs modeled after the city's particular version of the form (he produced one hundred in total).[4] One of these, Oldenburg noted, "should be set aside to be thrown through the plate glass of the gallery window, to launch the protest exhibition."[5] In some ways, the fireplugs were in keeping with his production to date. Though the artist's practice varied widely and extended across mediums during the 1960s, it had consistently prioritized engagement with the stuff of everyday life — stuff precisely like fireplugs. In 1961, he claimed, "I am for an art that embroils itself with the everyday crap . . . an art that takes its form from the lines of life itself."[6] Moreover, Oldenburg was already actively exploring the production of multiples.[7] Yet where earlier such experiments had taken the form of, say, slices of wedding cake [FIG. 1], the fireplugs abandon the saccharine for something darker in tone. Understood by Oldenburg as holding the potential for violence — indeed as modern-day cobblestones, able to be sent soaring through the gallery window — these rough-hewn, bright red multiples conjure truncated human torsos as well, perhaps also suggesting the fire hoses turned on protesters at times throughout the decade. In his fireplugs, Oldenburg merged his recently acquired language of violent social unrest with his long-standing attention to common objects. More than that, as political turmoil became an increasingly prominent part of life in the later 1960s, it is as if it, too, came to seem part of "the everyday crap" that Oldenburg drew upon in his work. Acts of protest were newly embedded within

Claes Oldenburg

*Fireplug Souvenir —
"Chicago August 1968"*

1968
plaster and acrylic paint

FIG. 1
Claes Oldenburg and
his plaster cake slices,
Wedding Souvenir, 1966.
Photo by Dennis Hopper

"the lines of life itself," violence as commonplace as
the fireplugs on the street. In his 1967 text, "America:
War & Sex, Etc.," Oldenburg wrote, "These be evil
times. What hurt, the work must show it.... Vulgar
USA civilization now beginning to interfere my art."[8]
When the following year he experienced something
of those "evil times" firsthand, subsequent work gave
them form. KM

1 Letter from Oldenburg to Richard
Feigen dated September 5, 1968,
reprinted in Patricia Kelly, ed., *1968:
Art and Politics in Chicago* (Chicago:
DePaul University Art Museum,
2008), 7.

2 Ibid. Though Oldenburg was
born in Stockholm, he spent much
of his childhood living in Chicago.
The artist then settled in New York
in 1956.

3 For an excellent account of
conditions in Chicago at this
moment, and around Feigen's show
in particular, see Kelly, *1968: Art and
Politics in Chicago*. The statement
about the boycott claimed, "As
painters and sculptors we know that
art cannot exist where repression
and brutality are tolerated." Dan
Sullivan, "Artists Agree on Boycott of
Chicago Showings," *New York Times*,
September 5, 1968, 41.

4 Kelly, *1968: Art and Politics in
Chicago*, 16.

5 Claes Oldenburg, *Claes Oldenburg,
Constructions, Models, and Drawings*
(Chicago: Richard Feigen Gallery,
1969), n.p. This comment is particu-
larly striking given that a plate-glass
window at the Hilton had been shat-
tered by protesters' bodies during the
convention.

6 Claes Oldenburg, "I am for an
Art . . ." (May 1961; expanded 1967),
reprinted in Kristine Stiles and Peter
Selz, eds., *Theories and Documents
of Contemporary Art: A Sourcebook
of Artists' Writings,* 2nd ed. (Berkeley:
University of California Press, 2012),
386.

7 See Claes Oldenburg et al., *Claes
Oldenburg: Multiples in Retrospect
1964–1990* (New York: Rizzoli
International, 1991).

8 Claes Oldenburg, "America: War
& Sex, Etc.," *Arts* 41, no. 8 (Summer
1967): 32. In this text, he also sugges-
tively aligns his initials with "consci-
entious objector."

Barnett Newman | b. 1905, New York City | d. 1970, New York City

SIX FEET TALL AND SKELETAL, ITS VERTICAL, rectangular form a menacing perversion of the modernist grid, *Lace Curtain for Mayor Daley* may surprise viewers accustomed to Barnett Newman's monumental color-field paintings. Newman produced the Cor-ten steel and barbed wire structure in response to violent attacks on antiwar protesters at the 1968 Democratic National Convention in Chicago. While it was unusual for Newman to make an object with specific references to current events, it completely aligned with his lifelong engagement with politics and his self-description as a "artist-citizen." Until 1968 he had made art and articulated his political consciousness in separate pursuits. But for Newman and much of the art world, events came to a volatile breaking point in Chicago during the last week of August 1968.

Many disparate antiwar groups had been planning to disrupt the Chicago convention in order to capitalize on the inevitable media attention the event would attract. Mayor Richard J. Daley, who had already ruled the city for thirteen years, was determined to keep "law and order" in Chicago and accordingly had planned for the dissenters.[1] Early reports suggested that as many as 100,000 protesters would arrive in the city that August. Ultimately, due to fears of violence and infighting among groups, the number of demonstrators was approximately 10,000.[2] That was enough to cause chaos in the city. Protesters included artists, student groups, and the Yippies—the Youth International Party.[3] Fear of vandalism kept the Chicago police force on edge. In anticipation of clashes, Daley ordered Police Superintendent James Conlisk to authorize police to "shoot to kill" arsonists and "shoot to maim or

cripple" looters—a controversial strategy that permitted extraordinary force. When violence erupted and often indiscriminate police attacks were broadcast to the nation, the National Guard mobilized and contributed to the volatility.

Events in Chicago registered the vast gap between the status quo and the antiwar movement in the United States. Chicago artists and the broader art world fiercely responded with artwork and protest exhibitions. Artists in California and New York proposed a two-year art boycott of Chicago until 1970, when Daley's term was anticipated to end.[4] As news of the proposed boycott spread, Claes Oldenburg canceled his solo exhibition at Chicago's Richard Feigen Gallery, which was scheduled to open in October.[5] To galvanize local and national outrage, Feigen proposed the *Richard J. Daley* protest show in place of Oldenburg's. Ten other galleries aided by artist groups followed Feigen's lead and organized protest exhibitions.[6]

Barnett Newman watched these events unfold, and he too reconsidered his participation in a Chicago exhibition. On September 3, he wrote to Charles C. Cunningham, director of the Art Institute of Chicago, to request the removal of his work, *Gea* (1944–45), from *Dada, Surrealism, and their Heritage,* set to open October 19. Newman had frequently written letters of complaint, often to newspapers and magazines, and in this one he explained, "I do not wish to be represented in this exhibition in protest against the uncalled-for police brutality of Mayor Daley, which fills me with disgust. I cannot in good conscience do otherwise."[7]

Newman did, however, contribute *Lace Curtain for Mayor Daley* to the Feigen exhibition.[8] Although Newman included steel loops at the top of the large metal frame so it could be suspended over the gallery floor, Feigen placed it on raw cinder blocks in the center of the gallery. There it confronted viewers authoritatively, its red paint-spattered barbed wire

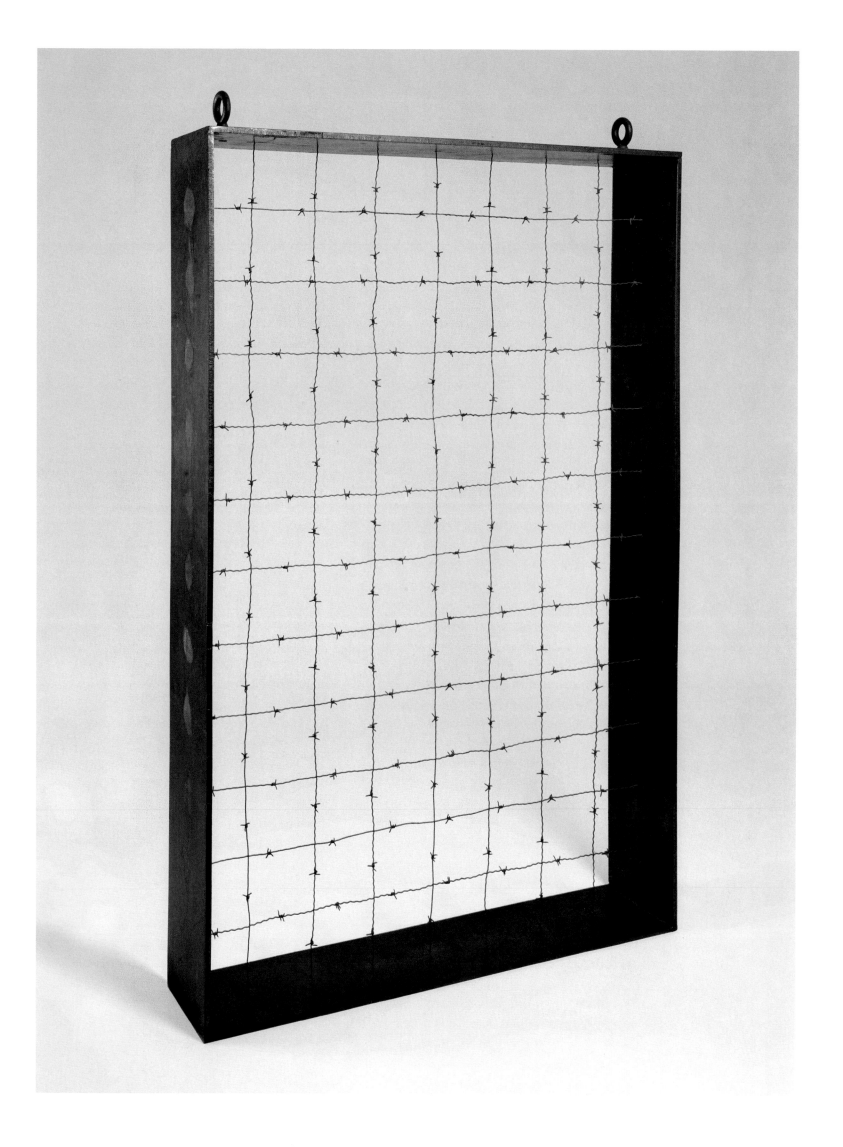

Barnett Newman

Lace Curtain for Mayor Daley

1968
Cor-ten steel, galvanized barbed wire, and enamel paint

menacing its audience as it mimicked the obscene barriers adhered to the front of army jeeps for crowd control during the street demonstrations [FIG. 1]. The title dug at Daley's Irish heritage in retort to the mayor's anti-Semitic heckling of Senator Abraham Ribicoff as he spoke at the convention, chiding Daley for "Gestapo tactics."[9] "Lace-curtain Irish" was a nasty slur in Daley's working-class neighborhood of Bridgeport and was intended to denigrate someone who tried to mask a modest background with superficial signs of finery. Newman's implication was that Daley's attempt to rise on the national scene could not conceal an underlying contempt for Chicago's citizens. His use of this demeaning phrase also brought the fight to Daley's vicious level.

Lace Curtain for Mayor Daley wove many threads of Newman's career together unexpectedly in a sculpture, a medium for which he was not well known. Its form brought his devotion to meaningfully conceived abstraction to bear on politics and events outside of art. The work also adopted a point of view he had articulated as a candidate for New York mayor in 1933 in which he expressed a distrust and even fear of career politicians. He wrote, "It is humanity's tragedy that today its leaders are either sullen materialists

or maniacs who express the psychology of the mob mind."[10] In the events of 1968, Newman found a way to critique and satirize a political mentality he reviled from an early age. As *Lace Curtain for Mayor Daley* also reveals, late in his career, Newman had the capacity to surprise and to tap into the culture of a volatile world. RC

1 The best account of the events leading up to the convention and of its aftermath appears in David Farber, *Chicago '68* (Chicago: University of Chicago Press, 1994).

2 Terry Anderson, *The Movement and the Sixties: Protest in America from Greensboro to Wounded Knee* (Oxford: Oxford University Press, 1995), 215–20.

3 The Yippies were among the more colorful protest groups, theatrical in nature and prone to absurd, comedic street actions that drew attention to what they viewed as the outrageousness of the war. At the convention they famously nominated Pigasus for the Democratic ticket—an actual pig whose opinion of the war (or interest in the nomination) was never recorded.

4 Dan Sullivan, "Artists Agree on Boycott of Chicago Showings," *New York Times,* September 5, 1968. Daley was mayor until his death in 1976; the boycott did not hold, as artists recognized that limiting their voice in their city would ultimately be counterproductive.

5 Claes Oldenburg to Richard Feigen, September 5, 1968. Reprinted in "Artists vs. Mayor Daley," *Newsweek,* November 4, 1968, 117. Oldenburg had spent important formative years in Chicago as an art student and then as a reporter for the Chicago News Bureau.

6 There was a strong activist community in Chicago that included artists. They had organized protest exhibitions against President Lyndon Johnson, most notably one held at Richard Gray Gallery in February 1967. For the complete list, see Patricia Kelly, ed., *1968: Art and Politics in Chicago* (Chicago: DePaul University Art Gallery, 2008), 26. This volume contains an invaluable survey of Chicago artists' responses to the convention.

7 Barnett Newman to Charles C. Cunningham, September 3, 1968. Reprinted in John P. O'Neill, ed., *Barnett Newman: Selected Writings and Interviews* (Berkeley: University of California Press, 1992), 43.

8 Newman planned a second, unrealized piece called Mayor Daley's Outhouse. Melissa Ho, "Chronology," in *Barnett Newman,* ed. Ann Temkin (Philadelphia: Philadelphia Museum of Art, 2002), 333.

9 Daley's reaction was seen by 8 million television viewers in real time as he reportedly said, "Fuck you, you Jew son of a bitch. You lousy motherfucker, go home." See David Burner, *Making Peace with the 60s* (Princeton, NJ: Princeton University Press, 1996), 213.

10 For Newman's full platform, with friend Alexander Borodulin, see "On the Need for Political Action by Men of Culture," in O'Neill, *Barnett Newman,* 4–8.

FIG. 1
Military police jeeps covered in barbed wire during the 1968 Democratic National Convention.
Photo by Charles Roland

PLATES AND ENTRIES

Emile de Antonio
releases his film *In the Year of the Pig*

James Gong Fu Dong
creates *Vietnam Scoreboard*

Rosemarie Castoro
creates *A Day in the Life of a
Conscientious Objector*

Claes Oldenburg
creates *Lipstick (Ascending) on
Caterpillar Tracks* and places it on the
Yale University campus in May

Faith Ringgold
paints *Flag for the Moon: Die Nigger*

Douglas Huebler
creates *Location Piece #13* after attending
the Moratorium March on Washington
in November

Carlos Irizarry
creates *Moratorium*

Hans Haacke
creates *News*

The Guerrilla Art Action Group
issues *A Call for the Immediate Resignation
of All the Rockefellers from the Board of
Trustees of the Museum of Modern Art*,
disrupting the museum's lobby with their
Blood Bath performance on November 18

Yoko Ono and John Lennon
create *WAR IS OVER!* Their posters and
billboards appear in cities worldwide
shortly before Christmas

1969

FIG. c21 Soldiers carry a stretcher during the Battle of Hamburger Hill, 1969.

FIG. c22 *Life Magazine*'s essay "One Week's Dead" lists the 242 Americans who died in the war during one week, 1969.

The Art Workers' Coalition forms in **JANUARY**. A loose confederacy of New York artists, writers, filmmakers, and other culture workers, the activist group focuses on artists' rights issues but also organizes protests against the war.

In **MARCH**, President Nixon secretly orders the bombing of North Vietnamese sanctuaries in Cambodia, an officially neutral country. This is intended to signal to Hà Nội Nixon's willingness to take more extreme measures than his predecessor and to force concessions from the North Vietnamese. The classified bombing of Cambodia will continue until August 1973.

In **APRIL**, the number of U.S. troops in Vietnam reaches 543,400, the peak level of the war.

In **MAY**, ARVN and U.S. forces lose more than one hundred men while capturing a hill heavily fortified by PAVN at Dong Ap Bia (Đồi A Bia in Vietnamese), only to abandon it soon after. The Battle of Hamburger Hill [FIG. c21], marred by heavy American losses for no sustained purpose, causes disaffection among U.S. troops and controversy in the United States.

On **JUNE 27**, *Life Magazine* publishes the article "Vietnam: One Week's Dead," featuring the names and portraits of 242 U.S. soldiers [FIG. c22]. Due to its timing, the photo spread inadvertently leads many readers to believe that all of those depicted were lost during the fighting at Hamburger Hill.

FIG. c23 Moratorium Day in Central Park, New York, 1969. Photo by J. Spencer Jones

Pursuing his plan of "Vietnamization"—the effort to reduce U.S. troop levels while building up the South Vietnamese military—President Nixon announces on **JUNE 8** that American soldiers will begin withdrawing from South Vietnam in **JULY**.

On **JULY 20**, millions of television viewers watch as American astronaut Neil Armstrong becomes the first person to walk on the moon.

On **SEPTEMBER 2**, Hồ Chí Minh dies of heart disease at age 79.

As many as two million people participate in the Moratorium to End the War in Vietnam, attending massive demonstrations and teach-ins across the country on **OCTOBER 15** [FIG. c23]. A month later, about half a million people participate in the Moratorium March on Washington.

President Nixon addresses the nation on television on **NOVEMBER 3**, appealing to the "great, silent majority" to support his war policies. "North Vietnam cannot defeat or humiliate the United States. Only Americans can do that."

Reported by the independent investigative journalist Seymour Hersh, news of the rape, murder, and mutilation of hundreds of Vietnamese civilians at Sơn Mỹ (My Lai) the prior year breaks in the United States in **NOVEMBER**. This is the most serious U.S. atrocity exposed during the war.

On **NOVEMBER 26**, President Nixon signs an amendment to the Military Selective Service Act that reinstates random selection for military conscription. On **DECEMBER 1**, the first draft lottery held since the Second World War takes place, establishing the draft priority for all men born from 1944 to 1950.

Peace talks in Paris remain deadlocked.

Emile de Antonio | b. 1919, Scranton, PA | d. 1989, New York City

IN EMILE DE ANTONIO'S FEATURE-LENGTH documentary *In the Year of the Pig*, Lyndon Johnson appears speaking at the presidential podium: "Every day someone jumps up and shouts and says, 'Tell us what is happening in Vietnam, and why are we in Vietnam, and how did you get us into Vietnam?'" Taking a pause, he leans forward and says, "I didn't get you into Vietnam. You've been in Vietnam ten years." Released in 1968, *In the Year of the Pig* addresses exactly this lacuna in public understanding. The United States had indeed intervened in events in Vietnam since at least the early 1950s; yet to most Americans, the origins of the ongoing conflict remained vague and difficult to understand. With no decisive outbreak of hostilities or official declaration of war, America had seemed to slide, inexorably, into a bloody struggle it now found impossible to escape. In her review of *In the Year of the Pig*, Pauline Kael observed that television coverage of the war offered "constant horror but no clear idea of how each day's events fitted in.... [We] feel helpless to understand the war; we want to end it, and the fact that we can't demoralizes us." De Antonio's film, she said, "does what American television has failed to do. It provides a historical background and puts the events of the last few years into an intelligible framework."[1] By demonstrating when and why the U.S. government decided to pursue war in Vietnam, de Antonio sought to convince the American public that they could likewise decide to end it.

In the Year of the Pig was born of de Antonio's "anger, outrage, and passion."[2] Yet this deeply polemical work does not, as one might expect, dwell on images of wartime suffering and death. A fiercely independent leftist filmmaker, de Antonio took seriously the need to build historical consciousness about Vietnam. He was frustrated by documentaries that condemned the war through bald emotional appeal rather than political intelligence—films that concerned themselves more with dead bodies than with facts. The working title for his film was *The Wars in Viet Nam*, a phrase that emphasizes the continuity between France's war in Indochina, the Cold War, and the U.S. war in Vietnam. Speaking in 1969, de Antonio insisted, "Vietnam exists in history. All other films on Vietnam leave that out. They may have more passion, more emotion. But I am interested in the political theories, in the mass of facts."[3] More than half of *In the Year of the Pig* is dedicated to subjects that predate President Johnson's 1965 escalation of the war. It touches on the French colonial enterprise, the early life of Hồ Chí Minh, the Japanese occupation of Vietnam, the Việt Minh victory at Điện Biên Phủ, the undermining of the Geneva Accords and support for Ngô Đình Diệm by the United States, and the circumstances behind the passage of the Gulf of Tonkin Resolution. The remainder of the film covers U.S. military tactics in Vietnam, the South Vietnamese presidential election of 1967, and observations shared by Western journalists and activists who had recently visited North Vietnam.

Throughout, de Antonio used a complex montage of found film and original interviews to lay bare what he saw as the dishonesty and irrationality of American policy in Vietnam. Drawing on newsreels, press conferences, and other footage of political and military leaders, de Antonio juxtaposes the official U.S. narrative of the war with assessments offered by scholars and journalists, as well as firsthand participants, such as diplomats, soldiers, and intelligence officers. Eschewing the use of voice-over—which he considered "hollow" and inauthentic—de Antonio challenges viewers to assess for themselves the informants and evidence on offer.[4] The testimony of ordinary American servicemen is, for example, pointedly

Emile de Antonio

In the Year of the Pig

1968
35mm film, black and white,
sound, 103 minutes

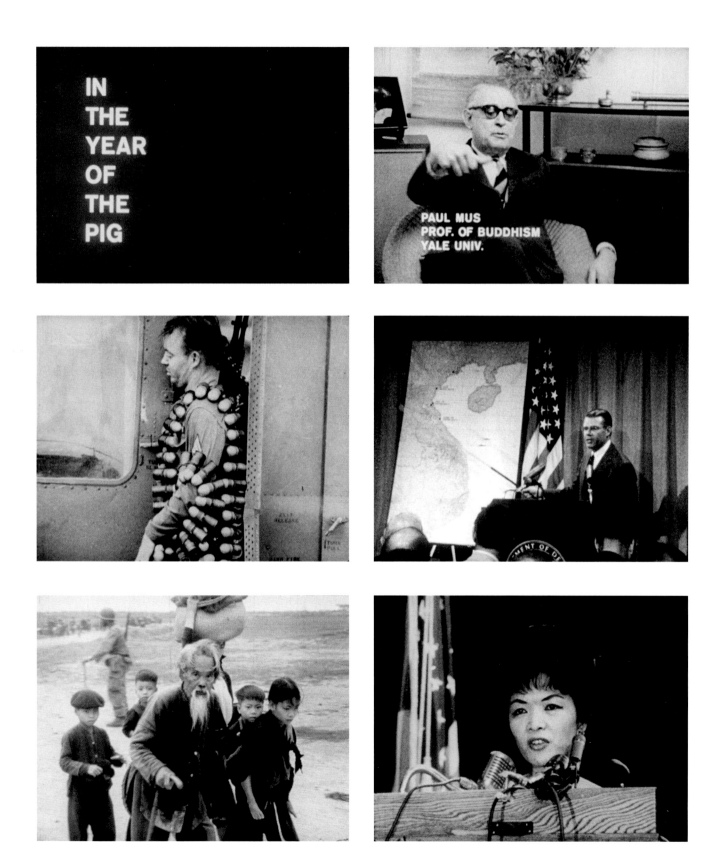

contrasted with that of their leaders regarding such disputed events as the alleged attacks against U.S. ships in the Gulf of Tonkin in August 1964. The film makes considerable demands on the audience's attention and critical powers. Its structure is not straightforwardly linear, images often appear unidentified and in isolation, and the near constant flow of spoken testimony is at times difficult to parse. This stream of conflicting images and voices demands hard work from the viewer and calls attention to the constructed nature of filmic meaning—and of historical understanding.

A tireless researcher, de Antonio considered it his responsibility as a documentary filmmaker to be honest and factual but not neutral. He recalled with satisfaction that when he screened *In the Year of the Pig* for a group of experts on Southeast Asia, "these scholars could not detect in my film a lie…nobody could see anything untruthful, even those who defend the U.S. position could not say you doctored the evidence."[5] At the same time, he was frank about

approaching all of his films from a "consciously left" point of view.[6] He considered objectivity a false goal for filmmaking: "Film, tape, the camera, the recorder and the [M]oviola on which film is edited are neutral—when not in use. They are neutral like a gun."[7] As Kael noted, *In the Year of the Pig* presents Hồ Chí Minh and the Vietnamese people simplistically and heroically, while highlighting U.S. leaders in such a way that "emotionally feeds our current [American] self-hatred." She conceded that casually racist comments by U.S. generals about an enemy "willing to die readily, as all Orientals are" makes it "easy for de Antonio to build his case."[8]

The son of Italian and Lithuanian immigrants and a veteran of the Second World War, de Antonio disagreed with the perception that he was anti-American: "I like this country, and if I didn't, I'd go somewhere else. I'm an American. This is my space and that's why I want to change it."[9] Easily overlooked, the very first image in *In the Year of the Pig* is of words carved into the stone base of a sculpture of the Marquis de Lafayette, the French general who fought on the side of the rebels during the American Revolution: "As soon as I heard of American independence my heart was enlisted in its cause / 1776."[10] This allusion to the revolutionary origins of the United States—at a time when many argued the country had adopted the role of colonizer in Vietnam—passes without explicit commentary or explanation. So do subsequent wordless shots of monuments dedicated to soldiers who fought for the Union in the American Civil War, a cause de Antonio considered just.[11] "The images were chosen because of my emotional response to them," he commented, "each one belongs morally and intellectually."[12] He tips his hand further at the very end of *In the Year of the Pig*, when the soundtrack explodes with "The Battle Hymn of the Republic" played on traditional Vietnamese instruments. De Antonio heard the cause of independence and enlisted his heart in it—though its tune now emanated from Vietnam, not the United States. **MH**

1 Pauline Kael, "Blood and Snow" (1969), reprinted in *Emile de Antonio: A Reader*, ed. Douglas Kellner and Dan Streible (Minneapolis: University of Minnesota Press, 2000), 201–2.

2 De Antonio, quoted in Gary Crowdus and Dan Georgakas, "History Is the Theme of All My Films: An Interview with Emile de Antonio," *Cinéaste* 12, no. 2 (1982): 21.

3 De Antonio, quoted in Jonas Mekas, "Movie Journal (1969)," in *Emile de Antonio: A Reader*, 221.

4 In a 1971 interview with Bernard Weiner, de Antonio discussed his use of firsthand informants in the film: "What I'm doing is presenting the real authorities rather than a hollow voice like [Walter] Cronkite. Cronkite, like most narrators, reads what writers write. That's a little disembodied for me and removed from fact, news, documentary. I'm looking for the integral fact in which the man who says it is the man who wrote it, thought it,

believed it, experienced it." Bernard Weiner, "Radical Scavenging: An Interview with Emile de Antonio," *Film Quarterly* 25, no. 1 (1971): 12.

5 De Antonio, quoted in Lil Picard, "Inter/view with Emile de Antonio" (1969), reprinted in *Emile de Antonio: A Reader*, 214.

6 De Antonio, quoted in Crowdus and Georgakas, "History Is the Theme of All My Films," 21.

7 Emile de Antonio, "Liner Notes for *Rush to Judgement* LP," in *Emile de Antonio: A Reader*, 193.

8 This comment by General Mark Clark appears in *In the Year of the Pig* and was quoted by Kael in her review of the film, "Blood and Snow" (1969), in *Emile de Antonio: A Reader*, 203–4.

9 De Antonio, quoted in Crowdus and Georgakas, "History Is the Theme of All My Films," 28.

10 The portrait of Lafayette was sculpted by Frédéric Auguste Bartholdi (1834–1904), who also created the Statue of Liberty [p. 76]. It is located in New York City's Union Square Park, near de Antonio's former studio.

11 "The [statue of a] soldier at the beginning and the end [of *In the Year of the Pig*] was an infantry private in the 163rd Pennsylvania Infantry during the Civil War, a just war. I was once a soldier in what I believed was a just war." Emile de Antonio, written response to Nell Brickman's students in Berlin (1988), 10, Emile de Antonio Papers, University of Wisconsin, Madison.

12 Ibid.

James Gong Fu Dong | b. 1949, San Francisco, CA

JAMES GONG FU DONG'S *VIETNAM SCOREBOARD* is imbued with the artist's lived experience and history as a Chinese American. To many in the United States, the fighting in South Vietnam might have been taking place on another planet, so unrecognizable to them were the lives of Vietnamese people. But for Americans with roots in Asia, the war felt much closer to home. Dong, for one, was well aware that his country was engaged in a war against poor people who "look like me"—a point driven home each time the same racist language used to denigrate the Vietnamese enemy was directed at him on the streets of San Francisco by fellow Americans.[1] *Vietnam Scoreboard* was an effort to elucidate the lived connections between "us" and "them" and to personalize the war's dehumanizing rhetoric of body counts.

In a brightly colored palette reminiscent of advertising or pop art, the print draws on imagery intimately connected to the artist. On the left is a formal photograph of Dong's paternal grandmother, uncle, aunt, and cousins in China. The portrait is made strange by being contrast-reversed, with its shadows appearing as bright yellow and its highlights flat black. Juxtaposed on the right is another photographic image, this one borrowed from an old magazine. It shows a smiling American pilot posing proudly in his cockpit. It takes a moment to realize that the scoreboard of the work's title refers to the victory marks on the side of the pilot's plane. These echo the silhouetted form of Dong's family— a portrait of real people converted into a symbol of achieved kills.

The first in his family to be born in the United States, Dong was raised in what he has described as the "small village" of the Ping Yuen housing projects of San Francisco's Chinatown. He recalled arriving at kindergarten speaking only Toishanese (a southern Chinese language) and quickly coming to understand that "if you don't speak English, don't speak at all"—so he sat silently at the back of the classroom and made drawings. Although Dong soon became fluent in English, art remained his preferred means of speaking out.[2] Such was the case during the Vietnam War, an event that spurred the emergence of Asian American consciousness among a generation and prompted from Dong a pointed artistic response to what he viewed as his country's destructive imperialist mind-set.

Dong was still an undergraduate when he created *Vietnam Scoreboard*.[3] He had entered San Francisco State College (now San Francisco State University) in 1967, a moment of intense political ferment on campus, with a multicultural student body raising its voice against both the war and the systemic Eurocentric bias in higher education. A season of picketing, sit-ins, and other protests climaxed in late 1968 with the advent of what would become the longest student strike in U.S. history. Led by a coalition of student groups known as the Third World Liberation Front, as well as the Black Student Union, the strike persisted until March 1969, when the college agreed to establish a School of Ethnic Studies—the country's first[4]—and to expand its program in Black Studies. Dong was a participant in these heady events and remembers the strike as a period of unprecedented political cohesion among his black, Latino, Native, and Asian peers. Many American students of color also felt a rising sense of solidarity with the struggle of oppressed and colonized people worldwide.

Dong had begun college originally intending to study math or engineering but shifted quickly to industrial arts and, soon after that, to fine art. He migrated to this department in part because he found there a community that shared his opposition to the

James Gong Fu Dong

Vietnam Scoreboard

1969
embossed etching

war in Vietnam. Although Dong's immigrant father had worked in a supply role for the legendary Flying Tigers unit, which fought against the Japanese air force during the Second World War[5]—Dong did not consider volunteering for the U.S. armed forces and considered himself lucky when he drew a sufficiently high lottery number to avoid being inducted by draft.[6] Among Dong's instructors at San Francisco State was Rupert García [pp. 191–93], a recent graduate and veteran of the war in Southeast Asia, who became a friend and sometime collaborator. Like García and others in the Chicano art movement, Dong considered art a tool for social activism and consciousness raising and turned to printmaking as a means of shaping perspectives on the U.S. war in Vietnam.

As an artist, educator, and community activist, Dong continued to promote social justice and to affirm the experiences of Asians in the United States through his work. In 1972, with Lora Foo and Michael Chin, Dong launched the Kearny Street Workshop. Originally situated beneath the International Hotel

in San Francisco's Manilatown,[7] Kearny Street was founded as a community-based art center and cultural incubator, serving its predominantly Filipino and Chinese American neighborhood through workshops, exhibitions, and mural projects. Like the Galería de la Raza—created in the Mission District by Chicano activists in 1970 as a cultural center for Latino artists and audiences—Kearny Street Workshop continues today, a living legacy of the artistic activism born during the Vietnam War era. MH

1 James Gong Fu Dong, interview with Melissa Ho, November 17, 2017.

2 Ibid.

3 *Vietnam Scoreboard* was first displayed in 1971 in an exhibition of James Gong Fu Dong's work, *A Question of Surrealism,* at the San Francisco Museum of Modern Art. The same year, it was also seen in New York in *The Artist as Adversary* at the Museum of Modern Art. See Betsy B. Jones, *The Artist as Adversary* (New York: Museum of Modern Art, 1971).

4 San Francisco State University's College of Ethnic Studies (born the School of Ethnic Studies in 1969) remains the country's only such freestanding liberal arts college within a university at the time of this writing. When founded, it consisted of four departments: American Indian Studies, Asian American Studies, Black Studies, and La Raza Studies. It currently consists of five departments—Africana Studies, American Indian Studies, Asian American Studies, Latina/Latino Studies, and Race and Resistance Studies—and enrolls more than 8,000 students per semester. My thanks to Kenneth P. Monteiro, acting director of the César E. Chávez Institute, College of Ethnic Studies at San Franciso State

University, for sharing information on the history of the college. See San Francisco State University, College of Ethnic Studies, History, accessed October 17, 2018, http://ethnicstudies. sfsu.edu/home2.

5 The Flying Tigers was a volunteer unit of American pilots who went into combat in Asia against the Japanese air force in 1941 and 1942. According to Dong, his father, Stanley Suey Wah Dong, an immigrant then living in New York, volunteered for service with the Flying Tigers, service which helped him gain amnesty to settle permanently in the United States.

6 Dong, interview with Ho.

7 The I-Hotel, as it was known, was a single-occupancy residency hotel, home to mainly elderly, low-income Filipino and Chinese American men. The owner sought to demolish the building beginning in the late 1960s, leading to a protracted struggle against eviction that ended when the last tenants were forced to leave in 1977. Kearny Street Workshop was one of many activist groups that rallied to the cause of the I-Hotel residents. The fight for the I-Hotel is now regarded as a seminal event in the Asian American struggle for civil rights and self-determination.

Rosemarie Castoro | b. 1939, New York City | d. 2015, New York City

ON TWENTY-FOUR DIFFERENT DAYS BETWEEN February 23 and March 27, 1969, Rosemarie Castoro spent one hour composing a poem. Each one is hand-printed on a separate sheet of graph paper in careful, variously colored block capitals. She marked the lower right of each poem with the date of its composition, revealing the temporality of her endeavor. She also added to that corner "hour #1" to "hour #24" to indicate when she'd written the poem, with each successive work begun one hour later than the previous one; it is thus suggested that together the poems track the unfolding of a day. The viewer may well expect the day replayed across the poems to tell the story of the single conscientious objector featured in the work's title. However, as James Meyer has pointed out, Castoro instead offers a range of perspectives occupied by men of draft age in 1969: draft dodger, fighting soldier, radical.[1]

The work was first shown in May 1969 at the Dwan Gallery's *Language III* exhibition in New York, one in a series of shows that contributed to the rise of conceptualism. On this occasion, Castoro framed each of the poems and displayed them alongside a slideshow that moved through their images; at a later date, she gave a reading of her poems as part of a performance.[2] Such different forms of presentation underscore the distinct viewpoints on service provided by the work—all equally available and viable at the moment of its creation.

A Day in the Life of a Conscientious Objector is in keeping with the breadth and variety of Castoro's work during the 1960s. Building on early experiments in dance and training in the graphic arts, Castoro, by the middle of the decade, was an active practitioner of minimalism with an output centered around painting and drawing. The late 1960s then saw her turn to performance, conceptualism, and the sort of concrete poetry at work in *A Day.*[3] Castoro was also actively involved with the Art Workers' Coalition—delivering a speech at the April 1969 Open Hearing—and she was one of two women to contribute to *Artforum*'s 1970 "Artist and Politics" symposium. In both venues, she stressed the economic hurdles faced by artists ("It's all a matter of economics, not politics").[4] Though not known for overtly political work, in *A Day* she joins her activist impulses with her manifold material explorations to highlight the complexities of military service in 1969.

Critic Lucy Lippard characterized the artist's work in 1975 by writing that its "major impetus is kinesthetic" and that it is about a "fine bond between mind and body."[5] This is palpable in the task-like language Castoro deploys throughout the work's poems: "TUMBLE/CHASE/ROLL/FLOP OVER," reads "Hour #22," for instance. Redolent of conceptualist instructions or Richard Serra's *Verb List* (1967–68), Castoro's poems are ultimately more akin to the lists Yvonne Rainer would make in preparation for her dance *WAR* the next year [p. 200] in their seeming connection to conflict.[6] More specifically, the poems outline different paths available to those confronted with the Selective Service: "HEAVE PUSH/COVER COMRADE" or "SIGN HERE/EMERGE BURDENED," for the deployed soldier or recent enlistee; "OPEN WARDROBE/SELECT DISGUISE" or "PASSWORD MENTION," for the figure evading the draft; "BREAK INTO/LEAVE BOMB," for the radicalized operative.[7] It is as if Castoro furnishes the script each figure might follow as he stages his own performance in relation to the war.

That these roles are ongoing parts is suggested by the temporality of the work. The way poetry, as such, exists in time is underscored by the clock-like rhythm of the projector. Equally important in this regard is the graphic quality of the poems: echoing

Rosemarie Castoro

*A Day in the Life of a
Conscientious Objector*

1969
digital projection

the sensitivity to line informing her earlier hard-edge abstractions, Castoro's disposition of verse suggests forward movement through space and time. And, of course, the artist both takes up "a day" as her ostensible medium and flags the duration of her own work on the project. *A Day* thus offers a sense of how these different voices weave together to make up any one twenty-four-hour period in the spring of 1969, as it also reveals Castoro's own ongoing reflection on such a day's constitutive perspectives. The proliferating "AGAIN"s of "Hour #20" appear to register the relentless repetition of the situations at play in her poems.

Roughly one-third of those who fought in the war in Vietnam were drafted, and the draft, along with its inherent inequities across racial and economic lines, was one of the hottest issues among antiwar protesters, prompting major draft reform just months after Castoro created her piece. Significantly, the issue of the draft was also one from which women in opposition to the war stood at a necessary remove. Yet with her work Castoro finds power in her guaranteed exemption from battle. Free from having to occupy any single position, she is instead able to show empathy for multiple points of view and, consequently, facilitate meditation on the fault lines surrounding engagement with the war. **KM**

1 For an incisive account of the work's operations, and one that has crucially informed this text, see James Meyer, "The Art Gallery in an Era of Mobility," in *Los Angeles to New York: Dwan Gallery, 1959–71* (Chicago: University of Chicago Press, 2016), 80–81.

2 Ibid., 81. *A Day in the Life* has also been exhibited as framed poems, a slideshow, and an audio recording of the poems being read.

3 For an account of the artist's diverse practice, see Tanya Barson et al., *Rosemarie Castoro: Focus at Infinity* (Barcelona: MACBA, 2018). See also Prudence Peiffer, "Portfolio," *Artforum* 54, no. 7 (March 2016): 220–33.

4 The Open Hearing was formally called "An Open Public Hearing on the Subject: What Should Be the Program of the Art Workers Regarding Museum Reform and to Establish the Program of an Open Art Workers' Coalition." Castoro's statement can be found in Dario Corbeira, ed., *The Art Workers' Coalition* (Madrid: Brumaria, 2010), 387–88. Also see Rosemarie Castoro, "The Artist and Politics: A Symposium," *Artforum* 9, no. 1 (September 1970): 36.

5 Lucy Lippard, "Rosemarie Castoro: Working Out," *Artforum* 13, no. 10 (Summer 1975): 60.

6 Castoro had on occasion performed in Rainer's works during the 1960s.

7 See Meyer, "The Art Gallery in an Era of Mobility," 80–81.

Claes Oldenburg | b. 1929, Stockholm, Sweden

IN A 1969 EXCHANGE WITH STUART WREDE,
an architecture student at Yale University, the philosopher Herbert Marcuse claimed that the erection of a monument by Claes Oldenburg "would be one of the most bloodless means to achieve a radical change." The successful realization of such a monument, the philosopher reasoned, was so unthinkable under current conditions that, were one to appear suddenly overnight, it would signal the end of society as it stood and the advent of the revolution.[1] Soon after this conversation, Wrede, along with others from his cohort, set out to test Marcuse's proposition.[2] Working without permission from the university administration, the group—deeming themselves the Colossal Keepsake Corporation—commissioned Oldenburg, a renowned alumnus, to create on campus what would be his first "feasible" monument: *Lipstick (Ascending) on Caterpillar Tracks*.[3]

At twenty-four-feet tall and 3,500 pounds, *Lipstick* consisted of constructed caterpillar tracks—produced first in cardboard and then remade by students in

FIG. 1
Claes Oldenburg's *Lipstick (Ascending) on Caterpillar Tracks* being transported by truck to the Yale University campus, 1969. Photo by Shunk-Kender

wood coated with epoxy—atop of which rested a monumental vinyl lipstick that was meant to be inflatable. Oldenburg claimed the work need not be read through the lens of war, but this possibility nevertheless immediately presents itself: the tracks are undoubtedly tank-like in appearance, and the reddish-orange lipstick conjures thoughts of missiles.[4] And though the fighting in Vietnam was not primarily tank warfare, that conflict and the unrest surrounding it seem crucial touchstones for the project. As Barbara Rose observed soon after the work's completion, the lipstick's phallic quality suggests the sort of link between the erotic and the militant that informed current critiques of the war.[5] Moreover, the convoy of oversized trucks that transported the monument to campus [FIG. 1] served as a ludic answer to less gentle signs of force that were contemporaneously appearing in response to protests on campuses.[6] Unsanctioned by the powers that be at Yale, the very placement of the monument in Beinecke Plaza was something of a guerrilla mission, the students' tactics echoing those made familiar abroad. Rose wrote of the students, "Barred from taking over the Pentagon, they invade their own campuses hoping that, if they cannot control American politics, at least they can control their own lives."[7] The idea that they could take over and transform space through a sculptural intervention was empowering for a younger generation faced with an unstable world.

That potential transformation was bound up with a type of collective action valued anew in the Vietnam era. Like its commissioning and transportation, the monument's May 15 installation on the plaza called forth a group effort from Corporation members as they tried to inflate the lipstick. In addition, a crowd of more than two hundred came together to bear witness to the work's placement, with cheers breaking out as assembly was completed.[8] This sort of gathering had been spurred, perhaps, by a *Special "Colossal Monument" Issue* of

Claes Oldenburg

Lipstick (Ascending)
on Caterpillar Tracks

1969
steel, wood, vinyl (later
replaced with aluminum),
and enamel

**Published by
students of the
Yale University
School of Art
and Architecture**

Novum Organum,
No. 7: Special "Colossal
Monument" Issue

May 15, 1969

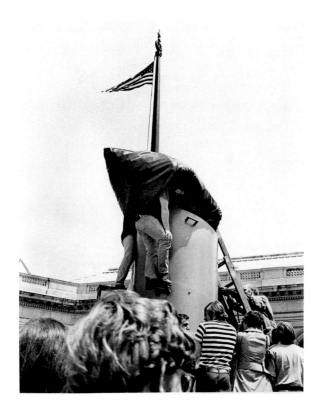

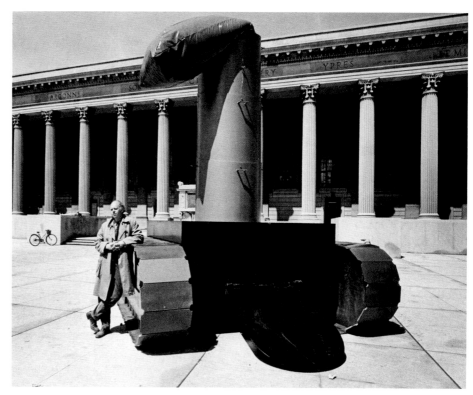

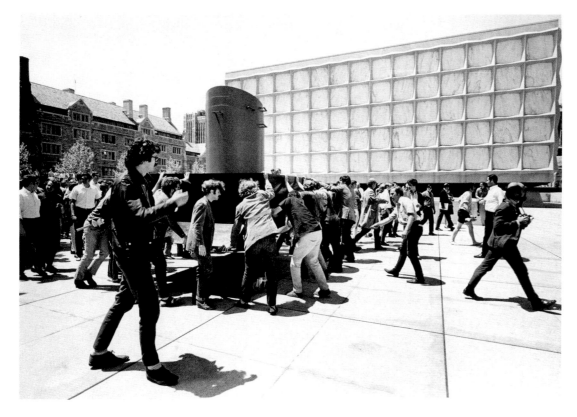

OLDENBURG'S REALISM

A number of students, faculty, alumni, and friends of Yale have invited Claes Oldenburg, one of its brightest alumni, to design a monument for the University. We are fortunate that he has consented to do so.

Yale is dedicated to the encouragement and preservation of the arts, and Oldenburg's monuments have done a number of things to sculpture that had to be done to it if it was going to remain an art. The problem was this:

Sculpture is the most physical of the arts. It is a body in space. In the past, all the greatest ages for sculpture have come when people thought of that body as real. It wasn't simply a projection of you or me. It was a creature itself, separate from us. It didn't "represent" it was. Therefore it might act; it might move. We had to watch out for that. It was immanent with the potency of action. The Kouroi stood upright on their legs. Their static firmness convinced us of their ability to stand, their structural articulation of their potential to movement. They are still real in the museums, because they were never really dependent upon an environment: sculpture challenges environments, as the act always does. When it is integrated with its environment it is less, though maybe still beautiful as part of architecture. Medieval sculpture is like that; its action is subordinate to the overall law of society which it wholly respects because its whole being comes from it. Renaissance sculpture fights to stand free, struggles in a conflict between contradictory modern impulses toward free act and perfect environment. Eventually it gives up (Michaelangelo) and integrates itself into a theatrical play with the environment as a whole (the Baroque). So act became theater. It settled for a pretended freedom in a world which was totally ordered in fact.

In the nineteenth century, sculpture became all painting; act and environment merged in flux and historical change and illusion. Nobody believed that a hunk of matter could be real. They were emancipated positivists and knew better, unlike those lesser breeds, whose work they arranged in ethnological museums. Until artists (men with the eyes of children and easily frightened) perceived that they were real. At the same time they saw that Greek sculpture had been real too. So they found a new humanism for a while (Maillol, Picasso, Lipchitz, Brancusi). They recognized that all acts are splendid terrible, and lonely, and so became existentialists, which was just yesterday. But how long could that last? It is already dead, because: 1) we couldn't believe for long that sculpture as a creature was really real, and 2) we are now profoundly distrustful of all pretensions to heroic action, having seen to what horrors of criminality such poses can lead us. The act has lost its innocence in America forever.

Hence Oldenburg: how many of the dilemmas he has resolved. A) sculpture is body, not space, not environment: he pinned that down first, with a project in which a mass of concrete wholly filled and blocked a busy intersection in New York. B) sculpture is separate from us, not a projection of ourselves, but dangerous: try dialling on his soft telephone; how loathsome a bite of his squashy hamburger. C) Sculpture is immanent with action: the gear shift for Trafalgar Square, the toilet floats rising and falling with the tide on the Thames.

With these and Oldenburg's other colossal monuments we come to the heart of the matter in two ways. Their size says that sculpture really does get in our way, and does force us to recognize a being other than ourselves. Their guise (disguise) of everyday mechanical objects avoids the anomaly of trying to induce us rationalists, to give in to the reality of sculpture as creature. We can accept the Thing as really a gear shift because it looks like one. So, it might move, or be moved by us, suddenly giants, or, awful thought, the playthings of giants. Hence, tricking our skepticism Oldenburg engages both our sense of action and our irony. Silly, isn't it, we can say, but awfully big, looming like the sun (toilet floats) or like a building falling (Popsicle for Pan Am) or like--it is, it is--a great ship going down (Ore boat for Chicago) or like a rocket to Mars, a mechanized coed, of just the Beinecke's natural complement on the dressing table, a colossal keepsake (lipstick for Yale).

It all shakes us up makes us laugh, and catches us thereby. Most of all, it permits us no heroics, which would sicken us soon. So arrives Oldenburg's only creature so far: his Teddy Bear for Central Park. A dolly. It is probably the wisest image of all, because it has to do with what we knew was real when we were children, before a fouled-up world gave us weird objectives and put twisted justifications in our brains. It is more awesome, the Teddy Bear, than all the emperors on horseback. So weak their reality compared to his, so tentative our concomitant reactions of admiration, resentment, respect, or envy in comparison with the terrible embrace of total love we now, awake, remember.

Vincent Scully

"

...The concept of "art" sounds fairly innocent. But as soon as one asks oneself how it is used and what it covers, it begins to loose its ingenuity. There is a high art, we are told, and we assume, inevitably, a low one. Whether explicit or implicit, such an elitish gesture of exclusion carries latent and blatant political (in the broadest and narrowest sense) implications: art is for an aristocracy, for those who claim to possess "taste", the connoisseurs, the happy few. Any form of art which does not conform to the criteria of this self-appointed elite is automatically rejected as "vulgar" (as everyone knows: which belongs to the mob, to the people)... ... When the word "vulgar" becomes laudatory, we'll know a revolution has taken place. But the hardest problem is that, in order to make this revolution permanent, scandal must be maintained at its highest degree of virulence. Only then, will it avoid being institutionalized...

Jacques Ehrmann

"

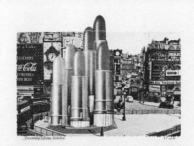

MASSED LIPSTICKS TO REPLACE FOUNTAIN OF EROS, PICADILLY CIRCUS, 1966

DEED OF GIFT

Know ye, all men, by these presents

that the Colossal Keepsake Corporation, a Connecticut corporation, for itself, its successors and assigns, hereby gives, conveys and transfers unto Yale University, a specially chartered Connecticut corporation, all its right title and interest in the monumental sculpture by Claes Oldenberg entitled "Lipstick Ascending on Caterpillar Tracks" (hereinafter the "Monument") so long as the Monument shall remain on that certain portion of Beinecke Plaza, on Wall Street at Yale University in New Haven, Connecticut, described and bounded as follows:

NORTH, by Freshman Commons seventy feet more or less;

EAST, by a line drawn contiguous with and extending from the West wall of Woodbridge Hall, One hundred twenty-eight feet more or less;

SOUTH, by a line drawn contiguous with and extending from the North wall of Woodbridge Hall seventy feet more or less; and

WEST, by the pit containing the Noguchi sculptures adjacent to the Beinecke Rare Book Library and a line drawn contiguous with and extending from the East wall of said pit, One hundred twenty-eight feet more or less.

In the event of a violation of the condition and reservation that the Monument remain on that certain portion of Beinecke Plaza herein described, and upon breach of said condition, the Monument and all right, title, and interest therein, shall revert to the grantor, its successors or assigns; provided, however, that the Monument may be temporarily removed from the herein described portion of Beinecke Plaza for a period not to exceed seventy-two hours twice in each calendar year.

Colossal Keepsake Corporation

1 2 3

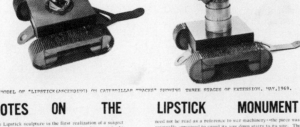

MODEL OF "LIPSTICK (ASCENDING) ON CATERPILLAR "TRACKS" SHOWING THREE STAGES OF EXTENSION, MAY, 1969.

NOTES ON THE LIPSTICK MONUMENT

The Lipstick sculpture is the first realization of a subject which has interested me since 1966, when I proposed a Lipstick on a grand scale to replace the Fountain of Eros in Piccadilly Circus. It is mounted on a movable base--the concept of movable outdoor sculpture was stimulated by watching road equipment and trucks near my new studio in New Haven. The use of treads is also a result in part of my use of corrugated cardboard in building monument models--corrugated cardboard translates easily into caterpillar (or tank) treads.

I have designated this piece a "feasible" monument, to distinguish it (and others in this scale to follow--I hope) from the impossible, so-called "colossal" proposals of the last few years.

The limited mobility of the Lipstick--moving up and down in a closed track--a caged or small-possibility of motion interests me as does the combination of hard and soft material. An earlier version of the Lipstick, in 1967, entirely of steel, in a flat form showed the point of the stick bent like melting wax, tracing a crescent of red. This too was made at Lippincott's. I have recently realized that the first syllable of the fabricator made (for my obsessional fantasy) the subject a necessity. I think that the combination of soft and hard in outdoor sculpture will expand this rather stiff medium. The right weatherproof material for the soft part has not yet been found. The soft part could also be replaceable after a pattern.

The subject is not just erotic--a motor car, which it resembles, is equally erotic. It also suggests an Ionic column (upside down), a Chicago fireplug, a drainpipe, or the famous tower of Tatlin for Red Square--the model of which I recently saw set up in the parking lot of Houston's Rice University.

In its changes, rising, the Lipstick imitates the male and the female sex organ--it is a bisexual object. The caterpillar track need not be read as a reference to war machinery--the piece was originally conceived to crawl its way down stairs to its site. The track and the machinery was later translated to a formal, static conception, based on studies from a Caterpillar catalog. Now the base only gives a suggestion of being able to move.

It remains at this time of writing to see just how the piece, the real piece, will look--the finished piece I find is usually surprising, and the interpretations must wait for the presence of the thing itself.

When I investigated possible sites on the campus earlier this year, I found that nothing would do but the central showplace-- the Plaza. The piece was suggested too by a long orange balloon I found fluttering from the antenna of a parked car as I stood contemplating the site. The balloon seemed huge, bouncing against the paternal classical and Egyptian edifices. Just what the place needs, I thought. The students who subscribed to the piece chose between two proposals--one the Lipstick showing three stages of erection (now on exhibit at the Sidney Janis Gallery in New York City), and the other a toothpaste being stepped on. Possibly the Lipstick recalls the tower of the New Fraternity mail I used to receive as an undergraduate from Alumnus Gondelfinger, which always brightened the day. I remembered also the day the Colgate Company mailed free samples of toothpaste to every student, tubes which were fired across the campus by laying them in rows on window sills and slamming the window down.

The piece is offered as a gift, less out of sentimentality for any abstract version of the University than a response to the opportunity provided by the students to erect my first "feasible" monument. I am grateful and happy to have given my time to do it.

Claes Oldenburg

Photos courtesy of Sidney Janis Gallery

DONORS

John Allen	Charles Moore
Peter Almond	Nancy Morton
Peter Bardezzi	Thomas Morton
Ed Bass	Sheldon Nodelman
Kent Bloomer	Wade Perry
Charles Brewer	Bruce Quick
Sam Callaway	Jim Righter
Robert Coombs	Peter Rose
Louis S. De Luca	Harold Roth
Steven B. Edwins	Vincent Scully
Jacques Ehrmann	Tom Singer
Brin Ford	Sidney Spiesel
Susan Foss	James Stirling
Wilson P. Foss	John Strawbridge
Everett Glover	Susan Strawbridge
Susan Goldberger	Charles Talbot Jr.
John Hall	Brink Thorne
George L. Hersey	Gordon Thorne
John Hersey	Christopher Tunnard
Philip Johnson	Don Watson
Joel Katz	Paul Weiss
Walter Langsam	Jeremy Scott Wood
Philip Monteleoni	Stuart Wrede

SPONSORS

The Coalition for a New University
The Department of Architecture
The Editorial Board of The Yale Daily News
The Yale Alumni Magazine
Perspecta The Yale Architectural Journal
Dwight Hall
Novum Organum

A trivial artifact has here been transformed, by wit and mastery, so that it is identical with a vital sexual organ. Mere utility has been wedded to sheer presence in a brilliant stroke which takes the absurd with the deadly seriousness. To see it is to laugh and to hesitate, to accept and to withdraw, alerted at once to what is before one, and to the somewhat ridiculous world that lies beyond us and it.

Paul Weiss

ANTI-MONUMENT

Claes Oldenburg's anti-monument for Yale embodies at many levels of complexity a challenge to those limiting forms of expectation and categorization which have come to comprise our traditional value-system, and which now serve to impoverish our possibilities of perception, therapy, and feeling. Therefore in intent and hopefully in its consequences it stands as a liberating gesture at a time of profound and urgent re-evaluation within the university as within our society at large. The fixed relations the one-valued logic (the "logic of domination" as it has acutely been called), the false finality and "objectivity" which have been part of the essential rhetoric of monumental form--clearly evident in Beinecke Plaza--no longer answer to the needs of the later twentieth century, though they permeate the institutional structure of our lives and are proclaimed in all the official pieties. Oldenburg's work claims no exclusivity. It engages instead in an open dialogue with the flux of life around it, with its physical environment as with the larger human environment which forms the specific texture of its historical circumstances. Its situation therefore is inseparable from its context. It seeks to transform that situation by illuminating it, by provoking us through its brutal, funny, and preposterous contrast with the inherent rhetoric of traditional forms, to a realization of the wider dimensions of our experience.

So the symbolic equation lipstick=phallus=missile on which it is based sets in motion a series of implicit juxtapositions and contradictions which carry far beyond any overt social comment. The every day banality, even vulgarity of the lipstick image, with its associations of the bedroom and the intimate underside of life, jars against the formality, the official public character, of Beinecke Plaza, emphasizing by its embarassing presence those realities of life which the official value-structure prefers to ignore. The flaccid, sagging limpiness of the soft sculpture (developing the contrast already present within the work between the smeary lipstick substance and the harshly metallic mechanism of the tank-chassis), with all its reference to the real--as against the ideal--human body, mocks the cold geometries of the environing architecture and the brick certainties which they assert. At the same time the blatant phallicism of the erect lipstick shaft unmistakably indicates the sexual component in that rhetoric of rigid forms and tectonic relationships The psychic anatomy of the world we have constructed for ourselves and precipitated in the forms of our artifacts is dissected in other ways too. The small object, familiar to the fingers, suddenly looms at gigantic size. Thus the scale of the surrounding architecture and therefore all those definitions which we have unconsciously accepted from it of our own size, our own capacity for movement, our own stance as perceiving and self-motivated creatures, are called into question. As received verities are forcibly re-examined, the arbitrary repressive, essentially life-negating character of much that we have taken for granted can no longer be denied. As the familiar object is alienated from us by the devices of inflated scale, altered context and transmitted substance, the suddenly absurd and even horrific image which results betrays the guilty nature of our commerce with these everyday objects which we thoughtlessly use and manipulate (and which therefore use and manipulate us). Familiarity and objecthood themselves are revealed as the terms of our profound alienation from our own experience.

The reawakening of our capacity for experience, on which in the present crisis of our culture the hope for the spiritual, and indeed the physical, survival of mankind now rests, has been that of the university as ideally conceived. Neither art nor the university, in their concrete social incarnations, has always served that purpose well. It is as a sign of hope, therefore, and an act of affirmation that many students, faculty, and friends of Yale have co-operated to bring to the Yale campus its first major, publicly visible and active work of contemporary American sculpture. Claes Oldenburg's gift to his alma mater.

Sheldon Nodelman

A GENTLE PARADIGM

Behavioral determinants have produced new forms

Reflecting society's current frustrations with war, sex and an obscene environment.

Where art probes it is repulsed.

Hence technics, biotechnics and bathroom humor.

Is this the lily of Mabul, that's born in secret mud?

Yes, for a revolutionary esthetic will reveal itself in hell's gloom

or in a deteriorating ecosystem.

It leads us forward and back, forward and back,

Forward and back.

Christopher Tunnard

THE COLOSSAL KEEPSAKE CORP.
THE COLOSSAL KEEPSAKE CORP.

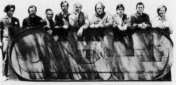

Directors of THE COLOSSAL KEEPSAKE CORP. From left to right:
Gordon Thorne, Charles Brewer, Bob Coombs, John Allen, Claes Oldenburg (V. Pres.), Danny Goodrich (Sec.), Stuart Wrede (Pres.) Vincent Scully, Sam Callaway (Treas.) Missing: Peter Almond.

The Colossal Keepsake Corporation is a non profit Corporation dedicated to the construction and donation of colossal monuments to Educational and Charitable institutions.

Monument fabricated by Lippincott Inc. at cost Treads built by Gordon Thorne. Vinyl lipstick sewn by Lee Allen, Birgitta Callaway, Elizabeth Greenberg, and Lee Lee Thorne.

no 7

SPECIAL "COLOSSAL MONUMENT" ISSUE Thursday, May 15, 1969. NOVUM ORGANUM is published at irregular intervals by students of the school of Art and Architecture at Yale. Address correspondence to: NOVUM ORGANUM Box 2121 Yale Station New Haven, Conn.

STAFF: Sam Callaway, Bob Coombs, Stuart Wrede. DESIGNED BY Michael O'Brien

the student publication *Novum Organum* just prior to *Lipstick*'s arrival; the broadside featured not only a statement on the work by Oldenburg but also a deed gifting it to the university along with renderings of the monument, texts by faculty addressing the project, and lists of donors and members of the Colossal Keepsake Corporation.[9] Oldenburg intended for *Lipstick* to remain a rallying point beyond the moment of its installation, conceiving of it "as a platform for speechmaking. Someone who wanted to make a speech would announce himself by pumping up the Lipstick."[10] Though this latter aspect of the work was not realized—indeed, the lipstick quickly lost air and irreparably drooped on installation—the monument's connection to collective address is nonetheless meaningful. Oldenburg and his patrons anticipated such addresses to bring about changes, as the speeches being delivered across American campuses in 1969 were rarely in support of the status quo.

The work's oppositional meaning was further fortified by its placement on campus. Sited on Beinecke Plaza, it entered into a standoff with the president's office and a memorial to World War I along with other architecturally grand spaces, which is to say with various forms of authority and tradition. The tradition of the memorial came under special scrutiny. The *New York Times* reported that the installation of the sculpture "at times resembled the raising of the flag on Iwo Jima," but, as Rose noted early on, the students' failure to keep the lipstick fully upright is more an "ironic paraphrase" of the Iwo Jima monument signaling the deflated status of such monuments in America at a moment when self-celebration seemed to many unearned. Yet *Lipstick* also breathed new life into the concept of the memorial. Rather than commemorate the past, it not only attended to the present—through its popular imagery as well as its otherwise topical bent[11]—but also sought to shape the present through its role as a congregation site on campus; it aimed to be a real-time player in unfolding events. Speaking of the project, Wrede claimed, "Our purpose is to make the arts more relevant to the world."[12] *Lipstick* was fashioned to fulfill this goal, to be the sort of work Oldenburg may have had in mind when, in 1961, he claimed he was for an art "that does something other than sit on its ass in a museum."[13] **KM**

1 Herbert Marcuse, "Commenting on Claes Oldenburg's Proposed Monuments for New York City," *Perspecta: The Yale Architectural Journal* 12 (1969): 75–76.

2 This was not the only activist project undertaken by these students. For more on activism within Yale's School of Art and Architecture and on *Lipstick* specifically, see Tom Williams's excellent essay, "*Lipstick Ascending*: Claes Oldenburg in New Haven in 1969," *Grey Room* 32 (Spring 2008): 116–44.

3 The Colossal Keepsake Corporation raised the funds that would allow for *Lipstick*'s construction and its subsequent donation to the school. Roughly fifty people contributed, including Philip Johnson. See John Darnton, "Oldenburg Hopes His Art Will Make Imprint at Yale,"

New York Times, May 16, 1969, 37. The term "feasible" is one Oldenburg used to distinguish works from his earlier "colossal" proposals, which were impossible to realize. See Claes Oldenburg, "Notes on the *Lipstick Monument*" (1969), in *Claes Oldenburg: Writing on the Side, 1956–1969* (New York: Museum of Modern Art, 2013), 341.

4 Oldenburg, "Notes on the *Lipstick Monument*," 341.

5 Barbara Rose, "Oldenburg Joins the Revolution," *New York Magazine*, June 2, 1969, 54. Williams ("*Lipstick Ascending*") productively complicates Rose's oft-cited account.

6 The day after the monument was erected, the *New York Times* covered its installation and, significantly, on the front page was the headline

"Shotguns and Tear Gas Disperse Rioters near the Berkeley Campus." See Darnton, "Oldenburg Hopes His Art Will Make Imprint at Yale," 37.

7 Rose, "Oldenburg Joins the Revolution," 54.

8 Darnton, "Oldenburg Hopes His Art Will Make Imprint at Yale," 37; Rose, "Oldenburg Joins the Revolution," 56–57.

9 The publication had been founded by art and architecture students the year before.

10 Oldenburg, quoted in in Barbara Haskell, ed., *Object into Monument* (Pasadena, CA: Pasadena Art Museum, 1971), 96. All of this is made more striking, as Williams points out, by the design of the plaza, which did not invite congregation (Williams, "*Lipstick Ascending*," 130).

11 The lipstick was timely owing not to its connection to war alone but also because Yale College began admitting women in the fall of 1969.

12 Stuart Wrede, quoted in Darnton, "Oldenburg Hopes His Art Will Make Imprint at Yale," 37.

13 Claes Oldenburg, "I am for an Art…" (May 1961; expanded 1967); reprinted in Kristine Stiles and Peter Selz, eds., *Theories and Documents of Contemporary Art: A Sourcebook of Artists' Writings*, 2nd ed. (Berkeley: University of California Press, 2012), 385. *Lipstick* was not destined to maintain its original form or remain on the plaza. After a week, the vinyl lipstick was replaced with an aluminum replica. During its subsequent ten-month tenure on the plaza, it was variously abused—vandalized, torn apart, painted over—and, owing to a

lack of maintenance, Oldenburg ultimately had it removed in March 1970. As Williams notes, however, even these degradations had led the plaza to become a site of public encounter (Williams, "Lipstick Ascending," 132). In 1974, the work was rebuilt and reinstalled elsewhere on campus. The occasion was marked by a corresponding exhibition at Yale University Art Gallery and the publication of an exhibition catalogue. See Susan P. Casteras, *The Lipstick Comes Back* (New Haven, CT: Yale University Art Gallery, 1974). On the afterlife of *Lipstick*, also see David Shapiro, "Sculpture as Experience: The Monument That Suffered," *Art in America* 62, no. 3 (May–June 1974): 55–58.

Faith Ringgold | b. 1930, New York City

FAITH RINGGOLD CONSOLIDATED A FEVER PITCH of social tensions in 1969, when she made this volatile variant on the nation's banner. The war in Vietnam coupled with ongoing struggles for civil rights and gender equality—issues Ringgold was directly engaged with—caused many artists to question what it meant to be American. Ringgold's painting emerged in the wake of reports that highlighted fissures in society and U.S. government priorities. Within the space of a few weeks in summer 1969, Americans witnessed both triumph and tragedy. On June 27, *Life Magazine* presented portraits of Americans killed in Vietnam during one terrible week, a story that had a strong impact on public opinion about the war [p. 129]. On July 20, Apollo 11 became the first successful manned spaceflight mission to land on the moon, an extraordinarily ambitious feat that suggested the government's attention was anywhere but on improving the lives of its most vulnerable citizens.

It was the lunar landing and the broadcast of Neil Armstrong and Buzz Aldrin's moonwalk—complete with a U.S. flag planted on the moon's surface—that seemed to trigger Ringgold's painting about hypocrisy. Here she skewers a government that invested in war and space exploration and ignored its citizens living in poverty.[1] *Flag for the Moon: Die Nigger* is a blunt and shocking title that contrasts with the camouflaged content embedded in the painting's design. It also reverberates with the fierce tone of two other works in contemporary black culture: the title of Black Panther Party leader H. Rap Brown's *Die Nigger Die! A Political Autobiography,* published the same year, and Gil Scott-Heron's song "Whitey on the Moon."[2] Ringgold's powerful composition appears at first glance like a conventional arrangement of the stars and stripes. The dimensions and the general design correspond to what the beholder might expect. Only when the viewer recognizes the embedded word "Die" in the star field and the racial slur "Nigger," reading on its side as the "white" stripes, does the shocking transformation become apparent.

Ringgold's phrase explicitly questions the sacrifices that African American soldiers had made and would continue to make in Vietnam (and by inference, past American wars) for a country rife with racism. It also renders the message, "We came in peace for all mankind," carried on the plaque that the Apollo astronauts left on the moon, full of irony. Her reconfigured banner interrogates what the emblem stands for, what social values it symbolizes, and whom exactly it inspires and rallies. The very fabric and structure of the flag is composed of a loathsome racist command. It cannot be separated out in Ringgold's design. Other artists in the late 1960s took up the flag as a critical weapon, including Yvonne Rainer [pp. 201-2], David Hammons [p. 109], Judith Bernstein [pp. 54-55], and William Copley [p. 80]. For those opposed to the war, the flag had become a symbol of unthinking patriotism and dangerous state power. Ringgold's painting, handmade and unique, feels at once intimate and personal, as though the artist were whispering the truth into your ear. In creating this modestly scaled but powerful image, she made a bold critique of multiple aspects of American exceptionalism when it counted most.

Indeed, a flag-themed art exhibition had already made headlines. Three years earlier, in December 1966, artist and former U.S. Marine Marc Morrel, who had returned from the war, opened an exhibition of provocative American flag–based constructions at the Stephen Radich Gallery in New York. Radich (the dealer), rather than Morrel (the artist), was arrested, charged, and convicted with violation of a New York law stating that no person shall "publicly mutilate, deface, defile or defy, trample upon or cast contempt

Faith Ringgold

Flag for the Moon:
Die Nigger

1969
oil on canvas

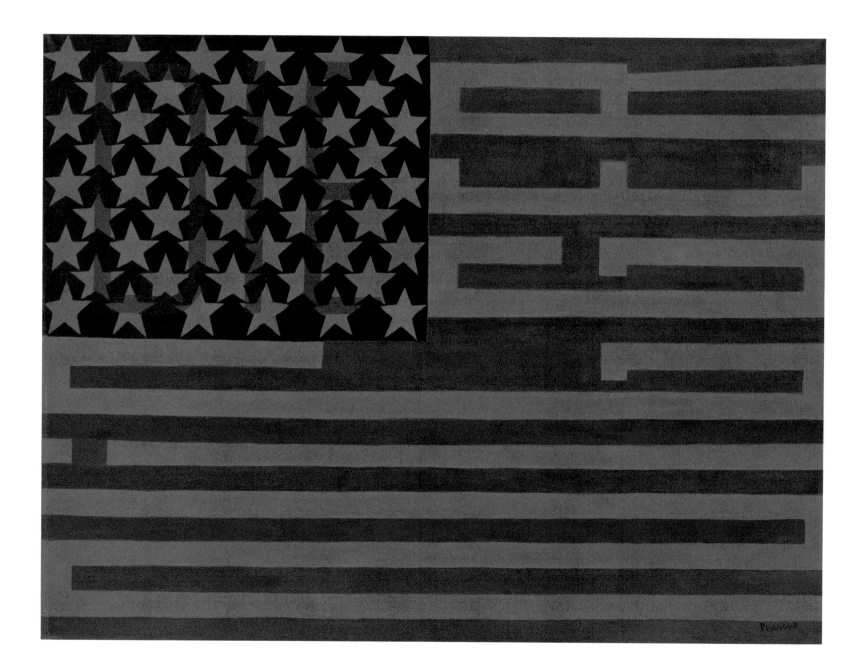

upon the American flag."[3] For Morrel and others, the flag opened wounds, stirred passions, and became a call to conflict.

By November 1970, when Ringgold's *Flag for the Moon: Die Nigger* appeared in *The People's Flag Show* at Judson Memorial Church, Morrel's case was pending before the U.S. Supreme Court. A group of artists including Ringgold, Jean Toche, and Jon Hendricks had organized the exhibition explicitly to challenge flag desecration laws and in moral support of Radich [FIG. 1].[4] Ringgold produced a poster announcing the call for entries, and her daughter, the activist and art historian Michele Wallace, wrote the prompt for it, which read, "The American people are the only people who can interpret the American flag. A flag that does not belong to the people to do with as they see fit should be burned and forgotten. Artists, workers, students, women, third world peoples, you are oppressed. What does the flag mean to you?" The exhibition, installed in a raucous and freewheeling manner, featured events in which participants

addressed the question posed on the poster and challenged freedom of expression.[5]

The inevitable backlash occurred on November 13, when Ringgold, Hendricks, and Toche (known thereafter as the Judson Three) were arrested and charged with desecration of the American flag.[6] The exhibition was closed by the attorney general's office of New York the day before it was scheduled to end. Eventually, despite the efforts of lawyers assisted by the American Civil Liberties Union, the Judson Three were found guilty but were released after paying fines. Unhindered, they burned tiny paper and toothpick American flags on the courthouse steps on their release. **RC**

1 United States Bureau of the Census, Current Population Reports, Series P60, no. 76, "24 Million Americans, Poverty in the United States: 1969," December 16, 1970, https://www2.census.gov/prod2/popscan/p60-076.pdf.

2 H. Rap Brown, *Die Nigger Die!* (New York: Dial Press, 1969). Gil Scott-Heron's song appeared on his debut album *Small Talk at 125th and Lenox* (1970), but the lyrics were written in 1969. Ringgold produced posters in support of the Black Panthers. Thom Collins and Tracy Fitzpatrick, eds., *American People, Black Light: Faith Ringgold's Paintings of the 1960s* (Purchase, NY: Neuberger Museum of Art, 2011).

3 For more on this case and related issues at the time, see Matthew Israel, *Kill for Peace: American Artists against the Vietnam War* (Austin: University of Texas Press, 2013), 60–63. See also Laurie Schneider Adams, *Art on Trial: From Whistler to Rothko* (New York: Walker, 1976).

4 The first federal Flag Protection Act was passed by Congress in 1968 specifically in response to flag burnings at antiwar protests. The U.S. Supreme Court overturned it and related state statutes in 1989 as unconstitutional restrictions on public free speech and expression.

5 *The People's Flag Show* was an open exhibition, meaning there was no selection committee, and anyone who wished to contribute a work was invited to do so. According to Ringgold, more than two hundred artists participated. Faith Ringgold, *We Flew over the Bridge: The Memoirs of Faith Ringgold* (Boston: Bullfinch Press, 1995), 181. Participants included Carl Andre, Judith Bernstein [pp. 54–55], GAAG [p. 159], Jasper Johns, Luis Jiménez, Kate Millett, and Yvonne Rainer [pp. 201-2].

6 "Flag Show Artists Fined $100 Apiece," *New York Times*, May 25, 1971. Hendricks, Ringgold, and Toche were arrested in a raid on the exhibition space on November 13, 1969. Many from the art world established a legal defense fund to support them, with contributions from gallerists Leo Castelli, Sidney Janis, and Virginia Dwan. After their court sentence, they released a statement that read in part, "We have been convicted, but in fact it is this nation and these courts who are guilty…[of] mutilating human beings [in Southeast Asia and at home]." They were later acquitted on appeal.

FIG. 1
Faith Ringgold speaking at the opening of *The People's Flag Show*, Judson Memorial Church, Washington Square, New York, with *Flag for the Moon: Die Nigger* installed behind her at far right, November 9, 1970. Photo by Jan van Raay

Carlos Irizarry

Moratorium

1969
screenprint

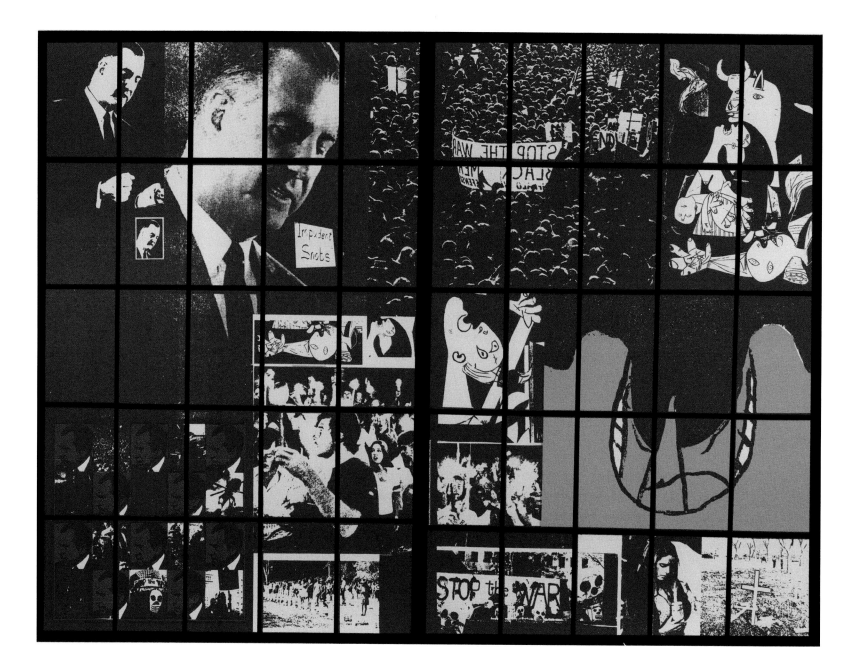

Hans Haacke

News

1969
newsfeed, printer, and paper.
Shown installed in the
exhibition *Software* at the
Jewish Museum, New York,
1970

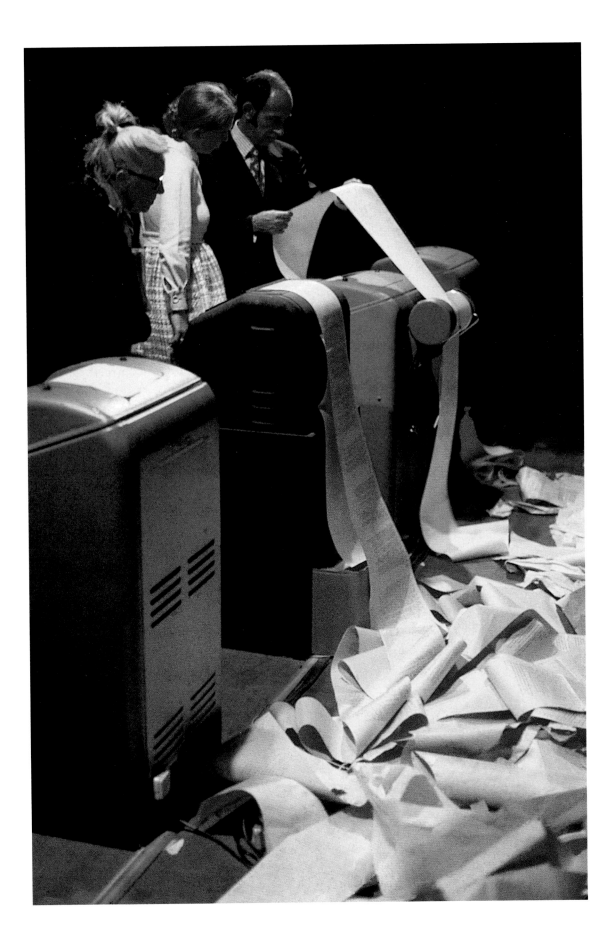

Hans Haacke | b. 1936, Cologne, Germany

LIKE SO MANY OTHERS, HANS HAACKE HAS dated his politicization to the later sixties—a moment in the United States defined by the escalation of the Vietnam conflict abroad and heightening tensions around civil rights at home.[1] A letter to critic Jack Burnham, a key early supporter of Haacke, composed soon after Martin Luther King Jr.'s assassination in April 1968, reflects the artist's awakening: "Nothing, but really absolutely nothing is changed by whatever type of painting or sculpture or Happening you produce on the level where it counts, the political level. Not a single napalm bomb will not be dropped by all the shows of 'Angry Arts.' Art is utterly unsuited as a political tool.... As I've said, I've known that for a number of years and I was never really bothered by it. All of a sudden it bugs me."[2] That Haacke was newly "bugged" by this situation was made clear in his actions as well as in his work. In addition to becoming involved with the Art Workers' Coalition in 1969, the artist increasingly turned away from the physical and biological systems that had informed his work early in the decade to attend instead to social systems. Compelled to engage the larger world in his art, Haacke began to incorporate into it actual events as they unfolded and in all their contingency.[3] *News* marks this turning point within the artist's practice.

In *News*, a teletype machine sits on a table transmitting information received through different newswire services, bringing headlines from across the globe into the gallery as they break. This information about current events is continuously printed on rolls of paper that are allowed to amass on the floor, and viewers are invited to enter into the growing pile of paper and read the reporting. As is regularly remarked, *News* thereby opens up the supposedly neutral space of the museum, and museumgoers, to happenings beyond its bounds.[4] Importantly, when the work was first exhibited as part of the group exhibition *Prospect 69* at the Kunsthalle Düsseldorf in fall 1969, and in subsequent iterations that year and the next, the information on display would have featured the conflict in Vietnam.[5] Yet Haacke's use of wire services ensured that no single aspect of the news was emphasized: news services featured not only social and political happenings but also those in sports, say, or entertainment, and they did so without hierarchy. Rather than focus on specific aspects of the war or the larger contemporary political situation, *News* instead stressed the overwhelming amount of available information.

That vast quantity, as well as its implications, is given form by the work. The ongoing noise of the teletype suggests there is no respite from breaking news, and the heaps of steadily accumulating printed paper underscore this point.[6] Photographs of visitors reading from the scrolls similarly foster recognition of the vast quantity of information on offer: even when audiences are engaged, it is clear that there is much they will miss. Viewers enact the difficulty of sorting through the news, each called upon to make decisions about where to direct his or her attention within the mounded morass of information on display. Emphasizing this challenge was especially insightful at the moment of the work's conception, given the extent to which Vietnam was a war of information and misinformation: the consequences of what a citizen read or failed to read (as well as viewed or failed to view) were real. News of body counts, massacres, and mass protests could create change "on the level where it counts," shifting public opinion and, with it, political positions. As Haacke's work disseminates such information, it also reveals the important work incumbent on its consumer.

At present, Haacke's *News* continues to engage with the news in real time, its headlines now coming

large-scale diptych print *My Son, the Soldier* [FIG. 2] reprises some of the same protest images and the black grid structure seen in *Moratorium*, yet more emphatically focuses on the tragic loss of life—both Vietnamese and American—caused by the war.[8]

Irizarry's transformation into a politically engaged artist brought an enduring shift to his practice. By the 1970s, Irizarry was back in Puerto Rico, where he initiated a series of radical works of art in support of Puerto Rican independence, an issue that many Puerto Rican activists tied to their antiwar platform. One of his conceptual artworks was deemed an act of terror by the courts and landed him a six-year federal prison sentence.[9] In just a few short years, Irizarry went from depicting acts of protest to enacting dramatic political dissent with his own art. **ECR**

FIG. 2
Carlos Irizarry, *My Son, the Soldier, Part I* (top) and *Part II* (bottom), 1970, screenprints, San Juan Racing Association Fund, The Museum of Modern Art, New York, NY, U.S.A.

1 The Moratorium to End the War in Vietnam was held across many American cities on October 15, 1969, and was followed a month later by the Moratorium March on Washington.

2 See Matthew Israel, *Kill for Peace: American Artists against the Vietnam War* (Austin: University of Texas, 2013), 61.

3 For more on the Iwo Jima sculpture, which was based on a Pulitzer Prize–winning photograph by Joe Rosenthal taken in Japan during World War II, see Karal Ann Marling and John Wetenhall, *Iwo Jima: Monuments, Memories and the American Hero* (Cambridge, MA: Harvard University Press, 1991).

4 On January 3 and 8, 1970, members of the Guerrilla Art Action Group and the Art Workers' Coalition staged protests in front of *Guernica* at the Museum of Modern Art. For more on these actions, see Matthew Israel, *Kill For Peace*, 142–43; and *The Guerrilla Art Action Group, 1969–1976: A Selection* (New York: Printed Matter, 1978), n.p.

5 Political parties and activist groups supporting Puerto Rican nationalism in New York and Puerto Rico linked American citizenship to the draft and death in Vietnam. The Young Lords, the most vocal activist group of young Puerto Ricans in New York, directly opposed the war in point eight of their thirteen-point program and platform. For more on Puerto Rican activism in New York, see Lorrin Thomas, "'Juan Q. Citizen,' Aspirantes and Young Lords: Youth Activism in a New World," in *Puerto Rican Citizen: History and Political Identity in Twentieth Century New York City* (Chicago: University of Chicago Press, 2010), 200–253.

6 Marimar Benítez, "Art and Politics: The Case of Carlos Irizarry," in *None of the Above: Contemporary Work by Puerto Rican Artists* (Hartford, CT: Real Art Ways, 2004), 118, originally published as "Arte y Política: El Caso de Carlos Irizarry," in *La Revista del centro de estudios avanzados de Puerto Rico y el Caribe,* no. 1 (July–December 1985), 86–89. Irizarry's geometric abstractions were featured in the exhibition *La Nueva Abstracción: Domingo López, Luis Hernández Cruz and Carlos Irizarry*, which was accompanied by a catalogue of the same name (San Juan: El Museo de la Universidad de Puerto Rico, 1966).

7 Irizarry exhibited in Ivan Karp's Hundred Acres Gallery in New York City. See Yasmin Ramírez, unpublished interview with Carlos Irizarry, May 2000, Carlos Irizarry Curatorial File, Smithsonian American Art Museum.

8 The first half of the diptych *My Son, the Soldier* features a large photograph of William Calley, the only U.S. soldier to be convicted in the atrocities perpetrated at Sơn Mỹ (My Lai), and an array of the gruesome photographs that brought these crimes to the attention of the American public in late 1969. The second half of the work focuses on Americans killed in the war, reproducing a large portion of the famous *Life Magazine* photo-story "Vietnam: One Week's Dead" (June 27, 1969). This print entered MoMA's collection and was featured in the exhibition *The Artist as Adversary* in 1971. See Betsy B. Jones, *The Artist as Adversary* (New York: Museum of Modern Art, 1971).

9 In protest against what Irizarry considered to be Puerto Rico's colonial status vis-à-vis the United States, he threatened to blow up an airplane traveling from San Juan to New York. He was tried in New York and served four years of his six-year sentence in a federal prison. See Benítez, "Art and Politics," 118–19.

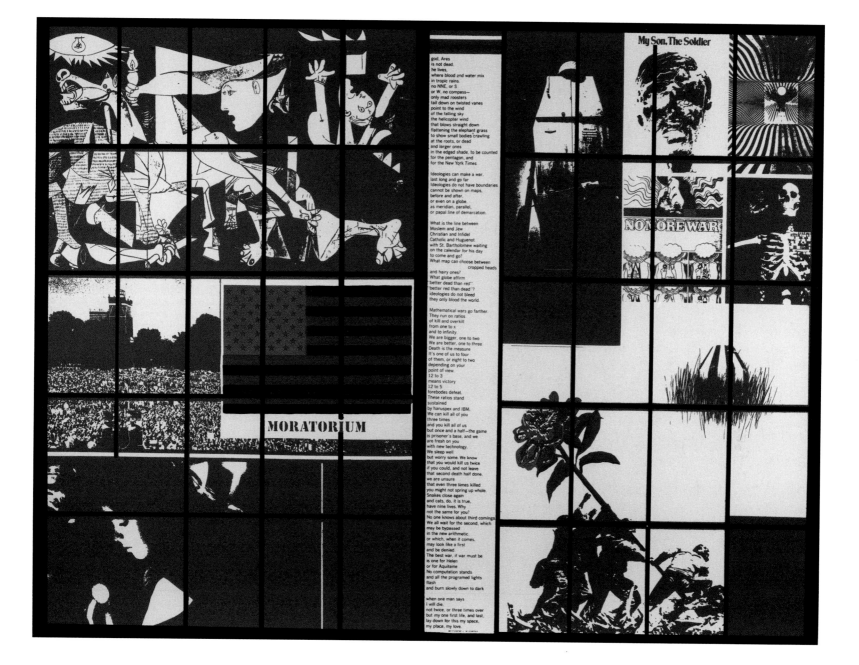

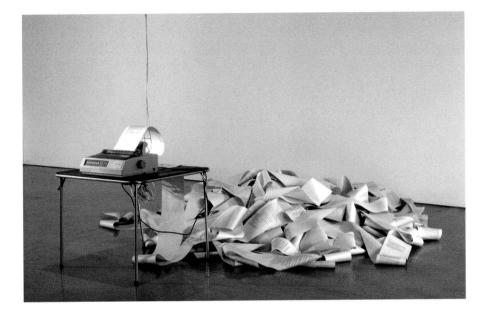

from an online RSS feed [FIG. 1]. The work thus persists in drawing on its immediate social and political context. But, as Julia Bryan-Wilson has pointed out, the nature of our relationship to information has changed since the piece's creation.[7] In the age of smartphones, visitors no longer wait for the news, as was done in 1969, but are instead accustomed to accessing it at will. More than that, they are easily able to select just which information they wish to register, and they can do so without ever acknowledging — wading through — all the other information scrolling out around it. Under these conditions, Haacke's work comes to carry fresh value: it stands as a material reminder of the meaningful choices we are continually making as we consume the news. **KM**

FIG. 1
Hans Haacke's *News*
installed at Paula Cooper
Gallery in 2005, Courtesy
of the artist and Paula
Cooper Gallery, New York

1 Hans Haacke, in Paul Taylor, "Interview with Hans Haacke: The Art of Politics," *Flash Art 41*, issue 261 (July–September 2008): 145. Haacke had also been in Paris in the early sixties where he witnessed the conflict swirling around France's Algerian policies and attended carefully to the events of May 1968. See Jack Burnham, "Steps in the Formulation of Real-Time Political Art," in *Hans Haacke, Framing and Being Framed: 7 Works, 1970–75* (Halifax: Press of the Nova Scotia College of Art and Design, 1975), 129. On this shift, also see Benjamin Buchloh, "Hans Haacke: The Entwinement of Myth and Enlightenment," in *Hans Haacke: "Obra Social"* (Barcelona: Fundacio Antoni Tapies, 1995), 45–49.

2 Hans Haacke, letter to Jack Burnham, cited in Burnham, "Steps in the Formulation of Real-Time Political Art," 130. Burnham had completed the first monographic study of Haacke in 1967. Jack Burnham, *Hans Haacke wind and water sculpture*, supplement to *Tri-Quarterly* (Evanston, IL: Northwestern University Press, 1967).

3 See Burnham, "Steps in the Formulation of Real-Time Political Art," 133.

4 See Ibid., 137; Luke Skrebowski, "All Systems Go: Recovering Hans Haacke's Systems Art," *Grey Room*, no. 30 (Winter 2008): 63; Tanya Zimbardo, "Hans Haacke," in *The Art of Participation: 1950 to Now*, ed. Rudolf Frieling, Boris Groys, Robert Atkins, and Lev Manovich (London: Thames & Hudson, 2008), 126.

5 In its first iteration, with the feed coming from a German wire service, and its second iteration, at Howard Wise Gallery in 1969, with the feed coming from an international service, the paper was displayed on the walls for continued reading the next day, then stored in tubes. When *News* was shown in the exhibition *Software* at the Jewish Museum in 1970, the work consisted of five machines, with feeds coming from five different international services, and the paper was allowed to gather on the floor.

6 Julia Bryan-Wilson, *Art Workers: Radical Practice in the Vietnam War Era* (Berkeley and Los Angeles: University of California Press, 2009), 176. For more on Haacke and the news, see Bryan-Wilson, *Art Workers*, 172–213.

7 Ibid., 212.

Guerrilla Art Action Group | active 1969–present

ON NOVEMBER 18, 1969, AN INCONSPICUOUSLY attired Jon Hendricks (b. 1939), Jean Toche (1932–2018), Poppy Johnson (b. 1949), and Silvianna (Sylvia Goldsmith) (b. 1929) entered the lobby of the Museum of Modern Art at 3:10 p.m. with two gallons of beef blood in plastic bags taped to their bodies. In the midst of museumgoers, the group then threw on the ground a hundred copies of a statement with the heading "A Call for the Immediate Resignation of All the Rockefellers from the Board of Trustees of the Museum of Modern Art" that lambasted the Rockefeller family for, among other things, the "use of art as a disguise, a cover for their brutal involvement in all spheres of the war machine" [FIG. 1]. After scattering the statement, the four artists began to attack each other. They tore off one another's clothing, bursting the sacs of blood hidden beneath. They screamed and, at times, shouted "rape." Dripping with blood and their clothes in tatters, the group began moaning as they fell to the floor, with their actions changing from "outward aggressive hostility into individual anguish."[1] After a short period of time, they got up and left, just missing the arrival of the police. According to Toche's recollection, "the whole thing probably didn't take more than five minutes."[2]

This action, also known as *Blood Bath*, was the work of the Guerrilla Art Action Group (GAAG), founded just the month before by Hendricks and Toche. Dismayed by what they saw as the ineffective protest techniques and even lack of commitment of other artists—particularly those associated with the Art Workers' Coalition—the group adopted a more radical approach to public interventions.[3] Drawing on connections to Happenings, Fluxus, and destruction art, they privileged spectacular and often confrontational actions designed to spur strong reactions.[4] Over time, the group's work adopted a range of forms. Days before *Blood Bath*, GAAG staged an action at the Whitney Museum of American Art in protest of that institution's decision not to close during the October Moratorium to End the War in Vietnam, a day of nationwide demonstrations against the war. After tossing red pigment and water on the floor, they soberly proceeded to mop and otherwise spread the blood-like substance across a vast area, noting, "We have to clean this place up, it is dirty from the war."[5] With *Blood Bath*, they opted to provoke by way of violence. The group's brutish attacks and the resulting "bloodshed" broadly signaled the fighting taking place abroad. Their tearing off of one another's clothes then appeared not only as a further marker of war's destructive, dehumanizing power but also as an allusion to the effects of napalm as it ravaged the body (the statement they distributed faulted the Rockefellers for facilitating the production of that substance).[6] And while their shouts of rape point toward the metaphorical rape of Vietnam, they also flag such assault as a not uncommon practice during war; indeed, the ripped clothes may also be significant in this regard. It is suggestive that GAAG staged their action soon after news of the carnage at Sơn Mỹ (My Lai) first broke: the images of seemingly violated bodies left in *Blood Bath*'s wake resonate in troubling ways with the Ron Haeberle photographs from Sơn Mỹ that would first be published two days after GAAG's intervention [pp. 10, 167].[7]

Brief as the event was, its context mattered enormously. "We basically did a war scene inside the lobby of the Museum," Toche remarked in 1972.[8] In so doing, GAAG presented on a concrete, corporeal level something of the atrocities of battle for a host of unsuspecting gallerygoers, thereby disrupting the institution's standing as a "diversion from the realities of war and social crisis."[9] That, according to Hendricks, the "large crowd" surrounding them

**Guerrilla Art Action
Group**

*A Call for the Immediate
Resignation of All the
Rockefellers from the
Board of Trustees of the
Museum of Modern Art*

1969
performance

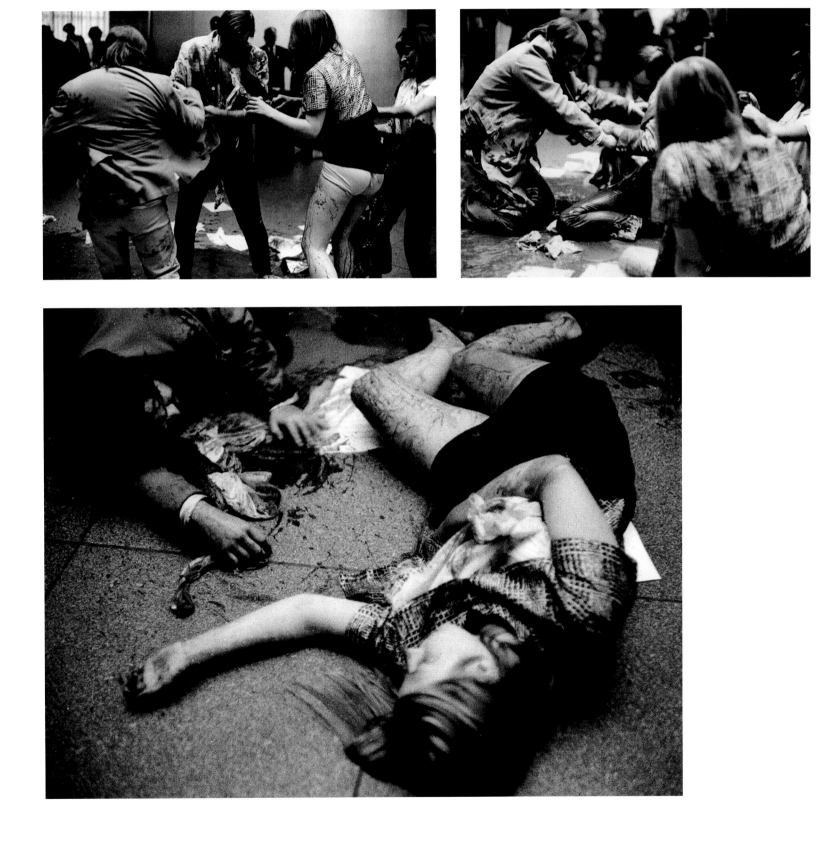

FIG. 1
Handbill distributed
by GAAG during *Blood
Bath* performance,
1969, Courtesy of the
Smithsonian Libraries,
Washington, D.C.

"didn't try to stop this apparent brutalization" was perhaps to the group's point.[10] *Blood Bath* highlighted the actions and inactions of Americans both at home and abroad (though someone did call the police). This bringing of the war to the museum also seems a retort to GAAG's sense—articulated in the statement they left strewn on the floor—that the museum, by way of the Rockefellers, had helped bring the war to Vietnam. Importantly, in their condemnation of the Rockefellers, the group offered research supporting their positions. As was the case for other artists dedicated to deploying information about the war as a form of protest, such as Douglas Huebler or Hans Haacke [pp. 149, 156], GAAG's text is as much reportage as it is polemic. Separating GAAG's action from that of other figures is the fact that they rendered the notion of the exposé literal and visceral as they exhibited themselves alongside their information. KM

A CALL FOR THE IMMEDIATE RESIGNATION OF ALL THE ROCKEFELLERS FROM THE BOARD
OF TRUSTEES OF THE MUSEUM OF MODERN ART

There is a group of extremely wealthy people who are using art as a means of self-glorification and as a form of social acceptability. They use art as a disguise, a cover for their brutal involvement in all spheres of the war machine.

These people seek to appease their guilt with gifts of blood money and donations of works of art to the Museum of Modern Art. We as artists feel that there is no moral justification whatsoever for the Museum of Modern Art to exist at all if it must rely solely on the continued acceptance of dirty money. By accepting soiled donations from these wealthy people, the museum is destroying the integrity of art.

These people have been in actual control of the museum's policies since its founding. With this power they have been able to manipulate artists' ideas; sterilize art of any form of social protest and indictment of the oppressive forces in society; and therefore render art totally irrelevant to the existing social crisis.

1. According to Ferdinand Lundberg in his book, The Rich and the Super-Rich, the Rockefellers own 65% of the Standard Oil Corporations. In 1966, according to Seymour M. Hersh in his book, Chemical and Biological Warfare, the Standard Oil Corporation of California - which is a special interest of David Rockefeller (Chairman of the Board of Trustees of the Museum of Modern Art) - leased one of its plants to United Technology Center (UTC) for the specific purpose of manufacturing napalm.

2. According to Lundberg, the Rockefeller brothers own 20% of the McDonnell Aircraft Corporation (manufacturers of the Phantom and Banshee jet fighters which were used in the Korean War). According to Hersh, the McDonnell Corporation has been deeply involved in chemical and biological warfare research.

3. According to George Thayer in his book, The War Business, the Chase Manhattan Bank (of which David Rockefeller is Chairman of the Board) - as well as the McDonnell Aircraft Corporation and North American Airlines (another Rockefeller interest) - are represented on the committee of the Defense Industry Advisory Council (DIAC) which serves as a liaison group between the domestic arms manufacturers and the International Logistics Negotiations (ILN) which reports directly to the International Security Affairs Division in the Pentagon.

Therefore we demand the immediate resignation of all the Rockefellers from the Board of Trustees of the Museum of Modern Art.

Supported by:
ART WORKERS
COALITION

New York, November 10, 1969
GUERRILLA ART ACTION GROUP
Jon Hendricks
Jean Toche

1 Guerrilla Art Action Group, "Communique," November 18, 1969, in *GAAG: The Guerrilla Art Action Group, A Selection, 1969–76* (New York: Printed Matter, 1976), n.p.

2 Christina Linden, "Interview with Jean Toche, Co-Founder, Guerrilla Art Action Group," *Art Spaces Archives Project*, December 2009, www.as-ap.org/content/oral-history-interview-jean-toche-3.

3 For more on GAAG, see Guerrilla Art Action Group, *GAAG: The Guerrilla Art Action Group, A Selection, 1969–76*, n.p. On *Blood Bath*, see "Communique," November 18, 1969, *GAAG*, n.p.; Bradford D. Martin, *The Theater Is in the Street* (Amherst: University of Massachusetts Press, 2004), 140–43; Julia Bryan-Wilson, *Art Workers: Radical Practice in the Vietnam War Era* (Berkeley: University of California Press, 2009), 184–87. On the group's break from the Art Workers' Coalition (AWC), see "Some of the Events That Led to GAAG'S Creation," in *GAAG*, n.p. Hendricks and Toche were particularly disheartened by the collapse of a protest on the day of the Moratorium following the decision of a number of AWC members to break for lunch. Importantly, however, the two groups did often work together, and Hendricks, Toche, and Johnson remained members of the AWC.

4 Hendricks had intimate knowledge of these movements due to time spent in Europe and work at the Judson Gallery, while both Hendricks and Toche had been associated with destructionist works around events like *Destruction Art: Destroy to Create* at Finch College in 1968.

5 Guerrilla Art Action Group, "Guerrilla Art Action at the Whitney Museum of American Art," in *GAAG: The Guerrilla Art Action Group*, n.p.

6 Bryan-Wilson, *Art Workers*, 185.

7 Ibid., 184. In November 1969, Seymour Hersh first reported that American military forces killed hundreds of unarmed civilians in the village of Sơn Mỹ on March 16, 1968. Photographs of the scene taken by Ron Haeberle were first published on November 20 in the Cleveland *Plain Dealer*.

8 Allen Schwartz, Oral History Interview with Jon Hendricks and Jean Toche, December 13, 1972, Archives of American Art, Smithsonian Institution, https://www.aaa.si.edu/collections/interviews/oral-history-interview-jon-hendricks-and-jean-toche-11910#transcript.

9 "Manifesto for the Guerrilla Art Action Group," in *GAAG*, n.p.

10 Schwartz, Oral History Interview with Jon Hendricks and Jean Toche.

John Lennon | b. 1940, Liverpool, England | d. 1980, New York City

Yoko Ono | b. 1933, Tokyo, Japan

FIGHTING RAGED ABROAD AND TENSIONS AT home continued to escalate, but in December 1969, Yoko Ono and John Lennon declared "WAR IS OVER!"—with the caveat, "IF YOU WANT IT." The pair's message appeared in a range of mediums: it was plastered on billboards and posters across the world; it was printed in newspapers and on postcards; it was even written in the sky by a plane and written into a song ("Happy Xmas (War Is Over)"). This multipronged, global campaign was launched at a moment when the efficacy of art in protesting war was being increasingly questioned by a number of creative figures. Ono, for one, observed in 1971: "Artists themselves are beginning to lose their confidence. They don't know whether they are doing something that still has value in this day and age where the social problems are so vital and critical. I wondered myself about this. Why am I still an artist? And why am I not joining the violent revolutionaries? Then I realized that destruction is not my game."[1] If *WAR IS OVER!* shows Ono and Lennon opting out of violent revolution, then it also shows them reimagining the shape productive artistic intervention might take.

The reputation Ono had earned as an avant-garde artist in the first part of the sixties was largely eclipsed by the celebrity that came with her March 1969 marriage to (soon-to-be former) Beatle John Lennon. That celebrity, however, afforded the couple a place of prominence from which to advocate for peace. Following their March *Bed-In for Peace*, which saw the honeymooning couple invite activists and journalists to engage them in conversation while they remained in their Amsterdam hotel bed [p. 326], Lennon and

Ono unveiled *WAR IS OVER!* in December.[2] Of these sorts of undertakings, Ono remarked, "We're using our money to advertise our ideas so that peace has equal power with the meanies who spend their money to promote war."[3]

It was precisely to the model of advertising, and particularly the clarity of its forms and messages, that the artists turned in *WAR IS OVER!*; with this campaign, they asked viewers to buy into the possibility of peace.[4] More than that, *WAR IS OVER!* seemed to acknowledge and exploit the extent to which the war in Vietnam was also being waged in mass media. If Ron Haeberle's photographs of the atrocities committed in Sơn Mỹ (My Lai) had brought the war home the month before, then Ono and Lennon were attempting to do the same for peace. Through their choice of popular media, the artists sought to make a vision of potential reconciliation as omnipresent as visions of ongoing war.

In Ono's earlier conceptual word pieces, the reader was left to enact—actually or imaginatively—a script: "Leave a piece of canvas or finished painting on the floor or in the street," reads her 1960 *Painting to Be Stepped On.*[5] Similarly, in *WAR IS OVER!*, the artists asked for their audience's participation, suggesting war could come to an end, but only if the viewer took action—or, more accurately, only if the multiplicity of viewers to whom the work was directed took action. For though *WAR IS OVER!* could seem meant for an individual reader—closing salutations from the artists give the message the feel of a personal missive—the media Lennon and Ono enlisted for their project were ones of large-scale address: billboards, newspapers, the sky [FIG. 1]. The work thus shifted the burden of peacemaking onto the public, framing the cessation of hostilities as contingent on a mass of individuals actively seeking it.[6] In this, Lennon and Ono were perhaps attempting to capitalize on a moment when the public was at its most mobilized: the Moratorium to End the War in Vietnam, which

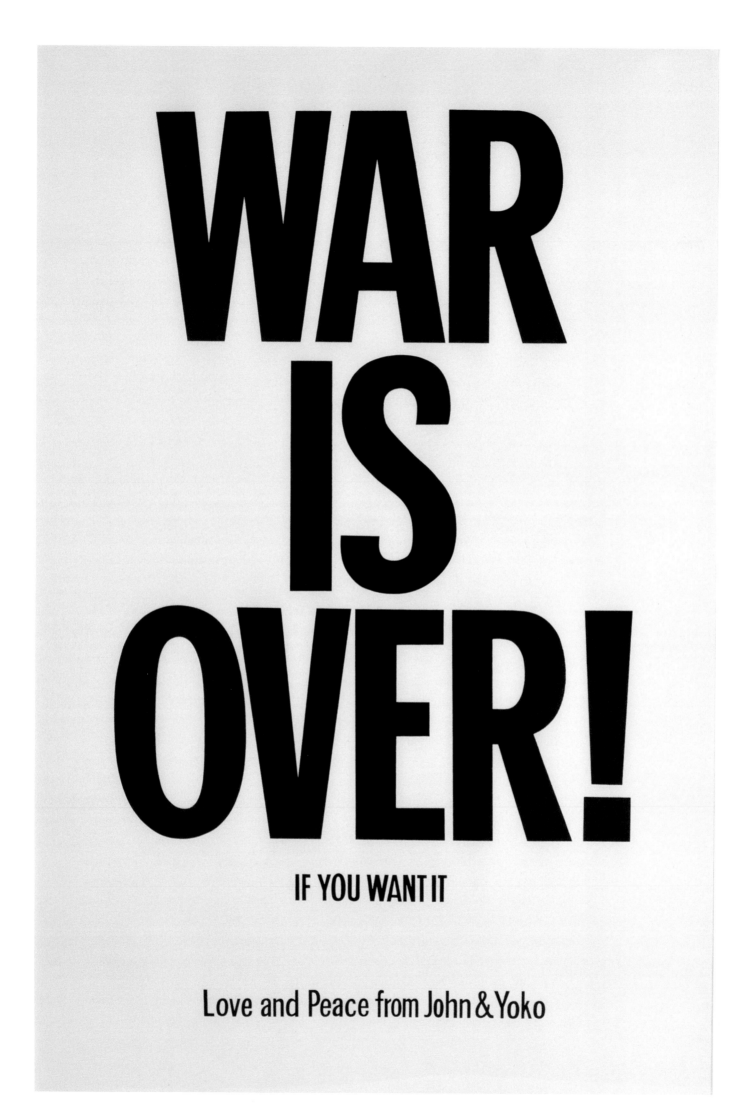

**John Lennon
Yoko Ono**

*WAR IS OVER!
IF YOU WANT IT*

1969
offset lithograph

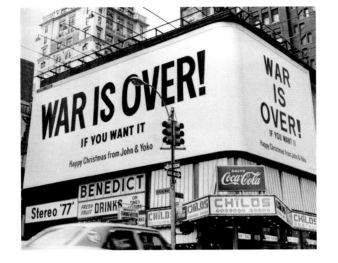

**FIG. 1
John Lennon and Yoko Ono,
WAR IS OVER! IF YOU WANT IT
billboard in New York City.
Three Lions/Hulton Archive/
Getty Images**

would turn out to be the largest national antiwar protest of the conflict, had taken place in October, and a related large-scale march on Washington had occurred in November. But even though such events made it seem that many individuals very much "want[ed] it," contra Ono and Lennon, war was not yet over as the new decade began. **KM**

1 Yoko Ono, "What Is the Relationship between the Artist and the World?," written for the Cannes Film Festival, 1971; reprinted in *Yoko Ono: Arias and Objects*, ed. Barbara Haskell and John G. Hanhardt (Salt Lake City, UT: Peregrine Smith Books, 1991), 109.

2 Another *Bed-In* took place in Montreal that spring, with a related documentary produced in conjunction with it. *WAR IS OVER!* then made its debut in the form of banners and posters during a performance of the Plastic Ono Supergroup at the Peace for Christmas UNICEF benefit in London. Though initially connected to Christmas, the *WAR IS OVER!* campaign continued beyond that holiday season. The first versions read "Happy Christmas from John & Yoko," while later versions read "Love and Peace from John & Yoko."

3 Charles Childs, "Penthouse Interview: John & Yoko Lennon," *Penthouse*, October 1969, 27. This interview took place during the Montreal *Bed-In*.

4 In this they were following a path trodden by Ono's earlier work. On Ono's turns to advertising, see Kevin Concannon, "Nothing Is Real: Yoko Ono's Advertising Art," in *Yes: Yoko Ono*, ed. Alexandra Munroe et al. (New York: Japan Society and Harry N. Abrams, 2000), 177–81. Also see Kevin Concannon, "War Is Over!: John and Yoko's Christmas Eve Happening, Tokyo, 1969," *Review of Japanese Culture and Society* 17 (December 2005): 72–85.

5 See Yoko Ono, *Grapefruit: A Book of Instruction and Drawings* (New York: Simon & Schuster, 1970).

6 While the United States and the conflict in Vietnam were major targets in Ono and Lennon's work for peace, the onus was not placed solely on America. This is one reason their message was always translated into the language of the country in which it appeared. Ono claimed, "In fact, we don't point a finger at the U.S. because of Vietnam alone. That's very dangerous—it's misleading to criticize one particular war or accuse one particular people. It's a danger for people to start thinking, not us but them. We're trying to say *everyone's* responsible, Canadians, Africans, all of us. It's not just the Vietnam War. The Vietnam War is just a symbol of all the violence in the world." Childs, "Penthouse Interview: John & Yoko Lennon," 18. It is worth noting that Ono has continued working with the phrase "War is over! If you want it" through at least 2017.

PLATES AND ENTRIES

Art Workers' Coalition
members Frazer Dougherty, Jon Hendricks, and Irving Petlin anonymously create the poster *Q. And babies? A. And babies.*

Terry Fox
performs *Defoliation* on the campus of the University of California, Berkeley as part of the exhibition *The Eighties* (March 17–April 12)

Bruce Nauman
creates the neon *Raw War*

Robert Smithson
creates *Partially Buried Woodshed* on the Kent State University campus

May Stevens
paints *Big Daddy Paper Doll*, part of a series begun in 1967

Jim Nutt
creates *Summer Salt*

Robert Morris
creates *Trench with Chlorine Gas*, part of *Five War Memorials*

Hans Haacke
creates *MoMA Poll* for the exhibition *Information* at the Museum of Modern Art (July 2–September 20)

Rupert García
creates the print *¡Fuera de Indochina!* for the National Chicano Moratorium

Liliana Porter
creates *Untitled* (The New York Times, *Sunday, September 13, 1970)*

Dennis Oppenheim
creates *Reading Position for Second Degree Burn*

Yvonne Rainer
presents *WAR* in New Jersey, New York, and Washington. Rainer also presents *Trio A with Flags* as part of *The People's Flag Show* at the Judson Memorial Church, New York (November 9–13)

Edward Kienholz
creates the Concept Tableau for *The Non-War Memorial, 1970*

1970

FIG. c24 Student protester faces National Guardsmen, Kent State University, 1970. Photo by John Filo

FIG. c25 A bullet-riddled window attests to the fatal shooting at Jackson State College, Mississippi, 1970.

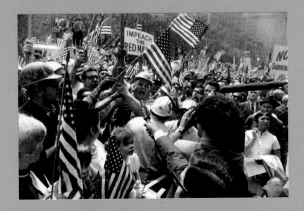

FIG. c26 Construction workers confront antiwar demonstrators during the Hard Hat Riots, New York, 1970. Photo by Garry Winogrand

As peace talks in Paris stall, secret negotiations begin in **FEBRUARY** between U.S. national security adviser Henry Kissinger and North Vietnamese politburo member Lê Đức Thọ.

On **MARCH 18**, Cambodia's neutralist head of state Prince Norodom Sihanouk is ousted in a military coup by pro-American General Lon Nol.

On **APRIL 28**, President Nixon authorizes sending American combat troops into Cambodia in an effort to destroy PAVN and NLF sanctuaries there.

Many Americans object to the U.S. incursion into Cambodia as an illegal widening of the war. Demonstrations erupt on college campuses across the country and the National Guard is sent to maintain order at twenty-one schools. On **MAY 4**, guardsmen open fire on a crowd of students at Ohio's Kent State University [FIG. c24], killing four and wounding nine. Eleven days later, police shoot at students of Jackson State College in Mississippi [FIG. c25], killing two and wounding twelve.

On **MAY 8**, a group of demonstrators, mostly students protesting the deaths at Kent State, are attacked by counterprotesters, mostly construction workers, at Federal Hall in New York City. Known as the Hard Hat Riots, the violent clash results in dozens of hospitalizations [FIG. c26].

Under political pressure following student deaths in Ohio, President Nixon announces on **MAY 8** that American troops will withdraw from Cambodia by the end of June.

As many as 150,000 demonstrators join a march in lower Manhattan on **MAY 20** organized by the Building and Construction Trades Council of Greater New York in support of Nixon's Vietnam policies and decrying flag desecration.

In **MAY** and **JUNE**, Congress repeals the Gulf of Tonkin Resolution and an amendment is proposed in the Senate to forbid U.S. ground forces from being reintroduced to Cambodia. These are Congress's first efforts to gain legislative control over the conduct of the war in Southeast Asia.

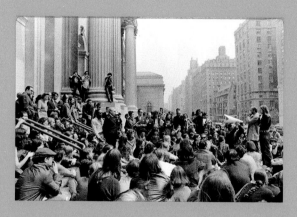

FIG. c27 Art Strike co-chairs
Robert Morris and Poppy
Johnson address strikers on
the steps of the Metropolitan
Museum of Art, New York,
1970. Photo by Jan van Raay

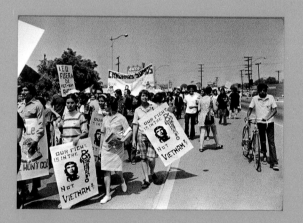

FIG. c28 Protesters carry
antiwar placards in the
National Chicano Moratorium
March, East Los Angeles, 1970.

The New York Art Strike against Racism, War, and Repression takes place on **MAY 22**. The strikers demand that New York City museums shut down and "make available their main floors to the public, free of charge, for information activities against war, racism, and repression." When the Metropolitan Museum of Art fails to close, it is picketed by hundreds of artists [FIG. c27].

On **AUGUST 29**, as many as 30,000 protesters take part in an antiwar demonstration in East Los Angeles organized by the National Chicano Moratorium [FIG. c28]. In subsequent police violence, three people are killed, including the prominent Chicano journalist Rubén Salazar.

In Cambodia, Lon Nol proclaims the formation of the Khmer Republic on **OCTOBER 9**. With backing and military aid from the United States, the new government begins a war for control against the Communist Party of Kampuchea, known as the Khmer Rouge, which is supported by North Vietnam and the NLF.

Beginning in **OCTOBER**, the Ad Hoc Women Artists' Committee, a female-led spin-off of the Art Workers' Coalition, launches a campaign protesting the underrepresentation of women in the Whitney Museum of American Art's annual exhibition. The activists stage demonstrations demanding that 50 percent of the artists in the show be women and half of those women be black. When the Whitney's Sculpture Annual opens in December, 20 percent of the artists are women, up from only eight out of 151 artists in 1969.

In solidarity with gallerist Stephen Radich, whose appeal of his 1967 conviction for flag desecration continues, *The People's Flag Show* is held at Judson Memorial Church in New York. Roughly one hundred artists submit artworks incorporating the American flag. On **NOVEMBER 13**, four days after opening, police close the exhibition, and three of the organizers—Jon Hendricks, Faith Ringgold, and Jean Toche—are arrested and charged with flag desecration. The so-called Judson Three are later convicted and fined but are acquitted on appeal.

Nixon's gradual troop withdrawal from South Vietnam continues. By the **END OF 1970**, 334,600 American troops remain in Vietnam. American fatalities for 1970 are 6,173, just over half the figure recorded in 1969 (11,780).

Art Workers' Coalition | active 1969–71

IN NOVEMBER 1969, JOURNALIST SEYMOUR HERSH broke the story of what came to be known as the My Lai Massacre. In a piece subsequently picked up by dozens of papers, he recounted how, on March 16, 1968, U.S. soldiers entered two hamlets in Sơn Mỹ (My Lai) and proceeded to kill by some accounts hundreds of unarmed civilians, rape women and girls, and burn their homes to the ground. Though the army had become aware of these crimes—charging Lt. William Calley, one of the perpetrators, in September of 1969 with the murder of more than one hundred villagers— the information had been largely hidden from the public. Hersh's reporting thus brought to light not only the event but also its institutional cover-up.[1] During the weeks following Hersh's shocking revelations, photographs of the massacre taken by army photographer Ron Haeberle were published in both black and white and color, first by the Cleveland *Plain Dealer* on November 20 and soon thereafter by *Life*, the *New York Times*, and other news outlets [FIG. 1]. These gruesome images further rocked the country and contributed to mounting public outrage. The Art Workers' Coalition

(AWC) sought to capture and amplify this outrage in its now iconic antiwar poster.[2]

Founded in January 1969, the AWC was a loosely organized group of artists largely dedicated to correcting injustices within the art world—especially those having to do with artists' rights, racism, and sexism—though it also undertook various antiwar activities.[3] In the immediate aftermath of Hersh's story, the group felt compelled to respond. They created a poster committee, and in this instance Frazer Dougherty (b. 1944), Jon Hendricks (b. 1939), and Irving Petlin (b. 1934–2018) were tasked with producing a poster addressing the massacre for widespread distribution. The resulting *Q. And babies?* makes use of one of Haeberle's disturbing images: a color photograph of slain women and children on a dirt road. Overlaid across its upper and lower edges is blood-like red typewriter text reading, "Q. And babies? A. And babies." This language was taken from a late November televised interview conducted by a stunned Mike Wallace with U.S. Army soldier Paul Meadlo, who had participated in the slaughter and here acknowledged that infants were among those killed; the transcript of their exchange was also printed in the *Times*.

That the poster's photograph and text both had roots in the mass media is not incidental. Indeed, the poster's journalistic points of origin seem, in a sense, justification for the group's decision to disseminate this shocking image. The transformation of a photograph of very real murdered women and children into an antiwar symbol could rightly be taken as a further denial or violation of those victims' humanity; additionally, it could be feared that the sweeping circulation of that image could dampen its visceral impact.[4] Yet it is as if the group ultimately viewed concrete, journalistic evidence as the most effective means of communicating the true horrors of the war—horrors the government preferred to keep out of view. They printed fifty

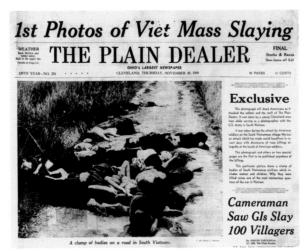

FIG. 1
"1st Photos of Viet Mass Slaying," *Plain Dealer* front page, November 20, 1969

thousand posters and distributed them for free to artists and those associated with the movement; their aim was not only to see that now-enlarged image infiltrate public spaces—with it plastered on walls, say, or held aloft during protests—but also, and consequently, to amplify its reach and effect.[5] The group shared the media's ambition to speak to a wide audience, but their target audience, by contrast, was not necessarily an active or willing one. Through their poster's content and placement alike, the AWC sought to make it difficult to look away from the war's grisly truths.[6]

The poster's content is also consistent with the belief held by many within the AWC that atrocity is best tackled by artists directly rather than allusively. As Lucy Lippard put the matter in a different context, "The *illustration* of any situation, no matter how ghastly, provides nothing but clichés."[7] Jean Toche similarly remarked, "[W]henever we express ourselves we should use a direct approach, and not a literary one."[8] This is not to say, of course, that the poster's composition—the arrangement

of photograph and text—did not contribute to its emotional impact. The selected image positions the beholder in the road almost as an observer of, or even participant in, the massacre.[9] The text, for its part, prevents the viewer from traveling beyond the carnage, instead forcing sustained reflection.[10] Yet the AWC's primary goal was not to create a work of art, but rather to use the methods of art-making to extend the reach of journalism and its ability to turn public opinion. Though now known as the work of Dougherty, Hendricks, and Petlin, the poster was intended to be an anonymous work of protest.

And it is through its public life as agitprop, not a rarefied art object, that the poster first entered the museum. The AWC had originally planned to produce the poster in collaboration with the Museum of Modern Art, but that institution ultimately backed out of the partnership because of the concerns of its board.[11] The museum's withdrawal from the project was taken as symptomatic of its complicity in the conflict and, particularly, the complicity of its benefactors—something Hendricks, as part of Guerrilla Art Action Group (GAAG), had recently brought to the fore with *Blood Bath* [p. 159]. In response, members of AWC and GAAG organized a protest against both the war and MoMA *at* the museum in January 1970. Positioning themselves around Pablo Picasso's *Guernica* (1937), itself an antiwar dissertation, the protesters held a memorial service for the young killed by the war as many of them held copies of the AWC poster [FIG. 2].[12] The poster both paralleled Picasso's own political intervention and—with the startling color of *Q. And babies?* popping against the black and white of *Guernica*—signaled an irruption, a new tone for activism within the museum. That photographs of this protest and its use of the poster appeared in *Newsweek, Studio International,* and the *New York Times* was to the point: the poster's reproducibility was central to its objective. KM

FIG. 2
Art Workers' Coalition and Guerrilla Art Action Group members protest in front of Pablo Picasso's *Guernica* at the Museum of Modern Art, New York, with the *Q. And babies?* poster, January 8, 1970. Photo by Jan van Raay

Terry Fox

Defoliation

1970
performance

Terry Fox | b. 1943, Seattle, WA | d. 2008, Cologne, Germany

PROMPTED TO TURN FROM PAINTING TO THE
immediacy of performance by his experience of the
May 1968 Paris demonstrations, Terry Fox deemed
his March 1970 *Defoliation* his "first political work."[1]
Photographs of the event taken by Barry Klinger
show Fox wielding a flamethrower reminiscent of the
type used in Vietnam and directing its flames at a
bed of jasmine plants on the University of California's
Berkeley campus. By the time the artist's work was
complete, he had burned a large, deliberate patch
into the small garden. "[I]t was the same thing that
they were doing in Viet Nam," he later remarked
of his action. He then continued, with an eye to
those who frequented the garden, "Nobody would
get excited about napalming Viet Nam, but you
burn some flowers that *they* like to sit near, and it's
like—."[2] Though in reality Fox's act of destruction
was hardly "the same thing" as what was being done
in Vietnam—the moral stakes being inarguably
much lower—his impulse to give pause to those on
the home front was shared by a growing number of
figures within (and outside of) the art world by 1970.
Indeed, though atypical for Fox in its overtly political

FIG. 1
U.S. Marines use a
flamethrower in Vietnam,
March 1967

nature, *Defoliation* was the sort of direct action that
was gaining currency among many of his more polit-
icized contemporaries, from the Guerrilla Art Action
Group to Yayoi Kusama to Asco [pp. 159, 119, 233].[3]

At the time of Fox's performance, defoliation
was central to the lexicon of the Vietnam War, both
strategically and within public discourse about the
conflict. Beginning in 1961, U.S. aerial forces sprayed
19 million gallons of herbicides and dropped nearly
400,000 tons of napalm across South Vietnam,
unprecedented amounts of these chemical weapons.
While the primary objectives of such attacks were
denying the enemy the cover of jungles and destroy-
ing their crops, bodily harm was a significant
by-product of these campaigns.[4] On the ground,
flamethrowers were used to similar effect [FIG. 1].
Though defoliation had garnered considerable nega-
tive media attention by 1970—and would be phased
out the following year—Fox's *Defoliation* aimed to
offer a fuller and lived sense of that term's meaning.
In recalling the performance, he noted that a somber
mood set in as the audience went from being enrap-
tured by the fire to recognizing "what was going on—
the landscape was being violated, flowers were being
burnt.... One woman cried for twenty minutes."[5]
Fox's choice of the jasmine was particularly charged.
That these plants were slow to bloom rendered
their decimation more powerful at a moment of
budding ecological consciousness in the United
States.[6] Moreover, the already mobilized students
on campus were not Fox's only audience; the artist
claimed his destruction was particularly geared
toward "extremely rich people, who obviously sup-
ported the war in some way or another" and for
whom the "garden was one of their favorite places
to eat lunch."[7]

Fox's actions opened onto not only the immediate
shock that accompanied his use of the flamethrower
but also long-term consequences. The destruction
wrought by defoliation efforts abroad was often

1 Hersh wrote explicitly about the cover-up for the *New Yorker* in 1972. See Seymour Hersh, "Coverup—I," *New Yorker*, January 22, 1972, 34–40; and "Coverup—II," *New Yorker*, January 29, 1972, 40–48.

2 On November 3, aware that a massacre already known to the government would soon be made public, Richard Nixon made his appeal to the "silent majority" of Americans whom he believed supported the war, and Spiro Agnew soon after attacked the media for bias in their reporting on Vietnam. It is as if by mass-producing a poster, the AWC sought to express a different majority position and to reveal that bias was not the issue.

3 On the AWC, see Dario Corbeira, ed., *The Art Workers' Coalition* (Madrid: Brumaria, 2010). Julia Bryan-Wilson offers a sophisticated account of the group in her *Art Workers: Radical Practice in the Vietnam War Era* (Berkeley: University of California Press, 2009), esp. 12–39.

4 On the ethics of using such images, see Frances Jacobus-Parker, "Shock-Photo: The War Images of Rosler, Spero, and Celmins," in *Conflict, Identity, and Protest in American Art*, ed. Miguel de Baca and Makeda Best (Newcastle upon Tyne: Cambridge Scholars Publishing, 2015), esp. 57–59.

5 Lucy Lippard, "The Art Workers' Coalition: Not a History" (1970), reprinted in *Get the Message? A Decade of Art for Social Change* (New York: E. P. Dutton, 1984), 15. The production of the poster was made possible by way of donations; a shop did the printing for free (Amalgamated Lithographers Union, though some there objected to the project), and a donor paid for the paper (Peter Brandt). Posters were by this time recognized as a key medium of the antiwar movement. For a contemporary take on the ubiquity of posters, see Hilton Kramer, "Postermania," *New York Times Magazine*, February 11, 1968.

6 The group had also wanted the image to appear simultaneously on the covers of all of the major art magazines; this would have prevented the art world in particular from being able to look away, at least momentarily. The plan was scuttled by the refusal of Tom Hess at *Art News*. See Amy Newman, *Challenging Art: Artforum, 1962–1974* (New York: Soho Press, 2000), 267.

7 Lucy Lippard, "The Dilemma" (1970), reprinted in *Get the Message?*, 8, emphasis in original.

8 Jean Toche, statement for "An Open Public Hearing on the Subject: What Should Be the Program of the Art Workers Regarding Museum Reform and to Establish the Program of an Open Art Workers' Coalition" (1969), in Corbeira, ed., *The Art Workers' Coalition*, 374.

9 For a compelling reading of Haeberle's images—as well as of the AWC poster—see Chris Balaschak, "Planet of the Apes: John Szarkowski, My Lai, and *The Animals*," *Art Journal* 71 (Fall 2012): esp. 16–19.

10 David McCarthy, *American Artists against War, 1935–2010* (Oakland: University of California Press, 2015), 81.

11 For more on this aspect of the poster's conception and realization, see the insightful account offered in Francis Frascina, *Art, Politics and Dissent: Aspects of the Art Left in Sixties America* (New York: Manchester University Press, 1999), 160–208.

12 McCarthy, *American Artists against War*, 82–83. The AWC also initiated an ultimately unsuccessful campaign to have Picasso's work removed from the museum. For more on this episode, see Frascina, *Art, Politics and Dissent*, 160–208.

Q. And babies?
A. And babies.

1970
offset lithograph

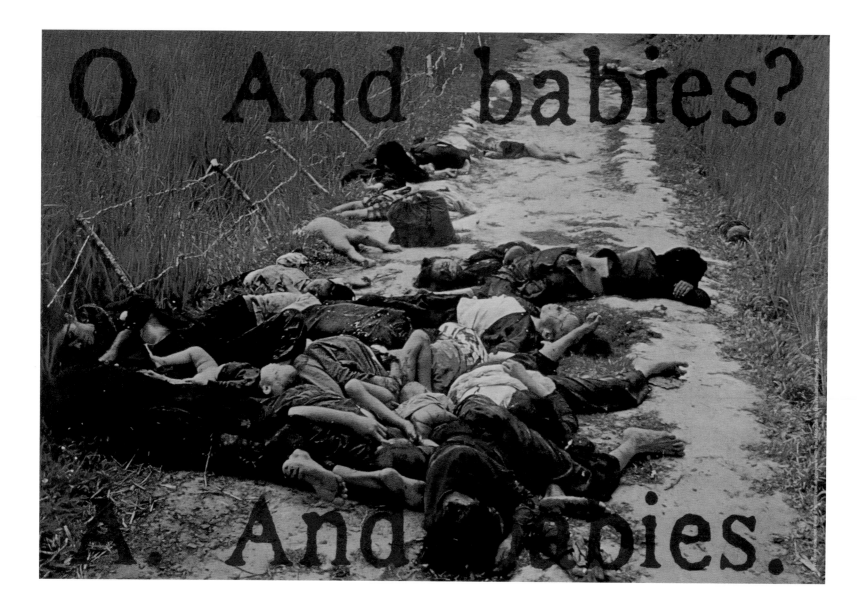

conveyed to Americans through photographs capturing decimated forests, napalm descending from above, or blazing flamethrowers, yet the impact of these actions was hardly limited to such singular locales and moments.[8] Vietnamese patterns of life were altered in lasting ways as agrarian communities were displaced from their longtime homes and the negative health consequences of exposure to chemicals used by the United States became clear.[9] Possibly thinking of these sorts of changes, Fox said of the day after his performance, "When these people came to have their lunch there, it was just a burned-out plot."[10] His work had a meaningfully protracted temporality, continuing to unfold both in photographs and in the form of a destroyed garden.

Like many of Fox's performances from the period, *Defoliation* engaged in active and pointed dialogue with its context. College campuses, Berkeley especially, had been hotbeds of resistance to the war—as well as to other injustices—since the first teach-ins during 1965, and antiwar mobilization on campuses increased following the war's escalation during the spring of Fox's performance. Campus was, in other words, a site well primed for an antiwar artistic intervention. More than that, the artist's work kicked off Brenda Richardson and Susan Rannells's exhibition *The Eighties* at the Berkeley University Art Museum. This show's aim, in the curators' words, was to encourage thinking about "the quality of life as it may exist in the eighties."[11] With *Defoliation*, Fox offers a bleak prediction for that future: in it, what was once valued has been spectacularly destroyed. Grounded as it was in the present, however, his vision was also immediately resonant. As one critic put it in reviewing the exhibition: "This show is, now, period. It couldn't relate to any other time except the present moment in Barrow Lane, the University of California at Berkeley, the Art Gallery."[12] **KM**

1 Willoughby Sharp, "Elemental Gestures: Terry Fox," *Arts Magazine* 44 (May 1970): 48. On his experience in Paris, part of a yearlong stint in Europe, see Constance Lewallen, *Terry Fox: Articulations (Labyrinth/Text Works)* (Philadelphia: Moore College of Art and Design, 1993), 9.

2 Robin White, "Terry Fox," *View* 2 (June 1979): 11.

3 During this period, Fox also made *Pisces* (1971), which was, among other things, a less overt meditation on the sacrifices being made in Vietnam. For more on this work, and on Fox in general, see Lewallen, *Terry Fox: Articulations*, esp. 14. For more on Fox's performances, also see Suzanne Foley and Constance M. Lewallen, eds., *Space/Time/Sound: Conceptual Art in the San Francisco Bay Area, the 1970s* (San Francisco: San Francisco Museum of Modern Art, 1980), 58–63.

4 See Michael Clodfelter, *Warfare and Armed Conflicts: A Statistical Encyclopedia of Casualty and Other Figures, 1492–2015,* 4th ed. (Jefferson, NC: McFarland & Company, 2017), 708. The major defoliation program was Operation Ranch Hand. For the official report on this program, see William A. Buckingham Jr., *Operation Ranch Hand: The Air Force and Herbicides in Southeast Asia, 1961–1971* (Washington, DC: Office of Air Force History, U.S. Air Force, 1982).

5 Sharp, "Elemental Gestures: Terry Fox," 48. Kim Jones's *Rat Piece* produced a similar effect [p. 273].

6 The year 1970 marked the first Earth Day, and on its occasion, Denis Hayes, national coordinator, connected antiwar and environmental efforts in claiming, "We cannot pretend to be concerned with the environment of this or any other country as long as we continue the war in Vietnam." Hayes, "The Beginning," in *Earth Day: The Beginning,* ed. National Staff of Environmental Action (New York: Bantam Books, 1970), xiii–xv.

7 White, "Terry Fox," 10.

8 That Fox gave an interview while performing, in addition to having photographs taken, suggests his interest in connecting his performance to the same media that delivered images of defoliation to the American people.

9 The herbicides used had a lethal legacy for Vietnamese and Americans alike. See Fred A. Wilcox, *Scorched Earth: Legacies of Chemical Warfare in Vietnam*, photographs by Brendan B. Wilcox (New York: Seven Stories Press, 2011).

10 White, "Terry Fox," 11. With "these people," Fox is referring to the group he understood to be rich war supporters.

11 Brenda Richardson and Susan Rannells, quoted in "U.C. Project for the Eighties," *Artweek* 1 (March 14, 1970): 3.

12 Jean Jaszi, "Projects for the 80's," *Artweek* 1 (March 28, 1970): 1.

Bruce Nauman

Raw War

1970
neon, glass tubing,
wire, transformer, and
sequencer

Bruce Nauman | b. 1941, Fort Wayne, IN

BRUCE NAUMAN'S NEON SIGN *RAW WAR* variously illuminates its titular phrase. Consisting of the letters W-A-R, it is first the letter R and then the letter A that each flash singly in red before all three letters flash together, again in red, to spell the word WAR (read left to right) or RAW (read right to left). The connection between the words "raw" and "war" is one Nauman repeatedly mined in a suite of works produced from 1968 to 1970; related are two drawings, his first mature lithograph, and a since-lost red tin box that when connected to a room's lighting flashed "raw war" in Morse code.[1] Asked in 1989 whether these pieces were done in response to Vietnam, Nauman answered, "Well, certainly there are political feelings present in them, but nothing more specific than that."[2] The artist's pivot to the general here is part of a larger pattern that has until recently led most critics to steer clear of politicizing his early output. Yet as Taylor Walsh has elegantly elucidated, despite a dearth of clear-cut social pronouncements from the artist, his work from the 1960s might nevertheless be productively read as registering, if only obliquely, something of the decade's ongoing tumult.[3] Indeed, Nauman's circlings around the phrase "raw war" as the conflict in Vietnam reached a crescendo, and on the heels of two years spent in a Bay Area replete with antiwar sentiment, hardly seem happenstance.[4] Building on recent artistic developments with its conceptualist turn to language and its pop-like adaption of ubiquitous neon signs, *Raw War*'s concise yet potent message might also be understood as taking up the lexicon of contemporary protest.

Like the historical period of its production, Nauman's neon is shot through with tension. On the one hand, the work makes overtures toward a kind of cool neutrality. The ostensibly detached device of wordplay—the fact that WAR is a reverse anagram of RAW—appears to generate the sign, and those words are given form by the relatively banal medium of neon. Moreover, across the top of his 1968 study for this neon work, the artist scrawled "sign to hang when there is a war on," avoiding an explicit connection to any one war. Yet, by the end of the 1960s, "WAR" would have had a very specific referent for most Americans, namely that being waged in Vietnam, and against this backdrop, the work's temperature begins to shift from cool to the red-hot of its blinking letters. The insistent flashing of Nauman's sign—raw war, raw war, raw war—comes to present as an alarm that has been triggered. Through his choice of word(s) and their manipulation, the artist issues an urgent warning about the nature of the conflict abroad, rendering material the mutual imbrication of "raw" and "war."

"Raw" proved an apt, as well as dire, descriptor of the Southeast Asian entanglement in a range of ways. The conflict remained raw in that it was still fresh or unresolved. Raw might also bring to mind wounds endured during war, and perhaps particularly the raw flesh of Vietnamese citizens burned by napalm. Awareness of such wounds, in turn, had been facilitated by what might be described as raw views or raw footage of the conflict made available by a relatively uncensored media.[5] At the same time, the war could be understood as a wound rubbed raw over time. The United States had been deeply invested in Vietnam since the early 1950s; and the escalation of the conflict during the 1960s had increasingly bred contention at home. Some of that opposition was related to the fact that rather than a clean war easily won at a remove through superior fire- and airpower, as it was initially billed, the fighting in Vietnam had turned out to be a viscerally raw endeavor, with intimate, hand-to-hand, guerrilla warfare no small part

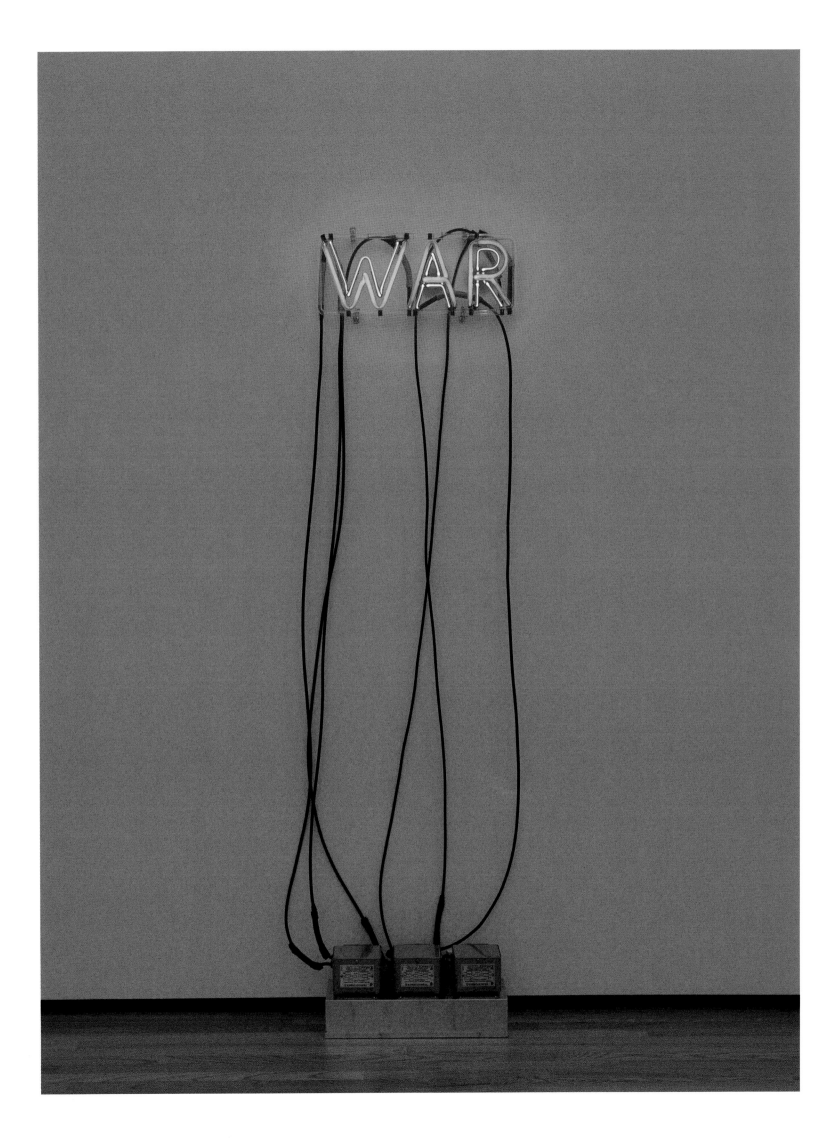

of it.[6] Importantly, in allowing multiple senses of the letters W-A-R to surface, Nauman's work not only variously evokes Vietnam but also, more basically, seizes upon the pliability of language.[7] Such manipulation is felt otherwise in the related works. The *Raw-War* lithograph (1971), for example, molds the letters themselves as it does their meaning; the work is driven by reversals, mirror-reversals, and superimpositions, as well as by varying graphic treatments of the characters. The multiple incarnations of *Raw War* artworks themselves similarly suggest the inherent flexibility of language. This use of the letters echoes the way that supporters and opponents of the war alike routinely bent the same language to different ends.

Importantly, Nauman's medium was of course not language alone but also neon.[8] In using a medium associated with commodity culture, the artist hints at the crass commodification of conflict and suggests a wry understanding of the profits that attend armed battles. More than that, his sign signals the extent to which the U.S. government persisted in selling the war to an increasingly skeptical American people—offering, in the view of many, what amounted to a raw deal, given that by 1970 a conflict long presented as both just and winnable seemed anything but. Like its commercial counterparts, Nauman's sign begs attention despite its relatively modest scale, aiming to draw in an audience beyond the solitary viewer. Rather than peddling war to masses,

however, it declares to its public a state of emergency. The neon's toggling between "raw" and "war" might even read as drawing that public into the call and response of protest, the human-scaled work adopting and adapting the cadence of civil disobedience. At the same time, its hum also takes on a slightly menacing charge: it conjures the rumblings of unrest surrounding the conflict in Vietnam. **KM**

1 See Neal Benezra, Kathy Halbreich, and Joan Simon, eds., *Bruce Nauman: Exhibition Catalogue and Catalogue Raisonné* (Minneapolis: Walker Art Center, 1994), 64.

2 Bruce Nauman, quoted in Christopher Cordes, "Talking with Bruce Nauman (1989)," in *Bruce Nauman*, ed. Robert C. Morgan (Baltimore: Johns Hopkins University Press, 2002), 295. Cordes asks specifically about the lithograph and neon.

3 Taylor Walsh, "*Small Fires* Burning: Bruce Nauman and the Activation of Conceptual Art," *October*, issue 163 (Winter 2018): 21–48. In her insightful reading of Nauman's *Burning Small Fires* (1968), Walsh identifies a host of ways in which the work is permeated by something of its social and political moment as she also compellingly argues that the political surfaces in the artist's work at an earlier moment than has to date been recognized.

4 After receiving his MFA at the University of California, Davis in 1966, Nauman went on to teach at the San Francisco Art Institute for the following two years and then at the University of California, Irvine starting in 1970 with a stint in New York in between. During this time, he initiated the exploration of diverse media—sculpture, film, photography, neon, and more—that would characterize his career. For a comprehensive account of Nauman's career, see Kathy Halbreich et al., *Bruce Nauman: Disappearing Acts* (New York: Museum of Modern Art, 2018).

5 A 1967 *Ramparts* article by William Pepper, for example, brought home horrific images of the suffering inflicted on the Vietnamese people, and in this instance children. See William Pepper, "The Children of Vietnam," *Ramparts* (January 1967): 45–68. It is important to note, however, that *Ramparts* was an independent and explicitly antiwar organ; the mainstream press tended to moderate what they chose to publish.

6 From the mid-1960s, North Vietnamese leaders understood that staying in close proximity to U.S. forces lessened their vulnerability to attacks from the air or artillery, that the best way to fight the Americans involved "grabbing them by the belt." See James Wright, *Enduring Vietnam: An American Generation and Its War* (New York: St. Martin's Press, 2017), 50. Moreover, though Nauman could not have been thinking of it when he first yoked the words, "raw" may have taken on an additional, and oppositional, valence for some viewers following the Vietnam Veterans against the War's direct action Operation RAW (Rapid American Withdrawal) in 1970—a three-day march that saw the group stage mock attacks on towns and mock prisoner interrogations in order to bring to light harsh truths about the military's conduct abroad.

7 For more on the role of language in Nauman's work, see Janet Kraynak, *Nauman Reiterated* (Minneapolis: University of Minnesota Press, 2014), 67–102.

8 For a discussion of the neon signs, see *Elusive Signs: Bruce Nauman Works with Light* (Cambridge, MA: MIT Press, 2006).

Robert Smithson | b. 1938, Passaic, NJ | d. 1973, Amarillo, TX

"SOONER OR LATER THE ARTIST IS IMPLICATED or devoured by politics without even trying," Robert Smithson observed in the September 1970 pages of *Artforum*.[1] This statement seems an apt gloss on his *Partially Buried Woodshed, Kent State*, a work often taken as his most political. Smithson completed the piece at Kent State University months before that campus saw National Guardsmen open fire on students protesting the expansion of the war into Cambodia, killing four and injuring nine. Nevertheless, those May 1970 events ultimately implicated the work in the upheaval of its historical moment and drew its latent politics to the surface.

Partially Buried Woodshed originated from an invitation Kent State issued to Smithson to visit for a week and take part in a creative arts festival. This Ohio stint was meant to end with a mud pour of the type the artist had recently been exploring, like his *Asphalt Rundown* (1969) in Rome or *Glue Pour* (1969)

FIG. 1
Robert Smithson's
*Partially Buried Woodshed,
Kent State* being created

in Vancouver.[2] When cold weather prevented the realization of such a piece, he and the students with whom he had been working turned to the possibility of burying a building. Permission was granted to use an old shed that stored dirt, gravel, and firewood on the outskirts of campus. On January 22, Smithson directed a backhoe to pile dirt onto the right half of the woodshed until its center beam cracked [FIG. 1]. This cracking signaled the end of Smithson's work on the project.

The artist donated *Partially Buried Woodshed* to the university soon after its completion. In related documentation, Smithson stated, "The entire work of art is subject to weathering and should be considered part of the work."[3] That weathering almost immediately involved battering by political winds. As is frequently observed, Smithson's emphasis on the cracking beam became retrospectively charged; it was viewed as emblematic of a breaking point reached nationwide during the spring of 1970.[4] Nancy Holt, Smithson's widow, later remarked, "Piling the earth until the central beam cracked, as though the whole government, the whole country were cracking."[5] That the work was situated at what would often be viewed as ground zero of that national fracturing facilitated such readings. For many, the May shootings at Kent State rendered the school synonymous with the public's broad distrust of a government perceived as woefully inadequate to the manifold challenges facing it. During the university's subsequent temporary closure, the connection between campus unrest and Smithson's work was literally inscribed upon the woodshed by whomever painted "May 4 Kent 70" in white across the structure's top [FIG. 2]. In Holt's words, "[I]t's an example of graffiti that enhances."[6]

While Holt suggested that Smithson saw the work as "prophetic," the sort of cracking she referenced was certainly well underway at the time of the piece's production.[7] In its attention to many of the artist's

most consistent concerns, *Partially Buried Woodshed* would have been of its political moment even without the events of May 4. The work, for example, continued Smithson's ongoing exploration of entropy, his embrace of the dissolution of the art object rather than its permanence. As the artist described the erosion that would surely greet the shed over time as an integral part of the work, a similar decay seemed a pervasive threat to American institutions and integrity. Likewise, Smithson's increasing aesthetic interest in locations removed from the art center of his home base of New York City—such as Ohio—does not seem entirely neutral. Questions of here versus there (in Smithson's terms, of "site" versus "nonsite") were circulating widely as the distant yet somehow proximate war raged on.[8] Indeed, even the very notion of burial, first taken up by the artist in this work, can take on a macabre cast against the backdrop of the Vietnam era.

In keeping with his larger openness to the evolution of his works, Smithson embraced widespread understandings of the piece as political. He even submitted a photograph of the woodshed—photodocumentation an indispensable component of his earthworks—to Lucy Lippard's 1971 *Collage of*

Indignation II, a presentation of protest poster designs to benefit the antiwar cause.[9] And the project's inevitable entanglement with the tumultuous time and place of its production made *Partially Buried Woodshed* a contentious topic on the Kent State campus for years to come. In 1975, administration officials sought to destroy the work, owing largely to the fact that campus expansions had left it much more centrally located. For a time, defenders of Smithson's work succeeded in preserving it to the extent possible, even after a fire ravaged one-half of the woodshed in the spring of 1975; yet what remained was ultimately completely removed by the university in 1984.[10] Driving these battles about the fate of *Partially Buried Woodshed* was, at least in part, the question of how much of our collective history we should remember and how much we should bury. KM

FIG. 2
Robert Smithson's
*Partially Buried Woodshed,
Kent State* with graffiti,
photographed in 1978

1 Robert Smithson, "The Artist and Politics: A Symposium," *Artforum* 9, no. 1 (September 1970): 39.

2 These site-specific works saw Smithson pouring large quantities of asphalt and glue down particular slopes.

3 Robert Smithson, quoted in Alex Gildzen, "*Partially Buried Woodshed*: A Robert Smithson Log," *Arts Magazine* 52 (May 1978): 118.

4 See Ron Horning, "In Time: Earthworks, Photodocuments, and Robert Smithson's Buried Shed," *Aperture* 106 (Spring 1987): 74–77; Ann Reynolds, *Robert Smithson: Learning from New Jersey and Elsewhere* (Cambridge, MA: MIT Press, 2003), 193–205; Dorothy Shinn, *Robert Smithson's* Partially Buried Woodshed (Kent: Kent State University Art Gallery/Ohio Arts Council, 1990), 5.

5 Nancy Holt, quoted in Shinn, *Robert Smithson's* Partially Buried Woodshed, 5. Holt went on: "Really, we had a revolution then. It was the end of one society and the beginning of the next."

6 Ibid.

7 Robert Hobbs, *Robert Smithson: Sculpture* (Ithaca, NY: Cornell University Press, 1981), 191.

8 For more on such concerns, see Eugenie Tsai, ed., *Robert Smithson* (Berkeley: University of California Press, 2004).

9 The photograph of *Partially Buried Woodshed* that Smithson exhibited in *Collage of Indignation II* is the same photograph featured in *Artists Respond*.

10 For more on this history, see Shinn, *Robert Smithson's* Partially Buried Woodshed.

Robert Smithson

Partially Buried
Woodshed, Kent State

1970
gelatin silver print

May Stevens | b. 1924, Boston, MA

MAY STEVENS EMBRACED ACTIVISM EARLY IN her career. She sought ways to promote change through artwork made in response to personal experiences that led her to the civil rights movement, antiwar efforts, and feminism. Stevens grew up with a father who, she recounted, "was always a racist. He spoke against blacks, Jews, Italians, and Catholics, which I heard throughout my childhood. I knew it was wrong, and it infuriated me because I loved my father. We were very close and I wanted him to be better than that.... I argued with him. He would listen to me, but he never changed his mind."[1] She eventually channeled her perception of him into Big Daddy, a character she developed during the Vietnam War to personify patriarchal authoritarianism.

Stevens's *Big Daddy* series grew out of a confluence of events, including her increasing activism and concern about her draft-age son. In 1966, Stevens and her husband, the artist Rudolf Baranik, began working with writer and activist Grace Paley at the Greenwich Village Peace Center and with the War Resisters League. When their son Steven decided to resist the draft, Stevens and Baranik relied on advice from photographer Karl Bissinger of the League. He helped Steven write a conscientious objector statement. Together with friends and other parents, they participated in an event at Sheep Meadow, Central Park, in which a group of young men, including Steven, burned their draft cards. "I wanted to support Steven in this act but was terrified for him," Stevens recalled. "We were also putting ourselves in jeopardy by aiding and abetting this act, which was against the law. But he wanted publicly to burn his draft card.... Our feeling about the war was that we did not want our son to go and do these horrible

things. I never thought about him getting killed. I didn't want him to kill other people."[2]

When Stevens accepted a guest teaching invitation from a university in Indiana around 1968, she was amazed by students' support of the war and realized that they knew little about its particulars. She met people who were proud of having sons fighting overseas and who did not question wartime policies. Of this new social context, she recalled, "It caused me to turn inward, and I did a great many of the Big Daddy drawings at that point.... There was no place for me to express my feelings very clearly outside or with others socially, so I was doing it very intensively inside at home."[3]

Big Daddy became her central motif for several years. The eponymous character is a self-satisfied, late-middle-aged man with a pasty white complexion and a bald, phallic head. He appears seated with arms crossed and a bulldog in his lap. Her inspiration came from a photograph of her parents in which her "mother looked totally defeated, a picture of despair. My father on the other side of the table is wearing an undershirt with a deep U and his arms are folded across his chest. While she looked abject, he looks defiant. It looks like he's saying, 'It's not my fault.' They were devastating photographs, and it hurt me to look at them."[4]

Stevens made two paintings based on this photograph, but she was captivated in particular by her father's portrait.[5] From it she conjured associations and began to transform and generalize his figure in a series that explored society's power structures. In the character of Big Daddy, Stevens generated an authoritarian figure that was mutable, his identity fluid. He came to represent the patriarchy, white supremacy, and unquestioning patriotism rolled into one. In place of his penis, she added a bulldog based on a mascot from an army publication. It became integral to Big Daddy's meaning and presentation. The convulsions and wrinkles in the man's face

May Stevens

Big Daddy Paper Doll

1970
acrylic on canvas

rhyme with those of the dog; each seems like it could turn on an observer. "There's a bestiality…in some of my images," she reflected. "The human and the beast is a very ancient, deeply felt, racial memory. It's the ambiguity that human beings feel about their bodies, the mind-body dichotomy."[6]

Stevens's most ambitious painting in the series is *Big Daddy Paper Doll*, a work that lays bare the interchangeability of Big Daddy's ominous personas. He sits in the center of a deep blue field, flanked by paper doll–style outfits representing an executioner, a soldier, a police officer, and a butcher. Each can be fit onto his blank, mountainous form. Altogether, the work projects anxieties regarding violence and surveillance. Big Daddy embodies this capacity for threat at an individual level but also the broader reach of American imperialism and the many ways it operates

in the world. On their own the outfits are empty, bodiless ciphers bearing a potential for surveillance and harm. It is when they are activated by the bodies that represent and execute power that they become dangerous. So, too, Big Daddy is vulnerable without his uniforms. He needs the costume, the mask, to enact and maintain that power. **RC**

1 Stevens, quoted in Patricia Hills, *May Stevens* (San Francisco: Pomegranate, 2005), 29.

2 Ibid., 31.

3 Lynn Katzman, Oral History Interview with May Stevens, ca. 1971, Archives of American Art, Smithsonian Institution, transcript p. 5.

4 Hills, *May Stevens*, 33.

5 Stevens made *The Family* (1967) and *Prime Time* (1967). Ibid., 85.

6 Cindy Nemser, "Conversations with May Stevens," *Feminist Art Journal* 3 (Winter 1974–75), 4.

Jim Nutt | b. 1938, Pittsfield, MA

JIM NUTT HAS BEEN RETICENT TO EXPLAIN THE
meaning of his work. A group of large-scale pieces
he made between 1968 and 1970, including *Summer
Salt*, shows a high concentration of mutilated bodies,
scenes of corporeal mayhem, and the results of tor-
ture.[1] Was it a coincidence that this extreme key of
imaginative violence occurred in Nutt's work during
the height of antiwar protest, the revelation of hor-
rific atrocities in Vietnam, and media saturation
detailing the war's human cost? Acknowledging the
mystery of his imagery, Nutt later said of the violence
in the work:

> *I'm left with the responsibility for them one way or
> another. But the idea that they dealt with a specific
> concept, like the concept of mutilation and what it
> means in our time—that was the type of thing I wasn't
> doing. The fact that some bodies were abbreviated or
> had amputations had more to do with how a particu-
> lar work developed than with some overall concept of
> meaning. The specific meaning of the paintings I can't
> really explain to myself or anyone else.[2]*

Although his political views remain ambiguous,
Nutt's work of 1968 to 1970 has an especially volatile
character that demands to be considered within the
context in which it emerged. He made *Summer Salt*
after he moved to California to take a job as assistant
professor at Sacramento State College in August 1968,
after which he acknowledged that he "became more
introspective—tended to fantasize more."[3] *Summer
Salt* depicts a man in his underwear sitting in what
appears to be a heap of seething excrement or gore
crawling with green maggots. His arms are tightly
bound far behind his back, suggesting that they may
be broken. Decapitated, his head has been forcibly
smashed back onto his torso, the fresh blood splash-
ing away from his neck, his eyes closed tightly, nose
bound hard and flat, and tongue edging past his lips.
His penis, painfully raw and engorged, floats upward
away from his body. Produced at a time when the
U.S. public was painfully aware of both war atrocities
committed against Vietnamese citizens, such as those
at Sơn Mỹ, and the plight of American POWs enduring
torture and harsh conditions in Vietnamese prisons,
Nutt's image seems to channel this horror and abject
cruelty. *Summer Salt*'s evocation of tortured soldiers
may be purely coincidental but registers the climate
with precision that is hard to miss.[4] Even its title, con-
sistent with the wordplay popular among the Hairy
Who, sounds like "some assault!"

Nutt's work is part of a long tradition of using the
bawdy and the bodily to reinforce our mortality and
humanity. Late medieval panel paintings, for exam-
ple, show grisly scenes of martyrial torture, and Nutt
also knew of similar depictions in the war-related
work of Jacques Callot, Francisco Goya, Otto Dix,
and Max Beckmann. Like much of Nutt's work of the
late 1960s and throughout the 1970s, *Summer Salt* is a
painted object crafted as a multisurface structure—
much the way that medieval objects of worship,
such as portable altarpieces, devotional panels, or
reliquaries, also combined use and meaning in their
forms. It is one of three works that Nutt made in an
identical format to resemble a window with its shade
pulled down.[5] A rectangular box protrudes at the
top, containing a roller fastened in place to which
is attached a clear vinyl sheet, which Nutt reverse
painted and fitted with a bar at the bottom.

When the "shade" is retracted, *Summer Salt*
reveals a painted wood surface decorated with a
hagiography of more wounds and dismemberments
arrayed across the panel like cropped collage pieces.
Among them, a knife slices into a finger bringing
forth red splashes; a woman knees a man in the groin;
a head floats upside down, eyes black slits; and a

Hans Haacke | b. 1936, Cologne, Germany

"WOULD THE FACT THAT GOVERNOR ROCKEFELLER has not denounced President Nixon's Indochina policy be a reason for you not to vote for him in November?" This is the question that Hans Haacke's *MoMA Poll* put to visitors of the Museum of Modern Art's 1970 exhibition *Information*. Positioned near the show's entrance, the work consisted of a panel posing that question along with instructions as to how to cast the ballot each museumgoer had been provided. Those ballots were color coded to reflect the entrance fee their recipients had paid (there were full-fare guests, members, guest pass users, and those who came on a free day), and they were to be deposited in one of two transparent plexiglass ballot boxes placed beneath Haacke's query—yes votes on the left, no votes on the right. Each box had an automatic counting device, and a chart beside the boxes offered a daily sum of votes cast. At the exhibition's end, the number of yes votes had reached 25,566, whereas the number of no votes was 11,563. While this final tally was certainly telling—more than twice as many votes against Rockefeller and, with him, the war—the question itself had already offered a revelation: it foregrounded connections between the museum, the Rockefellers, and Nixon's foreign policy.[1]

Curated by Kynaston McShine, *Information* ran from July to September of 1970 and featured conceptual art, focusing especially on works that traded in information and forms of communication. The exhibition was also bound up with the political unrest of its moment. Its catalogue in particular reflected something of the creative class's antiwar sentiment and the show opened on the heels of the protests that swept the nation owing to news about the United States' ground invasion of Cambodia (April); the

killings at Kent State and Jackson State (May); the New York Artists' Strike (May); and the congressional repeal of the Gulf of Tonkin Resolution (May/June). This was also a moment, not coincidentally, around which Haacke's practice took an increasingly political turn [p. 156]. That turn is apparent in his question; in addition to taking aim at Nixon's foreign policy, his formulation placed Nelson Rockefeller, who was not only the four-term governor of New York but also a trustee of MoMA, in its crosshairs. Haacke had first polled gallerygoers the year before, and though he had proposed another such work for *Information*, he did not submit his question until the eve of its opening. He had delayed with good reason, it turned out, as the work was met with considerable resistance from Rockefeller among others, including critics.[2] Emily Genauer noted in a contemporary review, "One may wonder at the humor (propriety, obviously, is too archaic a concept even to consider) of such poll-taking in a museum founded by the governor's mother, headed now by his brother, and served by himself and other members of his family in important and administrative capacities since its founding forty years ago."[3] But, of course, neither humor nor propriety were at stake for Haacke.

Instead, as Julia Bryan-Wilson has signaled, Haacke was invested in a notion of transparency, one that materializes within his work in a number of ways.[4] The voting the artist invites is done in public, and owing to the Plexiglas, the results of his poll are equally apparent. Moreover, the color-coded ballots meant the poll's results were necessarily, and visibly, classed. Through his phrasing, Haacke makes similarly clear the governor's position on the conflict abroad. And with Rockefeller serving as both governor and museum trustee, the exercise set into relief the connection between politics and art institutions and, by extension, between the war and the museum. In keeping with the concerns of the Art Workers' Coalition and the Guerrilla Art Action Group [pp. 159, 169], Haacke's work

was ultimately unrealized as a monument, that it is at once keyed to the monumental and poster-sized is central to its workings.[7] The lithograph's actual size, teamed with its trench's steep tilt toward the surface of the picture plane, narrows the distance between the print and the beholder, imaginatively pulling her into the monumentally scaled scene. As was the case with the minimalist objects it echoes, the trench then creates what Morris called "an extended situation," with the viewer's lived (or, in this case, imagined) experience of the memorial and its surrounding conditions facilitating understanding of it. Crucially, however, by contrast with Morris's minimalist sculpture, in *Trench* that experience was necessarily a dangerous one.[8] Years later the artist reflected on the

Vietnam Veterans Memorial that was erected in the nation's capital, asking, "Has there ever been a more svelte, minimal mask placed over governmental culpability?"[9] What then, for Morris, would be an adequate memorial? One potential answer: to remember is to enter the noxious trenches. **KM**

FIG. 1
Robert Morris, *Untitled (Dirt)*, 1968, earth, grease, peat moss, brick, steel, copper, aluminum, brass, zinc, and felt, overall dimensions variable, Dia Art Foundation

FIG. 2
Robert Morris, *Steam*, 1967, steam, multiple steam outlets under a bed of stones, outlined with wood, overall dimensions variable, Western Washington University, Bellingham

1 Julia Bryan-Wilson, *Art Workers: Radical Practice in the Vietnam War Era* (Berkeley: University of California Press, 2009), 83–126. On Morris's activism, also see Maurice Berger, *Labyrinths: Robert Morris, Minimalism, and the 1960s* (New York: Harper and Row, 1989), esp. 107–23. While some of his contemporaries saw Morris's sudden involvement in antiwar efforts as opportunistic, his heightened level of engagement might also be taken as indicative of the urgency surrounding the cause at this moment (Bryan-Wilson, *Art Workers*, 120–21).

2 Robert Morris, quoted in Grace Glueck, "Art Community Here Agrees on Plan to Fight War, Racism and Oppression," *New York Times*, May 19, 1970, 30.

3 The Emergency Cultural Government Committee was an offshoot of the New York Artists' Strike. Its most significant action was organizing the withdrawal of a majority of artists from the American Pavilion at the 1970 Venice Biennial in protest of the war. See Grace Glueck, "Artists to Withdraw Work at the Biennale," *New York Times*, June 6, 1970, 27.

4 For an overview of Morris's varied output, see *Robert Morris: The Mind/Body Problem* (New York: Guggenheim Museum, 1994). For an assessment of the political potential of land art, see Emily Eliza Scott, "Desert Ends," in *Ends of the Earth: Land Art to 1974*, ed. Philipp Kaiser and Miwon Kwon (Los Angeles: Museum of Contemporary Art, 2012): 67–85. Around this time Morris also

produced a portfolio of ten lithographs titled *Earth Projects* (1969).

5 For a contemporary perspective on the United States' use of chemicals in Vietnam, see J. B. Neilands, "Vietnam: Progress of the Chemical War," *Asian Survey* 10, no. 3 (March 1970): 209–29. The United States did not ratify the Geneva Protocol until 1975.

6 The insidiousness of the gas is suggested not only by its rising out of the trench but also by its echo in the clouds, their threat to the stenciled letters perhaps signaling a threat to the very possibility of memorializing.

7 Even as the monuments went unrealized, his lithographs' reproducibility and sometimes dissemination as posters perhaps widened their public impact. For instance, the project was part of Lucy Lippard's *Collage of Indignation II* show in 1971. See Bryan-Wilson, *Art Workers*, 247n106.

8 The importance of phenomenological engagement with the monuments is stressed in another way in a different *Five War Memorials* lithograph, *Infantry Archive*. Visitors are invited to traverse see-through coffins while barefoot; a realized version of the monument would thus literally bring the beholder into direct contact with the consequences of war.

9 Robert Morris, "Robert Morris Replies to Roger Denson (Or Is That a Mouse in My *Paragone*?)," in *Continuous Project Altered Daily: The Writings of Robert Morris* (Cambridge, MA: MIT Press, 1993), 302.

Robert Morris

Trench with Chlorine Gas

1970
lithograph

Robert Morris | b. 1931, Kansas City, MO | d. 2018, Kingston, NY

PROTEST BECAME CENTRAL TO THE WORK OF Robert Morris in the spring of 1970. The invasion of Cambodia by American forces in April and the killings at Kent State and Jackson State in May were followed by a surge in antiwar activity nationwide as well as in the New York art world specifically. As Julia Bryan-Wilson has elegantly explained, Morris, who had previously only been loosely engaged with activism, turned out to be a key player in the latter scene.[1] On May 13, he and other artists in the Jewish Museum's *Using Walls* show elected to shut down their exhibition early as a protest against campus violence and the situation abroad. On May 17, Morris succeeded in prematurely closing his one-person show at the Whitney Museum of American Art as an action against "intensifying conditions of repression, war and racism."[2] The next day, he was elected chairman of the New York Art Strike against Racism, War, and Repression with Poppy Johnson as co-chair, and following that May 22 strike he was involved with the Emergency Cultural Government Committee.[3] Whereas much of this oppositional work had a number of targets—not just the war but racism, oppression, and more—and took the form of refusal or strike, in *Trench with Chlorine Gas* Morris's focus narrows and his engagement becomes more concrete.

In this lithograph, one of the *Five War Memorials* series executed after the heady spring of 1970, an X-shaped trench with the eponymous chlorine gas rising to its top is set against a slightly darker, scumbled landscape. As in the other prints in the series, above the horizon line the block-lettered words "War Memorial" are centered amid nebulous, cloud-like forms. Unlike much of Morris's wide-ranging work from the 1960s in being both representational and two-dimensional, the lithograph nevertheless builds upon his existing practice. The trench might be seen as borrowing the simplified, geometric language of his minimalist objects, while the diffuse treatment of the remaining surface area could conjure the lateral splay of his more recent postminimalist scatter pieces. More important, however, is the way the work disinters the political resonance of his ongoing experimentations with earthworks. It is as if, for example, the mound of soil installed as *Untitled (Dirt)* (1968)—part of an exploration of contingent forms—is reimagined as the site of its excavation on a battlefield, and the steam emerging from underground valves in *Steam* (1967)—a consideration of both process and the dematerialization of the art object—becomes a deadly gas [FIGS. 1, 2].[4] With his lithograph, Morris lends engagement with, and specifically the disturbance of, the environment an (overtly) ethical dimension. His doing so appears especially charged when set against the backdrop of a war in which the violation of land—be it through sustained aerial bombing campaigns or defoliation programs—was a key military strategy. That Morris made his work as Agent Orange was phased out following peak usage in the late 1960s and as the United Nations called for adherence to the 1925 Geneva Protocol, which prohibited the use of certain gases during warfare, makes the artist's turn to chlorine gas in particular quite pointed.[5] Indeed, the use of chlorine gas, which was first deployed by both sides during World War I, was a key catalyst for the Geneva Protocol. Morris's implicit analogy between a long-banned substance and chemicals still being weaponized in Vietnam underscores America's erosion of the norms of war.[6]

With this series of prints, Morris joined other artists—like Edward Kienholz [pp. 116, 205]—in suggesting that memorials might highlight the horrors rather than the heroics of war. Though *Trench*, like the other works in Morris's *Five War Memorials* series,

broken wedge of glass drips blood at the corners. A visual analogy to Nutt's composition is the medieval "Arma Christi," or "weapons of Christ," in which objects from Christ's Passion are depicted as icons keyed to the full story.

Nutt first gained national attention as a member of the Hairy Who, a group of six Chicago-based artists who exhibited together annually from 1966 to 1969 and made collaborative comic book catalogues and other paraphernalia for their exhibitions.[6] Though not unified by philosophy or style, the transgressive body is a prominent subject in the Hairy Who's work.[7] They delighted in the body's imperfections as it emits sounds, smells, and secretions; the flesh sags and meanders in elaborate grotesqueries, while pimples and hair erupt in unexpected places. Loathsomeness and desirability, sensuality and repulsion, humor and horror often exist simultaneously. Nutt's imagery remains at once the most extreme and mysterious of their early work. In *Summer Salt* he may not have intended specific references to American POWs, Sơn Mỹ, or domestic assassinations of civil rights leaders.[8] However, the body was a contentious site in the late 1960s, and in the work of many Chicago artists it was politically and psychologically charged. Nutt's most disturbing images of the body emerged at a time when his generation was under siege, forced into political positions that had moral and sometimes legal consequences. With *Summer Salt* Nutt may not have been aware of the potential connotations his imagery might have, but it registers the period's climate with an eerie precision. RC

1 Other works that show this aspect at the time are *Running Wild* (1969–70, Lawrence and Evelyn Aronson collection, Glencoe, IL) and *Toot-Toot Woo-Woo* (1970, Elmhurst College Art Collection).

2 Russell Bowman, "An Interview with Jim Nutt," *Arts Magazine* 52, no. 7 (March 1978): 133.

3 Ibid., 135.

4 Nutt made three related drawings, *Quaffed*, which is a finished preparatory drawing (1969–70, Museum of Contemporary Art, Chicago); *Knife Time* (October 1969, The Art Institute of Chicago); and *Armed* (ca. 1970, Museum of Contemporary Art, Chicago).

5 The other works are in the collections of the Roger Brown Study Center at the School of the Art Institute of Chicago and the Pennsylvania Academy of the Fine Arts, Philadelphia. Curiously, the works belonged to three people important to Jim Nutt as friends, supporters, and intimates: Dennis Adrian (the present work), Roger Brown, and Ray Yoshida (now at PAFA). The back of each piece (as in much of Nutt's work) is also painted, often with handling instructions addressed to future preparators and collectors in stylized script.

6 For the Hairy Who, their work, activities, and their collaborative ephemera, see Thea Liberty Nichols, Mark Pascale, and Ann Goldstein, eds., *Hairy Who? 1966–1969* (New Haven, CT: Yale University Press, 2018); and Dan Nadel, ed., *The Collected Hairy Who Publications 1966–1969* (New York: Matthew Marks Gallery, 2015).

7 Although it has been downplayed, members of the Hairy Who engaged in protest exhibitions, made work about the war, and were instrumental in antiwar actions. Suellen Rocca and Nutt's wife, Gladys Nilsson, participated in protest exhibitions. Some of Karl Wirsum's contemporary imagery tended toward the apocalyptic. Art Green made paintings about Secretary of Defense Robert McNamara, and James Falconer helped found the Chicago branch of Artists against the Vietnam War. He was not present at the 1967 opening because he had gone to Canada, anticipating the draft. Jim Nutt, email correspondence with the author, April 5, 2013. For more on Chicago artists and the Vietnam era, see Robert Cozzolino, "Raw Nerves: 1947–1973," in *Art in Chicago: A History from the Fire to Now*, ed. Maggie Taft and Robert Cozzolino (Chicago: University of Chicago Press, 2018), 166–82. See also Patricia Kelly, ed., *1968: Art and Politics in Chicago* (Chicago: DePaul University Art Museum, 2008).

8 The group postponed the opening of their third, 1968 exhibition in Chicago out of respect for those mourning the death of Dr. Martin Luther King Jr.

Jim Nutt

Summer Salt

1970
acrylic on vinyl and
enamel on wood

Hans Haacke

MoMA Poll

1970
transparent acrylic boxes,
photoelectric counting
devices, and paper ballots.
Shown installed in the
exhibition *Information* at
the Museum of Modern Art,
New York, 1970

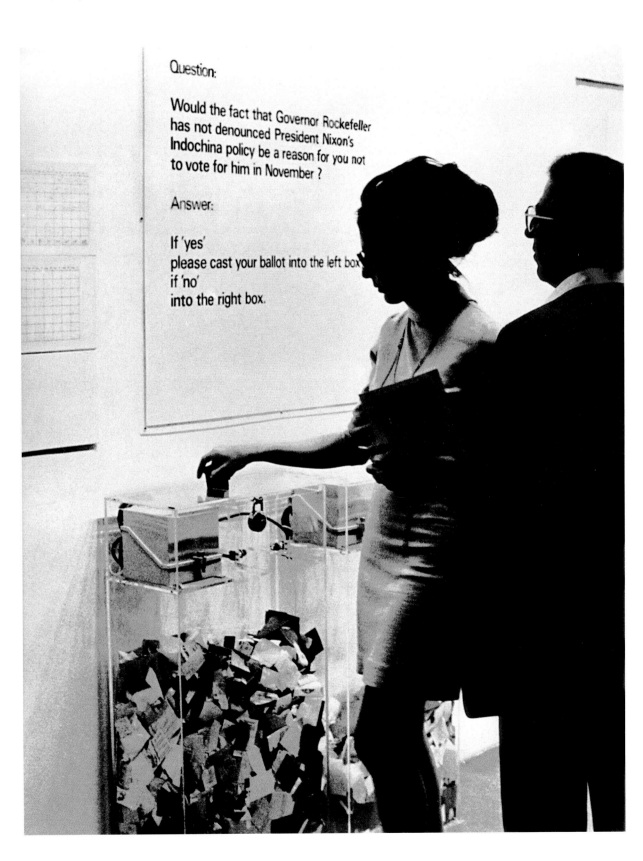

prompted thoughts about the museum's lack of neutrality. Indeed, *MoMA Poll* implied that, far from a neutral space, the museum was funded by those complicit in the conflict abroad.[5]

Equally important is the way this work called for the participation of others. As Haacke put it, answering his either-or question offered a "valve for the anger of a surprisingly large proportion of the visitors."[6] *MoMA Poll* also suggested that participants had the right to question or object publicly to those in power, a suggestion made all the more potent given that Haacke himself was questioning the power of the museum from within the museum. In casting their votes, museumgoers were transformed into active citizens, registering their positions in relation to the upcoming election and the war alike. The force of the work thus resides in both the information Haacke offered and the information he collected from visitors in real time. "Information presented at the right time and in the right place can be potentially very powerful. It can affect the general social fabric," the artist claimed in a 1971 interview, before qualifying the point by adding, "Of course, I don't believe that artists really wield any significant power. At best, one can focus attention. But every little bit helps. In concert with other people's activities outside the art scene, maybe the social climate of society can be changed."[7] KM

1 Haacke's first poll, *Gallery-Goers' Birthplace and Residence Profile* (1969), was staged at the Howard Wise Gallery in New York. For this work, he asked visitors to use pins to mark both their place of birth and their permanent residence on maps.

2 See Julia Bryan-Wilson's excellent account of this work in *Art Workers: Radical Practice in the Vietnam War Era* (Berkeley: University of California Press, 2009), 190–94.

3 Emily Genauer, quoted by Hans Haacke in Jeanne Siegel, "An Interview with Hans Haacke" (1971), in *Working Conditions: The Writings of Hans Haacke*, ed. Alexander Alberro (Cambridge, MA: MIT Press, 2016), 38.

4 Bryan-Wilson, *Art Workers,* 193.

5 Bryan-Wilson outlines the importance of Haacke's involvement with the Art Workers' Coalition to his use of information and to his interest in drawing out the connections between cultural institutions and the war. See Bryan-Wilson, *Art Workers,* 172–213.

6 Hans Haacke, "Provisional Remarks" (1971), in *Working Conditions: The Writings of Hans Haacke*, 56.

7 Hans Haacke, in Siegel, "An Interview with Hans Haacke" (1971), in *Working Conditions*, 38.

Rupert García | b. 1941, French Camp, CA

RUPERT GARCÍA SERVED FOUR YEARS IN THE U.S. Air Force until 1966, first in Montana, then in Thailand, where he guarded planes and munitions at the outset of the Vietnam War. From Thailand, he was frustrated and angered to learn of a burgeoning antiwar movement back home.[1] His perspective changed when he returned to the United States and enrolled at San Francisco State College on the GI Bill.[2] As a student, García did not reveal his military experiences but quietly reevaluated his wartime mind-set in light of his sociology studies, the emerging antiwar culture, and civil rights movements. The student strike at San Francisco State, which began in November 1968, solidified his antiwar stance. The five-month protest—the longest strike led by students in U.S. history—strengthened alliances among blacks, Latinos, Asians, and Native Americans on campus. As a student and later a teacher, García liaised between the art department and the Third World Liberation Front, which co-organized the strike with the Black Student Union. Having earned his BA in painting, he dedicated his art practice to screenprinting in 1968 during the strike, thereby aligning himself with Mexican American artists who lent the Chicano Movement a public image and voice.[3] For El Movimiento, political art was not a contradiction nor an exception, but the continuation of a vital legacy—from printmaking at the Taller de Gráfica Popular in Mexico City to Chicano muralism in the Southwest United States.[4]

By 1970, the same year he received his MA in printmaking from San Francisco State College, García translated his wartime experience abroad and on campus into a radically simple graphic denunciation of the Vietnam War: *¡Fuera de Indochina!* That

phrase—Get Out of Indochina!—appears in yellow, like graffiti across the lower third of the print. Above, a carefully rendered yet partially abstracted face gazes upward out of a seeming void, mouth agape. The light brown figure cries out in pain or rallies in fortitude, possibly wailing with grief or screaming the work's title in defiance. García based the face on a poster of a Vietnamese soldier, though he left the speaker's identity open to interpretation.[5] The racially ambiguous figure calls for solidarity among all oppressed peoples of Third World nations, while the artist speaks directly to hispanophones, especially fellow Latinos. García's bold imperative to withdraw America's military presence is written in Spanish, perhaps a self-critique of his own role as an American soldier. The scream implores Chicanos to disavow the U.S.-led war and directs Chicano soldiers to stop abetting bodily harm and ecological destruction in Vietnam. Moreover, García's declaration underscores shared oppression suffered by Vietnamese and Chicanos while projecting a broader anticolonial sentiment echoed internationally by Third World advocates. In his use of bold graphic forms and text, García declares aesthetic solidarity as well with Cuban postrevolutionary poster makers.

Two venues for distributing *¡Fuera de Indochina!* demonstrate its range and value. On August 29, 1970, more than 30,000 people marched down Whittier Boulevard in East Los Angeles during the National Chicano Moratorium March. The Moratorium framed its antiwar stance as a civil rights issue, citing statistics that Mexican Americans composed a disproportionate number of U.S. soldiers and casualties in Vietnam.[6] García, personally aware of the war's human toll, donated an edition of two hundred silkscreen prints to benefit the Moratorium's efforts. Similar to the *Artists and Writers Protest against the War in Vietnam* portfolio (1967) [pp. 79–81], García's edition raised funds for a larger protest movement. *¡Fuera de Indochina!* was also reproduced on the

Rupert García

¡Fuera de Indochina!

1970
screenprint

back cover of the widely distributed bilingual pamphlet *La Batalla Está Aquí* (The Battle Is Here) (1972).[7] The pamphlet's Chicana authors presented economic and statistical data to persuade young Chicanos to oppose the draft, including documentation of the

"real cost" paid by Vietnamese.[8] In this context, *¡Fuera de Indochina!* brought together local concerns of Chicano identity and self-possession with the humanist, global issue of safety and integrity for oppressed peoples. **JM**

1 García participated in a mission with the Central Intelligence Agency–affiliated Military Assistance and Air Advisory Group. Paul Karlstrom, Oral History Interview with Rupert García, September 7, 1995, to June 24, 1996, Archives of American Art, Smithsonian Institution, https://www.aaa.si.edu/collections/interviews/oral-history-interview-rupert-garcia-13572#transcript.

2 In 1974, San Francisco State switched from college to university status in California's public higher education system.

3 John Yau, "Images Are Not Neutral," in *Rupert García: The Magnolia Editions Projects* (Oakland, CA: Magnolia Editions, 2011), xiii. Between 1968 and 1975, García ceased painting except for two canvases. The National Portrait Gallery, Smithsonian Institution, recently acquired the artist's portrait *Rubén Salazar* (1970) from this period. A tear gas projectile killed *Los Angeles Times* journalist Salazar when the August 1970 National Chicano

Moratorium March broke into riots with police. Karlstrom, Oral History Interview, Archives of American Art.

4 Rupert García, "Chicano Poster Art" in *The Fifth Sun: Contemporary/Traditional Chicano & Latino Art* (Berkeley, CA: University Art Museum, 1977), 27–30.

5 Rupert García, interview for the exhibition *Decade of Dissent: Democracy in Action, 1965–1975*, Center for the Study of Political Graphics, Los Angeles, 2012, accessed September 21, 2018, https://www.youtube.com/watch?v=mQNAfKmAUF8.

6 In 1967, political scientist Rafael Guzmán published statistics on Mexican American deaths in Vietnam based on research he conducted for the Ford Foundation's Mexican American Study Project. Based on Spanish-language surnames of Vietnam War casualties as compared to then-current U.S. demographics, his findings were taken up by Chicano activists including the National Chicano Moratorium. See

Lorena Oropeza, "Antiwar Aztlán: The Chicano Movement Opposes U.S. Intervention in Vietnam," in *Window on Freedom: Race, Civil Rights, and Foreign Affairs, 1945–1988* (Chapel Hill: University of North Carolina Press, 2003), 207–8.

7 Lea Ybarra and Nina Genera, *La Batalla Está Aquí: Chicanos and the War* (El Cerrito, CA: Chicano Draft Help, 1972). The pamphlet includes images of Chicana/o protesters and reproduces drawings and paintings by García, Malaquias Montoya, and other artists.

8 Specifically, Ybarra and Genera argued against "the pull of militarized masculinity." See Belinda Linn Rincón, *Bodies at War: Genealogies of Militarism in Chicana Literature and Culture* (Tucson: University of Arizona Press, 2017), 57. *La Batalla Está Aquí* advocated "legal ways to stay out of the military," as stated on its cover. In 1973, the year following the pamphlet's publication, the U.S. government suspended its military draft system.

Liliana Porter | b. 1941, Buenos Aires, Argentina

THE FEMALE FIGURE IN *UNTITLED* (THE NEW YORK Times, *Sunday, September 13, 1970)* stares stoically forward, motionless. As suggested by the small type above the picture, which provides the work's sub-title—Liliana Porter excerpted and reprinted the image from a newspaper page, rendering it in high contrast. Without further contextual knowledge, one can only infer the scene the photograph depicts: a mostly unseen man reaches from outside the frame to adjust the automatic rifle pressed firmly against an Asian woman's temple. One might guess that he is an American soldier and she a Vietnamese being held on suspicion of communist affiliation.[1] *Untitled* (The New York Times, *Sunday, September 13, 1970)* does not, however, attempt a journalistic narrative. Porter is not providing a factual account of a specific incident; instead, she universalizes the woman to elicit our empathy. The print employs the relative "truth" of documentary photography in combination with poetic language to prompt a generative and capacious reading that honors in equal measure the immediate gravity of the woman's situation and her humanity.

Porter's early career spanned the Americas; Argentine by birth, she began her art training in Buenos Aires and studied printmaking in Mexico City in the late 1950s. Soon after emigrating to the United States, Porter cofounded in 1965 the New York Graphic Workshop with fellow South American expatriate artists Luis Camnitzer and José Guillermo Castillo.[2] The collective experimented with radical techniques for making prints in order to assert the medium's status as avant-garde art.[3] Despite their affiliation with politically motivated organizations and exhibitions, however, the New York Graphic

Workshop favored formal innovation over directly political content. Yet after the Workshop disbanded in summer 1970, Porter embraced an explicitly antiwar stance with *Untitled* (The New York Times, *Sunday, September 13, 1970).*[4] Given the imprimatur of the newspaper date above the image, a viewer in 1970 likely would have assumed that the artwork pictured current events in Vietnam. Photojournalist John Schneider in fact captured this harrowing moment several years earlier, in November 1967, and Porter extracted the photograph not from news coverage of the Vietnam War but from a *New York Times* review of the *2nd World Exhibition of Photography*, then on view at the New York Cultural Center. The exhibition had been organized in Germany two years prior under the broad theme of women as photographic subjects and was continuing to tour internationally.[5]

The catalogue for the *2nd World Exhibition of Photography* reproduces Schneider's photograph in a thematic section titled "Total War." It shares a page with three additional images of Vietnamese women in stages of grief, pain, and death [FIG. 1]. On the page opposite, women from Israel, the Dominican Republic, and Indonesia are shown as happy warriors, armed and smiling. Despite the active military role North Vietnamese women played in the war, the catalogue pictures no Vietnamese females wielding weapons.[6] By 1968, images of suffering and devastation in Vietnam had saturated Western media and consciousness.

Porter was likely attracted to the photograph in *Untitled* because it projects human dignity as well as victimization. The artist's poetic caption universalizes the woman's experience. She first positions the figure by gender and nationality, then relocates her identity through disparate geographies—to South Africa, Puerto Rico, Colombia—across places where colonialism and war have objectified and degraded populations. She begins with "black" (the "other" of colonial power) before naming her own

Liliana Porter

*Untitled (*The New York Times, *Sunday, September 13, 1970)*

1970
screenprint

THE NEW YORK TIMES, SUNDAY, SEPTEMBER 13, 1970

a photograph by John Schneider

This woman is
northvietnamese
southafrican,
puertorrican,
colombian,
black,
argentinian,
my mother,
my sister,
you, I.

FIG. 1
Karl Pawek, *2nd World
Exhibition of Photography*
(Hamburg: Gruner + Jahr,
1968), no pagination,
exhibition catalogue spread

native country ("argentinean"), followed by close
family members ("my mother, my sister"). Porter's
compassion ultimately guides each individual viewer
or reader to identify with this alienated, suffering
person as "you, I." **JM**

1 The Associated Press caption for
the photograph confirms this read-
ing, explaining that the man holding
the rifle was a U.S. soldier and the
woman was a Viet Cong suspect
being held for questioning by a South
Vietnamese national police officer at
Tam Kỳ in November 1967.

2 Luis Camnitzer (b. 1937) is a
German-born Uruguayan artist who
moved to the United States in 1964.
José Guillermo Castillo (1938–99)
was born in Venezuela. Florencia
Bazzano-Nelson, *Liliana Porter and
the Art of Simulation* (Burlington, VT:
Ashgate, 2008), 5.

3 The New York Graphic Workshop
focused on the medium's mechanical
and repetitive nature to redefine
it—printing, for example, on the side
of a ream of paper—in studies of lan-
guage, materials, and representation.

4 Porter printed *Untitled* at the
Collective Graphics Workshop, then
located inside the Women's Interart
Center in Hell's Kitchen, Manhattan.
The Workshop produced graphics
on commission (as was the case
with Porter's *Untitled*) as well as
original posters and screenprinted
items they sold at political events
and demonstrations. See Jacqueline
Skiles, "Anatomy of a Strategic
Alliance: The Door and the Creative
Women's Collective," *Journal of Arts
Management, Law and Society* 23,
no. 1 (Spring 1993): 51–68.

5 The exhibition showed the work
of 236 photographers. Karl Pawek,
2nd World Exhibition of Photography
(Hamburg: Gruner + Jahr, 1968);
and A. D. Coleman, "Photography:
A Mostly Male View of Women," *New
York Times*, September 13, 1970, D-33.

6 Pawek, *2nd World Exhibition of
Photography*, figures 280–87, n.p.

Dennis Oppenheim | b. 1938, Electric City, WA | d. 2011, New York City

IN 1970, DENNIS OPPENHEIM LAY ON JONES BEACH, Long Island, for five hours with volume two of William Balck's *Tactics: Cavalry, Field and Heavy Artillery in Field Warfare* (1914) on his bare chest.[1] Two photographs documenting the beginning and end of his action, deemed Stage I and Stage II, reveal that the artist's time on the beach left him sunburned everywhere except for the area covered by the book. This work, *Reading Position for Second Degree Burn*, engaged multiple creative trends of interest to Oppenheim: a performative use of the body; a turn to the environment as material; a consideration of photography, as documentary tool and otherwise; and an exploration of the connection between language and the visual.[2] Importantly, many of these artistic currents carried a special charge at a moment when the nation was well into—if still far from the end of—the war in Vietnam. Oppenheim's potential awareness of this fact is signaled by the book he opted to use; his selection of it, he told critic Willoughby Sharp, was something he thought about "for a long time."[3] *Reading Position* presents the artist as marked by warfare.

The notion of being marked and related thoughts of exposure are central to the work. During the late 1960s, Oppenheim began to conceive of his body as his medium.[4] In *Reading Position*, Oppenheim joined those artists—like Chris Burden [pp. 230-31] or Gina Pane—whose work pushed their stamina and endurance to the limits.[5] Rather than inflicting pain on himself, however, Oppenheim allowed his body to be acted upon. The artist remarked, "The piece incorporates an inversion or reversal of energy expenditure. The body was placed in the position of recipient, exposed plane, a captive surface.... You simply lie down and something takes over."[6] Made

during the year that saw the first Earth Day celebrated, Oppenheim highlights our mutual imbrication with the environment; it impacts us even as we fundamentally alter it.[7] Beyond the environmental realm in particular, the work also implies that exposure to the larger world scars us. Whereas at a glance Oppenheim's photographs might appear to be scenes of youthful leisure, documenting time spent at the beach, they come to metaphorize a generation prone before exterior forces. Oppenheim gives himself (his body) over to a greater power, here in the form of the sun, and consequently gets burned. One's ability to be shielded from weather—as from war, perhaps—is contingent, the work suggests, on having the appropriate tactics.

Exposure is important to the work in another way as well. While Oppenheim has connected *Reading Position* to traditions of painting by positioning his reddening skin as something like pigment, photography plays a key role, too.[8] Not only does the final work consist of photographs, but his body is also framed as photographic paper, left to be exposed, in the artist's words. With photography in mind, Oppenheim's comment that he could "feel the act of becoming red" is suggestive;[9] it pits felt color against its mediated image. At a moment when the U.S. population was being bombarded with images of war, Oppenheim's work seems an attempt to acknowledge corporeally—if ultimately insufficiently—the pain often pictured as well as a recognition of the beholder's distance—like that of the artist—from the lived suffering abroad.

That Oppenheim's burn was severe (second-degree) is pointed, especially given the situation in Vietnam. The artist retrospectively claimed: "From my point of view, Body Art was the most intense art form we have ever had because it asked so much of the artist and in quick concession. No one thought he would make it to thirty-five!"[10] Of course Oppenheim's cohort of artists was operating from a

Dennis Oppenheim

Reading Position for
Second Degree Burn

1970
color photograph

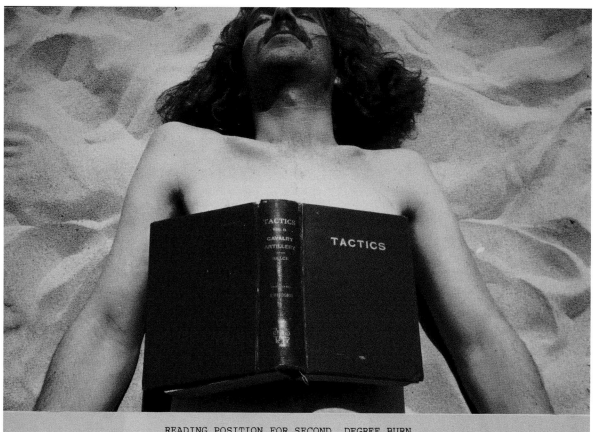

READING POSITION FOR SECOND DEGREE BURN
Stage I, Stage II. Book, skin, solar energy. Exposure time: 5 hours. Jones Beach. 1970

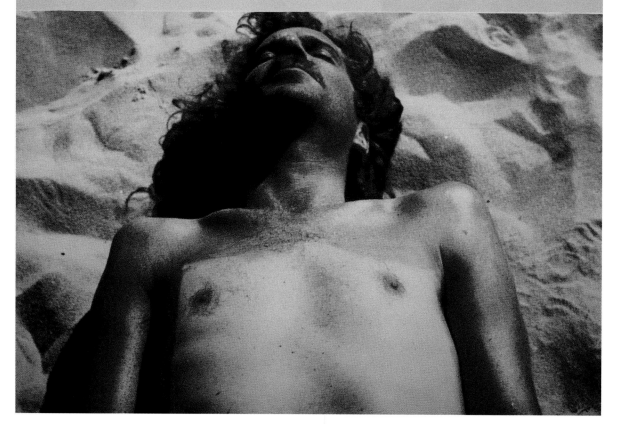

position of privilege as they creatively explored damaging bodies; they hardly faced the sort of dangers encountered by those in war zones, for whom the artist's proclaimed fear of a premature death was often all too real. Yet in doing actual physical harm to himself, Oppenheim nonetheless sought to register something of what many bodies in 1970 were made to endure. The body, as is frequently observed, was very much at stake at this historical moment; it was on the front lines not only of battle but also of the period's urgent social struggles from civil rights to antiwar efforts. The artist's weaponizing of the sun in particular may have had special resonance as reports of U.S. soldiers baking in the Vietnamese heat made their way home alongside stories of Vietnamese bodies also badly burned, far more gruesomely, by napalm. The seriousness of the burn also underscores the piece's temporal element, flagged linguistically in

the work by the phrase "exposure time." The damage done by the sun was a result of its steady beating down on Oppenheim's body. A similar relentlessness characterized the conflict in Vietnam. By 1970, years of engagement were adding up to grievous and heated consequences both abroad and at home. **KM**

1 See William Balck, *Tactics,* vol. 2, *Calvary, Field and Heavy Artillery in Field Warfare,* trans. Walter Krueger (Ft. Leavenworth, KS: U.S. Calvary Association, 1914).

2 For an overview of Oppenheim's work from this period, see Alain Parent et al., *Dennis Oppenheim: Retrospective, Works 1967–1977* (Montreal: Musée d'Art Contemporain, 1978). For a comprehensive monograph on the artist, see Germano Celant et al., *Dennis Oppenheim: Explorations* (Milan: Charta, 2001).

3 Willoughby Sharp, "Dennis Oppenheim Interviewed by Willoughby Sharp," *Studio International* 11 (November 1971): 188.

4 For more on Oppenheim's use of the body, see Nick Kaye and Amy van Winkle Oppenheim, *Dennis Oppenheim: Body to Performance 1969–73* (Milan: Skira, 2017).

5 The French Pane made three works related to the war in Vietnam: *Le Riz No. 1* (1970–71), *Action Escalade non-anesthésiée* (1971), and *Nourriture/ Acutalités télévisées/Feu* (1971). See Frédérique Baumgartner, "Reviving the Collective Body: Gina Pane's

Escalade non-anesthésiée," Oxford Art Journal 34, no. 2 (June 2011): 247–63.

6 Sharp, "Dennis Oppenheim Interviewed by Willoughby Sharp," 188.

7 In 1962, Rachel Carson published *Silent Spring,* which was excerpted in the *New Yorker* in June of that year. The environmental movement grew over the decade, with 1970 marking the first Earth Day. Oppenheim suggests something of the relation between his body and the earth when he tells Sharp in 1971, "I was interested in land as a parallel surface to skin." See Sharp, "Dennis Oppenheim Interviewed by Willoughby Sharp," 187.

8 See Anne Rorimer, "Reconfiguring Representation: Mechanical Reproduction and the Human Figure in Conceptual Art," in *Light Years: Conceptual Art and the Photograph,* ed. Matthew Witkovsky (Chicago: Art Institute of Chicago, 2011), 207–13.

9 Sharp, "Dennis Oppenheim Interviewed by Willoughby Sharp," 188.

10 Assumpta Bassas, "Interview with Dennis Oppenheim," in Celant et al., *Dennis Oppenheim: Explorations,* 335.

Yvonne Rainer | b. 1934, San Francisco, CA

THE AMERICAN FLAG TWICE BECAME A PLAYER in works by Yvonne Rainer in the fall of 1970, a moment when the nation's social upheaval was very much on her mind. In May of that year she wrote, "I am going thru [sic] hard times: In the shadow of real recent converging, passing, pressing, milling, swarming, pulsing, changing in this country, formalized choreographic gestures seem trivial"; she then underscored her ambivalence with a "Maybe fuck it."[1] As Carrie Lambert-Beatty has incisively elucidated, what the tumultuous political backdrop of the later 1960s meant for Rainer's choreographic practice was an ongoing and motivating question for the artist.[2] A leading figure of avant-garde dance during that decade, Rainer departed from the expressiveness and explicit virtuosity of traditional theatrical dance and instead mobilized neutral or ordinary movements and task-like actions, often available to dancers and nondancers alike. This stripped-down dance was frequently aligned with the less overtly political output of the minimalists, and in a 1968 statement Rainer argued that "ideological issues" had "no bearing on the nature of the work," adding, "neither does the tenor of current political and social conditions have any bearing on its execution."[3] Yet, importantly, she caveated this claim with doubts about its long-term viability, and in 1970 political and social conditions came to the fore in her *Trio A with Flags* and *WAR*.[4] With these works, Rainer excavated fresh meaning from her potentially "trivial" choreography, allowing familiar strategies to adopt new thrust as the ordinary increasingly appeared to be anything but.

Trio A with Flags was first performed on November 9, 1970, as part of *The People's Flag Show* at Judson Memorial Church, New York, an exhibition organized as a protest of flag desecration laws.[5] The event featured more than 150 works deploying that freighted symbol, each a response of sorts to a question posed in Faith Ringgold's poster for the show: "What does the flag mean to you?" Rather than choreograph something new, Rainer turned to *Trio A*, a work first danced in 1966 and among her most ambitious to date.[6] Lasting roughly four and a half to five minutes and performed by three dancers simultaneously though not necessarily in unison, *Trio A* is devoid of phrasing and climax alike. It instead presents as a steady continuum of movement executed by what Rainer has called a "neutral 'doer.'"[7] Whereas in performances of *Trio A* the dancers wore street clothes, in *Trio A with Flags* the now-six participants first tied three-by-five-foot flags around their necks, then stripped before entering a crowd that cleared for them, and executed the work twice.[8] The group danced in silence, and this respectful quiet encouraged meditation on the relationship between the flag and the body; between the state—and, for many in the audience, its warmongering—and the vulnerability of bared flesh.[9]

As choreography, *Trio A* underscored the fact that, in Rainer's words, "dance is hard to see."[10] That difficulty was then heightened by the flag, which, draped in front of the dancers, hid details of the body's already hard-to-track movements. The flag's ability to conceal was undoubtedly topical: questions about what the government had not disclosed with respect to Vietnam had been mounting since the 1968 Tết Offensive and reached a crescendo when Nixon announced his unexpected expansion of the war into Cambodia in the spring of 1970, prompting massive protests. Significantly, however, Rainer's flags just as often reveal. Swinging through the air as the dancers moved, the flags variously and repeatedly exposed each participant anew. As this still-taboo public nudity underscored the work's (and exhibition's) protest of censorship, the flags' revelations also conjure the way Seymour Hersh pulled back the curtain on

Peter Moore

Photographs of
Yvonne Rainer's
Trio A with Flags

1970
performance

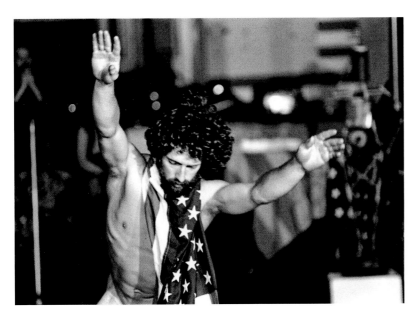

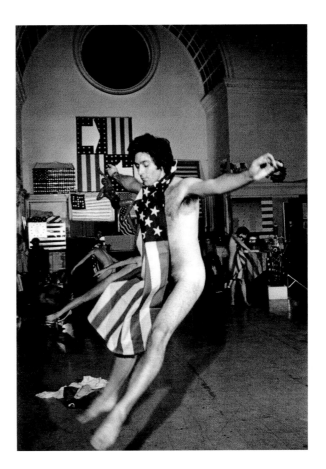

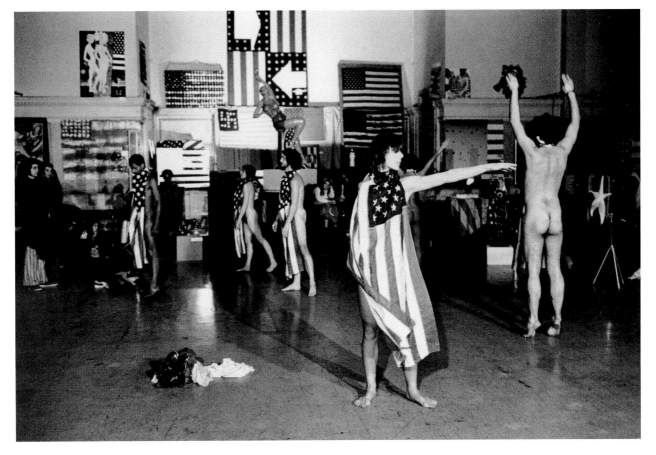

Peter Moore

Photographs of Yvonne
Rainer's *WAR* at the
Loeb Student Center,
New York University

1970
performance

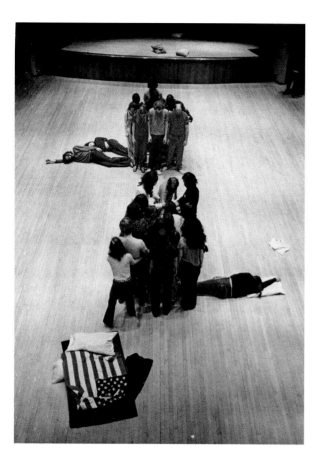

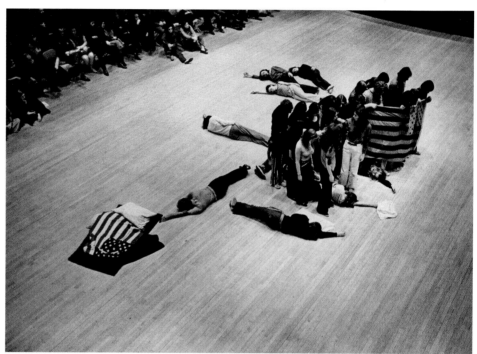

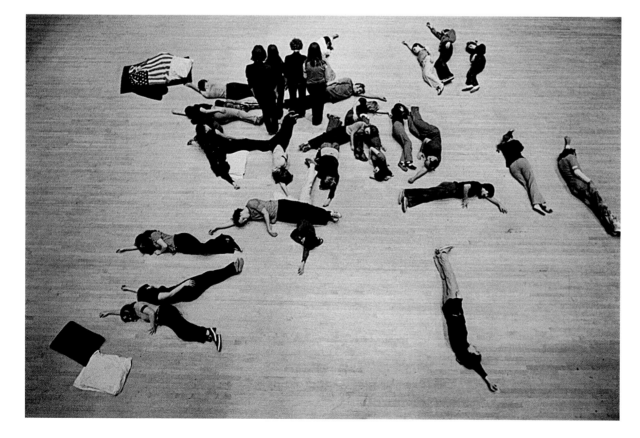

the Sơn Mỹ (My Lai) massacre in 1969, for example, or how the publication of the Pentagon Papers would soon uncover the depths of government deceit about the conflict abroad. The density of bodies dancing in the confined space of the church is striking in this context; a range of (American) concealments and revelations were simultaneously on display, with no indication of where the flag would finally settle.

A related uncertainty seems to animate *WAR*. Presented three times in November 1970, the approximately forty-minute work was executed by roughly thirty performers, many of them nondancers.[11] In preparing *WAR*, Rainer made a list of verbs drawn from newspaper accounts of Vietnam as well as texts dealing with other military conflicts. She then used those verbs—mobilize, occupy, resist—to create the work's largely task-based vocabulary. Split into two teams, the performers enacted these movements in an indeterminate order while a narrator read excerpts from Rainer's textual source material. The participants' freedom to improvise—the relinquishing of authorial control increasingly became a feature of Rainer's work in the later 1960s—seems symptomatic of the moment's larger distrust of authority. Moreover, within a wartime context, danced and lived alike, such improvisation begs timely questions about who is or should be in charge and about the agency that bodies on the front lines, so to speak, do or should possess. Yet Rainer also deliberately differentiated her "ass-backwards war" from the one raging abroad.[12] The two flags manipulated throughout the performance—one the standard red, white, and blue; the other made by Donald Judd after the black, green, and orange flag Jasper Johns had created the previous year for the Moratorium to End the War in Vietnam—kept thoughts of battlefields front and center, but these ensigns were hardly fiercely protected. Similarly, although photographs of the performance show teams huddling in opposition to one another and bodies strewn across the floor as if

felled during armed conflict, the movements themselves were not overtly aggressive; a group could "occupy" the other, for example, by simply standing among them. This cool abstraction of warlike maneuvers might suggest Rainer was more interested in outlining the rules of engagement than in any battle's ferocity or outcome. And in the aftermath of reports of massacres, potentially unlawful expanded bombings, and students shot by those meant to safeguard them, who could blame her? **KM**

1 Yvonne Rainer, "Statement on May 11, 1970," in *Information*, ed. Kynaston McShine (New York: Museum of Modern Art, 1970), 116.

2 See Carrie Lambert-Beatty, *Being Watched: Yvonne Rainer and the 1960s* (Cambridge, MA: MIT Press, 2008), esp. 143–52, 199–250.

3 Yvonne Rainer, "Statement," program for *The Mind Is a Muscle* (March 1968), in *Yvonne Rainer: Work 1961–73* (Halifax: Press of the Nova Scotia College of Art and Design, 1974), 71.

4 Ibid. By 1970, Rainer was also engaged in protest activities through her association with the Art Workers' Coalition.

5 More specifically, this show took up the cause of gallery owner Stephen Radich, who had been convicted in 1967 for casting contempt on the American flag. Charges against him were filed owing to his 1966 exhibition of works by former marine Marc Morrel that used the flag to protest Vietnam. For more on Radich, Morrel, and *The People's Flag Show*, see Matthew Israel, *Kill for Peace: American Artists against the Vietnam War* (Austin: University of Texas Press, 2013), 63.

6 There exists a growing body of literature on *Trio A*. See Elise Archias, *The Concrete Body: Yvonne Rainer, Carolee Schneemann, Vito Acconci* (New Haven, CT: Yale University Press, 2016), 30–35, 66–76; Lambert-Beatty, *Being Watched*, 127–65; Julia Bryan-Wilson, "Practicing *Trio A*," *October* 140 (Spring 2012): 54–74; and Catherine Wood, *Yvonne Rainer: The*

Mind Is a Muscle (London: Afterall Books, 2007). Rainer had already intimated the dance's political potential when she performed a version of it as *Convalescent Dance*—so named because she danced it while recovering from surgery—in another protest context, Angry Arts Week in January 1967.

7 Yvonne Rainer, "A Quasi Survey of Some 'Minimalist' Tendencies in the Quantitatively Minimal Dance Activity Midst the Plethora, or an Analysis of *Trio A*," in *Minimal Art: A Critical Anthology*, ed. Gregory Battcock (New York: E. P. Dutton, 1968; Berkeley: University of California Press, 1995), 267.

8 The work was danced by Rainer, Barbara Dilley, David Gordon, Nancy Green, Steve Paxton, and Lincoln Scott.

9 Lambert-Beatty attends to this juxtaposition in *Being Watched*, 211–12.

10 Rainer, "A Quasi Survey," 271.

11 *WAR* was performed at Douglass College, the Smithsonian Institution's Museum of History and Technology, and the Loeb Student Center at New York University. Work on the project had started during a residency at George Washington University. For more on *WAR*, see Lambert-Beatty, *Being Watched*, esp. 229–50. The number of dancers appears to have varied slightly across performances.

12 Yvonne Rainer, "War, Judson Flag Show, Indian Journal, Grand Union Dreams," in *Yvonne Rainer: Work 1961–73*, 161.

Edward Kienholz | b. 1927, Fairfield, WA | d. 1994, Sandpoint, ID

IN 1970, TWELVE YEARS BEFORE THE VIETNAM
Veterans Memorial was dedicated in Washington,
D.C., Edward Kienholz proposed what he called
The Non-War Memorial. "Non" because, as the artist
explained, "[W]hat had been the point? What on
earth was there to celebrate?"[1] Never fully real-
ized, the piece initially existed only as a Concept
Tableau, taking the form of a one-page prospectus
and a brass plaque inscribed with its title.[2] In 1972,
Kienholz expanded the gallery presentation of the
work to include a book of photographs titled *The Non-
War Memorial Book* and five army uniforms to be
filled with sand and sprawled on the floor like corpses.
These elements only gesture at the artist's full vision,
described in a statement shown here [FIG. 1].

True to its name, the imagined *Non-War Memorial*
upends conventional expectations of how a war
memorial should perform. Refusing nationalistic
pageantry or narratives of heroic sacrifice, the piece
situates the beholder in a landscape of vast waste
and destruction. Writer Lawrence Weschler reported
that Kienholz said of *The Non-War Memorial* that he
"wanted to see how much time and effort it would
take to create all that death."[3] Rather than statistics
flashed on a television screen (as referenced in the
artist's earlier work *The Eleventh Hour Final*; see
p. 115), the human toll of the Vietnam War would
become a literal burden—tons and tons of clay
corpses to be strenuously borne by willing citizens
into a devastated landscape. The physical work of
processing "[five hundred] bodies a day, seven days
a week, for more than three months" is translated
in *The Non-War Memorial Book* as 1,142 pages of pic-
tures of lifeless "bodies." While not depicting actual
people, these 50,000 photographs[4] of clay-filled

uniforms posed in the landscape evoke genuine images
of war violence and are surprisingly disturbing—much
more so than the army surplus uniformed corpses
displayed nearby.

The gridded format of the pages in *The Non-War
Memorial Book* [FIG. 2] echoes that of the famous *Life
Magazine* feature "Faces of the American Dead in
Vietnam: One Week's Toll" [p. 129], which in June
1969 provoked an intense emotional response. The
twelve-page spread, showing portrait after portrait
of young Americans killed during a single week in
Vietnam, prompted readers to "look into the faces"
of those lost; the accompanying text read, "More
than we must know how many, we must know who."[5]
By contrast, *The Non-War Memorial* offers no human-
izing specifics, foregrounding instead the brute corpo-
real effects of warfare, featureless bodies, appearing,
as the cliché goes, like limp rag dolls. What neither
Kienholz nor *Life Magazine* acknowledges are the
names, faces, or bodies of the millions of Southeast
Asian people brutalized and consumed in the conflict—
a volume of death that dwarfs the total number of
U.S. casualties.[6] The Vietnam Veterans Memorial
designed by Maya Lin similarly does not address
foreign losses, including the estimated 250,000
South Vietnamese fighters who died serving along-
side U.S. forces.[7]

Kienholz's directives to plow under the vegetation
and to chemically kill the soil as part of *The Non-War
Memorial* suggests he was not oblivious to the dire
ecological impact of the U.S. military intervention in
Southeast Asia. Environmental damage was not an
incidental side effect of the war in Vietnam. Chemical
and mechanical deforestation and massive rural
bombing were deliberate strategies aimed at depriv-
ing communist forces physical cover, food crops, and
community support. Destroying a "beautiful field of
alfalfa and wildflowers" in pristine northern Idaho
meant bringing a tiny bit of the Vietnam War home
to the American West.[8] Kienholz might also have had

Edward Kienholz

The Non-War Memorial

1970 / 1972
military uniforms, sand, book,
acrylic vitrine, plaque, and
printed statement

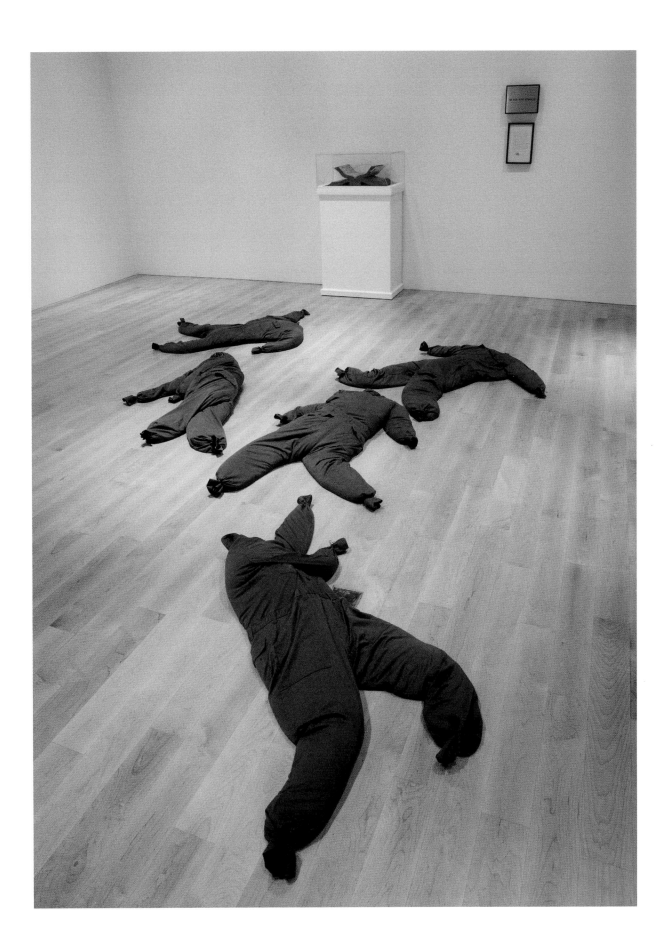

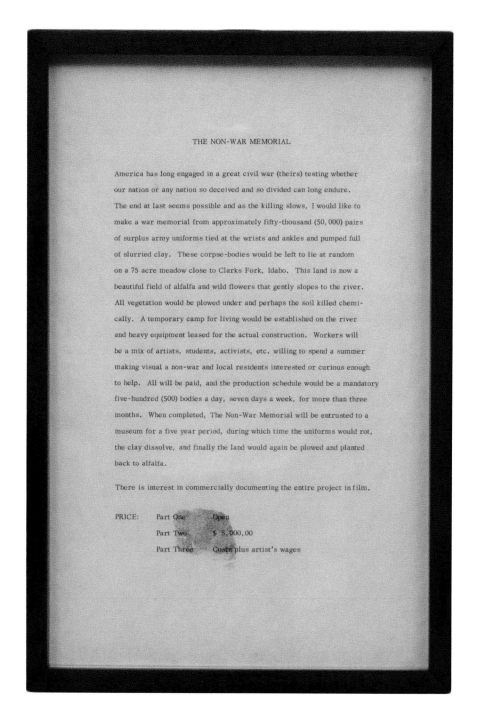

THE NON-WAR MEMORIAL

America has long engaged in a great civil war (theirs) testing whether
our nation or any nation so deceived and so divided can long endure.
The end at last seems possible and as the killing slows, I would like to
make a war memorial from approximately fifty-thousand (50,000) pairs
of surplus army uniforms tied at the wrists and ankles and pumped full
of slurried clay. These corpse-bodies would be left to lie at random
on a 75 acre meadow close to Clarks Fork, Idaho. This land is now a
beautiful field of alfalfa and wild flowers that gently slopes to the river.
All vegetation would be plowed under and perhaps the soil killed chemi-
cally. A temporary camp for living would be established on the river
and heavy equipment leased for the actual construction. Workers will
be a mix of artists, students, activists, etc. willing to spend a summer
making visual a non-war and local residents interested or curious enough
to help. All will be paid, and the production schedule would be a mandatory
five-hundred (500) bodies a day, seven days a week, for more than three
months. When completed, The Non-War Memorial will be entrusted to a
museum for a five year period, during which time the uniforms would rot,
the clay dissolve, and finally the land would again be plowed and planted
back to alfalfa.

There is interest in commercially documenting the entire project in film.

PRICE: Part One Open
 Part Two $ 5,000.00
 Part Three Costs plus artist's wages

FIG. 1
Edward Kienholz, *The Non-War
Memorial* description, 1970

in mind the ancient ritual of salting and cursing the land of the vanquished, as the Romans are said to have done at Carthage.[9] His proposal to kill a plot of American soil would seem an act of penance for the devastating effect on the environment of Operation Ranch Hand, the U.S. military's massive program of herbicidal warfare in Vietnam. Notably, Kienholz designed *The Non-War Memorial* as an unfixed, ephemeral work. Its presumed impermanence is this dark memorial's most optimistic aspect. The uniforms and clay would, Kienholz thought, decompose in five years and the site would be replanted to its prior beauty. Postwar environmental recovery in Southeast Asia has been much slower and more difficult in reality. Victims of Agent Orange dioxin exposure (including Americans, Laotians, and Cambodians but primarily Vietnamese) continue to suffer from its debilitating and lethal effects, and the clearing of ordnance and toxic chemicals from Southeast Asia remains a formidable challenge.[10] **MH**

FIG. 2
Edward Kienholz, *The Non-War
Memorial Book*, 1972

1 Lawrence Weschler, "A Thought Experiment (or who knows? perhaps something more) Arising from a Consideration of Ed Kienholz's Proposed *Non-War Memorial* (1970) and Other Such Memorials of that Ilk," *Glasstire,* September 21, 2014, http://glasstire.com/2014/09/21/ed-kienholzs-proposed-non-war-memorial-1970-and-other-such-memorials-of-that-ilk/.

2 In the 1960s, Kienholz initiated his practice of creating Concept Tableaux, proposals for ambitious works he did not have the means or opportunity to execute immediately. Represented by a plaque and a written description, the works were made available for sale, priced at what the artist estimated was one-third of the total cost needed to execute a given project. The owner of the concept would then have the option to pay Kienholz to physically realize the work. A few Concept Tableaux were purchased but never actualized. Others Kienholz himself later chose to complete, including his other unconventional memorial conceived during the Vietnam conflict, *The Portable War Memorial* (1968). See Walter Hopps, *Kienholz: A Retrospective* (New York: Whitney

Museum of American Art, 1996), 35. *The Portable War Memorial* [p. 291] is now in the collection of the Museum Ludwig in Cologne, Germany, where it remains on long-term view.

3 Weschler, "A Thought Experiment."

4 Ibid. Weschler reported that Kienholz did not document 50,000 different "bodies" but rather photographed "a half dozen or so such mock-ups, reproducing the results rightside up and upside down and sideways and backwards and so forth, till they initially read as 50,000 separate corpses."

5 The photographs and names of 242 U.S. soldiers were included in "Vietnam: One Week's Dead," *Life,* June 27, 1969.

6 The National Archives today counts 58,220 U.S. casualties of the Vietnam War. National Archives, "Vietnam War U.S. Military Fatal Casualty Statistics," accessed August 8, 2018, https://www.archives.gov/research/military/vietnam-war/casualty-statistics.
 The Socialist Republic of Vietnam released figures in 1995 estimating that nearly two million civilians and more than one million fighters died

during the war. Encyclopedia Britannica, "Vietnam War, 1954–1975," accessed August 8, 2018, https://www.britannica.com/event/Vietnam-War. The United States estimates that between 200,000 and 250,000 South Vietnamese fighters also died during the war.

7 Chris Burden's *The Other Vietnam Memorial* (1991, Museum of Contemporary Art, Chicago) addresses the American lack of awareness of the scale of Vietnamese deaths during the war by presenting some three million Vietnamese names etched on a series of towering copper plates. However, because no actual record of the Vietnamese dead is available, the artist had to computer-generate most of his list, working from names drawn from Vietnamese phone books. See Christopher Knight, "Chris Burden's 'The Other Vietnam Memorial' Is an Unsentimental Reminder of the War," *Los Angeles Times,* May 11, 2015, http://www.latimes.com/entertainment/arts/la-et-cm-chris-burden-vietnam-war-memorial-reminder-19920628-column.html. The Socialist Republic of Vietnam has erected numerous memorials—such as the prominent War Memorial in

Hà Nội —that honor fighters who died serving on the communist side of the war. The Vietnam War Memorial in Westminster, California, an area home to nearly 200,000 Vietnamese Americans, acknowledges both South Vietnamese and U.S. soldiers killed during the war. A small monument dedicated to Hmong and Laos combat veterans of the war is at Arlington National Cemetery outside Washington, D.C.

8 Kienholz once owned the property described in the proposal for *The Non-War Memorial*, but the land was later lost to an "ex-wife." The artist cited this as one of the reasons the work was never fully completed. LA Louver blog, July 20, 2017, http://blog.lalouver.com/post/163231531154/ed-kienholz-initially-conceived-the-non-war#.W2ssUIonbm8.

9 The Romans are often described as having covered the land with salt to prevent anything from growing after the Battle of Carthage (ca. 149 BCE), though modern scholars have not found evidence in ancient sources to support this claim.

10 For a short analysis of the lingering problem of unexploded ordnance and dioxin contamination in Vietnam,

see Ariel Garfinkel, "The Vietnam War Is Over. The Bombs Remain.," *New York Times*, March 20, 2018, https://www.nytimes.com/2018/03/20/opinion/vietnam-war-agent-orange-bombs.html. For more on current efforts to address Agent Orange dioxin contamination in Vietnam, see Le Ke Son and Charles R. Bailey, *From Enemies to Partners: Vietnam, the US and Agent Orange* (Chicago: G. Anton Publishing, 2017). In 2012, the United States embarked on the first and so far only American reclamation effort of a dioxin site in Vietnam, at the former U.S. air base in Đà Nẵng; the project is expected to be complete in 2018. U.S. Agency for International Development, "Environmental Remediation of Dioxin Contamination at Danang Airport Project Frequently Asked Questions," last modified August 3, 2018, accessed August 8, 2018, https://www.usaid.gov/vietnam/environmental-remediation-dioxin-contamination-danang-airport-project-frequently-asked-questions.

1971

The Winter Soldier Investigation, sponsored by Vietnam Veterans against the War, takes place in Detroit, **JANUARY 31** to **FEBRUARY 2**. More than one hundred Americans testify to war crimes they committed or witnessed in Vietnam from 1963 to 1970. By this time, VVAW's membership has grown to more than 20,000.

To demonstrate that Vietnamization is working, President Nixon urges President Nguyễn Văn Thiệu to pursue an independent military operation. In **FEBRUARY**, ARVN forces are sent into Laos to cut off the Hồ Chí Minh Trail (Operation Lam Son 719). All but 9,000 of 17,000 ARVN soldiers are killed or captured during the mission.

For the atrocities at Sơn Mỹ, Lt. William Calley is the only one convicted. He is sentenced to life in prison on **MARCH 31** for murdering twenty-two Vietnamese civilians. Public opinion polls show that 79 percent of Americans disagree with the verdict. After a few months, Calley's sentence is reduced from life in prison to twenty years. He will be pardoned by President Nixon in 1974.

Over five days in **APRIL**, Vietnam Veterans against the War stages its first national protest, Operation Dewey Canyon III, in Washington, D.C. [FIG. c29] Taking its name from an unofficial U.S. military incursion into Laos and Cambodia, the demonstration draws more than a thousand Vietnam War veterans from across the country. On the final day, more than 800 veterans toss their military medals over barricades erected to keep the protesters off the steps of the U.S. Capitol Building.

FIG. c29 Members of Vietnam
Veterans against the War
demonstrate at Arlington
National Cemetery, outside
of Washington, D.C., 1971.
Photo by Steven Clevenger

On **JUNE 13**, the *New York Times* begins publishing excerpts from the classified study of U.S. decisions in Vietnam that had been prepared at the request of Secretary of Defense Robert McNamara beginning in 1967. Known as the Pentagon Papers, the document is leaked by former Department of Defense official Daniel Ellsberg. According to the report, presidents from Truman to Johnson have manipulated congressional and public opinion through misrepresentation and secrecy. The Nixon White House appeals to the Supreme Court to halt further publication, but the court decides on **JUNE 30** in favor of the *Times* [FIG. c30]. Ellsberg is arrested and criminally charged for the leak.

The Nixon administration's illegal activities (later known as the Watergate scandal) begin in the wake of the Pentagon Papers' release. Concerned that his own war-related secrets will be revealed by Ellsberg, Nixon creates a White House Special Investigations Unit in **LATE 1971**. Initially aimed at combating leaks and discrediting political enemies, this covert unit, nicknamed the "plumbers," will go on to engage in unlawful activities on behalf of Nixon's reelection campaign, eventually leading to the Watergate hearings in 1973 and the president's resignation in 1974.

Running unopposed, President Nguyễn Văn Thiệu is reelected **OCTOBER 2** as president in South Vietnam.

The first issue of *Ms. Magazine*, cofounded by Gloria Steinem and Letty Cottin Pogrebin, is published in **DECEMBER**.

By the **END OF 1971**, U.S. troop levels in Vietnam are down to 156,800 [FIG. c31].

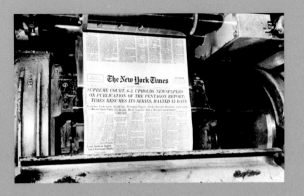

FIG. c30 *New York Times* headline declares that the U.S. Supreme Court upholds the paper's right to publish the Pentagon Papers, 1971. Photo by Jim Wells

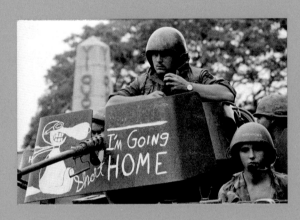

FIG. c31 American tank crew in South Vietnam, 1971.

Philip Jones Griffiths | b. 1936, Rhuddlan, Wales | d. 2008, London

WRITING IN 1972, WITH THE CONFLICT IN
Vietnam still ongoing, critic John Berger reflected
on the paradoxical effect of war photography. A
photograph that captures a moment of wartime
terror, death, or grief is often assumed to elicit moral
concern and political action. Berger observed, how-
ever, that such an image, when allowed to exist by
itself, "effectively depoliticizes" the events that led
to its existence: "The picture becomes evidence of
the general human condition. It accuses nobody and
everybody."[1] In the absence of relevant political and
ethical knowledge, a photograph can only say, "War
is hell, people suffer, and that is how the world is."

Philip Jones Griffiths resisted trafficking in such
easy generalities. His book *Vietnam Inc.* is the most
penetrating critical investigation of the Vietnam
War created by a photographer. Arriving in South
Vietnam in 1966, Griffiths set out to do more than
record fleeting moments of conflict; he was deter-
mined to unravel the war's dynamics and to con-
struct an in-depth analysis of what he came to see as
a tragically misguided clash between cultures. Such
a goal could not be fulfilled by selling individual
photographs to magazines and newspapers, thereby
allowing editors to decide which pictures to publish
and how. Instead, from the outset, Griffiths endeav-
ored to create a book over which he maintained full
authorial control, an unusual aim for a photojour-
nalist at the time.[2] He said, "All wars produce the
familiar iconic images of horror, which do little to
further anyone's understanding of a particular con-
flict. My purpose was to understand the nature of
the [Vietnam] war, and reveal the *truth* about it, with
photographs providing the visual proof. The pho-
tographs are the *evidence*."[3] Between 1966 and 1971,

Griffiths spent a total of three years in South Vietnam,
assiduously building a body of evidence.[4] He worked
"as if [he were] a police detective, following up on
every clue."[5]

The photographs in *Vietnam Inc.* do not appear
in the isolated, discontinuous fashion criticized by
Berger. Instead, the book's more than 260 pictures
are put in careful juxtaposition and sequence and
accompanied by texts, both short and long, written
by the photographer. Griffiths designed *Vietnam
Inc.* to encourage multiple readings and deepening
comprehension. Upon initial encounter, striking
visual images capture a viewer's attention. Next, the
captions—sometimes a mere sentence, sometimes an
entire paragraph—engage the mind further, convey-
ing often startling contextual information that com-
pels renewed concentration on the photos. Finally,
the longer texts, a series of thematic essays inter-
spersed throughout the book, can be read for deeper
analysis. Griffiths's voice, sardonic and astute, comes
through clearly. His writing is openly polemical, at
times scathing in tone. Much of the knowledge he
conveys is anecdotal, and powerfully so; his insights
have been recognizably earned through sustained,
firsthand observation of the war and its players.

Unlike many photojournalists who covered the
Vietnam War, Griffiths did not make combat his
primary subject. As his body of work attests, he cer-
tainly didn't avoid the heat of battle; indeed, he was
furious to find himself outside of Vietnam for the
first time in a year and a half when the Tết Offensive
broke out in 1968 and was desperate to return. (He
managed to be readmitted to the country quickly
enough to photograph the fighting in Huế.) But for
Griffiths, the most essential story of the war was the
collision he observed between two profoundly differ-
ent cultures, American and Vietnamese. In *Vietnam
Inc.*, he sought to convey how the war was not only
killing and injuring hundreds of thousands of people
but also radically transforming an entire society,

Philip Jones Griffiths

Vietnam

1967
gelatin silver print

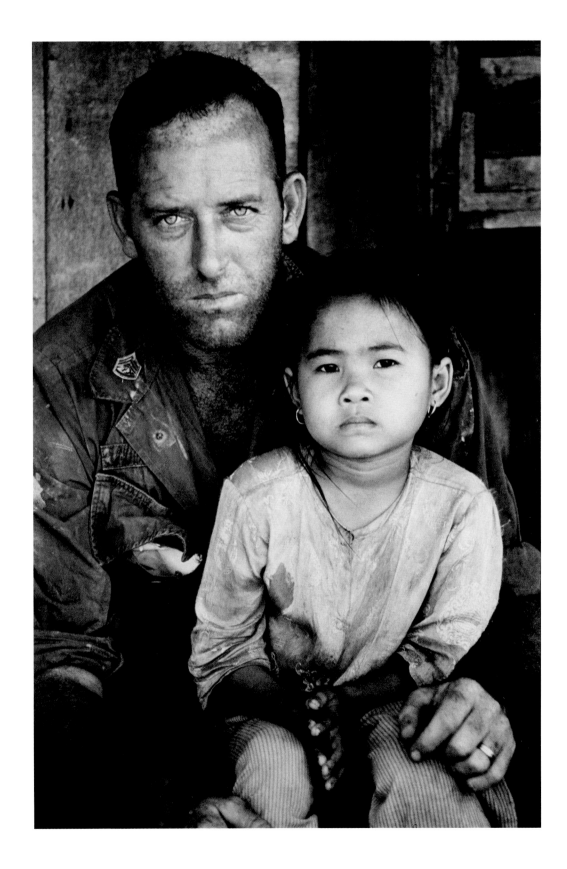

212

Philip Jones Griffiths

Vietnam

1970
gelatin silver print

Philip Jones Griffiths

Vietnam

1970
gelatin silver print

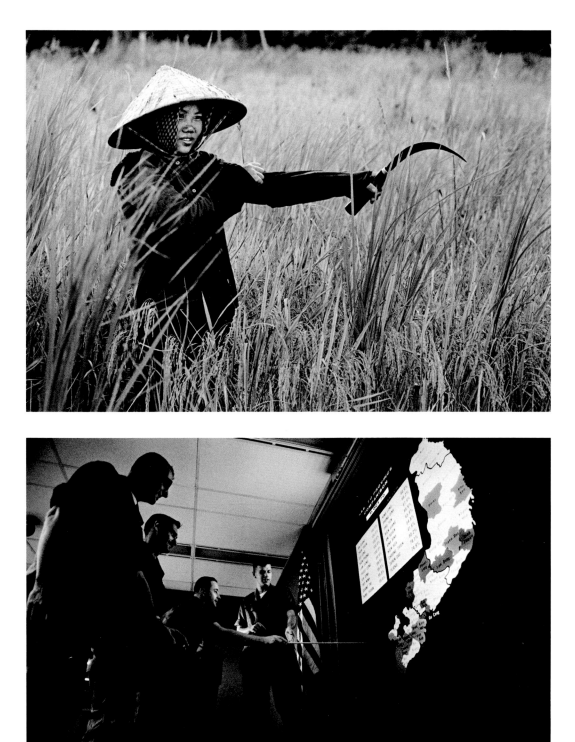

Philip Jones Griffiths

Vietnam

1967
gelatin silver print

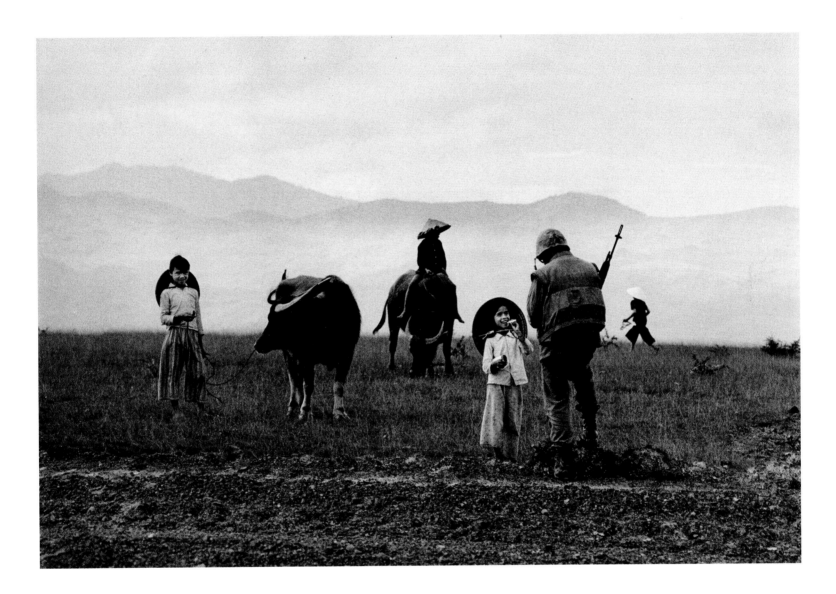

Philip Jones Griffiths

Vietnam

1970
gelatin silver print

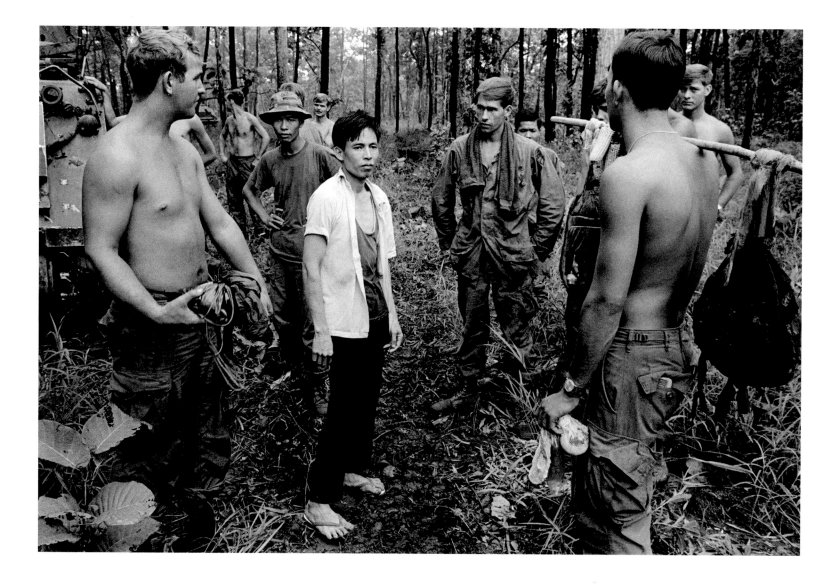

Philip Jones Griffiths

Qui Nhon, Vietnam

1967
gelatin silver print

Philip Jones Griffiths

Danang, Vietnam

1967
gelatin silver print

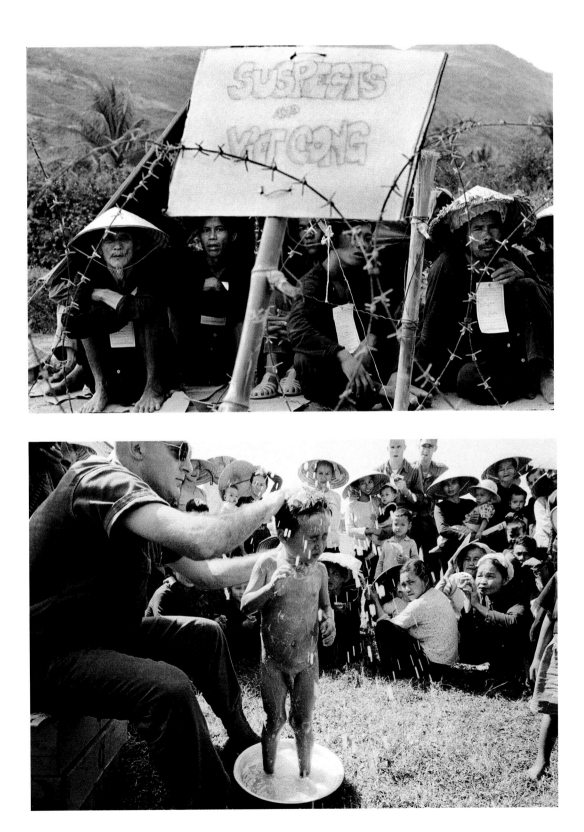

Philip Jones Griffiths

Saigon, Vietnam

1968
gelatin silver print

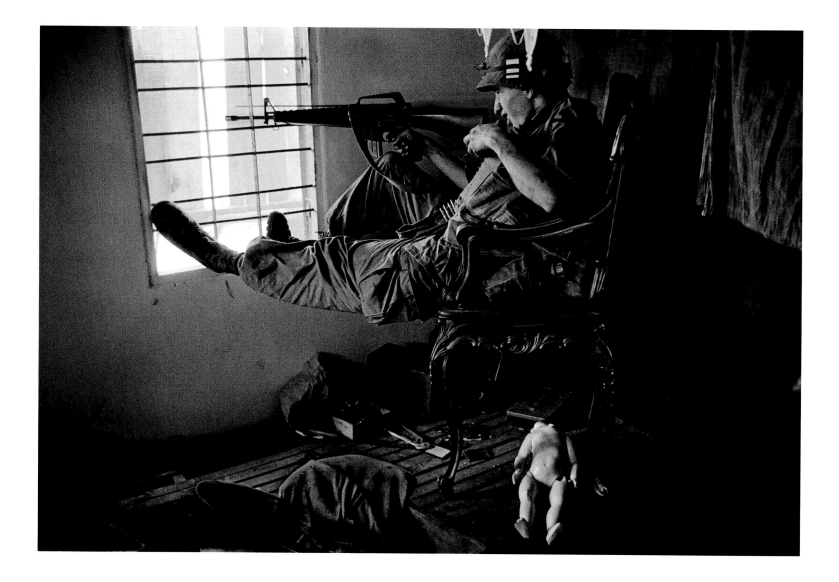

Philip Jones Griffiths

Saigon, Vietnam

1968
gelatin silver print

Philip Jones Griffiths

Can Tho, Vietnam

1967
gelatin silver print

Philip Jones Griffiths

Nha Be, Vietnam

1970
gelatin silver print

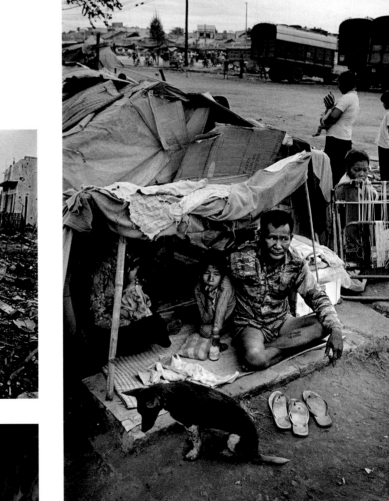

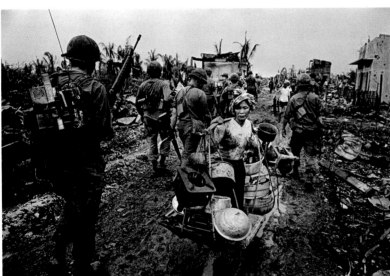

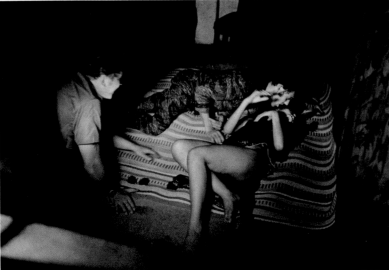

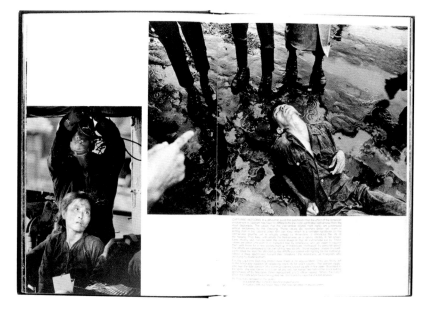

Vietnam Inc. is notable for the attention it pays to its Vietnamese subjects, who are shown in great variety, living out their lives in the country, the city, and around U.S. military bases.[7] Griffiths's admiration for the resilience and dignity of ordinary Vietnamese is clear, as is his dismay with what he considered the painful naïveté of most of the Americans caught up in the war. He was a keen observer of everyday encounters between GIs and civilians. His camera registered countless moments of distrust, frustration, exploitation, and, above all, miscommunication between the two: a girl delicately pickpocketing a brawny soldier in the middle of a crowded street, an American demonstrating the "proper" way to wash a baby before a group of disbelieving Vietnamese mothers, a farmer mistaken for a guerrilla fighter because of the circles under his eyes. But he also presents small moments of shared humanity, as in the dual portrait that opens *Vietnam Inc.* of an American staff sergeant with a Vietnamese girl perched on his lap. Huddled together, they face the camera soberly. The two appear as weary comrades in arms in a war whose course is beyond either one's understanding or control. **MH**

driving masses of rural Vietnamese into urban slums, overturning traditional social structures and gender roles, and encouraging a shift to a consumer-based culture (hence the title of the book). The United States' "misplaced confidence in the universal goodness" of its values and its blindness to the internal politics, history, and culture of Vietnam were, Griffiths believed, the animating force behind this catastrophic war.[6]

1 John Berger, "Photographs of Agony" (1972), in *About Looking* (New York: Pantheon Books, 1980), 40.

2 The papers of Philip Jones Griffiths indicate that he arrived in South Vietnam with a book contract executed with the publisher Donald Carroll. Due to the length of time that the project ultimately took, Griffiths later returned his advance to Donald Carroll and eventually published *Vietnam Inc.* in the United States with MacMillan. When Griffiths began his work in Vietnam, he had recently been nominated to the esteemed cooperative photo agency Magnum, which had been founded in 1947 with the aim of allowing its member-photographers to retain copyright of their pictures and to pursue stories

of their own choosing. Magnum photographers could therefore spend much more time investigating a subject than was possible when working on commissioned assignment. While in South Vietnam, Griffiths did, through Magnum, sell his photographs to magazines and newspapers, which helped support his major project of producing a book. See the Philip Jones Griffiths papers, uncatalogued, National Library of Wales, Aberystwyth. For the impact of Magnum on the practice of documentary photography, see Brett Abbott, "Engaged Observers: In Context," in *Engaged Observers*, ed. Brett Abbott (Los Angeles: The J. Paul Getty Museum, 2010), 1–31; and Clément Chéroux

and Clara Bouveresse, eds. *Magnum Manifesto* (London: Thames & Hudson, 2017).

3 Philip Jones Griffiths, "maelstrom," in *Dark Odyssey* (New York: Aperture, 1996), 116.

4 The papers of Philip Jones Griffiths indicate that the photographer lived in South Vietnam three times between 1966 and 1971: for roughly a year and half in 1966 and 1967; for about three months in 1968; and for almost a year and a half in 1970 and 1971. My thanks to Will Troughton, curator at the National Library of Wales, for his generous assistance with my research there. Heather Holden, working from her written correspondence with Jones

Griffiths, also lent valuable evidence to my understanding of his movements in and out of Vietnam.

5 Quoted from an unpublished and undated text held by the Phillips Jones Griffiths Foundation, New York.

6 Philip Jones Griffiths, *Vietnam Inc.* (London: Phaidon, 2011), 4n2.

7 Griffiths's engagement with Vietnam did not dissipate with the end of the war in 1975. Beginning in 1980, he returned dozens of times, eventually producing two more books that focus on life in Vietnam: *Agent Orange: Collateral Damage in Vietnam* (London: Trolley, 2003), and *Vietnam at Peace* (London: Trolley, 2005).

Philip Jones Griffiths

Quang Ngai, Vietnam

1967
gelatin silver print

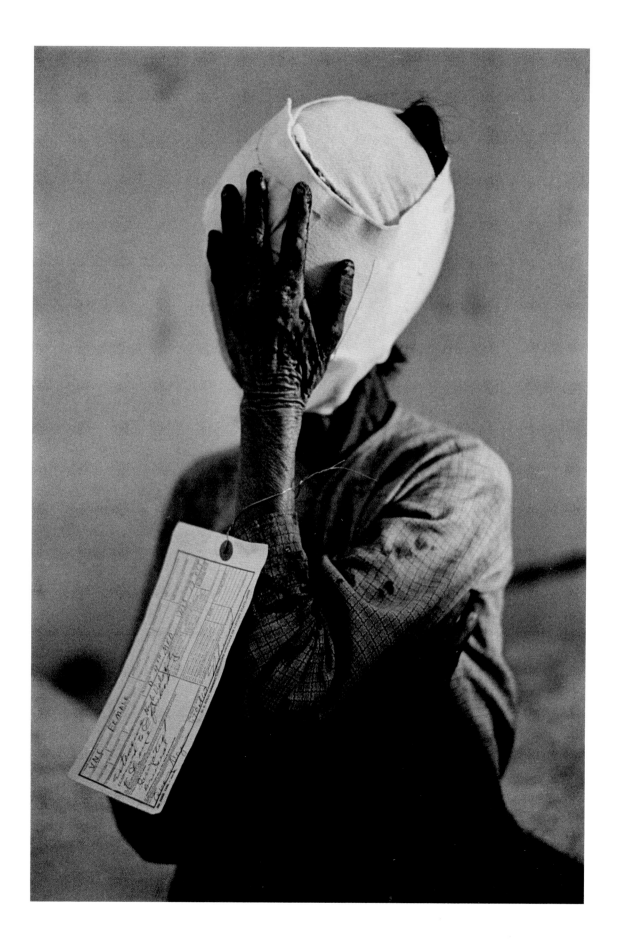

Carl Andre | b. 1935, Quincy, MA

WHEN CARL ANDRE ANSWERED THE CALL TO design a peace poster for the New York exhibition *Collage of Indignation II,* he was known as one of the foremost sculptors of the seemingly unrelated minimalist movement.[1] His reductive works—largely comprised of horizontal installations of metal plates, bricks, and wooden blocks—seemed incompatible with political protest. By the late 1960s, minimalism had been critically derided for its associations with corporatism and technology, criticisms also launched against America's role in the Vietnam War.[2] Yet as an art world figure, Andre's staunch political convictions positioned him as one of the most vocal members of the Art Workers' Coalition.[3] In 1971, he lent his voice to a larger set of protests, which achieved mass attendance—"not the 'silent majority' but the majority which speaks loudly for 'PEACE NOW!'"[4]

Andre seized the opportunity to create a work of overt political protest in *"It was no big deal, sir.",* which remains exceptional in his practice. Here Andre fastened a page from the medical manual *Synopsis of Traumatic Injuries of the Face and Jaws* (1942) to a larger sheet of paper.[5] The book, written by Douglas Parker, a professor in Columbia University's School of Dental and Oral Surgery, served as a field guide for surgeons who worked as primary responders. The manual offered efficient methods of care to be administered near the scene of an injury, limiting permanent disfigurement.

Andre selected one of the book's most traumatic illustrations, that of a man who sustained a gunshot wound that ripped through his lower jaw and cheek. The artist wrote *"It was no big deal, sir."* in ink on the sheet's lower right edge. That title repeats Lt. William Calley's public retrenchment of his role in the notorious atrocities committed against Vietnamese civilians by U.S. soldiers in Sơn Mỹ in 1968 (what became known as the My Lai Massacre). Calley's wanton statement was widely reported during his trial in February 1971, when Andre was tasked with designing a poster. Lt. Calley, the only American tried and convicted for the crimes at Sơn Mỹ, remained a divisive figure in the public debate over Vietnam War atrocities.[6] While some saw his sentence as just and necessary, most Americans found it too harsh and believed Calley served as a scapegoat. Andre dissented. Like the Art Workers' Coalition's poster *Q. And babies?...* [p. 169], a brief quotation self-incriminated the speaker. Yet Andre added layers of meaning to Calley's dismissive statement not with an image of civilian casualties, nor of Lt. Calley himself, but with a devastating laceration inflicted on a soldier during WWI. That soldier's stoic courage is reversed in *"It was no big deal, sir.",* Calley's words now the source of a scar on the nation. An image published to promote healing now reads as a permanent, dishonorable wound. As such, Andre—as a pacifist and an artist—created a scathing critique of Lt. Calley's—and by extension the nation's—moral failure.

Organizers of the *Collage of Indignation II* planned to produce offset posters of the most popular artworks to benefit the broader antiwar movement.[7] The 1971 exhibition, however, was not very successful as a fundraiser. Only one work, a print by Robert Rauschenberg, was eventually reproduced as an offset lithograph. Many of the originals, including Andre's collage, did not sell.[8] JM

Benny Andrews | b. 1930, Madison, GA | d. 2006, New York City

FOR YEARS LEADING UP TO 1971, BENNY ANDREWS had been on the forefront of purposeful protest in the art world.[1] An advocate for diversity in museums and artists' rights, he cofounded in 1969 the Black Emergency Cultural Coalition (BECC) in response to the Metropolitan Museum of Art having organized *Harlem on My Mind* without a black curatorial voice. The BECC's activities and aims were socially broad, and Andrews was critical to their work.[2] Andrews had been addressing racial inequality, misogyny, and social justice simultaneously in his art through an ambitious cycle of paintings called *The Bicentennial Series. American Gothic* belongs to that group and yet stands on its own as a cogent image of, as Andrews put it, "the military being used by misguided citizenry."[3]

American Gothic shows a grotesque couple in a stark, barren environment. A woman, possibly pregnant, straddles a gaunt, elongated figure that is naked except for boots, a helmet, and remnant of a sleeve bearing the insignia of a U.S. Army sergeant. The woman relaxes her full weight on the figure's lower back, riding it while holding a tiny American flag, mouth open as if singing. The military figure on hands and knees strains under her body, with his bones prominent and his pink and tan skin exposed and raw. His head is bowed as if exhausted or awaiting orders. Andrews inscribed an earlier title, "Pink Power," on the canvas verso, as if to emphasize the phallic form of the naked body positioned between the rider's legs, suggesting it is harnessed for sexual power. A more incongruous couple than the pair featured in Grant Wood's famous painting that is its namesake, Andrews heightened the unnerving relationship by adhering collage and fabric pieces to make the woman's face protrude forward into the viewer's space.[4]

Although Andrews had Wood's painting in mind, it seems to have been merely a departure point. He worked from his imagination rather than contemporary photographs related to protest or support of the war. *American Gothic* was inspired by middle-class citizens who offered vocal support for the war in the popular press and seemed to eagerly offer up their sons for combat. Andrews could not square that zealous patriotism with the revelation of the government's lies or the immense losses of life in the war. It seemed to him that the world had turned upside down, with the military deployed as a tool of jingoism rather than as a defense against imminent threat.[5]

Andrews's arrangement of the figures in *American Gothic* bears an uncanny resemblance to the unlikely theme of Aristotle and Phyllis. This moralizing tale was popular in the late Middle Ages and resurfaced from time to time through the twentieth century. In the story, the Greek philosopher Aristotle, also teacher of Alexander the Great, counseled the young ruler to resist the advances of his mistress Phyllis, so that he might concentrate more fully on affairs of state. Aristotle, however, ignored his own advice and accepted Phyllis's advances. The clever and charismatic Phyllis convinced the philosopher to let her ride him like a horse and Alexander secretly watched the incident, thereby witnessing his teacher's folly.

Andrews had studied art history at the School of the Art Institute of Chicago with Kathleen Blackshear, an educator who was influential to many generations of artists. Blackshear's former students remarked that she was "anti-[Italian] Renaissance" and instead emphasized the northern tradition and medieval art.[6] It is possible that Andrews saw northern Renaissance drawings and prints of this theme in her classes; later he could have seen a celebrated bronze depiction of the story in New York at the Metropolitan Museum of Art (or reproduced) [FIG. 1]. In Andrews's translation, the army is doing the absurd bidding of the citizenry—serving their lust

De Tocqueville: All those who seek to destroy the liberties of a democratic nation ought to know that war is the surest and the shortest means to accomplish it. This is the first axiom of the science.

Jefferson: If once they (the people) become inattentive to the public affairs, you and I, and Congress and Assemblies, Judges and Governors, shall all become wolves.

John Randolph: ...for a republic, the very apparatus of war is enough to destroy it...essentially at any rate.

Nathaniel Macon, 1812: This metaphysical war...a war, not for conquest, not for defense, not for sport - this war for honour, like that of the Greeks against Troy, may terminate in the destruction of the last experiment in...free government.

Daniel Webster: (The Mexican War is) a war of pretext, a war in which the true motive is not distinctly avowed, but in which pretenses, afterthoughts, evasions and other methods are employed to put a case before the community which is not a true case.

Walt Whitman: Ah! it's broad folds are destined to float yet - and we, haply shall see them - over many a good square mile which now owns a far different emblem. Mexico, though contemptible in many respects, is an enemy deserving a vigorous "lesson." We have coaxed, excused, listened with deaf ears to the insolent gasconnade of her government, submitted thus far to a most offensive rejection of an ambassador personifying the American nation, and waited for years without payment of the claims of our injured merchants. It is from such materials - from the Democracy, with its manly heart and its lion strength spurning the ligatures wherewith drivellers would bind it - that we are to expect the great FUTURE of this Western World! a scope involving such unparalleled human happiness and rational freedom, to such unnumbered myriads, that the heart of a true man leaps with a mighty joy only to think of it!

Frederick Douglass, North Star, March 17, 1848: PEACE! PEACE! PEACE! The shout is on every lip, and emblazoned on every paper. The joyful news is told in every quarter with enthusiastic delight. We are such an exception to the great mass of our fellow-countrymen, in respect to everything else, and have been so accustomed to hear them rejoice over the most barbarous outrages committed upon an unoffending people, that we find it difficult to unite with them in their general exultation at this time; and for this reason, we believe that by peace they mean plunder. In our judgment, those who have all along been loudly in favor of a vigorous prosecution of the war, and heralding its bloody triumphs with apparent rapture, and in glorifying the atrocious deeds of barbarous heroism on the part of wicked men engaged in it, have no sincere love of peace, and are not now rejoicing over peace, but plunder. They have succeeded in robbing Mexico of her territory, and are rejoicing over their success under the hypocritical pretence of a regard for peace. Had they not succeeded in robbing Mexico of the most important and most valuable part of her territory, many of those now loudest in their professions of favor for peace, would be loudest and wildest for war - war to the knife. Our soul is sick of such hypocrisy. We presume the churches of Rochester will return thanks to God for peace they did nothing to bring about, and boast it as a triumph of Christianity! That an end is put to the wholesale murder in Mexico, is truly just cause for rejoicing; but we are not the people to rejoice, we ought rather blush and hang our heads for shame, and in the spirit of profound humility, crave pardon for our crimes at the hands of a God whose mercy endureth forever.

Emerson: The United States will conquer Mexico, but it will be as the man swallows the arsenic which brings him down in turn. Mexico will poison us.

Thoreau: There are thousands who are in opinion opposed to slavery and to the war, who yet, in effect, do nothing to put an end to them.

North and South, 1863: A rich man's war and a poor man's fight.

T. Kroeber, Ishi, a guard, 1864: We must kill them big and little, nits will be lice.

General Phillip Sheridan, after the Massacre of Black Kettle's village on the Washita, 1867-68: The only good Indians I ever saw were dead.

Vine Deloria Jr., 1969: Never has America lost a war. When engaged in warfare the United States has always applied the principle of overkill and mercilessly stamped its opposition into the dust. Both Grant and Eisenhower made unconditional surrender their policy. No quarter, even if requested. Consider Vietnam, where the United States has already dropped more bombs than it did during the last world war - a classic of overkill.
 Consider also the fascination of America's military leaders with the body count. It is not enough to kill people, bodies must be counted and statistics compiled to show how the harvest is going.

Andrew Carnegie, 1885: The American people are satisfied that the worst native government in the world is better for its people than the best government which any foreign power can supply; that governmental interference upon the part of a so-called civilized power, in the affairs of the most barbarous tribe upon earth, is injurious to that tribe, and never under any circumstances whatever can it prove beneficial, either for the undeveloped race or for the intruder. They are further satisfied that, in the end, more speed is made in developing and improving backward races by proving to them through example the advantages of Democratic institutions than is possible through violent interference. The man in America who would preach that this nation should interfere with distant races for their civilization, and for their good, would be voted either a fool or a hypocrite.

T. Roosevelt to H.C. Lodge, 1895: Personally I rather hope the fight will come soon. The clamor of the peace faction has convinced me that the country needs a war.

Thomas Pascal, a Democratic politician of Texas, wrote privately to President Cleveland's Secretary of State that such a war would knock more pus out of the "anarchistic, socialistic, and populistic boil" than "would suffice to inoculate and corrupt our people for the next two centuries."

George F. Hoar, 1902: The Indian problem is not chiefly how to teach the Indian to be less savage in his treatment of the Saxon, but the Saxon to be less savage in his treatment of the Indian. The Chinese problem is not how to keep Chinese laborers out of California, but how to keep Chinese policies out of Congress. The negro question will be settled when the education of the white man is complete.
 That is a people, that is a power of the earth, that is a nation entitled as such to its separate and equal station among the powers of the earth by the territory, and independence it has achieved, an organized army, a congress, courts, schools, universities, churches, the Christian religion, a village life in orderly, civilized, self-governed municipalities; a pure family life, newspapers, books, statesmen who can debate questions of international law, like Mabini, and organize governments, like Aguinaldo; poets like Jose Rizal; ays, and patriots who can die for liberty, like Jose Rizal.
 We changed the Monroe doctrine from a doctrine of eternal righteousness and justice, resting on the consent of the governed, to a doctrine of brutal selfishness looking only to our own advantage. We crushed the only republic in Asia. We made war on the only Christian people in the East. We converted a war of glory to a war of shame. We vulgarized the American flag. We introduced perfidy into the practice of war. We inflicted torture on unarmed men to extort confession. We put children to death. We established reconcentrado camps. We devastated provinces. We baffled the aspirations of a people for liberty.

Thomas Reed, 1898: At the beginning of this year we were most admirably situated. We had no standing army which could overrun our people. We were at peace within our own borders and with all the world....
 We were then in a condition which secured to us the respect and envy of the civilised world. The quarrels which other nations have we did not have. The sun did set on our dominions and our drum-beat did not encircle the world with our martial airs. Our guns were not likely to be called upon to throw projectiles which cost, each of them, the price of a happy home, nor did any bombardment seem likely to cost us the value of a village.

H.R. Shapiro, The Public Life, 1970: Western machine politicians, however, had the job of standing guard against Populism and they began pressing McKinley to take steps against Spain as a way to destroy insurgency. In Nebraska, Bryan, too, came out for intervention in Cuba and for the same reason. The needs of power taking precedence over the fears of financiers, McKinley allowed Congress to declare war on Spain.
 Under cover of the Cuban intervention the expansionist clique under Lodge and Roosevelt now put in operation its cherished plan to seize the Philippines and so provide a basis for American expansion in the Pacific, with the "protection" of the Philippines as a permanent pretext.
 The annexation marked yet another profound break with the Republic. For the first time in our history we determined to rule as an imperial power over a subject people. Whether the Senate would agree to such a step and ratify the treaty of annexation was an open question until the ever-useful Bryan swung his support to imperial domination. The treaty passed by one vote.

Woodrow Wilson, Conscription Day, 1917: The day here named is the day on which all small present themselves for assignment to their tasks. It is for this reason destined to be remembered as one of the most conspicuous moments in our history...(it) is in no sense a conscription of the unwilling (but a) selection from a nation which has volunteered in mass.
 ...remember that God ordained I should be President of the United States.

New York Times, 1917: The Selective Service Draft Act gives a long and sorely needed means of disciplining a certain foreign element in this nation.

Attorney-General Gregory, 1917: May God have mercy on them (the opponents of war) for they can expect none from an avenging government.
 1918: It is safe to say that never in its history has this country been as thoroughly policed.

Josephus Daniels, 1918: Woodrow Wilson said grave problems after the war were such that he almost hoped the war would continue until his term of office expired.

Justice Holmes: ...when a nation is at war many things that might be said in time of peace are such a hindrance to its efforts that their utterance will not be endured so long as men fight, and no court could regard them as protected by any constitutional right.

Senator Johnson: It is a war, but good God, Mr. President, when did it become a war on the American people?

Tom Watson: Upon the pretext of waging war against Prussianism in Europe, the purpose of Prussianizing this country has been avowed in Congress with brutal frankness, by a spokesman of this administration. On the pretext of sending armies to Europe, to crush militarism there, we first enthrone it here. On the pretext of carrying to all the nations of the world the liberties won by the heroic lifeblood of our forefathers, we first deprive our own people of liberties they inherited as a birthright. On a pretext of unchaining the enslaved people of other lands, we first chain our own people with preposterous and unprecedented measures, knowing full well that usurpations of power, once submitted to, will never hereafter be voluntarily restored to the people.

R. LaFollette: Democracy in America has been trampled under foot, submerged, forgotten. Her enemies have multiplied their wealth and power appallingly. She has thousands of Morgans against her now. But she calls to us as never before. I fear it will be some time before an appeal for her can get much of a hearing. All the more reason to begin forcing the issue. I never felt more fit and eager.
 The forces of democracy which we had been organizing for twenty years have been scattered to the four winds by this mad stampede for democracy in Europe - led by the enemies of democracy in America.

H.R. Shapiro, The Public Life, 1970: As the great prop of oligarchy, Wilson championed a policy of European-style imperialism, for, as he wrote, "the plunge into international affairs and the administration of distant dependencies" created "strong government", that is, killed opposition. To keep the great mass of citizens properly "subordinate", Wilson, as a leading educator, had insisted that the children of ordinary citizens must "forgo the privilege" of an academic secondary education because, being "hewers of wood", they should be trained for mechanical labor.

F.D. Roosevelt, 1940: And while I am talking to you mothers and fathers, I give you one more assurance. I have said this before, but I shall say it again and again and again. Your boys are not going to be sent into any foreign wars. They are going into training to form a force so strong that, by its very existence, it will keep the threat of war away from our shores. The purpose of our own defense is defense.
 1942: I ask the Congress to take this action by the 1st of October. Inaction on your part by that date will leave me with an inescapable responsibility to the people of this country to see to it that the war effort is no longer imperilled by the threat of economic chaos. In the event that the Congress shall fail to act and act adequately, I shall accept the responsibility and I will act. At the same time that farm prices are stabilized, wages can and will be stabilized. This I will do.

Roosevelt, Stalin, Churchill, Teheran, 1943: Emerging from these friendly conferences we look with confidence to the day when all the peoples of the world may live free lives untouched by tyranny and according to their varying desires and their own consciences.

Robert Taft, 1951: Certainly if World War II was undertaken to spread freedom through the world, it was a failure.
 1952: The present action of the President is in line with his general disregard of the provisions of the Constitution and laws of the United States. It follows the usurpation of the power to make war in Korea. It follows the usurpation of the power to send American soldiers into Korea. It is in line with the general philosophy of the New Deal and the Fair Deal, that if there is any way to avoid coming to Congress for authority to act, it will be immediately adopted. I believe that the American people are determined that we return again to a government of laws rather than a government of men.

Dean Rusk, New York Times, March 23, 1971: Now it is true that each incoming administration wants not only to be different but appear to be different than the one which preceded it. And you hear a good deal of talk about that. But nevertheless there are more elements of continuity than elements of change in American foreign policy regardless of which party is in the White House or which party controls the Congress.
 But in general I would simply say that foreign policy doesn't change a great deal simply with the election of new Presidents...

Donald Judd

Untitled

1971
electro-photographic
print on yellow paper

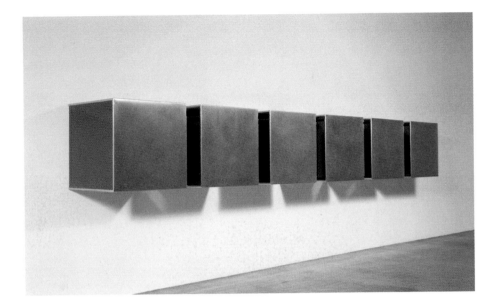

FIG. 1
Donald Judd, *Untitled*,
1966/68, stainless steel
and Plexiglas in six parts,
Layton Art Collection Inc.,
Purchase L1970.25

that of Judd's objects; the effect is a gesture toward the reality of what is being textually presented. The traditions of hypocrisy, activism, and debate over war were not to be ignored. As the final quotation in this work, dated 1971, reads, "[T]here are more elements of continuity than elements of change in American foreign policy." **KM**

1 Lucy R. Lippard, draft, Lucy R. Lippard Papers, Archives of American Art, Smithsonian Institution, Washington, D.C. In a suggestive acknowledgement of the limits of such interventions, Lippard added, "How far forward they are taking us can be debated, but how far back we'd be without them as constant reminders to the public is pretty definite."

2 As David Raskin noted, the Westbeth Peace Festival was held in both 1970 and 1971. Judd's work was contributed to the latter instantiation. See David Raskin, "Judd's Moral Art" in *Donald Judd,* ed. Nicholas Serota (New York: D.A.P., 2004), 94n90.

3 Donald Judd, "The Artist and Politics: A Symposium," *Artforum* 9, no. 1 (September 1970): 36.

4 See David Raskin, *Donald Judd* (New Haven, CT: Yale University Press, 2010), 87–112; and David Raskin, "Specific Opposition: Judd's Art and Politics," *Art History* 24 (November 2001): 682–706. For a discussion of the poster in particular, see Raskin, *Donald Judd,* 95, 103–104.

5 Curated by Robert Huot, Lucy Lippard, and Ron Wolin, this exhibition also included works by Carl Andre, Jo Baer, Robert Barry, Bill Bollinger, Dan Flavin, Robert Huot, Will Insley, David Lee, Sol LeWitt, Robert Mangold, Robert Murray, Doug Ohlson, and Robert Ryman. Though Judd did engage with the war in various ways, his engagement was limited by comparison with many other artists in his New York milieu. In this regard, it is perhaps worth noting that Judd, already in his early forties at the time of his poster's production, approached the conflict in Vietnam from a distinctive generational perspective: stationed in Korea before the onset of war there, yet too old to fight in Vietnam; a fixture of the art world, yet without the seniority of, say, his friend Barnett Newman.

6 Donald Judd, "Specific Objects," *Arts Yearbook* 8 (1965), reprinted in *Donald Judd: Complete Writings 1959–75* (Halifax: Nova Scotia College of Art and Design, 1975), 184.

7 Though of course in the poster, as in the artist's sculptural practice, Judd's hand was undoubtedly present.

Donald Judd | b. 1928, Excelsior Springs, MO | d. 1994, New York City

"I AM ASKING A GROUP OF ARTISTS TO DESIGN original posters for peace (or against war, or whatever [sic])," reads a letter drafted by Lucy Lippard in advance of the Westbeth Peace Festival, which was to benefit the New York Peace Action Coalition and Student Mobilization Committee to End the War in Vietnam. "I know how often you are being asked to do this kind of thing now," Lippard continued in her missive to potential contributors, "All I can add is that I don't think supporting continuing demonstrations against the war is a waste of time."[1] Neither did Donald Judd, who in 1971 submitted to the festival his so-called yellow poster, which would become perhaps his best-known work of opposition to the war in Vietnam.[2]

This was not the artist's first foray into either the political arena in general or engagements with Vietnam in particular. The year before he had responded to a question posed by *Artforum* about the appropriate relationship between artists and political action with a statement that began, "I've always thought that my work had political implications."[3] And though the pared-down, geometric objects of Judd's 1960s-born minimalist practice did not wear their politics on their sleeves [FIG. 1], they did, as David Raskin has elucidated, possess a general oppositional quality: resisting hierarchy, for example, or prioritizing empirical experiences over preexisting systems or ideas.[4] With regard to Vietnam specifically, Judd contributed to the 1966 *Artists' Tower of Protest* (also known as the *Peace Tower*), an antiwar project organized by the Artists' Protest Committee in Los Angeles; declared his resistance in his writings; marched against the war; and, with his wife, Julie Finch, published an announcement for the pacifist

War Resisters League in the *Aspen Times* during a 1968 residency at the Aspen Center of Contemporary Art. That same year he even suggestively yoked his minimalist work to the war effort by showing in a benefit exhibition of nonobjective art organized for the cause of peace at Paula Cooper's gallery in New York.[5]

Although a poster made explicitly for an antiwar cause and intended for distribution calls for a sort of political directness largely absent from the artist's contemporaneous sculptural practice, *Untitled* is decidedly a Judd. The poster brought together thirty-two statements sourced from both historical and contemporary texts that address pacifism, activism, governmental overreach, and war itself. These quotations were first typed on four mimeographed 8½-by-11-inch sheets of paper, then reprinted on one large sheet of yellow paper. The artist's oft-cited insistence on composition simply being a function of placing "one thing after another" seems to inform the poster's construction as well.[6] The original mimeographed sheets of paper might recall the seriality of his sculptures, while, more significantly, the quotations themselves have an almost paratactic arrangement that similarly conjures his objects. In the absence of tight chronological or thematic groupings, it appears as if Judd intended the organization of the quotations to present as the deployment of an already given order rather than the result of subjective compositional choices. Importantly, however, this given order is not one of precise repetitions or mathematical progressions, as was the case in his sculpture, but is instead that of the persisting rhetoric and realities surrounding American war making.[7] The seeming timelessness of many of Judd's selections drive this point home: "North and South. 1863: A rich man's war and a poor man's fight." While the density of type on the poster highlights the difficulty of parsing the language surrounding war, it also lends the work a dogged materiality, again not unlike

1 The original *Collage of Indignation* at New York University's Loeb Student Center in 1967 coincided with Angry Arts Week. Four years later, Lucy Lippard and Ron Wolin organized the exhibition's second iteration, which moved uptown to the New York Cultural Center at 2 Columbus Circle, a building that now houses the Museum of Arts and Design. Running from April 22 through June 27, 1971, *Collage of Indignation II* was timed to coincide with the April 24 peace marches in Washington and San Francisco.

2 See Karl Beveridge and Ian Burn, "Don Judd," *The Fox* 2 (1975): 138.

3 Andre also mixed his politics with occasions where his sculpture was shown, as in wearing a self-fashioned antiwar button to the opening of the *Minimal Art* exhibition at the Hague Gemeentemuseum in 1968. See James Meyer, *Minimalism: Art and Polemics in the Sixties* (New Haven, CT: Yale University Press, 2001), 315n83. See also Jeanne Siegel, "Carl Andre: Art Worker," *Studio International* 180, no. 927 (November 1970): 175–179; and Julia Bryan-Wilson, "Carl Andre's Work Ethic" in *Art Workers: Radical Practice in the Vietnam War Era* (Berkeley: University of California Press, 2009), 41–82.

4 Some 500,000 participants attended in New York and 150,000 in San Francisco. Quotation from a leaflet titled, "Come to a National Antiwar Convention Sponsored by the National Peace Action Coalition," July 2–4, 1971, Hunter College, New York.

5 Douglas B. Parker, *Synopsis of Traumatic Injuries of the Face and Jaws* (St. Louis: C. V. Mosby, 1942), 4, 72; Susan Heinemann, Oral History Interview with Lucy Lippard, March 15, 2011, Archives of American Art, Smithsonian Institution, https://www.aaa.si.edu/collections/interviews/oral-history-interview-lucy-lippard-15936#transcript. The paper was likely provided by Lippard and Wolin in order to create works of approximately uniform dimensions for *Collage of Indignation II*. Andre's mode of excerpting and representing personal and found images in his art dates to *Passport* (1960–62).

6 Lt. Calley's culpability and sentencing, later overturned, were debated throughout the war's later years. See "The Calley Disgrace," *New York Times,* March 4, 1974, 24.

7 The sale of original artworks from *Collage of Indignation II* and later editions were intended to benefit working people "who are tired of the human sacrifice and the loss of their real incomes resulting from the war's economic disruptions." Lucy Lippard Papers, box 26 folder 17, Archives of American Art, Smithsonian Institution.

8 Heinemann, Oral History Interview with Lippard. Lippard retrospectively assessed the exhibition in "Some Political Posters," *Data* 19 (November–December 1975): 64–69.

Carl Andre

"It was no big deal, sir."

1971
collage and ink on paper

Benny Andrews

American Gothic

1971
oil, cut and pasted burlap,
canvas, and fabric on canvas

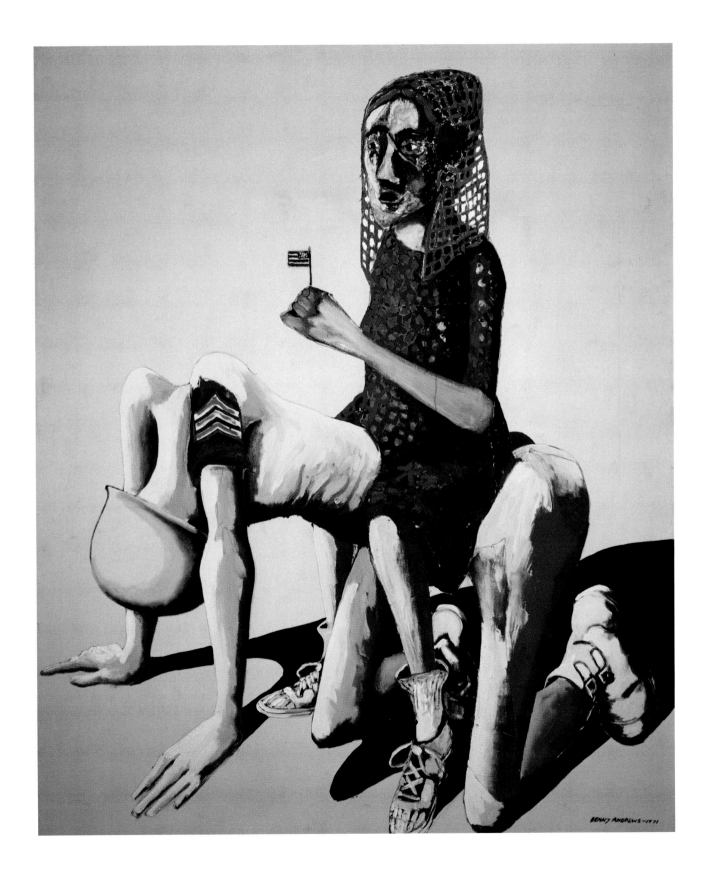

or raw patriotism, proving their devotion to country in a debased form.

Andrews's viewpoint towards the Vietnam War was shaped by his military experience. After serving stateside for four years as a military policeman during the Korean War, he read Norman Mailer's *The Naked and the Dead* and Erich Maria Remarque's *All Quiet on the Western Front*. "These two books formed my thinking about war, that it's an immoral and irrational thing," he reflected. "Wars are not started, as people claim, for patriotic reasons, but for economic reasons. People are manipulated and used for these purposes. A lot of my disappointment about people who were against the war in Vietnam was that they

were only against that war and not against all wars."[7] Like others of his generation, Andrews was suspicious of the relationship between politics, popular opinion, and foreign policy. He worried that the lessons of the past were lost in a cycle of repetition. "Until we see war as a continuous, universal threat, we will be picking our wars and forgetting about them afterward." RC

FIG. 1
Aquamanile in the Form of Aristotle and Phyllis, South Netherlandish, late 14th or early 15th century, bronze and quaternary copper alloy, The Metropolitan Museum of Art, New York, Robert Lehman Collection, 1975.1.1416

1 For background on Andrews's activism, see Richard J. Gruber, *American Icons: From Madison to Manhattan, the Art of Benny Andrews* (Augusta, GA: Morrison Museum of Art, 1997), 127–28, 131–33, 137–44.

2 For more on this and subsequent work of the BECC, see Susan E. Cahan, *Mounting Frustration: The Art Museum in the Age of Black Power* (Durham, NC: Duke University Press, 2016); and Darby English, *1971: A Year in the Life of Color* (Chicago: University of Chicago Press, 2016).

3 Benny Andrews, responses to a questionnaire from the Metropolitan Museum of Art, object record sheet, November 13, 1989. A pen and ink study for this painting dated February 28, 1971 is on loan to the Ogden Museum of Southern Art, New Orleans, LA.

4 Andrews noted that Grant Wood's painting was a reference point. He attended the School of the Art Institute of Chicago between 1954 and 1958 and first saw the painting there as a student. Andrews,

responses to the Metropolitan Museum of Art, November 13, 1989.

5 Andrews, responses to the Metropolitan Museum of Art, November 13, 1989. Andrews stated that a news report conveying the views of a woman from the Midwest prompted the subject.

6 Katharine Lee Keefe, "A Conversation [Don Baum, Roger Brown, Philip Hanson, Ed Paschke, Christina Ramberg, Barbara Rossi, and Ray Yoshida]," in *Some Recent Art from Chicago: The Ackland Art Museum, University of North Carolina at Chapel Hill, February 2–March 9, 1980* (Chapel Hill, NC: Ackland Art Museum, 1980), 26.

7 Andrews, quoted in C. David Thomas, ed., *As Seen by Both Sides: American and Vietnamese Artists Look at the War* (Boston, MA: Indochina Arts Project and the William Joiner Foundation, 1991), 84.

8 Ibid.

Chris Burden | b. 1946, Boston, MA | d. 2015, Topanga, CA

ON NOVEMBER 19, 1971, IN SANTA ANA, CALIFORNIA, Chris Burden performed his now iconic *Shoot* at the F Space gallery. As the artist dryly described it, "At 7:45 p.m. I was shot in the left arm by a friend. The bullet was a copper jacket .22 long rifle. My friend was standing about fifteen feet from me."[1] Though Burden had meant for the bullet merely to graze him, the gunshot resulted in a more significant injury, necessitating a visit to the hospital. Almost immediately sensationalized by the press (mainstream and art alike), *Shoot* remains one of the works with which the artist is most closely associated.[2] Though footage exists, perhaps more central to this ephemeral event's early and continued dissemination was a suite of photographs taken by Alfred Lutjeans, which later appeared in *Chris Burden Deluxe Photo Book, 71-73* (1974). These images document preparations for the performance, the moments surrounding the shooting, and its small audience. When these photographs were first published by the media, images of young men injured by bullets were hardly unfamiliar to the U.S. population, a reality to which Burden was certainly attuned. Though the issues raised by *Shoot* are not uncommon within the artist's practice, they take on a very specific cast when the piece is considered against the backdrop of the Vietnam era.[3]

Burden was one of a host of figures to turn to performance in the 1960s and 1970s and, like many of his peers, his early work was often built around pushing his body to its physical limits. One spread in *Deluxe Book* especially highlights the toll *Shoot* took on Burden. A tightly framed color photograph of Burden's wound is positioned across from a black-and-white image of the recently shot artist from the torso up, staring stunned into the camera. His boyish visage, teamed with his injury, can conjure the young men then being shot at in Vietnam, documented in a similar manner by photojournalists — Horst Faas's iconic 1965 photograph of a soldier wearing a helmet that reads "War Is Hell" might come to mind [FIG. 1].[4] That the friend who shot Burden had been drafted and trained as a marksman, though he never deployed, further registers something of *Shoot*'s wartime context.[5] Moreover, May 1970 had seen National Guardsmen open fire on antiwar activists at Kent State University, leading to the death of four students and the injury of nine others, and the Mississippi Highway Patrol fire on protesting students at Jackson State College, killing two and wounding twelve.[6] Having completed his master's degree at the University of California, Irvine in 1971, Burden was decidedly student as well as soldier aged. In 1973, the artist (in)famously remarked with regard to this work, "How can you know what it feels like to be shot if you don't get shot?"[7] It is as if in *Shoot* he sought to bridge the gap between what he had thus far come to know only at a remove — the touchstone of mediation flagged by the recurring appearance of the video camera in Lutjeans's images — and what he had felt firsthand. Significantly, however, he did so without ever relinquishing control of how that breach closed, a luxury not afforded to his peers serving abroad, or those in Ohio and Mississippi.

This chasm is also underscored by *Shoot*'s spectators. Despite their presence, they necessarily remain distanced from what being shot feels like. In one photograph, a bleeding Burden walks through the foreground as bystanders idly occupy the background; that dynamic is more perspicuous still on a page of *Deluxe Book* that combines a grisly image of Burden's oozing wound with one of four women placidly posing. As Frazer Ward has outlined, Burden pointedly raises the specter of the audience's complicity in his shooting.[8] Related thoughts about the culpability of those passively watching atrocities unfold

Chris Burden

Shoot

1971
performance

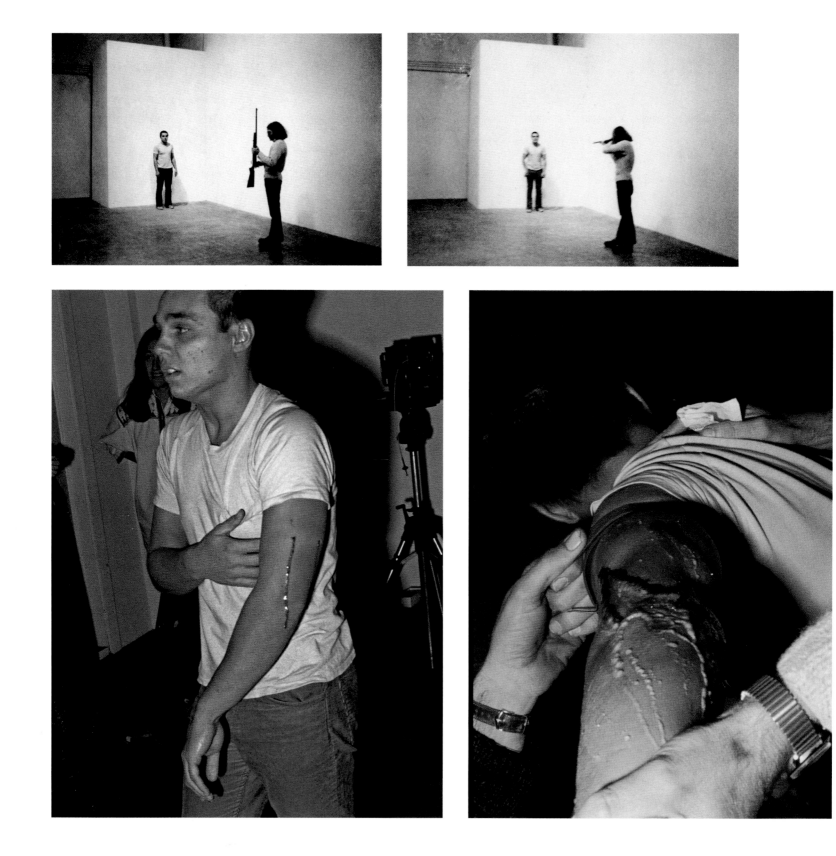

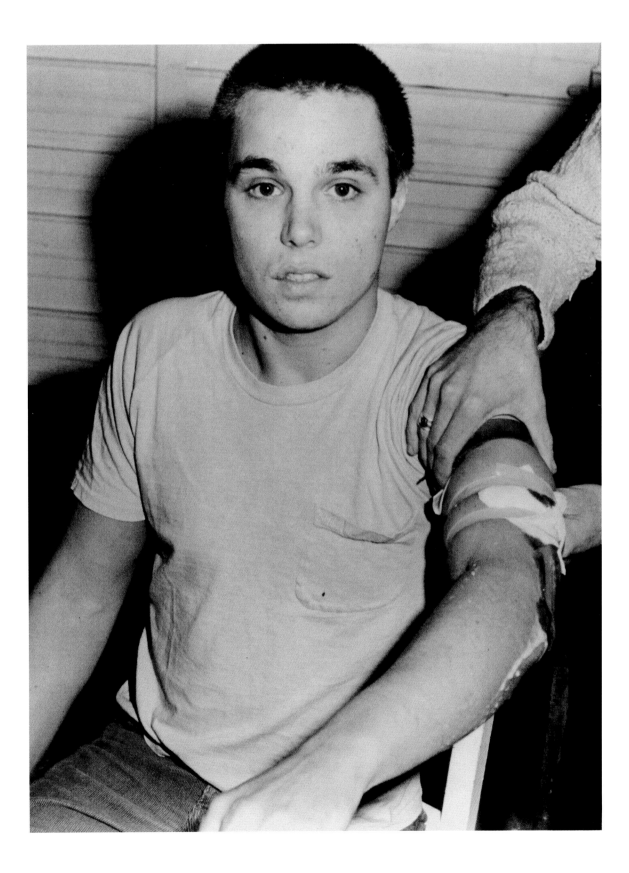

overseas had long surrounded discussions of the war, and continued to do so into the 1970s. The year *Shoot* was made, Vietnam Veterans against the War rejected complacency, speaking out about the violence they or others had committed abroad.[9] The contemporaneous leaking of the Pentagon Papers, which outlined many of the untruths behind the conflict, likewise might be

read as a refusal to remain in the background. With *Shoot*, Burden similarly seems to take up the call to action, put his body on the line, and enter the fray; yet when he later claimed, "I mean, there's no point in ever getting shot again," while discussing his work's incompatibility with repetition, the artist made plain just how far removed from that fray he had always been.[10] **KM**

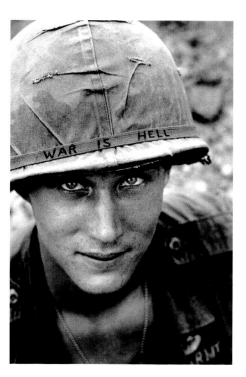

FIG. 1
Larry Wayne Chaffin of the 173rd Airborne Brigade, June 18, 1965, in Phước Vĩnh, South Vietnam. Photo by Horst Faas

1 Chris Burden, *Chris Burden Deluxe Photo Book, 71–73* (Los Angeles: Chris Burden, 1974), 24.

2 See Douglas Davis, "Art without Limits," *Newsweek*, December 24, 1973, 68; Peter Plagens, "He Got Shot—for His Art," *New York Times*, September 2, 1973, 87; "Proof that the Seventies have finally begun," *Esquire* 79, no. 5 (May 1973), 165.

3 This connection is frequently noted. For an expanded and incisive discussion of it, see Frazer Ward, "Gray Zone: Watching 'Shoot,'" *October* 95 (Winter 2001): 114–30.

4 However, the contrast between the knowing expression of the soldier, Larry Wayne Chaffin, and Burden's look of shock is indicative of the two men's very different experiences of violence.

5 Eric Kutner, "Shot in the Name of Art," Op-Docs, *New York Times*, May 20, 2015, www.nytimes.com/2015/05/20/opinion/shot-in-the-name-of-art.html?_r=0.

6 The protests at Jackson State, a historically black college, drew together opposition to the war abroad and racism at home.

7 Willoughby Sharp and Liza Béar, "Chris Burden: The Church of Human Energy, An Interview by Willoughby Sharp and Liza Béar," *Avalanche* 8 (Summer/Fall 1973): 54.

8 See Frazer Ward, *No Innocent Bystanders: Performance Art and Audience* (Hanover, NH: Dartmouth College Press, 2012), 81–108.

9 This group staged the Winter Soldier Investigation in Detroit in January 1971. It consisted of firsthand public testimony on atrocities perpetrated during the war.

10 Sharp and Béar, "Chris Burden: The Church of Human Energy," 60. Burden accepted a version of this point as early as 1973 in conversation with critic Peter Plagens. Plagens recounted how he compared Burden's bullet wound to "a *real* one, suffered by a Vietnam vet or a street gang member," then asked of the artist's injury, "Isn't it small potatoes?" Burden's answer was "Yes." Plagens, "He Got Shot—for His Art," 87, emphasis in original.

Asco | active 1971–87, Los Angeles, CA

ON CHRISTMAS EVE 1971, THE MULTIMEDIA performance art group later known as Asco[1] undertook its first public Happening, *Stations of the Cross*, an event that culminated with the artists barricading the entrance to a U.S. Marines recruiting office. Asco's original members—Harry Gamboa Jr. (b. 1951), Gronk (b. 1954), Willie Herrón III (b. 1951), and Patssi Valdez (b. 1951)—had begun working together earlier that year, enlisted by Gamboa to collaborate on the Chicano literary and political journal *Regeneración*.[2] All formerly students at Garfield High School in East Los Angeles, the four artists brought together varied interests in painting, film, performance, fashion, and activism. *Stations of the Cross* was a critical development for Asco, initiating their engagement with public space. Performed by the male members of the group (all of whom were of draft-eligible age), the piece was, in Gamboa's words, a walking "ritual of resistance" against the glorification of "useless deaths"[3] taking place in Vietnam.

The days leading up to Christmas are traditionally the time for *Las Posadas*, a religious festival popular in Mexico in which a group ritually walks the streets to reenact Mary and Joseph's journey to Bethlehem. *Stations of the Cross* usurps the form and timing of *Las Posadas* but, as its title suggests, evokes Christ's martyrdom rather than his birth. The piece presented Herrón as a Christ/Death figure, bearing an enormous cardboard cross, his face painted in the *calavera* makeup associated with Day of the Dead celebrations in Mexico, as well as the work of prerevolutionary Mexican printmaker José Guadalupe Posada (1852–1913) [FIG. 1]. Asco's use of *calavera* imagery affirms their interest in reinterpreting Mexican artistic and cultural references in a U.S. context. Behind Herrón came Gamboa as a bearded "zombie altar boy," with a dog skull fixed to his head and his body draped in lace. Bringing up the rear was Gronk as Pontius Pilate, wearing a flowered hat and carrying an oversized purse and a bag of popcorn (a reference to his performance alter ego known as Popcorn). The three proceeded slowly eastward along Whittier Boulevard for about a mile, weaving through holiday shoppers and other passersby. Gamboa—who later became the group's documentarian—did not at this early date own a camera.[4] It was only by chance that the quasi Passion Play was captured on film by photographer Seymour Rosen.[5]

Choosing Whittier Boulevard for their unsanctioned performance was a calculated gesture on Asco's part. By 1971, the street was a highly contested public space, the site of multiple antiwar and civil rights demonstrations, as well as routine acts of government surveillance and suppression. Not far from where *Stations of the Cross* began, rioting and police violence had broken out after the National Chicano Moratorium March against the Vietnam War on August 29, 1970 [FIG. 2]. Three people had been killed, including the prominent Chicano journalist Rubén Salazar.[6] On January 31 of the following year, Gamboa witnessed Los Angeles County sheriff's deputies fire into a crowd protesting police brutality at the intersection of Whittier and Arizona Boulevards, resulting

FIG. 1
José Guadalupe Posada, publisher: Arsacio Vanegas Arroyo, Mexico City, *Calavera de la Catrina* (*Skull of the Female Dandy*) from the portfolio *36 Grabados: José Guadalupe Posada* (*36 Engravings: José Guadalupe Posada*), ca. 1910, printed 1943, photo relief etching with engraving, The Museum of Fine Arts, Houston, Gift of the friends of Freda Radoff, 56.27.15

in at least one death. Asco's return to the site of this violence, in *Stations of the Cross* and subsequent performances,[7] was a pointed assertion of their right to claim public space even amid circumstances of police harassment so pervasive that, for many Chicano residents, East Los Angeles felt like "occupied territory."[8]

Stations of the Cross ended with the group blocking the entrance to a U.S. Marines recruiting office with their cross, having earlier measured the doorway and built the structure to size. After blessing the spot with a scattering of popcorn and a moment of silence, they left the scene. Asco's intent was to at least symbolically prevent any military recruitment that day from their working-class Mexican American neighborhood. Although the three men

had themselves managed to avoid combat service,[9] Gronk noted, "a lot of our friends were coming back in body bags and were dying."[10] As Gamboa recalled, the artists had "decorated" their cross with ash, mud, grease, makeup, and their own blood, intending to make it something "repulsive."[11] Through sardonic and transgressive pageantry, Asco expressed their disgust with the war and their government's apparent disregard for Chicano lives, both at home and when sent abroad to fight. Indeed, a sense of sickness and revulsion was the basis of the group's future name—*asco* meaning "nausea" or "loathing" in Spanish. According to Gronk, their early audiences would say "[our work] was giving them nausea. So we liked the word. . . . The name stuck."[12] MH

FIG. 2
National Chicano
Moratorium marchers
on Whittier Boulevard,
Los Angeles, on August 29,
1970

1 Although Gamboa, Gronk, Herrón, and Valdez began working together in 1971, the group only adopted its collective name "Asco" in 1973 or 1974. See Gamboa, "In the City of Angels, Chameleons, and Phantoms: Asco, a Case Study of Chicano Art in Urban Tones (or Asco Was a Four-Member Word)," in *Chicano Art: Resistance and Affirmation, 1965–1985*, ed. Richard Griswold de Castillo et al. (Los Angeles: Wight Art Gallery, UCLA, 1991), 125; and Herrón, cited in Max Benavidez, *Gronk* (Los Angeles: UCLA Chicano Studies Research Center, 2007), 37. Over the course of its existence, Asco involved a fluctuating number of participants, with the founding members also pursuing solo and duo projects throughout. The original members were most active in Asco as a foursome (with the frequent additional involvement of Humberto Sandoval) from 1972 through 1976. Asco's activities ceased altogether in 1987 (Gamboa, "In the City of Angels, Chameleons, and Phantoms," 129).

2 Gamboa was the editor of *Regeneración* for volume 2, issues 1–5. The journal was published by Francisca Flores.

3 Gamboa, "In the City of Angels, Chameleons, and Phantoms," 124.

4 Gamboa purchased his first 35mm camera in 1972. C. Ondine Chavoya, "Social Unwest: An Interview with Harry Gamboa Jr.," *Wide Angle* 20, no. 3 (1998): 55–78.

5 Well-known for his photographs of Watts Towers and the artists associated with the Ferus Gallery, photographer Seymour Rosen dedicated the bulk of his career to documenting vernacular art environments and Happenings. On the day he crossed paths with Asco, he was roaming Whittier Boulevard in search of a "traditionally Chicano" holiday subject. In 1978, he founded SPACES, a nonprofit organization committed to the study, preservation, and documentation of art environments and self-taught artistic activity. See C. Ondine Chavoya and Rita Gonzalez, "Asco and the Politics of Revulsion," in *Asco: Elite of the Obscure, A Retrospective 1972–1987* (Los Angeles: Williams College of Art and Los Angeles County Museum of Art, 2011), 50.

6 For more on Rubén Salazar and the circumstances of his death, see *Rubén Salazar: Man in the Middle*, directed by Phillip Rodriguez, originally aired April 29, 2014, PBS.

7 A notable subsequent piece is *Final Supper (After a Major Riot)*, 1974,

in which Asco staged a Last Supper on the traffic island at Whittier and Arizona Boulevards during rush hour.

8 Steven V. Roberts, "Mexican-American Hostility Deepens in Tense East Los Angeles," *New York Times*, September 4, 1970, https://www.nytimes.com/1970/09/04/archives/mexicanamerican-hostility-deepens-in-tense-east-los-angeles.html.

9 Gamboa received a deferment by enrolling in college. According to interviews with the Archives of American Art (in 1997 and 2000, respectively), both Gronk and Herrón were drafted, but apparently neither saw active duty. Gamboa wrote, "After a protracted struggle, the two artists [Herrón and Gronk] obtained legal alternatives to active combat duty." Gamboa, "In the City of Angels, Chameleons, and Phantoms," 123.

10 Jeffrey Rangel, Oral History Interview with Gronk, January 20–23, 1997, Archives of American Art, Smithsonian Institution, https://www.aaa.si.edu/collections/interviews/oral-history-interview-gronk-13586#transcript.

11 Harry Gamboa, conversation with the author, July 10, 2017.

12 Chavoya and Gonzalez, "Asco and the Politics of Revulsion," 38.

Asco

Stations of the Cross

1971
performance; photographs
by Seymour Rosen

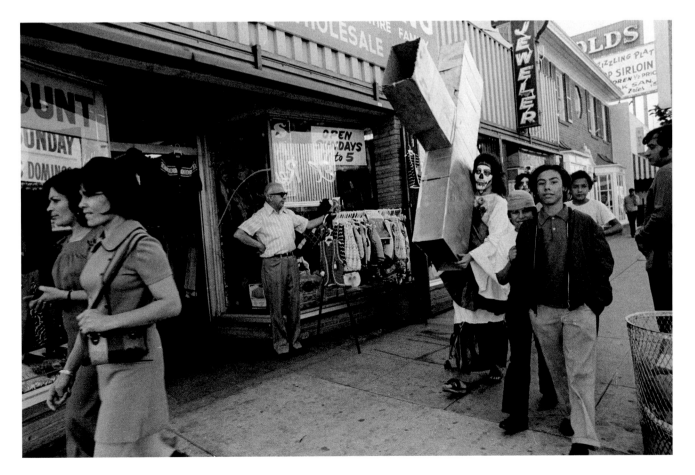

1972

In **FEBRUARY**, Richard Nixon becomes the first U.S. president to visit the People's Republic of China, an important step toward normalizing relations.

On **MARCH 22**, Congress passes the Equal Rights Amendment, designed to end discrimination against women in employment, property, and divorce. For the amendment to become part of the Constitution, thirty-eight states need to ratify it. Only thirty-five state legislatures will vote for ratification by the deadline of 1982.

At the end of **MARCH**, the PAVN launches the Easter Offensive—a conventional military invasion of South Vietnam on three fronts—to bolster North Vietnam's negotiating position in Paris. The assault gains territory in **APRIL**. To help reverse the tide, American air and naval power are brought to bear, and on **MAY 9**, President Nixon orders Operation Linebacker, the first full-scale bombing campaign over North Vietnam since Operation Rolling Thunder ended in 1968.

On **MAY 8**, President Nixon orders the mining of Hải Phòng Harbor, cutting off Chinese and Soviet ships bringing supplies to North Vietnam.

On **MAY 22**, President Nixon and Soviet leader Leonid Brezhnev sign the Strategic Arms Limitation Treaty (SALT) in Moscow. American détente with the Soviet Union, on top of warming relations between the United States and the People's Republic of China, is intended to isolate North Vietnam from its main allies and pressure Hà Nội to negotiate in earnest.

On **JUNE 17**, five men are arrested at the Watergate complex in Washington, as they break in and attempt to bug the offices of the Democratic National Committee. On **OCTOBER 10**, the *Washington Post* will report that the FBI has determined that the break-in is part of a larger campaign of political spying and sabotage run by the Nixon White House.

On **JUNE 28**, President Nixon announces that no new draftees will be ordered to South Vietnam, and that 10,000 additional troops will be withdrawn in **SEPTEMBER**.

On **JUNE 30**, General Frederick Weyand (MACV commander, 1972–73) replaces Creighton Abrams as commander of U.S. forces in Vietnam. Weyand will oversee the final withdrawal of U.S. troops from Vietnam.

On **SEPTEMBER 16**, A.I.R., the first gallery run by and for women artists, opens in New York City. The brainchild of Susan Williams and Barbara Zucker, the gallery is founded by a group of twenty artists, including Judith Bernstein [p. 53] and Nancy Spero [p. 48]. On the West Coast, Judy Chicago starts the country's first feminist art program at California State University, Fresno [p. 241].

FIG. c32 Supporters of Richard Nixon wave signs at the Republican National Convention, 1972. Photo by Wally McNamee

In **OCTOBER**, North Vietnam changes its strategy, proposing a peace plan in which each Vietnamese state retains the territory they currently hold; American and third-country troops withdraw; all prisoners of war are exchanged; and a National Council of Reconciliation and Concord administers elections in South Vietnam. Recognizing the threat to his government, President Nguyễn Văn Thiệu protests. However, Henry Kissinger and Lê Đức Thọ secretly agree on the terms of the armistice, and on **OCTOBER 26**, Kissinger announces, "Peace is at hand."

With the end of the war seemingly near, President Nixon is reelected on **NOVEMBER 7**, defeating George McGovern with almost 61 percent of the popular vote [FIG. c32].

After the U.S. election, President Nguyễn Văn Thiệu demands that the peace agreement under negotiation acknowledge the Republic of Vietnam as a legitimate state; the seventeenth parallel serves as the border between the two Vietnams; and all North Vietnamese troops withdraw from RVN territory. On **DECEMBER 13**, the communist delegations walk out of the negotiations.

In response to the breakdown of negotiations in Paris, President Nixon orders Operation Linebacker II, known as the Christmas Bombing, in **DECEMBER**. Over eleven days, bombers and fighter aircraft devastate North Vietnam's rail, petroleum, and electrical power infrastructure. Though the North Vietnamese return to the negotiating table in the coming weeks, the U.S. bombing does not result in any further concessions, and the operation is criticized by newspapers and other nations.

By the **END OF THE YEAR**, 24,200 U.S. troops remain in Vietnam.

TImothy Washington | b. 1946, Los Angeles, CA

BY THE TIME TIMOTHY WASHINGTON USED IT as the title for a 1972 work, "1A" was common parlance in American culture, widely recognized as designating an individual available for active military service. Executed as the draft was winding down, indeed the year the last draft calls of the war were made, Washington's mirror-like tondo *1A* appears as a reflection on that status's implications. That he felt compelled to revisit this topic at such a late date, and five years after he had first received the designation, is a testament to the powerful effects the draft notices had on young men over the course of the war, especially within African American communities, which were disproportionately affected by it for much of the conflict.[1] "I am dealing with message art: it is informative and relates to a poster in that it gives information," Washington claimed in a 1971 statement. "However, I want the information to be discovered; therefore, the message is subtle. I try to ask questions and make the viewer think and in turn look closer."[2] *1A* meets that goal as it seeks to ask and reveal what the draft had meant.

Trained in printmaking at Chouinard Art Institute in his native Los Angeles, Washington made *1A* by first spraying an aluminum surface with auto primer and then both etching into it and adding found materials.[3] Rather than going on to make a print, he considered that plate to be the final product. Washington's first turn to this use of drypoint had suggestively coincided with his first antiwar work. A 1967 Chouinard class in which he was enrolled had called upon students to make something considered personal; having recently been reclassified 1A, Washington etched a work in aluminum he described as "a social commentary against wars."[4] "I thought about war

being cold and hard, and that aluminum would be a material which I could work with," Washington claimed. "The challenge was to create warmth on the cold, hard material like aluminum."[5]

When he again turned to both aluminum and his draft status in *1A*, Washington succeeded in bringing together the cold realities of war and a type of, this time familial, warmth. With its figurative composition, *1A* is aligned with his other output as well as traditions within the Black Arts Movement that sought to address and communicate the realities of black experience.[6] In it, a defiant Washington is positioned in the foreground. His arms are outstretched on either side of a tombstone-like piece of leather that he has nailed to the aluminum's surface and in which he has embedded his boldly defaced draft card—his name replaced with John Doe, the date with forever.[7] Whereas his left hand opens outward, his right middle finger, pointedly, gestures in the direction of the draft card. Behind him looms his brother. Washington speaks of his brother as having played the role of father figure; in this work specifically, his brother tries to prevent the actions of his right hand.[8] The artist's protest of the draft thereby also becomes an emblem of the younger generation's widespread defiance of authority. Yet the brother's gesture seems somehow more urgent than this, more mournful than disciplinary. It is as if he is reaching toward Washington to pull him back from the premature grave that often, and here literally, is bound up with 1A status—a point underscored by the way the tondo makes a bullseye of the draft card. The artist's incorporation of this second figure allows the work to become more than a protest of a draft already slowing. Instead, *1A* appears a nuanced elucidation of the ramifications of each draft card already distributed; every one fateful not just for the designee but for all those who stand with and behind him.

Washington's chosen materials and their handling add to the work's complexity and message. While

Timothy Washington

1A

1972
etched aluminum, leather,
metal studs, nail, and draft card

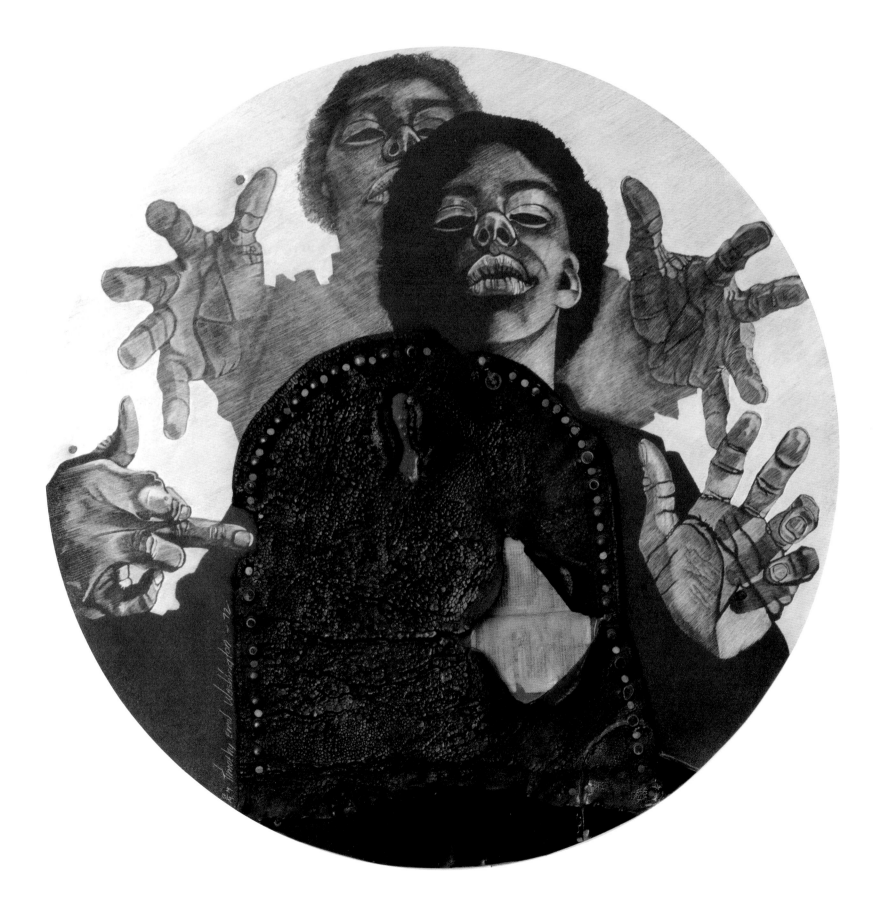

the use of metal seems a nod to the technology of war, his prioritization of the etched aluminum itself over its image's proliferation as a print suggests the intimate stakes of what is being conveyed.[9] "The plate said so much more to me because it had me within it," the artist claimed.[10] The artist also productively mobilizes the strategies of assemblage that were prominent in 1960s Los Angeles, particularly among many black artists working in the aftermath of the Watts Rebellion, which in 1965 rocked the neighborhood in which Washington was raised.[11] The soft, skin-like texture of the appended leather creates the warmth he claimed to seek, pulling the viewer in and directing her to the draft card that catalyzes the surrounding drama and pathos. Repurposing this latter object, especially, seems a powerful take on the conviction held by many black assemblage artists following Watts that what might start as a sort of debris or residue of destruction—surely ways to understand a draft card—can be transformed into socially resonant art. Moreover, the rugged dimensionality of the work's ordinary materials stands in meaningful contrast to the astonishing precision with which he has rendered the smooth figures: a sense that those figures exist in a dimension apart from the material world makes their story universal rather than particular.

Washington underscores his intended universality otherwise as well. John Doe has been drafted; the date specified is "forever." The downcast eyes of both brothers and the extent to which the elder seems to reach past Washington toward the beholder further suggests the importance of characters beyond those pictured. The frustration and fatigue resulting from the fact that the draft—and, more broadly, the war—had long played a role in shaping lives, thoughts, and relationships reached far beyond the surface of Washington's picture.[12] **KM**

1 For relevant statistics, see Melissa Ho, "ONE THING: VIET-NAM, American Art and the Vietnam War," in this volume, 28n61.

2 Timothy Washington, quoted in Joseph E. Young, *Three Graphic Artists: Charles White, David Hammons, Timothy Washington* (Los Angeles: Los Angeles County Museum of Art, 1971), 9. From the late 1960s, artists of color increasingly contested their exclusion from mainstream art institutions, and this exhibition was a by-product of those efforts in Los Angeles. On these struggles for equal representation, see Susan E. Cahan, *Mounting Frustration: The Art Museum in the Age of Black Power* (Durham, NC: Duke University Press, 2016); Mark Godfrey and Zoé Whitley, "Three Graphic Artists," in *Soul of a Nation: Art in the Age of Black Power* (New York: D.A.P., 2017), 98–105; and Kellie Jones, ed., *Now Dig This! Art and Black Los Angeles, 1960 1980* (Los Angeles: UCLA Hammer Museum of Art, 2011), 34–42.

3 Washington, interview with Melissa Ho, July 11, 2017.

4 Young, *Three Graphic Artists*, 9.

5 Timothy Washington, quoted in Mar Hollingsworth, *Inside My Head: Intuitive Artists of African Descent* (Los Angeles: Department of Cultural Affairs, 2009), n.p.

6 On the Black Arts Movement, see Godfrey and Whitley, "Amiri Baraka, Larry Neal and the Black Arts Movement," in *Soul of a Nation*, 36–39.

7 By 1972, draft cards had become highly charged symbols. With protesters first burning their draft cards in 1964, this antiwar practice was deemed a federal offense in 1965 yet gained increasing traction as an emblem of resistance. Washington's actions seem to fall within this tradition of opposition.

8 Washington, interviewed by Melissa Ho.

9 Godfrey and Whitley point out this material connection to the military-industrial complex in "Three Graphic Artists," 98.

10 Washington, quoted in Young, *Three Graphic Artists, Soul of a Nation*, 9.

11 On the Watts Rebellion, assemblage, and black artists in Los Angeles, see Naima J. Keith, "Rebellion and Its Aftermath: Assemblage and Film in L.A. and London," in *Now Dig This!*, 85–89.

12 Washington inscribed his picture, "G.M. Timothy Errol Washington 1972." That G.M. stands for "god's messenger" seems to support a reading of the work as universalizing in impulse (Washington, interviewed by Melissa Ho). As early as 1971, Young signaled something similar in his essay for *Three Graphic Artists*, writing about the "universal expression of man's basic humanity" that underpinned the works by Washington included in the show (p. 2).

Judy Chicago | b. 1939, Chicago, IL

IN JUDY CHICAGO'S *IMMOLATION*, A NUDE woman, body painted green, sits cross-legged with her head angled downward in the California desert. Surrounding her are a number of flares spewing a reddish smoke that swirls around the lower half of her body, perhaps soon to envelop her completely. While the image highlights Chicago's productive engagement with a range of contemporary art world trends—the desert suggests attention to land art; the pyrotechnics signal an interest in technology; the nude female body relates to a growing feminist sensibility—its composition and title also cue another, extra-artistic but equally important context of its production: the ongoing conflict in Vietnam.

Having spent the earlier part of the sixties working in a more minimalist vein, near the decade's end the artist began to organize outdoor pyrotechnical performances called *Atmospheres* that saw variously colored smoke released into a range of different landscapes. Her *Women and Smoke* series, of which *Immolation* is a part, belongs to the *Atmospheres* project and continued her experiments with smoke while also incorporating living figures.[1] All of these works can be framed in terms of Chicago's burgeoning feminist politics. The *Atmospheres* were, in part, retorts to what the artist viewed as the needlessly destructive and interventionist land art practices of her male peers. Her ephemeral works, by contrast, transformed the landscape without damaging it. Indeed, the *Atmospheres* stood as attempts to soften and thereby feminize not only the natural and built environments in which they were staged but also that of the art world Chicago inhabited.[2]

In a similar spirit, *Immolation* amplifies what we might take as Chicago's own recent feminist self-immolation. In October 1970, the artist traded her husband's name for that of her hometown as a means of asserting her independence; Judy Gerowitz became Judy Chicago in an act of self-determination, redolent of those recently undertaken by Malcolm X and Muhammad Ali. The image can thus seem a metaphor for her phoenix-like resurrection; the work's positioning of the female body as a priestess or goddess-like guardian of fire (common to much of the *Women and Smoke* series) likewise seems related to the artist's act of empowerment. At the same time, *Immolation* is also a rendering of the self-sacrifice Chicago viewed as part of a woman's experience in the world; the artist cites *sati*, the Indian practice of widows self-immolating following their husbands' deaths, as a key point of reference for the work.[3] Yet, the *Atmospheres* broadly, and *Immolation* more specifically, need not be read through a feminist lens alone; instead, they might be taken as instantiating the powerful crossover between the concerns of feminism and those of the antiwar movement.

While the pyrotechnical aspects of such works surely grew out of a salient sixties interest in

FIG. 1
Judy Chicago, *Bridge Atmosphere*, 1970, from the portfolio *On Fire*, printed 2013, inkjet print, Smithsonian American Art Museum, Museum Purchase through the Luisita L. and Franz H. Denghausen Endowment

combining art and science (Chicago herself founded the Aesthetic Research Center), the smoke takes on a darker cast with an eye to the Vietnam era.[4] As Susanneh Bieber has pointed out, the colors of Chicago's first three *Atmospheres* were the same as the colors designating the herbicides most frequently used for defoliation in Vietnam — Agents Orange, White, and Purple.[5] The sites of the artist's performances were at times similarly suggestive. A 1970 *Atmosphere* at Cal State Fullerton saw, in one critic's words, "white smoke bombs planted on six to eight of the high rise buildings on the campus."[6] Neither this description nor the intervention itself seem entirely neutral for a year that saw campuses become centers of protest and unrest. (The shootings at Kent State and Jackson State also occurred in 1970.) Another *Atmosphere* realized at Cal State Fullerton was executed on a bridge [FIG. 1] and may well have presented as equally ominous, particularly in light of the imagery of urban warfare that had been brought home by coverage of the Tết Offensive in 1968. In later reflecting on a series of *Atmospheres* staged during a 1970 trip along

the Northwest coast, Chicago wrote, "I see that it was a bit like guerrilla warfare — stopping, setting off smoke 'bombs,' carrying what looked like grenades and sticks of dynamite in our Ford Ranchero. Strange how one's art often says what one means even before one knows what one means to say."[7] Even if unknowingly, these works both conjured and were inflected by Vietnam — which was, in ways, an atmospheric war: herbicides dropping aerially, smoke creating groundcover — as they creatively merged home front and front lines.

Immolation works in a similar fashion, only now by corporeally embodying something of the conflict. By 1972, self-immolation was part of the well-established iconography of a war that appeared to be winding down, even if its end results remained far from determined. This was owed in part to Associated Press photographer Malcolm Browne's widely disseminated 1963 photographs of Buddhist monk Thích Quảng Đức setting himself aflame on a busy Sài Gòn road in protest of the Ngô Đình Diệm regime [FIG. 2].[8] Increasing numbers of monks followed suit as the decade progressed, with a far smaller but nevertheless significant number of U.S. citizens also lighting themselves on fire in opposition to the war.[9] As Chicago recently noted in discussing *Immolation,* "At the time [the work was made], a lot of monks in Vietnam had set fire to themselves to protest against the war and its expansion into Cambodia.... I was interested in the whole practice of immolation, forced and chosen."[10] Manifest, of course, in the work's title, this interest is also suggested by both the smoke's flame-like color and the actual flames at the left of the photograph. The touchstone of Vietnam in particular is palpable in the position of the nude figure, the artist Faith Wilding, which calls to mind Browne's iconic image. Though not an explicit work of protest, *Immolation* nevertheless places thoughts of the body and its vulnerabilities front and center at a

FIG. 2
Thích Quảng Đức, a Buddhist monk, burns himself to death on a Sài Gòn street June 11, 1963, to protest the South Vietnamese government. Photo by Malcolm Browne

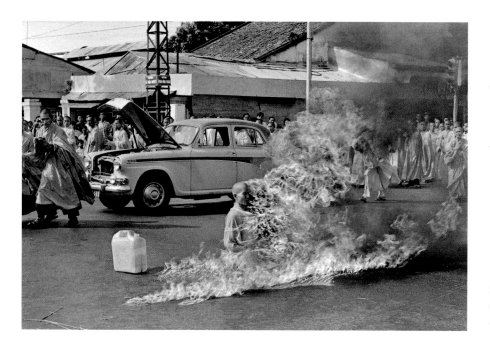

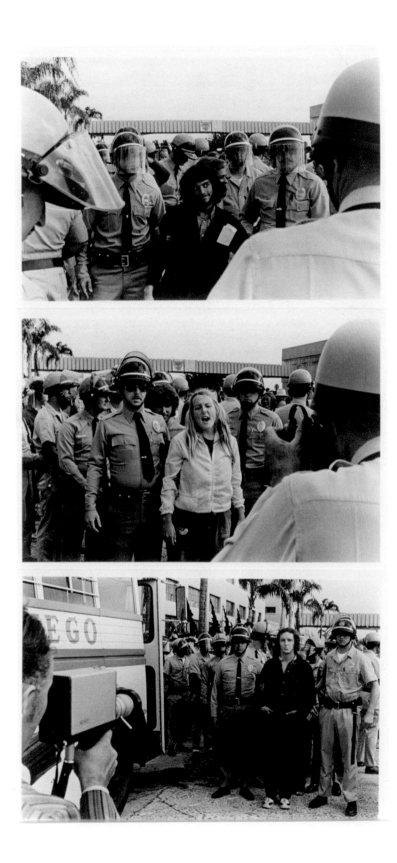

between arrestee and officer. Rather than resulting in additional records of criminal activity, however, the artist's photographs reveal something of the dynamics among the event's major characters. His expansive views of the scene suggest that the arrestees are outnumbered by officers. Lonidier's photographs also pit the seemingly innocuous character of many of those detained—several smile, some offer peace signs, all appear unarmed—against the gravity of the riot masks and helmets worn by the authorities physically restraining these nonviolent protesters. The artist's (literally) different position thus opens onto a different perspective of the episode. Underscoring the potential proliferation of such perspectives is the presence of a journalist in a number of photographs; ostensibly intent on straightforwardly documenting the unfolding event, his work will yield yet another view of the protest.[7]

The notion that photographs have an agenda held special force as the war in Vietnam continued to plod on. Images had shaped the public's reception of the conflict for much of the past decade, from Malcolm Browne's shot of a monk self-immolating to the more recently published photographs of the brutalities committed in Sơn Mỹ. Borrowing the language of photojournalism, Lonidier's work of art acknowledges and explores the political force that such photographic documentation always/already has. At the same time, it also takes aim at the contemporary artistic situation. Though it echoes Ed Ruscha's *Twentysix Gasoline Stations* (1963), the artist has called his title a "slam against the banal and above-it-all 'documentary' photography of Ed Ruscha."[8] As Benjamin H. D. Buchloh has noted, Lonidier transforms the seriality and documentary impulses of conceptualism into something more overtly political.[9] Ultimately, the seriality of *29 Arrests* points to the multiplicity of voices standing against the war—the variety of personalities on display in the "mug shots"—and positions them in opposition

Fred Lonidier | b. 1942, Lakeview, OR

FRED LONIDIER'S *29 ARRESTS* CONSISTS OF one text panel and twenty-nine silver gelatin prints arranged in a five-by-six grid. Each photograph captures a different arrestee at an antiwar protest staged, per Lonidier's text, at the "Headquarters of the 11th Naval District, May 4, 1972, San Diego." The spring of 1972 saw such protests gather renewed steam in response to Richard Nixon's heightened bombing campaigns, and the individuals Lonidier shows us were detained after a sit-in blocking the doors to the Naval Supply Center, which shipped war supplies overseas. As booking photographs were taken, Lonidier positioned himself just behind the officer with the camera and, in essence, imitated his actions in taking another set of pictures. Yet while Lonidier and the officer undertook a similar activity, it is framed—literally and conceptually—in meaningfully distinct ways by each. Central to *29 Arrests* are questions about precisely such contesting perspectives and their relation to photography and politics alike.

May 4, 1972, was hardly the first time Lonidier took photographs of protests. He had opposed the war while a student at San Francisco State College, where he became a national member of the organization

FIG. 1
Draft resistance protester, Seattle, 1967. Photo by Fred Lonidier

Students for a Democratic Society. After graduating in 1966, he joined the Peace Corps and was assigned to teach English in the Philippines. His service was truncated, however, by a failed draft appeal, and by 1967, he had returned to the United States, though he maintained his refusal to enlist.[1] Living then in Seattle, he became an active member of the city's draft resistance movement, documenting antiwar protests and often publishing these images in underground newspapers [FIG. 1].[2] In 1970, he was sentenced to two years in jail for his actions around his draft status but won an appeal once enrolled at the University of California, San Diego that fall.[3]

In San Diego, the artist came into direct contact with both the military-industrial complex and its conflicts with many on the university campus. These battles revolved around issues like government contracts, military recruiting, and the shipment of material and men to Indochina.[4] While at the university, Lonidier also participated in a larger contemporary rethinking of the photograph, especially the photograph's status as document. Two years earlier, Kynaston McShine's 1970 exhibition *Information* at the Museum of Modern Art investigated that very notion; more locally, it was being explored by Lonidier's colleagues and students at UCSD, including Eleanor Antin, Allan Sekula, and Martha Rosler [pp. 94–98].[5] Many in this latter group, including Lonidier, sought to contest what Sekula called "the folklore of photographic truth" and stressed the political forces and "socially-specific *encounters*" that underlie the photograph's making and reception.[6]

First shown as part of his MFA thesis show at UCSD, *29 Arrests* draws out those forces as well as the nature of those encounters. The officer tasked with photographing the arrested individuals appears to be creating portraits in the tradition of the mug shot, his images of individuals devoid of context and to be used as tools of control by the government. Lonidier's photographs attend to this transaction

moment when that body was crucially at stake, and even seen as under threat, both within feminism and, crucially, in the context of war. **KM**

1 Chicago described the relationships between these works in conversation with Melissa Ho, September 27, 2017. On these works, see Judy Chicago, *Through the Flower: My Struggle as a Woman Artist* (New York: Authors Choice Press, 1975, 1996), 57–62.

2 The *Atmospheres* received relatively little contemporary critical attention, despite their engagement with the sort of dematerialization Lucy Lippard and others were discussing at the time. Chicago in conversation with Ho. Chicago's feminism, by contrast, was more carefully considered. See "Judy Chicago Talking to Lucy R. Lippard," *Artforum* 13, no. 1 (September 1974): 60–65. For a recent discussion of the *Atmospheres*, see Alexxa Gotthardt, "When Judy Chicago Rejected a Male-Centric Art World with a Puff of Smoke," *Artsy*, July 26, 2017, https://www.artsy.net/article/artsy-editorial-judy-chicago-rejected-male-centric-art-puff-smoke.

3 Chicago in conversation with Ho. Also see Gotthard, "When Judy Chicago Rejected a Male-Centric Art World."

4 By the early 1970s many within artistic circles viewed the postwar promise of technology as broken, owing to its deployment in more violent contexts, such as war. See Anne Collins Goodyear, "From Technophilia to Technophobia: The Impact of the Vietnam War on the Reception of 'Art and Technology,'" *Leonardo* 41, no. 2 (2008): 169–73.

5 Susanneh Bieber, "Restaging Chemical Warfare in Art: The Affirmative Power of Judy Chicago's Atmosphere Pieces," paper presented at the Annual Conference of the Society for Literature, Science, and the Arts, Rice University, Houston, TX, November 12–15, 2015.

6 Thomas H. Garver, "Judy Chicago, Art Gallery, California State College, Fullerton," *Artforum* 9, no. 5 (January 1971): 92.

7 That same year a critic also noted the "guerrilla quality" of her *Atmospheres*. William Wilson, "Judy Chicago Exhibition at Cal State Fullerton Gallery," *Los Angeles Times*, November 2, 1970, F14.

8 See Christian G. Appy, *American Reckoning: The Vietnam War and Our National Identity* (New York: Penguin Books, 2016), 23–24.

9 Among these Americans was George Winne, who in May 1970 set himself ablaze at the University of California, San Diego—a moment when Chicago was also in California.

10 Judy Chicago, "Judy Chicago's Best Photograph: Woman and Smoke," *Guardian*, October 17, 2013.

Judy Chicago

Immolation

1972, printed 2013
inkjet print

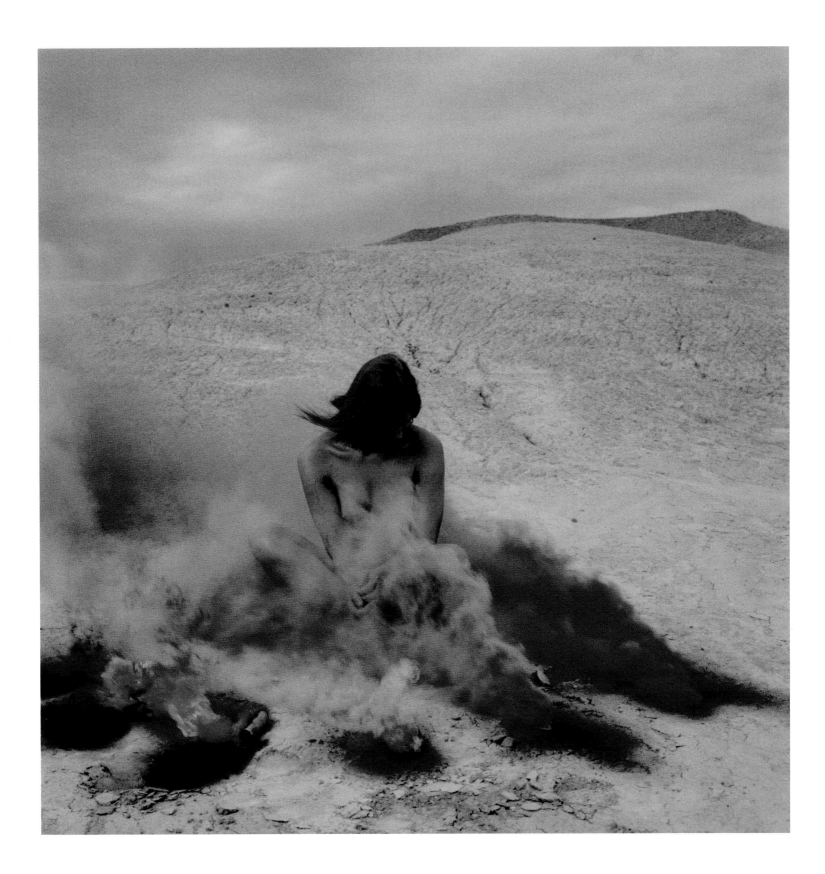

Fred Lonidier

29 Arrests

1972, printed 2008
photographs with text
on panel

to the homogenous block of officers standing in for state power. The piece's repetitions then imply that, though the state may remain a domineering and monolithic presence, there will always be a wide range of individuals willing to take collective action against it. Those repetitions might also allude to the potential violence of the state as, again and again, the officer holding the camera "shoots" a restrained citizen. The camera, Lonidier asks us to understand, can be a weapon, too. **KM**

1 The common understanding was that those in the Peace Corps would not be given 1A draft status; indeed, Lonidier was the first to be called up for military service while in the Peace Corps. He did not travel home quietly, publishing an article in the *Manila Times* questioning the president's dedication to peace, and his trip was closely followed by the press.

2 These images can be seen online courtesy of the Pacific Northwest Antiwar and Radical History Project at the University of Washington. http://depts.washington.edu/labpics/zenPhoto/antiwar/lonidier/.

3 This biographical background comes from Benjamin J. Young, "Documents and Documentary: San Diego, c. 1973," in *The Uses of Photography: Art, Politics, and the Reinvention of a Medium*, ed. Jill Dawsey (Berkeley: University of California Press, 2016), 126–27; and Melissa Ho's conversation with the artist, March 21, 2016.

4 For specific examples, see Young, "Documents and Documentary," 124–26.

5 Lonidier began at UCSD as a student and went on to build the photography department as a faculty member. For an incisive account of this group, see Young, "Documents and Documentary," 113–63. On the larger question, see Abigail Solomon-Godeau, "Who is Speaking Thus? Some Questions about Documentary Photography," in *Photography at the Dock: Essays on Photographic History, Institutions, and Practices* (Minneapolis: University of Minnesota Press, 1991), 169–83.

6 Allan Sekula, "Dismantling Modernism, Reinventing Documentary (Notes on the Politics of Representation)," *Massachusetts Review* 19, no. 4 (Winter 1978): 862–63, emphasis in original.

7 However, as Young pointed out in "Documents and Documentary," both daily newspapers in San Diego were owned by a conservative media company. This reality rendered Lonidier's reading of the event that much more significant (p. 132).

8 Fred Lonidier, "Artists on L.A.: Fred Lonidier," *Artforum* 50, no. 2 (October 2011): 296.

9 Benjamin H. D. Buchloh, "Allan Sekula, or What Is Photography?" *Grey Room* 55 (Spring 2014): 123.

Mark di Suvero | b. 1933, Shanghai, China

AS AN ACTIVIST AGAINST THE VIETNAM WAR,
Mark di Suvero is best known for his participation
in the Los Angeles *Peace Tower* of 1966,[1] but this
was hardly his only intervention. The sculptor was
twice arrested protesting American involvement
in Southeast Asia—during the 1967 March on the
Pentagon and at the 1968 Democratic National
Convention. His print *L. B. Johnson: MURDERER* was
part of the portfolio *Artists and Writers Protest against
the War in Vietnam* in 1967 [pp. 79–81], and he lost his
work space in Jersey City the same year due to his
antiwar activities. His most personal and sustained
protest, however, was his self-exile from the United
States beginning in 1971. Anguished over the seem-
ing endlessness of the conflict, di Suvero removed
himself to Europe, putting on hold a solo exhibition
at the Whitney Museum of American Art and vowing
not to return until the war in Vietnam finally ceased.[2]

FIG. 1
Mark di Suvero, *Mother
Peace*, 1969–70, painted
steel, Gift of the Ralph E.
Ogden Foundation.
© Collection of Storm King
Art Center, Mountainville,
New York. Installation at
*Mark di Suvero at Crissy
Field*, San Francisco
Museum of Modern Art,
May 2013–May 2014

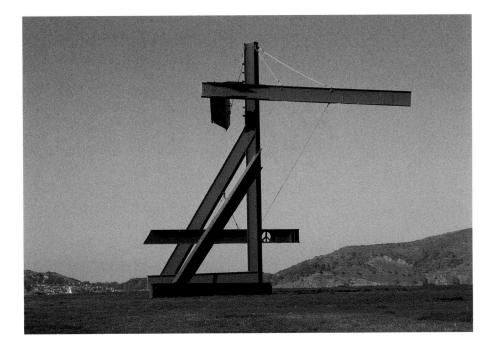

He remained abroad until 1975, living and working
during this time in Italy, the Netherlands, and France.[3]
He later told an interviewer, "The reason that I left
was that I thought America was incapable of righting
the ship."[4] On another occasion, he elaborated, "What
good does it do to leave? Well, I'll tell you. Art does good
for people, so the good I was doing was for a sick soci-
ety. And I didn't want to do any good for a sick society
like ours."[5]

Di Suvero's disgust with U.S. military action in
Vietnam was deeply felt, being rooted in his early
childhood experience of living in Asia amid conditions
of foreign occupation. Born in Shanghai to Italian par-
ents, di Suvero was raised in China until he was seven,
mostly in Tianjin, a city split into numerous inter-
national concessions and, in 1937, conquered by the
Japanese. With war consuming Europe and Asia and
his parents' antifascist beliefs no secret, his family's
position grew precarious. Fearing persecution if they
remained under Mussolini's rule as Italian citizens,
they came to America as political emigrés in 1941. It
was a sad reversal, then, for di Suvero to depart the
country his mother revered as "the land of Lincoln,
the land of Jefferson"[6] to seek a respite in Venice, the
ancestral home of his father. It was likely in that city
that he created *For Peace*. Lacking the space in Venice
to pursue sculpture, the artist spent most of his time
there drawing and painting.

Di Suvero may have physically distanced himself
from his country by 1972, but this drawing suggests
that his thoughts remained very much with America
and hopes for peace. An artist whose practice is
characterized by spontaneity and direct engagement
with materials, di Suvero has long valued drawing as
an immediate and fluid means of working through
ideas. While he has sometimes created drawings in
preparation for making sculpture, *For Peace* does not
anticipate a three-dimensional work to come—rather,
it looks back to the last major sculpture di Suvero
completed before departing the United States: a

Mark di Suvero

For Peace

1971–72
ink, watercolor, and
collage on paper

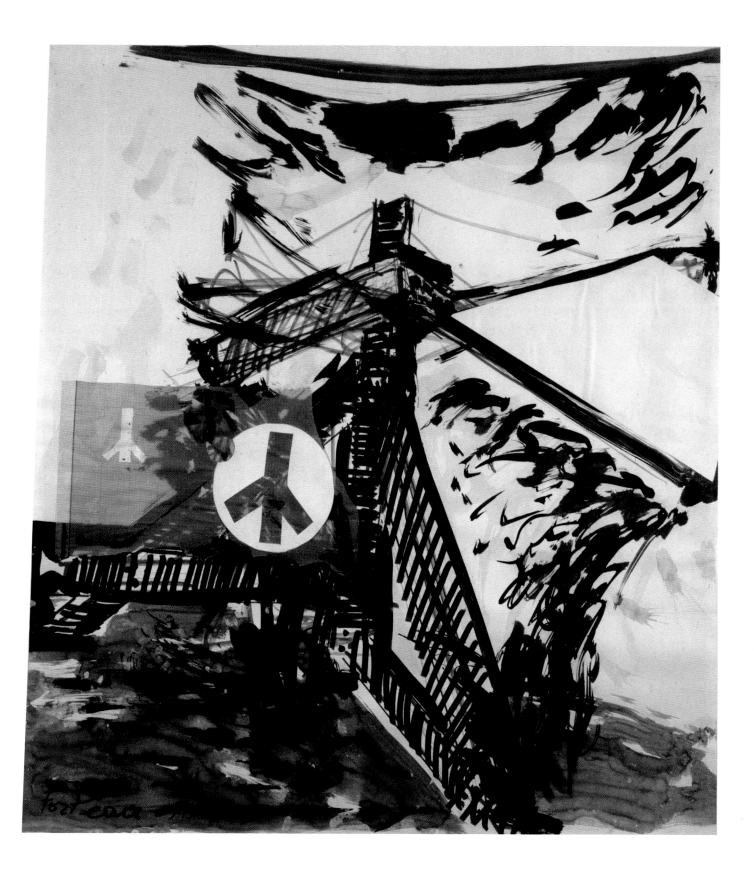

forty-one-foot-high orange-red structure initially titled *For Peace* but known by 1974 as *Mother Peace* [FIG. 1].[7] Like some other well-known artists opposed to the war (for example, Carl Andre and Robert Morris), di Suvero continued to pursue an abstract idiom while protesting his government and largely kept his political speech separate from his art. *Mother Peace* is a rare instance in which he made explicit reference to the subject of peace,[8] both in its title and by the symbol cut conspicuously into its lower hanging horizontal beam. The peace symbol is prominent in *For Peace* as well, appearing twice in elements collaged to its surface.

An impressionistic portrait, *For Peace* conveys the spirit of *Mother Peace*, if not all its physical detail. With emphatic, repeated hatch marks, di Suvero emphasizes the stability of the sculpture's tripod base in contrast with the suggested movement of the elements above. Very different from di Suvero's dark state of mind at the time he left the United States, *Mother Peace*—with its brilliant color and outstretched arms—projects vigor, optimism, and strength. Its huge beams, which are suspended and connected by cables, remain unfixed, their orientation subject to intervention by the weather or by people. The artist intends his large-scale sculptures to be displayed in public places where they can be approached—or even physically mounted and climbed—by people from many walks of life. Such interactive work has been seen as inherently social and political, given its emphasis on engagement and inclusion. When asked in the later 1970s, "Do any of your sculptures make a political statement?" di Suvero's response was immediate: "*Mother Peace* does. I think that whole piece is built around a peace symbol if you really look carefully at it."[9] Indeed, the work invites viewers to, in the artist's words, "actually enter and change the piece itself"[10]—an exhortation with a moral dimension when considered in relation to social movements of the Vietnam War

era. Patricia C. Phillips astutely described *Mother Peace* as both "a summons and an alert."[11] Coming together, a group of people might swing the peace sign–adorned lower beam to change the direction of the chevron form above; coming together, a group of people might stop the war. **MH**

1 The *Artists' Tower of Protest* was a collaborative effort spearheaded by the Los Angeles–based Artists' Protest Committee. Di Suvero became involved at the time of his 1965 Dwan Gallery exhibition when he met with Irving Petlin and Arnold Mesches about their plans for a large-scale statement by artists against the war. Di Suvero designed and built the tower in New York, and it was subsequently reassembled in California. Hundreds of panel paintings, submitted by an international group of artists, accompanied the *Tower*. For more on the *Artists' Tower of Protest*, see Francis Frascina, *Art, Politics and Dissent: Aspects of the Art Left in Sixties America* (Manchester, UK: Manchester University Press, 1999). See also Thomas Crow, "Bearing Witness in American Art of the Vietnam Era" in this volume, pp. 281–303.

2 Tom Armstrong, "Preface and Acknowledgements," in James K. Monte, *Mark di Suvero* (New York: Whitney Museum of American Art, 1975), 5.

3 For two accounts of di Suvero's activities and movements within Europe during this period, see Nora Lawrence, "Poetry and Balance: The Life of a Sculptor," in *Mark di Suvero*, ed. David R. Collens and Nora Lawrence (Cornwall, NY: Storm King Art Center, 2015); and Elizabeth Kelley, "Mark di Suvero: Sculptor of Space" (PhD diss., University of Louisville, 2011).

4 Mark di Suvero, in conversation with Marc Brugnoni, *North Star*, written by Barbara Rose and directed by François de Menil (Parrot Productions Ltd., 1977).

5 Mark di Suvero, quoted in Lawrence, "Poetry and Balance," 27.

6 "We were arriving to the land of Lincoln, the land of Jefferson." Di Suvero's mother, Matilde Millo di Suvero, in de Menil, *North Star*.

7 Writing in 1972, Carter Ratcliff referred to the sculpture, which had been completed by di Suvero in Pasadena, CA, in 1970 and since disassembled, as *For Peace* in "Mark di Suvero," *Artforum* 11, no. 3 (1972): 34–42. The work was exhibited with the title *Mother Peace* outside the Alameda County Courthouse as part of the Oakland Museum of California's exhibition *Public Sculpture/Urban Environment* in August 1974. It is now in the collection of the Storm King Art Center, Mountainville, NY, where it is on long-term display.

8 A few other sculptures made by di Suvero during the course of the war were given titles that directly reference Vietnam, including *Vietnam Piece*, 1968 (private collection); and *Homage to the Viet Cong*, 1971 (Staatsgalerie Stuttgart, Germany).

9 Mark di Suvero, in conversation with Marc Brugnoni in de Menil, *North Star*.

10 Mark di Suvero, in de Menil, *North Star*.

11 Patricia C. Phillips, "(In)visible Energies Working in Concert," in *Mark di Suvero*, ed. Collens, Lawrence, and Choi, 41.

1973

When the Paris peace talks resume in early **JANUARY**, the communist delegations refuse to concede the partitioning of South Vietnam or the withdrawal of PAVN troops from so-called liberated zones.

At the same time, Congress votes to cut off funding for the war in Vietnam as soon as the withdrawal of American troops is complete and all American prisoners of war repatriated.

To persuade President Nguyễn Văn Thiệu to accept the armistice terms, President Nixon promises assistance should North Vietnam violate its terms or resume hostilities; he also threatens to cut off all aid if South Vietnam continues to block the peace process. On **JANUARY 15**, President Nixon suspends all offensive military actions in North Vietnam and six days later, Nguyễn Văn Thiệu's government reluctantly withdraws its objections to the peace plan.

The Paris Peace Accords are formally signed on **JANUARY 27** [FIG. c33]. The next morning, a general cease-fire goes into effect in Vietnam.

After the armistice is signed, American news organizations pull correspondents from Vietnam, reducing the number of journalists covering the country from several hundred to about a dozen.

In **FEBRUARY** and **MARCH**, the United States begins withdrawing its remaining troops from South Vietnam.

FIG. c33 Delegations meet to sign the Paris Peace Accords, 1973.

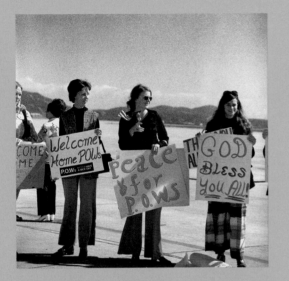

FIG. c34 The wives of U.S.
POWs await their return at
Camp Pendleton, CA, 1973.

In **FEBRUARY** and **MARCH,** a total of 591 American POWs are released from North Vietnam. Many have survived years of harsh treatment in DRV captivity [FIG. c34].

On **MAY 11,** citing "improper government conduct," a judge dismisses all charges made against Daniel Ellsberg for releasing the Pentagon Papers.

The Senate committee investigating Watergate begins televised hearings on **MAY 17.** A week later, Archibald Cox is appointed the Justice Department's special prosecutor for Watergate. The hearings will continue until President Nixon's resignation in August 1974.

On **JUNE 14,** Congress votes to end all U.S. military actions in Southeast Asia. Nixon vetoes the bill but agrees to stop the air campaign in Cambodia. Bombing of Cambodia finally ceases in **AUGUST.**

On **OCTOBER 20,** in a series of events known as the Saturday Night Massacre, President Nixon forces the firing of Watergate special prosecutor Archibald Cox, causing Attorney General Elliot Richardson and Deputy Attorney General William Ruckelshaus to resign. Pressure to impeach Nixon grows in Congress.

On **NOVEMBER 7,** Congress passes the War Powers Act, overriding Nixon's veto. The law stipulates that a U.S. president cannot commit armed forces to combat for more than sixty days without justifying the action to Congress. The law also requires the president to notify Congress within forty-eight hours of committing armed forces to military action.

After the U.S. Department of Justice uncovers evidence of his corruption, Vice President Spiro Agnew resigns on **OCTOBER 10.** On **DECEMBER 6,** House Minority Leader Gerald Ford is confirmed by the House of Representatives as the new vice president.

On **DECEMBER 10,** Henry Kissinger and Lê Đức Thọ are awarded the Nobel Peace Prize for "ending the war and restoring peace in Vietnam." Lê Đức Thọ refuses the prize, noting that peace had not yet come to Vietnam. Kissinger declines to attend the ceremony and donates the monetary prize to a scholarship fund for children of U.S. servicemen killed or missing in the war.

Malaquias Montoya | b. 1938, Albuquerque, NM

MALAQUIAS MONTOYA'S ACTIVIST ART-MAKING began in the context of the farm workers' movement but soon referenced the full cultural and political dimensions of the fight for Chicano civil rights that unfolded in the United States in the 1960s and 1970s. As an older student attending the University of California at Berkeley on the GI Bill, Montoya became a seminal figure who embodied the way in which many Chicano artists saw their relationship to pressing political and community needs. He was active with the Third World Liberation Front, the Mexican American Liberation Art Front, and groups that opposed the Vietnam War. Although he did not serve in Vietnam, his perspective on the war was shaped by his experience as a marine. On tours through Japan, the Philippines, and Taiwan between 1957 and 1960, he experienced the arrogant attitudes of his fellow soldiers toward the local populations. His humanist and internationalist vision of the world stems in part from these years.[1]

Viet Nam/Aztlan is not Montoya's first poster to address the conflict in Vietnam, but it is undoubtedly his most iconic and effective at revealing the deep links among the antiwar, anticolonial, and civil rights movements.[2] Montoya divided the print into three registers and repeatedly used the racialized hues of brown and yellow to color the text, faces, and clenched fists that animate the poster. The text on the top register equates Vietnam and Aztlán, the mythic Chicano homeland said to be located in what is presently the southwestern United States, giving rise to arguments that Chicanos are a conquered people within the United States.[3] In another gesture toward solidarity, Montoya translates Vietnamese text into Spanish.[4] The middle register juxtaposes the faces of a Vietnamese man and a Chicano man, who appear like twins conjoined at the back of their heads. With forceful conviction, the Vietnamese figure on the left holds his fist to his face, while the Chicano figure stares beyond the poster's edge, as if contemplating his future. The words *Chicano* and *Viet Nam* appear on the lowest register, over two fists and the Spanish word *fuera*, a declarative expression (meaning "out") that remains untranslated, thus suggesting that Montoya's target audience was Latino.

For activist artists like Montoya, the example of Cuban postrevolutionary posters was essential to their developing style and outlook. Cuban posters projected solidarity with revolutionary movements around the world—especially in Vietnam—and modeled a striking artistry that commanded attention.[5] Montoya emulated Cuban artists' bold graphic forms and use of multilingual text, to which he incorporated references to U.S. politics. In fact, in *Viet Nam/Aztlan*, Montoya replicates the face and pose of a Vietnamese figure that appears in a 1972 poster by Eduardo Bosch Jhones and uses a variation of the slogan *venceremos* ("we will overcome"), which was frequently emblazoned on Cuban posters and other forms of public art.[6]

Montoya was commissioned to create *Viet Nam/Aztlan* for a series of moratorium events held across California, but his ideas for the piece began earlier, when he met Lea Ybarra and Nina Genera, two activists who were working through their organization, Chicano Draft Help, to educate young Chicanos on ways to avoid the draft.[7] Montoya designed the letterhead for their organization, which closely resembles the middle register of the poster, and which also appears as an illustration in Ybarra and Genera's bilingual publication, *La Batalla Está Aquí*.[8] Working with a student, Montoya also designed the pamphlet's cover, showing an abstracted human figure reaching toward the sky, whose arm is trisected by barbed wire, perhaps a comment on domestic border issues [FIG. 1]. The pamphlet is a powerful work of activist writing

Leon Golub

Vietnam II

1973
acrylic on canvas

Leon Golub | b. 1922, Chicago, IL | d. 2004, New York City

LEON GOLUB WAS AN EARLY AND DEDICATED
activist against the U.S. war in Vietnam. In the fall
of 1964, the Chicago-born and -trained painter, with
the artist Nancy Spero [p. 49] and their three sons,
moved to New York, ending a five-year sojourn in
Paris. In France, Spero and Golub had witnessed
protests against the war in Algeria and were aware
of the important role French intellectuals played in
denouncing their government's conduct of it, but as
foreigners, they remained on the sidelines. Back in
their own country, they felt a heightened civic and
moral responsibility to speak out against the United
States' rapidly escalating military action in Southeast
Asia and soon joined Artists and Writers Protest
(AWP), a group that grew out of the Greenwich
Village Peace Center and War Resisters League. The
couple frequently hosted AWP meetings at their loft
and participated in countless demonstrations, includ-
ing major efforts like the *Peace Tower* and Angry Arts
Week. Golub emerged as a forceful advocate among
American artists against the war, arguing both
points of public policy and aesthetics. In a 1965 event
organized by the Artists' Protest Committee, for
example, he was among a few who publicly debated

with representatives of the RAND Corporation about
U.S. policy in Southeast Asia; and, on the occasion
of Angry Arts Week in 1967, Golub spoke out passion-
ately on radio and in print in favor of a politically
engaged, humanist art.[1]

During these years, Golub's work dwelled on the
theme of human physical violence. His *Gigantomachies*
are wall-sized, unstretched paintings that depict epic
scenes of warring, struggling men, their poses based
on sources ranging from sports photographs to the
Great Altar of Pergamon [FIG. 1]. These "barbaric and
gross"[2] figures were formed through a method of
layering, staining, and scraping paint on unprimed
canvas. Though hardly idealized, the nudes of the
Gigantomachies address the subject of men in conflict
in a universalizing manner, an approach that made
Golub increasingly uneasy as the real war continued.
He considered the contrast between his imagery and
the contemporary reality in Southeast Asia "glaring,"[3]
especially given the surfeit of television and photo-
graphic images of the seemingly unstoppable blood-
shed there. "I was making figurative images dealing
with violence and tension and stress," he recalled in
2001, "and there was violence and tension and stress
right in front of my eyes and the two didn't connect."[4]

Beginning in 1969, Golub created his *Napalm*
series, in which he conjured through congealed and
abraded pigment on cut canvas a sense of flayed
and burnt flesh [p. 21]. But it was his three *Vietnam*
paintings—made between 1972 and 1974—that finally
brought his life/art dilemma to resolution. These
paintings are painfully specific, showing American
and Vietnamese figures rendered in recognizable
detail of race, dress, and weaponry. Golub pieced
together the compositions using a collection of photo-
graphs clipped from magazines, military manuals,
and books on Vietnam [FIG. 2]. Similar to Martha Rosler
and Carolee Schneemann [pp. 94–98, 64–65], he devel-
oped a "photo mania"[5] during the war years—which,
in Golub's case, persisted and continued to feed the

FIG. 1
Leon Golub, *Gigantomachy II*,
1966, acrylic on linen, The
Metropolitan Museum of Art,
Gift of The Nancy Spero and
Leon Golub Foundation for
the Arts and Stephen, Philip,
and Paul Golub, 2016

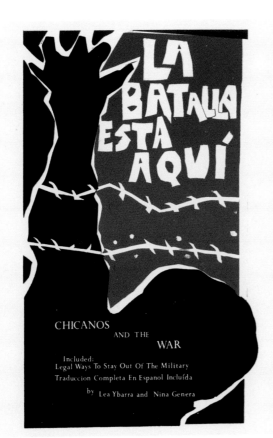

FIG. 1
Malaquias Montoya and
Linda Gallegos, cover
for *La Batalla Está Aquí:
Chicanos and the War*
(1972)

that spoke out against disproportionate Chicano death rates in the war, argued for the humanity of the Vietnamese, and identified the real battle as the quest for civil rights at home. The Vietnam War led Chicanos to rethink their relationship to military service, challenging the older view that service could secure Mexican American equality.[9] This activist stance mirrored Montoya's own developing artistic philosophy. In the ensuing years, he would argue that it was the artist's responsibility to "reveal reality and to actively work to transform it."[10] **ECR**

1 The summary of Montoya's formative years is drawn from Terezita Romo's monograph on the artist. See *Malaquias Montoya* (Los Angeles: UCLA Chicano Research Center Press, 2011).

2 Montoya created at least four works on the subject of the Vietnam War, including *Julio 26: Cuba Vietnam y nosotros venceremos* (1972), a print with a similar tripartite design. E. Carmen Ramos's conversation with the artist, January 23, 2018.

3 Aztlán was the mythic homeland of the Aztecs, which pre-Columbian creation stories located in the Southwest region of North America. As descendants of indigenous Mexicans, Chicanos laid claim to the Southwest as their original homeland and current site of their oppression. For more on Aztlán, see Michael Pina, "The Archaic, Historical and Mythicized Dimensions of Aztlán," in *Aztlán: Essays on the Chicano Homeland*, ed. Rudolfo Anaya, Francisco A. Lomelí, and Enríque R. Lamadrid (Albuquerque: University of New Mexico Press, 1989), 43–75.

4 Montoya adopted text from a Paris peace talks brochure. Montoya translates two phrases, the longer "Đoàn kết Chiến thắng" as "Unidos venceran" [Together we will be victorious] and "Đoàn kết" as "solidaridad" [solidarity]. See Romo, *Malaquias Montoya*, 8–10.

5 Cuban posters, actively circulated in the Bay Area during the war era, had a major impact on many artists, including Montoya, Rupert García,

and Emory Douglas. For more on the impact of Cuban posters on U.S. art, see Tere Romo, "¡Presente! Chicano Posters and Latin American Politics," in *Latin American Posters: Public Aesthetics and Mass Politics*, ed. Russ Davidson (Santa Fe: Museum of New Mexico Press, 2006), 51–63. Lincoln Cushing reproduces several Vietnam-themed Cuban posters in his book *¡Revolución! Cuban Poster Art* (San Francisco: Chronicle Books, 2003).

6 Jhones's circa 1972 poster bore the text, "Esta gran humanidad ha dicho ¡BASTA!" ("This great humanity has said Enough!") and was created for the Organization of Solidarity with the Peoples of Asia, Africa and Latin American (known by the acronym OSPAAAL). I thank Carol A. Wells from the Center for the Study of Political Graphics for pointing out this connection.

7 Ramos's conversation with the artist, January 23, 2018.

8 See *La Batalla Está Aquí: Chicanos and the War* (El Cerrito, CA: Chicano Draft Help, 1972), 49.

9 For more on the history of Mexican American military service and its relationship to the quest for equal rights, see Lorena Oropeza, "To Be Better and More Loyal Citizens," in *¡Raza Sí! ¡Guerra No! Chicano Protest and Patriotism during the Viet Nam War Era* (Berkeley: University of California Press, 2005), 11–46.

10 Romo, *Malaquias Montoya*, 4.

Viet Nam/Aztlan

1973
offset lithograph

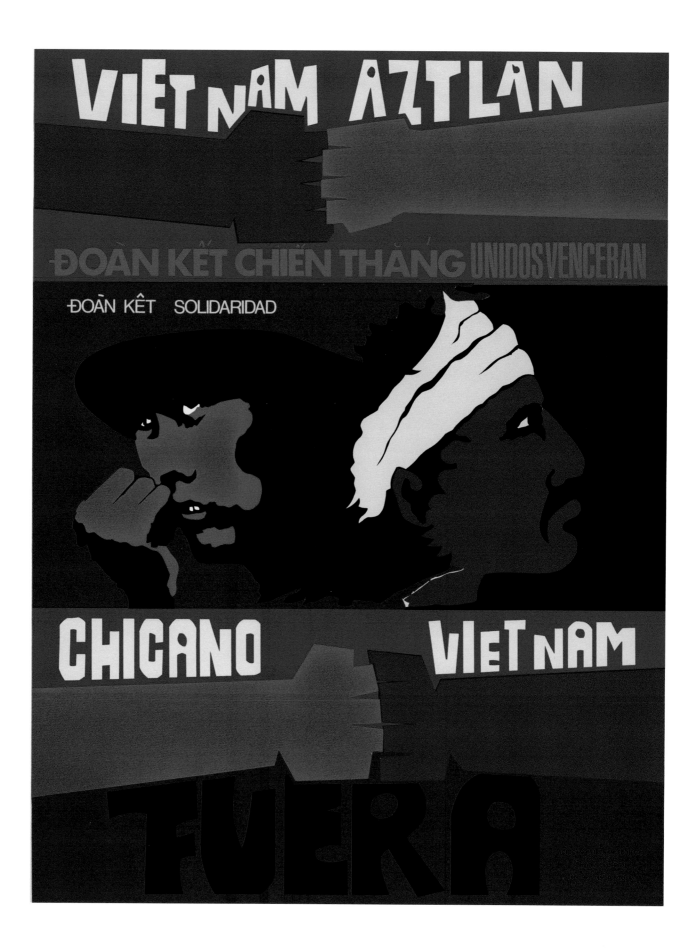

artist's work for the rest of his life. What has been described as his visual "encyclopedia of violence" eventually filled three file cabinets, with images organized by body part and pose.[6]

The extreme format of the *Vietnam* paintings defies the viewer to remain indifferent in the face of such a bald display of power and destruction. The works were created on the scale of public art—though Golub commented wryly about *Vietnam II* that "[i]t is a very public painting that nobody wanted."[7] At nine-and-a-half-feet tall and almost thirty-eight-feet long, *Vietnam II* is Golub's most enormous work. The composition places the viewer at the center of a dire scene, caught between heavily armed American soldiers advancing on the left and Vietnamese civilians fleeing in disarray on the right. Golub originally assigned this series the accusatory title *Assassins* but later changed it, realizing his mistake: "You can't blame the GIs for the guys who were initiating all this. The soldiers weren't assassins. So I became ashamed of the title."[8] The paintings

themselves do not present their American subjects as individuals so much as dangerously impersonal and amoral extensions of state power.

Golub intended the *Vietnam* paintings to be immediate and direct—"too close for comfort."[9] The irregular cuts in the canvases and the loose manner in which they hang from the wall emphasize the painter's refusal to shut the real world out of his art. Golub believed in the power of confrontation with a physical image: "The shock of encountering a brutal, tangible monster of this kind means that you have to take account of it—you have to figure out why such a thing appears in your world."[10] Golub's monsters are outsized power, violence, mass death. His paintings insist, "This is not make-believe; this is not fantasy, this is not symbolism…the situations which call these forces into existence actually exist."[11] **MH**

1 For more on the Artists' Protest Committee's activities with the RAND Corporation, see Francis Frascina, *Art, Politics and Dissent: Aspects of the Art Left in Sixties America* (Manchester, UK: Manchester University Press, 1999), 38–40. For Golub's statements during Angry Arts Week, see "The Artist as an Angry Artist: The Obsession with Napalm," *Arts* 41 (April 1967): 48–49, reprinted in Hans-Ulrich Obrist, ed., *Leon Golub: Do Paintings Bite?* (Berlin: Hatje Cantz Publishers, 1997), 153 55; and Jeanne Siegel, "How Effective Is Social Protest Art? (Vietnam)," transcript of a discussion with Leon Golub, Allen D'Arcangelo, Ad Reinhardt, and Marc Morrel on WBAI on August 10, 1967, printed in Jeanne Siegel, *Artwords: Discourse on the 60s and 70s* (Ann Arbor, MI: UMI Research Press, 1988), 101–19.

2 Golub, "Gigantomachies," unpublished essay, 1967, included in Obrist, ed., *Leon Golub: Do Paintings Bite?*, 170.

3 Golub, interview with David Procuniar, *Journal of Contemporary Art* 7, no. 2 (1995): 53–66, http://www.jca-online.com/golub.html.

4 Golub, quoted in David Levi Strauss, "Where the Camera Cannot Go: Leon Golub on the Relation between Painting and Photography," *Aperture*, no. 162 (Winter 2001): 55.

5 Golub, quoted in Strauss, "Where the Camera Cannot Go," 56.

6 Sarah Cowan, "They're Fucking Skulls," *The Paris Review*, June 3, 2015, https://www.theparis-review.org/blog/2015/06/03/theyre-fucking-skulls/.

7 Golub, "On the Day Clement Greenberg Died, New York, May 7, 1994," in Obrist, ed., *Leon Golub: Do Paintings Bite?*, 22.

8 Golub, quoted in Strauss, "Where the Camera Cannot Go," 55.

9 Golub, "On the Day Clement Greenberg Died," 25.

10 Golub, quoted in "On Art and Artists: Leon Golub," *Profile* 2, no. 2 (March 1982): 10.

11 Golub, quoted in "On Art and Artists: Leon Golub," cover.

FIG. 2
Leon Golub, study for
Vietnam II, ca. 1972–73,
collaged magazine images

Jesse Treviño | b. 1946, Monterrey, Mexico

BORN IN MEXICO AND RAISED IN SAN ANTONIO, Jesse Treviño was drafted into the U.S. Army in 1966. At the time, he was living in New York City, having won a scholarship to study painting at the Art Students League. He was also working at a portrait shop in Greenwich Village, where customers could have their likenesses drawn by an artist on the spot.[1] Though not yet an American citizen, Treviño came from a family with a strong record of U.S. military service, and, once drafted, he did not consider avoiding enlistment. In February 1967, a few months after arriving in Vietnam, Treviño was severely injured while on patrol, and in late 1970, complications from the injury made it necessary to amputate his right arm—the one he had previously used to wield a brush. *Mi Vida* marks Treviño's subsequent rebirth as an artist. Through its lengthy and painstaking creation, Treviño regained his craft and confidence, and also asserted a new subject matter for his art, one explicitly rooted in his personal experiences and cultural perspective as a Chicano. This content has defined his most important work since.

The ambition and size of *Mi Vida* is striking—not what one would expect from an artist forced to start over and indeed uncertain that he could continue as a painter. Today an experienced muralist, Treviño at the time had never attempted work on such a large scale. Eight feet high and fourteen feet long, *Mi Vida* was executed directly on the wall of Treviño's bedroom. The work's humble architectural origins can be easily read in its rough, irregular surface—and in the presence of an electrical socket preserved near its lower edge.[2] The rhetorical impact of *Mi Vida* is akin to an outdoor advertising billboard; yet, in its original site, the force of its address would have been aimed at an audience of one. Filling the wall across from where the artist slept, the painting was the first and last thing he saw each day. Treviño was coping with chronic pain and still struggling to adjust to his loss of limb and his return to civilian life as he labored on *Mi Vida*. These challenges are literally writ large in the work, expressed with an emotional directness no doubt facilitated by the painting's private setting.

Treviño remembers creating *Mi Vida* in near darkness. He had studied with Mel Casas and admired the drama conjured by the dark backgrounds in Casas's *Humanscape* paintings [pp. 112–13], works that are structured around the form of a movie screen.[3] With this example in mind, Treviño painted his bedroom wall black and even covered the room's sole window, blocking out the natural light. He then created his composition bit by bit, under the glare of a single strong light source. *Mi Vida*, as its title suggests, is a kind of self-portrait. The first element Treviño completed was the image of his prosthetic arm: it is presented front and center, the dominant fact of the artist's postwar life. Dangling from its hook is his Purple Heart medal, the official acknowledgment of his sacrifice for his country. The green Ford Mustang on the left is another compensatory item: it portrays the artist's first car, which he bought using his disability pay. To the right is a spectral image, like a dwindling memory, of Treviño dressed for combat, his body still intact. Arrayed above is a sequence of everyday comforts—*pan dulce* and a cup of coffee, cigarettes, a painkilling pill, a can of beer—all things ingested to soothe, relieve, and numb. Finally, looming behind the other images is the oversized face of a young woman. While the rest of the painting was rendered from photographs or life, the girl's face was based on Treviño's memory of a high school friend who had since died in a car accident. Her intense visage is lucid but mysterious, confronting the viewer from either the artist's past or the afterlife.

FIG. 1
Jesse Treviño, *Mis
Hermanos*, 1976, acrylic
on canvas, Smithsonian
American Art Museum,
Gift of Lionel Sosa, Ernest
Bromley, Adolfo Aguilar
of Sosa, Bromley, Aguilar
and Associates

Had Treviño not served in Vietnam, it is not clear what kind of artist he might have become—perhaps he would have remained in New York and continued as a commercial portraitist. Instead, he returned to his hometown and, beginning with *Mi Vida*, developed an art dedicated to his immediate world. Lying injured in Vietnam, Treviño had thought of "my family, my mom, and my neighborhood...everything I cherish,"[4] and he realized, "I had just painted whatever my teachers told me to paint....I had never painted my mother or my brothers. I'd never seen museum-quality paintings of the barrio" [FIG. 1].[5] He came home determined to represent and celebrate working-class Mexican American life in his art. As art historian Rubén Cordova put it, "a Chicano artist was born out of a near-death experience in a Vietnamese rice paddy."[6] **MH**

1 Jesse Treviño, conversation with the Melissa Ho, May 16, 2017.

2 Cindy Gabriel, who purchased Treviño's house from him, had the painting extracted and mounted on an aluminum panel in 2004. Elda Silva, "'Mi Vida' Is Getting a New Life; Current Owner of Jesse Treviño's Home to Preserve His Mural," *San Antonio Express-News*, July 22, 2004, 1F.

3 Treviño, conversation with Melissa Ho.

4 Cary Cordova, Oral History Interview with Jesse Treviño, July 15–16, 2004, Archives of American Art, Smithsonian Institution, https://www.aaa.si.edu/collections/interviews/oral-history-interview-jesse-trevio-11789#transcript.

5 Treviño, quoted in Rubén Cordova, "Jesse Treviño: Synonymous with San Antonio," *Rivard Report*, December 4, 2016, https://therivardreport.com/jesse-trevino-synonymous-with-san-antonio/.

6 Ibid.

Jesse Treviño

Mi Vida

1971–73
acrylic on drywall, mounted
on aluminum

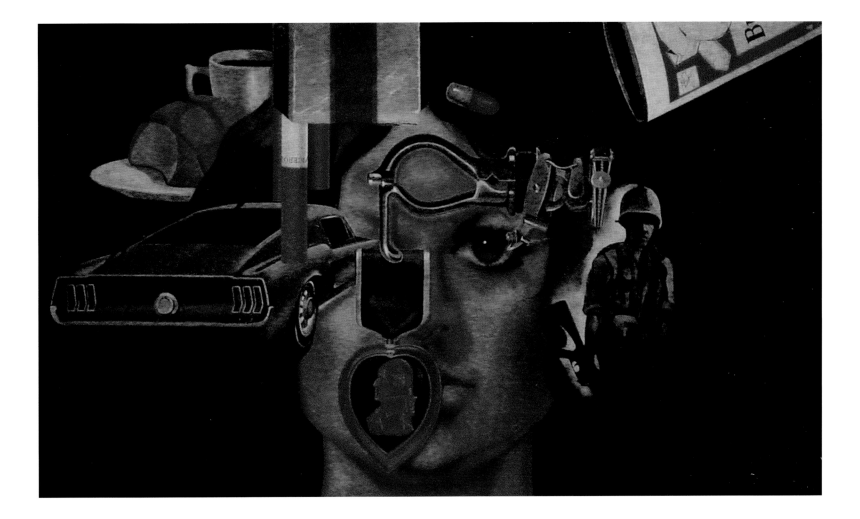

1974

Despite the armistice, both the Sài Gòn and Hà Nội governments seek to improve their military and political positions and full-scale war soon resumes.

In **MARCH**, the remains of twenty-three American servicemen listed as missing in action (MIA) in Vietnam are returned to the United States by the DRV. U.S. veterans groups will continue to demand information about their comrades whose fates are unknown. In the following decades, the remains of more missing Americans will be returned and, in 1989, President George H. W. Bush will convene a bipartisan congressional committee to look for evidence of living American POWs being held in Vietnam; after a four-year investigation, it will conclude that none exist.

The Supreme Court rules unanimously on **JULY 24** that President Nixon must turn over recordings of White House conversations and other subpoenaed materials related to Watergate, rejecting his claim of executive privilege.

On **JULY 27**, the House Judiciary Committee passes the first of three articles of impeachment against President Nixon, charging obstruction of justice.

In a televised address on **AUGUST 8**, Richard Nixon announces that he will resign effective the following day [FIG. c35]. Gerald Ford (in office 1974–77) takes the presidential oath of office in the White House East Room on **AUGUST 9**.

President Ford issues a pardon to Nixon on **SEPTEMBER 8** for any crimes he may have committed while president.

On **SEPTEMBER 16**, President Ford issues a conditional amnesty for Vietnam War draft evaders and military deserters, requiring that they perform a period of work service. Nearly 210,000 men have been charged with draft evasion during the war, with additional hundreds of thousands never formally charged. Canadian statistics suggest that between 20,000 and 30,000 draft-eligible men emigrated to Canada during the war.

In the **FALL OF 1974**, the North Vietnamese politburo approves a plan for a limited offensive against the south in 1975.

FIG. c35 Richard Nixon leaves the White House after his resignation.

1975

PAVN troops make preliminary incursions into South Vietnam's border outposts in **JANUARY** and are not met with any American response.

The Spring Offensive gathers momentum in **MARCH** when PAVN forces seize the city of Buôn Ma Thuột. On **MARCH 13**, President Nguyễn Văn Thiệu orders his army to withdraw from the Central Highlands in the hope that they will be able to hold and defend other key areas with population density and important natural resources. Enormous logistical difficulties turn what was planned as a strategic retreat into a flight toward the sea known as the Convoy of Tears—a tipping point in the military collapse of South Vietnam.

On **APRIL 10**, President Ford requests a $722 million supplemental military aid package for South Vietnam, plus $250 million in economic and refugee aid. Congress balks and ceases discussion on **APRIL 17**. Denied its only likely source of aid, South Vietnam's fate is sealed.

On **APRIL 17**, Khmer Rouge forces capture Phnom Penh, forcing the surrender of the Khmer Republic and the end of the Cambodian Civil War.

In **APRIL**, under orders to hold Xuân Lộc, the last ARVN mobile forces make a stand hoping to prevent PAVN forces from reaching Sài Gòn [FIG. c36]. The outnumbered ARVN inflict heavy losses on the PAVN attackers but are forced to withdraw after being almost completely isolated. With Xuân Lộc in communist control, the road to Sài Gòn is open and largely undefended [FIG. c37].

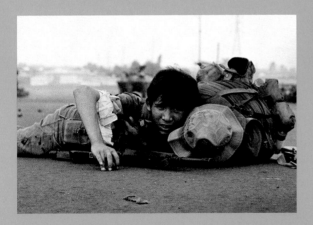

FIG. c36
ARVN soldiers during the
final North Vietnamese
advance on Sài Gòn.

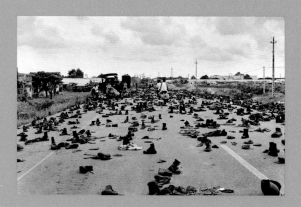

FIG. c37 Boots left by retreating
South Vietnamese troops as
PAVN advances on Sài Gòn, 1975.
Photo by Duong Thanh Phong

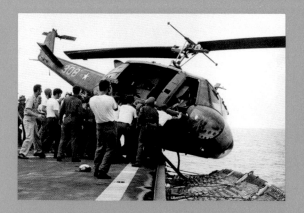

FIG. c38 A helicopter is pushed
off a U.S. carrier to make room for
more incoming evacuees, 1975.

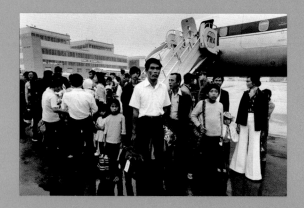

FIG. c39 South Vietnamese
refugees arrive in Harrisburg,
Pennsylvania, 1975. Photo by
Charles Isaacs

With the South Vietnamese National Assembly holding him responsible for the nation's political and military situation, President Nguyễn Văn Thiệu resigns on **APRIL 21** and soon after flees the country. South Vietnamese leadership passes first to Trần Văn Hương, who holds power for a week; he cedes the presidency to General Dương Văn Minh two days before the south surrenders.

Fearing panic among expatriate residents, U.S. Ambassador Graham Martin refuses to evacuate from Sài Gòn throughout **APRIL**, but other U.S. agencies begin moving their people out of the country. More than 43,000 are flown out of Sài Gòn on U.S. Air Force transports until the Tân Sơn Nhất airfield is shut down by PAVN shelling on **APRIL 29**.

As communist forces advance toward Sài Gòn, President Ford declares in a speech at Tulane University on **APRIL 23** that the war in Vietnam is "finished" for the United States. He announces, "Today, Americans can regain the sense of pride that existed before Vietnam. But it cannot be achieved by refighting a war."

The U.S. Navy's Seventh Fleet begins evacuating U.S. personnel and certain South Vietnamese citizens on **APRIL 29** (Operation Frequent Wind). About 1,000 Americans and 6,000 non-Americans are ferried by helicopter to aircraft carriers assembled in the South China Sea. On some ships, helicopters are pushed overboard to make more room for incoming evacuees [FIG. c38].

More than 130,000 South Vietnamese flee their homeland before communist troops arrive in Sài Gòn. About 90,000 of these refugees eventually settle in the United States [FIG. c39].

The last Americans board a helicopter from the roof of the American embassy around 8 a.m. on **APRIL 30**. By midmorning, North Vietnamese troops move into the center of Sài Gòn and accept the surrender of President Dương Văn Minh.

Philip Guston | b. 1913, Montreal, Canada | d. 1980, Woodstock, New York

FOLLOWING AN EARLY CAREER AS A SOCIALLY conscious muralist with the Works Progress Administration, Philip Guston, beginning in the 1950s, was among the vanguard of American abstract expressionists. Yet by 1965 he felt the need to change course, and he ceased painting for the next two years. His personal sense of dissatisfaction in the face of pressing social catastrophe increased throughout the decade: "When the 1960s came along I was feeling split, schizophrenic. The [Vietnam] war, what was happening in America, the brutality of the world."[1] After witnessing on television the violent suppression of protesters at the 1968 Chicago Democratic Convention, Guston painted scenes of Ku Klux Klansmen, a group he had witnessed as strikebreakers and depicted while a young artist in Los Angeles.[2] Guston's return to figurative painting met critical derision, however, at the first exhibition of those canvases in 1970. Hilton Kramer infamously dubbed Guston a "Mandarin pretending to be a Stumblebum," while Robert Hughes mocked the artist's WPA-era certitude, "when it was still believed that political comment could give art relevance."[3] Guston took offense. He would not show in New York for another four years. Guston's personal struggle over which mode of modernism to engage—his self-doubt about the degree of figuration and topicality appropriate to his art—underpinned his practice throughout the Vietnam War era.

In the 1970s, Guston rehearsed this broader uncertainty about the politics of representation through the figure of Richard Nixon. An avowed "Nixon watcher," he first caricatured the president in a private drawing series titled *Poor Richard*, which he created following the revelation of the Pentagon Papers in summer 1971. Nixon had staked his 1968 election on ending the war, and Guston portrays him as a menacing, self-righteous television personality [FIG. 1]. As Debra Bricker Balken has noted in her study of *Poor Richard*, television is also "a symbol that alludes to the impotency of abstract painting, the genre he abandoned in 1968, in part because of the content of the news that was carried into his home each evening. Abstraction had become, he felt, simply too disconnected and aloof from world events."[4] Despite Guston's aptitude and desire for brazen satire, he likewise distanced himself from the Nixon drawings. Only four of nearly eighty works in the series were published during Guston's lifetime.[5]

In one painting, *San Clemente*, from 1975, the artist worked through his ambivalence, elevating politics in general, and Nixon in particular, as a viable art subject.[6] In the wake of the Watergate hearings and on the brink of impeachment, Nixon became the first U.S. president to resign from office in August 1974. He retreated into exile at his "Western White House" in San Clemente, California.[7] In a 1975 letter to an artist friend, Guston explained, "Several months ago the old Nixxon [sic] feeling came back and I did a painting—just to see how it would look—But now the hell with it—all that good oil paint and Belgian linen wasted—More important images to make!!"[8] Here

FIG. 1
Philip Guston, *Untitled (Poor Richard)*, 1971, ink on paper, Private Collection, Courtesy Hauser & Wirth

Guston refers to this uncompromising portrait of
the disgraced former president. A vulture-like Nixon,
pushed to the front of the picture plane, hunches
at the waist to fit inside the frame. He stares at the
viewer through bloodshot eyes, a single tear running
down his scrotum-like jowls, visually rhyming with
his phallic, flaccid nose. Unlike the scheming, aspi-
rational Nixon of *Poor Richard*, the president in *San
Clemente* appears dejectedly self-pitying, his pain
caused by a contorted, grotesquely swollen leg. The
sense of spontaneity and caustic wit that initially
drove the Nixon caricatures — a generative if cau-
tiously held episode into directly political represen-
tation — no longer compelled the painter once his
active disdain gave way to disgust. In *San Clemente*,

the president's enlarged foot upholds an uncontain-
able mass of veiny, pustuled flesh. Altogether, these
deformities and disease manifest what Guston sees
as the corruption and deceit of Nixon's tenure in
American political life. JM

1 Jerry Talmer, "'Creation' Is for Beauty Parlors," *New York Post*, April 9, 1977, 22.

2 Dore Ashton, "Introduction," in *Philip Guston: Collected Writings, Lectures, and Conversations*, ed. Clark Coolidge (Berkeley: University of California Press, 2011), 5.

3 Hilton Kramer, "A Mandarin Pretending to be a Stumblebum," *New York Times*, October 25, 1970, B27; Robert Hughes, "Ku Klux Komix," *Time Magazine*, November 9, 1970, 62. For a thoughtful analysis of the critical aftermath of Guston's October 1970 show at the Marlborough Gallery, see David Kaufman, "Sick of Purity" in *Telling Stories: Philip Guston's Later Works* (Berkeley: University of California Press, 2010), 19–27.

4 Debra Bricker Balken, *Philip Guston's* Poor Richard (Chicago: University of Chicago Press, 2001), 9.

5 Dore Ashton, *Yes, but … A Critical Study of Philip Guston* (New York: Viking, 1976), 158.

6 This painting compositionally references a 1971 publicity photo-graph in which a contented Nixon strolls the San Clemente beachfront, linking the singular 1975 canvas to the moment when Guston began his Nixon caricatures in earnest. While

the painter's comradery with writer Philip Roth inspired the *Poor Richard* in summer 1971, Guston returned to the subject after reading William Corbett's poem "The Richard Nixon Story" in fall 1974. In 1975, Guston created a "Phlebitis Series" of five drawings, a "poem-picture" incor-porating the text of Corbett's poem, and the painting *San Clemente*, each taking the phlebitis-afflicted presi-dent as a motif. See Debra Bricker Balken, *Philip Guston's Poem-Pictures* (Andover, MA: Addison Gallery of American Art, 1994), 60-1; Balken, *Philip Guston's* Poor Richard, 100, 103n110; Musa Mayer and Sally Radic, eds., *Philip Guston: Nixon Drawings 1971 & 1975* (New York: Hauser & Wirth, 2017), 233–37, 247.

7 San Clemente itself triggered a scandal due to public funding of its exorbitant maintenance costs after the president purchased the home in 1969. Longtime Nixon cartoonist Herbert Block satirized the property as "Rip-Off Manor: Public Keep Out" in several cartoons from 1972–74. See Herbert Block, *Herblock Special Report* (New York: Norton, 1974), n.p.

8 Letter from Philip Guston to Lawrence Campbell, July 18, 1975, Art Students League Papers at the American Art and Portrait Gallery Library, Smithsonian Institution.

images in my life;"[12] Mudman speaks to the difficulty of reconciling wartime and peacetime lives. Nine months after the North Vietnamese victory, Mudman appeared in Los Angeles as a phantom of a war just ended—but which, for many veterans, was still marching on. **MH**

1 *Wilshire Boulevard Walk* was Jones's first official performance in that it was sponsored, announced, and documented by Carp, a group run by Barbara Burden and Marilyn Nix that organized and promoted performance art in Los Angeles. The work consisted of two walks both moving in the same direction along the same route.

2 The name "Mudman" evolved for Jones's performance persona over time. Sandra Firmin states that it was first used in print by the critic Kim Levin, writing in the *Village Voice* in 1982. "Lines in Time and Space," in *Mudman: The Odyssey of Kim Jones*, ed. Sandra Q. Firmin and Julie Joyce (Cambridge, MA: MIT Press, 2007), 112.

3 Kim Jones, conversation with Melissa Ho, December 21, 2015.

4 Ibid.

5 Speaking in 2003 about *Wilshire Boulevard Walk*, Jones reflected, "You can relate [the walking] back to the military. We did a lot of walking, walking up and down the mountains. When you're walking in line, with a long line of men you're out of control, you have to keep in line, keep in pace. The Wilshire walk is a reflection of that." Quoted in Peter Murray, "Rats Live On,

No Evil Star: The Art of Kim Jones," in *A Cripple in the Right Way May Beat a Racer in the Wrong One: Kim Jones* (Cobh, Ireland: Sirius Art Centre, 2003), 10.

6 Jones, conversation with Melissa Ho.

7 Jones, quoted in Murray, "Rats Live On," 7.

8 Jones studied at Chouinard Art Institute in Los Angeles for two years before enlisting in the U.S. Marine Corps. After his service, he returned to Chouinard and completed his BFA in 1971. He went on to earn an MFA from the Otis Art Institute, Los Angeles, in 1973.

9 Julie Joyce, "Sunset to Sunrise: Kim Jones in Los Angeles," in Firmin and Joyce, *Mudman: The Odyssey of Kim Jones*, 26.

10 See Murray, "Rats Live On," 13.

11 Jones, in *Unwinding the Vietnam War: From War Into Peace*, ed. Reese Williams (Seattle: Real Comet Press, 1987), 114.

12 Jones, quoted in Steve Durland, "Back from the Front: Artist Kim Jones Is the Veteran of an Experience America Cannot Forget," *High Performance*, no. 25 (1984): 26.

Following pages:

Kim Jones as Mudman walking at the Vietnam Veterans Memorial (detail). See p. 22

Kim Jones

Wilshire Boulevard Walk

1976
performance

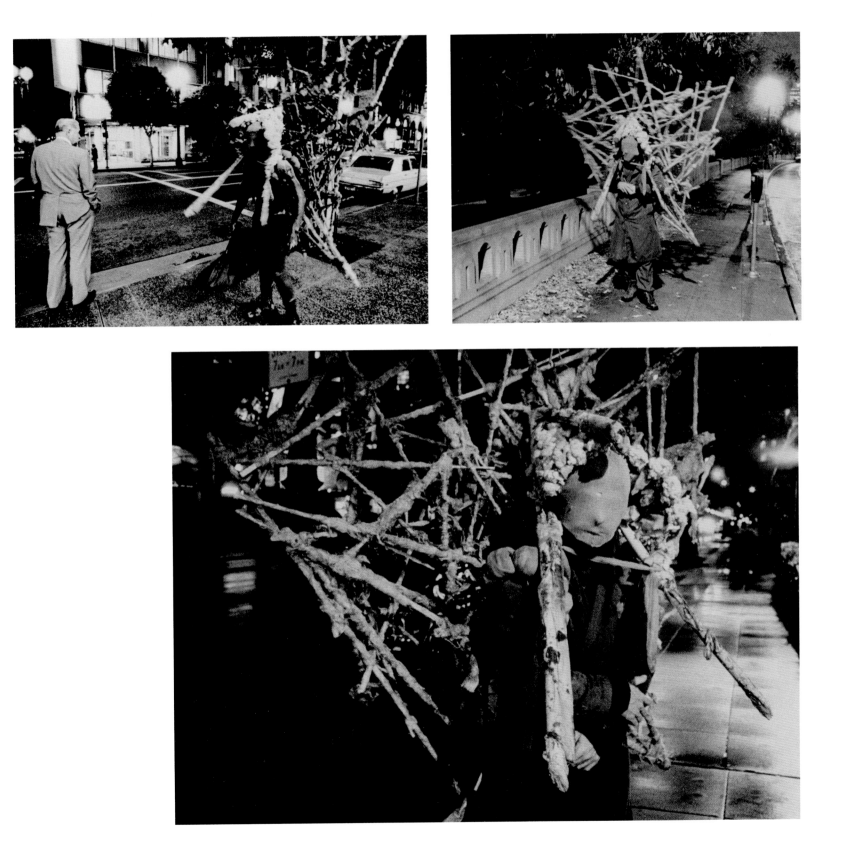

Wilshire Boulevard Walk

1976
performance

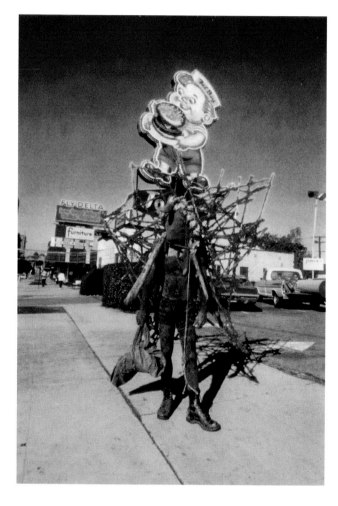

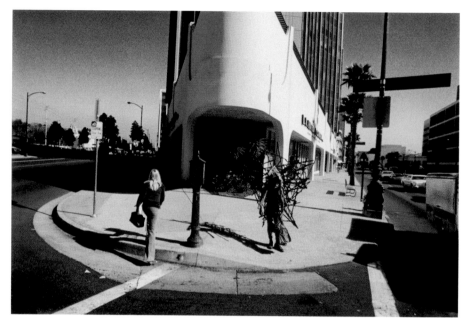

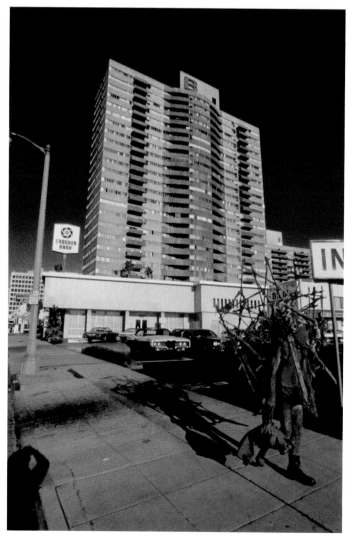

Kim Jones

*Mudman Structure
(large)*

1974
sticks, mud, rope, foam rubber,
shellac, acrylic; shown with
chair, boots, and bucket of mud

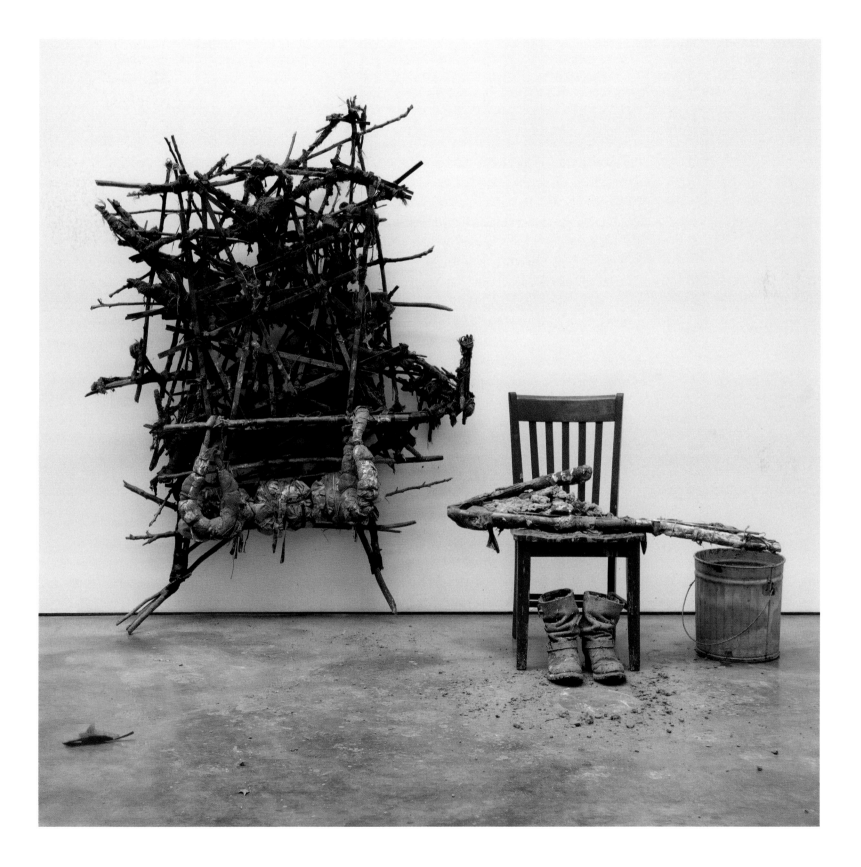

Kim Jones | b. 1944, San Bernardino, CA

IN THE EARLY MORNING OF JANUARY 28, 1976, Kim Jones set out on foot from near Pershing Square in downtown Los Angeles, heading west along Wilshire Boulevard. He was a strange sight: a man seemingly embedded within an irregular matrix of sticks and lengths of wood lashed together with bits of rope, cloth, and electrical tape. On his head he bore a smaller construction, predominantly of foam rubber and aviary wire, and over his face, a nylon stocking, rendering his visage featureless. He otherwise wore only shorts, combat boots, and, slathered over both his bare skin and clothes, a unifying layer of mud. Thus transformed, Jones marched slowly toward the Pacific Ocean, a trek that took him from dawn to dusk. A week later, on February 4, Jones repeated the walk along the same route, this time traveling from dusk to dawn.[1] His mask and the wooden structure on his back made him look intimidating, but they were also a burden, preventing Jones from seeing clearly or moving fast. He compares his self-presentation as Mudman[2] to a defensive feint: "[I]t's what animals do: make yourself seem more dangerous than you actually are.... [The structure] makes me larger but it also hides me...it makes me more powerful and it cripples me."[3]

Jones conceived of this performance, *Wilshire Boulevard Walk*, as "a walking sculpture that's eighteen miles long."[4] It was a durational, living artwork, unwitnessed in its entirety by anyone other than the artist himself. Over his twelve-hour trip, Jones walked in and out of the lives of countless passersby, a fleeting and startling apparition. While Jones does not openly announce performances like *Wilshire Boulevard Walk* as related to his experience of war, his choice of imagery—the combat boots,

the mud, the walking[5]—is recognizable enough that strangers have at times identified Mudman as a fellow Vietnam veteran: "[They] would sometimes approach me and say, 'Yeah, I know what it was like.'"[6] More often, people perceive Mudman as a kind of alien, pitiable or imposing but always "an outsider, a spiky thing, walking through the main artery of the city. Molecules fit in, but if something is spiky, it doesn't fit in."[7]

Before enlisting in the Marine Corps in 1966, Jones had been an art school student, studying drawing and painting. It wasn't until the early 1970s, several years after he returned from Vietnam and resumed his education, that he turned to performance art.[8] Inspired by the early body-based work of Vito Acconci and Chris Burden [pp. 230–31], Jones developed a performance practice grounded in lived reality. For him, performance is "not a metaphor...it actually is what it is."[9] He began going out into the streets as Mudman in 1973, initially in his immediate neighborhood in Venice and later venturing further afield.

Jones's dawn-to-dusk rendition of *Wilshire Boulevard Walk* took place on the artist's thirty-second birthday, which was also the eighth anniversary of his homecoming from active duty in Vietnam. On that day, he had made the final stage of his return by foot, walking from a bus depot in Santa Monica to his parents' house in Pacific Palisades. He has recalled how strange it felt to be back in "the world" after a year serving in Đông Hà, near the demilitarized zone between North and South Vietnam.[10] Of life there, he has written: "vietnam dong ha marines it's summer time 125 degrees heat sweat like pigs work like dogs live like rats red dust covered everything."[11] One imagines Jones felt very "spiky" to suddenly find himself strolling among civilians near the ocean on a peaceful Southern Californian day. Speaking of his art, Jones has said that he "reaches for the more potent

depicts himself and Feathers "drinkin' beer in Vietnam in 1967" [FIG. 1]. The image recalls an actual event, the sole time the two friends saw each other overseas, despite being stationed only miles apart. Cannon portrays the pair as proud Native warriors: instead of regulation haircuts they wear feathers and long hair, Kirby's set in braids. Yet the larger scene is far from glorious: behind them looms an enormous mushroom cloud, symbolic of overwhelming state violence and power.

Cannon was well aware that the government he served had killed, subjugated, and broken treaties with Native Americans.[6] Friends report that he returned from Asia with admiration for the Vietnamese people and new sympathy for the plight of the oppressed worldwide.[7] The complexities and contradictions of his experience as a Native American Vietnam veteran are hinted at in a photographic

portrait Cannon sat for in the early 1970s [FIG. 2]. Holding a war lance and with a rifle resting on his lap, the artist poses beneath both a portrait of the legendary Lakota Sioux leader Tatanka Iyotanka (Sitting Bull)—famous for his fierce resistance to the U.S. government—and a row of military medals Cannon earned in Vietnam. That Cannon ultimately viewed the war in Vietnam as a tragedy is made clear in a poem entitled "Hearts and Minds" that he wrote the same year he created his evocative self-portrait with a skeleton. In it, Cannon asks for blessings and forgiveness for all involved in the war—including those who "turned away and forgot to hear the anguish of young men." He ends the poem with these lines: "god forgive the fools of france and america. / never let them forget the folly / of what was done and those that did it. / god bless the sleeping soldiers of hanoi, ohio, dong ha, omaha, quang tri, and mobile, alabama." MH

1 Cannon was among a cohort of artists trained at the Institute of American Indian Arts in Santa Fe, New Mexico, in the mid-1960s who helped forge a new Native American modernism, changing the way people thought about contemporary Indian cultural expression. For more on this history and the significance of Cannon's art, see Karen Kramer, ed., *T. C. Cannon: At the Edge of America* (Salem, MA: Peabody Essex Museum, 2018).

2 See Cannon's letters reprinted in Joan Frederick, *T. C. Cannon, He Stood in the Sun* (Flagstaff, AZ: Northland Publishing, 1995), 44–47.

3 As Kirby Feathers recounted, "I had spent a tour in Vietnam, and after he [Cannon] joined up, I told him, 'You're stupid for joining and you shouldn't have done that.' He said, 'I'm a Kiowa.' He believed that. His tribe, the Kiowas, and mine, the Poncas, our whole societal structure is based on warriors. What you did set your place in the tribe....No matter what

happened, we were always respected as warriors." Feathers, quoted in Frederick, *T. C. Cannon, He Stood in the Sun*, 40.

4 It is notable that Cannon was initiated into the Kiowa Ton-Kon-Gah, or Black Leggings Warrior Society, along with his father, Walter Cannon, who served in World War II, in 1970. The Black Leggings Warrior Society is a Kiowa group honoring the tribe's combat veterans; every October the society holds a two-day ceremony near Oklahoma City. See Frederick, *T. C. Cannon, He Stood in the Sun*, 71.

5 More than 42,000 Native Americans served in Southeast Asia as military advisers or combat troops between 1960 and 1973. Representing less than 1 percent of the United States' population, they made up 2 percent of its soldiers in the war. For more on the experiences of Native Americans in the Vietnam War, see Tom Holm's thorough and groundbreaking study, *Strong Hearts,*

Wounded Souls: Native American Veterans of the Vietnam War (Austin: University of Texas, 1996).

6 Feathers reports that after the war, he and Cannon "came to the conclusion that we admired the North Vietnamese....We realized that the U.S. shouldn't have been there, but since we did go, there's nothing we could do about it." Quoted in Frederick, *T. C. Cannon, He Stood in the Sun*, 47.

7 See Melanie Benson Taylor's analysis in "Some Intensely Burning Theology: The Complex Truths of T. C. Cannon's Poetry," in *T. C. Cannon: At the Edge of America*, 176–84.

Untitled

(T. C. and Skeleton)

1975
ink on paper

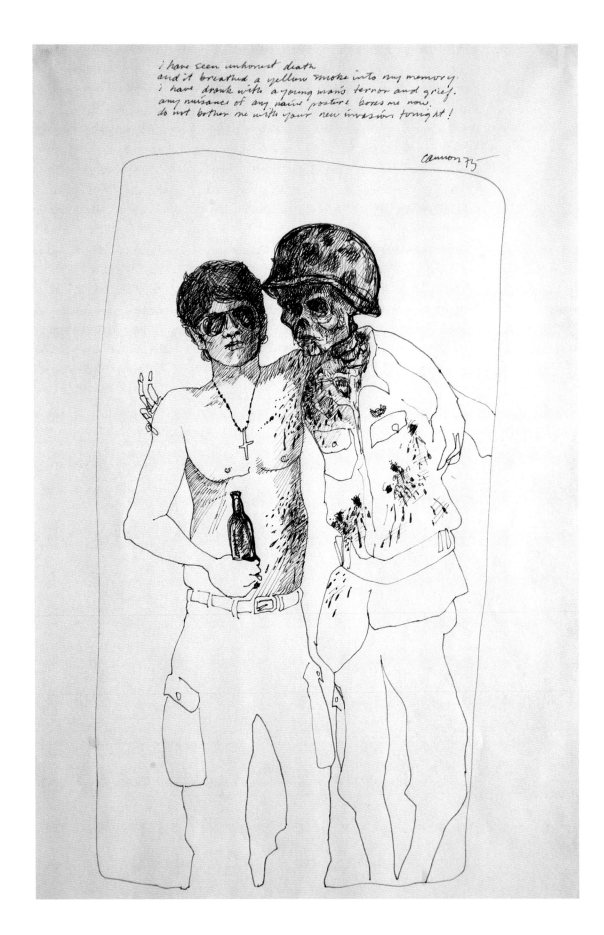

T. C. Cannon | b. 1946, Lawton, OK | d. 1978, Santa Fe, NM

IN 1975, THE YEAR THE LONG WAR IN VIETNAM finally came to an end, T. C. Cannon made this untitled portrait of himself as a young soldier. He had served in Biên Hòa in 1967 and 1968, having dropped out of his first semester at the San Francisco Art Institute to enlist in the army at age twenty. In the years following his military service, Cannon—an enrolled member of the Kiowa tribe and also of Caddo descent—emerged as one of the central figures of the New American Indian Art movement. His inventive paintings deftly address the complexity of contemporary Native experience via a multiplicity of cultural sources and references.[1] Acclaimed for his bold command of color and pattern, Cannon here creates an intimately scaled self-portrait in ink. Shirtless and clasping a bottle of beer, Cannon is shown with his arm slung around the shoulders of a comrade—who happens to be a skeleton in a combat helmet and blood-spattered fatigues.

The pair evokes the motif of Death and the Maiden: a figure of youthful beauty and promise posed next to the personification of death. But whereas the Maiden

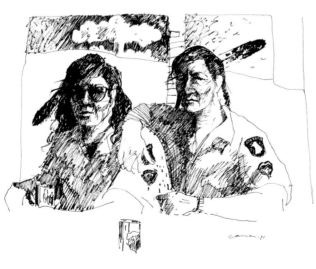

FIG. 1
T. C. Cannon, *Drinkin' Beer in Vietnam in 1967,* ink on paper, Private Collection

is sometimes depicted as shrinking from her inescapable mortality, Cannon does not recoil from but rather embraces the skeleton as a brother-in-arms. The two appear as twinned figures; both are marked by bloodstains, and the dark lenses of the artist's cool aviator glasses echo the skull's gaping eyeholes. Inscribed above the image is a poem by Cannon that begins, "i have seen unhonest death / and it breathed a yellow smoke into my memory."

The artist had encountered death at close range in Vietnam. He arrived in the country with the 101st Airborne Division in late 1967, only weeks before the surprise attacks of the Tết Offensive. In a letter written on February 1, 1968, he described how a friend, the stenographer for the division's commanding general, was killed by an enemy bullet while standing next to him in the seemingly safe confines of their base's office. Cannon went on to inherit the dead man's job. He noted, "I hope I don't meet the same fate as my predecessor." Writing to his former teacher Bob Harcourt, Cannon said, "I have already seen some young men die…and I don't like it…but maybe death wasn't meant to be friends with young men."[2] Perhaps not, but as Cannon's drawing attests, under conditions of war, death and the young become inevitable companions.

Like many Americans who served in Vietnam, Cannon expressed both pride and pain about his involvement in the war. According to his friend, fellow artist and Vietnam veteran Kirby Feathers (himself a member of the Ponca tribe), Cannon's enlistment in the army was motivated at least in part by a sense of allegiance to tribal warrior traditions.[3] Cannon was proud to continue an ancient tradition in arms by proving himself in combat.[4] In this he was apparently not alone: during the war in Vietnam, Native Americans served in the U.S. Armed Forces in greater numbers per capita than any other ethnic group; many, like Cannon, were volunteers.[5] In a 1971 drawing produced posthumously as a print, Cannon

Philip Guston

San Clemente

1975
oil on canvas

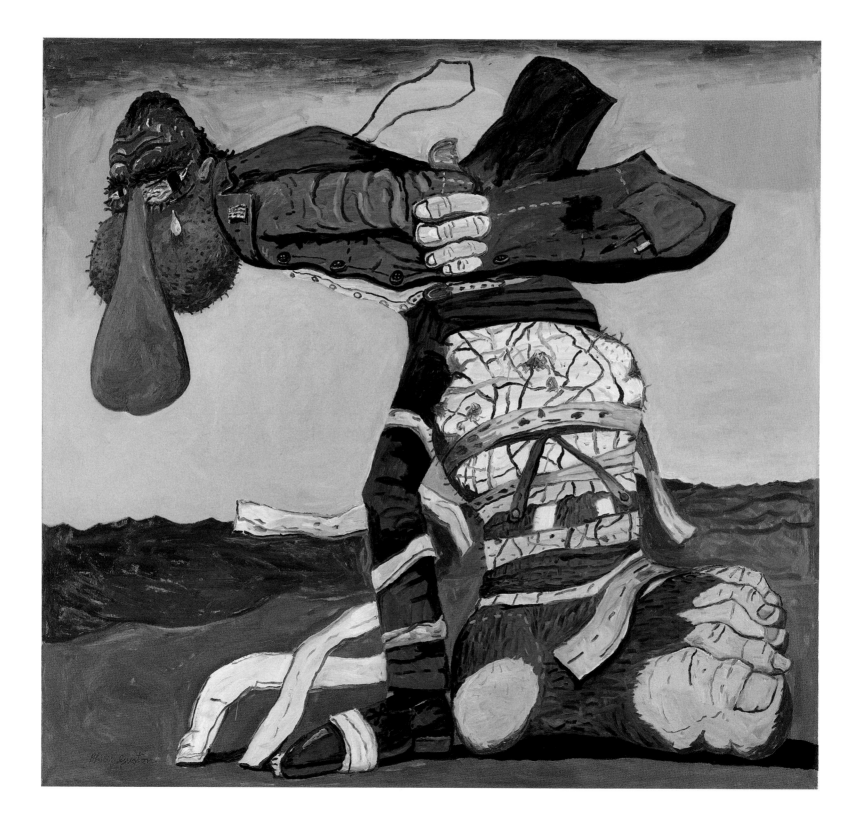

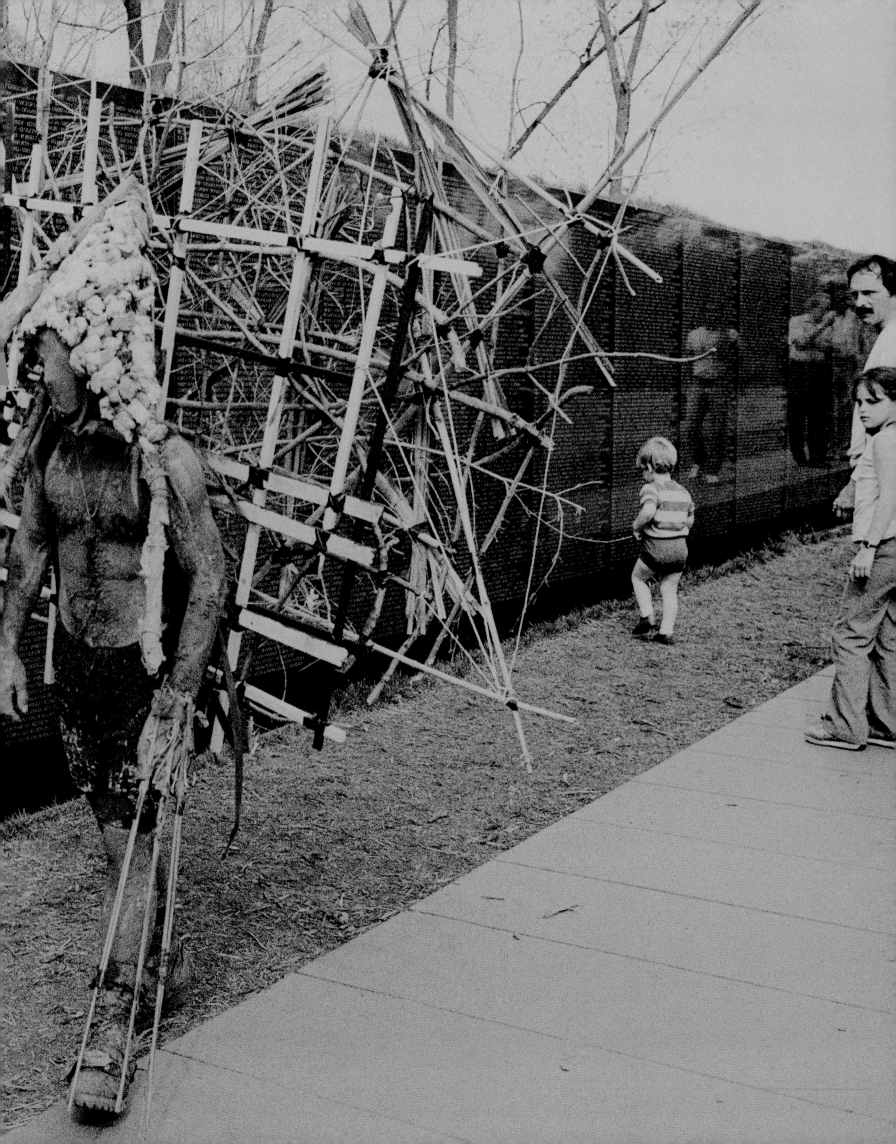

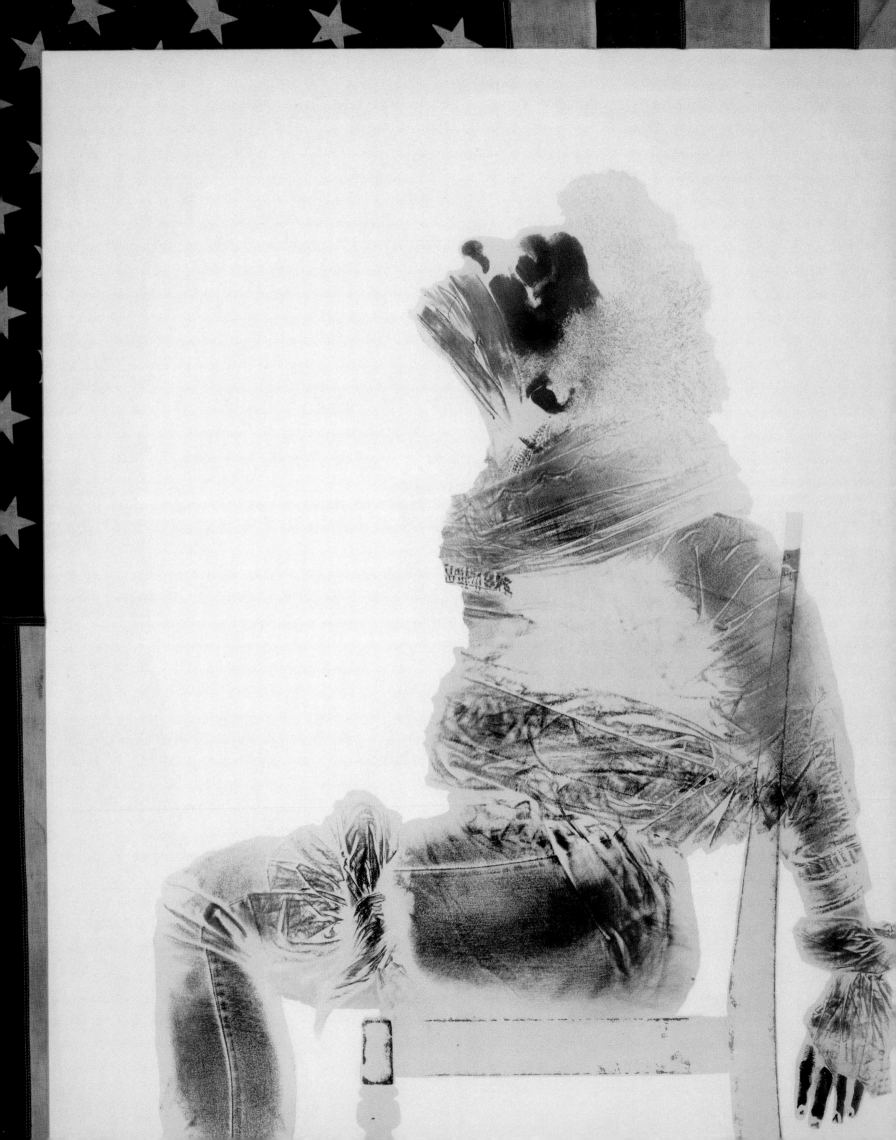

THOMAS CROW

When the first major protests against American military intervention in Southeast Asia erupted in the spring of 1965, major artists were inconspicuous among the participants in the teach-ins and marches that caught the war planners off guard. As the antiwar movement dramatically expanded over the late 1960s, gestures of protest by artists, individually and in ad hoc groups, figure more prominently in the historical record. At a key moment before those events, however, when the fateful entanglements of the American state in the political

Bearing Witness in American Art of the Vietnam Era

affairs of the region were yet barely known to a wider public, one major artist-to-be found himself an active participant in these machinations and thus a direct witness to events that would shape his subsequent career.

While still a teenager, James Turrell somehow squeezed an extended period between high school and college piloting aircraft over the treacherous escarpments of the Tibetan plateau on behalf of the Central Intelligence Agency. The planes were naturally not labelled as such nor were his missions military in nature. Their goal was providing supplies and means of escape to Tibetans who had fled south across the border into Nepal in the aftermath of their failed rebellion against Chinese occupation in 1959. Many had sheltered in the barren Nepalese

kingdom of Mustang, while remnant bands continued acts of resistance from the inaccessible valleys just across the Chinese border. Throughout the 1950s, the still-young Central Intelligence Agency entered into covert intrigues intended to frustrate Chinese influence, real or imagined, on its neighbors. Those ventures included encouraging and arming the discontented Buddhists of Tibet, a persistent thorn in the side of the People's Republic.

What would become the American war in Vietnam belongs to this larger and longer history of Cold War conflict with the China of Mao Zedong, along with which came predictably fatal incomprehension of the nationalist determination that drove the enemies of the American client regime in Sài Gòn. How exactly had Turrell come to take part in this prior proxy

David Hammons, *Injustice Case* (detail), 1970. See p. 292

conflict? The answer lay in the same convictions that would later draw him into active resistance after 1965: a Quaker pacifism encouraged by his rigorously observant maternal grandmother, which accompanied his precocious training as an aviator in Pasadena, California. His father, who died when Turrell was only ten, had taught aircraft technology at Pasadena City College. By sixteen, Turrell had earned his license as a pilot. The American Friends Service Committee, which pioneered the concept of alternative service as far back as World War I, was in this period regularly supplying relief in zones of civil conflict all over the world. That Quaker connection might explain how Turrell came to undertake his own alternative service flying mission to the refugees from the American-sponsored rebellion in Tibet at an age before he was even eligible for the draft or would have needed to register for conscientious-objector status.

Much later, an English reporter accompanied Turrell to his art studio at the Flagstaff, Arizona, airport and described his removing an exotic object from a case:

> a military-issue, high-altitude helmet with an anti-nuclear flash visor—a relic of the days in the early Sixties when he flew secret missions over Tibet and the Himalayas for the United States Government. He handles it very delicately, then places it on a bench for me to photograph. "This was never really issued to me," he says, alluding to the clandestine nature of the work, "so I never had to return it."[1]

Turrell has spoken more recently about unlisted planes whose pilots did not carry passports. "America has this shadow government," he told the gallerist Almine Rech; "It should stay in the shadows because it can't stand up in the light." Asked whether the Himalayan experience had been positive, Turrell replied, "It was nice in retrospect but we lost a lot of people.…The weather there is just capricious and tough. There are strong winds, and planes don't have a lot of performance at that altitude. The helicopters were a disaster…the crashes."[2] On his return, however, the perils and exhilaration of flying over the extreme altitude of the Tibetan plateau rarely, if ever, surfaced, at least according to the memories of his contemporaries at Pomona College, which he entered in 1961 at the customary age of eighteen. Little besides an exceptionally winning charisma seemed to set him apart from a Pasadena-Claremont masculine norm. One can, however, discern a link between the mental exertion necessary for a pilot to maintain a correct sense of orientation under conditions of dubious visibility—potentially a matter of life and death—and his choice to concentrate on perceptual psychology, then a particular strength of the Pomona curriculum. Indeed, Quaker strictures against objects of vanity restricted his art studies to the fashioning of ceramic vessels.

Neither his youthful ceramics nor his subsequently renowned light projections of the later 1960s offer representational content, still less reference to the American intervention in Indochina; yet the salience of his example to the themes of the exhibition *Artists Respond* is in no way diminished by that absence. As will emerge below, Turrell drew the moral core of his art from the danger and duress he had undergone in Southeast Asia and would again in 1966, when he placed himself on the legal front line of resistance to the military draft. His work thus physically as well as ethically bears witness to the violent enormity of the American incursion into Vietnam far beyond the safe, symbolic objections offered by a good many of his artist contemporaries. To place one's body on the line anchors one end of a spectrum along which antiwar testimony could and did lie. Nonconformist California—with its strong counterculture, historic receptivity to Asian religion and culture, enormous student populations, and direct exposure to military mobilization in the Pacific—provided the crucible. Among the artists included in this exhibition,

Wally Hedrick, in San Francisco, would give up the visionary richness of his painted imagery to an unrelieved blackness that swallowed his public artistic identity. As an African American artist in South Los Angeles, David Hammons did not have to imagine constant legal and physical jeopardy; when Black Panther Bobby Seale, on trial for his antiwar actions, was shackled like a slave in the courtroom, Hammons found a way to inscribe his own body as Seale's surrogate. Sister Mary Corita Kent, college instructor in the Archdiocese of Los Angeles, came to sacrifice her deepest personal vocation and grounds of selfhood to her convictions that the Vietnam War belonged to a long front of unendurable injustice. Rupert García, as part of the historic student rebellion at San Francisco State, threw all his talent into intransigent political action against the intertwined blights of racism and militarism. And latterly, during the 1970s, four young Chicano activists in Los Angeles, who called themselves Asco, crafted together a virtually underground art that refused any separation between the living reality of anti-Latino oppression and their still raw recollection of struggle against unjustifiable aggression abroad.

What unites these artists is that none of them held anything back or hedged their professional bets where their antiwar convictions were concerned. Fully to bear witness is to put one's personal interests on the line, to be prepared to let them go in the service of a cause greater than oneself. But that self-sacrifice does not exhaust the witnessing capacity of art in the face of conditions that make its normal conduct insupportable. There is a place on its spectrum for art that turns the tables and places the spectator, if only momentarily, in a subjective position of unnerving self-recognition and discomfort that shakes numbness and complacency. If, in the early 1960s, Turrell's involvement with U.S. government strategy in Asia remained unknown, a sharp-eyed observer could have caught at least one

sign of its antecedents in a primary Los Angeles art event of 1962: the room-filling installation by Edward Kienholz at the Ferus Gallery titled *Roxys*. With typical indifference both to decorum and sculptural boundaries, Kienholz recreated a 1943 brothel from Kellogg, Idaho—the scene of disagreeable coming-of-age memories in the region of his upbringing. Its wallpapered surrounding reproduces the trappings of domestic homeliness and patriotic uplift maintained by the establishment's madam. But Roxy herself greets visitors as the specter of a boar's skull surmounting a frayed and decaying black gown draped over a metal armature [FIG. 1], and the seven working prostitutes manifest themselves as grotesque, life-sized contrivances of raw, found objects, each one a parody of the erotic illusions that sustain submission to sad necessities of life.

Why recall such a downbeat memory in the midst of prosperous, sun-drenched Los Angeles at a high point of the Kennedy era? For the contrarian and irreverent Kienholz, the answer would not have been simple, but one clue to his motivation hangs on *Roxys* parlor wall: a portrait of General Douglas MacArthur, commander of U.S. forces in the Pacific at the time in which the installation is set [FIG. 2]. The nearly mythic aura of leadership that MacArthur then enjoyed, prolonged by his vice-regal imperium over postwar Japan, had in the interim been considerably dimmed by his dismissal by President Truman for insubordination and catastrophic misconduct in prosecuting the war with the Chinese in Korea. The buildups in personnel and hardware demanded by both conflicts had laid the foundation for the prosperity of Southern California, by this date the manufacturing hub for America's Cold War arsenal. MacArthur's visage, surveying the squalor of this whorehouse, resurrects the roots of contemporary affluence in the Far-Eastern extension of American power, while recalling the recurrent humbling of high aspirations in hubris and

FIG. 1
Edward Kienholz,
Roxys (detail), 1960–61,
installation photo, 2010

FIG. 2
Edward Kienholz,
Roxys (detail), 1960–61,
installation photo, 2010

overreach—a decade before this cycle would again play itself out in Indochina.

Kienholz displayed to his friends and professional colleagues the libertarian, hunting-and-fishing male persona of the intermountain West. Many would profess surprise when he later (as will emerge below) directed his caustic vision toward the knee-jerk patriotism manufactured to sustain the war effort in Vietnam. But a vivid series of his sculptures that preceded and followed *Roxys*, fashioned in the same profane idiom, angrily forced the viewer's attention to various open sores in American life, obscured by the compulsory optimism of the period—cruel capital punishment (*The Psycho-Vendetta Case*, 1960), women forced to seek out clandestine abortions (*The Illegal Operation*, 1962), lonely impoverishment among the aged (*The Wait*, 1965), and neglect of the institutionalized mentally ill (*The State Hospital*, 1966). That same polemic impulse would lead him eventually to address the murderous waste and dishonesty of the war machine. But another disabused Californian,

Wally Hedrick in San Francisco, preceded him in outrage over the drive to war.

Hedrick's early art education had been interrupted by active service in the Korean War. Having enlisted in the army reserves with the expectation of avoiding combat, he found himself called up in 1951. "We replaced the 24th Infantry Division that had just been shot to pieces by the Chinese," he told an interviewer in 2009, "They gave us guns and told us to go into these bunkers. I don't want to talk about it."[3] The deaths and injuries he witnessed there left Hedrick, always on the political left, deeply antagonistic to military adventurism on the MacArthur model. In 1957, he would have been one of the few Americans to notice the deployment of American advisers in support of armed forces of South Vietnam. Certain that this would presage carnage comparable to the Korean conflict, he fashioned an assemblage sculpture under the title *Rest in Pisces*, empty tuna

cans standing for the coffins to come.[4] By 1963, the alert Hedrick no doubt seethed at the presence of some sixteen thousand of these advisers on South Vietnamese soil, dispatched in support of South Vietnam's repressive, Catholic ruling family: Ngô Đình Diệm, his brother Ngô Đình Nhu, and sister-in-law Trần Lệ Xuân [FIG. 3], the assertive public face of the regime universally known as Madame Nhu.

In that year a new round of discriminatory measures against the form of Buddhism practiced by the majority of the southern population was met with tragically dramatic protests, beginning in June when Thích Quảng Đức became the first in a series of Buddhist monks to immolate himself in public as the ultimate act of defiance. On August 20, the leadership compounded their vicious shortsightedness by staging a coordinated raid by special forces on pagodas across South Vietnam, wantonly murdering monks and imprisoning others by the hundreds. When the university and high-school students turned out in protest, scores of them were imprisoned as well.[5]

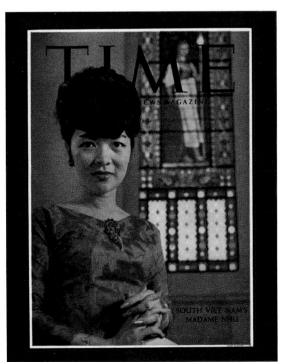

FIG. 3
Trần Lệ Xuân on the cover
of *Time*, August 9, 1963.
Photo by Larry Burrows

Unfortunately for the international reputation of Ngô Đình Diệm's family, Thích Quảng Đức's horrific suicide and those that followed were thoroughly captured by press photographers, becoming harbingers of the heightened, unfiltered visual evidence of the war's atrocities—in print and on television—that would set the Vietnam conflict apart from its predecessors. When pressed to offer some sympathy or regret over the public suicides, Madame Nhu was captured on film responding, "I would clap hands at seeing another monk barbecue show."[6]

On a canvas of the same year, Hedrick reacted by scrawling in capitals across a roughly painted, dark red heart "Madame Nhu's Bar-B-Q's" [p. 104]. Strokes of gold-colored paint inscribe flames curling below and arising from the heart, while a shadow-casting golden silhouette, both fire and bird, arises and takes the immediate foreground. It is likely that the painting had been in the works before the public suicides in Vietnam, as the phoenix-like creature and the cross at top center accord with Hedrick's eclectic interest over some years in matters of the "spirit."[7] But the specifically Buddhist import of the Vietnamese events makes a pointed appearance in Hedrick's carefully inscribing near the heart's point what may be the most widely recited of Buddhist mantras, "Om mani padme hum," an invocation of the Bodhisattva of compassion. Both the relative delicacy of the inscription and its humane sentiment counterpose themselves to the heartless, Americanized vulgarity of Madame Nhu's remark as rendered in Hedrick's title. With *Madam Nhu's Bar-B-Qs* and the companion painting *Anger*—the legend of which declares, "Madame Nhu Blows Chiang [Kai-shek]," its smaller heart cloven by a descending erect penis [FIG. 4]—Hedrick proclaimed himself cognizant of and inflamed by both the immediate Vietnamese atrocities and the longer history of anticommunist reaction in the region. (Kienholz had nothing on him where the force of blunt profanity was concerned.)

The United States had installed Ngô Đình Diệm as prime minister (then self-appointed president) of the new republic in the south to stand against Hồ Chí Minh's hegemony in the north at a time when Chiang Kai-shek's forced retreat from mainland China to Taiwan was still a fresh affront to perceived American interests. Hedrick's two Madame Nhu paintings have been cited as presciently "antiwar" works of art;[8] but that supposition needs to be qualified, first of all, by the fact that no active American combatants had yet overtly entered the conflicts between the gathering forces of the Viet Cong and the Army of the Republic of Vietnam (ARVN). Korea and the slow-burning proxy conflicts with Mao's China (such as the one into which the young Turrell had been drawn) still provided the context for his "anger." In his entirely justified disgust at the Catholic Vietnamese leadership's persecution of Buddhist clerics, the paradox of his invective lay in its alignment with the emerging official policy of the Kennedy administration and its just-dispatched ambassador, the patrician Henry Cabot Lodge. Arriving in Sài Gòn shortly after the anti-Buddhist crackdown, Lodge took little time in

deciding that the existing regime had so forfeited popular support that it would have to go or the ARVN's half-hearted battle against the expanding Viet Cong forces was already lost. Having brought President Kennedy around to the same conclusion, Lodge and the administration tacitly encouraged military plotters to stage their successful coup that toppled Ngô Đình Diệm on the first of November 1963—perhaps as the paint on Hedrick's canvases was still drying.

One can more accurately speak of antiwar American art once the U.S. war in Vietnam begins in earnest during the first half of 1965.[9] President Lyndon Johnson and his war advisers began Operation Rolling Thunder, the sustained bombing of North Vietnam in March; in the same month, two battalions of combat marines landed at Đà Nẵng airbase on the central coast in order to secure the launching point for the American aerial campaign. As noted at the outset of this essay, these watershed escalations of U.S. involvement in the conflict elicited an almost instantaneous riposte from antiwar intellectuals and students galvanized into the teach-in movement. The first major march on Washington followed almost immediately, with the early stirrings of regular peace vigils spreading through liberal cities and university towns across the country.[10]

Artists were not to be counted out of these developments, the most advanced collective action already emerging in Los Angeles that spring, as a swelling number of artists began to meet in antiwar solidarity at the Virginia Dwan Gallery in Westwood. Under the primary instigation of Irving Petlin, who taught studio art at the adjacent UCLA campus, the group called itself the Artists' Protest Committee and looked to create a theatrically visible form of street display: a shared project that became the *Artists' Tower of Protest*, otherwise known as the Los Angeles *Peace Tower*. With impressive coordination on the part of

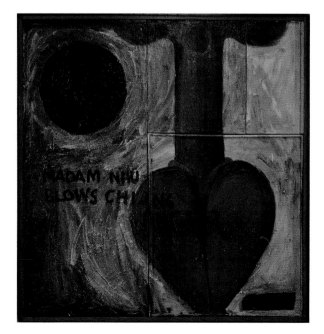

FIG. 4
Wally Hedrick, *Anger*, ca. 1959–63, oil on canvas, Collection of the San Jose Museum of Art, Museum purchase with funds contributed by the Collection Committee, 2005.04

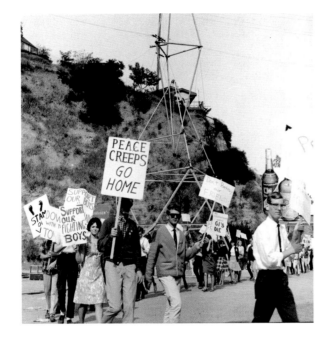

individuals professionally resistant to organizational direction, more than four hundred works were successfully solicited not only from local artists but from peers in New York and Paris, from the highly celebrated to the obscure, all of them agreeing to work in an identical format (two feet square) using materials durable enough to withstand the elements. At a highly visible junction halfway along the Sunset Strip, the nightlife center of the city, the committee wrangled a three-month lease on a vacant lot carved into the hillside, forming an earthen amphitheater. The twenty-score submitted panels were arrayed around the lot's perimeter, at the center of which sculptor Mark di Suvero, just off a well-received exhibition at the Dwan Gallery, designed a dramatic tower of steel pipes. A feat of both sculptural engineering and daring physical construction, the *Peace Tower*'s elegantly transparent geometry became a magnet for the attention of visitors and passersby in the heavily trafficked area.[11]

For the large majority of antiwar artists, protest entailed no greater personal witness than the act of signing petitions or advertisements in the *New York Times*. But for those on the ground at the *Peace Tower* site, commitment could entail confrontation and physical risk. Petlin boasted that a thousand visitors gathered around the tower each night after its opening in November. There is little reason to doubt the claim, with the necessary qualification that by 1966 a profusion of rock clubs along the Strip—these being the heady days of the Byrds, Love, Buffalo Springfield, Mothers of Invention, and the Doors—had created a rare pedestrian district for nighttime congregation, the scene of continual cruising by the young and car-proud. The authorities responded with relentless police harassment of clubs and club-goers as well as a legal curfew for anyone under eighteen. The county supervisor declared, "Whatever it takes is going to be done.…We're not going to surrender that area or any area to beatniks or wild-eyed kids."[12]

Wittingly or not, the Artists' Protest Committee planted their grand statement in the midst of an already charged focus of the emerging counterculture, which it heightened by drawing angry off-duty marines and right-wingers who were bent on verbal confrontation with peaceniks when not intending to damage the display [FIG. 5]. Countering the latter threat entailed posting fifteen to twenty volunteer guards around the sculpture and its accompanying works on a twenty-four-hour rota. Young African Americans from the local chapter of the Student Nonviolent Coordinating Committee took part, instructing the other guards in their techniques of resistance.[13] When artist Jim Gallagher was beaten and kicked by a sailor in civilian clothes, nearby sheriff's deputies let the punishment go on, then pushed Gallagher against a car and arrested him rather than his assailant for resisting arrest and disturbing the peace.[14]

Gallagher's bravery stands in contrast to later cost-free, virtue-signaling, even career-enhancing gestures like calling on museums to observe national strike days against the war. Like any effective installation work of the period, the *Peace Tower* extended

its meaning by altering its surroundings, but with the significant difference that its size, prominence, and subject matter brought genuine risks to its defenders. For his part, James Turrell, likewise in 1966, set a newly daunting standard in personal commitment, his actions directly following from his alternative service in the Tibetan precursor to the strategy that drove the war planners of the 1960s.

———————

After finishing his psychology degree at Pomona, Turrell had given in to his artistic inclinations and entered the fledgling master of fine arts program at the new Irvine campus of the University of California. He still sought ways to sidestep the making of vain possessions, exploring evanescent flame and projected light as his exclusive media, while he renewed his Quaker commitments by becoming a regular congregant at the Orange Grove Friends Meeting in Pasadena. Orange Grove stood out during these years by adding an extra measure of social activism to its "conservative," that is, egalitarian, open, and spontaneous, form of worship. As a former conscientious objector, Turrell offered counseling to young men seeking the same status as an alternative to military conscription. Current law countenanced this activity but drew a line against any explicit encouragement, which amounted to abetting draft evasion in the eyes of the authorities. "You might be surprised," he told David Pagel of the *Los Angeles Times* in 2007, "what you say over a period of six months. There was a couple. I took the woman to be the man's mother. She was not. She was an FBI agent." He went on to detail the consequences: "Everything [the couple] said was in truth a lie, and they just wanted to find me saying one thing—that I thought he should do this. I was positive I never had, I told my lawyer I never had, and then they had a tape of me out in the parking lot and apparently I said this is what he should do. And that was enough. I was arrested and served time in prison."[15]

This ambush put his art, to say the least, on extended hold after his sentencing in March 1966. He later recounted: "As a result of things I said as a draft counselor during the Vietnam War, I spent time in the penitentiary, and, to avoid being assaulted or raped, I would do things that got me into solitary. Solitary confinement was not a good thing, but at least there was safety, and I sought to get in there to be safe. Once you are there, it's tough because the cell isn't long enough to lie down or tall enough to stand up; it is meant to be physically confining."[16] It should be noted that these events only emerge in the art historical record via piecemeal revelations hardly more extensive *in toto* than the accounts quoted above. As a consequence, one can read through the greater number of synthetic sources on Turrell, right up to the present, and find no mention of it at all; the rare exceptions give it no more than a line or two. When the topic of his premature exit from the Irvine master's program arises, it is common simply to cite his saying, "It was time to stop becoming an artist and start being one," and that is deemed sufficient. If one were looking for a reason why Turrell interrupted his formal education in art, then only six months along, the trauma of arrest, trial, and jail time would seem a more powerful explanation than a vague desire to "be" an artist.[17]

That Turrell took a lease on a Santa Monica studio in November 1966 suggests his actual time served would have been about six months, though the sentence could have been longer. He found his working space in the defunct Mendota Hotel near the Pacific at Ocean Park, then a down-at-heel neighborhood named for the adjacent amusement pier (which has since burned down). From that redoubt, he emerged into the public eye on one occasion. John Coplans, with whom Turrell was working at Irvine, had since moved to a curatorship at the Pasadena Art Museum, where he greeted his old protégé's return to freedom with a show of the first light pieces in October

1967.[18] Turrell thereafter withdrew his light projections from any further public exhibition for nearly a decade—but not for any lack of encouragement. In 1969, the Museum of Modern Art in New York invited him to create an installation for a show they called *Spaces*, in which each invited artist was given the freedom of a solo gallery. Its curator, Jennifer Licht, wrote to her superior with some dismay and frustration at Turrell's indifference to the prospect of curating his own work in such a maximally prestigious venue. "On the trip to California I also approached an artist called James Turrell, whose work has never been seen here; indeed has hardly been seen on the West Coast. He consented, after much time and negotiation, to show me some pieces and I was enormously impressed." The outcome provides some measure of how complete his withdrawal from the public art world had become in the wake of the Pasadena Art Museum outing. Licht continued, "Subsequently Turrell announced that he does not want to allow his work to be involved with the 'system,' meaning, I believe, the marketing and

promotional system and therefore will never sell a piece or participate in any exhibition."[19]

But he was by no means idle, as he pursued a new cycle of nonportable (and eminently non-possessable) works based on the controlled release of ambient light, including street illumination and the lights of passing cars, onto the immaculate white walls of his darkened studio spaces. These ephemeral events, witnessed by only a few initiates, he came to call—with a nod to Marcel Duchamp's play on random events—the *Mendota Stoppages*. For all of Turrell's efforts to withdraw from view, however, his uncompromising stance served to attract attention, even from the mass media. The art critic for the then-popular *Newsweek* devoted an article in 1969 to "The View from Hill and Main" (the cross streets of the Mendota studio). "The 26-year-old Turrell… resists even the term 'artist,' together with the binding ties that the term inspires…. 'The only coherent statement I got from him,' says one gallery official, 'was that he didn't want people to see his works in a context where they could be considered eligible for possession.'"[20]

The tight-lipped Turrell would keep himself apart from normal transactions with the art world until the Vietnam War was over, and only gradually—via the elaboration of his monumental Roden Crater project in Arizona—would he re-enter the practice of fashioning saleable works.[21] Wally Hedrick had a term for his parallel abstinence before and during the same period: "withdrawal of services." He had already begun in the later 1950s obliterating existing works with an unrelieved black coating—all of them subtitled *Vietnam Series* [FIG. 6]. A few bore explicit titles; one in 1957 he called *Allen Dulles* after the director of the Central Intelligence Agency; *Black and Blue Ideas* (1958/1967) [p. 105] takes its name from a Louis Armstrong number beloved by the jazz-playing artist, transposing the musical title toward melancholy and bruising injury. Later in the next decade, he began

FIG. 6
Wally Hedrick, *The Absence of Light* installation at The Box, LA, 2016. Paintings left to right: *Vietnam/Irac*, 1970/2003; *Vietnam Series XXIII, Manifest Destiny Oil Oil Oil*, 1970/1991; *Rhondo*, 1970–92/2002, all oil on canvas

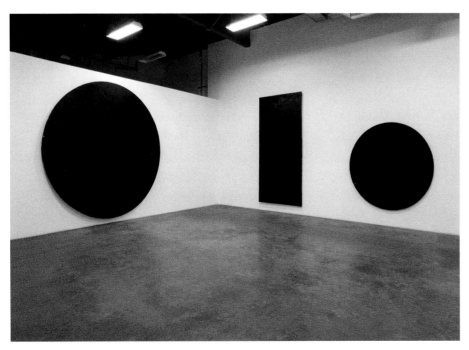

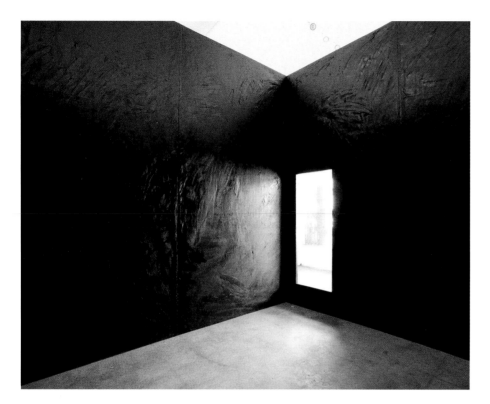

FIG. 7
Wally Hedrick, *War
Room* (interior view),
1967–68/2002, oil on
canvas, Courtesy of the
Collection of Paul and
Karen McCarthy

covering his supports in black pigment from scratch. These canvases did not for him connote the funereal; it was not "so much that they were black, but that they weren't light....Black to me is the absence of light."[22] The paintings would withhold their participation in any transaction with the viewer that entailed the stimulation of the optical faculties, like looking for one's face in a mirror when the room is entirely dark, to use one of his analogies. Until the world rid itself of the stain of war, Hedrick would make a show of giving it nothing to look at. Between 1967 and 1968, he made that blackness more enveloping, assembling eight large black paintings into an enclosed *War Room* [p. 106], eleven feet on a side, with their black surfaces facing inward. With one smaller black painting functioning as a door allowing ingress and egress [FIG. 7], Hedrick installed a strong spring so that the panel would slam shut once an entering visitor let go of it.

At that same juncture, Ed Kienholz's latest work seconded Hedrick's disgust over the war, complementing Hedrick's somber austerity with his characteristic abundance of incident. Hedrick's Buddhist-flavored witness against a regime of compulsive violence and dishonesty took the form, as had Turrell's, of masked light and withdrawn self-containment. Kienholz, by contrast, reveled in unabashed disclosure. The Los Angeles collector Monte Factor, a Kienholz friend and patron, had arranged for *The Portable War Memorial Commemorating VD Day* (to give it its original title) [FIG. 8] to be included in a group show (*Untitled, 1968*) at the San Francisco Museum of Modern Art. In contrast to the sprawling *Roxys*, the life-sized elements of the later tableau (the artist's term) aligned themselves within a relatively shallow plane, set against a rectangular backdrop of even height, encouraging a scanning view, as would a cinema screen or a painted mural. Closer approach opens up its wealth of details, among them, the absence of heads under the helmets of the soldiers in the flag-raising group; the names of 475 defunct nation-states scrawled in a disorderly cloud on the chalkboard beneath the commemorative plaque at the top center; the battered condition of the outdoor tables and chairs furnishing the hot-dog stand, its counter rendered in the two dimensions of a distressed photographic mural (except for the model of a small dog attached by a leash to a hand in the photograph); and the waxen female head atop a torso made from an overturned garbage can, from which the 1939 recording of Irving Berlin's "God Bless America" by belter Kate Smith pervades the space. "Spattered over the silvery surfaces of everything are gobs of transparent plastic goo," wrote the young San Franciscan Thomas Albright in December 1968. "They can be interpreted as mud and sweat on the GI uniforms, drops of rain falling from the awning of the hotdog stand, congealed

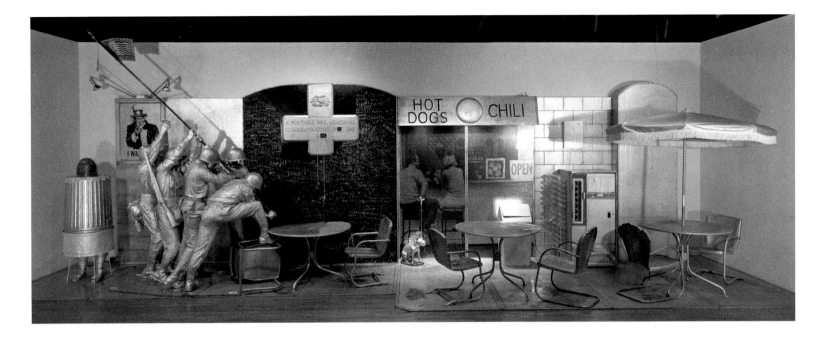

7-Up on the table-tops. They underline a sense of age, neglect, and utter emptiness."[23]

Kienholz's most forthright engagement with American militarism had found this enthusiastic critical response in a new quarter, Jann Wenner's recently launched rock-culture, youth-oriented *Rolling Stone*. A long feature by the overlooked Albright—who specialized in the visionary, eccentric, and inspired for the magazine's art/film beat— named *The Portable War Memorial* the overwhelming favorite, "a work of surpassing importance" among a roundup of contemporary New York stars such as Helen Frankenthaler, Frank Stella, and Donald Judd. Like a contained reprise of the Los Angeles *Peace Tower*, Kienholz's assemblage drew "almost record crowds, and record protests," its provocation aggravated by the fact that the museum then occupied the top floor of the War Memorial Veterans Building. That venue, among other structures in the Civic Center, commemorated the military forces of the First World War. Kienholz's monument nested itself inside, restricting its accumulation of imagery, for all of the Vietnam connotations extolled by Albright,

to the Second World War—a return to the temporal location of *Roxys*, but one profoundly changed in its character and effect by what Kienholz called "this chickenshit war in Vietnam." Portable in time as well as place, the *Memorial* transposes the necessary patriotic solidarity of the 1940s to the enforced patriotism engineered in the later 1960s, immersing viewers in corrosion, decay, and bathos. Hedrick had put the bodies of his exhibition visitors to work by drawing them into the *War Room*, momentarily trapping them inside a black prison when the door slammed shut. The life-sized models and abundant furniture of *Portable War Memorial* invite the spectator's vicarious if not actual inhabitation of the scene; in the artist's words at the time, "It is the viewer who brings the impact to the piece."[24]

What viewers brought to the piece by its late 1968 exhibition would have been profoundly altered, pro and con, by the events in Chicago that summer, when a wave of demonstrations against the war took place during the Democratic National Convention. These

prompted a wantonly violent police riot that subjected a far greater number of protesters to physical injury and danger than had any previous event. Antiwar militancy had assumed a new level of intensity following the assassinations the previous spring of Robert F. Kennedy, who would have taken the cause to the convention as charismatic standard-bearer, and Martin Luther King Jr., who on April 4, 1967, had put his accrued prestige with white America on the line (and defied the caution of close associates) by linking the campaign for African-American civil rights with opposition to the war in Indochina. In a bold address at the Riverside Church in New York City, King declared, "I knew that I could never raise my voice against the violence of the oppressed in the ghettos without

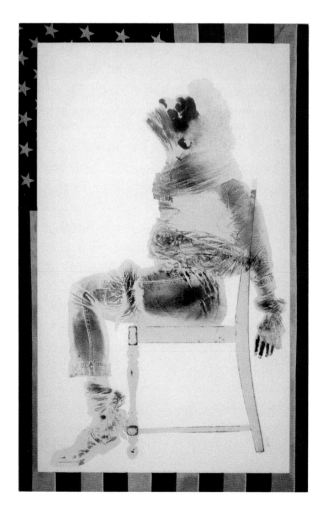

having first spoken clearly to the greatest purveyor of violence in the world today—my own government."[25] At certain points he approached the rhetoric used by those emerging black militants who had chafed at King's insistence on nonviolence. "These are revolutionary times. All over the globe men are revolting against old systems of exploitation and oppression, and out of the wounds of a frail world, new systems of justice and equality are being born."[26] In Vietnam, he declared unequivocally, the American government had placed its young draftees, many of them African Americans, on the wrong side of such a struggle.

With his own violent death a year later, King's differences with younger militants like the California-based Black Panthers had largely become moot: the two causes—opposition to the war machine and contestation of racial inequality—had become inseparable from one another. Richard Nixon's Department of Justice chose to exonerate the Chicago police by indicting a few for minor offenses while charging a select group of prominent protesters (and two obscure young professors) with felony conspiracy and incitement to riot. The prosecution of Black Panther cofounder Bobby Seale served the singular antipathy of FBI Director J. Edgar Hoover toward any form of African-American dissent—as Seale had not even known the other defendants and had given only a single, last-minute speech. The Chicago Eight trial was assigned to the venomously pro-government judge Julius Hoffman, against whose high-handed rulings Seale regularly erupted, demanding that he be allowed to represent himself. Hoffman's response, in a breathtaking reversion to the bondage of slavery, was to have the Black Panther leader gagged and shackled to his chair over four long days of courtroom proceedings.[27]

Such a hideous spectacle might well have overwhelmed the capacities of representational art had not David Hammons—an integral figure in the Los Angeles Black Arts Movement—already embarked on

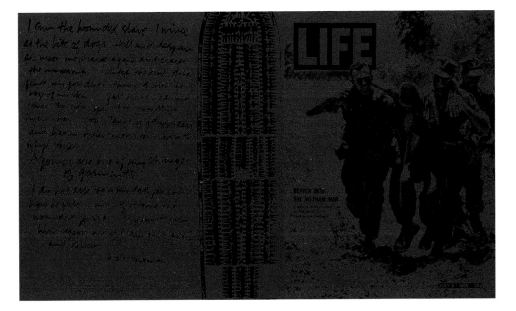

FIG. 10
Corita Kent, *news of the week*
(detail), 1969. See p. 88

a series of "body prints," which joined monochrome imprints of his own flesh with the patterns of the American flag, which were silkscreened in full color. Coating his body with margarine, he carefully laid a sticky imprint on a sheet unfurled on the floor, then covered that area with powdered pigment. In a courtroom where photography was barred, the enormity of Seale's treatment lacked compelling public representation until Hammons placed himself physically in the prisoner's place to create what is rightly the most enduring of these works: *Injustice Case* (1969) [FIG. 9]. The searing actuality of the event inspired a novel degree of actuality in the piece. Hammons set this supercharged body print against the slightly larger rectangle of a real flag, such that the national emblem both frames the event and bestows implied chauvinistic sanction upon it. When first displayed in 1970 at the black-owned and Black Arts Movement–affiliated Brockman Gallery, moreover, a second meaning of the title took literal form. *Injustice Case* appeared, as Kellie Jones relates, "not hung on the wall but in a seven-foot-high glass case with locked doors. The enclosure was lit and lined with black velvet, like a fixture used for displaying jewelry or

precious museum objects."[28] Inside, directly before the print, Hammons had placed a judge's gavel, both the instrument of Hoffman's authoritarian rule inside the courtroom and, more figuratively perhaps, the weapon with which the locked enclosing case might be smashed from the inside. By this date, King's address at the Riverside Church no doubt seemed old news, and Hammons's attitude toward the martyred leader's legacy may have been ambivalent, but no work of art ever expressed so forcefully and memorably — with anything like its degree of personal witness — King's argument that the U.S. government had become the "greatest purveyor of violence in the world today."

In 1969, the year of Seale's Chicago ordeal and Hammons's homage to his defiance, another implicit restatement of that thesis gained much wider visibility by virtue of promulgation as an inexpensive print, likewise linking the agonies of war-torn Vietnam with the horrors of the slave trade's Middle Passage. Titled *news of the week*, after the Warhol-like reprinting of a magazine cover image over an intensely red background, the artwork shows an American soldier in camouflage manhandling a half-naked Vietnamese man [p. 88]. Its headline reads, "Profile of the Viet Cong." Against a smaller field below, over a stingingly complementary green, appear two appropriated images: on the right, a cover from *Life Magazine* featuring more American soldiers, a uniformed pair holding a shirtless, wounded comrade between them; on the left appears a famous diagram from the late eighteenth century of bodies arranged in the hold of the slave ship, juxtaposed with a handwritten passage of poetry from Walt Whitman [FIG. 10]. The first line reads, "I am the hounded slave."

The artist was Corita Kent, a few years before widely known as Sister Corita and counted as one of the best-known artists in America [FIG. 11].[29] In the Christmas

FIG. 11
Corita Kent on the cover of
Newsweek, December 25,
1967. Portrait photos by Don
Ornitz and John Launois

FIG. 11
Corita Kent on the cover of
Newsweek, December 25,
1967. Portrait photos by Don
Ornitz and John Launois

season of 1967, *Newsweek* featured her on its cover
under the headline, "The Nun: Going Modern." In
that same December, the *Los Angeles Times*, a titanic
civic power in those days, named her—alongside
such national celebrities as Ella Fitzgerald and Billie
Jean King—one of nine "Women of the Year." The
reason for her celebrity appears all around her in the
Newsweek photograph: the boldly colored combina-
tions of text and abstract pattern she produced in
the silkscreen studio of Immaculate Heart College,
the East Hollywood institution where she chaired
the art department. For all her fame and institu-
tional achievement, however, Kent's position had
been rendered precarious in the extreme. In 1966,
Cardinal McIntyre, Archbishop of Los Angeles, had
already sternly written to the mother general of her
order, ordering Kent to abandon her flourishing
external career. "May I say further that we hereby
request again that the activities of Sister Carita [*sic*]

in religious art be confined to her classroom work
and under your responsibility. You are reminded of
the restrictions in this regard issued last year."[30]

Chief among the nun's offenses would have been
her passionate and sympathetic response to the
Watts Rebellion of 1965 in her print *my people* [FIG. 12],
in which she used a simple but powerful transfer of
the newspaper front page to instantiate the inscribed
words of Father Maurice Ouellet, pastor of the
Catholic parish in Selma, Alabama, where Martin
Luther King Jr. had led the famous and deadly con-
frontations over voting rights in the same summer
that Watts erupted. Civil-rights advocate Ouellet
takes Pope John XXIII's favorite collective term,
"people of God," and translates it as Christ's body
internally in turmoil, tortured all over again by racial
inequality and oppression of minorities.

Sister Corita's transcription reads:

> *The body of Christ is no more comfortable now than it*
> *was when it hung from the cross. Those who live in the*
> *well organized, well ordered, nourished, clean, calm*
> *and comfortable middle class part of Christ's body can*
> *easily forget that the body of Christ, as it now exists,*
> *is mostly disorganized, devoid of order, concerned*
> *with the material needs, hungry, dirty, not motivated*
> *by reason, fermenting in agonizing uncertainty and*
> *certainly most uncomfortable.*
>
> *Youth is a time of rebellion. Rather than squelch*
> *the rebellion, we might better enlist the rebels to join*
> *that greatest rebel of his time—Christ himself.*

No sentiment could have been better calculated to
enrage the reactionary archbishop, whose antipathy
to any sort of civil-rights agitation was intense and
undisguised. Ignoring his efforts to discipline her
artistic ambitions, Kent moved, like King, in 1967 to
protest the war in *stop the bombing* [p. 91], a flag-
colored print in which the headline exhortation
itself appears to follow a descending trajectory of

jet-launched projectiles, burying itself in red earth surmounted by a sliver of paler blue. The inscribed verse by Gerald Huckaby—a 1950s fighter pilot, former *Time* journalist, and Catholic activist who taught literature alongside Kent at Immaculate Heart— sounds the repeated refrain, "I am in Vietnam. Who will console me?"[31]

It will come as no surprise that McIntyre was an obdurate war hawk, like his former mentor, Cardinal Spelman of the New York archdiocese, who served as a pillar of support for Johnson's and later Nixon's determination to force North Vietnam into submission by relentless bombing attacks. Early in 1967, when some two thousand American religious leaders gathered in Washington to voice a collective statement of conscience against the war, not one of the country's 250 Catholic bishops attended.[32] Kent's speaking out against the war thus became a further offense in a lengthy bill of particulars against the Immaculate Heart sisters as a group. On May 17, 1968, Kent's close friend, Jesuit priest Daniel Berrigan, along with his brother Philip and seven others, entered the offices of a draft board outside

of Baltimore, Maryland, seized its records, and set them alight outside in a bath of napalm. After their arraignment, both the Berrigans then jumped bail for a fugitive life in the American underground (neither would be apprehended until 1970). Taking leave from her order in the summer of 1968, Kent travelled to Cape Cod to stay with friend and art dealer Celia Hubbard. Then, when the summer ended, she remained in Boston, artistically active—and activist—but religiously unaffiliated. The dominant motif in *news of the week* constituted Kent's farewell to the public person and cloistered nun she had been when that cover profile ran in *Newsweek*, substituting Christ's "least of these" in place of her former prominence. In taking that path, she anticipated the decision her Immaculate Heart sisters in Los Angeles would make in 1970 when faced with the cardinal's draconian ultimatum that they return to strict orthodoxy and obedience, which was to disband their order and the college with it. Her losses—of community, sisters, and students—had been profound. As much as Turrell, she paid a steep price for her testifying to the brutality and futility of the U.S. war in Indochina.

Kent had not been alone in her resolute stand against the reactionary forces within her church and in the larger political order; the dean of Immaculate Heart College, Sister Margaret Mary, and the mother general of their order, Anita Caspary, were, along with their students, just as unwavering. Compared with the wider landscape of California higher education, however, their small numbers and religious affiliation left them vulnerable to the suppression they soon suffered. But such was far from the case amid the vast complex of public universities and colleges in California, where the 1964 uprising fomented by the Free Speech Movement at the Berkeley campus had set the founding example for campus protest nationwide. It would prove only a matter of time before swelling discontent over the war in Vietnam set off a similar conflagration somewhere in the system. The spark occurred

FIG. 12
Corita Kent, *my people*, 1965, screenprint, Corita Art Center, Immaculate Heart Community, Los Angeles

in early May 1967, when six students occupied the president's office at San Francisco State College (now San Francisco State University) to protest the policy of providing male students' academic records to the Selective Service, that is, to the military draft. Loss of student deferment could of course lead to conscription and deployment to Vietnam. When the statewide chancellor refused to alter the policy, discontent grew to encompass other issues, primarily a drive to incorporate ethnic studies into the college curriculum, beginning with a program in Black Studies (the name reflecting emerging militancy inside the civil rights movement, which conspicuously included the Black Panther Party across the bay in Oakland). By spring 1968, a group calling itself the Third World Liberation Front had emerged to represent the full spectrum of minorities within the student body and speak to their frustrations. The campus remained in a state of continual disruption, with strikes and shutdowns, for nearly two years from that first sit-in over college complicity with the U.S. war machine.[33]

Rupert García had entered SF State in 1966, resuming studies in studio art that he had commenced closer to his Central Valley roots at Stockton Junior College in 1960. Between 1962 and 1966, he had voluntarily served in the U.S. Air Force, at first in relative peacetime and latterly directly in support of Rolling Thunder, the relentlessly punitive U.S. bombing of North Vietnam intended, without success, to force concessions in the south. The young Chicano found himself stationed in the uplands of Thailand, at a base from which sorties in the campaign were being launched in secret. As Turrell had been five years before, he became entangled with the Central Intelligence Agency. García's role was to guard the clandestine airfield and occasionally set a perimeter around unexploded bombs jettisoned from returning flights. In a 1995 interview, he recalled the unit's euphemistic name: "Military Assistance and Air Advisory Group, something like

that. Along with, as I recall, the CIA. And so we were supposed to wear a kind of a hat and look like Australians, with these bush hats."[34] His awareness of deception and subterfuge in the war effort did not then entail anything like Turrell's Quaker pacifism, however; indeed, on first hearing of antiwar agitation back home, he felt an indignant desire to refute the war's opponents on his return. Once re-enrolled in college, however, doubt overcame him, as he imbibed the critical, left-wing subject matter so abundant in the SF State curriculum. Of his time there, he later recalled: "No one knows that I had ever served in the Vietnam War. I didn't tell anybody; I kept this close to my chest. So when I started to participate in critical discussions, reading leaflets that people were passing out, and studying philosophy and sociology and anthropology, taking special courses that were designed specifically around critical thinking and new theory about the commodification of everyday life—I began reading New Left theory and was exposed to the Black Panther Party and other Third World liberation thinking. And it began to make sense to me; it really made critical sense."[35]

García's early artistic efforts gravitated toward the fine-art print medium of etching and aquatint, picking up, it would have seemed, where he had left off at Stockton. But exposure to "critical thinking and new theory" made an almost immediate impact on his work. Without diminishing the softened textures and atmospheric qualities inherent to his chosen medium, he condensed and toughened within it an emblematic imagery of sociopolitical awareness. He based one series on a condensed vignette he called *Black Man with Glasses*—an isolated bust, expression hidden behind opaque shades, with the pencil moustache and processed hair of an entertainer. In some prints the anonymous portrait appears alone; in *Black Man and Flag* [FIG. 13] it replaces the stars within a caustically rearranged

American flag, its direction reversed and black stripes running vertically like the bars of a prison cell: hipness caged.

Dated the to fall of 1967, this print came into being some months after King's address at the Riverside Church, the moment that had firmly aligned protest against racial injustice with opposition to the war in Indochina. García sounded the latter note in his contemporaneous *The War and Children* [FIG. 14], a vertically oriented, cruciform composition that likewise exploits the strength of compact figural vignettes and stark tonal contrasts. During 1967, publicity of atrocities suffered by children in Vietnam, owing to indiscriminate U.S. bombing and shelling, had helped overcome the political timidity of conventional Americans unused to questioning the military actions and policies of their government. At the start of the year, another printmaker, Lorraine Schneider in New York, came up with a design that, when enlarged, reproduced, and widely circulated as a poster, had arguably the greatest impact on public antiwar sentiment of any piece of graphic art: *War Is Not Healthy for Children and Other Living Things*. Its disarming effect arose from her intentionally childlike (but not childish) calligraphy and floral embodiment of innocent life. In *The War and Children*, García took the theme toward a distinctly contrasting mode of graphic economy, which foregoes didacticism for more ominous disquiet and menace. Here, the dark areas of helmets and shadows convey the brooding presence of an implacable military force, like the Roman soldiers at the Crucifixion, with virtually no superfluous detail. The balancing dark shape at the base of the cross resists a literal reading, appearing simultaneously as a grotesque flow from the mouth of the child or, conversely, a distorted hand gripping her throat and chin, one enlarged finger probing the same orifice.

The marks of traditional craft enhance rather than dilute the strength and clarity of García's

FIG. 13
Rupert García, *Black Man and Flag*, 1967, etching and collagraph, The Fine Arts Mueums of San Francisco, gift of Mr. and Mrs. Robert Marcus

FIG. 14
Rupert García, *The War and Children*, 1967, etching, Courtesy Rena Bransten Gallery, San Francisco

motifs, which resemble the stylized, high-contrast conventions that contemporary San Francisco designers used to advertise the countercultural rock ballroom scene. Another tributary of the same graphic current had flowed through Cuba to Paris, yielding in October 1967 the enduring, high-contrast portrait of Che Guevara fashioned by the expatriate Irish designer Jim FitzPatrick.[36] García reproduced FitzPatrick's template in a 1968 poster over the slogan "RIGHT ON!" in stencil-patterned capitals [FIG. 15]. For him and his peers, the intimate and labor-intensive character of fine-art media like etching had become an unsustainable luxury in the face of the escalating political conflict at the college. When the campus-wide strike was called in November 1968, students in the art department— García in a leading role—organized themselves into a publicity arm of the strike action. He recalled a professor visiting from England who was conversant with the silkscreened posters produced in Paris during the previous May by the Atelier Populaire, the workshop within the École des Beaux-Arts that blanketed the Latin Quarter with fly-posted invectives against authority and exhortations to change consciousness. García described his activist role in translating the Parisian prototype to the local context of San Francisco:

> I was a liaison between the art department and the other members of the Third World Liberation Front organizations. I would go talk to them and come back, and this kind of thing. And so we began to make posters dealing with the issues—issues from racism to better education to police brutality, antiwar, and much more. I mean, all the issues that were being addressed at that time made for a heady experience. Many of those issues were being dealt with in our poster brigade. And the posters were used in the demonstrations on campus, and some were used outside of campus, and some were sold to raise money to get people out on bail, people who had been arrested.[37]

One fierce outcome of his individual efforts was the incendiary 1969 poster *Down with the Whiteness* [p. 20], in which he rendered a beret-wearing Black Panther in full oratorical flight, black-gloved fists isolated against the speech balloon that bears the poster's titular slogan. In its combination of energy with formal elegance, along with its transposition via the definite article of white identity to an abstract condition (as blackness inheres in the ink itself), García's design easily matches the best of his Parisian predecessors on both technical and conceptual levels. García's local landscape of Chicano rebellion thus assumed a geographical universality while traversing from top to bottom the deep layers of New World history, lending weight and depth to its urgency in that particular political moment.

The secret bombing and invasion of Cambodia in the spring of 1970 brought a new sense of crisis and

FIG. 15
Rupert García, *Right On!*, 1968, lithograph, The Fine Arts Museums of San Francisco, gift of Mr. and Mrs. Robert Marcus, 1990.1.61

urgency, sparking the most widespread uprisings on college and university campuses of the Vietnam era, including the retaliatory murders at Kent State University in Ohio. That moment coincided with García's June 1970 exhibition marking the completion of his master's degree in fine art at SF State. The venue, however, was not on campus but at the Artes 6 gallery in the city's Mission District—a cooperative Latino counterpart to the Brockman Gallery in Los Angeles, where Hammons had exhibited his *Injustice Case* the year before. García recalled that none of his teachers attended the opening, a possible indicator that the ascent of the Third World Liberation Front had opened a split in the earlier, strike-born solidarity between students and faculty.[38] As a graphic artist, his most forceful response to the 1970 crisis placed his ethnic identity at the forefront of his renewed antiwar message. "Out of Vietnam" became ¡*Fuera de Indochina!* [p. 192]. No one needed to tell García that the theater of war in the region had always exceeded the notional boundaries of Vietnam, north or south. And his command of the high-contrast, international idiom of protest imagery had advanced to a level beyond the norm, far beyond his openly derivative take on Che Guevara. A minimal number of black intrusions into a terra-cotta field generate an elementally tortured visage that reaches from pre-Hispanic anguish over European conquest to the terrorized skyward gazes of Cambodian peasants under American onslaught.

Conclusions call for generalizations, in which this essay has been sparing. Unusual art made under extraordinary circumstances resists the drive of art history for readily graspable categories. The task of understanding cannot fall back on textbook rubrics, but must connect as much as possible to the human existence that brought the art about. The medium for that undertaking is narrative, neglect of which denies to the reader an adequate sense of depth in both historical and artistic comprehension. The linked stories that comprise this essay represent an effort to meet that requirement, made imperative by the extent to which the art in question extracted serious personal costs from virtually all concerned: their art was made from those sacrifices, and only a fuller sense of the life will convey that. The one artist in this account not known for conspicuous self-sacrifice, Ed Kienholz, stands out in his generation as its preeminent storyteller, as he does in his determination that forthright addresses to societal failings need in no way compromise aesthetic nuance and complexity.

Even at his most caustically provocative, however, Kienholz had the benefit of prominent venues and wide recognition in the circuits of the art system. His most direct heirs in Los Angeles, as they extended his actual space and scale into real time and real life, enjoyed no such advantages. On Christmas Eve of 1971, three unheralded young artists in ritualized costume staged a mock religious procession enacting the Christian Stations of the Cross, marching along Whittier Boulevard, the main shopping and car cruising thoroughfare of the East Side. Their march concluded when they deposited their fifteen-foot-long cardboard crucifix, defaced with blood, ash, and grease in front of a marine corps recruiting office [p. 235]. In their wake, as one of them reported, "rumors of a bizarre religious sect in East L.A. began to surface...a reverberating impression of spiritual doubt and doubtful spirituality."[39]

The artists who staged this pageant, with its travesty of ornate Latino Catholicism, were Harry Gamboa Jr., Willie Herrón III, and Glugio Nicandro, who calls himself Gronk.[40] The fourth founding member of the group, Pattsi Valdez, joined in a similarly parodic procession the next year, costumed as the Virgin of Guadalupe in what they called *Walking Mural*. The group had first come together as teenagers,

working together on the alternative publication *Regeneración*, supporting the "Blowouts," the Chicano mass boycott of the East Side high schools in 1968. That action brought police violence down on the students at a level anticipating the ferocious repression of the Chicano Moratorium March against the Vietnam War held in East Los Angeles at the end of August 1970. In contrast to contemporaneous protests mounted by predominantly white, middle-class marchers, their Chicano counterparts found themselves savagely set upon by the Los Angeles police and county sheriff's departments. Rubén Salazar, the most prominent Mexican American journalist in the region, was killed by a military-grade tear gas canister fired into the bar where he and others had taken refuge from the police onslaught.

The *Stations of the Cross* procession mourned Salazar, along with the assaulted dignity and hopes of the victimized marchers; it also channeled frustrated outrage over the disproportionate military draft of disadvantaged young Chicanos, with the disproportionate number of deaths and injuries among them that followed. No visible, galvanizing movement, of the kind that energized Rupert García, had followed the repression of 1970. For these young Chicano artists, excluded at the same time from any compensating support from local art institutions, gaining public attention required acting outside the system. In 1973, after performing such exploits as "signing" the Los Angeles County Museum of Art (having been told by a curator that Chicanos only made folk art and gang graffiti), Gamboa, Valdez, Herrón, and Gronk formally named themselves Asco—after the Spanish phrase *me da asco*: it makes me puke. But they did not let that off-putting image stand in the way of their exploiting a collective talent for inventive and flamboyant costume in the staging of hit-and-run events they referred to as *No Movies*, in ironic fealty to the apparatus of Hollywood that stood in close physical proximity but at vast socioeconomic distance from their

world. A shared vocation as storytellers joined with their valid awareness of always being in the line of fire led them into a consciously elusive, shape-shifting array of activities, one that brought out Gamboa's gifts as a writer and recording photographer; Valdez's improvised appropriation of film glamour in both acting and fashion design; Herrón's art training, showmanship, and major musical ability; and Gronk's protean self-invention along nearly every vector of gender identity and artistic medium.

Work of greater permanence on the part of the group was consequently rare, but their shared cinematic inclination infused the large mural painted by Herrón and Gronk, likewise in 1973, in the Estrada Courts housing project in East Los Angeles. The sight of freshly painted murals on outdoor surfaces in that area was by no means uncommon. (Eighty-two murals were commissioned for the Estrada Courts alone between 1972 and 1978.) And a group of prominent, older muralists would be dubbed that year with the collective name Los Four, their brightly hued, folkloric celebrations of Mexican heritage and local pride stood as recognized reminders of Chicano discontents, political militancy, and pride.

At first encounter, Herrón and Gronk's contribution to the genre would have appeared, by its scale and militant subject matter, to have conformed to type. But their first departure from the norm lay in the restriction of their palette to black and white [FIG. 16].[41] A grid-like arrangement of motifs sought to evoke the black-and-white grittiness of reportage on cheap televisions, alongside grainy projected images of the classic and New Wave European films that provided them with an alternative to the confining points of reference in their local surroundings. Those motifs pointed in particular to Gillo Pontecorvo's 1966 *Battle of Algiers*, which used quasi-documentary techniques to make vivid the Algerian nationalist resistance to French occupation—the anticolonialist struggle that followed directly upon the expulsion

of the French from Indochina by the forces led by Hồ Chí Minh. *Black and White Mural* linked the open wounds of French atrocities to fresh, aggrieved political memory of the events surrounding the Chicano Moratorium March against the Vietnam War. Alongside Warhol-like renditions of news photographs, Herrón and Gronk included a panel depicting the slain Salazar, his backward-tilted head in the foreground as if crucified upside down, a black arabesque of blood on his chest. Adjacent to the Salazar martyrdom they placed a close-up rendering of the white-faced mime Baptiste, the character played by Jean-Louis Barrault in Marcel Carné's 1945 *Children of Paradise*, a film produced under German occupation, a condition they implicitly likened to the permanent occupation of the Los Angeles barrio by the Anglo forces of order. Next to the mime's stock expression

of shock, Gronk placed a double portrait of himself in the comparably stylized, androgynous costume of a self-invented character he called Popcorn (whom he had played in the *Stations of the Cross*).

Even in the more enduring medium of paint on plaster, Herrón and Gronk aligned with Asco's ephemeral activities—coded and loaded to insiders, opaque and misdirecting to anyone else. Some of their *No Movies* emerged into public awareness via distorted echoes like the cult rumors following their *Stations of the Cross* procession or the photographic record of a 1976 performance they called *Decoy Gang War Victim* [FIG. 17], where Gronk lay as dead at the center of an empty downtown street during the early morning hours. Gamboa succeeded in inducing several television and print outlets to feature the image as the actual final victim of

FIG. 16
Willie F. Herrón III and Gronk, *Moratorium: The Black and White Mural*, 1973, Estrada Courts, East Los Angeles, CA. Restoration by Willie F. Herrón III and Leah Moscozo 2017

FIG. 17
Asco, *Decoy Gang War
Victim*, 1974, printed 2010,
chromogenic print,
Smithsonian American Art
Museum, Museum purchase
through the Luisita L. and
Franz H. Denghausen
Endowment

some ultimate gang war of attrition. His immediate target was the political stereotyping—undiminished since—of young Latino males as gang members and criminals. The history of the Vietnam War may then have been undergoing hasty repression from American collective memory. But their form of activism, like those of Hammons and García, had never admitted any separation between what they viewed as unconscionable aggression abroad and unjust oppression at home; nor would their own history have allowed them to forgo the implication in *Decoy Gang War Victim* of their classmates among the draftees brought home in coffins. Gamboa's stark, powerfully simplified photograph testifies to the war that never seems to end.

1 Mark Holborn, "Under the Volcano: James Turrell Used to Fly Secret Missions for the U.S. Government. Now He Is Completing One of the Most Ambitious Earthworks of Modern Times," *The Independent*, April 11, 1993.

2 Almine Rech, Interview with James Turrell, in Rech, ed., *James Turrell: Rencontres 9* (Paris: Images modernes: Almine Rech Gallery Editions, 2005), 24.

3 Leslie Goldberg, Interview with Wally Hedrick, *di Rosa Artist Interview Series*, 2009. Transcript available at http://www.wallyhedrick.org/pdfs/di_rosa_artist_interview_series.pdf.

4 Paul Karlstrom, Oral History Interview with Wally Hedrick, June 10–24, 1974, Archives of American Art, Smithsonian Institution, https://www.aaa.si.edu/collections/interviews/oral-history-interview-wally-hedrick-12869#transcript. "We weren't really there overtly but we were there. I was starting to hear things on the news broadcasts, 'We're sending 20 advisers.' And I said, 'Uh oh, here we go.' But see, I'd only been out of the army five years, and somehow I don't think I knew the difference between Korea and Vietnam. To me it was all the same. All I knew was we were there and we were going to get screwed again, you know. So it was sort of in honor of the people being killed, I guess."

5 Among many sources, see Neil Sheehan, *A Bright Shining Lie: John Paul Vann and America in Vietnam* (New York: Vintage, 1989), 351–58.

6 Letters to the *Times*: "Mrs. Nhu Defends Stand," *New York Times*, August 14, 1963.

7 Karlstrom, Interview with Hedrick.

8 See Peter Selz, *Art of Engagement* (Berkeley: University of California Press, 2006), 40.

9 For an excellent overview, see Matthew Israel, *Kill for Peace: American Artists against the Vietnam War* (Austin: University of Texas Press, 2013).

10 See Tom Wells, *The War Within: America's Battle over Vietnam* (New York: Henry Holt, 1996), 23–38.

11 These events are recounted in Francis Frascina, *Art, Politics and Dissent: Aspects of the Art Left in Sixties America* (New York: Manchester University Press, 1999), 57–87.

12 See Thomas Crow, *The Long March of Pop: Art, Music, and Design 1930–1995* (New Haven, CT: Yale University Press, 2015), 255–77.

13 See "Potpourri of Protest," unsourced press clipping, March 14, 1966, in papers of Charles Britten, box 5:3, special collections, Getty Research Institute, Los Angeles.

14 See Frascina, *Art, Politics and Dissent*, 72.

15 See David Pagel, "Turn on the Light," *Los Angeles Times,* October 21, 2007.

16 Alison Sara Jacques, Interview with James Turrell, in *James Turrell*, ed. A. S. Jacques and J. Svestka (Madrid: La Caixa, 1992), 57.

17 Yet the popularity of this remark in the literature is as much Turrell's responsibility as that of any incurious commentator. He has intentionally presented an elusively shifting target for biographical scrutiny. Establishing even a basic fact, such as the time Turrell spent in prison,

requires inference from other kinds of records. The early life narrative recounted here cannot be found in any one existing source; it had to be fashioned out of scattered fragments selectively disclosed to various interviewers over time. Any embarrassment or shame over the antidraft prosecution is out of the question, and Turrell has been forthright on the subject on a number of occasions. But these accounts of his arrest and imprisonment have generally been in general interest publications like the *Los Angeles Times* and even *Harper's Bazaar*, which may represent a kind of hiding in plain sight, exploiting the general allergy of the art establishment to the 1960s counterculture.

18 *Jim Turrell*, Pasadena Art Museum, October 1967.

19 Jennifer Licht to Walter Bareiss, MoMA archives, September 23, 1969, quoted in Lise Kjaer, "Awakening the Spiritual: James Turrell and Quaker Practice" (PhD diss., City University of New York, 2008), 139.

20 Douglas Davis, "View from Hill and Main," *Newsweek,* October 27, 1969, 111.

21 For this period in Turrell's career, see Crow, *No Idols: The Missing Theology of Art* (Sydney: Power Publications, 2017), 130–35.

22 Karlstrom, Interview with Hedrick.

23 Thomas Albright, "The Portable War Memorial Commemorating VD Day," *Rolling Stone*, December 21, 1968. The San Francisco Museum of Modern Art group exhibition *Untitled, 1968* ran from November 9 through December 29, 1968.

24 Ibid.

25 The text was published as "Declaration of Independence from Vietnam," in *Ramparts,* May 1967, 32–37; this passage on p. 33. On the event and responses to it, see Taylor Branch, *At Canaan's Edge: America in the King Years 1965–68* (New York: Simon & Schuster, 2006), 590–97.

26 Ibid., 37.

27 See Jason Epstein, "A Special Supplement: The Trial of Bobby Seale," *New York Review of Books,* December 4, 1969; for a summary of the case and trial, see Jon Weiner, "Introduction: The Sixties on Trial," in *Conspiracy in the Streets: The Extraordinary Trial of the Chicago Eight,* ed. Jon Weiner (New York: The New Press, 2006), 1–43.

28 Kellie Jones, *South of Pico: African American Artists in Los Angeles in the 1960s and 1970s* (Durham, NC: Duke University Press, 2017), 228.

29 The literature on Corita Kent was scant until relatively recently. See Julie Ault, *Come Alive! The Spirited Art of Sister Corita* (London: Four Corners Books, 2006); Ian Berry and Michael Duncan, eds., *Someday is Now: The Art of Corita Kent* (Munich: Prestel, 2014); and Susan Dackerman, ed., *Corita Kent and the Language of Pop* (Cambridge, MA: Harvard Art Museums, 2015). My own approach to the subject has been indebted to the deep scholarship of Kristen Gaylord. See Gaylord, "Catholic Art and Activism in Postwar Los Angeles," in *Conflict, Identity, and Protest in American Art,* ed. Miguel de Baca and Makeda Best (Newcastle-Upon-Tyne: Cambridge Scholars Publishing, 2015), 99–120.

30 James Francis McIntyre, archbishop of Los Angeles, letter of May 12, 1966, reproduced in Anita M. Caspary, *Witness to Integrity: The Crisis of the Immaculate Heart Community of California* (Collegeville, MN: Liturgical Press, 2003), 40–41.

31 The poem is included in the Gerald Huckaby collection *City, Uncity* (New York: Doubleday, 1969), each poem rendered by Kent in her distinctive calligraphy against her high-keyed, full-page designs. For a brief resumé of Huckaby's fascinating life, see the 2017 obituary published by his local newspaper, *The Medocino Beacon,* http://obituaries. mendocinobeacon.com/obituaries/ mendocinobeacon/obituary.aspx- ?pid=187857440, accessed May 2018; "Stop the Bombing" was read at his wake.

32 See Branch, *At Canaan's Edge*, 578.

33 See the chronology of events compiled by Helene Whitson at *Found SF,* accessed June 2018, http:// www.foundsf.org/index.php?title= S.F._STATE_STRIKE_1968-69_ CHRONOLOGY, .

34 Paul Karlstrom, Oral History Interview with Rupert García, September 7, 1995–June 24, 1996, Archives of American Art, Smithsonian Institution, https://www. aaa.si.edu/collections/interviews/ oral-history-interview-rupert-garcia- 13572#transcript.

35 Ibid.

36 On this development, see Crow, *The Long March of Pop*, 327–43.

37 Ibid.

38 See Cary Cordova, *The Heart of the Mission: Latino Art and Politics in San Francisco* (Philadelphia: University of Pennsylvania Press, 2017), 114–15.

39 See Harry Gamboa Jr., "In the City of Angels, Chameleons, and Phantoms: Asco, a Case Study of Chicano Art in Urban Tones (or, Asco Was a Four-Member Word)," in *Urban Exile: Collected Writings of Harry Gamboa Jr.,* ed. Chon Noriega (Minneapolis: University of Minnesota Press, 1998), 77.

40 For a comprehensive, multi- author overview, see C. Ondine Chavoya and Rita Gonzalez, eds., *Asco: Elite of the Obscure* (New York: Hatje Cantz, 2011).

41 One motive, they have claimed, was to hold back the supplied colored paints so they could use them in their own paintings. But the effect of the monochrome scheme transcended that expedient circumstance. Jeffrey J. Rangel, Oral History Interview with Willie Herrón, February 5–March 7, 2000, Archives of American Art, Smithsonian Institution, https://www. aaa.si.edu/collections/interviews/ oral-history-interview-willie-herrn- 12847#transcript.

FIG. 7
Peter Moore, photograph
of stage set for Carolee
Schneemann's *Snows*,
Martinique Theater, 1967

with *Viet-Flakes*, a film that attempts to bring a distant war closer while reimagining how news might be transmitted and received differently.

Viet-Flakes revolves around a collection of photographs of the war that Schneemann gathered from various sources over the course of several years.[44] She shot the film with a borrowed Bolex camera and

FIG. 5
Carolee Schneemann,
Viet-Flakes (still), 1962–67,
re-edited 2015

FIG. 6
Carolee Schneemann,
performance of *Snows*,
1967

cheap magnifying lenses, which she used to examine these images at close range. The film documents the fraught experience of looking closely at unbearable scenes of suffering in Vietnam. Striking details come in and out of focus quickly as Schneemann moves her camera over the photographs she refilms. The soundtrack, a tape collage by the composer James Tenney, her partner at the time, punctuates the film's lurching camera movements with a jarring mix of pop singles, strains of Vietnamese folk music, and fragments of Bach, reminiscent of radio signals coming in and out of range.[45]

Belatedly, images that appear in *Viet-Flakes* begin to recall actions performed on stage earlier in the performance. A photograph of a dead Viet Cong soldier being dragged behind an American tank, for example, evokes an earlier moment in *Snows* when two performers drag another performer across the stage.[46] An image of a man strung up by his ankles during an investigation by South Vietnamese mercenaries [FIG. 5] recalls the act of hanging a performer by a rope [FIG. 6].[47] These relationships across time and space are not always easy to perceive. The performance functions like a television set to an empty channel beset by visual noise, static, or "snow." There are images in the air, the work suggests, but they must be tuned in to be seen. Schneemann treats the bodies of her performers in *Snows*, and by extension those of her audience, like instruments of receptivity that can be trained to receive these signals.

Schneemann described her work as the creation of a "sensory arena" or environment where she could realize images "which dislocate, disassociate, compound, and engage our senses to expand into unknown and unpredictable relationships."[48] She transformed the interior of the off-Broadway theater where *Snows* was performed into a strange, immersive production studio, part bodily interior, part snowy exterior [FIG. 7]. The score for the work indicates that the audience was led into the space through the

one of the more politically oriented underground newspapers of the period, complained, "*In the Year of the Pig* does not really help you understand a revolutionary movement. It only tells you that the United States should not be there trying to stop it." The reviewer conceded, "Five years ago, when many of us were vaguely against the war, but thought we needed 'facts' to support our viewpoint, *In the Year of the Pig* would have been a powerful movie.…In 1969, most people who go to see such a film—and I would assume that people who go see it already have some feeling that the war is wrong—want to understand more than American errors. They—or at least I—want to understand what a war of national liberation really means."[39]

For Carolee Schneemann, opposition to the war required something other than films built around facts as well. Her performance *Snows* begins, however, not by presuming to know what a war of national liberation means for the people waging it, but with the problem of her own distance from their struggles. The work grew out of mounting frustration with what she described as the "inability to act directly on a situation" in which "evidence of the personal experiences of the Vietnamese" was accessible only "at a great remove."[40] Like de Antonio, Schneemann was compelled to experiment with new film forms but, in the process, also began to rethink the conditions of film exhibition and reception that de Antonio's work took for granted (failing to anticipate the way access to conventional screening spaces might be denied in practice). Though Schneemann was also critical of television's role in reducing militarized conflict in Vietnam to an everyday banality, she did not attempt to gather information missing from the nightly news. Instead she imagined a countermodel to television's mediation of war at a distance that would call upon the body as well as the eye. For Schneemann, the mediation of war had to be made meaningful somatically—in

the way protest and revolution make the stakes of political change felt and not simply understood.

Though she was less interested than de Antonio in ironic dissonance, Schneemann also relied on juxtaposition to structure her work. Schneemann described *Snows* as a performance "stretched out in time between five films" that "triggered" juxtapositions between "a winter environment and Vietnam atrocities."[41] Artificial white tree branches rescued from a department store's discarded Christmas display form a crystalline fringe around the stage. Fake snow falls gently from above, clinging to the performers' hair and eyelashes. Scattered heaps of aluminum foil and mounds of packing foam mimic the forms of snowdrifts. During the performance, grainy footage of skiers from World War II-era newsreels spills onto the walls of the theater, which are collaged with torn paper. A color 8mm diary film, shot in the snowy weeks leading up to the performance, is projected directly onto the bodies of performers on stage. *Snows* opens with the performers gathered to watch a newsreel from 1949 depicting a series of catastrophes: "a ship exploding, a sequence of tiny figures massed in a 'riot,'…tiny figures of 'red' Chinese, being shot by nationalist guards," what elsewhere the artist described as "one little horrific element after another," emphasizing the distancing effects of war's mediation.[42]

For the majority of the hour-and-a-half-long performance, Schneemann suspends direct reference to Vietnam. Images of the war appear only at the end of *Snows* during the projection of *Viet-Flakes*, a short collage film that synthesizes the two different film formats screened earlier in the performance: found newsreel and diary film. *Viet-Flakes* re-presents appropriated news imagery with the intimacy of a personal recording. The film forms what the artist called "the heart and core" of the performance.[43] *Snows* begins with a conventional experience of war glimpsed at a distance in the news and culminates

COL. GEORGE S. PATTON III
TANK COMMANDER

"Outtakes are the confessions of the system."[30] Like a lawyer, de Antonio lays out his case with great care, providing evidence that valorizes or undermines the credibility of the men on screen (it is primarily men who speak in his films), and the powers they represent, trusting his audience to make their own reasoned judgments in turn.

When *In the Year of the Pig* was completed in the fall of 1968, its deliberate and rational approach to antiwar protest provoked a series of angry and suppressive reactions. The night before its premiere in Los Angeles in early 1969, someone at the Cine Cienega Theatre scrawled in red paint across the screen: "LISTEN—TRAITORS ⊕ = ☭ = PROLONG THE WAR/YOU SLOBS KILLED 40,000 GOOD MEN!"[31] Elsewhere the film was simply silenced. Screenings were canceled in Scranton, Pennsylvania, de Antonio's hometown, and never booked at all in the nation's capital. In a letter to Noam Chomsky, he complained that the film had been rejected by the liberal Biograph Cinema in Washington, D.C., as "un-American."[32] *In the Year of the Pig* was met with bomb threats in Chicago and Houston, and stink bombs in Paris. When the film was screened in September of 1969 at a benefit for the Chicago Seven, the theater owner's life was threatened.[33] Police cars sat outside the box office with their sirens flashing, deterring people from attending the event. In Houston, threats forced de Antonio to move the screening to a local community center. When the tax-exempt status of the organization was challenged, it forced a second change of venue to a classroom at Rice University.[34]

Driven out of commercial theaters, the film found its way into other unconventional screening situations. As part of the Moratorium to End the War in Vietnam on October 15, 1969, for instance, de Antonio had *In the Year of the Pig* booked at twenty-five campuses. He developed a traveling program for other special screenings, which he advertised to student organizations and newspapers as "a new kind of political theater."[35] In addition to playing community centers and the college circuit, the film also played twenty-four hours a day for a period at a GI coffee house outside of Fort Dix, New Jersey. Though he had hoped to make a film that would provide an alternative to shouts of protest, de Antonio's film ultimately solicited enraged responses that affected the conditions under which it could be seen in public.[36]

De Antonio often expressed frustration with the reactionary responses *In the Year of the Pig* elicited, but the film's reception was far from entirely negative. It earned positive reviews and drew sizable audiences in Europe. Remarkably, in 1970 the film was nominated for an Academy Award for Best Documentary. And while de Antonio did not take home an Oscar that year, he did win awards for the film from festivals in Florence, Leipzig, and Cannes.[37] Offering a critical assessment of the film's legacy, de Antonio's biographer, Randolph Lewis, concluded, "Perhaps more important than the praise the film received was its efficacy as an organizing tool, for in addition to lecturing with the film on dozens of campuses in the United States, de Antonio donated showings to raise consciousness as well as money."[38] The most searing criticism of the film came from voices aligned with these organizing efforts. A review published in the *Old Mole*,

de Antonio to first try his hand at editing without the intervention of a narrator. Condensing 188 hours of material originally shown live on television, the film stitches together a series of dramatic turning points in the hearings, inviting viewers to judge the credibility of the public figures involved—Senator Joe McCarthy, but also the legal counsel for the U.S. Army, Joseph Welch. Rather than celebrate the fall of McCarthy, de Antonio hoped to reveal how both the senator and his adversary, Welch, had engaged in ethically suspect tactics. In fact, no party involved in the process was free from blame in de Antonio's view. "The army had truckled, the White House had been silent, the Senate had cowered, the press printed more and more, the victims were offered up, the peeps of protest were very small until near the end." For him, the hero of the film was not Joseph Welch "but the camera."[23]

De Antonio's critique of television was rooted in the conviction that the networks had too much control over historically significant material that should rightfully belong to the public record. The filmmaker often found his access to network television archives constrained or blocked altogether. CBS reluctantly agreed to license the footage of the Army–McCarthy Senate hearings to de Antonio for *Point of Order* but charged the filmmaker the exorbitant fee of $50,000 plus half of the profits of the film in perpetuity. While making *Rush to Judgment* (1967), de Antonio confronted "a great media crime" worse than the control networks exercised through price gauging.[24] Seeking footage of testimonies omitted by the Warren Commission, he screened hours of outtakes for a program produced by CBS on the occasion of the report's release. Eager to make use of the contradictory eyewitness accounts he discovered languishing in the archive, de Antonio submitted a request to purchase the material only to find out that it was no longer for sale and, even worse, now slated to be destroyed. Ultimately, he completed *Rush to Judgment* by filming witnesses he tracked down in

Dallas himself, with assistance from his collaborator, Mark Lane, and a small film crew. The interviews, shot in a sparse style described by de Antonio as "art brut," were intended to demonstrate the credibility and integrity of everyday Americans willing to speak truth to power, voices whose exclusion from the official historical record the filmmaker took to be a great injustice.[25] As de Antonio told the *New York Times*, *Rush to Judgment* was made to question "the investigational procedures of the [Warren] commission under Anglo-Saxon jurisprudence, with cross-examination as the cornerstone."[26] Elsewhere he explained that he thought of the film's audience as "a kind of jury."[27]

In the Year of the Pig braids together these two filmmaking strategies—the careful and deliberate editing of television footage against the grain in *Point of Order* and the collection of testimonies missing from television's account of events in *Rush to Judgment*. Though his films are highly verbal, de Antonio was interested in more than just the words being spoken by the figures on screen. In an interview conducted by his wife, Terry de Antonio, he explained that the immediacy of a film image "enables the viewer himself to perceive something about the nature of the process and the nature of character in a way that words could never do.… There's a revelation of character that interests me as much as structure."[28] He noted an example from *In the Year of the Pig* where a young Colonel George S. Patton (son of the Second World War's General Patton) recounts a solemn memorial service attended by his troops and concludes with a chilling grin, "They're still a bloody good bunch of killers" [FIG. 4]. No actor could perform the line the same way, de Antonio insisted.[29] As he saw it, with this single comment, Patton not only reveals himself on screen, he also reveals the total folly of the war. The shot, which de Antonio found with the help of a friendly film librarian, was edited out of a televised interview. Discoveries such as these prompted him to declare,

Paris. He ventured into French military film archives and gained access to footage never before seen in the United States from the German Democratic Republic. Japanese peace groups and Cuban film organizations helped de Antonio further extend the search for material to incorporate into the film.[21]

While *In the Year of the Pig* includes an incredible range of filmic documents, the strength of its rhetorical force derives from de Antonio's ability to coax establishment figures to speak candidly on camera during exclusive interviews. *New York Times* film critic Howard Thompson observed that, more than the historical background of America's involvement in Vietnam that the film provides, "It is the statements by the men who led us there…that cut through to the quick."[22] A striking example occurs when de Antonio interviews one of the leading Republicans in the Senate, Thruston Morton of Kentucky, about a secret meeting he attended in 1954 with Secretary of State John Foster Dulles where plans to bomb Điện Biên Phủ on behalf of embattled French forces were briefly on the table. While critiquing the deepening military conflict, Morton describes Hồ Chí Minh as "the George Washington" of Vietnam. This comparison had, in de Antonio's view, "more dramatic force, more credibility" than cries of moral outrage voiced from the left.

In the Year of the Pig brings together a chorus of other voices to flesh out the evocative analogy proposed by Morton, and by extension the alignment of the Vietnamese fight for self-determination with the founding principles of American independence. The French writer Jean Lacouture, author of Hồ Chí Minh's biography, recounts how the young revolutionary's political views were shaped by the persecution his father suffered at the hands of the French colonizers. Paul Mus, a scholar of Buddhism at Yale raised in French colonial Hà Nội, discusses his meeting with Hồ Chí Minh in 1945 at the behest of the French high commissioner of Indochina. With wry admiration, Mus describes him as a man of the people, recalling "the touch and feel" that he had for the peasantry of Vietnam despite many years spent abroad in exile. He also admits with devastating candor, "Every time Hồ Chí Minh has trusted us, we betrayed him." As the film charts the increased involvement of U.S. forces in Vietnam after the defeat of the French at Điện Biên Phủ, de Antonio's central line of argument emerges—America, a nation founded in anticolonial revolt, now finds itself on the wrong side of history, a claim intended to upend the consensus view that television coverage of the war took for granted.

De Antonio's practice of carefully constructing filmic evidence to build an argument point by point grows out of his engagement with two legal forms of investigation—the hearing and the deposition—that form the basis of a pair of earlier films concerned with television's role in shaping history: *Point of Order* and *Rush to Judgment*. *Point of Order* (1964) reconstructs one of the most closely watched broadcast events of the previous decade, the Army–McCarthy Senate hearings of 1954, while *Rush to Judgment* collects statements by witnesses to the assassination of President Kennedy excluded from the Warren Commission Report. *Point of Order* [FIG. 3], made entirely of kinescopes of the proceedings, enabled

FIG. 3
Emile de Antonio, *Point of Order* (still), 1964, Courtesy of Harvard Film Archive

FIG. 2
Emile de Antonio, *In the
Year of the Pig* (still), 1968,
Courtesy of Harvard Film
Archive

audiences into passivity, but rather than working
to heighten the emotional intensity of dissent, he
developed a film form that called upon the audience
to engage in greater scrutiny of the information (or
lack thereof) mobilized in defense of the war on
television and elsewhere.

In January 1967, before de Antonio began prepro-
duction on *In the Year of the Pig*, the artist Carolee
Schneemann staged a remarkable live film perfor-
mance entitled *Snows*. Her work explored the embod-
ied experience of protest that Newsreel's films would
later exploit for maximum effect. Like de Antonio,
she was concerned with the daily appearance of
the war in the news, but she focused on aspects of
the somatic and psychic effects of war's mediation
that his emphasis on historically informed dissent
left largely unexamined. Schneemann staged *Snows*
as a live event. The Happening-like performance
incorporated flashing lights and multiple film pro-
jections into a cybernetic environment that sought
to engage the body as intensely as *In the Year of the
Pig* sought to engage the intellect. Like other artists
and filmmakers of their generation, de Antonio and
Schneemann understood that opposing the television
war would require nothing less than the reinvention
of cinema as a medium. Considered side by side, their

work defines the wide spectrum of film experimen-
tation born of this shared conviction.

De Antonio's reinvention of film form begins
with his rejection of voice-over as a documentary
convention, which he found to be false, idiotic, and
even authoritarian "in the worst sense of the word."[18]
In the Year of the Pig helped to popularize a new
documentary mode, which Waugh identified as the
"document-dossier."[19] In an interview with the critic
Lil Picard, de Antonio emphasized the importance of
juxtaposition in this mode of filmmaking, which com-
pletely eschews narration for an associative, dialec-
tical mode of editing: "My essential method and
technique is irony—it is the placing of one image
against another, never with any explanation."[20]
Taking up footage of military officials and politicians,
often gleaned directly from television coverage of
the war, *In the Year of the Pig* exploits contradictory
statements that undermine the political order this
material was originally produced to secure. During a
sequence on the Gulf of Tonkin incident, for example,
an official at a press conference outlines the military's
account of the event as an act of aggression on the
part of North Vietnam. In the next shot, Senator
Wayne Morse declares, "They put out that propa-
ganda, but they got caught," insisting that the USS
Maddox had actually provoked the attack, a claim
supported by subsequent interviews with military
personnel involved in the incident.

Recounting the history of American involve-
ment in Vietnam long before the controversy over
torpedoes in the Gulf of Tonkin took shape, *In the
Year of the Pig* draws upon difficult-to-procure foot-
age in addition to widely seen television broadcasts.
Through a practice he described as "radical scav-
enging," de Antonio gathered television outtakes
and rare footage from North Vietnam. He sourced
this material from all over the world, including the
National Liberation Front office in Prague and the
embassy of the Democratic Republic of Vietnam in

Vietnam. De Antonio's *In the Year of the Pig* seizes upon the matter-of-fact style of reporting that dominated coverage of the war on television, subversively heightening the dissonance between statements by officials speaking from within the establishment. It also offers a detailed account of Hồ Chí Minh's early political formation and, in this regard, departs radically from the Cold War consensus that persists behind some of the criticism voiced in the film. The dispassionate, cool, and at times sharply ironic tone of *In the Year of the Pig* distinguishes it from the emotionally charged cries of protest characteristic of the moment. Film scholar Thomas Waugh observed, "Its aim was to convince, not to inflame, to do the homework that the marchers had no time for."[11] De Antonio conceived *In the Year of the Pig* as "an intellectual weapon" to be used against the war, but also as "a black comedy."[12] He explained his method to Jonas Mekas this way: "I am interested in establishing a line of thought."[13] Elsewhere he emphasized, "I do not make films that are shouts and screeds. I make films to change the form of film."[14]

By the time *In the Year of the Pig* was widely released in early 1969, the antiwar movement had taken a decisive step toward militancy. Newsreel, a radical filmmaking collective established in late 1967, had formed branches in cities across the country and was producing films that abandoned carefully elaborated arguments against the war, opting instead to capture scenes of conflict calculated to mobilize the masses.[15] De Antonio's deliberate and acerbic approach to antiwar filmmaking stands in sharp contrast to Newsreel's embrace of emotionally charged confrontation. *No Game* (1968), one of the earliest films completed by Newsreel, depicts the violent clashes that broke out between protesters and U.S. Marshals at the Pentagon during a march on Washington in October 1967. The soundtrack is densely layered with shouts and breathless statements by protesters recorded at the scene. At the climax of the film, the marshals guarding the building begin to wield their nightsticks against the crowd. Suddenly images from the war in Vietnam appear without warning or explanation. These scenes heighten the urgency and emotional impact of the protest as it erupts into violence, a tactic the group would pursue by increasingly putting their bodies on the line during moments of confrontational protest, "with or without their cameras" as one member of the group declared.[16] A statement published in late 1968 articulates the group's rationale for openly embracing "a form of propaganda that polarizes, angers, excites":

> *The subject population in this society, bombarded by and totally immersed in complex ostensibly "free" media, has learned to absorb all facts/information relatively easily. Within the formats now popularized by the television documentary, you can lodge almost any material, no matter how implicitly explosive, with the confidence that it will neither haunt the subject population, nor push them to move—in the streets, in their communities, in their heads.*[17]

De Antonio was also highly critical of conventional television documentary formats that lulled

FIG. 1
Don North reporting, Takayuki Senzaki mixing audio, Yastusune Hirashiki filming for ABC news in South Vietnam, February 26, 1967

to catch in action or portray as visually dynamic. When a film camera was present in the midst of fighting, there were material limitations that made recording difficult [FIG. 1]. Ronald Steinman, NBC bureau chief in Sài Gòn during the war, recounted:

> *Equipment was state of the art for the 1960s. We had heavy Auricon sound cameras with 400-foot magazines that held about twelve minutes of film, a thin strip of magnetic tape on it to record sound. In the field, crews carried extra rolls of film and newly charged batteries with a black bag to empty the used magazine and replace it with fresh film. (Reloading film in combat was, to say the least, particularly difficult and dangerous.) Including a shoulder brace, the whole rig might weigh as much as thirty-six pounds—formidable, especially in the jungle or on a mountain ridge during a firefight.*[6]

Furthermore, while it was technically possible after 1964 to transmit moving images recorded on film by satellite, the process was expensive and not always reliable. The majority of the footage shot in Vietnam that appeared on television during the war was shipped by airplane out of Sài Gòn and edited en route before arriving at network headquarters in New York, a process that often took at least two or three days.

Daniel Hallin's widely cited study on media coverage of the war found that the networks used footage of Vietnam primarily to accompany human-interest features on "our boys in the field" or weekly battlefield roundups, rather than stories reported as dramatic breaking news.[7] These reports often dealt with day-to-day military operations and celebrated advances in military technology. His analysis showed that television coverage of the war tended to portray American troops as the "good guys," leaning heavily on tropes of masculine grit and national unity in the face of adversity.[8] Hallin concluded that commercial television newscasters created dramatic coherence through narrative framing that was overwhelmingly

supportive and patriotic, particularly in the period prior to the Tết Offensive, rather than through the exploitation of violent imagery. His study demonstrated that the tone of television reporting on Vietnam reflected, rather than provoked, growing disillusionment with the war. But even as the possibility of a stalemate became a more widely accepted view, Hallin noted that television coverage never challenged the Cold War consensus that provided the justification for American military intervention in Vietnam.

Filmmakers and artists opposed to the war criticized television for fostering tacit acceptance of escalating military operations after 1965. Filmmaker Emile de Antonio objected to the way television rendered reports of combat familiar and routine at the expense of historical curiosity and analysis. "The networks have made the American people, in a final way, comfortable with the war—because it appears between commercials, every day....There's never the question asked, 'Why are we doing this?' 'What is this war about?'"[9] His feature-length antiwar documentary, *In the Year of the Pig* (1968) [FIG. 2], confronts the overwhelming presentism of television's reporting on Vietnam with what the filmmaker described as "history at twenty-four frames a second."[10] *In the Year of the Pig* reconstructs the circumstances that precipitated America's involvement with Vietnam going all the way back to the period of French colonial rule. In the process, it offers a new model for working with filmic documents as primary sources of history.

During the Vietnam War, reporters were granted unprecedented freedom from government control and direct censorship; nonetheless, television coverage still relied heavily on statements by government officials and soldiers in the field. When moments of crisis or conflict did surface in these reports, as Hallin demonstrated, they were rooted in disputes over tactics emanating from within the administration and military, rather than editorial skepticism toward the legitimacy of American intervention in

ERICA LEVIN

The Vietnam War was the most important ongoing story during the period in which television became a trusted source of news for millions of Americans. Reports from the battlefield had appeared on the big screen since the First World War, but by 1967 newsreels were vanishing from the theaters, and all three major U.S. broadcast networks were producing a thirty-minute nightly newscast.[1] Newsreels provided an entertaining visual supplement to print journalism. As television took their place, it worked to establish itself as a legitimate

To Change the Form of Film

Experiments in Cinema against the Television War

form of news media in its own right.[2] In his memoir, General William C. Westmoreland voiced the commonly held view that the increased prominence of television news directly influenced the withdrawal of popular support for military intervention in Vietnam. His criticism emphasized the constraints imposed by the medium of television on serious journalism: "The news had to be compressed and visually dramatic. Thus, the war that Americans saw was almost exclusively violent, miserable, or controversial: guns firing, men falling, helicopters crashing, buildings toppling, huts burning, refugees fleeing, women wailing."[3]

Military historian William Hammond offered a starkly different picture of the war Americans encountered on the small screen. He wrote, "Television

tended to show combat from a distance…soldiers moving into battle or firing on some vague target or pulling themselves together after an engagement. There was considerable commotion—rifles popping in the background, helicopters landing and taking off, smoke and dust—but little of the violence characteristic of Vietnam."[4] Hammond's account suggested something of the difficulty involved in bringing a distant war into view. Whereas in previous wars access to the battlefield had been strictly controlled by government censors, during the military conflict in Vietnam, which was never officially declared a war, news crews were granted relative freedom to maneuver.[5] However, combat operations in the midst of a guerrilla war were not always easy

Carolee Schneemann,
performance of *Snows*,
1967

backstage door and made to squeeze through two "floor-to-ceiling foam rubber 'mouths.'"[49] Scrambling in the dark over long planks of wood extended from the stage to the rear of the space to get to their seats, they were made aware of their own bodily vulnerability. These actions, squeezing through apertures and crawling, were then repeated by the performers on stage, who emerged moving on all fours through a set construction described by Schneemann as a "water-lens."[50] The edifice was a decidedly low-tech apparatus, a frame built from two-by-fours draped with plastic bags of colored water. With its grid-like form, it approximated the look of a bank of monitors, suggesting a primitive, hand-built television studio. The impression was reinforced by the presence of figures, described in the score as "technicians," who operated mobile projectors during the performance in plain view of the audience.

Snows is organized around a progression of structured sequences that feature actions or exercises that stress reciprocity and exchange. Early on, the six performers—three men and three women—pair off and slowly circle one another, lunging forward or giving in to the attack [FIG. 8]. Here *Snows* offers a glimpse of focused action and attentive reaction. While Schneemann provided her performers with a set of directives or parameters for their movements, these actions were not choreographed in the formal sense. Instead they grew out of practiced encounters that emphasized what Schneemann described as "organic necessity arising spontaneously in the unique circumstances of the work."[51] In an interview Schneemann explained how these exercises operate:

> *The condition is that you're always responsible for each other's fall, so you have to be completely identified with the impulse by which you are going to destabilize your partner, and your partner has to trust that, to yield enough to fall, so that you don't hurt each other by stiffening up. It takes a lot of practice.*[52]

Snows required intense training in order to yield the results Schneemann hoped to produce. Elsewhere she explained, "We were evolving not simply a 'performance,' but a microcosm of creative inter-relations."[53]

As *Snows* continues, collisions that emphasize the weight and force of bodies coming into contact give way to actions that involve more deliberate and slowly executed forms of mutual manipulation. Working in pairs, the performers cover each other's faces in white grease paint and take turns forming each other's facial expressions, as if molding them out of clay.[54] Flashing strobe lights momentarily freeze the performers' illegible facial expressions into a staccato series of snapshot-like freeze frames, a photographic effect further enhanced by the use of the white face paint, which functions as a kind of light-sensitive emulsion. Once the strobe subsides, the performers begin to "sculpt" one another's bodies into random and unreadable poses. This action unfolds under a softer play of colored lights activated unknowingly by members of the audience. In an essay on the making of *Snows*, Schneemann noted, "I knew I wanted the audience to somehow control the performance cuing systems, and I was obsessed with the contradictions I wanted the work to effect."[55] Elsewhere she explained the use of technology as a way to introduce chance into the work, or what she suggestively called "systems of interference": "I wanted to have these systems of interference, so that even after I could make the most complex, determined sequences of projections… there could be some system to interrupt them so that the performers or participants would also be constantly off-guard."[56]

Schneemann was drawn to technology through her interest in kinetic movement and bodily experience. She referred to *Snows* and other performances from this period as "kinetic theater." The term "kinetic" denotes movement and the forces or energies associated with that motion. Kinetic movement

in *Snows* animates relationships between performers on stage through exercises that emphasize the weight and force of bodies colliding. These relationships then continue to develop through deliberate manipulations of faces and bodies. In the final sequence of *Snows*, interactions between performers function more like brief gestural dramas that set the stage for the appearance of images that will appear during the screening of *Viet-Flakes* at the conclusion of the performance. In a series of notes published in 1969, Schneemann described her kinetic theater as the formation of a "corps" that begins with the body and reaches from "possibilities" concretized through physical interactions between performers into the "materials of the environment," which in *Snows* included, among other things, projected images of war.[57]

As a technology, television facilitates seeing at a distance. The term *television* yokes together the Greek root *tele*, meaning "far," to the Latin root, *visio*, meaning "seeing," to signify the concept of "seeing at a distance." *Snows* proposes embodied forms of "reaching" toward images as an alternative way of seeing at a distance. Technology that links the bodily responses of the audience to the embodied interactions taking place on stage facilitates the introduction of chance interference into the performance. The performers' attentive responsiveness to one another is tested and strengthened as they react to the unpredictable performance cues introduced by Schneemann's "systems of interference." Technology in *Snows* generates increased sensory awareness, but rather than extending disembodied vision, as television does, it engages the body as an instrument of perception.

Schneemann's incorporation of technology into *Snows* was facilitated by the efforts of the newly formed organization, Experiments in Art and Technology (E.A.T.), to bring engineering and art closer together. *Snows* was the first work officially to receive the group's support.[58] With the aid of E.A.T., Schneemann rigged up the theater with contact microphones and transmitters attached to the underside of randomly chosen seats. Restless shifting among members of the audience would be picked up by these sensors and fed into a switching system designed to trigger flashing colored lights, which then served as cues for action on stage.[59] Schneemann staged *Snows* during Angry Arts Week, an artist-led protest against the Vietnam War that took place in New York City in the winter of 1967. Promoted as a festival of dissent, it included more than forty performances, concerts, plays, films, and exhibitions by some five hundred artists.[60] Angry Arts Week followed shortly on the heels of the event that inaugurated the foundation of E.A.T.— *9 Evenings: Theatre and Engineering*, an ambitious, collective endeavor staged in New York in October 1966. *9 Evenings* provided artists and performers with an occasion to make use of new technology often associated with military applications (sonar, infrared cameras, Geiger counters, etc.). For example, *Open Score* by Robert Rauschenberg employed infrared cameras, a technology that was then still classified exclusively for military use, to create eerie images of a large crowd moving in the dark. By comparison, Angry Arts Week provided a decidedly more ambivalent setting for pursing the aesthetic appropriation of the tools of war.

Remarkably, the use of acoustic sensors in *Snows* anticipated the grim promise of the Hồ Chí Minh Trail wired up "like a drugstore pinball machine."[61] Plans to create an electronic barrier that detected the movement of the enemy were getting underway as Schneemann was in the process of developing *Snows*. In early 1966, faced with the failure of extensive bombing to stem the flow of weapons and supplies from the north, Secretary of Defense Robert McNamara began seeking a technological solution to the problem. In the spring of 1966, scientists from MIT and Harvard proposed a plan that involved

mining essential supply routes with thousands of electronic audio sensors camouflaged to resemble elements of the jungle's foliage. When activated, these devices would alert awaiting bombers to strike. By January 1967, as Schneemann was staging *Snows*, the project had been approved and given the highest national priority by the White House. The Air-Supported Anti-Infiltration Barrier became known as Operation Igloo White, a phrase that eerily recalls the title *Snows*.

The Pentagon's ambitious plan to monitor movement along vital supply routes with electronic sensors was not formally announced to the public until after *Snows* was performed.[62] Schneemann could not have known that the technology she employed in *Snows* would be adopted for this purpose. Nonetheless, the work's multiple references

to snow, "flakes," and winter weather suggest the blinding violence of bombs falling from the sky, as well as forms of surveillance subject to electronic noise. In this sense, *Snows* already anticipated the convergence of aerial bombing, electronic surveillance, and complex signaling systems that would inaugurate the era of technowar to come. Though the architects of Operation Igloo White imagined it might be possible to one day fully automate the battlefield, in practice the systems they built were often less than reliable.[63] Schneemann's ambivalence toward technology was born of this blind faith in its instrumentalization. *Snows*, she explained in an interview, responded to what she saw as "technocracy gone berserk," a situation where the demands of the military-industrial complex had more power to determine the course of

FIG. 8
Carolee Schneemann,
performance of *Snows*,
1967

the war than the democratic will of the people.[64] At the same time, Schneemann did not reject technology outright; instead she imagined how it might be used to foster the growth of what she called "creative inter-relations."

The title *Snows* also functions as a reference to the artist's own name (*schnee* means "snow" in German). Importantly, *Snows* places a filmed diary and taped audio drawn from the artist's own private daily life alongside publicly available newsreels, photographs, and music. In addition to the radio-like soundtrack of *Viet-Flakes*, *Snows* includes a recording from a tape deck Schneemann placed under the bed that she and Tenney shared, which included sounds of distant trains and the couple making love. *Snows* sought to extend the supportive intimacy of this erotic relationship into the relations it fostered between the performers on stage and, by extension, to the audience as well. In an interview

with Robert Coe from 1979, Schneemann described how her work developed "a praxis for seeing a political situation" by drawing upon possibilities generated through relationships rooted in "sensitivity, attentiveness, and trust."[65]

> *What would happen normally in that period is that [the audience] would absorb a sense of our sensitivity, attentiveness, and trust with one another and begin to build their own risks out of that, incorporating our work because they needed it and wanted it and because the other kind of blind, hostile, unrelational reaction wasn't possible anymore.*[66]

Elsewhere, Schneemann explained the role news media play in fostering the "unrelational" reactions she sought to counter in *Snows*. She observed: "We get all this information and there's absolutely no way to react.... You're reading some horror in your newspaper while eating your doughnut.... So, we're

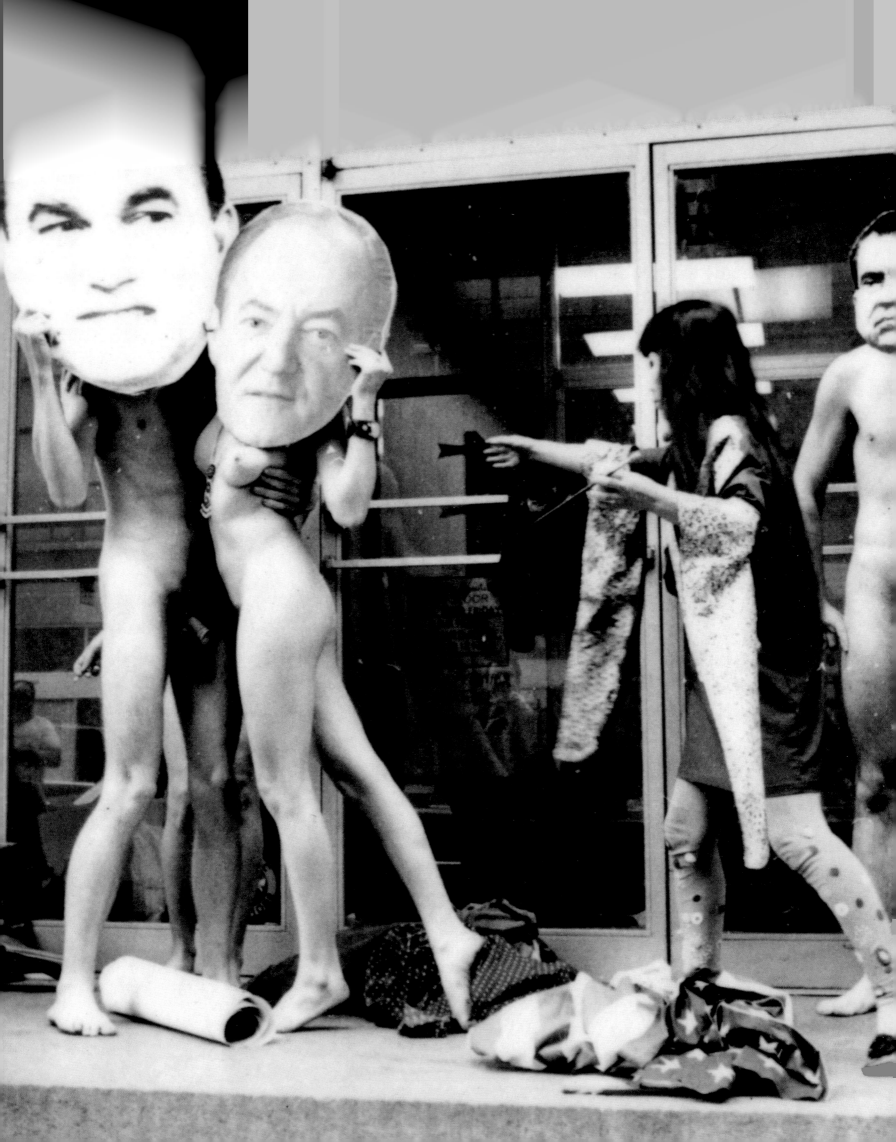

29 Michel Ciment and Bernard Cohn, "Entretien avec Emile de Antonio," *Positif* 113 (February 1970): 28.

30 Colin Westerbeck Jr., "Some Outtakes from Radical Film Making: Emile de Antonio," *Sight and Sound* (Summer 1970): 141.

31 Lewis, *Emile de Antonio: Radical Filmmaker*, 92.

32 Ladendorf, *Resistance to Vision: The Effects of Censorship*, 98.

33 Ibid., 105.

34 Ibid., 98–99.

35 Lewis, *Emile de Antonio: Radical Filmmaker*, 90.

36 Kellner and Streible, "Emile de Antonio: Documenting the Life of a Radical Filmmaker," in *Emile de Antonio, A Reader*, 99.

37 Lewis, *Emile de Antonio: Radical Filmmaker*, 95.

38 Ibid.

39 Gene Bishop, "Year of the Pig," *The Old Mole* 1, no. 9 (1969): 15.

40 Carolee Schneemann, *More than Meat Joy: Performance Works and Selected Writings*, ed. Bruce R. McPherson (New Paltz, NY: Documentext, 1979), 130.

41 Carolee Schneemann, "Snows," *Ikon* 1, no. 5 (March 1968): 28–29.

42 Schneemann, "Snows," 28. See also Gene Youngblood, *Expanded Cinema* (New York: Dutton, 1970), 368. In published notes and interviews, Schneemann often identifies the date of this newsreel as 1947. The sequence of events she describes date from 1949 and appears in the Castle Films News Parade of that year. Images from this newsreel are reprinted along with the score of *Snows* in Schneemann, *More than Meat Joy*, 139, 141, 144.

43 Schneemann, *More than Meat Joy*, 129.

44 Schneemann, *More than Meat Joy*, 146.

45 In 1961 Tenney arrived at Bell Labs to work as a composer in residence with a focus on what was then called psychoacoustics. While he was there he created a series of collaged compositions using tape recorders and began to write software that used computers to compose music, becoming one of the first experimental composers to do so. See Jean-Claude Risset, "About James Tenney, Composer, Performer, and Theorist," *Perspectives of New Music* 25, no. 1/2, (Winter–Summer, 1987). 549–61.

46 The photo of an American tank dragging the body of a Viet Cong soldier was taken by the Japanese photojournalist Kyōichi Sawada for the wire service United Press International. It won the World Press Photo of the Year award in 1966.

47 The photo of the hanging man, a Viet Cong suspect being interrogated by Nung Mercenaries working for U.S. Special Forces, was taken by Sean Flynn on assignment for *Paris Match* magazine and was reproduced widely enough that in May 1966 *Time* ran a story about its role in fueling growing antiwar sentiments. "Angle Shots," *Time Magazine*, May 6, 1966, 43.

48 Youngblood, *Expanded Cinema*, 369. Carolee Schneemann, "Image as Process," *Creative Camera*, no. 76 (October 1970): 304.

49 Schneemann, *More than Meat Joy*, 134.

50 Ibid., 148.

51 Ibid., 42.

52 Michael Bracewell, "Other Voices: Interview with Carolee Schneemann," *Frieze* 62 (October 2001), https://frieze.com/article/other-voices.

53 Schneemann, *More than Meat Joy*, 157.

54 Schneemann first explored this type of action in *Ghost Rev*, staged in November 1965 with Phoebe Neville in collaboration with USCO, which notably was also the first of her performances to incorporate film as a material element. Schneemann, *More than Meat Joy*, 97–101.

55 Ibid., 146.

56 Schneemann in conversation with Pamela M. Lee, New York, October 12, 2000, cited in Pamela M. Lee, *Chronophobia: On Time in the Art of the 1960s* (Cambridge, MA: MIT Press, 2004), 211–12.

57 Carolee Schneemann, "Notations (1958–66)," *Caterpillar* 8/9 (October 1969): 42.

58 Ralph Flynn, "*Snows* Technical Description," *E.A.T. News* 1, no. 2 (June 1, 1967): 17–18.

59 Schneemann, *More than Meat Joy*, 149.

60 Angry Arts Week ran from January 29 through February 5, 1967. *Snows* opened on January 21, before the program officially began, and ran a total of eight times (January 21–22, 27–29, February 3–5). Angry Arts Week involved artists, writers, poets, filmmakers, musicians, playwrights, dancers, actors, and stage technicians. The breadth of participation is documented in Rudolf Baranik's report, "The Angriest Voice" (May 1967). Rudolf Baranik Files, Folder 1, PAD/D Archives, Museum of Modern Art Library, New York.

61 Paul N. Edwards, *The Closed World: Computers and the Politics of Discourse in Cold War America* (Cambridge, MA: MIT Press, 1996), 4.

62 A few stories about the barrier made their way into the press in 1966, but the project was not officially made public until September 1967. For more on Operation Igloo White, see Edwards, *The Closed World*, 3–5. See also Paul Dickson, *The Electronic Battlefield* (Bloomington: Indiana University Press, 1976).

63 Edwards noted that this dream would never actually be achieved during the course of the operation's implementation in Vietnam. "Official claims for Igloo White's success were extraordinary. . . . But the official estimates, like so many other official versions of the Vietnam War, existed mainly in the never-never land of military public relations." The number of trucks the air force claimed to have destroyed in 1970, for example, exceeded the total number of trucks estimated to exist in North Vietnam at the time. Edwards, *The Closed World*, 4. See also Dickson, *The Electronic Battlefield*, 92–93.

64 Kate Haug, "An Interview with Carolee Schneemann," *Wide Angle* 20, no. 1 (1998): 41.

65 Robert Coe, "Carolee Schneemann: More than Meat Joy," *Performing Arts Magazine* no. 1 (1979): 9.

66 Ibid.

67 Youngblood, 370.

68 The movement was named after the title of an exhibition held in 1965 at the Galerie Creuze, *La Figuration Narrative dans l'art contemporain*. Sami Siegelbaum, "The Riddle of May '68: Collectivity and Protest in the Salon de la Jeune Peinture," *Oxford Art Journal* 35, no. 1 (2012): 62.

69 Gilles Lapointe, *Edmund Alleyn Biographie* (Montréal: Les Presses de l'Université de Montréal, 2017), 175.

70 Ibid., 189.

71 "Edmund Alleyn at MACM and Simon Blais," Art against Life blog, accessed December 23, 2017, https://artagainstlife.wordpress.com/2016/06/23/edmund-alleyn-at-macm-and-simon-blais/.

72 Lapointe, *Alleyn Biographie*, 202.

73 Ibid., 205.

74 Edmund Alleyn, *By Day, By Night, Writings on Art*, ed. Jennifer Alleyn and Gilles Lapointe (Montréal: Les éditions du passage, 2013), 17.

75 "Atelier Populaire OUI, Atelier Bourgeois NON," anonymous Atelier Populaire tract released May 21, 1968, reprinted in *L'Atelier Populaire présenté par lui-même* (Paris: Usine Universités Union, 1968), 8–10.

76 "Interview by Annabelle Ténèze," in *Then and Now, Carolee Schneemann, Oeuvres d' Histoire,* ed. Annabelle Ténèze (Dijon: Les presses du réel, 2013), 111–12.

77 Carolee Schneemann, Time and Space Concepts in Event Art panel, moderated by Lucy Lippard, transcription in *Time and Space Concepts in Art,* ed. Marilyn Belford and Jerry Herman (New York: Pleiades Gallery, 1980), 28.

1 By 1966 nearly 93 percent of households in the United States had at least one television. In 1967 Universal discontinued the last remaining newsreel service. Raymond Fielding, *The American Newsreel: A Complete History, 1911–1967*, 2nd ed. (Jefferson, NC: McFarland & Company, 2006), 309.

2 According to a study conducted by the Roper Organization for the Television Information Office, in 1964 Americans reported depending equally on television and newspapers for information. By 1972, the Roper surveys found that 64 percent of Americans named television as a primary source of news. Faced with conflicting or contradictory information, 48 percent of the respondents in 1972 said they would trust the television report over the newspaper story as compared to the 21 percent who reported trusting the newspaper more. Daniel C. Hallin, *The Uncensored War: The Media and Vietnam* (New York: Oxford University Press, 1986), 106.

3 General William C. Westmoreland, *A Soldier Reports* (New York: Doubleday, 1976), 555.

4 William M. Hammond, "The Press in Vietnam as an Agent of Defeat: A Critical Examination," *Reviews in American History* 17, no. 2 (June 1989): 315. Another study conducted by Lawrence W. Lichty found that from August 1965 to August 1970, only seventy-six of 2,300 television news reports (about 3 percent) showed anything approaching violent combat. Lawrence W. Lichty, "Comments on the Influence of Television on Public Opinion," in *Vietnam as History: Ten Years after the Paris Peace Accords*, ed. Peter Braestrup (Lanham, MD: University Press of America, 1984), 158. Scott Althaus argued that newsreel coverage of World War II and the Korean War was often more graphic in its depiction of combat than television coverage of the Vietnam War. Craig Chamberlain, "Did News Coverage Turn Americans against the Vietnam War?" *University of Illinois News Bureau*, September 5, 2017, https://news.illinois.edu/view/6367/551796.

5 The Kennedy administration did not impose military censorship on reporters, as previous administrations had done in earlier wars, in part to avoid calling attention to a story whose significance they hoped to diminish. The Johnson administration upheld this policy, even as it committed more military resources to the conflict in 1964 and 1965. Like the previous administration, it hoped that in relying on the press's voluntarily withholding of sensitive military information, it could avoid censorship and its attendant criticism. See Michael X. Delli Carpini, "Vietnam and the Press," in *The Legacy: The Vietnam War in the American Imagination*, ed. D. Michael Shafer (Boston: Beacon Press, 1990), 125–56.

6 Ronald Steinman, "The First Televised War," *New York Times*, April 7, 2017, https://www.nytimes.com/2017/04/07/opinion/the-first-televised-war.html.

7 Michael Mandelbaum suggested that footage of American troops "engaged in unspecified, but seemingly successful, military activity" may have helped foster "an unduly optimistic impression of the war and contributed to the public's disillusionment when events proved the optimism unwarranted." He observed, "It was not television alone, however, that was telling the American public that the war was being won." The Tét Offensive did not square with the narrative of progress being pushed by the Johnson administration. As he pointed out, "Tet did not make the war markedly less popular than it had been before; its effect was to reduce the level of support for Lyndon Johnson's conduct of it. During the fall of 1967, the Johnson administration had made a special effort to persuade the public that the war was going well, that it was being won, that the end was in sight. Tet demonstrated that there was a good deal of fight left in the enemy and suggested that the war was hardly close to a conclusion. The communist side was plainly determined and unlikely to give up easily or soon. Tet called into question the president's optimism, and public confidence in him dropped accordingly." Michael Mandelbaum, "Vietnam: The Television War," *Daedalus* 111, no. 4 (Fall 1982): 159–60.

8 Hallin summarized the primary themes or unstated assumptions that structured the coverage of the war on commercial network television as 1) War is a national endeavor; 2) War is an American tradition; 3) War is manly; 4) Winning is what counts; 5) War is rational. Hallin, *The Uncensored War*, 142–45.

9 Bernard Weiner, "Radical Scavenging: An Interview with Emile de Antonio," *Film Quarterly* 25, no. 1 (Autumn 1971): 7.

10 Emile de Antonio, "Movies and Me," in *Emile de Antonio, A Reader*, ed. Douglas Kellner and Dan Streible (Minneapolis: University of Minnesota Press, 2000), 100.

11 Waugh points out the difference between de Antonio's "cerebral" approach and the emotional, subjective quality of other contemporary antiwar films such as *Loin du Vietnam* (1967) and *The 17th Parallel* (1968). Thomas Waugh, *The Right to Play Oneself: Looking Back on Documentary Film* (Minneapolis: University of Minnesota Press, 2011), 115.

12 De Antonio, "Movies and Me," in *Emile de Antonio, A Reader*, 99. See also Alan Asnen, "De Antonio in Hell," in *Emile de Antonio, A Reader*, 206.

13 Jonas Mekas, "Movie Journal," in *Emile de Antonio, A Reader*, 221.

14 Emile de Antonio, "Why I Make Films," in *Emile de Antonio, A Reader*, 143.

15 On the formation of the radical film collective Newsreel, see Bill Nichols, *Newsreel: Film and Revolution* (master's thesis, University of California, Los Angeles, 1972). On de Antonio's conflict with members of Newsreel, see Randolph Lewis, *Emile de Antonio: Radical Filmmaker in Cold War America* (Madison: University of Wisconsin Press, 2000), 96–97.

16 Marilyn Buck, Norm Fruchter, Robert Kramer, and Karen Ross, "Newsreel," *Film Quarterly* 22, no. 2 (Winter 1968–69): 48.

17 Ibid., 45–46.

18 Bernard Eisenschitz and Jean Narboni, "Entretien avec Emile de Antonio," *Cahiers du Cinema* 214 (July/August 1969): 50.

19 Waugh, *The Right to Play Oneself*, 110.

20 Lil Picard, "Inter/view with Emile de Antonio," in *Emile de Antonio, A Reader*, 219.

21 Robert Ladendorf, "Resistance to Vision: The Effects of Censorship and Other Restraints on Emile de Antonio's Political Documentaries" (master's thesis, University of Wisconsin, 1977), 71. See also Lewis, *Emile de Antonio: Radical Filmmaker*, 84–86.

22 Howard Thompson, "The Screen: *In the Year of the Pig*, Documentary, Bows," *New York Times*, November 11, 1969.

23 Emile de Antonio, "The Point of View in *Point of Order*," in *Emile de Antonio, A Reader*, 150. This is not to say that de Antonio believed that the camera alone could furnish the truth. He was fiercely critical of what he described as the myth of "fake technological objectivity" promoted by filmmakers such as Frederick Wiseman. De Antonio insisted, "No camera can present the truth. A person presents the truth." Susan Linfield, "Irrepressible Emile de Antonio Speaks," in *Emile de Antonio, A Reader*, 116.

24 Terry de Antonio, "An In-depth Interview with Emile de Antonio," in *Emile de Antonio, A Reader*, 89.

25 Emile de Antonio, "A Very Brief Note on the Style of *Rush to Judgment*," *Rush to Judgment* Film Press Kit (New York: Impact Films, 1967), 49, quoted in Douglas Kellner and Dan Streible, "Emile de Antonio: Documenting the Life of a Radical Filmmaker," in *Emile de Antonio, A Reader*, 31.

26 "Film to Examine Kennedy Inquiry," *New York Times*, August 23, 1966.

27 Kellner and Streible, "Emile de Antonio: Documenting the Life of a Radical Filmmaker," in *Emile de Antonio, A Reader*, 31.

28 Terry de Antonio, "An In-depth Interview with Emile de Antonio," in *Emile de Antonio, A Reader*, 90–91.

she would be delivered back out into the street, a site of daily alienation but also potentially extraordinary collective uprising.

Alleyn's *Introscaphe* was designed to provoke an isolated viewer to action but left open how that action might take shape and unfold. Schneemann's *Snows*, by comparison, was concerned with what it feels like to move with and among others within an environment pervaded by images of war. While Alleyn invited viewers into the *Introscaphe* to experience a polysensory intensification of the televisual viewing experience at the site of reception, Schneemann brought them inside an indeterminate televisual space, simultaneously a scene of production and transmission, and stitched their bodily responses to the work into the process of its staging. Both artists contrasted the automated immediacy of technology's effects on the body to the much more uncertain and embodied work of fostering "creative inter-relations" in and through political struggle.

After the protest at the Pentagon in October 1967 and other antiwar demonstrations early the next year in which protesters found themselves caught up in violent clashes with police, Schneemann began to offer workshops on how to deal with the bodily hazards entailed in these confrontations, making use of exercises that grew directly out of her performance work. She explained, "I wanted to extend some of the principles of the kinetic theater work to see if we could develop techniques for resisting when police tried to push, beat, or grab us, for saving ourselves and for collaboration, helping each other evade police brutality."[76] During a roundtable discussion in 1979, she recalled that at the time, there hadn't been a "marked division" in her mind between street movement, organizing, and sensitivity awareness. These activities were, for her, all "of a piece."[77] Significantly, though *Viet-Flakes* was produced

independently of *Snows* and continues to be shown as an autonomous work of art, Schneemann's impulse was not to use the film as an organizing tool as de Antonio had used *In the Year of the Pig*, but instead to organize workshops around the embodied movement exercises the film inspired.

Despite their differences, Schneemann and de Antonio's efforts to reinvent film form in the service of critiquing the television war offer a number of lessons worth revisiting today. Pursuing starkly different approaches to filmmaking and political engagement, de Antonio and Schneemann nevertheless share a passionate commitment to cinema's capacity to transform consciousness. Though the emphasis falls on different dimensions of political awareness in their work, instead of valorizing one over the other, we have more to gain by asking how their discursive and embodied approaches to political art might be productively brought together in our own moment. With hindsight, we can see how de Antonio's insistence on historical analysis needs Schneemann's attention to the social and technological conditions of perception and mediation, and vice versa. One casts a backward glance, while the other asks how to move forward in the face of overwhelming political frustration. Both perspectives are vitally necessary for any artist engaged in political struggle today. Importantly, despite their differences, de Antonio and Schneemann were both wary of modes of engagement rooted in provocation and shock. Instead, they put faith in their audiences to stay with the difficult process of thinking, sensing, and feeling that their challenging work demands. Today, more than ever, when so many forces are aligned to foment distraction and despair, we need art that puts its faith in us to remain engaged and that helps us imagine how we might come together to radically transform an unjust world in the process.

Impressed by the group's efforts to integrate technology into the artistic process, he later recounted, "The use of technology to express a sociopolitical awareness was at that time central to my concerns. This evening with E.A.T. perhaps planted the germ of the *Introscaphe* in my mind."[70] While Rauschenberg and many of the other artists who participated in *9 Evenings* used technology to create new, strange, and spectacular images, Alleyn was drawn to the spectacle of technology itself.

The *Introscaphe* was first shown at the Musée d'Art Moderne de la Ville de Paris in 1970. Described by one critic as "a reverse sensory-deprivation tank," Alleyn conceived the apparatus as an "object-trap" made to seduce with "the fascination we all feel for this technical mythology."[71] The enclosed screening space of the *Introscaphe* closely resembles the cockpit of a fighter plane or space capsule. Alleyn explained that the ship-like form of the *Introscaphe* "promises space, cosmic journeys, all that a gadget can offer," but once inside the viewer encounters a film "about things that we might rather turn away from and not face."[72] The film Alleyn produced for the *Introscaphe*, entitled *Alias*, begins like a newscast that has been overtaken by the cast of a campy B movie. This lighthearted opening sequence is followed by a disconcerting montage of sexualized commodity images and news photos depicting the horrors of war—beheaded Viet Cong soldiers, planes dropping bombs, scarred flesh, and other atrocities. As the film builds toward its apocalyptic climax, German storm troopers face off against a sea of red flags and giant posters of Che Guevara and Mao Zedong.

The unnerving experience of viewing *Alias* inside the tightly enclosed space of the *Introscaphe* is further intensified by rattling vibrations and blasts of hot or cold air timed to correspond to moments of tension in the film. *Alias* exaggerates the discontinuity of unrelated news reports while highlighting common themes that emerge from what the artist described as "the daily menu of mass media: war, imperialism, advertising-sex, technological saturation, racism, revolution, etc."[73] In doing so, it mimics television's antipathy toward critical analysis. In Alleyn's words, "Television has, for a long time, used the thrills of technology to invalidate thought by suppressing the silences that allow the latter to begin to form."[74]

Like *Snows*, which Schneemann staged as part of Angry Arts Week, the *Introscaphe* was shaped by Alleyn's participation in political protest. He began work on his screening apparatus shortly after taking part in the events of May 1968. The experience informed his contradictory stance toward technology, which he invested with revolutionary possibility, but also treated as an inadequate substitute for the transformative, embodied experience of engaging in collective political action. During May 1968, he joined other artists, students, and workers in the anonymous production of posters at the Atelier Populaire in the lithograph studio of the École nationale supérieure des Beaux-Arts. The students and workers of the Atelier Populaire declared their desire "to inaugurate a new form of education which would transform the relations of artists among themselves, artists with art, and art with society."[75] Though the *Introscaphe* debuted at a museum exhibition, Alleyn had conceived it as a prototype for a new mode of popular exhibition that would take place in the street, inspired by the power of the Atelier Populaire's posters to lay claim to urban space. He hoped to return cinema to its roots in the nickelodeon, a distinctly working-class entertainment, while simultaneously evoking the promise of a space age yet to come, where military technology might be entirely repurposed for utopian endeavors. Alleyn imagined a viewer who would encounter the *Introscaphe* in passing, someone curious but without any preconceptions. Once inside, however, she would be made to confront the contradictions of contemporary society; thereafter

trapped with all these fears of real impotence." Under such conditions people crave what she called "tactile confirmation." They want to "be in touch with their physicality, to be able to communicate, and to grow, to touch one another and be touched."[67]

Snows creates a sensory arena where the experience of touching and being touched is called upon to challenge feelings of impotence and alienation induced by media overload. At the same time, by incorporating "systems of interference," the work also acknowledges the difficulty of overcoming these conditions of mediation. Schneemann's work allows for the possibility that images may fail to register and relationships fail to form over time and across space. Nonetheless, it puts its faith in the body as an instrument of sensory perception strengthened through the process of forging "creative inter-relations," rather than in the automation of technology.

The production of a complex space of collective, yet intimate reception in *Snows* warrants a brief comparison to another remarkable, but less well-known screening space designed by Edmund Alleyn, a Canadian artist living in Paris at the time

Schneemann was producing *Snows*. Though his work falls outside the purview of this exhibition, it provides a useful counterpoint to Schneemann's approach to embodiment and technology. Protest against the Vietnam War in France was informed by its own long history of colonial rule in Indochina and inflected through the fresh memory of the Algerian Revolution. This dissent, set against the backdrop of widespread social unrest, was made more urgent by growing concerns about France's rapidly Americanizing consumer and media culture. Alleyn's work was shaped by these conditions, which reflected the fraught and deeply intertwined relationship between France and the United States at that moment.

As a painter, Alleyn was associated with the narrative figuration movement, formed in response to American pop art's deadpan embrace of commodity culture.[68] In 1968, increasingly concerned that his work was not "touching the people [he] would have liked to touch," Alleyn began construction on a futuristic screening apparatus, which marked a radical, if temporary, break with painting. He called this device, which took the form of a glossy white ovoid-like space pod, the *Introscaphe*.[69] Like an arcade game or a photo booth, it included a coin slot on the exterior [FIG. 9]. With the insertion of some pocket change, it was designed to slide open and reveal a screening chamber for a single viewer [FIG. 10]. Once someone sat down inside, it would slide shut and automatically initiate a disconcerting polysensory screening experience involving sound, vision, changes in temperature, and kinetic movement.

Alleyn's interest in technology was inspired by the work of E.A.T. (though not aided directly by the group as Schneemann's had been). In 1967 Alleyn attended the Expo '67 in Montreal, where he was captivated by the immersive, expanded cinema installations on view. Not long after, he attended a meeting of E.A.T. in New York, where he met Rauschenberg and other artists associated with the organization.

Make love, not war—that's all we're sayin'. —John Lennon and Yoko Ono, *Bed-In*, May 1969

MIGNON NIXON

What were they sayin'? In March of 1969, Yoko Ono and John Lennon celebrated their recent marriage by inviting the world's press into their bedroom in Amsterdam's Hilton Hotel. Anticipating a titillating scene, a throng of reporters and photographers arrived to find the couple lying propped up in bed side by side, offering to talk with visitors about peace for a week [FIG. 1]. Forgoing a honeymoon, the newlyweds marked their union with a peace protest, in which they offered an egalitarian model of sexual relationship between citizens

What's Love Got to Do, Got to Do with It?

Feminist Politics and America's War in Vietnam

Yayoi Kusama, *Anatomic Explosion at the Board of Elections*, 1968. See p. 341

of former enemy nations, Japan and Britain, and different ethnicities, as a concrete demonstration of the individual change that, they suggested, could help bring about an end to war.[1]

Later that spring, after Lennon was denied permission to enter the United States and prevented from performing a second *Bed-In* in New York, the couple moved the event to Montreal, circumventing the Nixon administration's travel ban by giving broadcast interviews that reached over the border to American audiences.[2] In one, conducted during the People's Park protest in Berkeley, California, they warned demonstrators against provoking armed

police and the National Guard to wider violence.[3] "Make love, not war—that's all we're sayin'," Lennon implored the crowd.[4] The *Bed-In for Peace* in Vietnam was also a *Bed-In for Peace* in America. What we do in bed, the couple proposed, matters for what we do in war, at home and abroad.

By lying down and talking, Ono and Lennon put their bodies on the line in a new way. "I like to fight the establishment by using methods that are so far removed from establishment-type thinking that the establishment doesn't know how to fight back," Ono remarked.[5] The *Bed-In* was a media event beamed around the world, but it was also an event in Ono's

FIG. 1
John Lennon and Yoko Ono
receive the press at their
bedside in the Presidential
Suite of the Hilton Hotel,
Amsterdam, 1969

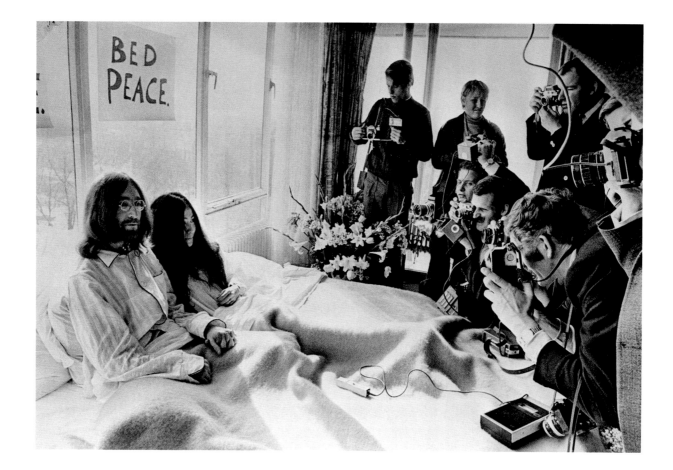

specific sense of the term. "Event," the artist once explained, "is not a get togetherness," but "a dealing with oneself.…It has no script as Happenings do, though it has something that starts it moving—the closest word for it may be 'wish' or 'hope.'"[6] To stay in bed in response to war was to "deal with one-self" and one's own violence as an essential part of the work of responding to war. Stretched out beside Ono, Lennon aligned himself with his partner, a Japanese avant-garde artist, war survivor, and femi-nist. Defining his political role in alliance with a co-equal woman, he adopted a posture that was rare in the antiwar movement, which was still dominated by the same macho mentality that prevailed in the cul-ture at large. "Bed peace," proclaimed a handmade sign hung above the bed in Amsterdam. This later became the title for the piece. To perform a *Bed-In*

for Peace was to demonstrate in bed, for peace, but also to demonstrate for peace in bed, for bed peace.

In 1969, the antiwar movement was in gender crisis. "The war presented a paradox," the feminist historian Alice Echols observed.[7] While opposition to the war brought women and men together in a common political project that sought to level gender, class, and racial hierarchies, "building in the present the desired community of the future," the widening of the war in Southeast Asia and the intensification of violence against protesters at home by police and the National Guard created a climate in which "almost anything short of 'picking up the gun' seemed impo-tent," Echols recalled.[8] Divided between militant and nonviolent philosophies, the movement was also split along gender lines. Marginalized as "helpmates or worse," she observed, female activists increasingly

refused to accept male supremacy.[9] Their resistance to masculine authority, and to the implied claim that the antiwar movement was itself an extension of the traditionally masculine domain of war, exposed deep trends of misogyny in antiwar culture.

In one notorious incident, at the counterinaugural protest staged by the National Mobilization Committee to End the War in Vietnam (Mobe) in January 1969, two feminist speakers, Marilyn Webb and Shulamith Firestone, were heckled by men in the audience who jeered at Webb to "take it off" and demanded that she be removed from the stage and sexually assaulted.[10] The excesses of war as a culture of sexualized violence had come home to the antiwar movement in spectacular fashion. Meanwhile, Ono and Lennon were quietly preparing their *Bed-In*. "We worked for three months thinking out the most functional approach to boosting peace before we got married," Ono recalled, a timeline that places the genesis of the piece at about the time of

Richard Nixon's inauguration and the Mobe protest.[11] Counteracting the attempts by some men to intimidate their female peers with threats of sexual violence, or by attempting to force them, even bodily, off the public stage, Lennon and Ono shared a bed, a stage, a feminist politics, and a peace message. *Bed Peace* was a real-time performance of the proposition that, in Echols's words, "the restructuring of personal life and renunciation of male privilege" was integral to the process of ending this war and preventing future ones.[12] The event expressed, in Ono's terms, a wish or hope that changing the way we behave in bed might help bring an end to war. "We're saying to the young people—and they have always been the hippest ones—we're telling them to get the message across to the squares," Lennon summed up.[13]

We are sisters together; we will help each other; we wish neither Vietnamese nor American loss It was instant love. —Cora Weiss

On November 1, 1961, picketers in sixty cities across the United States walked off their jobs and "out of their kitchens" to demand an end to nuclear testing, calling their action a women's strike for peace.[14] At the height of the Cold War, Women Strike for Peace (WSP) protested nuclear escalation in the name of mothers. In contrast to antiwar strikes of the Vietnam era soon to come—including *Bed Peace*, with its invitation to "stay in bed" for peace—WSP protests displayed a conspicuous conformity to gender and social convention. Demonstrating at the United Nations (UN) in the midst of the Cuban missile crisis, hatted and gloved WSP protesters carried handlettered placards urging President Kennedy to "be careful," and "let the UN handle" it [FIG. 2].[15] Called to testify before the notorious House Un-American Activities Committee (HUAC) in 1962 to answer charges that WSP was a communist front, Dagmar Wilson, the artist who had initiated the 1961

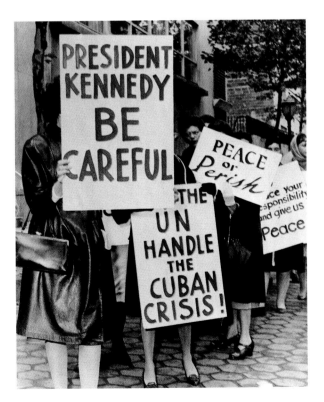

FIG. 2
Members of Women Strike for Peace protest near the United Nations building in New York, October 1962. Photo by Phil Stanziola

strikes, gently mocked the absurdity of the charges, addressing the chairman as "my dear sir" and eliciting applause and laughter from a hearing room packed with women, some with small children in tow [FIG. 3].[16] This "motherist" peace rhetoric, couching calls for multilateral nuclear disarmament under international control in an exaggerated feminine politesse, was fashioned for the McCarthy era, a time of rigid conservatism and rampant anticommunism.[17] As intended, WSP's polite tactics disarmed the political establishment, attracting widespread, appreciative press attention and galvanizing public support for nuclear disarmament. In 1963, President John F. Kennedy signed the test ban treaty, with a nod to WSP's appeals to think of the children.[18]

Before Ono and Lennon, WSP had created a new form of individualistic, "structureless," "unorganizational," antiwar politics.[19] Staging "photogenic political 'events'" that, like *Bed Peace*, appealed to the press as novelties, WSP was able to circumvent the filters that excluded pacifist voices from mainstream reporting.[20] In the process, this movement "helped to legitimize a radical critique of the Cold War and U.S.

militarism," WSP historian Amy Swerdlow observed.[21] In its first two years of existence, a movement widely dismissed as naive had not only helped bring about a nuclear test ban treaty but also brought down HUAC, which never recovered from the damage to its fearsome image inflicted by the WSP witnesses' admonishments. The work of raising "motherist consciousness" about American militarism, however, had only begun.[22]

Histories of the antiwar movement typically relegate women to a supporting and belated role in opposing the war, reproducing the masculine supremacy of the antiwar movement itself, a mindset *Bed Peace* actively challenged at the time. In reality, women played a pivotal role from the start. Women Strike for Peace was among the first peace groups to call out the incursion into Vietnam as a dangerous extension of Cold War nuclear politics. In June 1963, at its second national conference, WSP pledged to "alert the public to the dangers and horrors of the war in Vietnam and to the specific ways in which human morality is being violated by the U.S. attack on... women and children."[23] Arguing that the anticommunist hysteria that had led the United States to the brink of nuclear war was also driving its aggressive policy toward Vietnam, WSP pivoted from its successful push for a nuclear test ban treaty to intensive opposition to American military involvement in Indochina. With its unorganizational grassroots ethos and its principle that each individual must assume responsibility for war in her or his own way, WSP also pioneered models of resistance that were soon adopted by the broader antiwar movement. As it had from the outset, the group advocated for the rights of the young. The war in Vietnam, WSP contended, was an extension of the same Cold War nuclear mentality it had sought to expose since the first demonstration in 1961, when protesters demanded "Pure Milk, Not Poison," in response to fears of nuclear fallout. Now, it was American forces,

"our sons," who poisoned children and threatened future generations with extinction. Protesting the war as a threat to the humanity of those sons, WSPers, as they called themselves, exploited their protected social position as a self-described, middleclass "housewife brigade" to form networks for draft counseling, advising conscripts and their parents on tactics for avoiding the draft.[24] Insistently connecting the moral threat to American youths with the suffering of children in Vietnam, they also drew public attention to the effects of carpet bombs, cluster bombs, napalm, and defoliants on civilians, raising consciousness about the war's calculated maiming and killing of noncombatants. "Don't force our sons to kill women and children whose only crime is to live in a country ripped by civil war," WSP exhorted President Johnson in a 1966 advertisement in the *New York Times*, announcing a "Mother's March on Capitol Hill to Stop the Killing."[25]

The internationalist perspective of the WSP sisterhood and its focus on women brought a distinctive person-to-person culture of female solidarity to the broader antiwar movement. As early as 1965, WSP activists visited Hà Nội, observing firsthand the effects of American bombing on the city. "We travelled half way around the world to enemy country, and to me it felt like coming home to family and friends," remarked one woman of the experience of meeting the leaders of the North Vietnamese Women's Union in Hà Nội.[26] Visiting Laos and Vietnam, recalled mother-of-four Amy Swerdlow, "took me out of the suburbs…without feeling guilty about leaving my children."[27] Women leaders of the Vietnamese revolution also visited North America. In 1969—the same year that Ono and Lennon, banned from traveling to the United States to perform the second *Bed-In*, opted instead to hold it in Canada—Women Strike for Peace joined with other women's peace groups, including Canada's Voice of Women and the Washington, D.C.–based Women's Anti-Imperialism Collective, to invite

Vietnamese revolutionaries, barred by their enemy status from visiting the United States, to attend a peace conference in Canada. There, American women could meet them by crossing the border, as other Americans did to evade the draft. In the end, there were two events, a conference in Toronto and a meeting in Vancouver, attended by a thousand American women. Writing in the WSP journal *MEMO*, one participant heard a "simple message" in Toronto: "We are sisters together; we will help each other; we wish neither Vietnamese nor American loss.…it was instant love."[28] By other accounts, the meetings exposed tensions in the peace and women's liberation movements, "coming out of factionalism, racism, liberalism, and other movement maladies," as a contributor to the women's liberation journal *off our backs* reported.[29] But with the encouragement of the Vietnamese to work "collectively with love for each other," women of different generations and histories began to examine the conditions of their own oppression, and that of their sisters at home and in Vietnam, as the core of what needed to be analyzed and transformed to bring an end to war.[30]

My antiwar work was done through my feminist group. While we were fighting for women, and I use these terms loosely, the word "fighting,"…we had to lend our efforts to trying to stop killing people.
—Martha Rosler

In October 1970, a photomontage showing a young girl with an amputated leg balancing on her one foot at the edge of a sea of carpet in a suburban living room appeared anonymously on the back page of the biweekly San Diego feminist newspaper *Goodbye to All That!* [FIG. 4]. Dwarfing the scene behind her, she stands like a frail and stricken Alice, fallen down the rabbit hole from a killing field into a "living-room war," the phrase television critic Michael Arlen used

to convey the surreal effects of a distant war brought home to the public through magazines and television.[31] *Goodbye to All That!* published a heady mix of local reporting, firstperson stories recounting individual experiences of sexism, opinion pieces, and political theory. It also covered the war in Vietnam extensively, devoting its entire October issue to the Indochinese Conference in Vancouver. "A lot of my objections to the antiwar movement were directly confronted by the Indochinese women in Vancouver," one participant remarked, echoing another's observation that many women had abandoned the antiwar movement out of frustration with "the way women were excluded from decision making" in the male-dominated power structure.[32] While WSP had exploited a loophole in the antifeminist orthodoxy of the Cold War, revealing a "latent political power" in maternal morality, by 1969 it had also exposed the limitations of motherist politics, including self-sacrificing acceptance of women's subordinate position.[33] The

women's liberation movement maintained that the political and sexual emancipation of women was inseparable from, even a prerequisite for, the work of ending the war. The Vietnamese revolutionary leaders who visited Canada in 1969 embraced both groups, welcoming "new friends" in the women's liberation movement alongside "old friends" from WSP,[34] and allowing Ellin, another correspondent for *Goodbye to All That!*, to feel, after Vancouver, "that we were sisters, that we had bonds as women that made it possible for us to speak intimately."[35]

Tron (Amputee) was the work of the young artist Martha Rosler, who began producing feminist antiwar agitprop around 1967, prompted in part by a photograph she came across while reading a newspaper at her mother's kitchen table. The picture showed an everyday scene in occupied Vietnam: women and children fleeing a village under aerial attack from U.S. forces.[36] In contrast to the idealization of domestic life in Cold War America, exemplified in mass-media

FIG. 4
Martha Rosler, *Tron (Amputee)* in *Goodbye to All That*, October 13, 1970, photomontage reproduced in newspaper, Collection of the artist

FIG. 5
Nguyễn Thị Tròn, portrait by Larry Burrows, on the cover of *Life Magazine*, November 8, 1968

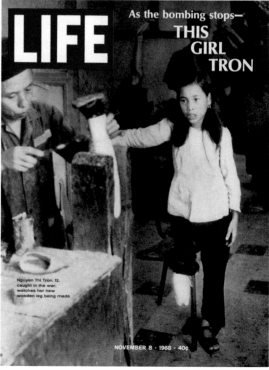

images of the nuclear family home, photographic reportage revealed that the war in Vietnam was being waged against women, children, and families through the systematic destruction of villages, a point WSP pressed in its outreach to the "ordinary woman." Rosler shared WSP's aim of awakening a wider public to the realities of the war. In an extensive body of agitprop collages later grouped under the title *House Beautiful: Bringing the War Home* (ca. 1967–72), she articulated the complexities of trying to "speak intimately" in relation to this war. By combining apparently disparate photographic types—documentary war reportage and advertising imagery taken from the illustrated news magazine *Life* and interior design spreads from decorator magazines, including *House Beautiful*—Rosler exposed their latent continuities.

The story of Nguyễn Thị Tròn, a twelve-year-old girl who was picking wild vegetables on the outskirts of a refugee camp when her leg was blown off by gunfire from an American helicopter operating in a "free fire zone," was the subject of a photo essay by the acclaimed documentary war photographer Larry Burrows that appeared in *Life*'s November 8, 1968, issue [FIG. 5]. In the issue's cover image, headlined "This Girl Tron," the child watches as a simple prosthetic leg is fashioned for her use. As framed in *Life*'s heavily captioned format, Burrows's photographs of a maimed child make Tron's experience "grievable" for American audiences, but also consumable in the form of an illustrated news story about distant events.[37] Rosler's counterstrategy is to de-domesticate the war image, concentrating on the alienating effects of a living-room war. Shifting the figure to the edge of the frame, she estranges it from its place in the genre of popular war reportage, stranding the injured girl in a political and psychic space of haunting. No crutch or prop to shore up fantasies of the war as a reality elsewhere, the war image functions in *House Beautiful: Bringing the War Home* as a perverse extension of everyday American life.

In 1963, Betty Friedan, a writer for women's magazines, published *The Feminine Mystique*, a withering critique of a postwar consumer culture that, as she put it, "narrowed woman's world down to the home."[38] The avatar of this domestic world was the "happy housewife," whose "really crucial function," Friedan drily remarked, was "to buy more things for the house."[39] Drawing on the very type of design and lifestyle magazines that Friedan had identified as constructing the home as a mythic realm in order to content women with buying things for it, Rosler extended Friedan's warning about the conning of housewives into complicity with their own social disempowerment to include Cold War militarism.[40]

"Many of these photomontages," Rosler observed of *House Beautiful: Bringing the War Home*, "used the advertising and architectural imagery of an earlier era: the 1950s," a retro effect that makes a historical point about the roots of the war in Cold War culture.[41] Trapped in a suburban time warp, the inmates of *House Beautiful: Bringing the War Home* have the brittle, vacant mien of Friedan's happy housewives, their lives "domesticated and privatized" by a postwar gender ideology that narrowed women's lives down to the home [p. 98].[42]

The continuities between mass-cultural consumption and women's oppression were not a new theme for Rosler. Since 1966, she had been making "feminist montages" by conjugating two gendered genres, women's fashion magazines and men's sex magazines.[43] This series, *Body Beautiful, or Beauty Knows No Pain* (ca. 1966–72) parodies the commodification of the female body in a postwar culture of consumption, in which, as Friedan noted, the happy housewife, the invention of mass-circulation magazines, represented a new type: "young and frivolous, almost childlike; fluffy and feminine; passive; gaily content in a world of bedroom and kitchen, sex, babies, and home" [FIG. 6].[44] With *House Beautiful: Bringing the War Home*, Rosler put

FIG. 6
Martha Rosler, *Bowl of
Fruit* from the series *Body
Beautiful, or Beauty Knows
No Pain*, ca. 1966–72,
photomontage, Courtesy
of the artist and Mitchell-
Innes & Nash, New York

FIG. 7
Martha Rosler, *Vacation
Getaway* from the series
*House Beautiful: Bringing
the War Home*, ca. 1967–72,
photomontage, Courtesy
of the artist and Mitchell-
Innes & Nash, New York

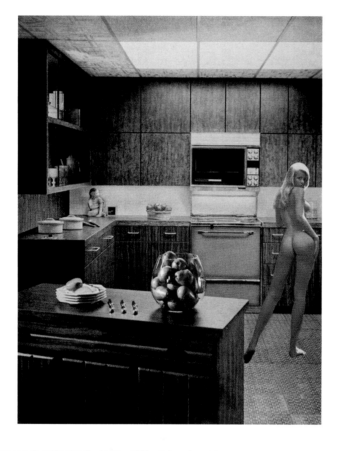

In a secluded vacation spot, privacy isn't a problem, so you go all out with glass, for view, light, and visual spaciousness. Simple or no-pattern coverings, soft colors, and small-scale furnishings add to illusion of size. Blue of the ceiling and brown of the beams extend through the glass walls to the eaves from living room to the outdoors

this suburban world on a war footing, asking how women infantilized by a postwar culture of masculine supremacy, early marriage, and compulsory consumerism—women who, as Friedan put it, "only read magazines"—would be enlisted by the mass media in a "living-room war," and how an alternative visual culture engaged with feminist politics might help them to resist.[45]

Countering the common view that television and photographic reportage shocked the public, galvanizing opposition to the war, Rosler dwells on the Cold War consensus that stymied dissent and fostered a dreamy acquiescence to a "twilight war."[46] In *House Beautiful: Bringing the War Home*, suburban life goes on in an uncanny way while war looms at the edge of the patio and corpses stack up on the lawn. Like the dream images of Dada and surrealism that provoked Rosler to use a montage technique, these scenes fracture the semblance of normality promulgated in newspapers, television, and advertising, as well as in political speech.[47] Figments, roaming the abandoned ruins of a suburban dreamworld, find no one home. The empty rooms echo, like stage sets. A "vacation getaway" with a panoramic view [FIG. 7] or a color-splashed kitchen purport an everyday reality untouched by war, a transparent fiction dispelled by the intrusion of dirty secrets into pristine, patently fake, domestic scenes. Grunts on patrol, the grieving, and the afflicted wander the precincts of an ersatz world, whose few inhabitants—a family of three playing with a toy airplane on a magic carpet mattress [p. 97], or a woman perpetually vacuuming the drapes—seem frozen in time, locked in a perpetual present. This culture of oblivion, Rosler suggests, exists to preserve Cold War domestic myth, but its paradoxical effect is to hollow out the home.

Throughout the Cold War period, "one of the most important myths of the militarists," Swerdlow observed, "was that wars are waged by men to protect women and children."[48] Rosler's photomontages

deconstruct this myth, suggesting that the living room, refuge of the Cold War nuclear family, and the war zone, where American men were sent to drive Vietnamese women and children from their homes, were only apparently worlds apart.[49] American women, she suggested, could buy into this mythology and be complicit in its violence, or resist. "My antiwar work was done through my feminist group," Rosler recalled. "While we were fighting for women, and I use these terms loosely, the word 'fighting,'…we had to lend our efforts to trying to stop killing people."[50] In *House Beautiful: Bringing the War Home*, "fighting for women" and "trying to stop killing people" are bound together by an imperative to connect, and speak intimately about, apparently disparate realities.

My anger really flowed…thinking as a mother.
—Nancy Spero

In her antiwar photomontages, Rosler deconstructs the mythos of the Cold War family and its rigid gender roles, casting the home as the social and psychic nucleus of America's war in Vietnam. In *Bed Peace*, Ono and Lennon performed gender equality and sexual peace as counterfantasies to the mythic masculinity that lends its charisma to war. Just as the drive to dominate is both intimate and political, and leads to war at home and abroad, peace, too, begins at home and depends upon beginning to live and desire otherwise, the couple proposed. In contrast to the language American officials used to promote the war in Vietnam to the public as a calculated application of technoviolence, these and other feminist artistic interventions underscored the war's irrationality. Rosler's adaptation of Dada and surrealist montage techniques invited comparison with artistic responses to the Great War and the rise of fascism, while also claiming that the subjugation of women in postwar America was the irrational kernel of Cold War fantasies of omnipotence that

had given rise to this war. Ono and Lennon, survivors of total war in Europe and Japan, bore witness to the past effects of patriarchal mythologies of nation, imploring the young to eschew nationalist identifications and assume responsibility for war as individuals. Both bodies of work offered models of resistance to patriarchal authority, contending, in effect, that hegemonic masculinity was out of control. In her *War Series* (1966–69), Nancy Spero made this crisis of masculinity the cardinal theme.

The *War Series*, Spero recalled, began with the bomb, a headless figure drunk on war [FIG. 8].[51] Summoning ancient tropes of madness and mayhem, Male Bombs erupt in ecstatic displays of sexual sadism. Female Bombs seethe with blood. Armies of tongues hurl flaming missiles to the ground. Echoing Sigmund Freud's observation in "Thoughts for the Times on War and Death" (1915), written during the First World War, that belligerent nations "still obey their passions far more readily than their interests," Spero represents American military policy in Vietnam as the projection of phallic power in the throes of mindless destruction.[52] The interests of aggressive nations, Freud claimed, "serve them, at most, as rationalizations for their passions; they put forward their interests in order to be able to give reasons for satisfying their passions."[53] Casting the war's policies as those of irrational, hysterical excess—rather than, as the military doctrine of the time would have it, a statistically precise logic of escalation—Spero portrayed the war in Vietnam as a catastrophic "de-repression."

"War is a de-repression," the feminist psychoanalyst Juliet Mitchell has remarked, in that it lifts the social prohibition on killing. War has its own rules, the rules of so-called legitimate violence, but in all wars, Mitchell contends, the de-repression of murderous impulses ensures that war "crimes" will occur. At the sadistic extremes, the atrocities of war bear the marks of violence-perversion, she argues, asserting that the

polymorphous perversity of our early, uninhibited sexuality finds a corollary in our destructive fantasies toward others. "Are we not as children 'polymorphously perverse' in our wish to kill?" she asks. In war, the polymorphously perverse trends of our early sexual and destructive fantasies converge, she suggests.[54] Spero's *War Series* exemplifies this claim.

Concealed in the cool and detached managerial rhetoric of the so-called McNamara Doctrine, the historian Marilyn Young has observed, was a wild idea, that of "air persuasion."[55] To justify aerial warfare against noncombatants, she explains, the militarists spoke of a "special language addressed to the enemy," communication by bomb.[56] In the *War Series*, this *doxa* of war as a rational administration of violence comes up against a graphic phantasmagoria of human bombs: atomic Sperm Bombs, ejaculating Male Bombs, multibreasted Female Bombs [p. 49], baby bombs expelled from shit-smeared backsides [FIG. 9]. Fusing bodies with weapons of mass killing, these bombs dramatize the mania of war, its blindness to self-interest, but also its "profound entanglement

with myth," to borrow a phrase the art historian Benjamin H. D. Buchloh has used to describe not war but Spero's relationship to history and painting.[57] As a figurative artist, drawing on myriad representational traditions at a time when the dominant modes of art repressed the figural and historical in the abstract, Spero's syncretic iconography was, Buchloh pointed out, intensely political. In the *War Series*, this mnemonic politics becomes explicit. Breaking permanently with painting, which she now abandoned as an "elegiac" medium, to work exclusively on paper, Spero underscored the urgency and immediacy of her response to the war.[58] Her mythic iconography, however, also summoned the persistence of war, a seemingly ceaseless cycle of repetition with a shared cultural root. War, Spero suggests, is not the special province of military experts, but the cultural legacy of us all—women and mothers included—who know its passions intimately, and who may lend them to the belligerent state or draw upon them in resistance to it.

"My anger really flowed with the *War Series*... thinking as a mother," Spero once recalled. "Everything burst out."[59] Returning to the United States from Paris in 1964 to settle in New York with her partner Leon Golub and their three young sons, the artist confronted the escalating American involvement in Vietnam by "working rapidly on paper," producing "angry works, often scatological, manifestoes against a senseless obscene war, a war my sons (too young then) could have been called up for. Those works were exorcisms to keep the war away."[60] The imagery Spero devised for this exorcism hardly complies with conventional expectations of what a mother's outrage might produce. What Spero does, "thinking as a mother," is to incarnate the phantasmatic dimension of war, to invoke the infantile, sadistic, often sexualized mania that pervades even the most calculated forms of aggression.

FIG. 8
Nancy Spero, *The Male Bomb*, 1966, gouache and ink on paper, Courtesy Galerie Lelong & Co.

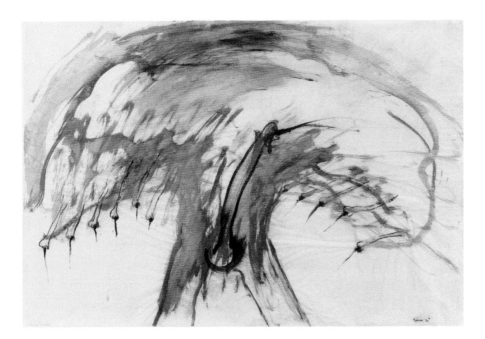

In place of a head to reason, a dark cloud, bristling with faces in profile, screaming madly, tongues thrust out like the poisoned tips of projectiles, crowns *The Bomb* (1966) [FIG. 10]. Smeared on and rubbed in, the brown medium suggests a fecal cloud, the noxious discharge of a dirty war. Twin phalli shoot out from the crotch, gape-mouthed Gorgon heads spewing the same red venom as their maenad sisters in the cloud above. Echoing the scatological, obscene vocabulary of the war's brutalized, fantastical masculinity, which found its literary apotheosis in Michael Herr's *Dispatches* (1977), Spero's Male Bombs project anxieties of helplessness.[61] For the omnipotent phallic body of a Male Bomb is also a castrated and decapitated one. Fantasies of overkill project corresponding anxieties of emasculation and vulnerability.[62] "Thinking as a mother," Spero protests the destruction of male bodies as vociferously as she protests the violence those bodies are exhorted to commit, including sexual violence.

Sexual violence was "an everyday feature of the American war," historian Nick Turse has written.[63] "The reports of sexual assault implicated units up and down the country," he observes, while "gang rapes were a horrifyingly common occurrence."[64] Rape, in the words of one soldier, was "virtually standard operating procedure" in his unit. Sexualized torture and rape-murder were also widespread.[65] At Sơn Mỹ (My Lai), Turse notes, "a number of soldiers became 'double veterans,' as the GIs referred to men who raped and then murdered women."[66] The crimes of Sơn Mỹ, he contends, were no aberration.[67] The testimonies of witnesses and perpetrators that slowly came to light in the later stages of the war and long after its end are corroborated by the contemporary reports of Vietnamese women. Speaking to WSP representatives at the Paris Conference for Women to End the War in Vietnam in April 1968, their Vietnamese counterparts recounted the sexualized torture of women under interrogation and bore

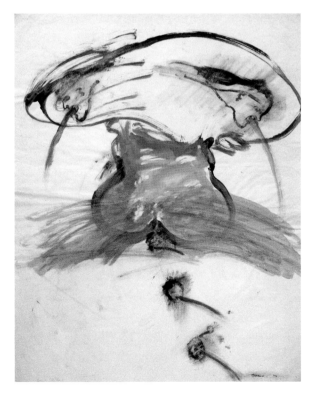

FIG. 9
Nancy Spero, *Bomb Shitting*, 1966, gouache and ink on paper, Courtesy Galerie Lelong & Co.

FIG. 10
Nancy Spero, *The Bomb*, 1968, gouache and ink on paper, Collection National Gallery of Canada, Gift of the artist, New York, 1994

FIG. 11
Nancy Spero, *F.U.C.K.*,
1966, gouache and ink on
paper, Courtesy Galerie
Lelong & Co.

Opposite:

FIG. 12
Nancy Spero, *Christ,
Victims and Gunship*,
1966, gouache and ink on
paper, Courtesy Galerie
Lelong & Co.

FIG. 13
Nancy Spero, *Sperm Bomb*,
1966, gouache and ink on
paper, Courtesy Galerie
Lelong & Co.

witness to the killing of mothers by "American troops thrusting bayonets into the bellies of pregnant women." For the listeners, it was "almost unbearable" to hear of the atrocities committed by American troops against women and girls, but these revelations also deepened the WSP's sense of solidarity with, and responsibility to, Vietnamese women, whom they deemed "subject to the greater burden in the war because of their sex."[68]

Even today, the pervasiveness and brutality of sexual violence in "the atrocity-producing situation" of this war, as the psychiatrist Robert Jay Lifton termed it, remains a blind spot, a neglected, even repressed dimension of the war's history.[69] The *War Series* is exceptional in rendering sexual violence visible, not as an aberration of the war, but as a hallmark. To do this, Spero does not treat rape as a separate theme, which might seem to portray it as an anomaly, but incorporates violent sexual imagery throughout the series. Naked figures—ejaculating murderously, dangling from the mouths of planes, as in *F.U.C.K.* [FIG. 11], or impaled on the blades of helicopters—point to an "automatic" association of

sexuality and war violence.[70] "How do we account for the rampant sexuality of war, the seemingly inevitable rapes and gang rapes that accompany killing," for the fact that "sexual violence seems to 'automatically' accompany war violence?" asks Juliet Mitchell.[71] Anticipating this question by decades in the *War Series*, Spero delves into the fantasy structure of "limited," technocratic war, and more specifically aerial war, a mode of destructiveness as comprehensively sexualized as any in the history of war. If Vietnam was an "atrocity-producing situation," as Lifton claimed, sexualized violence was an endemic, even manic, feature of that situation. In the *War Series*, Spero calls for a cultural reckoning with the war's pervasive sexual atrocity, one that would recognize the sexual drives as part of the sadistic logic of the "most lopsided air war ever fought," but also as a psychic and cultural heritage we might use to make sense of that violence.[72]

Alongside the obscenity of the war and the perversities of its sadistic violence, the *War Series* also, and disarmingly, gives expression to sensuality, desire, and pleasure. Infiltrating the scene of technowar, erotic vignettes—a couple engaging in cunnilingus amid the chaos of a helicopter attack [FIG. 12], for example—attest to a polymorphous perversity of violence in war sexuality, but also to the persistence of Eros, in its twin senses of life and love, even at the height of war, and to the potential for sensuality and desire to be incorporated in war resistance. The *War Series* portrays war sexuality, very much including feminine war sexuality (multi-breasted Female Bombs, maenads, and Gorgons litter the pages), as a cultural and psychic palimpsest. Our drive for war, Spero observes, is ancient and is bound up with our sexuality in puzzling ways, a fragmentary legacy these drawings instigate us to unravel. In war, sexual fantasy reaches hyperbolic extremes, but in a nuclear, MAD world[73]—which Spero evokes most explicitly in the

FIG. 16
Carolee Schneemann,
poster for *Snows*, Courtesy
the artist, P·P·O·W, and
Galerie Lelong & Co.,
New York

Snows incorporated five films, splashed onto the walls by two projectors suspended from the ceiling and swinging in arcs across the theater. The last of these was *Viet-Flakes*. At the end of the performance, flickering images of its fragmented sequences bled onto the white floors and walls of the theater, onto the stage, and onto the moving bodies of the performers.

November 11, 1968
AN OPEN LETTER TO MY HERO, RICHARD M. NIXON:

> *Our earth is like one little polka dot, among millions*
> *of other celestial bodies, one orb full of hatred and*
> *strife amid the peaceful, silent spheres. Let's you and I*
> *change all that and make this world a Garden of Eden.*
> * Let's forget ourselves, dearest Richard, and become*
> *one with the Absolute, all together in the altogether.*
> *As we soar through the heavens, we'll paint each other*
> *with polka dots, lose our egos in timeless eternity, and*
> *finally discover the naked truth: You can't eradicate*
> *violence by using more violence. This truth is written in*
> *the spheres with which I will lovingly, soothingly adorn*
> *your hard masculine body. Gently! Gently!*
> * Dear Richard, calm your manly fighting spirit!*
> * —Yayoi Kusama*[87]

In November 1968, days after Richard Nixon was elected to the presidency, Yayoi Kusama, in one of the more improbable acts of opposition to the American war in Vietnam, published an open love letter to the straitlaced president-elect and, with the help of four naked protesters, distributed it to passersby in lower Manhattan. Mingling the contemporary patois of cosmic love with the doomsday scenario of atomic war, Kusama cajoled the president-elect with a fantasy of self-obliteration in which we forget ourselves in love rather than destroy ourselves in war. Her action was the subject of a news story in the *New York Times*, picked up by dozens of newspapers across the United States. "Four persons stripped off

another, their movements evoking, without mimicking, the contorted postures imposed on bodies as they appeared in Schneemann's atrocity collection: bodies shackled, noosed, or hanging upside down, bodies burning, dragged, drowning.[85] "The performance imagery is finally ambiguous," she remarked, "shifting metaphors in which performers are aggressor and victim, torturer and tortured, lover and beloved."[86]

Schneemann thematizes the viewing process itself, asking what it is like to incorporate war into psychic reality through images.

Spreading photographs from her atrocity collection out in an arc on the studio floor, she panned over them, zooming in and out with makeshift lenses. "I used a close-up lens and magnifying glasses to 'travel' within the photographs," she recalled.[81] With its abrupt cuts and distortions, *Viet-Flakes* makes a pressing problem of distance and perspective. Rapid cutting, close-ups, extreme cropping, and overexposure create fragmented, often illegible sequences, which relentlessly repeat. Then there's the sound. "James Tenney made the soundcollage for *Viet-Flakes*," Schneemann recalled, "by breaking music sources we selected into sound fragments so small that they became recognizable only cumulatively, in time."[82] "What the world needs now, is love sweet love," the lyric goes, but not in this version. Splintering recordings into fragments by slicing audiotape into snippets and splicing them together as a collage, Tenney produced a sound track that combines the effects of a needle skipping on a vinyl record and a radio knob being repeatedly spun across the spectrum from the classical station to Top 40. Interspersed among a Mozart piano concerto, Bach cantatas, the Beatles, and Jackie DeShannon are the keening strains of Vietnamese

folk songs, distilled into fleeting, spellbinding calls. Short, staccato notes, broken into slivers and arranged in a disjointed, dissonant pattern intensify the abrupt rhythms of the film montage as image and sound collide in incongruous, jarring juxtapositions, evoking a war inside.

Viet-Flakes is a haunting film, a film that uses the technique of animation to awaken the dead—as a tactic for awakening the living. In distinction from documentary war reportage, which also aims to arouse conscience, here the liveliness of the dead overshadows the living. In *Viet-Flakes*, the living, including President Lyndon Johnson, whose image flashes up repeatedly in the film, emerging from the hospital after a gallbladder operation, clasping thumb and forefinger to sign that LBJ is OK—nursing a scar but back on the job—are the psychic dead, while the dead, "people burning, dragged, drowning," assume the guise of life, of Eros.

In the winter of 1967, New York artists in their hundreds, led by Artists and Writers Protest against the War in Vietnam, came together, as they put it to the press, "to proclaim unanimously our revulsion for this war" and to protest it "through work in our fields."[83] Schneemann's contribution to Angry Arts Week was *Snows*, a multimedia "kinetic theater" piece she presented at the Martinique Theater at the invitation of Paul Libin [FIG. 16]. "We talked about a country without a connection to conscience, an art world/a culture vapid, intensely self-absorbed, devorative, frenetic, corrupt, mechanical in its emotions and insane with cold lusts," Schneemann recalled.[84] Audience members entered the Martinique Theater through the backstage door. In the dark, they squeezed through two huge pink foam rubber "mouths" and crawled over and under two long planks to their seats. As the performance unfolded, six performers, three women and three men, circled and grasped one another, wrapped one another's bodies in tin foil and painted one another's faces, grappled with and stroked one

FIG. 15
Carolee Schneemann, *Fuses* (still), 1964–66, 29:51 min., color, silent, 16 mm film on video, Smithsonian American Art Museum, Museum purchase made possible by the Ford Motor Company

Vietnamese poet at the University of Illinois alerted her to the then-secret U.S. military involvement in Vietnam.[76] Assembled from foreign and underground publications, circumventing the censorship and self-censorship of the mainstream American press, this graphic imagery took on, in *Viet-Flakes*, the hypna-gogic rhythms of dream. In a few intense minutes, it tracks the process by which war images intercept and overlap the everyday and the personal, bypassing our filters and defenses to become stuck in our heads. Akin to the fragmented sequences of *Fuses*, the rapid cutting of *Viet-Flakes*, compounded by Tenney's nerve-jangling sound collage, also showed how, like the erotic ecstasies documented in *Fuses*, war is ulti-mately "unseeable," even with the help of explicit images, not because it is too remote, but because it is a part of us from the start.[77] War, as Gertrude Stein once observed, and as *Viet-Flakes* attests, is always already "inside in me."[78]

Schneemann conceived *Fuses* [FIG. 15] as a response to the fetishizing of the female body and the negation of women's desire, in film and more broadly across visual culture, including pornogra-phy. Countering a reductive logic of objectification and subjugation, by which women identify with the image of the female body as an object of masculine desire and so are enlisted in their own erotic and political oppression, *Fuses* portrayed a reciprocal

dynamic of desire.[79] Passing a wind-up camera between them, or positioning it in the room as wit-ness, Schneemann and Tenney together created the footage that would become the material of a handmade collage film, the fragmented, saturated palimpsest of a shared domestic and sexual life in which the woman's pleasure is fully as expan-sive and intense as that of her male partner, and in which eroticism itself is decentered, fluid, and spread out. In contrast with pornography's focal-ized, monotonous repetition, which insistently recruits the viewer into a mastering relationship to the object of the gaze, in *Fuses* desire comes in waves. Layers of paint, built up and scratched out, transform the film stock itself into a dense historical text, laden with accumulated gestures of recollec-tion and reworking. Claiming the erotic as an open-ended, receptive state, deeply marked by history and fantasy, *Fuses* portrays the personal of sexual-ity as political in its potential to transform a stale dynamic of domination, mastery, and repetition into one of reciprocity and possibility.

Fuses bears upon the politics of war by suggest-ing that we are capable of desiring differently, that it is possible to intervene in the process by which we internalize sexual and gender roles, roles that also play out in war's fantasies of domination and con-trol.[80] With *Viet-Flakes* [p. 64], Schneemann turned to her archive of atrocity to reflect upon a country so "mechanical in its emotions" that even the most graphic war images often failed to "strike empathy" in its citizens. Like Rosler, she mined war reportage as an archive of indifference, testimony to a "vapid" and "self-absorbed" culture "armored" against every evidence of its own destructiveness. To alter this men-tality, *Viet-Flakes*, like *House Beautiful: Bringing the War Home*, suggested that an escalation of the "image war" might be self-defeating, might risk reinforcing the same manic defenses against empathy and grief that the war itself aroused. Instead, in *Viet-Flakes*,

mushroom clouds of the drawings entitled *Sperm Bomb* [FIG. 13]—our technological prowess gives us the power to enact our wildest fantasies. Just as dangerous, she suggests, the denial of the passions that is the crux of technowar has become a passion in itself, embodied in a bureaucratic litany of body counts and kill ratios, fatal for others but also for ourselves. Our mania for killing, Spero suggests, is bound up with our sexual drives, and the "obscenity" of the war in Vietnam was to act out our fantasies and deny them at once.

We talked about a country without a connection to conscience, an art world/a culture vapid, intensely self-absorbed, devorative, frenetic, corrupt, mechanical in its emotions and insane with cold lusts to be gotten at, to feel and so armored nothing could strike empathy, root, viscera in its snobbish plastic body. —Carolee Schneemann

Carolee Schneemann saw a country in the grip of "cold lusts." Like Spero, she was moved by a technocratic militarist culture, a culture she described as "mechanical in its emotions," to make the war's erotic excesses and repressions the focus of her resistance. The erotic was already intimately and inextricably bound up with the political in Schneemann's work. She was in the midst of editing *Fuses,* an experimental collage film using self-shot footage to depict the erotic and domestic rhythms of a "loving life" and "lived sense of equity"[74] in her relationship with the composer James Tenney when, prompted by nightmares and hallucinations of smoldering villages and "Vietnamese bodies hanging in the trees," she turned her attention to another film, *Viet-Flakes* [FIG. 14 and p. 64].[75] This seven-minute montage, with a sound track by Tenney, was a "rough animation" of photographs drawn from Schneemann's "atrocity image collection," a personal archive she began assembling in the early 1960s, when a chance encounter with a

their clothes on Reade Street near Lower Broadway yesterday and handed out copies of an 'open letter' to President-elect Richard M. Nixon that said that 'anatomic explosions are better than atomic explosions," the *Times* recorded. "The naked protesters, three men and a woman, stood on the sidewalk for fifteen minutes and were daubed with body paints by a woman who identified herself as Yayoi Kusama.... As a crowd of 150 people watched, Miss Kusama urged peace in Vietnam."[88]

The protest was the culmination of several nude events Kusama conducted around town with a changing cast of accomplices during the 1968 presidential campaign—at Federal Hall on Wall Street, the Statue of Liberty, the United Nations, and, on the eve of voting in November, at the New York City Board of Elections on Varick Street, where her performers appeared wearing only oversized paper cut-out masks of the candidates—Hubert Humphrey, George Wallace, and Richard Nixon [FIG. 17]. Key to Kusama's strategy was exposure. "My name was in the tabloids day after day," the artist recalled, "magazines carried stories about me, and the public was fascinated by my activities and movements."[89] There is ample evidence to support the claim. On Monday, July 15, a UPI headline announced, "All's Quiet on Stock Market, but Wall Street 'Bares' Busy" [FIG. 18], over a story reporting a

FIG. 17
Yayoi Kusama, *Anatomic Explosion at the Board of Elections*, November 3, 1968, photographer unknown, Courtesy Yayoi Kusama Inc.

staged protest in which Kusama directed four professional dancers, accompanied by a conga drummer, to strip and frolic with *Rite of Spring*-like abandon on the sidewalk in front of the Stock Exchange and on the plinth of the George Washington statue opposite, while the artist, clothed in a flowing frock and discreetly accompanied by her lawyer, spray-painted polka dots on their bodies. In the next day's newspapers, reports of a protest performance, *Anatomic Explosion on Wall Street* [pp. 119–20], often ran above the fold, opposite the Associated Press account of the new U.S. Defense Secretary Clark Clifford's first visit to Vietnam.[90] "Clifford Gets Briefings during Visit" was the main story of the day, reflecting the confused state of the war in the aftermath of the Tết Offensive, former Secretary of Defense Robert McNamara's fall from grace, and Lyndon Johnson's dramatic announcement that he would not seek reelection.

Kusama's nude performances dramatized the vulnerability that peace protest exacts. Scorned by the art press for enacting libidinal rather than militant gestures of resistance, she turned ridicule into opportunity, energetically exploiting every occasion for publicity that a playful politics could generate for her antiwar message. Kookie Kusama, they called her. "Let the pants fall where they may," the artist retorted, demanding that the presidential candidates give the public the "bare facts."[91]

The *Anatomic Explosions* used ludic tactics to dramatize the absurdity of war, the mendacity of the war makers, and the ridiculous lengths to which peaceful war protest must go to attract the attention of the press. This playful approach to war protest, coupled with punning allusions to America's atomic history, belies the fact that Kusama herself was a war survivor. Born in Japan in 1929, she had witnessed the ravages of economic depression, totalitarian militarism, and all-out war before the United States dropped atomic bombs on Hiroshima and Nagasaki. "I could barely feel my life," she recalled of the arrival

of U.S. bombers flying over the Japanese mainland in 1944.[92] Yet, she insisted, "staying in Japan was out of the question....My art needed a more unlimited freedom, and a wider world."[93] With a cache of small drawings packed in a suitcase, she arrived in Seattle in 1957, determined "that my paintings be criticized in New York."[94] A year later, her debut New York show of five *Infinity Nets*, vast white paintings overspread by scintillating, reticulated patterns, produced in marathon sessions of intense concentration, attracted perceptive early reviews from Dore Ashton and her future friend Donald Judd. "I make them and make them and keep on making them, until I bury myself in the process. I call this 'obliteration,'" she explained, describing the obsessional logic of her production and introducing the signature expression she would soon adopt in her protest performances.[95]

Self-obliteration was Kusama's strategy for psychic and artistic survival in the shadow of war and death. Evoking the legacy of atomic war—which she, like WSP, saw as lying at the root of the war in Vietnam—she articulated a connection between aesthetic, subjective, and political techniques of resistance to Cold War militarism. Kusama, however, refrained from openly bearing witness to her own war history. She protested the war as a youthful bohemian and body-painting exponent of sexual revolution, not a war survivor.[96] Rather than subject her audience to the testimony of a war victim, and risk arousing the resistance and mistrust still associated with the war experiences of the Japanese, she exposed herself and her dancers to ridicule, to being written off as "Kookie Kusama" by the art press, which had once given serious critical attention to her work. Shedding her critical reputation to join the counterculture, she also gained a new audience in the national press, which provided extensive coverage of her pacifist actions.

Kusama's countercultural rhetoric was in marked contrast to the dignified, occasionally prim, style of the WSP, but the disarming tactics she employed were in the spirit of that movement. Her idiosyncratic performances freely acknowledged the cultural attitude that assuming individual responsibility for war is a fool's errand, while implicitly asking where folly truly lies in the postatomic age. Without any explicit reference to the atomic bombing of Hiroshima and Nagasaki, her public appeal for peace to a newly elected U.S. president invoked the threat of self-annihilation as an argument for restraint in Vietnam. Women Strike for Peace had warned President Kennedy to "be careful" and "let the UN handle it." Kusama cajoled a new American president in more intimate terms. "Let's forget ourselves, dearest Richard, and become one with the Absolute, all together in the altogether," she implored.[97] The implication of Kusama's mystical appeal to "my hero, Richard Nixon" was that war masculinity had itself succumbed to a hallucinatory unreality. "My dear sir," the politely mocking form Dagmar

Wilson adopted to address the chair of HUAC in 1961, showed the WSP's flair for political theater, revealing the extent to which women were obliged to play up their submissive femininity for the privilege of even the most circumscribed public speech. Kusama's overture, "Let's forget ourselves, dearest Richard," suggested that Cold War politics had descended into gender farce, that the hyperbolic masculinism responsible for a genocidal war in Vietnam was inextricably bound up with the anxieties and repressions of nuclear-mentality culture.[98]

I wanted them to be as ugly and horrifying as the war was. —Judith Bernstein[99]

A rubber-masked effigy of LBJ planted on the studio floor is supplied with a smoke, reprising the grisly practice of stuffing the mouth of a trophy head with a cigarette [FIG. 19]. The desecration of corpses— "dressing them up, clowning around with them, or mutilating them"—was a ritual commonly practiced by soldiers in Vietnam, who also routinely took photographs of these tableaux to fill scrapbooks.[100] Those albums, recalled Michael Herr in the memoir of his time as a combat correspondent, "all seemed to contain the same pictures...the severed head shot...or a lot of heads, arranged in a row, with a burning cigarette in each of the mouths, the eyes open."[101] Mimicking the macabre rites celebrated by soldiers "in-country" in Vietnam, Kusama conducted politically themed Happenings and performances in her studio, among them her darkly comic presidential orgies.[102] The degraded masculinity cultivated in the "atrocity-producing situation" of Vietnam was not restricted to the arena of war, Kusama suggested, or to those who participated directly in the "criminal orgy" the war had become.[103] In these burlesques of war camp, a promiscuous intermingling of obscenity and violence points to a more extensive cultural de-repression.

FIG. 19
Yayoi Kusama, *Johnson Orgy* at Kusama's studio, 1968, photographer unknown, Courtesy Yayoi Kusama Inc.

In the collage drawings and paintings she produced in response to the war, Judith Bernstein remembers, she was "inspired by the graffiti I found in the bathrooms at Yale."[104] Bernstein entered the Yale School of Art as a graduate student in painting in 1964, just as Lyndon Johnson, the newly elected "peace candidate," began ramping up the draft to meet the demand for troops to escalate the war. In the male bathrooms at Yale, Bernstein found ample evidence of her fellow students' opposition to the draft. "I'd rather save my ass than Johnson's face," read one message, which she quotes in her 1967 collage *L. B. J.* [FIG. 20], a flag-formatted, bulletin board–like palimpsest of newspaper clippings, paper scraps, and graffiti-like scribbling, dominated by a newspaper photograph of Johnson, his face wreathed in steel wool, pasted on a star-spangled field in the right-hand corner of the sheet. Like Kusama's LBJ orgy, this scabrous tribute tars the war president with the same caustic brush as any other rogue soldier, before adding, in scrawled red letters: "No, he's worse."

Bernstein's antiwar work is scathing in its indictment of the war establishment as the model of a debased masculinity that is not aberrant, but, as the leitmotif of screwed- and fucked-up flags attests, emblematic. In *L. B. J.*, a dirty flag, flipped, is reduced to a ground, the bulletin board–like surface onto which war news, scribbled notes, and pictures are stuck, including the photograph of Johnson, his face—the one so many asses were being put on the line to save—encircled with a garland of steel wool that, in Bernstein's material lexicon, is the ultimate scatological insult, a sign for male pubic hair. In the foreground of *Vietnam Garden* [p. 54], a stout flagdraped caricature of a triumphal war column stands sentinel over the derelict graveyard of heroic war masculinity as five phallic tombstones, planted on their scruffy scrota, flags-on-sticks flying from their swollen tips, announce a myth's ignominious demise.

What's love got to do, got to do with it?
—Tina Turner

By the time Tina Turner sang the question, in 1984, the sexual revolution had flamed out, John Lennon had been murdered, Yayoi Kusama had returned to Japan, and Ronald Reagan, governor of California during the People's Park Protest, was president of the United States. "Make love, not war" was no longer what they were sayin'.

In our time of perpetual war, resurgent militarism, and hyperbolic, "toxic" masculinity, the significance of sexual and gender roles in shaping America's war in Vietnam remains a historical blind spot, a neglect of the obvious that may help to account for our cultural failure to "wipe out the depression of Vietnam," as the psychoanalyst and antinuclear activist Hanna Segal encapsulated the unfinished struggle to end the war on a psychic as well as a political level.[105] Suggesting that subsequent American wars might be part of this effort, Segal argued that the repetition of war could be considered a social form of denial, in which fantasies

FIG. 20
Judith Bernstein, *L. B. J.*, 1967, newspaper, fabric, found paper, charcoal, oil stick, steel wool, and tape on paper, Whitney Museum of American Art, New York; purchase, with funds from the Drawing Committee, 2010.86

of domination and control distract from feelings of guilt and loss.[106] The possibility that a lingering sense of failure and humiliation in the wake of Vietnam has perpetuated and expanded the crisis of masculinity that precipitated the war itself still animates the work of artists who first responded to the war from a feminist perspective and that of generations who have followed. Some of this work addresses recent American wars, understanding them, as Segal does, as a continuation of Vietnam. In response to the wars in Afghanistan and Iraq, Martha Rosler produced a second series of *House Beautiful: Bringing the War Home* featuring new avatars of hyperbolic masculinity, including the virile female soldier and the badass female interrogator [see p. 353].[107] Masculinist militarism, as she demonstrated in the original series, relies on the complicity of women, who, as she now showed,

can also take up masculine roles without this altering them. Nancy Spero used drawings from the *War Series* to generate the imagery for *Maypole: Take No Prisoners*, her installation for the American pavilion at the 2007 Venice Biennale, signaling that the wars associated with 9/11 were part of a protracted cycle of destruction with its roots in the horrors of Vietnam. Carolee Schneemann has produced an extensive and manifold body of work in response to a catalogue of U.S. military involvements abroad and at home, while Yayoi Kusama's refrain that "anatomic explosions are better than atomic explosions" and Judith Bernstein's "fuck war" protest, which also takes on "culture's war against women's equality," resonate anew.[108] Meanwhile, Ono and Lennon's *WAR IS OVER! IF YOU WANT IT* campaign, begun in 1970, is ongoing. The question remains: Do we want it?

1 For a discussion of Lennon's disavowal of heroic masculinity and engagement with feminist politics in collaboration with Ono, see Kristine Stiles, "Unbosoming Lennon: The Politics of Yoko Ono's Experience," Art Criticism 7, no. 2 (1992): 21–52.

2 "We tried to do it in New York," Lennon later explained, "but the American government wouldn't let us in. They knew we'd done it in Amsterdam; they didn't want any peaceniks here, which is what we heard the Department of whoever controls that said." Andy Peebles, The Lennon Tapes: John Lennon and Yoko Ono in Conversation with Andy Peebles (London: BBC Books, 1981), 22–23.

3 On May 15, 1969, then-governor of California Ronald Reagan ordered two thousand armed members of the National Guard to quash demonstrations that erupted after James Rector, a twenty-five-year-old man, was shot in the back and killed by police during a protest at People's Park, a community park in Berkeley. Ono and Lennon pleaded over the radio with protesters as passions

flamed and rocks flew in response to the shooting, beating, and gassing of demonstrators.

4 Yoko Ono and John Lennon, Bed Peace (1969), accessed August 13, 2018, http://imaginepeace.com/#videos. See quotation at 30:24.

5 Ono, "Letter to the Editor," Syracuse Post-Standard, October 9, 1971.

6 Ono, "To the Wesleyan," in Grapefruit: A Book of Instructions and Drawings (New York: Simon and Shuster, 1970), n.p.

7 Alice Echols, "'Women Power' and Women's Liberation: Exploring the Relationship between the Antiwar Movement and the Women's Liberation Movement," in Give Peace a Chance: Exploring the Vietnam Antiwar Movement, ed. Melvin Small and William D. Hoover (Syracuse, NY: Syracuse University Press, 1992), 181.

8 Ibid., 173, 180–81.

9 Ibid., 173.

10 Ibid., 179–80. Echols added that when Webb returned home after the protest, "she received a phone call from a prominent SDS leader in D.C.

who warned her that if she or anyone else 'ever gives a speech like that again, we're going to beat the shit out of you wherever you are.'"

11 Ritchie Yorke, "John and Yoko in Canada: Boosting Peace," Rolling Stone, June 28, 1969, https://www.rollingstone.com/music/music-news/john-and-yoko-in-canada-boosting-peace-46611/.

12 Echols, "Women Power," 180.

13 Yorke, "John and Yoko in Canada: Boosting Peace," Rolling Stone.

14 Amy Swerdlow, Women Strike for Peace: Traditional Motherhood and Radical Politics in the 1960s (Chicago: University of Chicago Press, 1993), 15.

15 Ibid., 89–90.

16 Ibid., 117. In her triptych Mimus (2012), the artist Mary Kelly revisits the history of WSP and its HUAC testimony, summoning their resonance for current war discourse. See Mignon Nixon, "Mary Kelly's Mimus: Feminism's Waves," in Mary Kelly October File (Cambridge, MA: MIT Press, 2017).

17 Swerdlow, Women Strike for Peace, 141.

18 Ibid., 95–96.

19 Ibid., 19, 3.

20 Ibid., 21.

21 Ibid., 3.

22 Ibid., 141.

23 Ibid., 129.

24 On the WSP's antidraft work, including draft counseling, see Swerdlow, "Not Our Sons, Not Your Sons, Not Their Sons: Hell No, We Won't Let Them Go," in Women Strike for Peace, 159–86. WSP activists were "convinced that antidraft activity, particularly draft counseling, would be an ideal vehicle for attracting the much sought-after 'ordinary woman,' whose concern for the welfare of her son might open her ears and her heart to the deeper moral and political arguments against the war," Swerdlow observed (p. 160).

25 Ibid., 133.

26 Ibid., 217.

27 Ibid., 8.

28 Cora Weiss, quoted in Ibid., 227.

29 Quoted in Ibid., 229.

30 Ibid.

31 Michael Arlen, "Television's War," in *Living-Room War* (Syracuse, NY: Syracuse University Press, 1997), 83.

32 Unidentified, "End the War," *Goodbye to All That!*, Indochinese Conference Issue, April 20–May 4, 1970, 6.

33 Jean Bethke Elsthain and Sheila Tobias, eds., *Women, Militarism and War: Essays in History, Politics and Social Theory* (Totowa, NJ: Rowman and Littlefield, 1990), cited in Swerdlow, *Women Strike for Peace*, 234.

34 Swerdlow, *Women Strike for Peace*, 228.

35 Ellin, "Meeting Vietnamese Women," *Goodbye to All That!*, 4.

36 The photograph Rosler recalls may have been Kyōichi Sawada's iconic 1965 photograph of two women and three children fleeing their village near Quy Nhơn, which also features in Carolee Schneemann's *Viet-Flakes* (p. 351). The photocollage later entitled *Tron (Amputee)* was not Rosler's only contribution to the issue. She also furnished "nonphotographic elements" to that issue and others. Email correspondence with Martha Rosler, August 13, 2018.

37 Judith Butler, *Frames of War: When Is Life Grievable?* (London: Verso, 2016). In Butler's now-classic argument about the media's portrayal of state violence, she cites photographic reportage of the war in Vietnam as enabling Americans to perceive the suffering and death of the Vietnamese as grievable and not the inevitable "collateral damage" of war.

38 Betty Friedan, *The Feminine Mystique* [1963] (New York: Dell Publishing, 1974), 58–59.

39 Ibid., 197.

40 Ibid., 58.

41 Rosler, "Here and Elsewhere," *Artforum* 46, no. 3 (2007): 50.

42 Swerdlow, *Women Strike for Peace*, 13.

43 Martha Rosler, video interview with Lynn Hershman Leeson, May 12, 2006, New York, in Lynn Hershman Leeson, "!Women Art Revolution: Voices of a Movement," https://exhibits.stanford.edu/women-art-revolution/catalog/nr432md8338.

44 Friedan, *The Feminine Mystique*, 30.

45 Ibid., 45. Friedan cited research showing that in the 1950s, as middle-class women started marrying at an earlier age than their mothers, they stopped reading books and "only read magazines."

46 Stressing "the enormous strength of the Cold War consensus in the early 1960s," which was "shared by journalists and policy-makers alike," media historian Daniel C. Hallin concluded that journalists tended to behave "as 'responsible' members of the political establishment, upholding the dominant political perspective." See Daniel C. Hallin, *The "Uncensored War": The Media and Vietnam* (Oakland: University of California Press, 1989), 9. For at least the first two years, the press helped sell the war to the public: "television reports were…simply recitations of official press conferences" (p. 164). Later, as doubt and dissent increased, some mainstream journalists adopted a more critical stance. But contrary to conventional wisdom about uncensored reports bringing the war home to American living rooms through the television set, Hallin observed, coverage was never "so consistently negative" as proponents of the war claimed (p. 10). On the twilight war, see George C. Herring, *LBJ and Vietnam: A Different Kind of War* (Austin: University of Texas Press, 1994).

47 See Benjamin H. D. Buchloh, "A Conversation with Martha Rosler," in *Martha Rosler: Positions in the Life World*, ed. Catherine de Zegher (Cambridge, MA: MIT Press, 1998), 25: "My initial influences…included Max Ernst's surrealist collage novellas and other surrealist works, and even the quirky San Francisco artist Jess. But collage was obviously the medium of the twentieth century."

48 Swerdlow, *Women Strike for Peace*, 242.

49 Ibid., 159–86.

50 Martha Rosler, interview with Lynn Hershman Leeson.

51 Spero, quoted in Amei Wallach, *"Hysterical Men, Castrated Women*: Nancy Spero's Exquisite Corpse," in *Nancy Spero: Selected Works from Codex Artaud, 1971–72* (Dartmouth: University Art Gallery, University of Massachusetts, Dartmouth, 2001), 9.

52 Sigmund Freud, "Thoughts for the Times on War and Death" (1915), vol. 14, *The Standard Edition of the Complete Psychological Works of Sigmund Freud*, ed. and trans. James Strachey (London: Hogarth Press, 1957/2001), 288.

53 Ibid.

54 The term polymorphous perversity to describe early sexuality is from Sigmund Freud, "Three Essays on the Theory of Sexuality" (1905), in *The Standard Edition*, vol. 7. Juliet Mitchell, *Siblings: Sex and Violence* (Cambridge, UK: Polity Press, 2003), 36.

55 Marilyn B. Young, "Bombing Civilians from the Twentieth to the Twenty-First Centuries," in *Bombing Civilians: A Twentieth-Century History*, ed. Yuki Tanaka and Marilyn B. Young (New York: New Press, 2009), 155.

56 Ibid., 163.

57 Benjamin H. D. Buchloh, "Spero's Other Traditions," in *Inside the Visible: An Elliptical Traverse of 20th-Century Art in, of, and from the Feminine*, ed. M. Catherine de Zegher (Cambridge, MA: MIT Press, 1996), 242.

58 Spero referred to the "elegiac mode" of her earlier *Black Paintings* in Wallach, "Hysterical Men, Castrated Women," 29.

59 Spero, unpublished statement, no date. See "Spero's Curses," *October*, no. 122 (Fall 2007): 13, https://doi.org/10.1162/octo.2007.122.1.3.

60 Spero, "Creation and Pro-Creation," in "Forum: On Motherhood, Art and Apple Pie," *M/E/A/N/I/N/G* 12 (1992): 118–19.

61 Michael Herr, *Dispatches* [1977] (London: Picador, 2004).

62 Nick Turse, *Kill Anything that Moves: The Real American War in Vietnam* (New York: Henry Holt, 2013). See ch. 3, "Overkill," pp. 76–107. "American war managers were all but certain that no Third World people, even with Soviet and Chinese support, could stand up to the mightiest nation on Earth as it unleashed firepower well beyond levels that had brought great powers like Germany and Japan to their knees….Overkill was supposed to solve all American problems, and the answer to any setbacks was just more overkill" (p. 79).

63 Turse, *Kill Anything that Moves*, 165. The extent of sexual assault in Vietnam began to emerge with the testimony of returning veterans in the Winter Soldier Investigation. See Richard Stacewicz, *Winter Soldiers: An Oral History of the Vietnam Veterans against the War* (Chicago: Haymarket Books, 2008). See also Daniel Lang, *Casualties of War* (New York: Pocket Books, 1989).

64 Turse, *Kill Anything That Moves*, 167, 168.

65 Ibid., 167.

66 Ibid., 170.

67 Ibid., 170, and "Introduction: An Operation, Not an Aberration," 1–23. Turse draws on military archives logging reports of rape, sexualized torture, and rape-murder, in particular, War Crimes Allegations, Case Summaries, Record Group 319, Records of the Army Staff, Office of the Deputy Chief of Staff for Personnel (ODSPER), Records of the Vietnam War Crimes Working Group, War Crimes Allegations, Case Studies, box 1.

68 Swerdlow, *Women Strike for Peace*, 221. Among the forms of torture reported by the Vietnamese women was to "put poisonous snakes in the trousers of girls and tie the ends to force them to give information on where the Vietcong were hiding. The snakes wriggled into the internal organs of the girls."

69 Robert Jay Lifton, *Home from the War: Vietnam Veterans: Neither Victims nor Executioners* (New York: Simon & Schuster, 1973).

70 Juliet Mitchell, *Mad Men and Medusas: Reclaiming Hysteria and the Effect of Sibling Relationships on the Human Condition* (London: Allen Lane, 2000), 129.

71 Ibid.

72 Turse, *Kill Anything that Moves*, 80.

73 MAD is the acronym for Mutual Assured Destruction, the Cold War doctrine according to which the two nuclear superpowers were presumed to be deterred from using nuclear weapons in a first strike by the knowledge that such action could result in their own country's annihilation. On the psychic dynamics of MAD, see Hanna Segal, "Silence Is the Real Crime," in *Psychoanalysis, Literature, and War, Papers 1972-1995*, ed. John Steiner (London: Routledge, 1997), 143-56. An earlier, pivotal analysis of the psychoanalysis of Cold War nuclear politics is Franco Fornari's *The Psychoanalysis of War*. Fornari argues that the "frantic armaments race seems to be a cycle…in which each of the adversaries, by wasting an enormous amount of wealth on armaments, hopes to intimidate the other and prove his own superiority." Fornari, *The Psychoanalysis of War*, trans. Alenka Pfeifer (Garden City, NY: Anchor Books, 1974), 19.

74 Kate Haug, "An Interview with Carolee Schneemann," *Wide Angle* 20, no. 1 (1998): 27.

75 Schneemann, "On the Making of *Snows*," Carolee Schneemann Papers, Getty Research Institute, Los Angeles, California, box 2, file 1.

76 Carolee Schneemann, "Snows," in *More Than Meat Joy: Performance Works and Selected Writings*, ed. Bruce R. McPherson (Kingston, NY: Documentext, 1979/1997), 131; Schneemann and Duncan White, "On the Development of *Snows* and Other Early Expanded Cinema Works," in *Expanded Cinema: Art, Performance, and Film*, ed. A. L. Rees et al. (London: Tate Publishing, 2011), 86.

77 Haug, "An Interview with Carolee Schneemann," 86.

78 Gertrude Stein, *Wars I Have Seen* (1945) (London: Brilliance Books, 1984), 6. See also Mignon Nixon, "War Inside/War Outside: Feminist Critiques and the Politics of Psychoanalysis," *Texte zur Kunst* 17, no. 68 (December 2007): 134-39.

79 The classic analysis of women's identification with the male gaze in film is Laura Mulvey, "Visual Pleasure and Narrative Cinema" [1975], in Laura Mulvey, *Visual and Other Pleasures* (Bloomington: Indiana University Press, 1989).

80 For a fuller discussion of the interplay between *Fuses* and *Viet-Flakes*, see Mignon Nixon, "Schneemann's Personal Politics," in *Carolee Schneemann: Kinetic Painting*, ed. Sabine Breitwieser (Salzburg: Museum der Moderne Salzburg and Prestel, 2015), 44-53.

81 Schneemann, "Snows," 131.

82 Schneemann and White, "On the Development of *Snows* and Other Early Expanded Cinema Works," 86.

83 For an account of Angry Arts Week, see ch. 3 in Francis Frascina, *Art, Politics and Dissent: Aspects of the Art Left in Sixties America* (Manchester, UK: Manchester University Press, 1999), 108-59.

84 Kristine Stiles, ed. *Correspondence Course: An Epistolary History of Carolee Schneemann and Her Circle* (Durham, NC: Duke University Press, 2010), 114.

85 Schneemann, "Snows," in *More than Meat Joy*, 128-49.

86 Ibid., 131.

87 Kusama, "An Open Letter to My Hero, Richard M. Nixon" (1968), reprinted in *Yayoi Kusama*, ed. Laura Hoptman, Akira Tatehata, and Udo Kultermann (London: Phaidon, 2000), 106.

88 "4 in Nude Protest the War in Vietnam," *New York Times*, November 12, 1968, 35.

89 Kusama, *Infinity Net: The Autobiography of Yayoi Kusama*, trans. Ralph McCarthy (London: Tate Publishing, 2011), 139.

90 See, for example, "All's Quiet on Stock Market but Wall Street 'Bares' Busy," *Ogden* (Utah) *Standard-Examiner*, July 15, 1968, 1; and "Barefoot in the Street," *Evening Star* (Washington, D.C.), July 15, 1968. In an even lighter vein, see Hugh Wyatt, "Nudies Dance on Wall Street and Cops Don't Pinch 'Em," *New York Daily News*, July 15, 1968.

91 "'Bare Facts' Presented at Political Protest," *New York Times*, November 4, 1968; "4 Bare All to Get at Naked Truth," *Long Island Press*, November 4, 1968. The event was also widely reported in local newspapers across the United States. In Kusama's press release for the event, she calls for letting "the pants fall where they may."

92 Quoted in Midori Yamamura, "Rising from Totalitarianism: Yayoi Kusama 1945-1955," in *Yayoi Kusama*, ed. Frances Morris (London: Tate Publishing, 2012), 170.

93 Kusama, *Infinity Net*, 93.

94 From a letter of 1957 to Georgia O'Keeffe, excerpted in Bupendra Karia, ed., *Yayoi Kusama: A Retrospective* (New York: Center for International Contemporary Arts, 1989), 73.

95 Kusama, *Infinity Net*, 47. On the infinity logic of Kusama's art and politics, see Mignon Nixon, "Infinity Politics," in *Yayoi Kusama*, 177-86.

96 Kusama was identified in the *New York Times* at the time of the postelection *Anatomic Explosion* as a "28-year-old Japanese artist," which would have made her a child of four rather than an adolescent at the time of the atomic bombings of Japan. "4 in Nude Protest the War in Vietnam," 35.

97 Kusama, "An Open Letter to My Hero, Richard M. Nixon," 106.

98 Nuclear-mentality culture is the formulation of the psychoanalyst and antinuclear activist Hanna Segal. See Segal, "From Hiroshima to the Gulf War and After: Socio-political Expressions of Ambivalence," in *Psychoanalysis, Literature, and War*, 166. For a fuller discussion of Kusama's political protest performances in the perspective of psychoanalytic theories of war, see Nixon, "Anatomic Explosion on Wall Street," *October*, no. 142 (Fall 2012), https://doi.org/10.1162/OCTO_a_00105.

99 Judith Bernstein, quoted in Kate Wolf, "Sitings 5: War's a Dick," 2011, *Artslant*, accessed September 14, 2018, https://www.artslant.com/la/articles/show/23438-sitings-5-wars-a-dick.

100 Turse, *Kill Anything That Moves*, 161-62.

101 Michael Herr, *Dispatches*, 202.

102 Kusama gave the name orgy to an extensive series of private and public performances, including, most famously, her *Grand Orgy to Awaken the Dead at MoMA (Otherwise known as the Museum of Modern Art)*, a guerrilla performance conducted at MoMA on Sunday, August 24, 1969. For critical perspectives on Kusama's orgies, see Alexandra Munroe's "Obsession, Fantasy, and Outrage: The Art of Yayoi Kusama," in *Yayoi Kusama: A Retrospective*, 20; Midori Yamamura, *Yayoi Kusama: Inventing the Singular* (Cambridge, MA: MIT Press, 2015); and Mignon Nixon, "Anatomic Explosion on Wall Street."

103 On the concept of "criminal orgy" in war, see Fornari, *The Psychoanalysis of War*, 81.

104 Bernstein, quoted in Magdalena Kröner, "Conversations with Artists, Judith Bernstein, 'I Have Never Heard Any Good Reason for Censorship,'" *Kunstforum International*, no. 207 (March/April 2011): 12.

105 Hanna Segal, "From Hiroshima to the Gulf War and After: Socio-political Expressions of Ambivalence," 165.

106 Ibid., 166-67.

107 Rosler first exhibited a photographic edition of the original *House Beautiful: Bringing the War Home* in 1992, at the time of the First Gulf War. For an illuminating contemporary reflection on the resonances of the series with that time, see Brian Wallis, "Living Room War," *Art in America*, February 1992, 104-7.

108 Bernstein, quoted in Kröner, "Conversations with Artists": "Currently, I have a mural on a Bowery gate across from the New Museum [in lower Manhattan] that says 'Fuck War.'…In the last ten years, I have continually produced work protesting various wars—and this also includes culture's war against women's equality, and it is a war" (p. 19).

MARTHA ROSLER

I was trained as an abstract painter, and that is what I expected to be. But the force of events steered me in a different direction. Even before high school, my interest in social affairs and in seeking after justice was always keen. (The ethical component, I later realized, probably stemmed in good part from early engagement with moral questions; my first eight or nine years of elementary education were spent at a religious school.) | When I entered college, the Vietnam War was underway and heating up, but it was a forbidden topic on campus, as it was

Vietnam Story

considered outside our purview as students. This was, after all, during the Cold War, and dissent against government policies was muted at best; political challenge was likely to gain you a reputation as a Red and cost you your future livelihood.

Gradually, however, the spirit of activism began to swell among the huge postwar generation (the baby boomers), who were inspired by the civil rights and antinuclear movements. We began to chafe at the bit of the stifling conformism and materialist striving of our older brothers and sisters. We lost our fear of arrest and government reprisal.

We saw the war as a betrayal of the American ideals we were raised on and in which we deeply believed. The war became a focus of self-determination for young activists as part of the Free Speech Movement, which began in 1964 in Berkeley, at the flagship school of the University of California, but spread around the nation and the world. We wanted, quite simply, to

Martha Rosler, *Cleaning the Drapes* (detail), ca. 1967–72. See p. 96

be treated as adults, and that demand included the right to apply our intellectual and social engagement to understanding, and even stopping, the war.

I remember dawdling in bed one morning and hearing on the news that General Westmoreland wanted to increase troop strength in Vietnam to five hundred thousand men. "That's half a million men! A real invasion!" I said it out loud. I was startled even to imagine it. By then the war was not only being discussed on radio and television news; the war, complete with battlefield film, was also broadcast on TV at dinner hour. Critics began to refer to the war as the first "living-room war," though to me it was the dinnertime war. I wondered, "How do we eat dinner while watching a war! Had we no human feelings?" Perhaps I had grown up expecting that images of death — of the dead and wounded in war — were always a solemn thing, not to be treated lightly, and not to use terms like "body count" as a kind of

FIG. 1
Martha Rosler, *Small Wonder*, from the series *Body Beautiful, or Beauty Knows No Pain*, ca. 1966–72, photomontage, Courtesy of the artist and Mitchell-Innes & Nash, New York

FIG. 2
Martha Rosler, *Transparent Box, or Vanity Fair*, from the series *Body Beautiful, or Beauty Knows No Pain*, ca. 1966–72, photomontage, Courtesy of the artist and Mitchell-Innes & Nash, New York

reassuring way of keeping score. I had grown up watching war films, but this was real—and current.

During most of the Second World War, news coverage excluded images of wounded soldiers and much else. Far from being sanitized and hidden from view, *this* war was always there for us to see: huge helicopter gunships named for Indian tribes; B-52s dropping more bombs than in all of the Second World War; and acre upon acre of napalm-blasted jungles and rice paddies and torched huts; our troops, active, wounded, or dead; terrified, fleeing refugees and tormented, captured, or humiliated opponents. Americans at home, including most young people, seemed to tune in and then tune out the war. No matter how much we might be against the war, our "world picture" was split in two: "over here" and "over there." There was plenty at home to occupy attention. There were devastating urban uprisings in

Watts, in Detroit, in Newark. The Black Power movement, largely in the urban north, lent a different, more militant character to demands for social justice and models of community concern. Young women were about to restart the feminist movement, and the lesbian and gay rights movement was nascent.

As the decade progressed and the war and urban unrest persisted, demonstrations, occupations, sit-ins, and university teach-ins became larger and more widespread, alternating with love-ins and be-ins—the other generational gatherings that culminated in Woodstock in 1969. These two currents of opposition, the antiwar and the hippie, came together in the teach-ins and public gatherings in university communities and elsewhere—often in conjunction with the urban resistance groups that developed out of the civil rights movement, including African American, Chicano, Latino, and Asian movements.

The Reverend Martin Luther King Jr., in agreement with other religious and secular leaders, by 1965 began voicing his opposition to the war in Vietnam, culminating in a major speech at Riverside Church in New York City.

Like many people I marched and sat in against the war. But I was also reconsidering my approach to art, moving away from abstract painting and toward other forms, including sculpture, photography, and photomontage. In art, the dominant modernist paradigms of abstraction and transcendence were faltering; with the ascendancy of mass entertainment culture and consumer culture, pop art was on the rise, as was the more widespread and amorphous counterculture. Both pop art, making its break with high modernism, and the counterculture, which encompassed youth culture and the frankly antimodernist hippie dropout culture, challenged received narratives of art, culture, and power—and everyday life. It is an understatement to point out the repressed discontents of the postwar world erupted during the decade.

Reflecting my generation's consternation over the hypocrisy and bland conformism we saw around us, by the mid-1960s I was intrigued by images of the political rituals captured for the camera, the gestures and interactions of social masks and bodily postures, along with the coded signals of clothing and other trappings; I made large, pop-inspired collages out of those images. I made other works in light of the

growing disquiet women were expressing over their socially assigned roles and images, a discontent that preceded the full-fledged return of feminism. I made photomontages by cutting figures from ads for women's clothing and lingerie in the *New York Times Magazine* and putting them together with elements from *Playboy* and cheap porn magazines. The *Playboys*, obtained from the discard pile in the basement of my apartment building, were typically several years old, which made them seem slightly quaint [FIGS. 1, 2].

I thought about using my art to protest the war— few artists were doing so then, though in New York at least, quite a few participated in antiwar events. But I had no plan. I was put off by the antiwar flyers handed to us on marches, which mostly wound up in the nearest trash can. You might agree with the sentiments, but they had too many words with few images and little blank space—just political arguments, strangely worded.

One evening, at my mother's dining table, my eyes lit upon a front-page tabloid photo of a young Vietnamese woman apparently swimming for her life. She was up to her chest in water, with another woman and some small children around her and an infant in her arms. The black-and-white photo, taken from above, showed them heading toward the camera's vantage point [FIG. 3]. Horrified and transfixed, I suddenly had an idea: I could adapt the montage strategy I had been using for representations of women to produce a critique of the war. I wanted to turn them into flyers that would put those people caught up in the faraway landscapes of the war into scenes of the American way of life—into images of "our spaces," our homes—but how?

Americans seemed to me to oscillate between identification and disidentification with the people being displaced and killed "over there," finally consoling themselves that those strangely dressed people were not, after all, like us "over here." I wanted to

FIG. 3
Civilians flee U.S. bombing of their village in Bình Định province, Vietnam, 1965.
Photo by Kyōichi Sawada

interrupt that vehement denial. I thought that by resituating the problem from "there" to "here," people would see this war that was pictured everywhere, all the time, in a different light, unfiltered by body counts, troop call-ups, appeals to patriotism, or invocations of geopolitical domino theory, godless communism—and even unashamed racism.

I turned to the war as brought to us in mass-circulation magazines. Back then war photos were mostly in black and white, and photos of home interiors generally were not. The weekly picture magazine *Life* was in virtually every home, with officially sanctioned storytelling enshrined on its large-format pages and those of its text-heavy sister publication, *Time*. Between them they marked the boundaries of the knowable and the sayable. In *Life*, up-to-date photos of war and other subjects shared space with ads for consumer goods for the idealized homes they depicted. The American home at midcentury, whose very walls spoke of order, comfort, status, and certitude, effectively embodied a promise to block out trouble. One might say that this promise reinforced our mental division of the world into regions whose people are entitled to safety and comfort and those whose inhabitants are entitled only to lie dead outside: the people sharing the pages of *Life*. I placed the cut-out figures of war into those homes [pp. 94–98]. For pictures of more lavish digs with chic furnishings and expensive artworks, I turned to *House Beautiful* and other upscale interior design magazines.

The strategy I settled on, then, was to use photomontage to bring the war images into those pictured homes. By creating a space in which such different narratives could be seen to collide, I hoped to remind people of the unity, not the separation, of the "worlds" in which the war was taking place and in which we in the United States live. I wanted to suggest our responsibility for what was happening not only to the lives and bodies of our troops but also to those of the inhabitants of the war zones.

In disrupting the war story, I also intended to indicate the demands on women in creating and maintaining these fortress-homes, which, after all, allowed for aggression abroad to be recast as protection and safeguard, and in which women were often presented as a type of home appliance.

I was convinced that these works should be—unlike virtually all material positioned for or against war—absolutely wordless. They would have to rely on the images brought into the same frame, resting easily or uneasily together in the same rational space. This space, looking like a *place*, was where I wanted to invite the viewer in, to stand and think. By adopting a recognizable space for most of the works, I was offering the viewer a place to stand, literalizing the question, "Where do you stand?" You see yourself standing there rather than considering what you see from some disconnected vantage point.

I wanted tableaux more than action images or atrocity photos. Some aren't all that rational as spaces, while others have no military subjects. But still, they stitch together those figures and grounds into one visual field, although the joins are often visible—not to mention the lettering peeking through from the backs of the magazine pages. I aimed to undercut any suggestion that the scenes were meant to seem "real," to show clearly that no high-handed moves were going on here. By using collage as simple as that taught in grade school, I wanted to suggest to the viewer that this was all well within their reach and that maybe they ought to make some works like this themselves.

I assumed I'd be accused of making propaganda rather than art, and I decided I'd accept the charge. I wanted these works to be agitational and didn't intend for them to enter the art world; putting images of casualties of an ongoing war into a museum or gallery seemed obscene. I didn't sign or date the collages, to remind myself that they were the background to the production of photographic images

well—as soon as I got the money! I knew rendering the works as photographs would encourage a deeper reading, although their status as art would always be in question, no matter what the medium.

Even after the war ended, I continued to show them in the slide talks I gave about my work in art schools and universities, since offering a model for simple, straightforward production has always been one of my interests. Many years later, the works came to the attention of the art world and entered as representations of the agitational works they used to be. Decades later, I reinstituted the series as part of the opposition to the wars in Iraq and Afghanistan, and to remind people that art of opposition can be a simple enough thing to produce.

I restarted the series almost inadvertently in 2004. I was by then part of an artist collective that had come together in 2002 in opposition to the upcoming war against Afghanistan and in particular against Iraq, the real target of the war—a country which clearly hadn't been responsible for the September 11, 2001, Al Qaeda attacks on New York and Washington. My group, Artists against the War, designed and produced artworks for our protests. But in addition to working as part of a group, I wanted to do something on my own, since the visual works of the collective were generally produced by other members (almost exclusively women, of several generations), all far better poster and graphic artists than I proved to be.

When I was invited to participate in an art show centered on the 2004 presidential election,[1] I decided to make a couple of photomontages, revisiting the process I'd left off in the early 1970s. But I was seized by a flurry of new ideas, and ultimately produced about twenty images in two groups, in 2004 and 2008. The earlier, Vietnam War works were by then widely known in art circles.[2] I predicted—correctly, as it turned out—that resuming the series to address the current war would provoke questions like, "Why this? Why now?" and criticisms on the order of

to be widely and cheaply disseminated, not independent artworks. I'd been introduced to the Xerox machine by my father, a storefront lawyer who had fallen in love with the technology for its ability to produce rapid, multiple copies of legal papers. I used the process to copy my montages and handed the copies out at demonstrations and wherever it made sense to do so. Eventually I also published a few in the underground newspapers that were so much a feature of the age. From the earliest days, however, I'd also intended to print them as photographs as

FIG. 5
Martha Rosler, *The Gray
Drape*, from the series
*House Beautiful: Bringing
the War Home, New Series*,
2008, photomontage,
Courtesy of the artist and
Mitchell-Innes & Nash,
New York

provoke a wave of jingoistic patriotism is to find and pursue an external enemy.) We were heading for the same quagmire, the Big Muddy that had potently described our position back then.

For the new series, I determined to work with paper and scissors as in the earlier series to underline my literal return to the earlier mode of production. But I did make use of Photoshop for resizing elements and finishing works, thus departing a bit from the original mode. And this time around, fashion models, not simply women doing housework or housewives, appeared in the works because models had become figures in popular culture in a way they had not been earlier [FIG. 4]. In the second group of these later images, from 2008, the backgrounds in which the figures were situated were outdoor sites on foreign soil or sand "over there" [FIG. 5].

I decided to show these works within the art world, which had greatly expanded its cultural reach: catering to wider publics, becoming more visible and more concerned with urgent, up-to-the-minute issues. I knew as well that the images would be reproduced in publications and online, inserting them into public discourses in a way the earlier works about Vietnam could not achieve.

Acting together with full-throated social protest, such works can encourage a rethinking and rejection of the arguments usually made in favor of distant wars that we may view only on our screens. Condensing an argument by offering a different framing of the issues is one of the things that art can help us do.

Yes, our wars continue on; there has hardly been a moment since its founding when our country hasn't been at war. Yet once again, our people are growing tired of war; it's one thing to start a war, but the trick is how to end it without appearing to concede defeat. Vietnam was then our longest war, and as it turns out, one that we lost; but now we are still engaged in another apparently unwinnable war that has long superseded Vietnam as our longest shooting war. And

"Can't teach an old dog new tricks." My reply was that I was returning to something I'd done decades ago because our country seemed to be mired in the 1970s. We as a nation had doggedly forgotten or repressed anything we might have learned from our Vietnam debacle, thanks to decades of careful grooming by a compliant media, which helped support a resurgent bravado that passed for masculinity. (Besides, it's a truism that the easiest way to

yet, our national taste for further military adventures, elsewhere, may not yet be slaked. Today, while we are considering this seemingly unending attachment to war making, there is a wider public discussion about what has recently gained the name "toxic masculinity" and its predilection toward violence, often directed against some fever dream of femininity. (I will simply mention here the glaring example of widespread, even routinized, gender aggression and dominance behavior exposed under the #MeToo rubric.)

As I've suggested, these works of mine have long been concerned with the depiction of the presumed realms of the feminine—of empathy and caring, nest building, and family reproduction and maintenance— as they stand in imaginary opposition to the male realm. Although I cannot accept the idea that wars are started because of biological imperatives, I have no doubt that rigid and still highly enforced gender roles demand an imagined identity for men as warriors on the social stage, whether literally or in other arenas— business and politics, social circles, and the family itself. A common element of military and other primarily male-centered training has rested on defeating the inner feminine in young men, in which the feminine is defined as *lack*, lack of the presumed masculine qualities such as steadfastness and bravery, not to mention—to put it bluntly—the readiness to physically attack and kill those identified as opponents.

Working for change, in the political arena no less than in the most intimate, often requires one to be committed for the long haul. We need to acknowledge the complexity of the undertakings, which can never rely solely on the efforts of artists or even political leaders, but rather require citizens and residents to inform themselves and engage and mobilize politically.

1 The exhibition *Election* was held at American Fine Arts gallery, New York, in 2004. It was organized by James Meyer.

2 One of the images, known as *House Beautiful: Giacometti*, was featured in an article in *Artforum* by critic and historian Benjamin Buchloh. Benjamin H. D. Buchloh, "Allegorical Procedures: Appropriation and Montage in Contemporary Art," *Artforum* 21, no. 1 (September 1982): 51. With great economy, that is how the works entered the art world, though I had been showing them in slide form at virtually every presentation on my work, and in a few decades, I'd given hundreds. In 1991, the gallerist Simon Watson showed a selection (ten of the twenty) at his small New York gallery in a show that took its title from the series, *House Beautiful: Bringing the War Home.*

Checklist of the Exhibition

* Washington, D.C., only
** Minneapolis only

p. 41

On Kawara
b. Kariya, Japan 1932
d. New York City 2014

Title
1965
acrylic and collage on
canvas
left panel: 46⅜ × 61⅜ in.;
center panel: 51¼ × 62¾ in.;
right panel: 46¼ × 61⅜ in.
National Gallery of Art,
Washington, Patrons'
Permanent Fund,
2006.40.1.1

pp. 44–45

Yoko Ono
b. Tokyo, Japan 1933

Cut Piece
1964, performed 1965
performance, 16 mm film
by Albert and David Maysles
transferred to video;
black and white, sound,
8:25 minutes
Courtesy of
Yoko Ono Lennon

pp. 49–51

Nancy Spero
b. Cleveland, OH 1926
d. New York City 2009

Female Bomb
1966
gouache and ink on paper
33¾ × 27¼ in.
The New School Art
Collection, New York, NY

The Bug, Helicopter, Victim
1966
gouache and ink on paper
19 × 23¼ in.
Pennsylvania Academy
of Fine Arts, Philadelphia,
John S. Phillips Fund Art

*Victims on Helicopter
Blades*
1968
gouache and ink on paper
25 × 39 in.
Collection of Terri Weissman

Gunship *
1966
gouache on paper
27½ × 39½ in.
Collection of Stephen
Simoni and John Sacchi

pp. 54–55

Judith Bernstein
b. Newark, NJ 1942

Fucked by Number
1966
charcoal and mixed media
on paper
22 × 30 in.
Collection of Danniel Rangel

Vietnam Garden *
1967
charcoal, oil stick, and steel
wool on paper
26 × 40 in.
Whitney Museum of
American Art, New York,
Purchase, with funds from
the Drawing Committee,
2010.80

A Soldier's Christmas
1967
oil, fabric, steel wool,
electric lights, and mixed
media on canvas
46 × 92 in.
Collection of Paul and
Karen McCarthy

p. 58

Dan Flavin
b. New York City 1933
d. Riverhead, NY 1996

*monument 4 for those who
have been killed in ambush
(to P. K. who reminded me
about death)*
1966
red fluorescent light
96 in. wide × 72 in. deep
The Estate of Dan Flavin

pp. 64–65

Carolee Schneemann
b. Fox Chase, PA 1939

Viet-Flakes
1962–67, re-edited 2015
16 mm film transferred to
digital video; toned black
and white, sound, 7 minutes
Smithsonian American Art
Museum, Museum purchase
through the Frank K. Ribelin
Endowment

Snows
1967, re-edited 2009
kinetic theater performance,
16 mm film transferred to
digital video; color and
black and white, sound;
20:30 minutes
Electronic Arts Intermix
(EAI), New York

p. 69

Paul Thek
b. New York City 1933
d. New York City 1988

Warrior's Leg, from the
series *Technological
Reliquaries* *
1966–67
plexiglass, wax, leather,
metal, and paint
26¼ × 8¼ × 14½ in.
Hirshhorn Museum and
Sculpture Garden,
Smithsonian Institution,
Joseph H. Hirshhorn
Bequest Fund, 1990

pp. 71–72

Peter Saul
b. San Francisco, CA 1934

Saigon *
1967
acrylic, oil, enamel, and
fiber-tipped pen on canvas
93¼ × 142¼ in.
Whitney Museum of
American Art, New York,
Purchase, with funds from
the Friends of the Whitney
Museum of American Art,
69.103

Target Practice
1968
acrylic on canvas
92½ × 99½ in.
Hirshhorn Museum and
Sculpture Garden,
Smithsonian Institution,
Joseph H. Hirshhorn
Purchase Fund, 2016

p. 76
Tomi Ungerer
b. Strasbourg, France 1931

Eat
1967
offset lithograph
26½ × 21¼ in.
Oakland Museum of
California, All Of Us Or
None Archive, Gift of the
Rossman Family

p. 79
Carol Summers
b. Kingston, NY 1925
d. Santa Cruz, CA 2016

Kill for Peace, from the
portfolio *Artists and
Writers Protest against the
War in Viet Nam*
1967
screenprint with punched
holes
23⅜ × 19¼ in.
International Center of
Photography, Gift of the
Artists' Poster Committee
with funds provided
by the ICP Acquisitions
Committee, 2002

p. 80
William Copley
b. New York City 1919
d. Sugar Loaf Key, FL 1996

Untitled, from the portfolio
*Artists and Writers Protest
against the War in Viet Nam*
1967
screenprint
20¹⁵⁄₁₆ × 25¹³⁄₁₆ in.
International Center of
Photography, Gift of the
Artists' Poster Committee
with funds provided
by the ICP Acquisitions
Committee, 2002

p. 81
Ad Reinhardt
b. Buffalo, NY 1913
d. New York City 1967

Untitled, from the portfolio
*Artists and Writers Protest
against the War in Viet Nam*
1967
screenprint and collage
on paper
image: 11⅜ × 3⅜ in.;
sheet: 25⅞ × 21¹⁄₁₆ in.
International Center of
Photography, Gift of the
Artists' Poster Committee
with funds provided
by the ICP Acquisitions
Committee, 2002

p. 84
William Weege
b. Milwaukee, WI 1935

Napalm, from the portfolio
Peace is Patriotic
1967
offset lithograph
25¼ × 20 in.
Courtesy of the artist and
Corbett vs. Dempsey,
Chicago

pp. 88–92
Corita Kent
b. Fort Dodge, IA 1918
d. Boston, MA 1986

news of the week
1969
screenprint
23 × 12 in.
Corita Art Center,
Immaculate Heart
Community,
Los Angeles, CA

right
1967
screenprint
30 × 36 in.
Corita Art Center,
Immaculate Heart
Community,
Los Angeles, CA

yellow submarine
1967
screenprint
23 × 35 in.
Corita Art Center,
Immaculate Heart
Community,
Los Angeles, CA

handle with care
1967
screenprint
23 × 35 in.
Corita Art Center,
Immaculate Heart
Community,
Los Angeles, CA

stop the bombing
1967
screenprint
15½ in. × 23 in.
Corita Art Center,
Immaculate Heart
Community,
Los Angeles, CA

phil and dan
1969
screenprint
23 × 11¾ in.
Corita Art Center,
Immaculate Heart
Community,
Los Angeles, CA

pp. 94–98
Martha Rosler
b. New York City 1943

Red Stripe Kitchen, from
the series *House Beautiful:
Bringing the War Home*
ca. 1967–72
photomontage
24 × 20 in.
The Art Institute of Chicago,
through prior gift of
Adeline Yates; exhibition
copy provided by Mitchell-
Innes & Nash, New York

Booby Trap, from the
series *House Beautiful:
Bringing the War Home*
ca. 1967–72
photomontage
24 × 20 in.
The Art Institute of Chicago,
through prior gift of
Adeline Yates; exhibition
copy provided by Mitchell-
Innes & Nash, New York

Makeup/Hands Up, from
the series *House Beautiful:
Bringing the War Home*
ca. 1967–72
photomontage
24 × 20 in.
The Art Institute of Chicago,
through prior gift of
Adeline Yates; exhibition
copy provided by Mitchell-
Innes & Nash, New York

First Lady (Pat Nixon), from
the series *House Beautiful:
Bringing the War Home*
ca. 1967–72
photomontage
20 × 24 in.
The Art Institute of Chicago,
Claire and Gordon Prussion
Fund for Contemporary Art;
exhibition copy provided by
Mitchell-Innes & Nash,
New York

Cleaning the Drapes, from
the series *House Beautiful:
Bringing the War Home*
ca. 1967–72
photomontage
20 × 24 in.
The Art Institute of Chicago,
through prior gift of
Adeline Yates; exhibition
copy provided by Mitchell-
Innes & Nash, New York

Beauty Rest, from the
series *House Beautiful:
Bringing the War Home*
ca. 1967–72
photomontage
24 × 20 in.
The Art Institute of Chicago,
through prior gift of
Adeline Yates; exhibition
copy provided by Mitchell-
Innes & Nash, New York

Balloons, from the series
*House Beautiful: Bringing
the War Home*
ca. 1967–72
photomontage
24 × 20 in.
The Art Institute of Chicago,
through prior gift of
Adeline Yates; exhibition
copy provided by Mitchell-
Innes & Nash, New York

pp. 104–6
Wally Hedrick
b. Pasadena, CA 1928
d. Bodega Bay, CA 2003

Madame Nhu's Bar-B-Qs
1963
oil on canvas
66 × 48 in.
The Fine Arts Museums of
San Francisco, Museum
purchase, Unrestricted Art
Acquisition Endowment
Income Fund, 2004.95

Black and Blue Ideas
1958/1967
oil on canvas
78 ½ in. × 39 in.
Courtesy of the Wally
Hedrick Estate and
The Box, LA

War Room
1967–68/2002
oil on canvas
132 × 132 × 132 in.
Collection of Paul & Karen
McCarthy

p. 109
David Hammons
b. Springfield, IL 1943

America the Beautiful
1968
lithograph and body print
sheet: 39 in. × 29 ½ in.
Oakland Museum of
California, The Oakland
Museum Founders Fund

p. 113
Mel (Melesio) Casas
b. El Paso, TX 1929
d. San Antonio, TX 2014

Humanscape 43
1968
acrylic on canvas
78 × 102 in.
Mel Casas Family Trust

pp. 116–17
Edward Kienholz
b. Fairfield, WA 1927
d. Sandpoint, ID 1994

The Eleventh Hour Final
1968
tableau: wood paneling,
concrete TV set with
engraved screen and
remote control, furniture,
lamp, ash trays, artificial
flowers, *TV Guide*, pillows,
painting, wall clock,
window, and curtain
96 ⅞ × 164 ⅝ × 141 ⅜ in.
Glenstone Museum,
Potomac, MD

pp. 119–20
Yayoi Kusama
b. Matsumoto, Japan 1929

*Anatomic Explosion on
Wall Street*
1968
two performance
photographs, exhibition
copies
14 × 11 in. each
Courtesy of
Yayoi Kusama Inc.

p. 123
Claes Oldenburg
b. Stockholm, Sweden 1929

*Fireplug Souvenir —
"Chicago August 1968"*
1968
plaster and acrylic paint
two pieces; 8 × 8 × 6 in. each
Courtesy of the artist
and Paula Cooper Gallery,
New York

p. 126
Barnett Newman
b. New York City 1905
d. New York City 1970

*Lace Curtain for
Mayor Daley*
1968
Cor-ten steel, galvanized
barbed wire, and enamel
paint
70 × 48 × 10 in.
The Art Institute of Chicago,
Gift of Annalee Newman,
1989.433

p. 132
Emile de Antonio
b. Scranton, PA 1919
d. New York City 1989

In the Year of the Pig
1968
35 mm film, black and white,
sound, 103 minutes
UCLA Film and Television
Archive

p. 135
James Gong Fu Dong
b. San Francisco, CA 1949

Vietnam Scoreboard
1969
embossed etching
image: 16 ¼ × 22 in.;
sheet: 21 × 27 in.
San Francisco State College
Art Department Collection

pp. 138–39
Rosemarie Castoro
b. New York City 1939
d. New York City 2015

*A Day in the Life of a
Conscientious Objector*
1969
digital projection
dimensions variable
The Estate of Rosemarie
Castoro, Courtesy of
Hal Bromm Gallery

p. 142
Harry Shunk
b. Reudnitz, Germany 1924
d. New York City 2006

János Kender
b. Baja, Hungary 1937
d. West Palm Beach, FL
2009

Claes Oldenburg's Lipstick
(Ascending) on Caterpillar
Tracks
1969
three inkjet prints,
exhibition copies
two 11 × 14 in.; one 14 × 11 in.
Getty Research Institute,
Los Angeles, 2014.R.20

p. 143
**Published by students
of the Yale School of Art
and Architecture**

Novum Organum, No. 7:
Special "Colossal
Monument" Issue focusing
on recent gift of Claes
Oldenburg's *Lipstick
(Ascending) on Caterpillar
Tracks*
May 15, 1969
broadside: photo offset and
screenprint (recto and verso)
34 × 22 in.
Yale University Art Gallery,
Gift of Stuart H. Wrede, B.A.
1965, M. Arch. 1970

p. 146
Faith Ringgold
b. New York City 1930

*Flag for the Moon:
Die Nigger,* from the
series *Black Light*
1969
oil on canvas
36 × 48 in.
Glenstone Museum,
Potomac, MD

p. 149
Douglas Huebler
b. Ann Arbor, MI 1924
d. Truro, MA 1997

*Location Piece #13
(Washington March)*
1969
three color photographs,
two gelatin silver prints,
and typewritten paper
left panel: 37 × 51¼ in.;
right panel: 37 × 28¾ in.
Courtesy of Paula Cooper
Gallery, New York

pp. 152–53
Carlos Irizarry
b. Santa Isabel, PR 1938
d. San Juan, PR 2017

Moratorium
1969
screenprint
left panel: 21½ × 27¾ in.;
right panel: 21⅜ × 28⅜ in.
Smithsonian American Art
Museum, Museum purchase
through the Luisita L. and
Franz H. Denghausen
Endowment, 2013.24.1a, b

p. 156
Hans Haacke
b. Cologne, Germany 1936

News
1969, reconstructed 2019
newsfeed, printer, and
paper
dimensions variable
San Francisco Museum of
Modern Art, Purchase
through gifts of Helen
Crocker Russell, the Crocker
Family, and anonymous
donors, by exchange, and
the Accessions Committee
Fund

p. 159
**Guerrilla Art Action
Group**
active New York City 1969–

*A Call for the Immediate
Resignation of All the
Rockefellers from the Board
of Trustees of the Museum
of Modern Art*
1969
performance,
three photographs by
Ka Kwong Hui
8 × 10 in.
Collection of Jon Hendricks

p. 160
*A Call for the Immediate
Resignation of All the
Rockefellers from the Board
of Trustees of the Museum
of Modern Art*
handbill
November 10, 1969
Collection of Jon Hendricks

(not pictured)
*A Call for the Immediate
Resignation of All the
Rockefellers from the Board
of Trustees of the Museum
of Modern Art*
communique describing the
performance
November 18, 1969
Collection of Jon Hendricks

p. 162
John Lennon
b. Liverpool, UK 1940
d. New York City 1980

Yoko Ono
b. Tokyo, Japan 1933

*WAR IS OVER!
IF YOU WANT IT*
1969
offset lithograph
30 × 20 in.
Courtesy of
Yoko Ono Lennon

p. 169
Art Workers' Coalition
active 1969–71

*Q. And babies?
A. And babies.*
1970
offset lithograph
25 × 38 in.
Smithsonian American Art
Museum, Gift of Jon
Hendricks, 2017.10

p. 172
Terry Fox
b. Seattle, WA 1943
d. Cologne, Germany 2008

Defoliation
1970, printed 2010
performance, photographs
by Barry Klinger, six gelatin
silver prints
8 × 10 in. each
University of California,
Berkeley Art Museum and
Pacific Film Archive,
Gift of Brenda Richardson,
2014.1.a–f

p. 175
Bruce Nauman
b. Fort Wayne, IN 1941

Raw War
1970
neon, glass tubing, wire,
transformer, and sequencer
dimensions variable
The Baltimore Museum of
Art, Gift of Leo Castelli,
New York, BMA 1982.148

p. 179
Robert Smithson
b. Passaic, NJ 1938
d. Amarillo, TX 1973

*Partially Buried Woodshed,
Kent State*
1970
gelatin silver print
framed: 30 ⁵⁄₁₆ × 39 ⅜ in.
International Center of
Photography, Gift of the
Artists' Poster Committee
with funds provided by the
ICP Acquisitions Committee,
2002

p. 181
May Stevens
b. Boston, MA 1924

Big Daddy Paper Doll
1970
acrylic on canvas
72 × 168 in.
Brooklyn Museum, Gift of
Mr. and Mrs. S. Zachary
Swidler, 75.73

p. 183
Jim Nutt
b. Pittsfield, MA 1938

Summer Salt
1970
acrylic on vinyl and enamel
on wood
61¼ in. × 36 in. × 3½ in.
Museum of Contemporary
Art, Chicago, Gift of Dennis
Adrian in honor of Claire B.
Zeisler, 1980.30.1

p. 186
Robert Morris
b. Kansas City, MO 1931
d. Kingston, NY 2018

*Trench with Chlorine Gas,
from the series Five War
Memorials*
1970
lithograph
image: 20½ × 40¼ in.;
sheet: 24¼ × 42½ in.
Private collection,
Courtesy of Castelli Gallery

p. 189
Hans Haacke
b. Cologne, Germany 1936

MoMA Poll
1970
transparent acrylic boxes,
photoelectric counting
devices, and paper ballots
each box 40 × 20 × 10 in.
Courtesy of the artist
and Paula Cooper Gallery,
New York

p. 192
Rupert García
b. French Camp, CA 1941

¡Fuera de Indochina!
1970
screenprint
23¾ × 18 in.
The Fine Arts Museums of
San Francisco, Gift of
Mr. and Mrs. Robert Marcus,
1990.1.83

p. 195
Liliana Porter
b. Buenos Aires, Argentina
1941

*Untitled (The New York
Times, Sunday,
September 13, 1970)*
1970
screenprint
overall: 27¾ × 19½ in.
Collection of
Leah and Andrew Witkin,
Brookline, MA

p. 198
Dennis Oppenheim
b. Electric City, WA 1938
d. New York City 2011

*Reading Position for
Second Degree Burn*
1970
color photograph
23 in. × 16½ in.
Collection of Linn Meyers

p. 201
Yvonne Rainer
b. San Francisco, CA 1934

Trio A with Flags
1970
performance film
transferred to video;
black and white, sound,
11:50 minute excerpt from
18:32 minute original
Getty Research Institute,
Los Angeles, 2006.M.24

p. 202
Peter Moore
b. London, UK 1932
d. New York City 1993

**Photographs of
Yvonne Rainer's *WAR* at
the Loeb Student Center,
New York University**
1970, printed 2008
three gelatin silver prints
two 11 × 14 in.; one 14 × 11 in.
Courtesy of Paula Cooper
Gallery, New York

pp. 205–7
Edward Kienholz
b. Fairfield, WA 1927
d. Sandpoint, ID 1994

The Non-War Memorial
1970/1972
military uniforms, sand,
book, acrylic vitrine, plaque,
and printed statement
dimensions variable
Whitney Museum of
American Art, New York,
Gift of Nancy Reddin
Kienholz, 2003.14a–h

pp. 211–19
Philip Jones Griffiths
b. Rhuddlan, UK 1936
d. London, UK 2008

Vietnam
1967
gelatin silver print
12¹¹⁄₁₆ × 8½ in.
The J. Paul Getty Museum,
Los Angeles, 2010.3.7

Vietnam
1970
gelatin silver print
9½ × 13⅜ in.
Philip Jones Griffiths
Foundation

Vietnam
1970
gelatin silver print
8¾ × 13 in.
Philip Jones Griffiths
Foundation

Vietnam
1967
gelatin silver print
8⅜ × 12½ in.
The J. Paul Getty Museum,
Los Angeles, 2010.3.2

Vietnam
1970
gelatin silver print
7 × 10 in.
Philip Jones Griffiths
Foundation

Qui Nhon, Vietnam
1967
gelatin silver print
8¾ × 13 in.
Philip Jones Griffiths
Foundation

Danang, Vietnam
1967
gelatin silver print
9 × 13 in.
Philip Jones Griffiths
Foundation

Saigon, Vietnam
1968
gelatin silver print
6¼ × 9¼ in.
Philip Jones Griffiths
Foundation

Saigon, Vietnam
1968
gelatin silver print
6⅛ × 9¼ in.
Philip Jones Griffiths
Foundation

Can Tho, Vietnam
1967
gelatin silver print
13 × 8½ in.
Philip Jones Griffiths
Foundation

Nha Be, Vietnam
1970
gelatin silver print
8⁹⁄₁₆ × 12¾ in.
The J. Paul Getty Museum,
Los Angeles, 2010.3.6

Vietnam, Inc.
1971
first edition book
10¹³⁄₁₆ × 16 in.
Philip Jones Griffiths
Foundation

Quang Ngai, Vietnam
1967
gelatin silver print
11³⁄₁₆ × 7⁹⁄₁₆ in.
The J. Paul Getty Museum,
Los Angeles, 2010.3.1

p. 221
Carl Andre
b. Quincy, MA 1935

"It was no big deal, sir."
1971
collage and ink on paper
31³⁄₁₆ × 24³⁄₁₆ in.
International Center of
Photography, Gift of the
Artists' Poster Committee
with funds provided by
the ICP Acquisitions
Committee, 2002

p. 225
Donald Judd
b. Excelsior Springs, MO
1928
d. New York City 1994

Untitled
1971
electro-photographic print
on yellow paper
22⁷⁄₁₆ × 17¹⁄₁₆ in.
International Center of
Photography, Gift of the
Artists' Poster Committee
with funds provided by
the ICP Acquisitions
Committee, 2002

p. 227
Benny Andrews
b. Madison, GA 1930
d. New York City 2006

American Gothic *
1971
oil, cut and pasted burlap,
canvas, and fabric on
canvas
60 × 50 in.
The Metropolitan Museum of
Art, Purchase, The Eugene
and Estelle Ferkauf
Foundation Gift, 1989,
1989.61

pp. 230–31
Chris Burden
b. Boston, MA 1946
d. Topanga, CA 2015

Shoot
1971
performance, photographs
by Alfred Lutjeans
left panel: 20¼ × 23¾ in.;
center panel: 20¼ × 33½ in.;
right panel: 20¼ × 35½ in.
Courtesy of the
Chris Burden Estate

p. 235
Seymour Rosen
b. Chicago, IL 1935
d. Los Angeles, CA 2006

Photographs of Asco's
Stations of the Cross
1971, printed 2019
three gelatin silver prints
one 10 × 8 in.; two 8 × 10 in.
Smithsonian American Art
Museum, Museum purchase
through the Frank K.
Ribelin Endowment

p. 239
Timothy Washington
b. Los Angeles, CA 1946

1A
1972
etched aluminum, leather,
metal studs, nail, and
draft card
23½ × 23½ in.
Private collection, Courtesy
of Tilton Gallery, NY

p. 243
Judy Chicago
b. Chicago, IL 1939

Immolation, from the
portfolio *On Fire*
1972, printed 2013
inkjet print
16 × 16 in.
Smithsonian American Art
Museum, Museum Purchase
through the Luisita L. and
Franz H. Denghausen
Endowment, 2018.11.6

pp. 246–47
Fred Lonidier
b. Lakeview, OR 1942

29 Arrests
1972, printed 2008
photographs with text on
panel
30⅜ × 39⁵⁄₁₆ in.
Museum of Contemporary
Art, Chicago, Restricted gift
of the Buddy Taub
Foundation, 2014.51

p. 250
Mark di Suvero
b. Shanghai, China 1933

For Peace
1971–72
ink, watercolor, and collage
on paper
51 × 45 in.
Private collection

p. 255
Malaquias Montoya
b. Albuquerque, NM 1938

Viet Nam/Aztlan
1973
offset lithograph
image: 22½ × 17¼ in.;
sheet: 26 × 19 in.
Smithsonian American Art
Museum, Museum purchase
throuth the Frank K.
Ribelin Endowment,
2015.29.3

pp. 258–59
Leon Golub
b. Chicago, IL 1922
d. New York City 2004

Vietnam II
1973
acrylic on canvas
115¾ × 453⅓ in.
Tate: Presented by the
American Fund for the Tate
Gallery, Courtesy of Urlich
and Harriet Meyer (Building
the Tate Collection), 2012

p. 263
Jesse Treviño
b. Monterrey, Mexico 1946

Mi Vida
1971–73
acrylic on drywall,
mounted on aluminum
108 × 180 in.
Collection of
Inez Cindy Gabriel

p. 269
Philip Guston
b. Montreal, Quebec,
Canada 1913
d. Woodstock, NY 1980

San Clemente
1975
oil on canvas
68 × 73¼ in.
Glenstone Museum,
Potomac, MD

p. 271
T. C. Cannon
b. Lawton, OK 1946
d. Santa Fe, NM 1978

*Untitled (T. C. and
Skeleton)* **
1975
ink on paper
13½ × 9½ in.
Collection of
Jason Aberbach

pp. 274–76
Kim Jones
b. San Bernardino, CA 1944

Mudman Structure (large)
1974
sticks, mud, rope, foam
rubber, shellac, and acrylic;
shown with chair, boots,
and bucket of mud
approx. 83⅞ × 103⅞ × 39⅜ in.
Courtesy of Zeno X Gallery,
Antwerp

Wilshire Boulevard Walk
1976, printed 2016
performance, four
photographs by Jeff Gubbins
8 × 10 in.
Courtesy of Zeno X Gallery,
Antwerp

Wilshire Boulevard Walk
1976, printed 2016
performance, photograph
by Jeff Gubbins
11 × 8 in.
Courtesy of Zeno X Gallery,
Antwerp

Wilshire Boulevard Walk
1976, printed 2016
performance, photograph
by Jeff Gubbins
12 × 8 in.
Courtesy of Zeno X Gallery,
Antwerp

pp. 330, 332
Martha Rosler
b. New York City 1943

Tron (Amputee), from the
series *House Beautiful:
Bringing the War Home*,
in *Goodbye to All That*,
Issue 3, October 13, 1970
1970
newspaper
17 × 22 in. spread
Courtesy of the artist

Vacation Getaway, from
the series *House Beautiful:
Bringing the War Home*,
in *Goodbye to All That*,
Issue 3, October 13, 1970
1970
newspaper
17 × 22 in. spread
Courtesy of the artist

and if only we arrange our life according to that principle which counsels us that we must always hold to the difficult, then that which now seems to us the most alien will become what we most trust and find most faithful. How should we be able to forget those ancient myths that are at the beginning of all peoples, the myths about dragons that at the last moment turn into princesses; perhaps all the dragons of our lives are princesses who are only waiting

Selected Bibliography

PART I: ARTISTS

Carl Andre

Develing, Enno. "Carl Andre: Art as a Social Fact." *Arts Canada* 150 (December 1970–January 1971): 47–49.

Feldman, Paula, Alistair Rider, and Karsten Schubert, eds. *About Carl Andre: Critical Texts since 1965*. London: Ridinghouse, 2006.

Oral history interview with Carl Andre, 1972. Archives of American Art, Smithsonian Institution.

Siegel, Jeanne. "Carl Andre: Artworker." *Studio International* 180, no. 927 (November 1970): 175–79.

Vergne, Philippe, and Yasmil Raymond. *Carl Andre: Sculpture as Place, 1958–2010*. New York: Dia Art Foundation in association with Yale University Press, 2014. Exhibition catalogue.

Benny Andrews

Alloway, Lawrence. *Benny Andrews: The Bicentennial Series*. Atlanta, GA: High Museum of Art, 1975. Exhibition catalogue.

Black Emergency Cultural Coalition, Artists and Writers Protest against the War in Vietnam. *Attica Book*. Edited by Benny Andrews and Rudolf Baranik. South Hackensack, NJ: Customs Communications Systems, 1972.

Gruber, Richard J. *American Icons: From Madison to Manhattan, the Art of Benny Andrews, 1948–1997*. Augusta, GA: Morris Museum of Art, 1997. Exhibition catalogue.

Kuspit, Donald B., et al. *The Collages of Benny Andrews*. New York: Studio Museum in Harlem, 1988. Exhibition catalogue.

McDaniels III, Pellom. *Benny Andrews: The Bicentennial Series*. New York: Michael Rosenfeld Gallery, 2016. Exhibition catalogue.

Oral history interview with Benny Andrews, June 30, 1968. Archives of American Art, Smithsonian Institution.

Sims, Lowery Stokes. *Benny Andrews: There Must Be A Heaven*. New York: Michael Rosenfeld, 2013.

Art Workers' Coalition

Art Workers' Coalition. *Art Workers' Coalition: Documents: Open Hearing*. Seville, Spain: Editorial Doble J, 2009.

Balaschak, Chris. "Planet of the Apes: John Szarkowski, My Lai, and The Animals." *Art Journal* 71, no. 3 (2012): 6–25.

Bryan-Wilson, Julia. *Art Workers: Radical Practice in the Vietnam War Era*. Berkeley: University of California Press, 2009.

Corberia, Darío, and Daniel Patrick Rodríguez, eds. *Art Workers' Coalition*. Madrid: Brumaria A.C., 2010.

Frascina, Francis. *Art, Politics, and Dissent: Aspects of the Art Left in Sixties America*. Manchester, UK: Manchester University Press, 1999.

Glueck, Grace. "Art Notes: Yanking the Rug from Under." *New York Times*, January 25, 1970, D25.

Lippard, Lucy R. "The Art Workers' Coalition: Not a History." *Studio International* 180, no. 927 (November 1970): 171–74.

Asco

Benavidez, Max. *Gronk*. Minneapolis: University of Minnesota Press, 2007.

Chavoya, C. Ondine. "Internal Exiles: The Interventionist Public and Performance Art of Asco." In *Space, Site, Intervention: Situating Installation Art*, edited by Erika Suderburg, 189–208. Minneapolis: University of Minnesota Press, 2000.

Chavoya, C. Ondine. "Social Unwest: An Interview with Harry Gamboa, Jr." *Wide Angle* 20, no. 3 (1998): 55–78.

Chavoya, C. Ondine, and Rita Gonzalez, eds. *Asco: Elite of the Obscure, A Retrospective, 1972–1987*. Los Angeles: Los Angeles County Museum of Art in association with the Williams College Museum of Art and Hatje Cantz, 2011. Exhibition catalogue.

Cockcroft, Eva Sperling, and Holly Barnet-Sánchez, eds. *Signs from the Heart: California Chicano Murals*. Albuquerque: University of New Mexico Press, 1993.

Gamboa Jr., Harry. "In the City of Angels, Chameleons, and Phantoms: Asco, a Case Study of Chicano Art in Urban Tones (or Asco Was a Four-Member Word)." In *Chicano Art: Resistance and Affirmation, 1965–1985*, edited by Richard del Castillo, Theresa McKenna Griswold, and Yvonne Yarbro-Bejarano, 121–30. Los Angeles: Wight Art Gallery, University of California, Los Angeles, 1991. Exhibition catalogue.

González, Rita, Howard N. Fox, and Chon A. Noriega, eds. *Phantom Sightings: Art after the Chicano Movement*. Berkeley: University of California Press, 2008.

Noriega, Chon A. "'Your Art Disgusts Me': Early Asco, 1971–75." *Afterall: A Journal of Art, Context and Enquiry*, no. 19 (Autumn/ Winter 2008): 109–21.

Corita Kent, *right* (detail), 1967, screenprint. See p. 89

Oral history interview with Harry Gamboa Jr., Apr. 1–16, 1999. Archives of American Art, Smithsonian Institution.

Oral history interview with Gronk, Jan. 20–23, 1997. Archives of American Art, Smithsonian Institution.

Oral history interview with Willie Herrón, Feb. 5–Mar. 17, 2000. Archives of American Art, Smithsonian Institution.

Oral history interview with Patssi Valdez, May 26–June 2, 1999. Archives of American Art, Smithsonian Institution.

Judith Bernstein

Belcove, Julie L. "Judith Bernstein, an Art Star at Last at 72, Has Never Been Afraid of Dirty Words." *Vulture*, May 5, 2015. http://www.vulture.com/2015/05/judith-bernstein-isnt-afraid-of-dirty-words.html.

Bernstein, Judith. *Dicks of Death*. Zurich: Edition Patrick Frey, 2016.

Fateman, Johanna, et al. *Judith Bernstein: Rising*. Stravanger, Norway: Kunsthall Stravanger in association with Mousse Publishing, 2016. Exhibition catalogue.

Micchelli, Thomas, et al. *Judith Bernstein: Cabinet of Horrors*. New York: Drawing Center, 2018. Exhibition catalogue.

Miller, M. H. "How to Screw Your Way to the Top: Judith Bernstein Brings Her Signature Style to the New Museum." *Observer*, October 9, 2012. https://observer.com/2012/10/how-to-screw-your-way-to-the-top-judith-bernstein-brings-her-signature-style-to-the-new-museum/.

Norton, Margot. *Judith Bernstein: HARD*. New York: New Museum, 2012. Exhibition catalogue.

Chris Burden

Ayres, Anne, and Paul Schimmel. *Chris Burden: A Twenty-Year Survey*. Newport Beach, CA: Newport Harbor Art Museum, 1988. Exhibition catalogue.

Davis, Douglas. "Art without Limits." *Newsweek*, December 24, 1973, 68–74.

Kutner, Eric. "Shot in the Name of Art." *New York Times*, May 20, 2015. https://www.nytimes.com/2015/05/20/opinion/shot-in-the-name-of-art.html.

Philips, Lisa, and Massimiliano Gioni. *Chris Burden: Extreme Measures*. New York: New Museum, 2013. Exhibition catalogue.

Plagens, Peter. "He Got Shot—For His Art." *New York Times*, September 2, 1973, 87.

Sharp, Willoughby, and Liza Béar. "Chris Burden: The Church of Human Energy. An Interview by Willoughby Sharp and Liza Béar." *Avalanche* (Summer/Fall 1973): 54–61.

Ward, Frazer. "Burden." In *No Innocent Bystanders: Performance Art and Audience*, 81–108. Hanover, NH: Dartmouth College Press, 2012.

——— . "Gray Zone: Watching 'Shoot.'" *October* 95 (Winter 2001): 114–30.

T. C. Cannon

Benton, William. "T. C. Cannon: The Masked Dandy." *American Indian Art Magazine* 3, no. 4 (Autumn 1978): 34–39.

Frederick, Joan. *T. C. Cannon: He Stood in the Sun*. Flagstaff, AZ: Northland Publishing, 1995.

Kramer, Karen, ed. *T. C. Cannon: At the Edge of America*. Salem, MA: Peabody Essex Museum, 2018. Exhibition catalogue.

Marshall, Ann E., and Diana F. Pardue, eds. *Of God and Mortal Men: T. C. Cannon*. Santa Fe: Museum of New Mexico Press, 2017. Exhibition catalogue.

Scholder, Fritz, and T. C. Cannon. *Two American Indian Painters: Fritz Scholder & T. C. Cannon*. Washington, D.C.: Smithsonian Institution Press, 1972. Exhibition catalogue.

Yi, Joyce Cannon, ed. *My Determined Eye: Writings of T. C. Cannon*. La Mirada, CA: Cannon Yi Publishing, 2006.

Mel (Melesio) Casas

Baugh, Scott L., and Victor A. Sorell. *Born of Resistance: Cara a Cara Encounters with Chicana/o Visual Culture*. Tucson: University of Arizona Press, 2015.

Casas, Mel. *Mel Casas: An Exhibition*. Austin, TX: Laguna Gloria Art Museum, 1988.

Cordova, Rubén C. "The Cinematic Genesis of the Mel Casas Humanscape, 1965–1967." *Aztlán: A Journal of Chicano Studies* 36 (Fall 2011): 51–87.

——— . *Con Safo: The Chicano Art Group and the Politics of South Texas*. Los Angeles: UCLA Chicano Studies Research Center Press, 2009.

Kelker, Nancy L. *Mel Casas: Artist as Cultural Adjuster*. Lascassas, TN: High Ship Press, 2014.

Oral history interview with Mel Casas, Aug. 14–16, 1996. Archives of American Art, Smithsonian Institution.

Rosemarie Castoro

Castoro, Rosemarie. "The Artist and Politics: A Symposium." *Artforum* 9, no. 1 (September 1975): 36.

Faus, Clàudia, and Clara Plasencia, eds. *Rosemarie Castoro: Focus at Infinity*. Barcelona: Museu d'Art Contemporani de Barcelona, 2017. Exhibition catalogue.

Lippard, Lucy R. "Rosemarie Castoro: Working Out." *Artforum* 13, no. 10 (Summer 1975): 60–62.

Meyer, James. *Los Angeles to New York: Dwan Gallery, 1959–1971.* Washington, D.C.: National Gallery of Art, 2016. Exhibition catalogue.

Peiffer, Prudence. "Portfolio: Rosemarie Castoro." *Artforum* 54, no. 7 (March 2016): 220–33.

Judy Chicago

Bieber, Susanneh. "Restaging Chemical Warfare in Art: The Affirmative Power of Judy Chicago's Atmosphere Pieces." Paper presented at the Annual Conference of the Society for Literature, Science, and the Arts, Rice University, Houston, TX, November 12–15, 2015.

Chicago, Judy. *Through the Flower: My Struggle as a Woman Artist.* Garden City, NY: Doubleday, 1975.

Gotthardt, Alexa. "When Judy Chicago Rejected a Male-Centric Art World with a Puff of Smoke." *Artsy,* July 26, 2017. https://www.artsy.net/article/artsy-editorial-judy-chicago-rejected-male-centric-art-puff-smoke.

Judy Chicago: Painting, Sculpture, Photographs of Atmospheres. Fullerton: California State University, 1970. Exhibition catalogue.

Lippard, Lucy R. *Judy Chicago.* New York: Watson-Guptill Publications in association with the Elizabeth A. Sackler Foundation, 2002. Exhibition catalogue.

McGrew, Rebecca. *It Happened at Pomona: Art at the Edge of Los Angeles 1969–1973.* Pomona, CA: Pomona College Museum of Art, 2011. Exhibition catalogue.

William Copley

Celant, Germano, and Toby Kamps, eds. *William N. Copley.* Milan: Fondazione Prada, 2016.

Friese, Kaus Gerrit, ed. *William N. Copley: Among Ourselves.* Ostfildern, Germany: Hatje Cantz, 2009.

Oral history interview with William Copley, Jan. 30, 1968. Archives of American Art, Smithsonian Institution.

Emile de Antonio

Crowdus, Gary, and Dan Georgakas. "History Is the Theme of All My Films: An Interview with Emile de Antonio." *Cinéaste* 12, no. 2 (1982): 20–28.

Emile de Antonio Papers. Wisconsin Center for Film and Theater Research, University of Wisconsin, Madison.

Hoenisch, Michael. "1960s Documentary Film, Perceptions of the Vietnam War in the USA and Germany." In *The Transatlantic Sixties: Europe and the United States in the Counterculture Decade,* edited by Grzegorz Kosc, Clara Juncker, Sharon Monteith, and Britta Waldschmidt-Nelson, 174–202. Bielefeld, Germany: Transcript-Verlag, 2013.

Kellner, Douglas, and Dan Streible. *Emile de Antonio: A Reader.* Minneapolis: University of Minnesota Press, 2000.

Lewis, Randolph. *Emile de Antonio: Radical Filmmaker in Cold War America.* Madison: University of Wisconsin Press, 2000.

Rosenthal, Alan. "Emile de Antonio: An Interview." *Film Quarterly* 32, no. 1 (Fall 1978): 4–17.

Weiner, Bernard. "Radical Scavenging: An Interview with Emile de Antonio." *Film Quarterly* 25, no. 1 (Autumn 1971): 3–15.

Mark di Suvero

Collens, David R., Nora R. Lawrence, and Theresa Choi, eds. *Mark di Suvero.* Mountainville, NY: Storm King Art Center in association with DelMonico Books/Prestel, 2015.

de Menil, François, et al. *North Star: Mark di Suvero.* United States: Parrot Productions, 1977. Film, 54 min.

Kelley, Elizabeth L. "Mark di Suvero: Sculptor of Space." PhD diss., University of Louisville, 2011.

Mark di Suvero and di Suvero Family Papers, 1934–2005. Archives of American Art, Smithsonian Institution.

Monte, James K. *Mark di Suvero.* New York: Whitney Museum of American Art, 1975. Exhibition catalogue.

"Peace Tower: Irving Petlin, Mark di Suvero and Rirkrit Tiranvanija Revisit the Artist Tower Protest, 1966." *Artforum* 44, no. 7 (March 2006): 252–57.

Ragain, Melissa. "Kinetics of Liberation in Mark di Suvero's Play Sculpture." *American Art* 31, no. 3 (Fall 2017): 26–51.

Ratcliff, Carter. "Mark di Suvero." *Artforum* 11, no. 3 (1972): 34–41.

Rose, Barbara. "On Mark di Suvero: Sculpture Outside Walls." *Art Journal* 35, no. 2 (Winter 1975–76), 118–25.

Simon, Joan. "Urbanist at Large." *Art in America* (November 2005): 156–64, 193–94.

James Gong Fu Dong

Machida, Margo. *Icons of Presence: Asian American Activist Art.* San Francisco: Chinese Culture Foundation of San Francisco, 2008. Exhibition catalogue.

Wye, Deborah. *Committed to Print: Social and Political Themes in Recent American Printed Art.* New York: Museum of Modern Art, 1988. Exhibition catalogue.

Dan Flavin

Flavin, Dan. *Dan Flavin, Fluorescent Light.* Ottawa: National Gallery of Canada, 1969. Exhibition catalogue.

Getsy, David J. *Abstract Bodies: Sixties Sculpture in the Expanded Field of Gender.* New Haven, CT: Yale University Press, 2015.

Govan, Michael, and Tiffany Bell, eds. *Dan Flavin: A Retrospective.* Washington, D.C.: National Gallery of Art in association with Yale University Press and Dia Art Foundation, 2004. Exhibition catalogue.

Graham, Dan. "Flavin's Proposal." *Arts Magazine* 44, no. 4 (February 1970): 44.

Meyer, James. "The Minimal Unconscious." *October* 130 (Fall 2009): 141–76.

Müller, Grégoire. "Dan Flavin." In *The New Avant-Garde: Issues for the Art of the Seventies*, 9–12. New York: Praeger Publishers, 1972.

Weiss, Jeffrey S., and Briony Fer. *Dan Flavin: New Light.* Washington, D.C.: National Gallery of Art in association with Yale University Press, 2006.

Terry Fox

"A Discussion with Terry Fox, Vito Acconci, and Dennis Oppenheim." *Avalanche* 2 (Winter 1971): 96–99.

Fox, Terry. *Terry Fox: Articulations (Labyrinth/Text Works).* Philadelphia: Goldie Paley Gallery, 1992. Exhibition catalogue.

Lewallen, Connie. "The Eighties in 1970." *The Exhibitionist*, no. 2 (June 2010): 16–20.

Marioni, Tom. "Terry Fox: Himself." *Art and Artists* 7, no. 10 (January 1973): 38–41.

Oliva, Achille Bonito. "Terry Fox." *Domus* 521 (April 1973): 45.

Richardson, Brenda. *Terry Fox.* Berkeley, CA: University Art Museum, 1973. Exhibition catalogue.

Sharp, Willoughby. "Elemental Gestures: Terry Fox." *Arts Magazine* 44 (May 1970): 48–51.

White, Robin. "Terry Fox." *View* 2, no. 3 (June 1979): 1–24.

Rupert García

Cordova, Cary. "The Third World Strike and the Globalization of Chicano Art." In *The Heart of the Mission: Latino Art and Politics in San Francisco*, 92–125. Philadelphia: University of Pennsylvania Press, 2017.

Favela, Ramón. *The Art of Rupert García: A Survey Exhibition.* San Francisco: Mexican Museum in association with Chronicle Books, 1986. Exhibition catalogue.

García, Rupert. *Rupert García: Prints and Posters, 1967–1990.* Boston: Northeastern University Press in association with Fine Arts Museums of San Francisco, Centro Cultural/Arte Contemporáneo, and Fundación Cultural Televisa, 1990. Exhibition catalogue.

Gómez-Peña, Guillermo, and Rupert García. "Turning it Around: A Conversation between Rupert García and Guillermo Gómez-Peña." In *Aspects of Resistance*, 13–16, 33–35. New York: The Alternative Museum, 1994. Exhibition catalogue.

Oral history interview with Rupert García, Sept. 7, 1995–June 24, 1996. Archives of American Art, Smithsonian Institution.

Sims, Lowery Stokes. *Rupert García: Rolling Thunder.* San Francisco: Rena Bransten Gallery, 2018. Exhibition catalogue.

Yau, John. *Rupert García: The Magnolia Editions Projects, 1991–2011.* Oakland, CA: Magnolia Editions, 2011.

Leon Golub

Alloway, Lawrence. "Leon Golub: Art and Politics." *Artforum* 13, no. 2 (October 1974): 66–71.

Bird, Jon. "'Infvitabile Fatum': Leon Golub's History Painting." *Oxford Art Journal* 20, no. 1 (1997): 81–94.

———. *Leon Golub: Echoes of the Real.* London: Reaction Books, 2000. Exhibition catalogue.

Golub, Leon. *Leon Golub: Do Paintings Bite?, Selected Texts, 1948–1996.* Edited by Hans-Ulrich Obrist. Ostifildern, Germany: Distributed Art Publishers, 1997.

Horsfield, Kate, and Lyn Blumenthal, eds. "Profile: Leon Golub." *Video Data Bank* 2 (March 1982).

Kuspit, Donald. "Golub's Assassins: An Anatomy of Violence." *Art in America* 63, no. 3 (May/June 1975): 62–65.

———. *Leon Golub: Existential, Activist Painter.* New Brunswick, NJ: Rutgers University Press, 1985.

Procuniar, David. "Leon Golub. " *Journal of Contemporary Art* 7, no. 2 (1995): 53–66.

Sandler, Irving. "Rhetoric and Violence: Interview with Leon Golub." *Arts Magazine* 44, no. 4 (February 1970): 22–23.

Siegel, Jeanne. "How Effective Is Social Protest Art? (Vietnam)." Transcript of a discussion with Leon Golub, Allen D'Arcangelo, Ad Reinhardt, and Marc Morrel on WBAI on August 10, 1967. Printed in Jeanne Siegel, *Artworks: Discourse on the 60s and 70s*, 101–19. Ann Arbor, MI: UMI Research Press, 1988.

Philip Jones Griffiths

Abbott, Brett. *Engaged Observers: Documentary Photography since the Sixties*. Los Angeles: J. Paul Getty Museum, 2010.

Griffiths, Philip Jones. *Agent Orange: "Collateral Damage" in Viet Nam*. London: Trolley, 2003.

———. *Dark Odyssey*. Text by Murray Sayle. New York: Aperture, 1996.

———. *Vietnam at Peace*. London: Trolley, 2005.

———. *Vietnam Inc*. New York: Collier Books, 1971.

Messer, William. "Presence of Mind: The Photographs of Philip Jones Griffiths." *Aperture* 190 (Spring 2008): 56-67.

Miller, Russell. *Magnum: Fifty Years at the Front Line of History*. New York: Grove Press, 2013.

Philip Jones Griffiths Papers. National Library of Wales, Aberystwyth, Wales.

Stallabrass, Julian. "Interview: Philip Jones Griffiths." *Photoworks* (2007): 18-23.

van Kesteren, Geert, Brigitte Lardinois, and Julian Stallabrass. "Interview with Philip Jones Griffiths." 2007. In *Memory of Fire: Images of War and the War of Images*, edited by Julian Stallabrass, 56-79. Brighton, UK: Photoworks, 2013.

Guerrilla Art Action Group

GAAG: The Guerrilla Art Action Group, 1969-1976, A Selection. New York: Printed Matter, 2011.

Martin, Bradford D. *The Theater Is in the Street: Politics and Performance in Sixties America*. Amherst: University of Massachusetts Press, 2004.

Oral history interview with Jon Hendricks, March 24, 2010. Art Spaces Archives Project, New York.

Oral history interview with Jon Hendricks and Jean Toche, Dec. 13, 1972. Archives of American Art, Smithsonian Institution.

Oral history interview with Jean Toche, Dec. 18, 2009. Art Spaces Archives Project, New York.

Philip Guston

Auping, Michael. *Philip Guston Retrospective*. Fort Worth, TX: Modern Art Museum of Fort Worth in association with Thames & Hudson, 2003. Exhibition catalogue.

Ashton, Dore. *Yes, but...: A Critical Study of Philip Guston*. New York: Viking Press, 1976.

Balken, Debra Bricker. *Philip Guston's Poor Richard*. Chicago: University of Chicago Press, 2001.

Danto, Arthur C. "Philip Guston: The Nixon Drawings." In *Unnatural Wonders: Essays from the Gap between Art and Life*, 139-46. New York: Farrar, Straus and Giroux, 2005.

Guston, Philip. *Philip Guston: Collected Writings, Lectures, and Conversations*. Edited by Clark Coolidge. Berkeley: University of California Press, 2011.

Kaufmann, David. *Telling Stories: Philip Guston's Later Works*. Berkeley: University of California Press, 2010.

Mayer, Musa, and Sally Radic, eds. *Philip Guston: Nixon Drawings, 1971 & 1975*. New York: Hauser & Wirth Publishers, 2017. Exhibition catalogue.

Serota, Nicholas, ed. *Philip Guston: Paintings, 1969-1980*. London: Whitechapel Art Gallery, 1982. Exhibition catalogue.

Slifkin, Robert. *Out of Time: Philip Guston and the Refiguration of Postwar American Art*. Berkeley: University of California Press, 2013.

Hans Haacke

Borja-Villel, Manuel. *Castles in the Sky*. Madrid: Museo Nacional Centro de Arte Reina Sofía, 2012. Exhibition catalogue.

Buchloh, Benjamin. "Conceptual Art 1962-1969: From the Aesthetic of Administration to the Critique of Institutions." *October* 55 (Winter 1990): 105-43.

Burnham, Jack. "Steps in the Formulation of Real-Time Political Art." In *Hans Haacke, Framing and Being Framed: 7 Works 1970-75*, 129. Halifax, Canada: Press of the Nova Scotia College of Art and Design, 1975.

———. "Systems Esthetics." *Artforum* 7, no. 1 (September 1968): 30-35.

Debbaut, Jan, Catherine Lacey, and Hans Haacke, eds. *Hans Haacke*. Eindhoven, Netherlands: Stedelijk Van Abbemuseum in association with the Tate Gallery, 1984. Exhibition catalogue.

Haacke, Hans. *Working Conditions: The Writings of Hans Haacke*. Edited by Alexander Alberro. Cambridge, MA: MIT Press, 2016.

Jones, Caroline, and Edward Fry. *Hans Haacke: 1967*. Cambridge, MA: MIT List Visual Arts Center, 2011. Exhibition catalogue.

Siegel, Jeanne. "An Interview with Hans Haacke." *Arts Magazine* 45, no. 7 (May 1971): 18-21.

Skrebowski, Luke. "All Systems Go: Recovering Hans Haacke's Systems Art." *Grey Room* 30 (Winter 2008): 54-83.

Tyson, John. "Hans Haacke: Beyond Systems Aesthetics." PhD diss., Emory University, 2015.

David Hammons

Godfrey, Mark. "Flight Fantasies: The Work of David Hammons." In *David Hammons: Give Me a Moment, The George Economou Collection*, 19–41. Athens: Artesia, 2016. Exhibition catalogue.

Hammons, David. *David Hammons: Five Decades*. New York: Mnuchin Gallery, 2016. Exhibition catalogue.

Jones, Kellie. *Now Dig This! Art and Black Los Angeles*. New York: Prestel, 2011. Exhibition catalogue.

———. *South of Pico: African American Artists in Los Angeles in the 1960s and 1970s*. Durham, NC: Duke University Press, 2017.

Tilton, Connie Rogers, and Lindsay Charlwood. *L.A. Object & David Hammons Body Prints*. New York: Tilton Gallery, 2011. Exhibition catalogue.

Young, Joseph E. *Three Graphic Artists: Charles White, David Hammons, Timothy Washington*. Los Angeles: Los Angeles County Museum of Art in association with the Santa Barbara Museum of Art, 1971. Exhibition catalogue.

Wally Hedrick

Coplans, John. "Wally Hedrick: Offense Intended." *Artforum* 1, no. 11 (May 1963): 28.

Dunham, Judith L. "Wally Hedrick Vietnam Series." *Artweek*, June 28, 1975, 20.

Goldberg, Leslie. Interview with Wally Hedrick, August 16, 2002. di Rosa Artist Interview Series.

Oral history interview with Wally Hedrick, June 10–24, 1974. Archives of American Art, Smithsonian Institution.

Rubin, David S. *Wally Hedrick: Selected Works*. San Francisco: San Francisco Art Institute, 1985. Exhibition catalogue.

Solnit, Rebecca. *Secret Exhibition: Six California Artists of the Cold War Era*. San Francisco: City Lights Books, 1990.

Tooker, Dan. "Dan Tooker Interviews Wally Hedrick." *Art International* 19 (1975): 10–14.

Van Proyen, Mark. "An Interview with Wally Hedrick." *Éxpo-See* 16 (Summer 1985): n.p.

Douglas Huebler

Berger, Christian. "Douglas Huebler and the Photographic Document." *Visual Resources* 32, nos. 3–4 (2016): 210–29.

Honnef, Klaus. "Douglas Huebler." *Art and Artists* 7, no. 10 (1973): 22–25.

Huebler, Douglas. *Douglas Huebler: Works from the 1960s*. Essay by Ann Goldstein. New York: Paula Cooper Gallery, 2017.

———. "untitled statements." In *Arte Povera: Conceptual, Actual or Impossible Art?*, edited by Germano Celant, 43. New York: Praeger Publishers, 1969.

Hughes, Gordon. "Exit Ghost: Douglas Huebler's Face Value." *Art History* 32, no. 5 (December 2009): 894–909.

Carlos Irizarry

Benítez, Marimar. "Art and Politics: The Case of Carlos Irizarry." In *None of the Above: Contemporary Work by Puerto Rican Artists*, edited by Deborah Cullen, 118–23. Hartford, CT: Real Art Ways, 2004. Exhibition catalogue.

Hargrove, Yasmin Ramírez, et al. *Pressing the Point: Parallel Expression in the Graphic Arts of the Chicano and Puerto Rico Movements*. New York: Museo del Barrio, 1999.

La Nueva Abstracción: Domingo López, Luis Hernández Cruz and Carlos Irizarry. San Juan, Puerto Rico: El Museo de la Universidad de Puerto Rico, 1966. Exhibition catalogue.

Ramírez, Yasmin. Unpublished interview with Carlos Irizarry, May 2000. Carlos Irizarry Curatorial File, Smithsonian American Art Museum.

Ramos, E. Carmen. *Our America: The Latino Presence in American Art*. Washington, D.C.: Smithsonian American Art Museum, 2014. Exhibition catalogue.

Kim Jones

Durland, Steve. "Back from the Front: Artist Kim Jones Is the Veteran of an Experience America Cannot Forget." *High Performance* 25 (1984): 26–29.

Firmin, Sandra, and Julie Joyce. *Mudman: The Odyssey of Kim Jones*. Cambridge, MA: MIT Press, 2007. Exhibition catalogue.

Harries, Martin. "Regarding the Pain of Rats: Kim Jones's Rat Piece." *TDR: The Drama Review* 51, no. 1 (Spring 2007): 160–65.

Jones, Kim. Untitled contribution. In *Unwinding the Vietnam War: From War into Peace*, edited by Reese Williams, 112–20. Seattle: Real Comet Press, 1987.

Kim Jones. Conversation with Robert Storr. Antwerp: Zeno X Books, 2016.

Kim Jones: War Paint. Conversation with Susan Swenson. Brooklyn: Pierogi, 2005.

Maine, Stephen. "Things He Carried. " *Art in America* (November 2007): 184–90.

Murray, Peter. *A Cripple in the Right Way May Beat a Racer in the Wrong One*. Cobh, Ireland: Sirius Arts Centre, 2004. Exhibition catalogue.

Stiles, Kristine. "Teaching a Dead Hand To Draw: Kim Jones, War, and Art (2007)." In *Concerning Consequences: Studies in Art, Destruction and Trauma*, 176-93. Chicago: University of Chicago Press, 2016.

Donald Judd

Judd, Donald. *Donald Judd: Complete Writings 1959-1975*. Marfa, TX: Judd Foundation, 2016.

Raskin, David. *Donald Judd*. New Haven, CT: Yale University Press, 2017.

———. "Specific Opposition: Judd's Art and Politics." *Art History* 24 (November 2001): 682-706.

Schellmann, Jorg, and Mariette Josephus Jitta, eds. *Donald Judd: Prints and Works in Editions, 1951-1993*. New York: Edition Schellmann, 1993.

Serota, Nicholas, ed. *Donald Judd*. London: Tate Publishing, 2004. Exhibition catalogue.

Smith, Brydon, ed. *A Catalogue of the Exhibition at the National Gallery of Canada, Ottawa, 24 May-6 July 1975: Catalogue Raisonné of Paintings, Objects, and Wood Blocks, 1960-1974*. Ottawa: National Gallery of Canada, 1975. Exhibition catalogue.

On Kawara

Chiong, Kathryn. "Kawara on Kawara." *October* 90 (Autumn 1999): 50-75.

Kawara, On. *On Kawara, continuity/discontinuity, 1963-1979*. Stockholm: Moderna Museet, 1980. Exhibition catalogue.

———. *On Kawara 1952-1956 Tokyo*. Tokyo: Parco Col, 1991.

Lippard, Lucy R. *On Kawara 1967*. Los Angeles: Otis Art Institute Gallery, 1977. Exhibition catalogue.

Wall, Jeff. "Monochrome and Photojournalism in On Kawara's *Today* Paintings." In *Robert Lehman Lectures on Contemporary Art*, 135-65. New York: Dia Center for the Arts in association with Dia Art Foundation, 1996.

Watkins, Jonathan. *On Kawara*. London: Phaidon, 2002.

Weiss, Jeffrey. *On Kawara: Silence*. New York: Guggenheim Museum Publications, 2015. Exhibition catalogue.

———. "On Kawara, Title." *Circle Bulletin, National Gallery of Art* 35 (Fall 2006): 26-27.

Woo, Jung-Ah. "On Kawara's 'Date Paintings': Series of Horror and Boredom." *Art Journal* 69, no. 3 (Fall 2010): 62-72.

———. "Terror of the Bathroom: On Kawara's Early Figurative Drawings and Postwar Japan." *Oxford Art Journal* 33, no. 3 (2010): 263-76.

Corita Kent

Ault, Julie. *Come Alive! The Spirited Art of Sister Corita*. London: Four Corners Books, 2007.

Berry, Ian, and Michael Duncan, eds. *Someday is Now: The Art of Corita Kent*. Munich: Prestel, 2014. Exhibition catalogue.

Crow, Thomas. *No Idols: The Missing Theology of Art*. Sydney: Power Publications, 2017.

Dackerman, Susan, ed. *Corita Kent and the Language of Pop*. New Haven, CT: Yale University Press, 2015. Exhibition catalogue.

Galm, Bernard. "Los Angeles Art Community: Group Portrait, Corita Kent." Interview with Corita Kent, April 6-20, 1976. Oral History Program, University of California, Los Angeles.

Gaylord, Kristen. "Catholic Art and Activism in Postwar Los Angeles." In *Conflict, Identity, and Protest in American* Art, edited by Miguel de Baca and Makeda Best, 99-120. Newcastle upon Tyne, UK: Cambridge Scholars Publishing, 2015.

Edward Kienholz

Albright, Thomas. "The Portable War Memorial Commemorating VD Day." *Rolling Stone*, December 21, 1968. https://www.rollingstone.com/culture/culture-news/the-portable-war-memorial-commemorating-vd-day-191862/.

Arce, Hector. "Eleventh Hour." *Home Furnishings Daily,* May 9, 1968, n.p.

Edward Kienholz. *Edward Kienholz: 11 + 11 Tableaux*. Stockholm: Moderna Museet, 1970. Exhibition catalogue.

Hopps, Walter. *Kienholz: A Retrospective*. New York: Whitney Museum of American Art, 1996. Exhibition catalogue.

Kienholz, Edward. "Letter." *Artforum* 7, no. 10 (Summer 1969): 4-5.

Lipschitz, Ruth. "Re-presenting America: Edward Kienholz's *Portable War Memorial* and Cold War Politics." *de arte* 37, no. 65 (2002): 22-41.

Weinhart, Martina, and Max Hollein. *Kienholz: The Signs of the Times*. Frankfurt: Schirn Kunsthalle, 2011. Exhibition catalogue.

Weschler, Lawrence. "A Thought Experiment (or who knows? perhaps something more) Arising from a Consideration of Ed Kienholz's Proposed *Non-War Memorial* (1970) and Other Such Memorials of That Ilk." *Glasstire,* September 21, 2014. https://glasstire.com/2014/09/21/ed-kienholzs-proposed-non-war-memorial-1970-and-other-such-memorials-of-that-ilk/.

Yayoi Kusama

Hoptman, Laura, Akira Tatehata, Udo Kultermann, and Catherine Taft. *Yayoi Kusama*. London; New York: Phaidon Press, 2017.

Kusama, Yayoi. *Infinity Net: The Autobiography of Yayoi Kusama.* Chicago: University of Chicago Press, 2011.

Morris, Frances, ed. *Yayoi Kusama.* London: Tate Publishing, 2012. Exhibition catalogue.

Nixon, Mignon. "Anatomic Explosion on Wall Street." *October* 142 (Fall 2012): 3–12.

Van Starrex, Al. "Kusama and Her Naked Happenings." *Mr. Magazine* 12, no. 9 (August 1968): 38–61.

Yamamura, Midori. *Yayoi Kusama: Inventing the Singular.* Cambridge, MA: MIT Press, 2015.

Zelevansky, Lynn. *Love Forever: Yayoi Kusama, 1958–1968.* Los Angeles: Los Angeles County Museum of Art, 1999. Exhibition catalogue.

John Lennon

Herzogenrath, Wulf, and Dorothee Hansen, eds. *John Lennon: Drawings, Performances, Films.* Stuttgart: Cantz in association with Distributed Art Publishers, 1995.

Stiles, Kristine. "Unbosoming Lennon: The Politics of Yoko Ono's Experience." *Art Criticism* 7, no. 2 (1992): 21–52.

Fred Lonidier

Canbaz, Melissa. "Fred Lonidier," *Frieze d/e* (Autumn 2011).

Dawsey, Jill, ed. *The Uses of Photography: Art, Politics, and the Re-invention of a Medium.* San Diego: Museum of Contemporary Art San Diego, 2016. Exhibition catalogue.

Dillon, Brian. "Police, Camera, Action: The Arresting Photographs of Fred Lonidier." *Art Review* 50 (May 2011): 42.

"Fred Lonidier Draft Resistance Seattle Collection." Pacific Northwest Antiwar and Radical History Project, University of Washington, Seattle. http://depts.washington.edu/labpics/zenPhoto/antiwar/lonidier/.

Inzule, Egija. "Fred Lonidier: Conceptual Artist in the Labor Movement, or Vice Versa." In *Whitney Biennial 2014*, edited by Stuart Comer et al., 96–99. New York: Whitney Museum of American Art, 2014.

Mizota, Sharon. "Review: '70s Social Commentary Still Resonates in Fred Lonidier Artworks." *Los Angeles Times*, June 27, 2014.

Wallis, Brian. "Fred Lonidier: The Agitator." *Aperture* 226 (Spring 2017): 100–107.

Malaquias Montoya

Goldman, Shifra M. "Fifteen Years of Chicano Posters." *Art Journal* 44, no. 1 (Spring 1984): 50–57.

Malaquias Montoya: The 1997 Adaline Kent Award Exhibition. San Francisco: San Francisco Art Institute, 1997. Exhibition catalogue.

Montoya, Malaquias, and Lezlie Salkowitz-Montoya. "A Critical Perspective on the State of Chicano Art." *Metamórfosis: Northwest Chicano Magazine of Literature, Art and Culture* 3, no. 1 (Spring–Summer 1980): 3–7.

Oral history interview with José and Malaquias Montoya, Feb. 28–June 2, 1988. Archives of American Art, Smithsonian Institution.

Romo, Terezita. *The Art of Protest: The Posters of Malaquias Montoya.* San Jose, CA: MACLA/San José Center for Latino Arts, 1997. Exhibition catalogue.

———. *Malaquias Montoya.* Los Angeles: UCLA Chicano Studies Research Center Press, 2011.

Robert Morris

Berger, Maurice. *Labyrinths: Robert Morris, Minimalism, and the 1960s.* New York: Harper & Row, 1989.

Bryan-Wilson, Julia, ed. *Robert Morris.* Cambridge, MA: MIT Press, 2013.

Compton, Michael, and David Sylvester. *Robert Morris.* London: Tate Gallery, 1971. Exhibition catalogue.

Krens, Thomas, and Rosalind Krauss. *Robert Morris: The Mind/Body Problem.* New York: Solomon R. Guggenheim Foundation, 1994. Exhibition catalogue.

Morris, Robert. *Have I Reasons: Work and Writings, 1993–2007.* Edited by Nena Tsouti-Schillinger. Durham, NC: Duke University Press, 2008.

Tucker, Marcia. *Robert Morris.* New York: Whitney Museum of American Art, 1970. Exhibition catalogue.

Bruce Nauman

Cordes, Christopher. "Talking with Bruce Nauman (1989)." In *Bruce Nauman*, edited by Robert C. Morgan, 295. Baltimore: Johns Hopkins University Press, 2002.

Halbreich, Kathy. *Bruce Nauman: Disappearing Acts.* New York: Museum of Modern Art, 2018. Exhibition catalogue.

Ketner, Joseph D. *Elusive Signs: Bruce Works with Light.* Milwaukee, WI: Milwaukee Art Museum, 2006. Exhibition catalogue.

Kraynak, Janet. *Nauman Reiterated.* Minneapolis: University of Minnesota Press, 2014.

Nauman, Bruce. *Please Pay Attention Please: Writings and Interviews.* Edited by Janet Kraynak. Cambridge, MA: MIT Press, 2005.

Plagens, Peter. *Bruce Nauman: The True Artist*. London: Phaidon, 2014.

Walsh, Taylor. "*Small Fires* Burning: Bruce Nauman and the Activation of Conceptual Art." *October* 163 (Winter 2018): 21–48.

Walsh, Taylor, ed. *Bruce Nauman (October Files)*. Cambridge, MA: MIT Press, 2018.

Barnett Newman

Ho, Melissa, ed. *Reconsidering Barnett Newman*. Philadelphia: Philadelphia Museum of Art, 2005.

Newman, Barnett. *Barnett Newman: A Catalogue Raisonné*. New Haven, CT: Yale University Press, 2004.

———. *Barnett Newman: Selected Writings and Interviews*. Edited by John P. O'Neill. Berkeley: University of California Press, 1992.

Temkin, Ann. *Barnett Newman*. Philadelphia: Philadelphia Museum of Art, 2002. Exhibition catalogue.

Jim Nutt

Bowman, Russell. "An Interview with Jim Nutt." *Arts* 52, no. 7 (March 1978): 133.

Bowman, Russell, and Margaret Andera, eds. *Jim Nutt*. Milwaukee, WI: Milwaukee Art Museum, 1994. Exhibition catalogue.

Halstead, Whitney. *Jim Nutt*. Chicago: Museum of Contemporary Art, 1974. Exhibition catalogue.

Nadel, Dan, ed. *The Collected Hairy Who Publications 1966-1969: Jim Falconer, Art Green, Gladys Nilsson, Jim Nutt, Suellen Rocca, Karl Wirsum*. New York: Matthew Marks Gallery, 2015.

Nichols, Thea Liberty, Ann Goldstein, and Mark Pascale, eds. *Hairy Who? 1966-1969*. Chicago: Art Institute of Chicago, 2018.

Warren, Lynne. *Jim Nutt: Coming into Character*. Chicago: Museum of Contemporary Art, 2011. Exhibition catalogue.

Claes Oldenburg

Casteras, Susan P. *The Lipstick Comes Back*. New Haven, CT: Yale University Art Gallery, 1974. Exhibition catalogue.

Darnton, John. "Oldenburg Hopes His Art Will Make Imprint at Yale." *New York Times*, May 16, 1969.

Haskell, Barbara, ed. *Claes Oldenburg: Object into Monument*. Pasadena, CA: Pasadena Art Museum in association with Ward Ritchie Press, 1971. Exhibition catalogue.

Hochdörfer, Achim, Maartje Oldenburg, and Barbara Schröder. *Claes Oldenburg: Writing on the Side, 1956-1969*. New York: Museum of Modern Art, 2013.

Marcuse, Herbert. "Commenting on Claes Oldenburg's Proposed Monuments for New York City." *Perspecta: The Yale Architectural Journal* 12 (1969): 75–76.

Oldenburg, Claes. "America: War and Sex, Etc." *Arts* 41, no. 8 (Summer 1967): 32–38.

———. *Claes Oldenburg: Constructions, Models and Drawings*. Chicago: Richard Feigen Gallery, 1969. Exhibition catalogue.

Rose, Barbara. "Oldenburg Joins the Revolution." *New York Magazine*, June 2, 1969.

Rottner, Nadja, ed. *Claes Oldenburg*. Cambridge, MA: MIT Press, 2012.

Shapiro, David. "Sculpture as Experience: The Monument That Suffered," *Art in America* 62, no. 3 (May-June 1974): 55–58.

Williams, Tom. "Lipstick Ascending: Claes Oldenburg in New Haven in 1969," *Grey Room* 32 (Spring 2008): 116–44.

Yoko Ono

Biesenbach, Klaus, and Christophe Cherix, eds. *Yoko Ono: One Woman Show, 1960-1971*. New York: Museum of Modern Art, 2015. Exhibition catalogue.

Bryan-Wilson, Julia. "Remembering Yoko Ono's *Cut Piece*." *Oxford Art Journal* 26, no. 1 (2003): 101–23.

Childs, Charles. "Penthouse Interview: John & Yoko Lennon." *Penthouse*, October 1969.

Concannon, Kevin. "*War Is Over!*: John and Yoko's Christmas Eve Happening, Tokyo, 1969," *Review of Japanese Culture and Society* 17 (December 2005): 72–85.

———. "Yoko Ono's *Cut Piece*: From Text to Performance and Back Again." *PAJ: A Journal of Performance and Art* 30, no. 3 (September 2008): 81–93.

Munroe, Alexandra, and Jon Hendricks, eds. *Yes Yoko Ono*. New York: Japan Society in association with Harry N. Abrams, 2000. Exhibition catalogue.

Pfeiffer, Ingrid, Max Hollein, and Jon Hendricks, eds. *Yoko Ono: Half-a-wind Show, a Retrospective*. Frankfurt: Schirn Kunsthalle Frankfurt in association with Prestel, 2013. Exhibition catalogue.

Rhee, Jieun. "Performing the Other: Yoko Ono's *Cut Piece*." *Art History* 28, no. 1 (February 2005): 96–118.

Dennis Oppenheim

Burnham, Jack. "Dennis Oppenheim: Catalyst 1967-1970." *ArtsCanada* 27, no. 4 (August 1970): 29–36.

Celant, Germano. *Dennis Oppenheim: Explorations*. Milan: Charta, 2001.

"Discussions with Heizer, Oppenheim, Smithson." *Avalanche Magazine* 1 (Fall 1970): 48–71.

Kaye, Nick, and Amy Van Winkle Oppenheim. *Dennis Oppenheim: Body to Performance, 1969–73.* Milan: Skira, 2016.

Oppenheim, Dennis. *Dennis Oppenheim: 1968, Earthworks & Ground Systems.* San Francisco: Haines Gallery, 2012. Exhibition catalogue.

Oral history interview with Dennis Oppenheim, June 23–24, 2009. Archives of American Art, Smithsonian Institution.

Sharp, Willoughby. "Dennis Oppenheim Interviewed by Willoughby Sharp." *Studio International* 182, no. 938 (November 1971): 188.

Liliana Porter

Baler, Pablo. "The Subconscious of Civilization: An Interview with Liliana Porter." *Sculpture* 20, no. 1 (2001): 36–41.

Bazzano-Nelson, Florencia. *Liliana Porter and the Act of Simulation.* Burlington, VT: Ashgate Publishing, 2008.

Fajardo-Hill, Cecilia, and Andrea Giunta. *Radical Women: Latin American Art, 1960–1985.* Los Angeles: Hammer Museum, University of California in association with DelMonico Books/Prestel, 2017. Exhibition catalogue.

Perez-Barriero, Gabriel, Ursula Davila-Villa, and Gina McDaniel Tarver, eds. *The New York Graphic Workshop, 1964–1970.* Austin, TX: Blanton Museum of Art, the University of Texas at Austin in association with Distributed Art Publishers, 2009. Exhibition catalogue.

Porter, Liliana. *Liliana Porter: Fragments of the Journey.* Bronx, NY: Bronx Museum of the Arts, 1992. Exhibition catalogue.

Porter, Liliana, Inés Katzenstein, Gregory Volk, and Fundación Cisneros. *Liliana Porter: In Conversation with/En conversación con Inés Katzenstein.* New York: Fundación Cisneros/Colección Patricia Phelps de Cisneros, 2013.

Rexer, Lyle, Lius Camnitzer, and Liliana Porter. "New York Graphic Workshop." *Art on Paper* 13, no. 1 (2008): 50–59.

Yvonne Rainer

Archais, Elise. *The Concrete Body: Yvonne Rainer, Carolee Schneemann, Vito Acconci.* New Haven, CT: Yale University Press, 2016.

Bear, Liza, and Willoughby Sharp. "The Performer as a Persona: An Interview with Yvonne Rainer." *Avalanche* 5 (Summer 1972): 46–59.

Blumenthal, Lyn. "On Art and Artists: Yvonne Rainer." *Profile* 4, no. 5 (Fall 1984): 2–48.

Bryan-Wilson, Julia. "Practicing Trio A." *October* 140 (Spring 2012): 54–74.

Lambert, Carrie. "Moving Still: Meditating Yvonne Rainer's *Trio A.*" *October* 89 (Summer 1999): 87–112.

Lambert-Beatty, Carrie. *Being Watched: Yvonne Rainer and the 1960s.* Cambridge, MA: MIT Press, 2008.

Platt, Ryan. "The Ambulatory Aesthetics of Yvonne Rainer's *Trio A.*" *Dance Research Journal* 46, no. 1 (April 2014): 41–60.

Rainer, Yvonne. *Feelings Are Facts: A Life.* Cambridge, MA: MIT Press, 2013.

———. "Trio A: Genealogy, Documentation, Notation." *Dance Research Journal* 41, no. 2 (Winter 2009): 12–18.

———. *Yvonne Rainer: Work, 1961–73.* Halifax, Canada: Press of Nova Scotia College of Art and Design, 1974.

Sachs, Sid. *Yvonne Rainer: Radical Juxtapositions, 1961–2002.* Philadelphia: University of the Arts, 2002. Exhibition catalogue.

Wood, Catherine. *Yvonne Rainer: The Mind Is a Muscle.* London: Afterall Books, 2007.

Ad Reinhardt

Bois, Yve-Alain. *Ad Reinhardt.* New York: Rizzoli, 1991.

Corris, Michael. *Ad Reinhardt.* London: Reaktion, 2008.

Frelik, Edyta. "Ad Reinhardt: Painter-as-Writer." *American Art* 28, no. 3 (Fall 2014): 104–25.

Lippard, Lucy. *Ad Reinhardt.* New York: H. N. Abrams, 1981.

Marie, Annicka. "Ad Reinhardt: Mystic or Materialist, Priest or Proletarian?" *Art Bulletin* 96, no. 4 (December 2014): 463–84.

Reinhardt, Ad, and Barbara Rose. *Art-as-Art: The Selected Writings of Ad Reinhardt.* Berkeley: University of California Press, 1991.

Siegel, Jeanne. "How Effective Is Social Protest Art? (Vietnam)." Transcript of a discussion with Leon Golub, Allen D'Arcangelo, Ad Reinhardt, and Marc Morrel on WBAI on August 10, 1967. Printed in Jeanne Siegel, *Artwords: Discourse on the 60s and 70s.* Ann Arbor, MI: UMI Research Press, 1988.

Faith Ringgold

Collins, Thom, and Tracy Fitzpatrick. *American People, Black Light: Faith Ringgold's Paintings of the 1960s.* Purchase, NY: Neuberger Museum of Art, Purchase College, State University of New York, 2010. Exhibition catalogue.

Farrington, Lisa E. *Art on Fire: The Politics of Race and Sex in the Paintings of Faith Ringgold.* New York: Millennium Fine Arts, 1999.

Flomenhaft, Eleanor, et al. *Faith Ringgold, a 25 Year Survey.* Hempstead, NY: Fine Arts Museum of Long Island, 1990. Exhibition catalogue.

Gouma-Peterson, Thalia, and Kathleen McManus Zurko. *Faith Ringgold: Painting, Sculpture, Performance.* Wooster, OH: College of Wooster, Art Museum, 1985. Exhibition catalogue.

Hill, Patrick. "The Castration of Memphis Cooly: Race, Gender and Nationalist Iconography in the Flag Art of Faith Ringgold." In *Dancing at the Louvre: Faith Ringgold's French Collection and Other Story Quilts*, edited by Dan Cameron, 26–38. Berkeley: University of California Press, 1988.

Oral history interview with Faith Ringgold, 1972. Archives of American Art, Smithsonian Institution.

Oral history interview with Faith Ringgold, Sept. 6–Oct. 18, 1989. Archives of American Art, Smithsonian Institution.

Ringgold, Faith. *Faith Ringgold.* St. Louis: Saint Louis Art Museum, 1994. Exhibition catalogue.

———. *Faith Ringgold: Twenty Years of Painting, Sculpture, and Performance, 1963-1983.* New York: Studio Museum in Harlem, 1984. Exhibition catalogue.

———. *We Flew Over the Bridge: The Memoirs of Faith Ringgold.* Boston: Little, Brown and Company, 1995.

Martha Rosler

Alexander, Darsie, et al. *Martha Rosler: Irrespective.* New Haven, CT: Yale University Press, 2018. Exhibition catalogue.

Aliaga, Juan Vicente, et al. *Martha Rosler: The House, The Street, The Kitchen.* Granada, Spain: Diputación de Granada, 2009. Exhibition catalogue.

Blazwick, Iwona. "Taking Responsibility: Martha Rosler Interviewed by Iwona Blazwick." *Art Monthly* 314 (March 2008): 1–7.

Cottingham, Laura. "The Inadequacy of Seeing and Believing: The Art of Martha Rosler." In *Inside the Visible: An Elliptical Traverse of 20th Century Art, in, of, and from the Feminine*, edited by M. Catherine de Zegher, 157–63. Cambridge, MA: MIT Press, 1998. Exhibition catalogue.

de Zegher, Catherine, ed. *Martha Rosler: Positions in the Life World.* Cambridge, MA: MIT Press, 1998. Exhibition catalogue.

Jacobus-Parker, Frances. "Shock-Photo: The War Images of Rosler, Spero, and Celmins." In *Conflict, Identity, and Protest in American Art*, edited by Makeda Best and Miguel de Baca, 57–74. Newcastle upon Tyne, UK: Cambridge Scholars Publishing, 2015.

Moss, Karen. "Martha Rosler's Photomontages and Garage Sales: Private and Public, Discursive and Dialogical." *Feminist Studies* 39, no. 3 (2013): 686–721.

"On Art and Artists: Martha Rosler Interviewed by Craig Owens." *Profile* 5, no. 2 (Spring 1986): 2–49. Transcript of an interview produced by Lyn Blumenthal and Kate Horsfield, 1985, available through Video Data Bank, School of the Art Institute of Chicago. http://www.vdb.org/titles/martha-rosler-interview.

Rosler, Martha. *Decoys and Disruptions: Selected Writings, 1975-2001.* Cambridge, MA: MIT Press in association with the International Center of Photography, 2004.

Peter Saul

Cameron, Dan, ed. *Peter Saul.* Newport Beach, CA: Orange County Museum of Art in association with Hatje Cantz, 2008. Exhibition catalogue.

McCarthy, David. "Defending Allusion: Peter Saul on the Aesthetics of Rhetoric." *Archives of American Art Journal* 46, nos. 3/4 (Fall 2007): 46–51.

———. "Dirty Freaks and High School Punks: Peter Saul's Critique of the Vietnam War." *American Art* 23, no. 1 (Spring 2009): 78–103.

Oral history interview with Peter Saul, 1972. Archives of American Art, Smithsonian Institution.

Richards, Judith Olch. Oral history interview with Peter Saul, November 3–4, 2009. Archives of American Art, Smithsonian Institution.

Saul, Peter. *Peter Saul: From Pop to Punk, Paintings from the '60s + '70s.* New York: Venus Over Manhattan, 2015. Exhibition catalogue.

Saul, Peter, and Joe Raffaele. "Los Angeles: Subversive Art, Peter Saul & Joe Raffaele." *Arts Magazine* 41 (May 1967): 51.

Storr, Robert. *Peter Saul: A Retrospective.* Newport Beach, CA: Orange County Museum of Art, 2008. Exhibition catalogue.

Weinhart, Martina. *Peter Saul.* Cologne, Germany: Snoech Verlag, 2017. Exhibition catalogue.

Zack, David. "That's Saul, Folks." *ARTnews* (November 1969): 56–58.

Carolee Schneemann

Breitwieser, Sabine. *Carolee Schneemann: Kinetic Painting.* Munich: Prestel, 2016. Exhibition catalogue.

Cameron, Dan, ed. *Carolee Schneemann: Up to and Including Her Limits.* New York: New Museum of Contemporary Art, 1996. Exhibition catalogue.

Carolee Schneemann Papers, Special Collections, Getty Research Institute, Los Angeles.

Schneemann, Carolee. *Correspondence Course: An Epistolary History of Carolee Schneemann and Her Circle.* Edited by Kristine Stiles. Durham, NC: Duke University Press, 2010.

———. *Imaging Her Erotics: Essays, Interviews, Projects.* Cambridge, MA: MIT Press, 2002.

———. *More than Meat Joy: Complete Performance Works & Selected Writings.* Edited by Bruce McPherson. New Paltz, NY: Documentexts, 1979.

Wallace, Brian, et al. *Carolee Schneemann: Within and Beyond the Premises.* New Paltz, NY: Samual Dorsky Museum of Art in association with the State University of New York Press, 2010. Exhibition catalogue.

White, Kenneth. "Carolee Schneemann." *Third Rail Quarterly* 4 (Spring 2015).

White, Kenneth, ed. *Carolee Schneemann: Unforgivable.* London: Black Dog Publishing, 2015.

Robert Smithson

Flam, Jack, ed. *Robert Smithson: The Collected Writings.* Berkeley: University of California Press, 1996.

Gildzen, Alex. "'Partially Buried Woodshed': A Robert Smithson Log." *Arts* 52, no. 9 (May 1978): 118-20.

Horning, Ron. "In Time: Earthworks, Photodocuments, and Robert Smithson's Buried Shed." *Aperture* 106 (Spring 1987): 74-77.

Martin, Richard. "Robert Smithson's *Partially Buried Woodshed.*" *Arts* 59, no. 1 (September 1984): 104-5.

Reynolds, Ann. *Robert Smithson: Learning from New Jersey and Elsewhere.* Cambridge, MA: MIT Press, 2003.

Shinn, Dorothy. *Robert Smithson's Partially Buried Woodshed.* Kent, OH: Kent State University Art Galleries, 1990. Exhibition catalogue.

Smithson, Robert. *Structures of Experience: An Exhibition in Response to Robert Smithson at Kent State University.* Kent, OH: Kent State University Art Galleries, 2005. Exhibition catalogue.

Tsai, Eugenie. *Robert Smithson.* Los Angeles: Museum of Contemporary Art, Los Angeles, 2004. Exhibition catalogue.

Nancy Spero

Bird, Jon, Jo Anna Isaak, and Sylvère Lotringer. *Nancy Spero.* London: Phaidon, 1996.

Borja-Villel, Manuel J., et al. *Nancy Spero: Dissidences.* Madrid: Museo Nacional Centro de Arte Reina Sofía, 2008. Exhibition catalogue.

Golub, Leon. "Bombs and Helicopters—The Art of Nancy Spero." *Caterpillar* 1 (1967): 46-53.

Horsfield, Kate. "On Art and Artists: Nancy Spero." *Profile* 1 (January 1983): 3.

Jacobus-Parker, Frances. "Shock-Photo: The War Images of Rosler, Spero, and Celmins." In *Conflict, Identity, and Protest in American Art,* edited by Makeda Best and Miguel de Baca, 57-74. Newcastle upon Tyne, UK: Cambridge Scholars Publishing, 2015.

Lyon, Christopher. *Nancy Spero: The Work.* New York: Prestel, 2010.

Nixon, Mignon. "Spero's Curses." *October* 122 (Fall 2007): 3-30.

Posner, Helaine. *Nancy Spero & Leon Golub: War and Memory.* Cambridge, MA: MIT List Center, 1995. Exhibition catalogue.

Spero, Nancy. *Codex Spero: Nancy Spero: Selected Writings and Interviews, 1950-2008.* Edited by Roel Arkesteijn. Amsterdam: Stichting Roma Publications, 2008.

Storr, Robert, et al. *Nancy Spero: The War Series, 1966-1970.* Milan: Charta, 2003. Exhibition catalogue.

May Stevens

Hills, Patricia. *May Stevens.* San Francisco: Pomegranate, 2005.

Lippard, Lucy. *May Stevens: Big Daddy, 1967-75.* New York: Lerner-Heller Gallery, 1975. Exhibition catalogue.

Nemser, Cindy. "Conversations with May Stevens." *Feminist Art Journal* 3, no. 4 (Winter 1974-75): 4-7, 23.

Oral history interview with May Stevens, circa 1971. Archives of American Art, Smithsonian Institution.

Stevens, May. *May Stevens's Big Daddy Paintings 1967-1976: Random Notes on a Persistent Icon.* New York: Bee Sting Press in association with Mary Ryan Gallery, 1997. Exhibition catalogue.

Carol Summers

Carol Summers Woodcuts: 50 Year Retrospective. Woodstock, NY: Woodstock Artists Association, 1999. Exhibition catalogue.

Summers, Carol. *Carol Summers: Catalogue Raisoné, Woodcuts, 1950-1988.* Milwaukee, WI: David Barnett Gallery in association with the Randall Beck Gallery and CCA Galleries, 1988.

Paul Thek

Amy, Michaël. "The Meat Sculpture of Paul Thek." *Sculpture* 33, no. 10 (December 2014): 36-39.

Falckenberg, Harald, and Peter Weibel, eds. *Paul Thek: Artist's Artist.* Karlsruhe: ZKM/Center for Art and Media in association with Sammlung Falckenberg Hamburg. Exhibition catalogue.

Flood, Richard. "Paul Thek: Real Misunderstanding." *Artforum* 20, no. 2 (October 1981): 48-53.

Sussman, Elisabeth, and Lynn Zelevansky. *Paul Thek: Diver, A Retrospective.* New Haven, CT: Yale University Press, 2010. Exhibition catalogue.

Swenson, Gene R. "Beneath the Skin." *ARTnews* 63, no. 35 (April 1966): 35, 66–67.

Tomic, Milena. "Biopolitical Effigies: The Volatile Life-Cast in the World of Paul Thek and Lynn Hershman Leeson." *Tate Papers* 24 (Autumn 2015). https://www.tate.org.uk/research/publications/tate-papers/24/biopolitical-effigies-paul-thek-and-lynn-hershman-leeson.

Jesse Treviño

Cordova, Rubén. "Jesse Treviño: Synonymous with San Antonio." *Rivard Report,* December 4, 2016. https://therivardreport.com/jesse-trevino-synonymous-with-san-antonio/.

McDonnell, Sharon. "Treviño Creates a Vision of Hope." *Hispanic; Miami* 16, no. 12 (December 2003): 64–65.

Oral history interview with Jesse Treviño, July 15–16, 2004. Archives of American Art, Smithsonian Institution.

Ramos, E. Carmen. *Our America: The Latino Presence in American Art.* Washington, D.C.: Smithsonian American Art Museum, 2014. Exhibition catalogue.

Salas, Abel. "Art Veteran." *Hispanic; Miami* 10, no. 9 (September 1997): 30–32.

Treviño, Jesse. *Three Decades of Art by Jesse Treviño.* San Antonio: Instituto Cultural Mexicano, 1993. Exhibition catalogue.

Tomi Ungerer

Adams, Brooks, and Lisa Liebmann. "Out of Line." *Art in America* 102, no. 11 (December 2014): 114–21.

Friedrich, Anton, ed. *Tomi Ungerer, Politrics: Posters, Cartoons, 1960–1979.* Zurich: Diogenes, 1979.

Gilman, Claire. *Tomi Ungerer: All in One.* New York: Drawing Center, 2015. Exhibition catalogue.

Kunzle, David. "Posters of Protest," *ARTnews* 70, no. 10 (February 1972): 51–55, 61–64.

Rennert, Jack. *The Poster Art of Tomi Ungerer.* New York: Darien House, 1971.

Rothenhäusler, Paul. *Amerika für Anfänger: ein Schnellkurs für Europäer.* Zurich: Diogenes, 1960.

Ungerer, Tomi. *Tomi: A Childhood under the Nazis.* Niwot, CO: Roberts Rinehart, 1998.

Timothy Washington

Brockman Davis, Dale. "Pathways, 1966–89." In *African American Artists in Los Angeles, A Survey Exhibition,* edited by Cece Sims, 35–42. Los Angeles: City of Los Angeles Cultural Affairs Department, 2009. Exhibition catalogue.

Inside My Head: Intuitive Artists of African Descent. Los Angeles: California African American Museum, 2009. Exhibition catalogue.

LeFalle-Collins, Lizzetta, and Cecil Ferguson. *19 Sixties: A Cultural Awakening Re-evaluated, 1965-1975.* Los Angeles: California Afro-American Museum Foundation, 1989. Exhibition catalogue.

Mizota, Sharon. "Wonders of Timothy Washington at Craft and Folk Art Museum." *Los Angeles Times,* March 6, 2014.

Young, Joseph E. *Three Graphic Artists: Charles White, David Hammons, Timothy Washington.* Los Angeles: Los Angeles County Museum of Art, 1971. Exhibition catalogue.

William Weege

Colescott, Warrington, and Arthur Hove. *Progressive Printmakers: Wisconsin Artists and the Print Renaissance.* Madison: University of Wisconsin Press, 1999.

Damer, Jack, William Weege, Karin Broker, Rosalie Goldstein, and Milwaukee Art Museum. *Wisconsin Printmakers, Damer, Weege, and Students: Jack Damer, William Weege, Karen [i.e. Karin] Broker, Paul Douglas, Tim High, Edwin Kalke, Anne Marie Karlsen, Wilfred McKinzie, Tony Rubey.* Milwaukee: Milwaukee Art Museum, 1982. Exhibition catalogue.

Hansen, Trudy V., David Mickenberg, Joann Moser, and Barry Walker. *Printmaking in America: Collaborative Prints and Presses, 1960–1990.* Evanston, IL: Northwestern University in association with Harry N. Abrams, 1995. Exhibition catalogue.

Weege, William. *Peace Is Patriotic: Printworks, Collage, and Social Commentary 1966-1976.* Chicago: Corbett vs. Dempsey Gallery, 2017. Exhibition catalogue.

PART II: ART AND ART HISTORY

PRIMARY SOURCES

Books and Periodicals

"The Artist and Politics: A Symposium." *Artforum* 9, no. 1 (September 1970): 35–39.

"Artists Protest at Rand Corp." *Los Angeles Free Press,* June 25, 1965, 1.

"Artists vs. Mayor Daley." *Newsweek*, November 4, 1968, 117.

"The Arts: Protest on All Sides." *Newsweek,* July 10, 1967, 83–86.

"End Your Silence." *New York Times,* April 18, 1965, 5E; and "End Your Silence," *New York Times,* June 27, 1965, 18X.

"Hollywood Gets a Protest Tower." *New York Times*, February 27, 1966, 38.

"Los Angeles: Tower for Peace." *ARTnews* 65 (1966): 25, 71.

"On Vietnam." *New York Times*, June 5, 1966, 207.

"Political Communications." *Artforum* 9, no. 3 (November 1970): 39–41.

"Political Communications." *Artforum* 9, no. 5 (January 1971): 25.

"Political Communications." *Artforum* 9, no. 6 (February 1971): 31

"Political Communications." *Artforum* 9, no. 9 (May 1971): 12.

"Potpourri of Protest." *Newsweek*, March 14, 1966, 101.

"The Role of the Artist in Today's Society." *Art Journal* (Summer 1975): 327–31.

"Tower against War." *Nation*, February 7, 1966, 143.

"We Dissent." *Los Angeles Free Press*, May 14, 1965, 6.

Akston, Joseph James. "Editorial." *Arts Magazine* 45, no. 1 (September–October 1970): 5.

Art Workers' Coalition. "To the Editor." In "Art Mailbag: Why MoMA Is Their Target." *New York Times*, February 8, 1965.

Ashton, Dore. "Angry Arts or Angry Artists?" *Arts & Architecture* 84 (April 1967): 5–6.

———. "The Artist as Dissenter." *Studio International* 171 (1966): 164.

———. "The Artist as the Conscience of Society." *Arts & Architecture* 84, no. 28 (June 1967): 33.

———. "Response to Crisis in American Art." *Art in America* 57, no. 1 (1969): 24–35.

Baker, Elizabeth. "Pickets on Parnassus." *ARTnews* 69, no. 5 (September 1970): 30–33, 64–65.

Battcock, Gregory. "Art and Politics at Venice: A Disappointing Biennale." *Arts* (September/October 1970): 22–26.

———. "The Art Critic as Social Reformer, with a Question Mark." *Art in America* 59, no. 5 (1971): 26–27.

———. "Art: Reviewing the Above Statement." *New York Free Press*, October 31, 1968.

———. "Informative Exhibition at the Museum of Modern Art." *Arts* (Summer 1970): 24–27.

Berger, John. "Photographs of Agony," in *About Looking*, 41–44. New York: Vintage, 1980.

Berman, Art. "Art Tower Started as Vietnam Protest." *Los Angeles Times*, January 28, 1966.

Brown, Gordon. "Effigies of Dragons & Advocates." *Arts Magazine* 41, no. 4 (February 1967): 51.

Glueck, Grace. "Art Notes." *New York Times*, October 27, 1968.

———. "Art Notes: Escalation." *New York Times*, January 30, 1966.

———. "Art Notes: Yanking the Rug from Under." *New York Times*, January 25, 1970, D25.

———. "Art Notes: At the Whitney, It's Guerrilla Warfare." *New York Times*, November 1, 1970.

———. "Art World Seeks Ways to Protest War." *New York Times*, May 20, 1970.

———. "Peace Plus." *Art in America* 58, no. 5 (September/October 1970): 38–42.

———. "A Strange Assortment of Flags Is Displayed at 'People's Show.'" *New York Times*, November 10, 1970.

———. "500 in Art Strike Sit on Steps of Metropolitan." *New York Times*, May 23, 1970.

Golub, Leon. "Art and Politics." *Artforum* 13, no. 2 (1974): 66–71.

———. "The Artist as an Angry Artist: The Obsession with Napalm." *Arts* 41 (April 1967): 48–49.

———. "Letter." *Artforum* 7, no. 1 (March 1969): 4.

Harnack, Curtis. "Week of the Angry Artist…" *Nation*, February 20, 1967, 246.

Hess, Thomas B. "The Artists and Mr. Daley." *ARTnews* 67, no. 7 (November 1968): 29.

Jones, Betsy B., ed. *The Artist as Adversary*. New York: Museum of Modern Art, 1971. Exhibition catalogue.

Kaprow, Allan. *Assemblage, Environments & Happenings*. New York: H. N. Abrams, 1966.

Kay, Jane Holtz. "Artists as Social Reformers." *Art in America* 57, no. 1 (January 1969): 44–47.

Kienholz, Edward. "Letter." *Artforum* (Summer 1969): 4–5.

Kosuth, Joseph. "Art after Philosophy Part II, 'Conceptual Art' and Recent Art." *Studio International* 178, no. 916 (November 1969): 160–61.

———. "1975." *The Fox* 1, no. 2 (1975): 87–96.

Kozloff, Max. "Collage of Indignation." *Nation*, February 20, 1967, 248–49.

———. "The Late Roman Empire in the Light of Napalm." *ARTnews* 69, no. 7 (November 1970): 58–60, 76–78.

Kramer, Hilton. "Artists and the Problem of 'Relevance.'" *New York Times*, May 4, 1969.

Leider Philip. "How I Spent My Summer Vacation or, Art and Politics in Nevada, Berkeley, San Francisco and Utah." *Artforum* 9, no. 1 (September 1970): 40–48.

Lewis, Lamella S., and Ruth G. Waddy. *Black Artists on Art*. Los Angeles: Contemporary Crafts Publishers, 1969.

Lippard, Lucy R. "The Art Worker's Coalition, Not a History." *Studio International* 180, no. 927 (November 1970): 171-74.

———. "The Dilemma." *Arts* (November 1970): 27-29.

———. "Flagged Down: The Judson Three and Friends." *Art in America* 60, no. 3 (May/June 1972): 48.

———. "(I) Some Political Posters and (II) Some Questions They Raise about Art and Politics." In *Get the Message? A Decade of Art for Social Change*, 26-36. New York: E. P. Dutton, 1984.

McShine, Kynaston. *Primary Structures: Younger American and British Sculptors*. New York: Jewish Museum, 1966. Exhibition catalogue.

McShine, Kynaston, ed. *Information*. New York: Museum of Modern Art, 1970. Exhibition catalogue.

Miller, James E., Jr., and Paul D. Herring, eds. *The Arts & the Public*. Chicago: University of Chicago Press, 1967.

Neubert, George W. *Public Sculpture/Urban Environment*. Oakland, CA: Oakland Museum, 1974. Exhibition catalogue.

Perreault, John. "Art: Repeating Absurdity." *Village Voice*, December 14, 1967.

Robins, Corinne. "The N.Y. Art Strike." *Arts Magazine* 69, no. 5 (September/October 1970): 27-28.

Rose, Barbara. "The Lively Arts: Out of the Studios, on the Barricades." *New York Magazine*, August 10, 1970, 54-57.

———. "The Politics of Art Part I." *Artforum* 6, no. 6 (February 1968): 31-32.

———. "The Politics of Art Part II." *Artforum* 7, no. 5 (January 1969): 44-49.

———. "The Politics of Art Part III." *Artforum* 7, no. 9 (May 1969): 46-51.

Rose, Barbara, and Irving Sandler. "Sensibility of the Sixties." *Art in America* 55, no. 1 (January/February 1967): 44-57.

Rosenberg, Harold. *Artworks and Packages*. New York: Horizon Press, 1969.

———. "On Violence in Art and Other Matters" (1969), in *The Case of the Baffled Radical*, 137-43. Chicago: University of Chicago Press, 1985.

Roth, Moira. "The Aesthetic of Indifference." *Artforum* 16, no. 3 (November 1977): 46-53.

Schulze, Franz. "Is It Art or Is It Politics?" *Panaroma—Chicago Daily News*, October 26, 1968.

Schwartz, Therese. "The Politicization of the Avant-Garde I." *Art in America* 59, no. 6 (November/December 1971): 97-105.

———. "The Politicization of the Avant-Garde II." *Art in America* 60, no. 2 (March/April 1972): 70-79.

———. "The Politicization of the Avant-Garde III." *Art in America* 61, no. 2 (March/April 1973): 67-71.

———. "The Politicization of the Avant-Garde IV." *Art in America* 62, no. 1 (January/February 1974): 80-84.

Shikes, Ralph E. *The Indignant Eye: The Artist as Social Critic in Prints and Drawings from the Fifteenth Century to Picasso*. Boston: Beacon Press, 1969.

Sontag, Susan. *On Photography*. New York: Farrar, Straus and Giroux, 1973.

Weber, Anna Nosei, and Otto Hahn. "La sfida del sistema. Inchiesta sulla situazione artistica attuale negli Stati Uniti e in Francia." *Metro: An International Review of Contemporary Art*, no. 14 (June 1968): 34-71.

Special Collections

Charles Brittin Papers. Special Collections, Getty Research Institute, Los Angeles.

Center for the Study of Political Graphics, Los Angeles.

Emile de Antonio Papers. Wisconsin Center for Film and Theater Research, University of Wisconsin, Madison.

Mark di Suvero Papers. Archives of American Art, Smithsonian Institution, Washington, D.C.

Leon Golub Papers. Archives of American Art, Smithsonian Institution, Washington, D.C.

Philip Jones Griffiths Papers. National Library of Wales, Aberystwyth, Wales.

John B. Hightower Papers. Museum of Modern Art Archives, New York.

Lucy Lippard Papers. Archives of American Art, Smithsonian Institution, Washington, D.C.

Kynaston McShine *Information* Exhibition Research. Museum of Modern Art Archives, New York.

The Paley Center for Media, New York.

Yvonne Rainer Papers. Special Collections, Getty Research Institute, Los Angeles.

Carolee Schneemann Papers. Special Collections, Getty Research Institute, Los Angeles.

SPACES—Saving and Preserving Arts and Cultural Environments. Aptos, California.

Nancy Spero Papers. Archives of American Art, Smithsonian Institution, Washington, D.C.

May Stevens Papers. Archives of American Art, Smithsonian Institution, Washington, D.C.

Women's Building Records, 1970–1992. Archives of American Art, Smithsonian Institution, Washington, D.C.

Artist Interviews with Melissa Ho

Bernstein, Judith. January 26, 2016.

Chicago, Judy. September 27, 2017. (phone)

di Suvero, Mark. November 2, 2017. (phone)

Dong, James Gong Fu. November 17, 2017. (phone)

Gamboa Jr., Harry. July 10, 2017.

Haacke, Hans. June 23, 2017.

Hendricks, Jon. December 15, 2016.

Jones, Kim. December 21, 2015.

Lonidier, Fred. March 21, 2017.

Rosler, Martha. February 25, 2016.

Saul, Peter. December 18, 2015.

Schneemann, Carolee. January 29, 2016.

Treviño, Jesse. May 16, 2017.

Washington, Timothy. July 11, 2017.

SECONDARY SOURCES

The Vietnam War and American Art

Adler, Edward J. "American Painting and the Vietnam War." PhD diss., New York University, 1985.

Aulich, James, and Jeffrey Walsh, eds. *Vietnam Images: War and Representation*. New York: St. Martin's Press, 1989.

Berger, Maurice. *Representing Vietnam: The Antiwar Movement in America*. New York: Hunter College Art Gallery, 1988. Exhibition catalogue.

Bryan-Wilson, Julia. *Art Workers: Radical Practice in the Vietnam War Era*. Berkeley: University of California Press, 2009.

Frascina, Francis. *Art, Politics, and Dissent: Aspects of the Art Left in Sixties America*. Manchester, UK: Manchester University Press, 1999.

Goodyear, Anne Collins. "From Technophilia to Technophobia: The Impact of the Vietnam War on the Reception of 'Art and Technology.'" *Leonardo* 41, no. 2 (2008): 169–73.

Israel, Matthew. *Kill for Peace: American Artists against the Vietnam War*. Austin: University of Texas Press, 2013.

Lippard, Lucy R. *A Different War: Vietnam in Art*. Bellingham, WA: Whatcom Museum of History and Art, 1990. Exhibition catalogue.

McCarthy, David. *American Artists against War, 1935–2010*. Oakland: University of California Press, 2015.

———. "Fantasy and Force: A Brief Consideration of Artists and War in the American Century." *Art Journal* 62, no. 4 (2003): 93–100.

Nyugen, Viet Thanh. "Industries of Memory: The Viet Nam War in Art." In *American Studies as Transnational Practice: Turning toward the Transpacific*, edited by Yuan Shu and Donald Pease, 311–39. Hanover, NH: Dartmouth College Press, 2015.

"Peace Tower: Irving Petlin, Mark di Suvero and Rirkrit Tiranvanija Revisit the Artist Tower Protest, 1966." *Artforum* 44, no. 7 (March 2006): 252–57.

Schlegel, Amy. "My Lai: 'We Lie, They Die': Or, a Small History of an 'Atrocious' Photograph." *Third Text* 33 (Summer 1995): 47–66.

Sinaiko, Eve, and Anthony F. Janson. *Vietnam: Reflexes and Reflections*. New York: H. N. Abrams, 1998.

Thomas, C. David, ed. *As Seen by Both Sides: American and Vietnamese Artists Look at the War*. Boston: University of Massachusetts Press, 1991. Exhibition catalogue.

War and Memory: In the Aftermath of Vietnam. Washington, D.C.: Washington Project for the Arts, 1987. Exhibition catalogue.

Zegher, M. Catherine de. *Persistent Vestiges: Drawing from the American-Vietnam War*. New York: Drawing Center, 2005. Exhibition catalogue.

American Art of the 1960s and 1970s

Alberro, Alexander, and Blake Stimson, eds. *Conceptual Art: A Critical Anthology*. Cambridge, MA: MIT Press, 2000.

Anderson, Irene Poon, Mark Johnson, Dawn Nakanishi, and Diane Tani, eds. *With New Eyes: Toward an Asian American Art History in the West*. San Francisco: San Francisco State University, 1995.

Ault, Julie, ed. *Alternative Art, New York, 1965–1985: A Cultural Politics Book for the Social Text Collective*. Minneapolis: University of Minnesota Press, 2002.

Banes, Sally. *Democracy's Body: Judson Dance Theater, 1962–1964*. Ann Arbor, MI: UMI Research Press, 1983.

Battcock, Gregory. *Minimal Art: A Critical Anthology*. Berkeley: University of California Press, 2009.

Boettger, Suzaan. *Earthworks: Art and the Landscape of the Sixties*. Berkeley: University of California Press, 2002.

Broude, Norma, and Mary D. Garrard, eds. *The Power of Feminist Art: The American Movement of the 1970s, History and Impact.* New York: Harry N. Abrams: 1996.

Butler, Cornelia, and Lisa Gabrielle Mark. *WACK! Art and the Feminist Revolution.* Cambridge, MA: MIT Press, 2007. Exhibition catalogue.

Cahan, Susan E. *Mounting Frustration: The Art Museum in the Age of Black Power.* Durham, NC: Duke University Press, 2016.

Campbell, Mary Schmidt. *Tradition and Conflict: Images of a Turbulent Decade, 1963-1973.* New York: Studio Museum in Harlem, 1985. Exhibition catalogue.

Carbone, Teresa, and Kellie Jones, eds. *Witness: Art and Civil Rights in the Sixties.* New York: Brooklyn Museum of Art, 2014. Exhibition catalogue.

Chang, Gordon H., and Mark Dean Johnson, eds. *Asian American Art: A History, 1850-1970.* Stanford, CA: Stanford University Press, 2008.

Collins, Lisa Gail, and Margo Natalie Crawford. *New Thoughts on the Black Arts Movement.* New Brunswick, NJ: Rutgers University Press, 2006.

Cordova, Cary. *The Heart of the Mission: Latino Art and Politics in San Francisco.* Philadelphia: University of Pennsylvania Press, 2017.

Cornell, Daniell, and Mark Dean Johnson, eds. *Asian / American / Modern Art: Shifting Currents, 1900–1970.* Berkeley: University of California Press, 2008. Exhibition catalogue.

Crow, Thomas E. *The Long March of Pop: Art, Music and Design, 1930-1995.* New Haven, CT: Yale University Press, 2015.

———. *The Rise of the Sixties: American and European Art in the Era of Dissent.* New York: Harry N. Abrams, 1996.

Dawsey, Jill, ed. *The Uses of Photography: Art, Politics, and the Re-invention of a Medium.* San Diego: Museum of Contemporary Art San Diego, 2016. Exhibition catalogue.

del Castillo, Richard Griswold, Theresa McKenna, and Yvonne Yarbro-Bejarano, eds. *Chicano Art: Resistance and Affirmation, 1965-1985.* Los Angeles: Wight Art Gallery, University of California, Los Angeles, 1991. Exhibition catalogue.

Foley, Suzanne, and Constance M. Lewallen, eds. *Space, Time, Sound: Conceptual Art in the San Francisco Bay Area, the 1970s.* San Francisco: San Francisco Museum of Modern Art, 1981. Exhibition catalogue.

Foster, Hal. *The First Pop Age: Painting and Subjectivity in the Art of Hamilton, Lichtenstein, Warhol, Richter, and Ruscha.* Princeton, NJ: Princeton University Press, 2014.

Fusco, Coco, ed. *Corpus Delecti: Performance Art of the Americas.* London: Routledge, 2000.

Godfrey, Mark, and Zoe Whitley, eds. *Soul of a Nation: Age in the Art of Black Power.* London: Tate Publishing, 2017. Exhibition catalogue.

Goldberg, RoseLee. *Performance: Live Art since 1960.* New York: Henry N. Abrams, 1998.

Goldstein, Ann, and Anne Rorimer. *Reconsidering the Object of Art: 1965-1975.* Cambridge, MA: MIT Press, 1995.

Jones, Amelia. *Body Art/Performing the Subject.* Minneapolis: University of Minnesota, 2007.

Jones, Kellie. *Now Dig This! Art and Black Los Angeles.* New York: Prestel, 2011. Exhibition catalogue.

———. *South of Pico: African American Artists in Los Angeles in the 1960s and 1970s.* Durham, NC: Duke University Press, 2017.

Kaiser, Philip, and Miwon Kwon, eds. *Ends of the Earth: Land Art to 1974.* Los Angeles: Museum of Contemporary Art, Los Angeles, 2012.

Kaplan, Ilee, Carol A. Wells, and Lincoln Cushing. *Peace Press Graphics: Art in the Pursuit of Social Change.* Long Beach: University Art Museum, California State University, 2011. Exhibition catalogue.

Kaprow, Allan. *Essays on the Blurring of Art and Life.* Edited by Jeff Kelley. Berkeley: University of California Press, 1993.

Kardon, Janet. *1967: At the Crossroads.* Philadelphia: Institute of Contemporary Art, 1987. Exhibition catalogue.

Kelly, Patricia, ed. *1968: Art and Politics in Chicago.* Chicago: DePaul University Art Museum, 2008. Exhibition catalogue.

Kozloff, Max. *Cultivated Impasses: Essays on the Waning of the Avant-Garde, 1964-1975.* New York: Marsilio Publishers, 2000.

Lee, Pamela M. *Chronophobia: On Time in the Art of the 1960s.* Cambridge, MA: MIT Press, 2004.

LeFalle-Collins, Lizzetta, and Cecil Fergerson. *19 Sixties: A Cultural Awakening Re-evaluated, 1965-1975.* Los Angeles: California Afro-American Museum Foundation, 1989. Exhibition catalogue.

Lewallen, Constance M., and Karen Moss. *State of Mind: New California Art circa 1970.* Berkeley: University of California Press, 2011. Exhibition catalogue.

Lippard, Lucy R. *From the Center: Feminist Essays on Women's Art.* New York: Dutton, 1976.

———. *Get the Message? A Decade of Art for Social Change.* New York: E. P. Dutton, 1984.

———. *Six Years: The Dematerialization of the Art Object 1966 to 1972.* Berkeley: University of California Press, 2007.

———. "Time Capsule." In *Art and Social Change: A Critical Reader,* edited by Will Bradley and Charles Esche, 408-21. London: Tate Publishing, 2007.

Machida, Margo. *Icons of Presence: Asian American Activist Art*. San Francisco: Chinese Culture Foundation of San Francisco, 2008. Exhibition catalogue.

Martin, Bradford D. *The Theater Is in the Street: Politics and Performance in Sixties America*. Amherst: University of Massachusetts Press, 2004.

Meyer, James. *Minimalism: Art and Polemics in the Sixties*. New Haven, CT: Yale University Press, 2001.

Morris, Catherine, et al. *We Wanted a Revolution: Black Radical Women, 1965–1985: New Perspectives*. Brooklyn: Brooklyn Museum, 2018.

Nadel, Dan. *What Nerve! Alternative Figures in American Art, 1960 to the Present*. Providence, RI: RISD Museum of Art, 2014.

Newman, Amy. *Challenging Art: Artforum, 1962–1974*. New York: Soho Press, 2000.

Nichols, Thea Liberty. *Hairy Who? 1966–1969*. Chicago: Chicago Art Institute in association with Yale University Press, 2018.

Noriega, Chon A. *Just Another Poster? Chicano Graphic Arts in California*. Santa Barbara: University Art Museum, University of California, Santa Barbara, 2001. Exhibition catalogue.

Noriega, Chon A., Terezita Romo, and Pilar Tompkins Rivas. *L.A. Xicano*. Los Angeles: UCLA Chicano Studies Research Center Press, 2011.

O'Dell, Kathy. *Contract with the Skin: Masochism, Performance Art and the 1970s*. Minneapolis: University of Minnesota Press, 1998.

Peabody, Rebecca, Andrew Perchuk, Glenn Phillips, and Rani Singh, eds. *Pacific Standard Time: Los Angeles Art 1945–1980*. Los Angeles: Getty Publications, 2011.

Phelan, Peggy, ed. *Live Art in LA: Performance in Southern California, 1970–1983*. New York: Routledge, 2012.

Plagens, Peter. *Sunshine Muse: Art on the West Coast, 1945–1970*. Berkeley: University of California Press, 1999.

Ramos, E. Carmen. *Our America: The Latino Presence in American Art*. Washington, D.C.: Smithsonian American Art Museum, 2014. Exhibition catalogue.

Rorimer, Anne. *New Art in the 60s and 70s: Redefining Reality*. London: Thames & Hudson, 2004.

Roth, Moira, and Mary Jane Jacob, eds. *The Amazing Decade*. Los Angeles: Astro Artz, 1983.

Sandler, Irving. *American Art of the 1960s*. New York: Harper & Row, 1988.

Schimmel, Paul, ed. *Out of Actions: Between Performance and the Object, 1949–1979*. Los Angeles: Museum of Contemporary Art, Los Angeles, 1998.

Selz, Peter. *Art of Engagement: Visual Politics in California and Beyond*. Berkeley: University of California Press, 2005.

Shannon, Joshua. *The Recording Machine: Art and Fact during the Cold War*. New Haven, CT: Yale University Press, 2017.

Siegel, Jeanne. *Artwords: Discourse on the 60s and 70s*. New York: Da Capo Press, 1992.

Smith, Richard Cándida. *Utopia and Dissent: Art, Poetry and Poetics in California*. Berkeley: University of California Press, 1995.

Stich, Sidra. *Made in USA: An Americanization in Modern Art, the 50s and 60s*. Berkeley: University of California, 1987.

Sundell, Nina Castelli. *The Turning Point: Art and Politics in 1968*. Cleveland, OH: Cleveland Center for Contemporary Art, 1988.

Taft, Maggie, and Robert Cozzolino, eds. *Art in Chicago: A History from the Fire to Now*. Chicago: University of Chicago Press, 2018.

Ward, Frazer. *No Innocent Bystanders: Performance Art and Audience*. Hanover, NH: Dartmouth College Press, 2012.

Witkovsky, Matthew S. *Light Years: Conceptual Art and the Photograph, 1964–1977*. Chicago: Art Institute of Chicago, 2011.

Wood, Paul, Francis Frascina, Jonathan Harris, and Charles Harrison. *Modernism in Dispute: Art since the Forties*. New Haven, CT: Yale University Press is association with the Open University, London, 1993.

Wye, Deborah. *Committed to Print: Social and Political Themes in Recent American Printed Art*. New York: Museum of Modern Art, 1988. Exhibition catalogue.

War Photography and Photojournalism

Abbott, Brett. *Engaged Observers: Documentary Photography since the Sixties*. Los Angeles: J. Paul Getty Museum, 2010.

Chéroux, Clément, and Clara Bouveresse, eds. *Magnum Manifesto*. London: Thames & Hudson, 2017. Exhibition catalogue.

Kennedy, Liam. *Afterimages: Photography and U.S. Foreign Policy*. Chicago: University of Chicago Press, 2016.

———. "Framing Compassion." *History of Photography* 36, no. 3 (August 2012): 306–14.

Leith, Denise. *Bearing Witness: The Lives of War Correspondents and Photojournalists*. Milsons Point, Australia: Random House, 2004.

Miller, Russell. *Magnum: Fifty Years at the Front Line of History*. New York: Grove Press, 2013.

Moeller, Susan D. *Shooting War: Photography and the American Experience of Combat*. New York: Basic Books, 1989.

Solomon-Godeau, Abigail. "Who is Speaking Thus? Some Questions about Documentary Photography." In *Photography at the Dock: Essays on Photographic History, Institutions, and Practices*, 169–83. Minneapolis: University of Minnesota Press, 1991.

Sontag, Susan. "Looking at War." *New Yorker*, December 9, 2002.

———. *Regarding the Pain of Others*. New York: Farrar, Straus and Giroux, 2003.

Stallabrass, Julian. "Not in Our Name." *Art Monthly*, no. 293 (February 2006): 1–4.

Stallabrass, Julian, ed. *Memory of Fire: Images of War and the War of Images*. Brighton, UK: Photoworks, 2013.

Taylor, John. *Body Horror: Photojournalism, Catastrophe and War*. New York: Manchester University Press, 1998.

Tucker, Anne Wilkes, Will Michels, and Natalie Zelt. *War/Photography: Images of Armed Conflict and Its Aftermath*. Houston: Museum of Fine Arts, 2012. Exhibition catalogue.

Weinberg, Adam. *On the Line: The New Color Photojournalism*. Minneapolis: Walker Art Center, 1986. Exhibition catalogue.

Visual Art in Wartime Vietnam

Another Vietnam: Pictures of the War from the Other Side. Washington, D.C.: National Geographic Society, 2002.

Buchanan, Sherry. *Mekong Diaries: Viet Cong Drawings and Stories 1964–1975*. Chicago: University of Chicago Press, 2008.

Faas, Horst, and Tim Page, eds. *Requiem: By the Photographers Who Died in Vietnam and Indochina*. New York: Random House, 1997.

Harrison-Hall, Jessica, ed. *Vietnam behind the Lines: Images from the War, 1965–1975*. London: British Museum Press, 2002.

Martin, Susan, ed. *Decade of Protest: Political Posters from the United States, Viet Nam, Cuba, 1965–1975*. Santa Monica, CA: Smart Art Press, 1996. Exhibition catalogue.

Tam, Pham Thanh. *Drawing under Fire: War Diary of a Young Vietnamese Artist*. London: Asia Ink, 2005.

Taylor, Nora. *Painters in Hanoi: An Ethnography of Vietnamese Art*. Honolulu: University of Hawai'i Press, 2004.

———. "Re-authoring Images of the Vietnam War: Dinh Q. Le's *Light and Belief* Installation at dOCUMENTA (13) and the Role of the Artist as Historian." *South East Asia Research* 25 (2017): 47–61.

PART III: HISTORY AND CULTURE

Addington, Larry H. *America's War in Vietnam: A Short Narrative History*. Bloomington: Indiana University Press, 2000.

Appy, Christian G. *American Reckoning: The Vietnam War and Our National Identity*. New York: Viking, 2015.

———. *Patriots: The Vietnam War Remembered from All Sides*. New York: Penguin, 2003.

Arlen, Michael J. *Living-Room War*. New York: Penguin, 1982.

Carroll, Al. *Medicine Bags and Dog Tags: American Indian Veterans from Colonial Times to the Second Iraq War*. Lincoln: University of Nebraska Press, 2008.

DeBenedetti, Charles. *An American Ordeal: The Antiwar Movement of the Vietnam Era*. Syracuse, NY: Syracuse University Press, 1990.

Duiker, William J. *Ho Chi Minh: A Life*. New York: Hyperion, 2000.

Duncan, Donald. "'The Whole Things Was a Lie!': Memoirs of a Special Forces Hero." *Ramparts* 4, no. 10 (February 1966): 12–24.

Elliott, Duong Van Mai. *The Sacred Willow: Four Generations in the Life of a Vietnamese Family*. 1999; Reprint, New York: Oxford University Press, 2000.

Erikson, Robert S., and Laura Stoker. "Caught in the Draft: The Effects of Vietnam Draft Lottery Status on Political Attitudes." *American Political Science Review* 105, no. 2 (May 2011): 221–37.

Espiritu, Yến Lê. *Body Counts: The Vietnam War and Militarized Refuge(es)*. Oakland: University of California Press, 2014.

Eymann, Marcia A., and Charles Wollenberg, eds. *What's Going On? California and the Vietnam Era*. Oakland: Oakland Museum of California in association with University of California Press, 2004. Exhibition catalogue.

Farrell, John A. *Richard Nixon: The Life*. New York: Doubleday, 2017.

FitzGerald, Frances. *Fire in the Lake: The Vietnamese and the Americans in Vietnam*. 1972; Reprint, Boston: Little, Brown, 2002.

Foley, Michael S. *Confronting the War Machine: Draft Resistance during the Vietnam War*. Chapel Hill: University of North Carolina Press, 2003.

Hall, Simon. *Rethinking the American Anti-War Movement*. London: Routledge, 2011.

Hallin, Daniel C. *The "Uncensored War": The Media and Vietnam*. New York: Oxford University Press, 1986.

Hammond, William M. *Reporting Vietnam: Media & Military at War*. Lawrence: University Press of Kansas, 1998.

Herring, George C. *America's Longest War: The United States and Vietnam, 1950–1975*. 5th ed. New York: McGraw-Hill, 2014.

Hersh, Seymour. "My Lai 4: A Report on the Massacre and Its Aftermath." *Harper's*, May 1970, 53–84.

Holm, Tom. *Strong Hearts, Wounded Souls: Native American Veterans of the Vietnam War*. Austin: University of Texas Press, 1996.

Hunt, Andrew E. *The Turning: A History of Vietnam Veterans against the War*. New York: New York University Press, 1999.

Ishizuka, Karen L. *Serve the People: Making Asian America in the Sixties*. New York: Verso, 2016.

Karnow, Stanley. *Vietnam, A History*. New York: Viking Press, 1983.

Kiernan, Ben, and Taylor Owen. "Making More Enemies than We Kill? Calculating U.S. Bomb Tonnages Dropped on Laos and Cambodia, and Weighing Their Implications." *Asia-Pacific Journal* 13, no. 3 (April 27, 2015): 1–9.

Jeffreys-Jones, Rhodri. *Peace Now! American Society and the Ending of the Vietnam War*. New Haven, CT: Yale University Press, 1999.

Logevall, Fredrik. *Embers of War: The Fall of an Empire and the Making of America's Vietnam*. New York: Random House, 2012.

Louie, Steve, and Glenn Omatsu, eds. *Asian Americans: The Movement and the Moment*. Los Angeles: UCLA Asian American Studies Center Press, 2006.

Mailer, Norman. *The Armies of the Night*. New York: Penguin, 1968.

Mariscal, George. *Aztlan and Viet Nam: Chicano and Chicana Experiences of the War*. Berkeley: University of California Press, 1999.

McMaster, H. R. *Dereliction of Duty: Lyndon Johnson, Robert McNamara, the Joint Chiefs of Staff, and the Lies That Led to Vietnam*. New York: Harper Collins, 1997.

Miller, Edward, and Tuong Vu. "The Vietnam War as a Vietnamese War: Agency and Society in the Study of the Second Indochina War." *Journal of Vietnamese Studies* 4, no. 3 (Fall 2009): 1–16.

Neer, Robert M. *Napalm: An American Biography*. Cambridge, MA: Belknap Press of Harvard University Press, 2013.

Neu, Charles E. *America's Lost War: Vietnam: 1945–1975*. Wheeling, IL: Harlan Davidson, 2005.

Nyugen, Viet Thanh. *Nothing Ever Dies: Vietnam and the Memory of War*. Cambridge, MA: Harvard University Press, 2016.

———. *The Sympathizer*. New York: Grove Press, 2016.

Pepper, William F. "The Children of Vietnam." *Ramparts* 5 (January 1967): 44–68.

"Reporting Vietnam: One Week's Dead." *LIFE*, June 27, 1969.

Rostker, Bernard. *I Want You! The Evolution of the All-Volunteer Force*. Santa Monica, CA: RAND Corporation, 2006.

Schwenkel, Christina. *The American War in Contemporary Vietnam: Transnational Remembrance and Representation*. Bloomington: Indiana University Press, 2009.

Shafer, Michael D., ed. *The Legacy: The Vietnam War in the American Imagination*. Boston: Beacon Press, 1990.

Sontag, Susan. *Trip to Hanoi*. New York: Farrar, Straus and Giroux, 1969.

Swerdlow, Amy. *Women Strike for Peace: Traditional Motherhood and Radical Politics in the 1960s*. Chicago: University of Chicago Press, 1993.

Taylor, Nora A. "ORIENTALISM/OCCIDENTALISM: The Founding of the Ecole des Beaux-Arts d'Indochines and the Politics of Painting in Colonial Viet Nam, 1925–1945." *Crossroads: An Interdisciplinary Journal of Southeast Asian Studies* 11, no. 1 (1997): 1–33.

Terry, Wallace. *Bloods: Black Veterans of the Vietnam War: An Oral History*. 1984; Reprint, New York: Ballantine, 2006.

Trujillo, Charley. *Soldados: Chicanos in Viet Nam*. San Jose, CA: Chusma House Publications, 1990.

Ueda, Reed. *Postwar Immigrant America: A Social History*. Boston: Bedford Books, 1994.

Ward, Geoffrey C., and Ken Burns. *The Vietnam War: An Intimate History*. New York: Random House, 2017.

Wei, William. *The Asian American Movement*. Philadelphia: Temple University Press, 1993.

Wiest, Andrew A., and Michael Doidge, eds. *Triumph Revisited: Historians Battle for the Vietnam War*. New York: Routledge, 2010.

Williams, Reese, ed. *Unwinding the Vietnam War: From War into Peace*. Seattle: Real Comet Press, 1987.

Wingo, Hal. "The Massacre at Mylai." *LIFE*, December 5, 1969, 36–45.

Wyatt, Clarence R. *Paper Soldiers: The American Press and the Vietnam War*. New York: W. W. Norton, 1993.

Young, Marilyn. *The Vietnam Wars, 1945–1990*. New York: Harper Collins, 1991.

Index

Collage of Indignation (exhibition, Angry Arts Week, New York; 1967), *12*, 27n484, 28n58, *60*, 222n1

Collage of Indignation II (exhibition, New York; 1971), 178, 187n7, 208, 220, 222n1, 222n7

Collective Graphics Workshop, 196n4

Colossal Keepsake Corporation, 141-44

communist expansion, U.S. concerns about, 8, 10, 27n38, 34, 204

Con Safo, 111

conceptualism, 13, 17, 28n69, 40, 137, 148

Connell, Brian, 99n11

conscientious objectors, 21, 137-40, *138, 139*, 180, 204n8, 282, 288

Conlisk, James, 125

Convoy of Tears, 265

Cooper, Alice, 59n9

Cooper, Paula, 223

Coplans, John, 107n2, 288

Copley, William, 23, 60, 78, 145; *Untitled* (1967), 78, *80*

Corbett, William, "The Richard Nixon Story" (poem, 1974), 268n6

Cordova, Rubén, 262

Cox, Archibald, 253

Creeley, Robert, 82n1

Cronkite, Walter, 100-101

Cuban missile crisis, 327

Cuban poster art, 254, 256n5, 298

cultural impact of war, 23-25

Cunningham, Charles, 125

Đà Nẵng, 15, 38, *39*, 207n10, 286

Dada, 333

Đắk Tô, Battle of (1967), 62

Daley, Richard J., 86, 100, 122, 125, 127

d'Arcangelo, Allan, 82n1

Davis, Angela, 99n11

de Antonio, Emile, 6, 306-12, 322n23; *Point of Order* (1964), *309*, 309-10; *Rush to Judgment* (1967), 309, 310; *In the Year of the Pig* (1968), 18, 128, 131-33, *132*, 306-12, *308, 311*, 321

Death and the Maiden, 270

defoliation/herbicide campaigns in Vietnam, 36, *171*, 171-73, 185, 206, 242, 329

Democratic Republic of Vietnam (DRV; North Vietnam), 4, 32, 34, 35, 37, 39, 46, 101, 253, 264, 308

destruction art, 158

di Suvero, Mark, 5, 24, 25n12, 29n91, 46, 78, 82n1, 249, 287; *Homage to the Viet Cong* (1971), 251n8; *L. B. Johnson: MURDERER* (1967), 249; *Mother Peace* (1969-70), 236, *249*, 251; *For Peace* (1972), *ii*, 236, 249-51, *250*; *Vietnam Piece* (1968), 251n8

Điện Biên Phủ, *34*, 100, 131, 309

Dilley, Barbara, 203n8

Dix, Otto, 182

documentary images: as art, 8; AWC, *Q. And babies? A. And babies.* (1970), 164, *167*, 167-70, *168, 169*; de Antonio's *In the Year of the Pig* (1968), 18, 128, 131-33, *132*; Griffiths's *Vietnam Inc.* (1971), 18, 208, 210-18, *211-19*; Huebler's *Location Piece #13* (1969), 148, *149*; Lonidier's *29 Arrests* (1972), 236, 245-48, *246, 247*; Porter's *Untitled*

(The New York Times, Sunday, September 13, 1970), 194-96, *195, 196*; as response to war, 17-19; technical issues of filming in war zone, 305-6, *307*; televised/visualized conflict, Vietnam as, *10*, 18-19, 27n39, 93, 99n7, 115, 131, 305-7, *307*, 310, 316, 322nn1-2, 322nn4-5, 322nn7-8, 346n46, 349-50; visualization of war and, *10*, 18-19. *See also* film

domino theory, 34

Dong, James Gong Fu, 19; *Vietnam Scoreboard* (1969), 15, 128, 134-36, *135*

Dougherty, Frazer, 164, 167, 168

Douglas, Emory, 256n5

Dow Chemical Company, 47, 60, 83, *85*

Dow Chemical Company protests (1967), *85*, 86n1, 86n6, 86n8

draft, 9, 10, 11, 14, 21-22, 37, 39, *47*, 61, 62, 91, 102, 130, 136, 140, 180, 184n7, 238, 240n7, 245, 254, 264, 288, 295, 345n24

DRV (Democratic Republic of Vietnam; North Vietnam), 4, 32, 34, 35, 37, 39, 46, 101, 253, 264, 308

Duchamp, Marcel, 289

Dulles, Allen, 289

Dulles, John Foster, 309

Duncan, Robert, 82n1

Dunlap, Bruce, 28n77

Dương Văn Minh, 36, 266

Earth Day (1970), 173n6, 197, 199n7

Easter Offensive (1972), 236

E.A.T. (Experiments in Art and Technology), 66n9, 316, 319-20

Echols, Alice, 326-27, 345n10

Edelson, Morris, 83, 86n1

Edwards, Paul N., 323n54

The Eighties (exhibition, University of California, Berkeley; 1970), 164, 173

Eisenhower, Dwight, 34, 35

Election (exhibition, American Fine Arts Gallery, New York; 2004), 353, 355n1

Ellin, 330

Ellsberg, Daniel, 17, 209

Emergency Cultural Government Committee, 185, 187n3

Emerson, Eric, 59n9

environmentalism and antiwar sentiment, 173n6, 204-6

Equal Employment Opportunity Commission, 47

Equal Rights Amendment, 236

Ernst, Max, 346n47

Eshleman, Clayton, 82n1

Experiments in Art and Technology (E.A.T.), 66n9, 316, 319-20

Faas, Horst, 229, *232*

Feathers, Kirby, 270-72, 272n3, 272n6

Feigen, Richard, 122, 125

feminism and feminist art, 13, 325-45, 350, 351; Ad Hoc Women Artists' Committee protest at Whitney (1970), 52, 166; A.I.R., *56*, 236; Fresno State College, first feminist art program at, 236; *Goodbye to All That!* (San Diego feminist newspaper), 329-30;

macho and misogyny in antiwar culture, 326-27, 328, 330, 333, 344-45; motherist peace rhetoric, 328-29, 330; *Ms. Magazine,* 209; NOW, founding of, 47; Ono and Lennon's *Bed-In for Peace* (1969) as, 325-26, *326*, 327, 328, 329, 333, 345n2; Ono's *Cut Piece* (1965), feminist readings of, 43; patriarchy, Stevens's *Big Daddy* representing, 180; pluralism, rise of, 14; rape and sexual assault, 32, 70, 73, 101, 158, 167, 288, 327, 335-36, 346n63, 346nn67-68; sexism and visibility of war-related art, 7, 14; women-led peace groups, *14*, 27n57, 38, *327*, 327-29, *328*. *See also* Bernstein, Judith; Chicago, Judy; Kusama, Yayoi; Rosler, Martha; Schneemann, Carolee; Spero, Nancy

film, 10, 305-21; Alleyn's *Alias* (1970), 320; Alleyn's *Introscaphe 1* (1968-70), *318, 319*, 319-21; as art, 8; Carné's *Children of Paradise* (1945), 301; *Loin du Vietnam* (1967), 322n11; Maysles film of Ono's *Cut Piece* (1965), 43, 45; Newsreel, 307, 308; *No Game* (film; 1968), 307; Pontecorvo's *Battle of Algiers* (1966), 300; *The 17th Parallel* (1968), 322n11; television versus, 10, 305-8, 310, 316; voice-over versus document-dossier mode, 308. *See also* de Antonio, Emile; documentary images; Schneemann, Carolee

Finch, Julie, 223

Firestone, Shulamith, 327

Firmin, Sandra, 277n2

First Indochina War (between France and Vietnam; 1946-54), 1, 5, 9-10, 32, *34*, 34-35

First World War (Great War), 291, 305, 333

Fitzgerald, Ella, 294

Image Credits

Jacket

Front: © Martha Rosler, Courtesy of the artist and Mitchell-Innes & Nash, New York. Back: © Estate of William N. Copley/Copley LLC/Artists Rights Society (ARS), New York, Photo courtesy of the International Center of Photography.

Front Matter

p. ii: © Mark di Suvero, Courtesy the artist and Spacetime C. C., Photo by Jerry L Thompson; pp. vi, vii: © Kienholz, Courtesy of L.A. Louver, Venice, CA; p. viii: Courtesy James Cohan, New York, © Holt/Smithson Foundation, Licensed by VAGA at Artists Rights Society (ARS), NY; p. viii: Artwork © Claes Oldenburg 1969, Photograph Shunk-Kender © J. Paul Getty Trust, Getty Research Institute, Los Angeles (2014.R.20); p. x: © 1969 Carlos Irizarry, Photo by Gene Young; pp. xvii–xix: Courtesy the Wally Hedrick Estate and The Box, LA, Photos © Fredrik Nilsen Studio.

"One Thing: Viet-Nam" (Ho)

pp. xx, 3: © One Million Years Foundation, Photo courtesy One Million Years Foundation and David Zwirner; p. 4: Photo © the Trustees of the British Museum, All rights reserved; p. 6: © Tiffany Chung, Photo courtesy the artist and Tyler Rollins Fine Art, New York; (2) © Tiffany Chung, Courtesy the artist and Tyler Rollins Fine Art, New York, Photo by Dan Finn; p. 10: © 1969 Time Inc. All rights reserved. Reprinted/Translated from LIFE and published with permission of Time Inc., Reproduction in any manner in any language in whole or in part without written permission is prohibited, Photographs by Ronald S. Haeberle/The LIFE Images Collection/Getty Images; p. 12: Photo © E. Tulchin; p. 14: Bettmann Archive/Getty Images; p. 15: (1) Courtesy of the artist; (2) Courtesy of the Chinese American Museum, Los Angeles; p. 17: © Peter Saul, Courtesy Venus Over Manhattan, New York; p. 18: Photo by Hans Haacke © Hans Haacke/Artists Rights Society (ARS), New York/VG Bild-Kunst, Bonn, Courtesy the artist and Paula Cooper Gallery, New York; p. 20: © Rupert García, Courtesy Rena Bransten Gallery, San Francisco; p. 21: © 2018 The Nancy Spero and Leon Golub Foundation for the Arts/Licensed by VAGA at Artists Rights Society (ARS), New York, Photo by the Jewish Museum, New York | Art Resource, NY; p. 22: Performance © Kim Jones, Courtesy Zeno X Gallery, Antwerp, Photo © Mark Gulezian/Quicksilver, 1983.

Chronology and Plates

pp. 30, 31: Photo by Dickey Chapelle, Courtesy Wisconsin Historical Society, WHS-75427; p. 34: (1) National Archives; (2) Photo by Jean Peraud/Keystone-France/Gamma-Rapho via Getty Images; p. 35: Photo by Dickey Chapelle, Courtesy Wisconsin Historical Society, WHS-115399; p. 36: (1) AP Photo/Horst Faas; (2) Bettmann Archive/Getty Images; p. 37: (1) Bettmann Archive/Getty Images; (2) AP Photo.

1965

p. 39: (1) Bettmann Archive/Getty Images; (2) The Getty Research Institute, Charles Brittin Papers, 2005.M.11.30, published in the *Los Angeles Free Press;* p. 41: © One Million Years Foundation, Photo courtesy One Million Years Foundation and David Zwirner through the National Gallery of Art; p. 42: © One Million Years Foundation, Photo courtesy One Million Years Foundation and David Zwirner; pp. 44, 45: © Yoko Ono 1965/2019.

1966

p. 46: UCLA Library Special Collections, Charles E. Young Research Library, University of California, Los Angeles, Photo *Los Angeles Times* Photographic Archive (Collection 1429); p. 47: (1) Courtesy National Archives, photo no. 342-C-K20653; (2) © 1966 Dick Durrance, All rights reserved; pp. 48, 49: © 2018 The Nancy Spero and Leon Golub Foundation for the Arts, Licensed by VAGA at Artists Rights Society (ARS), NY, Courtesy Galerie Lelong & Co.; p. 50: (1) © 2018 The Nancy Spero and Leon Golub Foundation for the Arts, Licensed by VAGA at Artists Rights Society (ARS), NY, Courtesy Galerie Lelong & Co., Photo courtesy of the Pennsylvania Academy of the Fine Arts; (2) © 2018 The Nancy Spero and Leon Golub Foundation for the Arts, Licensed by VAGA at Artists Rights Society (ARS), NY, Courtesy Galerie Lelong & Co.; p. 51: © 2018 The Nancy Spero and Leon Golub Foundation for the Arts, Licensed by VAGA at Artists Rights Society (ARS), NY, Courtesy Galerie Lelong & Co.; p. 54: (1) Courtesy of the artist and The Box, LA, Photo © Fredrik Nilsen Studio; (2) © Judith Bernstein, Courtesy of the artist and The Box, LA, Digital image © Whitney Museum, N.Y.; p. 55: Courtesy of the artist and The Box, LA, Photo © Fredrik Nilsen Studio; p. 56: Photo by and courtesy of Judith Bernstein; p. 58: © 2018 Stephen Flavin/Artists Rights Society (ARS), New York, Photo courtesy David Zwirner.

1967

p. 60: Photo by Karl Bissinger; p. 61: AP Photo; p. 62: © Leonard Freed/Magnum Photos; p. 64: (1–8) © 2018 Carolee Schneemann/Artists Rights Society (ARS), New York, Courtesy the artist, P·P·O·W, and Galerie Lelong & Co., New York, Photos by Dan Finn; p. 65: (1) © 2018 Carolee Schneemann/Artists Rights Society (ARS), New York, Courtesy the artist, P·P·O·W, and Galerie Lelong & Co., New York, Photo by Alec Sobelewski; (2, 3) © 2018 Carolee Schneemann/Artists Rights Society (ARS), New York, Courtesy the artist, P·P·O·W, and Galerie Lelong & Co., New York, Photos Herbert Migdoll; p. 67: © The Estate of George Paul Thek, New York, Courtesy of Alexander and Bonin, New York; p. 69: © The Estate of George Paul Thek, Courtesy of Alexander and Bonin, New York, Photo courtesy Hirshhorn Museum and Sculpture Garden, by Cathy Carver; p. 71: © Peter Saul, Digital image © The Whitney Museum, New York; p. 72: © Peter Saul, Photo courtesy Hirshhorn Museum and Sculpture Garden, by Cathy Carver; p. 73: © Peter Saul, Photo courtesy Venus Over Manhattan, New York; p. 75: © Tomi Ungerer/Diogenes Verlag AG, Zürich, Switzerland, All rights reserved, Image courtesy Musées de Strasbourg; p. 76: © Tomi Ungerer/Diogenes Verlag AG, Zürich, Switzerland, All rights reserved, Image courtesy Oakland Museum of California; p. 79: Photo courtesy of the International Center of Photography; p. 80: © 2018 Estate of William N. Copley/Copley LLC/Artists Rights Society (ARS), New York, Photo courtesy of the International Center of Photography; p. 81: © 2018 Estate of Ad Reinhardt/Artists Rights Society (ARS), New York; pp. 83, 84: © William Weege, Images courtesy of Corbett vs. Dempsey; p. 85: Photo courtesy Wisconsin Historical Society, WHS-56532; pp. 88–92: © Corita Art Center, Immaculate Heart Community, Los Angeles, Photos by Arthur Evans; pp. 94–98: © Martha Rosler, Courtesy of the artist and Mitchell-Innes & Nash, New York.

1968

p. 100: © Tim Page/CORBIS/Corbis via Getty Images; p. 101: (1) © Don McCullin/Contact Press Images; (2) © Burt Glinn/Magnum Photos; p. 102: (1) Photo by Paul Sequeira/Getty Images; (2) Dirck Halstead Photographic Archive, e_dh_0992, The Dolph Briscoe Center for American History, The University of Texas at Austin; p. 104: Courtesy of the Wally Hedrick Estate, Image courtesy the Fine Arts Museums of San Francisco; pp. 105, 106: Courtesy of the Wally Hedrick Estate and The Box, LA, Photos © Fredrik Nilsen Studio; p. 108: Photo © 1974 Bruce W. Talamon, All rights reserved; p. 109: © David Hammons, Photo courtesy the Oakland Museum of California; p. 110, © David Hammons, Photo courtesy Tilton Gallery, New York; pp. 112, 113: Courtesy Mel Casas Family Trust; pp. 116, 117: © Kienholz, Courtesy of L.A. Louver, Venice, CA; pp. 119, 120: © YAYOI KUSAMA, Courtesy YAYOI KUSAMA Inc.; p. 123: © 1968 Claes Oldenburg, Courtesy Paula Cooper Gallery, New York; p. 124: Artwork © Claes Oldenburg 1966, Photo by Dennis Hopper; p. 126: © 2018 The

Barnett Newman Foundation, New York/Artists Rights Society (ARS), New York, The Art Institute of Chicago/Art Resource, NY; p. 127: Chicago History Museum, ICHi-062716, Dr. Charles Roland, photographer, © Chicago Historical Society, published on or before 2014, All rights reserved.

1969

p. 129: (1) Bettmann Archive/Getty Images; (2) © 1969 Time Inc., All rights reserved, Reprinted/Translated from LIFE and published with permission of Time Inc., Reproduction in any manner in any language in whole or in part without written permission is prohibited; p. 130: AP Photo/J. Spencer Jones; p. 132: (1–6) From the estate of Emile de Antonio; p. 135: © Jim Dong, Courtesy of the artist, Photo by Mindy Barrett; pp. 138, 139: (1–24) © The Estate of Rosemarie Castoro; pp. 141, 142: Artwork © Claes Oldenburg 1969, Photographs Shunk-Kender © J. Paul Getty Trust, Getty Research Institute, Los Angeles (2014.R.20); p. 143: Claes Oldenburg and Coosje van Bruggen © 1969 Claes Oldenburg; p. 146: © 2018 Faith Ringgold, member Artists Rights Society (ARS), New York, Photo courtesy Glenstone Museum; p. 147: Photo © Jan van Raay; pp. 149, 150: © 2018 Douglas Huebler, Courtesy Darcy Huebler/Artists Rights Society (ARS), NY, Courtesy Paula Cooper Gallery, NY; p. 151: Image courtesy Hirshhorn Museum and Sculpture Garden, Smithsonian Institution, Photo by Lee Stalsworth; pp. 152, 153: © Carlos Irizarry, Photos by Gene Young; p. 154: Digital image © The Museum of Modern Art/Licensed by SCALA | Art Resource, NY; pp. 156, 157: © Hans Haacke/Artists Rights Society (ARS), NY/VG Bild-Kunst, Bonn, Courtesy the artist and Paula Cooper Gallery, NY; p. 159: Photos by Ka Kwong Hui; p. 160: Photo by Mindy Barrett; p. 162: © Yoko Ono 1969/2019; p. 163: Three Lions/Hulton Archive/Getty Images.

1970

p. 165: (1) Photo by John Filo/Getty Images; (2) Bettmann Archive/Getty Images; (3) © The Estate of Garry Winogrand, Courtesy Fraenkel Gallery, San Francisco; p. 166: (1) Photo © Jan van Raay; (2) *Los Angeles Times* Photographic Archive (Collection 1429), UCLA Library Special Collections, Charles E. Young Research Library, University of California, Los Angeles; p. 167: © *The Plain Dealer*; p. 168: Photo © Jan van Raay; p. 169: © 1970 Irving Petlin, Jon Hendricks, and Frazer Dougherty, Photo by Mindy Barrett; p. 171: Courtesy National Archives, photo no. 127-N-A373070; p. 172: © Estate of Terry Fox, Cologne, Photographed for the University of California, Berkeley Art Museum and Pacific Film Archive by Jonathan Bloom; p. 175: © 2018 Bruce Nauman/Artists Rights Society (ARS), New York, Photo by Mitro Hood; pp. 177, 178: Courtesy James Cohan, New York, © Holt/Smithson Foundation/Licensed by VAGA at Artists Rights Society (ARS), NY; p. 179: © 2018 Holt/Smithson Foundation/Licensed by VAGA at Artists Rights Society (ARS), NY, Photo courtesy the International Center of Photography;